The Adobe[®] Photoshop[®] Lightroom[®] 3 Book

The Complete Guide for Photographers

Martin Evening

The Adobe[®] Photoshop[®] Lightroom[®] 3 Book

The Complete Guide for Photographers

Martin Evening

This Adobe Press book is published by Peachpit.

Peachpit

1249 Eighth Street Berkeley, CA 94710 510/524-2178 510/524-2221 (fax) Peachpit is a division of Pearson Education. For the latest on Adobe Press books, go to www.adobepress.com. To report errors, please send a note to: errata@peachpit.com

Copyright © 2010 by Martin Evening Editor: Rebecca Gulick Production Editor: Hilal Sala Compositors: Martin Evening with David Van Ness Copyeditor: Elle Yoko Suzuki Proofreader: Elizabeth Kuball Cover Designer: Charlene Charles-Will Cover Photo: Martin Evening Indexer: James Minkin Technical Reviewer: Ian Lyons

Notice of Rights

All rights reserved. No part of this book may be reproduced or transmitted in any form by any means, electronic, mechanical, photocopying, recording, or otherwise, without the prior written permission of the publisher. For information on getting permission for reprints and excerpts, contact permissions@peachpit.com.

Notice of Liability

The information in this book is distributed on an "As Is" basis without warranty. While every precaution has been taken in the preparation of the book, neither the author nor Peachpit shall have any liability to any person or entity with respect to any loss or damage caused or alleged to be caused directly or indirectly by the instructions contained in this book or by the computer software and hardware products described in it.

Trademarks

Adobe, Lightroom, and Photoshop are registered trademarks of Adobe Systems Incorporated in the United States and/or other countries. All other trademarks are the property of their respective owners.

Many of the designations used by manufacturers and sellers to distinguish their products are claimed as trademarks. Where those designations appear in this book, and Peachpit was aware of a trademark claim, the designations appear as requested by the owner of the trademark. All other product names and services identified throughout this book are used in editorial fashion only and for the benefit of such companies with no intention of infringement of the trademark. No such use, or the use of any trade name, is intended to convey endorsement or other affiliation with this book.

ISBN-13: 978-0-321-68070-9 ISBN-10: 0-321-68070-7

98765432

Printed and bound in the United States of America

Dedicated in memory of Bruce Fraser.

Introduction

Work on the Adobe Photoshop Lightroom program began toward the end of 2003 when a small group of Adobe people, headed by Mark Hamburg, met up at photographer Jeff Schewe's studio in Chicago to discuss a new approach to raw image editing and image management. What would it take to meet the specific needs of those photographers who were now starting to shoot digitally? More specifically, what would be the best way to help photographers manage their ever-growing libraries of images? It was shortly after this that I was invited to join an early group of alpha testers and help work out what sort of program Lightroom (or Shadowland as it was known then) should become. As we began to discuss our different digital photography workflows, it became increasingly obvious why we needed a better way to manage and process our digital photos. Lightroom underwent some pretty major changes in those early stages as the team tried out different workflow ideas, but eventually we ended up with the Lightroom program you see now.

The Adobe Photoshop Lightroom 3 Book represents the culmination of over five years' work, in which I have worked actively with the Lightroom team. Basically, this book is intended to be the ultimate reference guide to Lightroom and is designed to help you get the maximum benefit out of the program. In writing this book, I have had in mind both amateur and professional photographers and have aimed to provide what I believe is the most detailed book ever on this subject. At the same time, I have wanted to make sure that equal space was given to explaining some of the fundamental aspects of digital imaging, such as white balance and exposure. The feedback I have received on previous editions of this book have all been encouraging. It seems that the newbies to Lightroom have found it easy to access and understand all the basics, while the advanced professional users have appreciated all the background detail that's provided. I have to confess that when I first started work on this project, I never imagined the book would end up being over 670 pages in length. Mark Hamburg recently joked that he must have failed in his mission to make Lightroom "unreasonably simple", if you needed a book as thick as mine in order to understand it!

So many changes have taken place since Lightroom 1.0 was released. As a result, not only has the book ended up being a lot bigger, but I have also had to rewrite almost everything that was in the original edition. Although there aren't quite so many major new features in this latest version of Lightroom, there are actually a lot of smaller, less obvious changes that deserve close attention, all of which have been documented here. Then there are the technological changes in hardware and the latest operating systems that have had to be taken into account. As always, I suggest you approach the *Adobe Photoshop Lightroom 3 Book* by reading it in chapter order, starting with Chapter 1: Introducing Photoshop Lightroom, which shows a typical studio photo shoot workflow. This is just one of the ways you can integrate Lightroom into a photography workflow, and it provides you with a good overview of what Lightroom can do.

The Lightroom catalog is a major feature of the program, which is why I have devoted almost 200 pages of the book to providing in-depth advice on how to work with the Library module, including how to import photos and manage your photos better through the use of keywords and metadata. An equal amount of space has been devoted to providing the lowdown on how to make use of all the Develop module controls. Here, I have included some great picture examples, which show how Lightroom can help you unleash your creativity.

This edition of the book has a companion Web site: www.thelightroombook.com. The site contains additional resource material in the form of Lightroom movie tutorials, a few sample images, templates and PDF downloads, plus breaking news on new Lightroom features.

Overall, I am still as excited about Lightroom as I was at the beginning of the program's development, and I hope the book provides the inspiration and insight to help you get the most out of the program, too.

Martin Evening, May 2010

Acknowledgments

I would like to thank my editor, Pamela Pfiffner, for prompting me to get started on this project and for her advice and help during the planning stage of this book. For this particular edition, Rebecca Gulick project-managed the book and has, once again, done an excellent job of making sure everything went smoothly. Other members of the publishing team included the Production Editor, Hilal Sala; Copyeditor, Elle Yoko Suzuki; Proofreader, Elizabeth Kuball; Indexer, James Minkin; and additional compositing and corrections by David Van Ness. I would also like to thank Charlene Charles-Will for her work on the cover and interior design, as well as Damon Hampson, who works on the marketing.

Lightroom is really the brainchild of Mark Hamburg, without whom none of this would have happened. Since Lightroom was developed, I have been helped a lot by the various Lightroom engineers and other members of the team. It is all thanks to them that I have managed to gather the background technical knowledge required to write this book. In particular, I would like to thank Thomas Knoll, Zalman Stern and Eric Chan (who worked on the Camera Raw engineering), as well as Lightroom engineers Troy Gaul, Melissa Gaul, Tim Gogolin, Seetha Narayanan, Eric Scouten, Kevin Tieskoetter, Andrew Rahn, Daniel Tull, Phil Clevenger (who designed the Lightroom interface), and Andrei Herasimchuck (who helped guide Lightroom through the early stages). I would also like to thank product manager Tom Hogarty, product evangelists Bryan O'Neil Hughes and Julieanne Kost, as well as previous product evangelist George Jardine for the support and help they have given me. I would especially like to thank Ian Lyons, who tech-edited the book. Thank you, Ian, for clarifying all the many technical

www.thelightroombook.com

points and providing additional insights. Thanks, too, go to Sean McCormack who provided me with valuable feedback and assistance.

A number of photographic shoots have been carried out specifically for this book. I would like to thank the models, Lucy at Bookings, Sofia at MOT, and Yuliya and Kelly from Zone; Camilla Pascucci for makeup; Terry Calvert and James Pearce for hair; Harriet Cotterill for the clothes styling; Stuart Weston and Neil Soni for the use of their studios; and Harry Dutton for assisting me. Also a big thank-you to Jeff Schewe and George Jardine for documenting the shoots with stills and video.

It has been an interesting experience to see a new program emerge from scratch and has been a pleasure to share the development process in the company of a great group of alpha testers and fellow authors, all of whom were willing to share their knowledge about the program with each another. From this group, I would most like to pay tribute to some of the fellow testers: John Beardsworth, Matthew Campagna, Richard Earney, Katrin Eismann, Jeffrey Friedl, Peter Krogh, Karl Lang, Seth Resnick, Andrew Rodney, Jeff Schewe, and last but not least, the mighty John Hollenberg, who at times it seemed, managed to report every bug going in Lightroom! You will notice that this book is dedicated to the memory of Bruce Fraser who sadly passed away in December 2006. Bruce was one of the original core group of Lightroom alpha testers who helped shaped the program. The Lightroom capture and output sharpening are both based on Bruce's original work on Photoshop sharpening techniques. Bruce was a true genius and is deeply missed by all those who knew and worked with him.

A book like this would be rather boring to read without having some decent photographs to illustrate it with. I supplemented my own photography with that of George Jardine, Sean McCormack, Eric Richmond, and Jeff Schewe, all of whom are credited throughout the book and all of whom I would like to thank. And lastly, I would like to thank my wife, Camilla, and daughter, Angelica, for yet again being so understanding and patient while I was glued to the computer!

Contents

1	Introducing Adobe Photoshop Lightroom 1	
	What is Adobe Photoshop Lightroom?	
	Keeping things simple	
	Modular design	
	Lightroom performance	
	Adobe Camera Raw processing	
	Color controls4	
	The Lightroom workflow5	
	Managing the image library	
	Where does Photoshop fit in? 6	
	Integrating Lightroom with Photoshop 7	
	What you'll need8	
	Installing Lightroom	
	Flash updates	
	64-bit processing 10	
	Single vs. multiple catalogs 10	
	Lightroom preferences	
	Customizing the Identity Plate and appearance 14	
	Help menu	
	Introducing the Lightroom interface	
	A quickstart guide to Lightroom	
	Importing the photos into Lightroom	
	Viewing photos in the Library module	
	Simplifying the interface	
	Zooming in	
	Working in the Develop module	
	Synchronizing Develop settings	
	Reviewing and rating the photos	
	Making contact sheet prints	
	Dimming the lights	
	Saving the shortlisted photos as a collection	
	Retouching a photograph in Lightroom	
	Editing a copy in Photoshop	
	Creating a Web photo gallery	
	Making a final print	
	Exporting the edited photos	
	Working through the book	

2	Importing photos
	Importing images from a card44
	Copy as DNG, Copy, Move, or Add?
	Expanded Import dialog
	Source panel
	Content area
	Destination panel
	File Handling panel
	Secondary backups
	File handling limitations
	File Renaming panel
	Renaming catalog images later
	Apply During Import panel
	Import Presets menu
	Planning where to store your imported photos
	Converting to DNG
	Updating DNG files
	Adding photos from a folder to the catalog
	Importing photos via drag and drop 62
	Importing to a selected folder
	Importing video files64
	Auto imports
	Importing photos directly from the camera
	Connecting the camera to the computer
	Lightroom tethered shooting
	Speedier tethered shooting
	How imported photos are organized
	Image management by metadata

The Library module panels
Navigator panel
The Catalog panel
The Library module Toolbar
Folders panel
Filter bar
Exploring the Library module
Grid view options 80
Library Grid navigation
Working in Loupe view
Loupe view options
Working with photos in both Grid and Loupe views 86

Loupe view navigation	38
Loupe zoom views	39
Loupe view shortcuts	39
About the Lightroom previews	90
Establishing the default Develop settings	90
The initial preview building routine	91
Preview size and quality	91
Generating the 1:1 previews	93
Discarding 1:1 previews	93
Working in Survey view	94
Compare view display options	97
Compare view mode in action	98
Navigating photos via the Filmstrip	00
Working with a dual-display setup	02
How to get the most out of working with	
two displays 10	
Refining image selections 10	
Rating images using picks and rejects	
Rating images using numbered star ratings	
Working with color labels 1	
Lightroom and Bridge labels	
Other labeling methods	
Filtering photos in the catalog 1	
Three ways to filter the catalog 1	
Filtering photos via the Filmstrip	
Adding folders as favorites	
Filtering flagged photos	
Filtering options	
Creating refined color label selections via the Filmstrip. 1	
Color label filtering	
Virtual copy and master copy filters 1	
Subfolder filtering1	
Grouping photos into stacks 1	
Automatic stacking	
Image selection options	
Removing and deleting photos	23

4 Managing photos in the Library module 125

Working with metadata 126
The different types of metadata
A quick image search using metadata
Metadata panel132
Metadata panel view modes

General and EXIF metadata items.	134
File Name	134
Sidecar Files	134
Copy Name	134
Metadata Status	136
Cropped photos	137
Date representation	137
Capture time editing	138
Camera model and serial number	139
Artist EXIF metadata	139
Custom information metadata	140
Metadata presets	140
Editing and deleting metadata presets	142
IPTC metadata	142
IPTC Extension metadata	144
A more efficient way to add metadata	145
Metadata editing and target photos	146
Mail and Web links	148
Copyright status	149
Keywording and Keyword List panels	150
Three ways to add new keywords	150
Applying and managing existing keywords	152
Auto-complete options	152
Removing keywords	154
Keyword hierarchy	154
Keyword filtering	155
Importing and exporting keyword hierarchies	155
Implied keywords	156
Keyword suggestions	157
Keyword sets	158
Creating your own custom keyword sets	159
The Painter tool	160
Photo filtering and searches	163
Filter bar	163
The Filter bar layout	164
Text filter searches	164
Search rules	165
Combined search rules	166
Fine-tuned text searches	166
Attribute filter searches	
Metadata filter searches	167
Metadata filter options	168
Metadata filter categories	
Locating missing photos	170

Custom filter settings 171
Empty field searches 171
No content searches 172
Advanced searches 174
Quick Collections 176
Collections
Target collection
Collections sets
Smart Collections
Publishing photos via Lightroom
Saving and reading metadata
Saving metadata to the file
Tracking metadata changes
XMP read/write options
Where is the truth?
Synchronizing IPTC metadata settings
Synchronizing folders 194
Sorting images
Sort functions
The sort by label text solution
Extra tips for advanced users
Audio file playback
GPS metadata and linking to Google Earth™
How to embed GPS metadata in a photo
GeoTagging with GeoSetter for PC
GeoTagging with HoudahGeo for Mac

About Lightroom catalogs
Creating and opening catalogs
Creating a new catalog
Opening an existing catalog 216
Exporting catalogs217
Exporting with negatives
Exporting without negatives
Including available previews
Opening and importing catalogs
Limitations when excluding negatives
Changed Existing Photos section
Export and import summary 221
Copying a catalog to another computer
A catalog export and import in action

How to merge two catalogs into one
Backing up the catalog file 232
Backup strategies234
Backup software 235
Time Machine backups (Mac)
The catalog/folders relationship 235
Adding new folders 237
Lightroom folders and system folders
Finding the link from the catalog to a folder

Image editing in Lightroom	244
Smarter image processing	244
Camera Raw compatibility	245
Process versions	246
Steps for getting accurate color	247
Calibrating the display	247
Choosing a display	247
Calibrating and profiling the display	247
White point and gamma	248
Matching white balances	248
Steps to successful calibration and profiling	249
Quick Develop panel	252
Quick Develop controls	252
Color controls	253
Auto Tone control	253
Other Tone controls	253
A typical Quick Develop workflow	255
Quick Develop cropping	258
Synchronizing Develop settings	259
Raw or JPEG?	260
The Develop module interface	262
Develop module cropping	264
Rotating the crop	264
Crop aspect ratios	264
Crop to same aspect ratio	268
Repositioning a crop	268
Crop guide overlays	269
Crop guide orientation	271
Cancelling a crop	271
Automatic lens corrections	272
Tool Overlay menu	272

The Tool Overlay options	272
Histogram panel	273
Basic panel controls	274
Basic image adjustment procedure	276
White Balance tool	277
White Balance corrections	279
Creative white balance adjustments	281
Basic adjustments and the Histogram panel	282
Auto Tone setting	
Highlight clipping and Exposure Settings	284
Setting the blacks	284
Vibrance and Saturation	289
Clarity slider	292
Using Clarity to decompress the levels	293
Negative Clarity adjustments	294
Correcting an overexposed image	296
Correcting an underexposed image	298
Match Total Exposures	300
Tone Curve controls	302
Point curve editing mode	304
The Tone Curve zones	306
Combining Basic and Tone Curve adjustments	308
Tone range split point adjustments	314
HSL / Color / B&W panel	316
Selective color darkening	318
False color hue adjustments	319
Using the HSL controls to reduce gamut clipping	320
Lens Corrections panel	322
Chromatic aberration adjustments	324
Defringe controls	326
All Edges corrections	327
Automatic lens corrections	330
Accessing and creating custom camera lens profiles .	331
Perspective corrections	331
Effects panel	334
Post-Crop vignettes	334
Post-Crop vignette options	
Adding grain to images	338
Camera Calibration panel	340
Camera profiles	340
How to create a custom calibration	2001
with DNG Profile Editor	
Creative uses of the Camera Calibration panel	345

Assess	ing your images	348
	Comparing Before and After versions	348
	Managing the Before and After previews	350
lmage	retouching tools	354
	Spot Removal tool	354
	Clone or Heal	356
	Click and drag	356
	Resizing the Spot Removal circles	356
	Repositioning the Spot Removal circles	356
	Tool Overlay options	357
	Undoing/deleting Spot Removal circles	357
	Auto source point selection	357
	Synchronized spotting	358
	Auto Sync spotting	359
	Red Eye Correction tool	360
	Adjusting the cursor size	360
	Localized adjustments.	364
	Initial Adjustment brush options	365
	Editing the Adjustment brush strokes	366
	Saving effect settings	366
	Adjustment brush and gradient performance	366
	Automasking	368
	Previewing the brush stroke areas	370
	Beauty retouching with negative clarity	370
	Hand-coloring in Color mode	372
	Clarity and Sharpness adjustments	374
	Graduated Filter tool	376
	History panel	379
	Snapshots panel	380
	Synchronizing snapshots	382
Easing	the workflow	384
	Making virtual copies	384
	Making a virtual copy the new master	384
	Synchronizing Develop settings	386
	Auto Sync mode	386
	Lightroom and Camera Raw	388
	Viewing Lightroom edits in Camera Raw	388
	Viewing Camera Raw edits in Lightroom	388
	Keeping Lightroom edits in sync	389
	Synchronizing Lightroom with Camera Raw	390
	Copying and pasting Develop settings	
	Copying and pasting settings via the Library module	
	Applying a previous Develop setting	
	Saving Develop settings as presets	

Auto Tone preset adjustments	95
The art of creating Develop presets	95
Creating a new Develop preset	96
Understanding how presets work	97
How to prevent preset contamination	98
Reset settings	01
How to set default camera Develop settings4	02

Black-and-white conversions 406
Black-and-white Develop controls
Black-and-white conversion options
How not to convert
Temperature slider conversions 410
Auto B&W plus white balance adjustments
Manual B&W adjustments
B&W slider tip 417
Black-and-white infrared effect
Fine-tuning black-and-white images 422
Split Toning panel
Split-toning a color image
HSL panel: Desaturated color adjustments
The HSL B&W method
Camera Calibration adjustments

Capture sharpen for a sharp start
Improved Lightroom 3 raw image processing
Default Detail panel settings
Sharpen preset settings435
Sharpen – Portraits
Sharpen – Landscapes
Sample sharpening image
Evaluate at a 1:1 view
Luminance targeted sharpening
The sharpening effect sliders
Amount slider
Radius slider
The suppression controls
Detail slider
Interpreting the grayscale sharpening preview

Masking slider 447
Masking slider preview mode
How to apply sharpening adjustments 450
Creative sharpening with the adjustment tools
Negative Sharpness 453
Noise reduction
Luminance noise reduction
Color noise reduction
Noise reduction tips 455
Color noise corrections

Opening images in Photoshop	460
The Edit in Photoshop options	460
Edit in Adobe Photoshop	461
Edit in additional external editing program	461
File settings options	462
External editing filename options	463
Camera Raw compatibility	464
Creating additional external editor presets	465
How to use the external editing options	466
Photoshop as a sandwich filler for Lightroom.	468
Extended editing in Photoshop	472
How to speed up extended editing in Lightroom	474
Opening photos as Smart Objects in Photoshop	476
Exporting from Lightroom	480
Export presets	480
Export Location	480
Exporting to the same folder	482
File Naming and File Settings	484
TIFF options	484
Original format	484
Saving non-raw files as DNG	484
File Settings	485
Image sizing	486
When to interpolate?	487
Output sharpening	
Metadata	488
Watermarking	489
How to create new watermark settings	490
Post-Processing	
Adding Export Actions in Lightroom	192

Export plug-ins	496
Photomatix Pro export plug-in	497
Exporting catalog images to a CD or DVD	499

10	Printing
	Preparing for print
	The Print module
	Layout Style panel
	Image Settings panel
	Layout panel
	Margins and Page Grid
	Guides panel 509
	Multiple-cell printing510
	Page panel
	How to add a photographic border to a print514
	Page Options 516
	Photo Info
	Picture Package and Custom Package panels
	Image Settings panel
	Rulers, Grid & Guides Panel
	Cells panel
	Page panel
	Custom Package layout
	Page Setup
	Print resolution
	Print Job panel
	Print job color management
	The Lightroom printing procedure
	Managed by printer print settings (Mac)
	Managed by printer print settings (PC)
	Print
	Printing modes533
	Print sharpening 533
	16-bit output
	Print to JPEG File 534
	Custom profile printing 535
	Managed by Lightroom print settings (Mac)536
	Managed by Lightroom print settings (PC) 537
	Rendering intent
	Saving a custom template 539

11	Presenting	your	work		541
----	------------	------	------	--	-----

The Slideshow module
The slide editor view in the content area
Layout panel 545
Options panel
Overlays panel
Creating a custom identity plate
Adding custom text overlays
Working with the anchor points
Backdrop panel
How to create a novelty slideshow template
Titles panel
Playback panel
Preview and Play
Navigating slideshow photos
Slideshows and selections
Template Browser panel
Exporting a slideshow564
Export slideshows to PDF 565
Export slideshows to JPEG
Export slideshows to Video
The Web module
Layout Style panel
The Lightroom HTML and Flash galleries
Lightroom HTML Gallery layout
Lightroom Flash Gallery layout
Airtight AutoViewer gallery
Airtight PostcardViewer gallery
Airtight SimpleViewer gallery
Third-party gallery styles
Site Info panel 577
Color Palette panel
Choosing a color theme
Appearance panel
Appearance settings for the HTML Gallery
Appearance panel settings for the Flash Gallery581
Appearance panel settings for the Airtight galleries 584
Identity Plate options
Image Info panel
Adding titles and captions
Customizing the title and caption information
Creating a custom Text template
Output Settings panel

Previewing Web galleries 591
Image appearance in Slideshow and Web modules
Slideshow module colors
Web module colors
Exporting a Web gallery 592
Uploading a Web gallery 593
Template Browser panel

Appendix A Lightroom Preferences 599

General preferences
Splash screens
Updates
Catalog selection
Import options
Completion sounds and prompts
Presets preferences
Camera-linked settings
Location section
Lightroom Defaults section
External Editing preferences 604
File Handling preferences 606
Import DNG Creation 606
Convert and Export DNG options
DNG compression609
Reading Metadata options610
File Name Generation options610
Camera Raw cache
Interface preferences 611
Panel end marks
Custom panel end marks 613
Panel font size 613
Lights Out
Background614
Keyword Entry
Filmstrip preference options
Interface tweaks615

Appendix B
Lightroom settings
Lightroom settings and templates
The Lightroom preference file
Accessing saved template settings
The Lightroom catalog folder
The catalog database file
Journal file
Lightroom previews data
Thumbnail processing routines
Customizing the Lightroom contents
Hacking the Lightroom contents
The Lightroom RGB space
RGB previews
Tone curve response
Balancing the tone curve
The ideal computer setup for Lightroom
RAM633
Graphics card
Hard drives
Drive configurations
Striped RAID635
Mirrored RAID
A mirror of stripes
RAID 5
Just a bunch of disks
The ideal system?637

Index	
-------	--

Introducing Adobe Photoshop Lightroom

An introduction to the main features in Lightroom, showing an example of a typical studio shoot workflow

Welcome to Adobe Photoshop Lightroom, an image processing and image asset management program that is designed to meet the needs of digital photographers everywhere. This book explains all the main tools that are in Lightroom and provides inspiration and advice on how to get the most out of the program. It also offers tips on how to set up your computer and how to get the best results from your digital camera files.

Lightroom was designed from the ground up to provide today's digital photographers with the tools they need most. This is reflected in the way Lightroom separates the various tasks into individual modules, is able to process large numbers of images at once, and lets you archive and retrieve your images quickly. But before I get into too much detail, let me begin by explaining a little about the basic concept of Lightroom. Then I'll move on to an overview of all the main features and how you might go about using them in a typical digital photography workflow.

What is Adobe Photoshop Lightroom?

Lightroom is a high-quality image processor and image database management system rolled into one, with a modern interface and fast image processing capabilities. The guiding light behind Lightroom's development was Mark Hamburg, who had once been the chief scientist working on Adobe Photoshop. For a good many years, Mark and the rest of the Lightroom team at Adobe looked closely at how photographers worked digitally and the problems they faced when processing and managing large numbers of digital images. This is the result of that research. Lightroom is not a single, monolithic application; instead, it should be viewed as a suite of application modules that combine to provide an ideal workflow for digital photographers.

Keeping things simple

One of the early goals of the Lightroom project was to remove complexity, and right from the start, the founding principle of Lightroom has been to provide "unreasonable simplicity." Lightroom's tools are, therefore, designed to streamline the image management and editing process and to make the user experience as smooth and simple as possible. The program aims to provide photographers with the tools they need most and eliminates the call for complicated workarounds. For the most part, I think you will find that Lightroom has managed to do this. It does not have too many complicated preference dialogs, nor does it demand that you do anything special to optimize the program settings before you get started. For example, there are no color management settings dialogs to configure, since the color management in Lightroom is carried out automatically without requiring any user input. The Lightroom team has, on the whole, managed to achieve its aim of keeping things simple, but as the program has evolved, these principles have, to some extent, been compromised with the introduction of more options and new features.

Modular design

Lightroom was created from scratch. This allowed the engineers to build upon their experience and knowledge of how Photoshop works to produce a brand new program that is purpose-built for modern-day image processing requirements. The Lightroom program is composed of individual, self-contained modules that are built around a core that contains the advanced image processing and image database engines (**Figure 1.1**). Each module can be thought of as offering a unique set of functions, and in Lightroom there are five separate modules: Library, Develop, Slideshow, Print, and Web. This modular approach will make it easier in the future to add and maintain new features. For example, if at some point it is

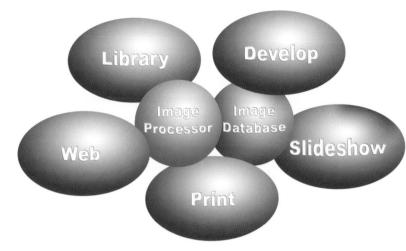

Figure 1.1 Lightroom is engineered using a modular architecture system. At the heart of Lightroom are the image processor and image database engines. Lightroom is designed so that all individual modules are able to tap into these two core components of the application. This is what gives Lightroom its speed and adaptability.

decided that Lightroom needs high dynamic range image editing capabilities, a new self-contained module might be added. From an engineering point of view, this enables Lightroom to run more efficiently because each module can have direct access to the central engines at the core of the program. If there are flaws or bugs in any particular module, these show up only in the functionality of that module and do not compromise or affect the performance of any of the other components. This adds to the overall stability of the program.

One of the reasons Adobe Photoshop rose to such prominence as an image editing application was because of the way Adobe openly encouraged third-party companies to create their own filter plug-ins for Photoshop. Lightroom continues that tradition, and the potential is there for third parties to create add-on features for Lightroom such as Export plug-ins. It is too soon to tell if this will result in lots more third-party products for Lightroom, but rest assured that as new modules are added, Lightroom will never risk becoming bloated since it is easy to turn off or remove the plug-ins and modules you don't need (see Appendix B).

Lightroom performance

As long as the computer you are using meets the minimum requirements listed on page 8, you have all you need to get started, although Lightroom's performance will vary according to the size of your image captures. The basic specifications shown here may be fine for 5- to 6-megapixel camera captures, but if you are shooting with an 11- to 22-megapixel camera, you will definitely want to use a modern, dual-core processor computer with a minimum of 4 GB of RAM in order

NOTE

There are a number of filter-like features in Photoshop (such as Liquify and Vanishing Point) that have been implemented via separate modal dialogs. The downside of this approach is that modal plug-ins do not have access to the central Photoshop image engine to carry out the image processing work and are like applications that have to work within the Photoshop application. This explains why most modal plug-ins act quite sluggish compared to when you are working directly in Photoshop. Lightroom's modular architecture means that as new features are added, they will all have equal access to the image processing and image database engines in Lightroom.

NOTE

You can use the following Mac shortcuts when switching between individual modules (PC users should use [Ctrl][Ait] plus the number):

 Image: Alt: -1 to select Library

 Image: Alt: -2 to select Develop

 Image: Alt: -3 to select Slideshow

 Image: Alt: -4 to select Print

 Image: Alt: -5 to select Web

 Image: Alt: The top to back to the previous module

In addition, (G selects the Library module in Grid mode, (E) selects the Library module in Loupe mode, and (D) selects the Develop module.

NOTE

There is certainly no shortage of "experts" who love to argue that the raw processor program they use produces superior results compared to everything else. I won't argue or deny the quality and potential of other raw processing programs, such as Capture One from Phase One and the proprietary software that is bundled with certain digital cameras. Who am I to try to dissuade people of their heartfelt opinions if they are satisfied with the results they are getting? But Adobe Camera Raw does have some unique features not found in other raw converter programs. More important, the Camera Raw image processing as implemented in Lightroom benefits from a more streamlined workflow.

to get the best performance from the program. With a well-configured computer, you'll have the ability to quickly navigate a collection of images, apply image adjustments, and synchronize settings across a collection or folder of photos. Image catalog searches are fast, and the Lightroom interface is designed to make it easy to update the metadata and narrow your search selections. Wherever possible, Lightroom uses the cached image data to generate the previews, and as a result, you will find it takes no time at all to generate a slideshow or a Web photo gallery. Plus, when you are in the Print module, the Draft mode should take only a few seconds to generate a set of contact sheets. This is because Lightroom is able to print directly from the high-quality image previews instead of re-rendering each image from the master files.

It goes without saying that the performance speed and image quality should be of paramount importance. For Lightroom 3, the engineers have carried out a complete overhaul of the underlying Lightroom architecture and revised the way the previews are generated and managed. This is reflected in the way that the Grid view previews remain sharp when scrolling and the Library module navigation is snappier when you jump from one folder to another. Lightroom has also removed some of the bottlenecks that tended to cause the program to stutter whenever it was overloaded by such requests.

Adobe Camera Raw processing

If you are accustomed to using the Adobe Camera Raw plug-in via Bridge or Photoshop, some of the controls in Lightroom's Develop module will already be familiar to you. This is because Lightroom shares the same Adobe Camera Raw (ACR) processing engine that was originally developed by Thomas Knoll, who with his brother, John Knoll, created the original Photoshop program. It has since evolved to become one of the best raw processing tools on the market, supporting more than 250 different proprietary raw file formats, including most notably the full range of Canon and Nikon digital SLRs. Thomas has now been joined by Zalman Stern and Eric Chan, both of whom have made significant contributions with their work on Camera Raw.

Color controls

Lightroom is intended mainly for working with raw images, but the image adjustment controls in the Develop module can also be applied to TIFF, PSD, or JPEG images that are in RGB, Grayscale, CMYK, or Lab mode (but note that Lightroom image adjustments are always carried out in RGB). The Basic and Tone Curve panels provide intuitive controls with which you can easily adjust the colors and tones in any photograph. The B&W panel offers an adaptable approach to black-and-white conversions whereby you can adjust the balance of color information that is used to create a monochrome version of a color original. As you dig deeper, you will discover that the split tone controls work nicely on color images as well as black-and-white converted pictures. With a little experimentation, you can easily produce quite dramatic cross-processed type effects. The Develop module provides further tools to optimize your photographs. The sliders in the HSL / Color / B&W panel behave exactly the way you would expect them to, so you can easily manipulate the brightness and color characteristics of targeted colors. There are also tools for spotting and applying localized adjustments. Above all, Lightroom 3 has seen a major leap forward in image quality, with the improvements made to the demosaic, sharpening, and noise reduction. These new features alone are a good enough reason for upgrading to version 3.

It is worth pointing out that all Develop adjustments in Lightroom are nondestructive and are recorded as edit instructions that are stored with the image. This means that a single raw master file can be edited in many ways and printed at different sizes without having to make lots of different pixel image versions from the original. Any image edits and ratings you make in Lightroom will also be recognized in current versions of Bridge and Photoshop. The same is true of labels and metadata. Any metadata information that is added to an image via another program will be preserved and updated in Lightroom. For example, if you add keywords and assign a colored label to an image in Bridge, these changes can be transferred to Lightroom and updated in the Lightroom catalog—although this does raise the question of which settings are correct when a single image has been modified in two separate programs. In this situation, Lightroom informs you of any conflicts and lets you decide (see the accompanying Note on updating settings in Lightroom).

The Lightroom workflow

All the modules are presented in a logical order: In the initial import stage, you bring your photos into the Library module. Then you process them in the Develop module. Finally, you export your images or output them via the Slideshow, Print, or Web module.

Managing the image library

Lightroom has been designed to offer a flexible workflow that meets the requirements of all types of photographers. When you work with Lightroom, you begin by explicitly choosing the photos you would like to add to the catalog. From this point on, the way Lightroom manages those images is actually not that much different from working with any other type of browser program. Most browser programs are like glorified versions of the Mac Finder or Windows Explorer; they are mainly useful for inspecting the contents on a computer and allowing you to see everything that is on a drive or in a specific folder. The main difference with Lightroom is that you control which images are imported into Lightroom. Images can be imported from a camera card, directly from the camera (via the Tethered

NOTE

An Adobe Camera Raw adjustment made in one Adobe program will always preview identically in any other Adobe program. If an image has been altered outside Lightroom, a warning exclamation point will alert you and let you decide whether to stick with the current image settings or update using the new settings that have been applied outside of Lightroom.

Capture panel), or by copying them from an existing folder. Or, you can tell Lightroom to add photos to the catalog by importing them from the current folder location. After images have been imported into the catalog, anything you do in Lightroom (such as changing a folder name or filename, deleting a file, or moving a file) are mirrored at the system level. When deleting, you have the option to remove the file from the catalog only or move the file to the trash for permanent deletion. Working with the Folders panel in Lightroom is, therefore, not dissimilar from working with a hierarchical folder list tree view in a browser program. But in Lightroom, the list tree in the Folders panel shows only those photos that you have requested to be in the catalog and nothing else. Of course, a hierarchical folder management is fine if you know in which folders your images are stored. But when you start working with many thousands of photographs, you'll soon find this is no longer such a practical solution. Lightroom can store all your images in a neat hierarchy of folders, but its real power as an image asset manager comes in when you use the Filter bar features to search for images in the catalog. Once you get into the habit of entering descriptive keyword information each time you import new photos, you'll be able to search your archive more easily and more quickly when browsing for specific photographs.

Where does Photoshop fit in?

For many years now, Photoshop has pretty much dominated the pixel image editing market, constantly adapting to meet the varying demands of lots of different types of Photoshop customers, from graphic designers to illustrators to special effects artists working in the motion picture industry. Although Photoshop is a powerful image editing program with a wide range of tools to suit everyone's requirements, it has also become increasingly complex. When the two Knoll brothers, Thomas and John, first created Photoshop, they could hardly have predicted then what Photoshop users in the future would be doing with their program, much less predict the technological demands that digital capture would make. Photoshop started out as a program for editing single images in real time (as opposed to the deferred image processing route), and the legacy of this basic Photoshop architecture has led to various compromises being made as the number of features in Photoshop have expanded.

Many Photoshop authors love to write about what they describe as "simple Photoshop techniques," but then proceed to take up eight pages with step-bystep instructions. (Before anyone gets too upset, I confess that I have been just as guilty as anyone else when it comes to writing about Photoshop!) And then there are all those bits of contradictory advice, such as "Don't use Convert to Grayscale when converting a color image to black and white," or "Don't use the Brightness and Contrast dialog to adjust the brightness and contrast." Sometimes it is almost impossible to avoid going into such detail because to write anything less would only cause more confusion. Plus, some features, such as the Brightness and Contrast command, have been in Photoshop for so long that it would be unwise to remove them now. Lightroom is unencumbered by such legacy issues. You don't have to follow complex workarounds to achieve optimum results, and the Develop module controls all behave exactly the way you would expect them to.

Because Lightroom was built from scratch, the engineers have designed a program that not only addresses current demands but anticipates future needs. For example, take image adjustments. Whenever you apply consecutive image adjustments in Photoshop, you progressively degrade the image. Lightroom, on the other hand, allows you to make as many adjustments and changes as you like, but it only applies them as a single adjustment at the point where you choose Edit in Photoshop or export the photo as a fixed-pixel image.

The Adobe Camera Raw plug-in that is used by both Bridge and Photoshop does provide the same level of flexibility, but only up to the point where you render a raw file as a pixel image to be edited in Photoshop. In Lightroom, the photos in the catalog are like your digital negatives. Whether they are raw files, PSDs, TIFFs, or JPEGs, these are always preserved in their original state throughout the entire Lightroom workflow. You can create slideshows, generate Web galleries, or make print outputs without ever physically altering the original files.

Integrating Lightroom with Photoshop

People often ask if Lightroom could ever become a complete replacement for Photoshop. I somehow doubt it, because Photoshop will always be a specialist tool for retouching single images, making photo composites, and other essential production tasks such as CMYK color conversions. Lightroom, however, can currently be used to perform many of the jobs that, up until now, would have been carried out in Bridge and Photoshop. Lightroom is an ideal front-end application for importing new images and building a searchable database of your master photographs. Once your photos are in Lightroom, you have all the controls you need to carry out image edit selections, group and rename photos, and make basic and advanced Develop adjustments. When you're ready to take your photos into Photoshop, you can use the Photo \Rightarrow Edit in Adobe Photoshop command, or use the File \Rightarrow Export command to process selected images and have these automatically added to the catalog in the same folder as the master files or, if you prefer, to a separate new folder location. Personally, I prefer to keep the archives of the raw files on one drive and the Photoshop-edited derivative files on a separate drive, and I make sure all these files are regularly backed up to drives that are stored off-site.

Although you can use Photoshop to output your photos as prints, the Print module in Lightroom is perfect for all types of print jobs, from draft contact sheets to fine art printing, especially with the dedicated output print sharpener that is built into the Lightroom print processing.

NOTE

Once you start bringing images into Lightroom, you aren't necessarily locked into working exclusively in Lightroom the way you are with some other programs. Lightroom is flexible enough to allow you to work simultaneously with Bridge or other image browser programs.

TIP

To see if the raw files from your camera are supported in Lightroom, go to the Adobe Photoshop Web site at www. adobe.com/products/ photoshop/cameraraw.html.

Those cameras that are capable of capturing raw images using the Digital Negative (DNG) format are also supported by Lightroom. The DNG format offers many benefits: It is a self-contained raw format that can incorporate externally edited XMP metadata (no need for .xmp sidecar files) and, moreover, because DNG is an open standard format, it offers better long term support.

What you'll need

Lightroom is designed specifically for photographers working with digital capture images. Lightroom can process JPEG, TIFF, or raw images, but if your camera is capable of capturing raw images, I advise you to shoot in raw mode whenever possible. Lightroom currently supports more than 250 different raw camera formats.

You will need a computer that meets the minimal specifications listed below. Although it is possible to run Lightroom with a minimum of RAM, Lightroom will certainly benefit from having as much RAM as possible, so install at least 2 GB of RAM. Choosing a computer with a fast chip speed will help, of course, and you will also see a further speed improvement if you are able to run Lightroom via a 64-bit operating system. You don't need much hard disk space to install and run Lightroom, but you will need to give serious consideration as to how you will store all the images in the catalog. Some people can easily shoot 10 GB of images or more in a single day. If you export some of those files as rendered TIFFs or PSDs, your storage requirements can grow considerably in a short amount of time. For more information on computer systems and backup strategies, see Appendix B. Here, though, are the minimum requirements for Mac and PC systems:

Mac

Intel Macintosh processor

Mac OS X 10.5 or 10.6

2 GB of RAM (minimum recommendation)

1 GB or more of hard disk space

Color monitor display with 1024 x 768 resolution or greater

PC

Intel Pentium 4 (or compatible) processor

Windows 7, Windows XP with Service Pack 3, Windows Vista Home Premium, Business, Ultimate, or Enterprise

2 GB of RAM (minimum recommendation)

1 GB or more of hard disk space

Color monitor display with 1024 x 768 resolution or greater

Installing Lightroom

The Lightroom installation process should be quick and easy. All you need to do is download the program or load the installation DVD and run the installer. **Figure 1.2** shows the Mac OS installation dialog and **Figure 1.3** shows the PC version. Simply click the Continue or Next button and follow the on-screen instructions. All you have to do is confirm which drive you want to install Lightroom to and that's it. If you have an earlier version of Lightroom on your computer, the Lightroom installer will know exactly what to do (see sidebar). The first time you launch Lightroom, you will need to read and agree to the terms and conditions and, if installing for the first time, enter a program serial number. If you are installing Lightroom 3 and upgrading an existing Lightroom catalog, you will also be asked at this stage if you would like Lightroom to run a verification process to test the integrity of the current catalog.

NOTE

If you are installing a new full version of Lightroom, the installer will leave the old version and old catalog intact on the computer system and upgrade the old catalog to create a new one. If you are updating Lightroom with a dot release update (i.e., Lightroom 3.1), the installer will overwrite the current 3.x version of Lightroom in the Application/Programs folder.

Figure 1.2 The Lightroom installation dialog for Mac OS X.

Figure 1.3 The Lightroom installation dialog for Windows XP.

Figure 1.4 To enable Lightroom in 64-bit mode for an Intel Macintosh computer, locate the application, go to the Finder, and choose File \Rightarrow File Info. Uncheck the Open in 32 Bit Mode check box and relaunch Lightroom.

Flash updates

Make sure that you read the Read Me file, and download and install the latest Flash update. You will need this to preview Flash galleries generated from the Web module.

64-bit processing

If your computer hardware is 64-bit enabled and you are also running a 64-bit operating system, you can run Lightroom as a 64-bit program either on an Intel Mac or on a Windows Vista 64-bit or Windows 7 system. Intel Mac users will need to follow the instructions in Figure 1.4 to enable the program in 64-bit mode, while Windows Vista and Windows 7 users will need to make sure they download or install the 64-bit version of the program. The 64-bit versions of Lightroom allow you to go beyond the 4 GB RAM limit that was imposed on 32-bit operating systems, assuming that you have more than 4 GB of RAM installed on your computer. If you do have more than 4 GB of RAM installed, then you should see an 8 percent to 12 percent boost in performance speed. Lightroom's performance will be relative to the size of your master image files. The minimum specifications outlined on page 8 may suffice if you are editing only raw or JPEG files from a 5- or 6-megapixel camera. If you want to process files larger than this, you will almost certainly need a faster computer with more RAM memory. With 64-bit processing, you will be able to access the extra memory that is installed on your computer.

Single vs. multiple catalogs

To start with, you will probably want to work with just one Lightroom catalog, which, if you run out of space on your main hard drive, can always be moved to a new disk location at a later date. I know some people have been tempted to work with multiple catalogs. Some have done this as a way to manage their image catalogs in a more browser-like fashion, and others have done so because of problems with Lightroom performance when working with large catalogs of images. Bear in mind that a lot of the Lightroom 3 engineering work has been focussed on improving the catalog file management, so you should now see faster performance when working with large individual catalogs.

Some photographers probably feel comfortable using a folder management system for organizing their photos. But metadata management is now becoming increasingly popular. For example, there are now smarter ways to search a computer archive, such as the Spotlight feature on Mac OS X, which bypasses the need to navigate by folder when you are searching for a specific file. Similarly, Windows Vista encourages you to search the contents of your entire computer system by using text searches to discover all files with matching data.

Lightroom preferences

The default Library location for your Lightroom catalog is the *username/Pictures* folder (Mac) and the *username/My Documents/My Pictures* folder (PC). If you want to create a new catalog in a different location, you can do so by restarting Lightroom with the Alt key (Mac) or the Ctrl key (PC) held down during startup. This displays the Select Catalog dialog shown in **Figure 1.5** where you can click the Create a New Catalog button to select a location to store a new Lightroom catalog. After you have successfully launched the program, go to the Lightroom menu (Mac) or the Edit menu (PC) and choose Preferences. This opens the General Preferences dialog shown in **Figure 1.6** followed by the other preference sections shown in **Figures 1.7** through **1.10**. You can read more about the preference settings in Appendix A, so I'll just point out the key settings for now.

Select a recent catalog to			
Lightroom 3 Cata	log-2-2-4.lrcat	/Volumes/Hard Drive 3/silvertone	folder
Always load this catal	og on startup		Test integrity of this catalog
	Note: Lightroom Catal	ogs cannot be on network volumes or in re	ad-only folders.
		a New Catalog	Quit Open

	Preferences	
Ge	eneral Presets External Editing File Handling Inter	face
	Settings: 🗹 Show splash screen during startup	
	Automatically check for updates	
Default Catalog		
When starting up	use this catalor ✓ Load most recent catalog Prompt me when starting Lightroom	
Import Options	/Volumes/Hard Drive 3/silvertone folder/I Other	Lightroom 3 Catalog-2-2-4
	enerated folder names when naming folders	
	ext to raw files as separate photos	
Completion Sounds		
When finished impor	rting photos play: No Sound	
When finished expor	rting photos play: No Sound	•
Prompts		
	Reset all warning dialogs	
Catalog Settings		
Some settings are ca	talog-specific and are changed in Catalog Settings.	to Catalog Settings

Figure 1.6 In General Preferences, the Default Catalog section also lets you choose which catalog to use when you launch Lightroom. The default setting is "Load most recent catalog," or you can choose "Prompt me when starting Lightroom." If you have already created other catalogs, you can select these from the drop-down menu. If you want the Lightroom Import Photos dialog to appear automatically each time you insert a camera card ready for download, I recommend checking "Show Import dialog when a memory card is detected." **Figure 1.7** You can click the Go to Catalog Settings button in Figure 1.6 to open the Catalog Settings dialog. This allows you to set the catalog backup policy, the catalog preview sizes, and metadata handling settings. You can read more about configuring the catalog settings in Chapters 3 and 5.

1.7	Catalog Settings	
	General File Handling Metadata	
Information		
Location:	/Volumes/Hard Drive 3/silvertone folder	Show
File Name:	Lightroom 3 Catalog-2-2-4.lrcat	
Created:	27/09/2009	
Last Backup:	27/09/2009 @ 11:06	
Last Optimized:	27/09/2009 @ 11:06	
Size:	96.97 MB	
Backup		
Back up catalog		6
	Once a month, when exiting Lightroom	
	Once a week, when exiting Lightroom Once a day, when exiting Lightroom	
	Every time Lightroom exits	
	When Lightroom next exits	

Figure 1.8 Here you can see the Presets section is selected in the Lightroom preferences dialog. If you mostly take photographs of general subjects, you might like to check the "Apply auto tone adjustments" option, especially where you have no control over the lighting. Otherwise leave this option unchecked. But I suggest checking the "Apply auto mix when first converting to black and white" option. We'll be looking at the camera default settings later, but for now leave these unchecked. You might like to check the "Store presets with catalog" option. This allows you to store custom preset settings as part of the catalog. This means that when you export a catalog (see Chapter 5), you can include all custom presets as part of the export. However, the downside of this approach is that the presets will not be available to other catalogs and vice versa.

1	Preferences
	General Presets External Editing File Handling Interface
Default Devel	lop Settings
	y auto tone adjustments
Apply	y auto mix when first converting to black and white
🗌 Make	defaults specific to camera serial number
🗌 Make	defaults specific to camera ISO setting
	Reset all default Develop settings
Location	
Store	presets with catalog Show Lightroom Presets Folder
Lightroom De	efaults
	Restore Export Presets Restore Keyword Set Presets
	Restore Filename Templates Restore Text Templates
	(Restore Local Adjustment Presets) (Restore Color Label Presets)
	Restore Library Filter Presets

*			Preferences
	General Presets	Exter	nal Editing File Handling Interface
dit in Adobe Photosl	hop CS4		
File Format:	TIFF	•	16-bit ProPhoto RGB is the recommended choice for best preserving color details from Lightroom.
Color Space:	ProPhoto RGB		
Bit Depth:	16 bits/component	•	
Resolution:	300		
Compression:	ZIP	•	
Additional External E	ditor		
Preset:	Custom	hiadain	and shift and the state of the st
Application:	Adobe Photoshop CS4.a	рр	Choose Clear
File Format:	TIFF	•	8-bit files are smaller and more compatible with various programs and plug-ins, but will not preserve fine tonal detail as well as 16-bit
Color Space:	ProPhoto RGB	•	data. This is particularly true in wide gamut color spaces such as ProPhoto RGB.
Bit Depth:	8 bits/component	•	
Resolution:	300		
Compression:	None	•	
Edit Externally File N	laming:		
Template:	Custom Settings	in an	
remplace.			Start Number: 1

Figure 1.9 In the Lightroom External Editing preferences you can customize the pixel image editing settings for Photoshop plus an additional external editor. These are the file format, color space, and bit depth settings that are used whenever you ask Lightroom to create an Edit copy of a catalog image to open in an external pixel editing program. The File Format options include Photoshop's native PSD file format or TIFF. The Color Space can be ProPhoto RGB (which is fairly close to the chromaticities of the native Lightroom workspace), or Adobe RGB (which many photographers like using in Photoshop), or sRGB (which is ideal for Web-based output only). The Bit Depth can be 16 bits, which preserves the most amount of Levels information but doubles the output file size, or 8 bits, which is a more standard bit depth but won't necessarily preserve all the Levels information that is obtainable from your master library images.

Figure 1.10 In the File Handling preferences, the Import DNG Creation section lets you customize the DNG settings for when you choose to import and convert to DNG directly. These DNG options, as well as the others listed here, are discussed more fully in Appendix A.

0	Preferences
	General Presets External Editing File Handling Interface
Import DNG Creati	on
	File Extension: dng
	Compatibility: Camera Raw 5.4 and later
	JPEG Preview: Medium Size
	Embed Original Raw File
Reading Metadata	
Treat '/' a	s a keyword separator s a keyword separator s a keyword separator bierarchies instead of flat keywords. The vertical bar is automatically recognized as a hierarchy separator.
File Name Generat	
Treat the fol	llowing characters as illegal: /:
Replace illeg	al file name characters with: Dashes (-)
w	hen a file name has a space: Leave As-Is
Camera Raw Cache	e Settings
Locatio	on: /Users/martin_evening/Library/Caches/Adobe Camera Raw Choose
Maximum Si	ze: 30.0 GB Purge Cache

NOTE

The Identity Plate can also be used by the Slideshow, Print, and Web modules as a custom overlay. Although an Identity Plate logo design to go in the top panel area must be no bigger than 57 pixels tall, you can add Identity Plates that are bigger in pixel size, so that they print properly at a decent pixel resolution when added as an overlay in the Print module.

Customizing the Identity Plate and appearance

There are several ways that you can customize the appearance of the Lightroom program. To start with, we will look at the Identity Plate options where you can replace the standard Lightroom logo with one of your own custom designs. You can also edit the font and colors for the top panel module selector, as well as edit the background color/pattern for the main content area.

Enable Identity Pl	ate MEP text	•		ADOBE
	im environment with your o		and choose a complementary typeface for the module	- Chultoma
	ening Photograp			ideshow »
Helvetica	Regular	20	Myriad Web Pro	22 💌 🗍

1. The top panel in the Lightroom interface contains the Lightroom Identity Plate and module selectors. If you go to the Lightroom menu and select Identity Plate Setup, you will see the dialog shown here. This allows you to enable the Identity Plate, which then appears in the top-left section of the Lightroom interface, replacing the normal Adobe Photoshop Lightroom logo. If you select the "Use a styled text identity plate" option, this displays the name that is registered as the computer administrator using the default Zapfino font. But you can change the font type and font size and use any font that is available on your computer. In the example shown here, I edited the text to show the full name of my company and changed the font to Helvetica.

Name:	MEP text
	Cancel Save

2. After you have configured a custom Identity Plate, you can go to the Identity Plate pull-down menu and choose Save As to save this setting as a new custom template design.

 O O - MEPLtd.png @ 100% (RCB/8) MARTIN EVENING PHOTOGRAPHY LTD 100% 100 ity Plate Edi Enable Identity Plate Custom 0 ADOBE Personalize the Lightroom environment with your own branding elements and choose a complementary typeface for the module picker button O Use a styled text identity plate (Use a graphical identity plate MARTIN EVENING PHOTOGRAPHY LTD Library Develop Slideshow (Clear Image) Myriad Web Pro 🗘 Regular 22 Locate File... Cancel OK (Hide Details)

3. If you select the "Use a graphical Identity Plate" option, you can add an image logo by copying and pasting or dragging a PDF, JPEG, GIF, PNG, TIFF, or PSD (see sidebar note) into the Identity Plate area. The logo image you place here should not be more than 57 pixels tall, but it can contain transparent pixels. Graphical identity plates can also be used in Slideshow and Web module templates, but be warned that a 57-pixel-tall logo will be far too small as an identity plate that is used in a print layout. For print work, you will probably want to create separate Identity Plate graphics that exceed this 57-pixel limit and are, therefore, big enough to print with. You can also customize the appearance of the module selector by choosing a new replacement font in any size you like. And if you click either of the little color swatch icons (circled), you can change the font colors for the active and non-active modules.

NOTE

PSD files can be added only via the Identity Plate Editor using the Macintosh version of Lightroom.

	· A
Martin Evening Photograph	Library Develop Slideshow Print Web
000 L	ightroom 3 Catalog-2-2-4.lrcat - Adobe Photoshop Lightroom - Library

4. Now let's see how the top panel looks after customizing the Identity Plate. You can see here examples of how both the graphical and styled text identity plates looked when viewed in the top panel. **5.** In the Lightroom Interface preferences, you can customize various items such as the appearance of the interface when using the Lights Out and Lights Dim modes (which are discussed later in Step 12 on page 34). You can also customize the background appearance of the main window and secondary window when viewing a photo in Loupe view. You can set separate fill colors and textures for these two window displays.

6. In this example, the main window Fill Color was set to Medium Gray with the Overlay Texture set to Pinstripes (see close-up view).

End Marks:	Flourish (default)	Font Size: Small (default)
Lights Out		
Screen Color:	Black (default)	Dim Level: 80% (default)
Background		
	Main Window	Secondary Window
Fill Color:	Medium Gray (default)	Medium Gray (default)
Texture:	None	None
Keyword Entry		
Separate keyw	vords using: Commas	Spaces are allowed in keywords
Filmstrip		
Show rating	gs and picks	Show photos in navigator on mouse-over
Show badge	es	Show photo info tooltips
Show stack	counts	
Tweaks		
Zoom clicke	ed point to center	☑ Use typographic fractions

Help menu

Figure 1.11 shows the Help menu, as found in the Library module. If you select Library Module Help, you can access the off-line Lightroom user guide where you can browse the help options for the current module (**Figure 1.12**). If you select Lightroom Help, this takes you to the Adobe Lightroom Help and Support page (**Figure 1.13**).

Figure 1.12 The Lightroom off-line Help guide. This guide is installed with the program and displays the contents in a Web browser format.

Figure 1.13 The Adobe Lightroom Help and Support page.

Help	\$	
	Search	
	Lightroom Help The Five Rules	F1
	Lightroom Online Check for Updates	
	System Info	
	Library Module Help	\`36 ?
	Library Module Shortcuts	ж/
	Plug-in Extras	Þ

Figure 1.11 The Help menu is common to all Lightroom modules. This screen shot shows the Library module Help menu. The other modules look similar except they show help items and shortcuts relevant to that particular module. The Lightroom Help option (F1) will take you to a new Adobe AIR-based community help system.

Lightroom menu bar

As with any application, the main menu commands are located in the Lightroom menu bar at the top of the screen (Mac) or at the top of the document window (PC). If you are in absolute full-screen mode, the menu bar will be hidden, but it can be revealed by simply rolling the mouse to the top of the screen.

Top panel

The top panel section contains the Identity Plate, which normally shows the Lightroom logo. But you can customize this via the Lightroom ⇒ Identity Plate Setup menu. For example, you can replace this with your own name or add a company logo graphic. On the right, you have the module selector menu for selecting the Lightroom modules. The Library module is where you preview and manage your catalog collections. Develop is for processing images. Slideshow enables you to output image collections as on-screen presentations. The Print module is for making prints, and the Web module allows you to generate Web sites and upload them automatically to a specified FTP server. You can use the F5 key to toggle showing and hiding the Top panel.

Introducing the Lightroom interface

The following screen shots provide a quick overview of the Lightroom interface, which you'll find provides a consistent layout design from one module to the next. One of the new features in Lightroom 3 is that the side panels' auto show/hide behavior is not quite so sensitive as it was previously. This means if you overshoot with the mouse, you are less likely to reveal the side panels by accident. Unfortunately, it has so far only been possible to implement this interface refinement on the Mac version.

Metadata View

Window

Help

Lightroom File Edit Library Photo

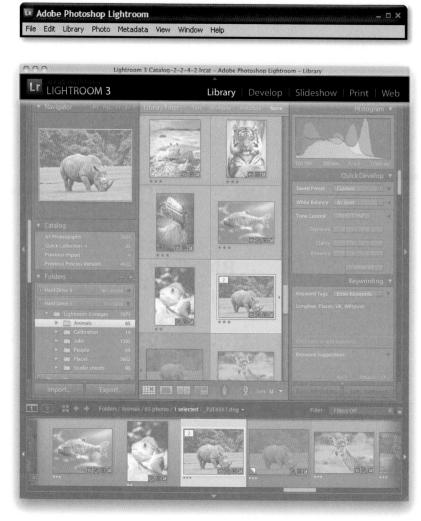

Content area

The content area is the central section of the interface where you can view the photos you are working on. In the Library module Grid view (shown here), you see the images displayed as thumbnails in a grid cell layout. In the Library module Loupe view and Develop module, the photos are displayed at a fit-to-view or 1:1 scale size. In the other modules— Print, Slideshow, and Web—you can see previews of how the images or screen pages will look before you output them from Lightroom.

Attri	Text Any Searchable Field	STATES OF THE OWNER	Metadata None Contains All 🔹 🔍 UK			Custom Filter 🗢
Attri						
Attri	ibute i Flag & & & & i ft			PRES (**** 0		1
			大学学学者 Color			Copy Status
	Camera		Lens All (16 Lenses)	1127 []	None	
1127		1127		CONSISTENT OF		
		0.000		1323		
				100000000000000000000000000000000000000		
				1000000		
				-		
State and				0355388		
				South State		
CLASSIC D				000000		
States and States and						
12000	Unknown Cantera			42		
			EF24-70mm f/2.8L USM	333		
7			EF24-105mm f/4L IS USM	3		
277			EF28-135mm f/3.5-5.6 I5	11		
			EF70-200mm f/2.8L IS USM	322		
	11 4 140 39 92 285 3 285 3 283 283 253 2 27	Canon EOS SD 4 Canon EOS 400D DIGITAL 50 Canon EOS ViellAREB 62 Canon EOS ViellAREB 7 Canon EOS NiellAREB 7 Canon EOS NiellAREB	1 Canon EOS SID 2 4 Canon EOS A0D 3 140 Canon EOS A0D DIGITAL 160 30 Canon EOS HOLD KER. 4 40 Canon EOS HOLD KER. 4 40 Canon EOS-ID Mark II 4 40 Canon EOS-IDS Mark II 44 40 Canon EOS-IDS Mark II 738 40 Canon EOS-IDS Mark III 738 40 Canon EOS-IDS Mark III 738 53 Unknown Camera 6 7 7 77	1 Canon EOS 5D 2 10.0-22.0 mm 4 Canon EOS 20D 3 12-24mm 100 Canon EOS 40D DIGTAL 160 12.0-24.0 mm 30 Canon EOS 40D DIGTAL 160 12.0-24.0 mm 30 Canon EOS 10D Mark II 4 240-70.0 mm 30 Canon EOS 10D Mark II 6 240-70.0 mm 280 Canon EOS 10D Mark II 6 240-70.0 mm 281 Canon EOS 10D Mark II 160 70.0-300.0 mm 285 Unknown Camera 8 EF147mm //2.8.L USM 286 E24-70mm //2.8.L USM E724-70mm //2.8.L USM 277 E724-108mm //4.1.K USM E724-108mm //4.1.K USM	11 Canon EDS SD 2 10.0-22.0 mm 4 4 Canon EDS SDD 2 11.0-22.0 mm 4 44 Canon EDS SDD 3 12-24mm 85 100 Canon EDS SDD DIGTAL 160 12-0-24.0 mm 17 39 Canon EDS DIGTAL EBE 4 240-70.0 mm 17 39 Canon EDS DIGTAL EBE 4 240-70.0 mm 17 30 Canon EDS DIGTAL EBE 4 240-70.0 mm 17 30 Canon EDS DIS Mark II 4 700-200.0 mm 21 31 Canon EDS-IDS Mark II 738 EF-1470.0 mm 4 32 Canon EDS-IDS Mark II 738 EF-1470.0 mm 4 33 Disknown Camera 8 EF14mm f/2.8 LI USM 4 34 EF24-70mm f/2.8 LI USM 4 27 EF24-70mm f/2.4 USM 4 3277 EF24-135mm f/3.55.615 11 14 14	11 Canon EOS SD 2 10.0-22.0 mm 4 2 Canon EOS SDD 3 12.24mm 95 100 Canon EOS SDD DistTAL 100 12.0-24.0 mm 17 100 Canon EOS SDD DistTAL 100 12.0-24.0 mm 17 100 Canon EOS DistTAL REB 4 240-70.0 mm 17 100 Canon EOS TO Mark II 6 28.0-135.0 mm 28 286 Canon EOS TOS Mark II 10 700-300.0 mm 21 286 Canon EOS TOS Mark II 700-300.0 mm 4 22 286 Canon EOS TOS Mark III 738 EF1-10.22mm (73.5-4.5 USM 55 287 Unknown Camera 8 EF1-40mm f/2.8 U.USM 40 287 EF24-70mm f/2.8 U.SM 30 277 EF24-155mm f/2.8 U.SM 31

Filter bar

Whenever you are in the Library module Grid view, the Filter bar can be made to appear at the top of the content area. This allows you to carry out matching text searches using the Text search section, or search by rating or flag status using the Attribute section. Or, you can use the customizable panels in the Metadata filter section to search for photos using various search criteria, such as a specific date, camera type, or lens type. You can use the Ashift key to display more than one Filter bar section at a time and use the \square key to toggle showing and hiding the Filter bar.

Toolbar

A Toolbar is available in all of the Lightroom modules and is positioned at the bottom of the content area. The Toolbar options will vary according to which module you are in and can be customized when you are in the Library or Develop module via the Toolbar options menu (circled). You can use the T key to toggle showing and hiding the Toolbar.

Left panel

In the Library module, the left panel is mainly used for selecting the source photos via the Catalog, Folders, or Collections panel. In the Develop module it is used for the Presets, Snapshots, and History panels, and in the remaining modules it is mainly used for accessing preset settings and collections. For example, if you are working in the Develop module, you can save custom Develop settings as presets, where they can be readily applied to other images. The individual panels can be expanded or collapsed by clicking on the panel bar header. Alt – clicking a panel bar toggles expanding to show the contents of that panel only or expanding to show all panels. You can use the Tab key to toggle showing and hiding both the left and right panels.

Right panel

The right panel section mostly contains panels that provide information about an image, the controls for adjusting an image, or the layout control settings. In the Library module, you can manage the metadata settings for the currently selected photos, and in the Develop module, you can apply image adjustments. In the Slideshow and Print modules, the right panel controls govern the layout and output. As with the left panel, individual panels can be expanded or collapsed by clicking the panel bar header. Alt-clicking a panel bar toggles expanding to show the contents of that panel only, or expanding to show all panels. You can also use the 🕱 key (Mac) or Ctrl key (PC) in combination with a keypad number (0, 1, 2, 3, etc.) to toggle opening and closing individual panels in the order they are listed from the top down.

Filmstrip

The Filmstrip is located at the bottom of the Lightroom window. It contains thumbnails of all the images currently displayed in the Library, highlighting those that are currently selected. The Filmstrip thumbnails are accessible in all the other modules, which allows you access to individual images or sub-selections of images without having to switch back to the Library module.

A quickstart guide to Lightroom

Let's start with a quick overview of how to use Lightroom. I thought that the best way to do this would be to carry out a shoot specifically for this book (**Figure 1.14**). The idea here was to provide an example of a complete workflow from start to finish, showing how Lightroom can be used to process and manage photos that were taken on a typical studio fashion shoot. Of course, there are lots of ways that you can integrate Lightroom into a photography workflow, but rather than try to introduce every feature in the program, I thought it better to show you the way a photographer like myself uses Lightroom in a studio setting. Hopefully, the workflow that's described over the following pages will provide a clear insight into what Lightroom does, how it can be used to speed up the way you work, and how best to integrate Lightroom with Photoshop.

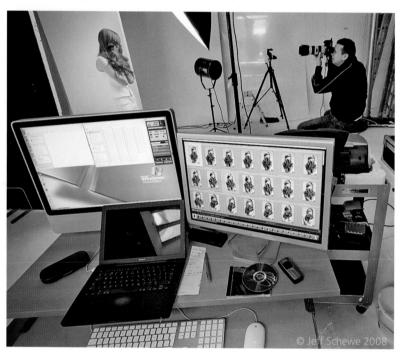

Figure 1.14 *Here is a picture of me at work, shooting with a tethered cable setup and directly importing the photos into Lightroom.*

Importing the photos into Lightroom

There are several ways that you can import your photos into Lightroom. The standard procedure is to insert the camera card into a card reader so that it triggers displaying the Import Photos dialog for configuring the import settings. However, because this was a studio shoot, I chose to shoot in tethered shooting mode (which is described more fully in Chapter 2). With a tethered setup, photos can be imported directly from the camera into the Lightroom 3 catalog.

	Tethered Capture Settings
Session	
Session Name:	LRBook
	Segment Photos By Shots
Naming	
Sample:	LRBook-3003-10012.DNG
Template:	Session+date+sequence
Custom Text:	Start Number: 1
Destination	
Location:	/Volumes/Hard Drive 3/Lightroom 3 images/Studio shoots Choose
Information	
Metadata:	Basic Info
Keywords:	Camilla Pascucci > Makeup artists, Harriet Cotterill, James Pearce, MOT, Sofia
	Cancel OK
	Initial Shot Name
nitial Shot Nam	e: Shot 1
	Cancel OK
Tanon EOS 400D	* 37 17 150 WR Develop Settings Shot 1 9 160 200 Daylight Camera Standard #

1. Before I began shooting any photographs, I went to the File menu and chose File \Rightarrow Tethered Capture \Rightarrow Start Tethered Capture. This opened the main dialog shown here (top). I first entered an appropriate shoot name for the job I was about to shoot, selected a file naming scheme for the images as they were to be imported, and selected a destination folder to download the capture files to. I was also able to establish the metadata settings that should be added to the imported photos, adding the keywords seen here. When I clicked OK in the Tethered Capture Settings dialog, the middle dialog appeared, asking me to create a shot name. I clicked OK, which then opened the Tethered Capture control panel (bottom). When the camera was switched on, this displayed the current camera data settings, and the camera name appeared in the top-left section. The only settings that needed adjusting on a shot-by-shot basis were the Keywords in the Tethered Capture Settings and the Develop settings in the Capture control panel. Once everything had been configured, I was able to start shooting (**Figure 1.15**).

NOTE

By using meaningful names for your imported shoots, you can keep track of where your image files are stored. The same is true if you add keywords and other metadata at this stage. This information will further help with the management of the Lightroom catalog.

Figure 1.15 Whether you prefer to work in tethered mode or by importing directly from the camera card, once the Import settings have been configured at the beginning of the day, you can carry on shooting and let Lightroom batch process the photos for you.

Viewing photos in the Library module

Figure 1.16 The status indicator shows the progress of background processes such as importing images or rendering previews.

2. The imported images started to appear in the Library module, which is shown here in Grid view. The activity viewer in the top-left corner indicates that Lightroom was actively carrying out a background process. In this example, it was importing photos. If more than one operation is taking place at a time, you will see the grouped status indicator (**Figure 1.16**). If you click the small arrow to the right, you can toggle the status indicator between each task that is in progress and the grouped indicator. The imported images normally appear in the grid in the order of preference (such as sort by filename or capture time), and you can make selections of images by using either the grid or the Filmstrip at the bottom. In this example, I rearranged the order of the photos in the grid by choosing the descending sort order option so that the newest photos appeared first at the top of the grid.

3. I now switched to viewing the photos in the Loupe view, which allowed me to preview the images on the screen one at a time. You can go to the Loupe view from the grid by clicking the Loupe view button, pressing the **(E)** key, or just double-clicking an image to jump to Loupe view. The arrow keys on the keyboard let you quickly shuttle through all of the images in the current image selection. To scroll through a selection without scrolling the images, just drag the Filmstrip scroll bar at the bottom of the screen. The base magnification can be set to either fit or fill the width of the content area, while the magnified Loupe view can be set from a 1:4 to an 11:1 zoomed pixels view (yes, Lightroom goes to 11!). The Loupe view is ideal for checking photos for detail and focus and rating your images. Also shown here is the Quick Develop panel for making rough Develop adjustments without having to switch to the Develop module.

TIP

You can open and close the Lightroom panels by clicking anywhere on the panel tab. If you (Alt)-click a panel tab, you can switch to a solo mode of operation, where clicking an individual tab will open that panel only and close all the others. (Alt)-click a panel again to restore the normal panel behavior.

Simplifying the interface

TIP

The default side panel behavior can be modified with a right-click to access the contextual menu options. The default setting is Auto Hide & Show where the side panels auto-reveal and hide as you roll the cursor to the sides of the screen. The Auto Hide option hides the panels, which will be revealed (overlaying the image) only when you click the side arrow. In Manual mode, you can toggle between hiding the panels and revealing them again, but with the content area resizing to fit the available space. **4.** Now let's look at ways to make Lightroom's interface simpler to work with, as well as how to hide interface components and place more emphasis on the images. If you press the Tab key, this temporarily hides the two side panels and provides more space for the photo to be displayed in the Loupe view. Press Tab and the two side panels are revealed once again. However, when one or more of the side panels are hidden, you can still access the side panels by rolling the mouse cursor over to the edges of the screen. Do this and the panels are revealed again. You will notice how the panels temporarily overlay the image below, but you can still access the panel controls as usual. If you click the little arrow in the middle of the side of the screen, you can lock these panels independently. When you do this, the image will center-adjust to reveal the entire image area again. The panel rollover behavior described here can be modified via the contextual menu (see side panel). In this example, I hid the left panels only, but I could reveal them again by rolling the mouse cursor to the left edge of the screen.

5. So far, I had been working with the Lightroom interface in the document window mode. If you press the F key, the interface switches to full-screen mode and expands to fill the whole screen. Press F a second time, and the interface switches to absolute full-screen mode (shown here) where the system menu bar disappears and Lightroom overrides any operating system rollover behaviors. For example, on the Mac, the absolute full-screen mode overrides the Dock as you roll the mouse cursor to the bottom or side of the screen. But you can still access the system menu bar by rolling the mouse cursor to the top of the screen. You can press the F5 key to toggle hiding and showing the Lightroom top panel and press the F6 key to hide and show the Filmstrip at the bottom. In addition, you can use ﷺAtt F (Mac) or Ctrl Att F (PC) to return directly to the normal document window mode, or use ∰GShift) F (Mac) or Ctrl Gshift) F (PC) to toggle between a document window view and a full-screen view with the top, bottom, and side panels hidden. Finally, you can use GShift Tab to hide and show everything!

TIP

If you ever get stuck in a situation where you need to reset the interface layout, press ☆ Shift Tab a couple of times to restore everything back to the default layout.

Zooming in

TI

You can use \Re + (Mac), Ctrl + (PC) to zoom in and \Re - (Mac), Ctrl - (PC) to zoom out. This will magnify the photo from Fit to view, to Fill view, to 1:4 and a 1:1 magnification. You can also use \Re Alt + (Mac), CtrlAlt + (PC) to zoom in using gradual increments up to 11:1 and use \Re Alt - (Mac), CtrlAlt - (PC) to zoom out again using gradual zoom increments. **6.** I wanted to stay in the full-screen Loupe mode with the side panels hidden, so I rolled the mouse over to the left of the screen to reveal the left panel, which could then be locked into position (see Step 4). I could then get the image to zoom smoothly to a 1:1 or custom magnified pixels view by clicking anywhere on the photo. If I clicked the image again, it would return to the normal screen view. Whether you are in Grid or Loupe view, if you press (Z), the image will be instantly displayed at the 1:1 (or custom) magnified view mode. Press (Z) again and the image reverts to the Library Grid view. The Navigator panel can also be used to zoom and scroll the image. Click inside the image preview to select an area to zoom to and then drag the small rectangle to scroll the photo. You can also use (Spacebar) to toggle between the standard and magnified Loupe viewing modes.

Working in the Develop module

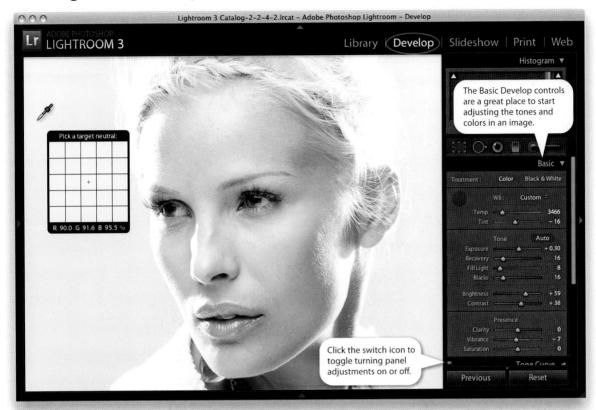

Then I went to the Develop module so I could initially adjust the tone and 7. color in a sample image from the shoot. If you are accustomed to working with the Adobe Camera Raw plug-in in Bridge and Photoshop, you will already be familiar with the Basic controls. There is a lot you can do to correct an image using the Basic panel adjustments as well as the other panel controls, such as Tone Curve, HSL / Color / B&W, Split Toning, Detail, Effects, and Camera Calibration. On a busy photo shoot, I typically use just the Basic panel controls to fine-tune the white point and adjust the tone controls such as Exposure and Blacks. In this example, the White Balance tool is shown hovering over the image. I could have used this to click in the backdrop area and correct the blue cast, but it so happened I quite liked the cool-blue effect, so I left this as it was. Once I like the effect achieved using the Develop adjustments, I may choose to save these as a custom preset for future use (Figure 1.17). For example, if you refer back to Step 1, you'll remember I mentioned how you can apply custom Develop settings via the Tethered Capture panel. By saving custom Develop settings for a particular look, you can apply these via the Tethered Capture panel at the time of import. The same applies for regular camera card imports via the new Import dialog.

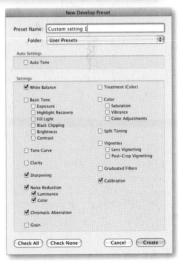

Figure 1.17 You can save your favorite Develop settings such as cameraspecific Develop settings as presets.

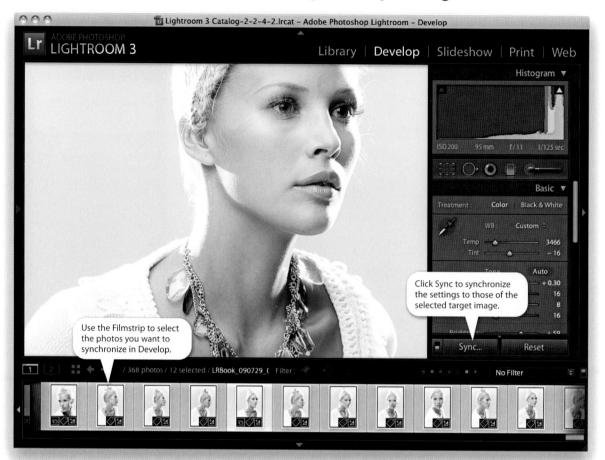

Synchronizing Develop settings

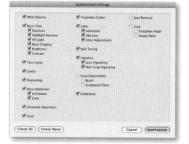

Figure 1.18 Develop settings such as the Spot Removal, Crop, and Straighten settings can be selectively synchronized across other images.

8. Once I had adjusted the Develop settings to get one photo looking the way I liked, I was able to synchronize the Develop settings with all the other photographs from the same shoot sequence. To do this, I selected the photos I wanted to synchronize via the Filmstrip. (You can briefly pop back to the Library Grid view, if you find this easier.) I made sure the image I wanted to synchronize all the other selected image, and clicked the Sync button to synchronize all the other selected photos with this photo (Figure 1.18). Note that Lightroom offers unlimited undo options, so you can always choose Edit □ Undo or ℜ[Z] (Mac) or Ctrl 2 (PC) any time you need to revert to a previous step. If you want to redo a step, use ℜ Oshift Z] (Mac) or Ctrl Oshift Z] (PC). The History panel offers even more flexible control, allowing you to preview and revert to any of the history steps associated with the image; plus, the history states always remain stored with the photo. I'll explain more about History and Snapshots in Chapter 6.

Reviewing and rating the photos

So far, this first set of photos had been added to the catalog using the 9. Tethered Capture setup so that the photos ended up in the designated folder location, with a new filename and IPTC and keyword metadata added. The tethered import process applied an initial Develop setting that I had later updated by synchronizing a new Develop setting across the selected photos belonging to this first shoot series. I was now ready to start reviewing the pictures and mark which ones were the favorites. You can do this in the Develop or Library module, but the Library module is faster for this type of editing. By now, Lightroom should have processed all the photos to create standard previews, but if not, you can always go to the Library menu and choose "Render Standard-sized previews." I could rate the images in different ways. I could rate the best images using the flag system (pressing P to mark a photo as a flag pick), or I could use the numbered rating system. In this example, I pressed 1 to mark photos with a 1-star rating, 2 to mark those that deserved a 2-star rating, and so on. In the above screen shot, all the 1-star and higher images were currently selected.

1P

Use 黑D (Mac) or Ctrl D (PC) to deselect a Library selection of images, and use 黑슈Shift D (Mac) or Ctrl 슈Shift D (PC) to select the most selected (or active) photo only.

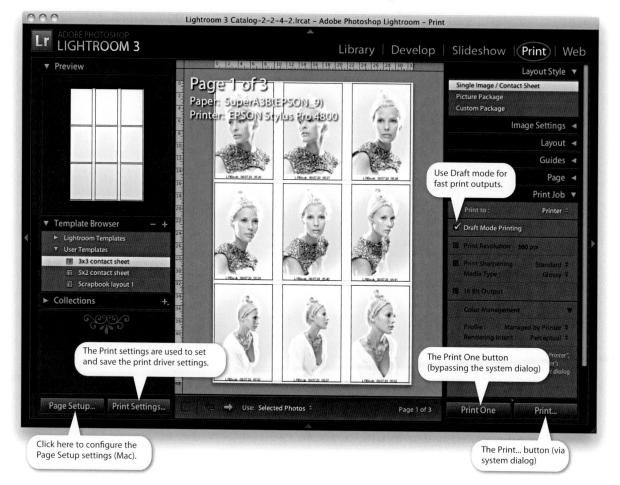

Making contact sheet prints

Figure 1.19 Some clients like having contact sheets of the 1-star rating and higher images. This is because they can edit the photos anywhere without the need for a computer; plus, they can write notes on the contact sheet prints.

10. I am often required to provide clients with contact sheets from a day's shoot (**Figure 1.19**). This is where the Draft Mode Printing option in the Print module comes in handy. In the example shown here, I kept the same selection of images active and picked a modified contact sheet print template from the Template Browser panel. Lightroom displays a preview of the contact sheet that contains the currently selected images, and the Info overlay indicated here that I was looking at page 1 out of 3 printable contact sheet pages. For speedy printing, the Draft Mode Printing option was checked in the Print Job panel. This grayed out all the other options, meaning that I would need to turn on the printer's color management option when I configured the Print Settings and make sure I used a correctly matched media/paper type setting. I'll discuss the Page Setup and Print Settings options in Chapter 10. Note here that the Windows version of Lightroom shows just a single Print Settings button.

Reviewing the final shortlist in Survey mode

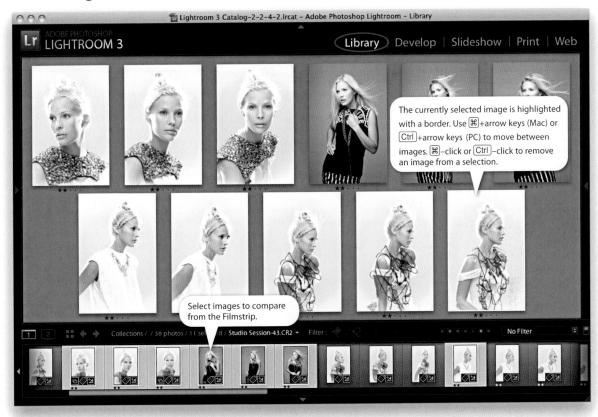

11. Contact sheets aren't always necessary, but as you can see in Figure 1.20, it does make it easier for clients to spread out the contact sheets on a table and compare all the shots at once. If there is time to go through the pictures on the computer, you can always do so using the Loupe view. Whichever method you use, the goal will be to narrow down a selection of photos so that you end up with a shortlist of favorite images from which you may wish to select just one or two final candidate shots. At this stage I often find it useful to switch to the Survey view in the Library module (N). The main advantage of working in the Survey view is that you can easily compare all the shortlisted photos at once and the individual images are displayed as big as possible on the screen. This is because, in Survey view, the selected images are automatically resized to fit within the content area. If you want to inspect a particular image in close-up, you can double-click to open it in Loupe view and double-click (or press N) to return again to the Survey view mode. When you are in the Survey view, you can) –click (Mac) or Ctrl –click (PC) on an image to remove it from the current selection and thereby whittle down the remaining selection of images to choose from. In the example shown here, I managed to refine the selection down to a choice of 11 photos.

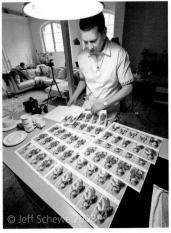

Figure 1.20 This shows me sorting through a set of contact sheet prints before giving them to the client.

Dimming the lights

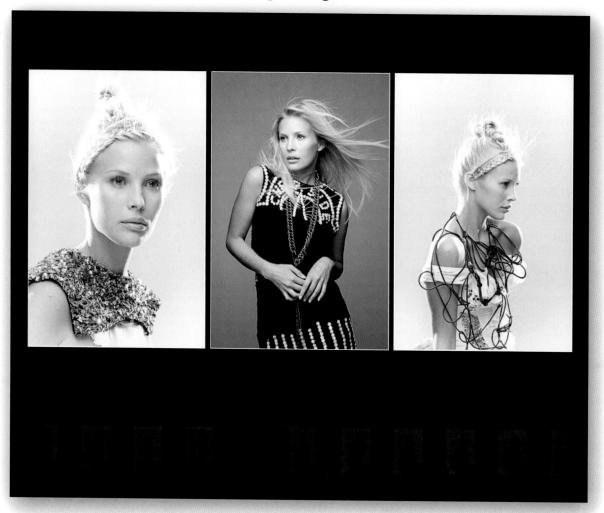

NOTE

The default Lights Dim and Lights Out modes use varying opacities of black. If you go to the Lightroom Interface preferences (see page 16), you can set the Lights Out screen color to other shades of gray and adjust the dim level opacity. This is useful if you prefer to view your images isolated against a light neutral gray instead of a solid black. **12.** It can sometimes help to work with the program interface subdued or hidden. To this end, Lightroom has the Lights Dim and Lights Out modes. These two viewing modes allow you to dim or hide the interface so you can focus more on what is going on in the photographs, yet still have easy access to the interface when you need it. To see how these work, press the L key once. This switches Lightroom to a Lights Dim mode (which is the view shown here). The Lights Dim mode just darkens the interface so you can still see (and access) all the Lightroom controls and menu items. Pressing L a second time takes you to the Lights Out mode, and then pressing L again takes you back to the default viewing mode. Note that if you roll the mouse to the top of the screen, you can still view the menu bar at normal brightness.

Saving the shortlisted photos as a collection

13. Once ratings or flags have been added, you can easily make filtered shortlist selections. However, you can only do this to reveal the filtered photos in one folder at a time or when filtering, say, a keyword selection. To save groups of images from different filter search results, you'll need to use collections. In other words, you can use collections to save groups of images that have portfolio potential by selecting groups of photos from two or more shoot folders. In the example shown here, I made a selection of all the 2-star or higher images and pressed the B key to add these to the Quick Collection section of the Catalog panel. Quick Collections are useful for creating temporary image groupings, but if you want to make a collection more permanent, you can click the plus button in the Collections panel to add a new collection to the list. Collections can be used to store module-specific attributes; plus, you can set up Smart Collections to automatically add photos to a collection based on set criteria. For more about working with Collections, refer to Chapter 4.

NOTE

You can use the Filter bar at the top of the content area to filter photos by ratings higher than, lower than, or by a specific rating only. You can also filter photos according to flag status or color labels, and the text search field can be used to carry out text-based searches.

Retouching a photograph in Lightroom

NOTE

The localized adjustments also let you apply other types of adjustments to a photo such as darken, boost the saturation, add clarity, or colorize portions of a photo. **14.** Once you have decided which photos have made the final shortlist, the next stage will be to take them through to the photo finishing stage before making a final print output. The Develop tools in Lightroom have come a long way from the early days of Adobe Camera Raw for Photoshop. You can carry out the majority, if not all, of the adjustments that are needed to prepare an image ready for retouching. Lightroom even provides tools for making localized image adjustments using the Adjustment brush or Gradient Filter tools. In this step, I made a few fine-tuning adjustments to the Basic panel settings. I then used the Adjustment brush tool to apply a darkening exposure adjustment to the hair. Finally, I used the Spot Removal tool to remove a couple of sensor dust spots that were visible in the backdrop area.

Editing a copy in Photoshop

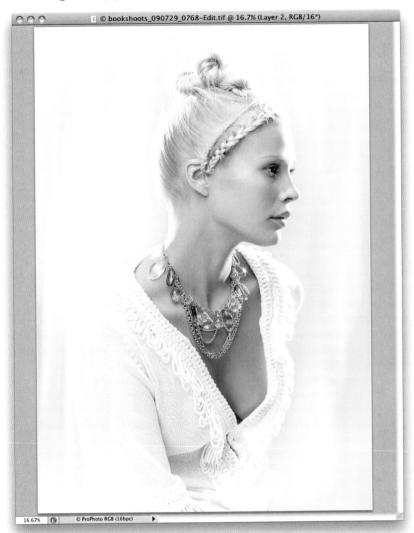

15. Even though there is a lot you can do in Lightroom, it will usually be necessary to use Photoshop to carry out the more detailed retouching. In the example shown here, I went to the Photo menu and chose Edit in Photoshop ($\mathbb{E}[\mathbb{E}]$ [Mac], $\mathbb{C}trl[\mathbb{E}]$ [PC]). How the photo opened would depend on how the Edit options were configured (see sidebar). For example, the photo shown here opened as a ProPhoto RGB 16-bit image. I then used my Photoshop skills to tidy up some of the loose hairs and smooth out the skin tones. When I was done editing, I chose File \Rightarrow Save, which saved the image using the preconfigured file format setting (see page 13) and added the photo to the Lightroom catalog in the same folder location as the raw original.

NOTE

The external editor options are discussed on page 13 of this chapter as well as on page 454 in Chapter 9. Basically, you can establish the RGB space, bit depth, and file format options that should be used whenever you use the Edit ▷ Open in Photoshop or Edit ▷ Open in additional external editor options.

Creating a Web photo gallery

Server	waw.martinev	ening.com	
Username	Administrator		Password
			Black password in preset
Server Path:	/review		a cost
13311	FTP [0]	Port 21	Passive mode for data transfers. Passive
Protocol			

Figure 1.21 The Configure FTP File Transfer dialog.

NOTE

When you select one of the Flash templates, Lightroom checks to see that you have the latest Adobe Flash Player installed. If you don't, it will provide a link for you to install it. **16.** The Web module can be used to generate Web photo galleries using HTML or Flash gallery styles. You'll find that the Web module options give you full control to modify and create your own Web photo galleries. This screen shot shows a preview of the final shortlist of shots, displayed using an Airtight PostcardViewer gallery style. The preview displayed in the content area actually shows you a Web browser view of a fully coded Web site. When you are happy with the way the site looks, you can click the Upload button to upload the complete site files and folders to a preconfigured server address (which can be specified in the Upload Settings panel). You will need to configure the FTP settings for a server only once and add these settings as an FTP preset (**Figure 1.21**). Once you have done this, it is an easy process to upload new Web photo galleries to a saved favorite server location. Web galleries offer a great way to share photos with friends, create portfolio presentations, or, as shown here, provide clients with an overview of the best photos from a shoot.

Making a final print

17. To make a high-quality print output, you can start by selecting one of the default single-page templates and customizing the settings to suit the paper size you will be using. Depending on how you want the image to appear on the page, you might want to click the Page Setup button to configure the printer for land-scape or portrait printing. In the Print Job panel, you will want to disable the Draft Mode Printing option, and in the Color Management section, select a profile that matches the printer and print media you will be using. If you don't see the profile you are looking for listed here, you can select Other from the Profile pop-up menu to browse the system *Profiles* folder. In the screen shot shown here, I selected a known profile for the printer/paper combination I was about to print to, selected the Relative Rendering Intent, and set the Print Sharpening to Standard and for Glossy media. The Print Settings would also need to be configured for the correct media paper setting with the printer color management turned off. All I had to do then was click the Print One button to bypass the system Print dialog and make a finished print.

TIP

As you create custom print settings, these can be saved as user print templates. To update an existing template, hold down the Ctrl key (Mac), or hold down the right mouse button (both Mac and PC), select a print preset, and choose "Update with current settings" from the contextual menu. This saves the Page Setup and Print settings to the print template. This can really make printing a lot more foolproof. After you have saved all your print settings to a template, there is no need to reconfigure them the next time you select that particular template.

NOTE

Note that when the TIFF, PSD, or JPEG options are selected, you can choose which RGB color space to use, constrain the pixel dimensions, and set the pixel resolution for the exported images.

NOTE

The File Settings section now includes an option to include video files in an export. This will simply export any selected video files in their original format. You can also export all image files in their original file formats. In fact, this is the only way you can export imported CMYK images.

Exporting the edited photos

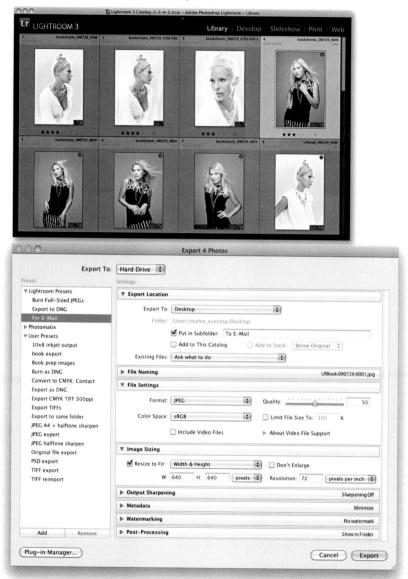

18. The Export command can be used whenever you wish to apply the Lightroom settings to an image and export a photo (or collection of photos) as a JPEG, PSD, TIFF, or DNG file. To export from Lightroom, make a selection of photos and choose File ⇒ Export (or click the Export button). In the Export dialog, choose which folder the images should be exported to, how you might want to rename them, and the file format you want the files to be in. In this example, I selected the For E-mail preset, which can be used to prepare low-res versions of the master photos using the sRGB color space at an appropriate size for sending by e-mail.

Working through the book

This concludes the introduction to working with Lightroom. In the remainder of the book, we will explore each aspect of the program in greater depth. Lightroom has been designed almost exclusively for digital photographers. This makes my task slightly easier, because being a photographer myself, I have a clearer idea of what other photographers will find important and useful to know. To this end, I have structured the book to match a typical workflow, starting with the various ways you can import your photos into Lightroom. At the beginning of this chapter, I described how the philosophy behind Lightroom was to offer "unreasonable simplicity." If Adobe has been successful in this mission, you should find that much of the Lightroom program is fairly self-explanatory. For example, if you go to the Help menu, you will see a Shortcuts item for whichever module you happen to be using (Figure 1.22 shows the shortcuts for the Library module). In keeping with the spirit of Lightroom, I have tried as much as possible to avoid discussing the technical workings of the program and have focused on discussing what Lightroom does best: managing, editing, and outputting photographs. If you really want to know more about how Lightroom works, I have reserved Appendix B to elaborate on various technical features like the Lightroom native RGB space. I have also included several pages devoted to side topics that relate to working in Lightroom, and you will find lots of quick tips in the page margins of this book. These will also help increase your understanding of the program.

TIP

To find out all the latest news about Adobe Photoshop Lightroom, go to the Lightroom News Web site at http://lightroom-news.com.

View Chartcute

View Shortcuts	
Esc	Return to previous view
Return	Enter Loupe or 1:1 view
E	Enter Loupe view
C	Enter Compare mode
G	Enter Grid Mode
Command + Return	Enter Impromptu Slideshow mode
F	Cycle to next Screen Mode
Command + Option + F	Return to Normal Screen Mode
L	Cycle through Lights Out modes
Command + J	Grid View Options
l	Cycle Grid Views
/	Hide/Show the Filter Bar
Rating Shortcuts	
1-5	Set ratings
Shift + 1-5	Set ratings and move to next photo
6-9	Set color labels
Shift + 6-9	Set color labels and move to next photo
0	Reset ratings to none
[Decrease the rating
]	Increase the rating
Flagging Shortcuts	
	Toggle Flagged Status

•	Toggle Flagged Status	
Command + Up Arrow	Increase Flag Status	
Command + Down Arrow	Decrease Flag Status	

Target Collection Shortcuts

В	Add to Target Collection	
Command + B	Show Target Collection	
Command + Shift + B	Clear Quick Collection	

Figure 1.22 It is always worth selecting the Shortcuts item in the Help menu $-\mathfrak{K}$ (Mac) or $[\mathfrak{Ctn}]$ (PC)—to find out more about the shortcuts for each module.

Library Shortcuts

Photo Shortcuts	
Command + Shift + I	Import photos
Command + Shift + E	Export photos
Command + [Rotate left
Command +]	Rotate right
Command + E	Edit in Photoshop
Command + S	Save Metadata to File
Command + -	Zoom out
Command + =	Zoom in
Z	Zoom to 100%
Command + G	Stack photos
Command + Shift + G	Unstack photos
Command + R	Reveal in Finder
Delete	Remove from Library
F2	Rename File
Command + Shift + C	Copy Develop Settings
Command + Shift + V	Paste Develop Settings
Command + Left Arrow	Previous selected photo
Command + Right Arrow	Next selected photo
Command + L	Enable/Disable Library Filters

Panel Shortcuts

Tab .	Hide/Show the side panels	
Shift + Tab	Hide/Show all the panels	
0	Hide/Show the toolbar	
Command + F	Activate the search field	_
Command + K	Activate the keyword entry field	
Command + Option + Up Arrow	Return to the previous module	

11.3

5

考え

2

Importing photos

A guide to the various ways you can bring your photos into Lightroom

Lightroom is essentially a catalog management program and raw image processor combined into one. It is also important to appreciate how Lightroom differs from browser programs such as Adobe Bridge, where you simply point Bridge at a folder to inspect the contents. The browser method is really suited for those times when you want the freedom to search everything that's on your computer. The downside of this approach is that you first have to know *where* to look in order to find what you are searching for; plus, you will also be shown all the files that are contained in any folder. This can make image browsing quite tricky when you have lots of non-image files to sort through, too.

Lightroom is different, because for Lightroom to manage your photos, you must first import them and make a conscious choice as to which photos you want added to the catalog. As you will see, the import procedure has now been radically improved to offer a more adaptable import workflow, one that can be streamlined through the use of Import presets. You should also notice how Lightroom 3 can now find thousands of files more quickly, scan for duplicates, and aim to provide the fastest and most efficient import process possible. This, along with the improvements to the demosaic processing and noise reduction, is one of the big new features in Lightroom.

TIP

On a Macintosh, the Lightroom Preferences are located on the Lightroom menu (or use the ﷺ <, shortcut). On a PC, they are located on the Edit menu (or use the Ctrl <, shortcut).

TIP

While I recommend converting your raw files to DNG, I don't think it is always such a good thing to do at the import stage since it involves importing copies and converting them to the DNG format. This can greatly add to the time it takes to get your photos from the card to viewing them in the Library module.

NOTE

The Import dialog uses the expanded mode as the default view, but I chose to feature the compact mode here first in order to demonstrate how the import process can now be much simpler to manage.

Importing images from a card

We'll start with the most common method of file import: how to automatically import, rename, and manage your image captures each time a camera card is inserted into a card reader.

00	Preferences	
	General Presets External Editing File Handling Interface	
	Settings: 🗹 Show splash screen during startup	
	Automatically check for updates	
Default Catalog		
When st	arting up use this catalog: Load most recent catalog	:
Import Options		
0	not dialog when a memory and is descend	
9	port dialog when a memory card is detected	
	amera-generated folder names when naming folders	
Treat JPE	G files next to raw files as separate photos	
Completion Sour	nds	
When finish	red importing photos play: No Sound	•
When finish	ned exporting photos play: No Sound	•
Prompts		
	Reset all warning dialogs	
Catalog Settings		
Some settin	gs are catalog-specific and are changed in Catalog Settings. Go to Catalog Sett	ings

1. Before you import any photos, go to the Lightroom menu and choose Preferences. In the General section, check the "Show Import dialog when a memory card is detected" option. This lets you decide how Lightroom responds when a memory card is detected. When checked, Lightroom automatically shows the Import Photos dialog every time it recognizes a camera memory card.

L	 	 	

EOS_DIGITAL

FROM EOS_DIGITAL *	→ Copy as DNG Copy Movie Add copy photos to a new location and add to catalog	→ To Hard Drive 4 ÷ / Users / martin_evening / Pictures	
Metadata Preset None Keywards	File Handling Ignore Duplicates, Minimal Previews	Into Subfolder Organize By date Date Format 2009/2009-12-11	
30 photos / 368 MB	Import Preset : None 🕈	Cancel Impo	rt

3. If the Lightroom Preferences are configured as shown in Step 1, Lightroom automatically opens the Import Photos dialog every time a card is inserted. How the import dialog is displayed will depend on whether you last used the compact interface (shown here) or had checked the expand dialog button (circled) to reveal the full range of options in the expanded mode view. For now, let's look at an import using the minimal version first. In this example, the EOS_DIGITAL camera card appeared in the From section. In the next section, you can choose to Copy as DNG, Copy, Move, or Add. For card imports, the choice boils down to Copy as DNG or Copy. I nearly always select Copy here.

FROM EOS_DIGITAL ÷	Ð	Copy as DNG Cop Copy photos to a new locati	and selected and a recorded	estination		
Metadata Prëset None Keywords		File Handling Ignore Duplica	tes, Minimal Previews	Into Subfolder Organize Date Format	By date	
30 photos / 368 MB		Import Preset :	None 🕈	Cancel	Import	

4. The To section (at the upper right) initially points to the computer user's Pictures folder. This is a sensible default, but if you wish, you can select an alternative destination folder.

FROM EOS_DIGITAL ÷ All photos	Ð	Copy as DNG Copy Move Add Copy photos to a new location and add to catalog	→ To Hard Drive 4:
Metadata Préset None Keywords		File Handling Ignore Duplicates, Minimal Previews	Into Subfolder Organiz V By date Into one folder
30 photos / 368 MB		Import Preset : None 🗘	Cancel Import

5. For camera card imports, you will want to import your images using folders segmented "By date" or "Into one folder." There is a lot to be said for the "By date" option. All your files are imported and placed in dated folders, which provides a neatly ordered way to manage your camera card imports. However, to make this work effectively, you'll need to tag the imported photos with at least

one keyword; otherwise, you'll experience difficulties later when tracking down specific photos. Importing photos into one folder is a more foolproof method of folder management and allows you to search for photos by the Folders panel name as well as by keywords.

FROM EOS_DIGITAL : All photos	÷	Copy as DNG Copy Move Add Copy photos to a new location and add to catalog		Hard Drive 4 ÷
Metadata Preset None Keywords		File Handling Ignore Duplicates, Minimal Previews	✓ Into Subfolder Organize	Westgate-on-sea
30 photos / 368 MB		Import Preset : None 🕈	Cancel	Import

6. If you select the "Into one folder" option, then you will most likely want to check the Into Subfolder box (as shown here) and type a name for the subfolder you wish to create in the destination location.

FROM EOS_DIGITAL *	Copy as DNG Copy Nowe Add Copy photos to a new location and add to catalog		Hard Drive 4 ÷
Metadata Preset Basic IPTC	File Handling Ignore Duplicates, Minimal Previews	✓ Into Subfolder Organize	Westgate-on-sea
30 photos / 368 MB	Import Preset : None 🕈	Cancel	Import

7. If you already have a prepared IPTC metadata template, it is a good idea to select this from the Metadata Preset menu list (circled). When you are done, just click on the Import button to commence the camera card import, or click the Cancel button to exit the Import dialog.

8. After you have configured the Import Options and clicked the Import button, Lightroom imports the files from the card to the Lightroom catalog. As the images are imported, the thumbnails start to appear one by one in the Library module view. Meanwhile, the status indicator in the top-left corner shows the import progress. Oftentimes, there may be at least two processes taking place at once: the file import and the preview rendering. The progress bars give you a visual indication of how the import process is progressing. If more than one operation is taking place at a time, you will see the grouped status indicator (above left). If you click the small arrow to the right, you can toggle the status indicator among each of the tasks in progress and the grouped indicator.

9. Normally, you should not encounter any problems when importing files from a camera card. But if you choose the Copy Photos as DNG option, you will be alerted to any corruptions in the files as they are imported. After you have successfully imported all the images to the computer and backup drive (if applicable), you can safely eject the camera card and prepare it for reuse. However, at this stage, I usually prefer to completely delete all the files on the card before removing it from the computer. The reason I suggest doing this is because when you reinsert the card in the camera, you won't be distracted by the fact that there are still images left on the card. This might cause you to wonder whether you have removed all the images or not (see sidebar). I would also advise you to always reformat the card using the camera formatting option before you start capturing further images. This is a good housekeeping practice that will help reduce the risk of file corruption as new capture files are written to the card.

NOTE

When you choose Copy as DNG and then import, the Lightroom DNG converter should report a problem whenever it is unable to convert any supported raw file that has a raw file extension (including the Canon TIFF extension). However, this does not guarantee that all file corruptions will be reported. Only those that the Lightroom/Adobe Camera Raw processor is able to detect will be reported.

TIP

For studio shoots, I find it helps to establish a routine in which the files are deleted immediately via the computer before ejecting the camera card. I will make sure the cards are reformatted, too, but I find on a busy shoot it helps to avoid confusion by clearing the cards as soon as the files have been imported. Otherwise, you may pick up a card, put it in the camera, and not be sure if this is one you have imported from already or not.

NOTE

The import terminology has again been changed in Lightroom 3 (and made a lot simpler). For the benefit of previous Lightroom 1 and Lightroom 2 users, "Copy Photos as Digital negative (DNG) and add to catalog" or "Convert to DNG" is now simply known as Copy as DNG. "Copy photos to a new location and add to catalog" is now known as Copy. "Move photos to a new location and add to catalog" is now called Move and "Add photos to catalog without moving" is now called Add.

Copy as DNG, Copy, Move, or Add?

Let's look more carefully at the ways in which images can be imported, starting with those that are relevant to camera card imports only: The Copy as DNG option copies the files from the card and at the same time converts them to the DNG file format. This option offers more peace of mind, because the DNG file format is widely regarded as a more versatile and, therefore, more appropriate file format for the long-term archival storage of raw camera files. The DNG conversion process also conveniently flags any files that happen to be corrupted as they are imported. However, as I have already mentioned, converting to DNG can easily double the time it takes to complete an import and, therefore, isn't really a viable option on busy, professional shoots. The Copy option makes a straightforward copy of all the images that are on the memory card and stores them in the designated destination folder or subfolder.

If you intend to import photos from an existing folder of images, you can consider using any of the four import options. In this case, Copy as DNG is only useful if the folder of images you are copying from contains unconverted raw images. You could convert non-raw images such as JPEGs to DNG, but there isn't any point in doing so. The Copy option can again be used to make copies of the files, import them into Lightroom, and add them to the catalog using the destination folder location. Remember, you don't always want to end up creating any more duplicate versions of master images than you need to, so "copying" files is mainly useful where you need to copy from a camera card or a DVD. If your intention is to import photographs from existing folders on your computer and add them to the Lightroom catalog, the two options you want to focus on are Move and Add. The Move option copies files from the selected source folder to the destination folder and then deletes the folder and files from the original location. This is a neat solution for importing photos into Lightroom, placing them in the exact folder location you want them to end up in, and avoid ending up with yet more duplicate images. The downside is that any amount of file copying takes up time. The Add option is the one I suggest using most often here, since an Add import is where you tell Lightroom to simply "reference" the files wherever they are located on the computer. When you Add files at the import stage, it takes a minimal amount of time to complete the import process. You also have to bear in mind that Lightroom does not place any real restrictions on how or where the images are stored on your computer. The image files you add to the Lightroom catalog can be stored anywhere you like. The only thing you are restricted from doing is referencing files that are stored on a network-attached storage device. The reason for this is that it would mess up Lightroom if other users could have access to the original master images across a network. To summarize, I mainly suggest you use Copy for all card imports (and convert your raw files to DNG later) and use Add or Move for most folder imports.

Expanded Import dialog

If you click the button circled in Step 3 on page 45, this opens the Import dialog in the expanded view shown in **Figure 2.1**. To return to the compact standard view, just click the button again. As you can see, there are lots of options here, so let me take you through them in the order you would use them. At the top, we have the same import workflow bar, except it is now expanded to fill the width of the Lightroom interface. Below that, you have access to additional options. At a quick glance, you'll notice how you set the import source on the left, preview the selected images in the middle, and set the destination and import manage options on the right.

NOTE

In the expanded mode, the Import dialog becomes more like a file browser. The browsing is also fine-tuned so that Lightroom knows to wait for a folder to be selected in the Source panel before populating the content area with the available images to import.

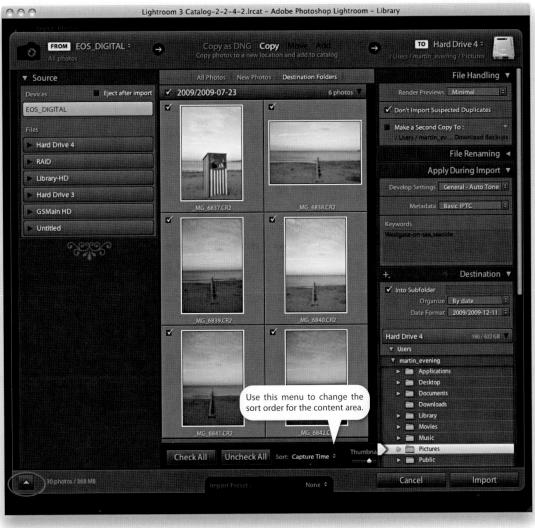

Figure 2.1 This shows the layout of the advanced import dialog showing all the panels.

Figure 2.2 The Source panel in card import mode.

▼ Source	
Files	🗹 Include Subfolders
Hard D	rive 4
► RAID	
Library-	HD
Hard D	rive 3
	Casting photos
i 🗀 1	lowData
	ightroom 3 images
P 🗖 P	Rawfiles
	ilvertone folder

Figure 2.3 The Source panel in volume drive import mode.

TIP

In both the Grid and Loupe views, You can use the "pick" keyboard shortcut (ℙ) to add a photo to an import selection and use the "unpick" keyboard shortcut (Ū) to remove a photo from an import selection. You can hold down the @Shift key as you mark images in this way to auto-advance to the next photo. In Grid view mode, you can also simply hover the cursor over an image and use the spacebar to toggle adding or removing a photo from an import selection.

Source panel

You can use the Source panel to navigate and find the photos you wish to import. To keep things simple, when you insert a camera card, the card should automatically be selected as the source (see **Figure 2.2**). There is also an "Eject after import" option, should you want the card to be ejected after all the photos have been imported. This is a handy option as it saves you having to do so manually at the system level. For other types of imports where you wish to Copy as DNG, Copy, Move, or Add a folder of images to the Lightroom catalog via an existing volume directory, the Source panel can be used to locate the pictures you wish to import, just as you would with a regular file browser program (**Figure 2.3**). Note here that Lightroom 3 displays all available directory volumes regardless of whether they contain image files (the same is true for the Destination panel). This allows you to instantly view the entire drive and folder structure on your computer.

Content area

As you navigate using the Source panel, the main content area displays the directory contents. Remember, Lightroom only sees supported image files (including video files). If no images are displayed when you select a volume disk folder, you may see an Include Subfolders button in the middle of the content area. If you click on it, this automatically selects the Include Subfolders option for you (see Figure 2.3). As you can see, each photo in the content area has a check box next to it and you can click on these to add or remove individual photos from an import. Plus you can use the Check All and Uncheck All buttons in the Toolbar (Figure 2.4). Unchecked photos are displayed with a dark vignette to indicate that they won't be included in the subsequent import. It's also useful to know that you can Shift)-click to make contiguous selections of photos or use a) (第一click(Mac) or Ctrl)-click (PC) to make a discontiguous selection and then click on any check box to select or deselect all the photos in that selection. Also, in the Toolbar are the Sorting options. These allow you to sort the photos by capture time, checked state, or filename. Next to this is a Thumbnails zoom slider to make the thumbnails appear bigger or smaller.

When a destination folder is selected in the Destination panel and you have the Don't Import Suspected Duplicates option checked in the File Handling panel (see page 53), Lightroom carries out a background check to see if any of these files are already included in the current catalog. Those that are suspected duplicates are displayed grayed out (see **Figure 2.5**). The content area also offers a Loupe view mode that lets you see the photos you are about to import in close-up. This may be useful if you are importing photos from a folder and need to quickly check whether you have the right ones selected before you carry out the import.

Figure 2.4 The Import dialog Toolbar in volume drive import mode.

Figure 2.5 This shows two close-up views of the content area in which a copy card import is being carried out. You will notice that some of the thumbnails are grayed out, which indicates that these are suspect duplicate photos, which won't be imported. If you deselect any of the remaining photos, these will appear with a dark vignette. The version on the left shows an All Photos view, while the version on the right shows the source contents segmented into Destination folders. How the photos are segmented in this view depends on whether you have the By Original Folders or By Date Organize option selected in the Destination panel. The New Photos view is useful where you wish to limit the import to avoid showing duplicate photos.

Destination panel

Once you have selected a source folder and decided to import by Copy or by Move you need to decide where the imported photos should go. Basically, for those times where you are doing an import by Copy or by Move, the Destination panel provides a secondary file browser that allows you to select a destination folder for the imported photos. Because the Destination panel includes its own segmenting options, it can also be used to override the settings applied in the Workflow bar. Imported photos can be organized in one of three ways. The "Into one folder" import option allows you to import the selected photos to a specific, named folder location; in addition to this, you can specify a new subfolder as the target folder location. For example, I could choose Users/Username/Pictures as the folder destination. Then I could check the "Into one folder" option and type the name of the subfolder destination. In the Figure 2.6 example, this would be Westgate-on-Sea and the full destination directory path would be Users/ Username/Pictures/Westgate-on-Sea. The other option is to segment the photos by Original Folders. If the source images on the drive are in more than one folder, you can preserve the folders and folder hierarchy on import. Finally, you can choose to organize "By date." This segments the imported photos into dated folders; the way it does this will depend on which date segment option is selected

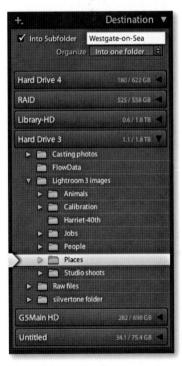

Figure 2.6 The Destination panel. Notice how the volume headers in the Destination panel reveal how much disk space remains out of the total hard drive volume capacity.

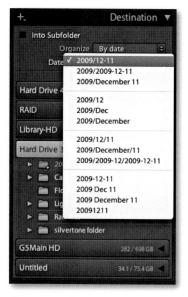

Figure 2.7 The Destination panel showing the segment folder options (also found in the Workflow bar).

Calculating dates for 823 p	
	10105.

Figure 2.8 This shows the date calculation in progress where a large number of files have been imported.

(see **Figure 2.7**). Here, you can not only segment by date, but choose from a list of different date segmenting options. However, If you have a large number of images to import, the date calculation dialog may appear, indicating that Lightroom is reading in the capture date metadata of all the files that are available to be imported (see **Figure 2.8**).

If you choose either the Original Folders or "By date" options, you can click on the Destination Folders button at the top of the content area (see Figure 2.5) to preview how the photos will be segmented before you click Import.

Which is the best folder organization method? If you are less than rigorous in applying keyword metadata to every image you import, then you may be better off importing and organizing your photos into named folders. You can still apply keyword metadata and have the option to search by keywords or effectively browse by folder name. But the problem with folder-based organization is how to categorize something like a wedding. Do you organize such folders by *Weddings/Name of couple* or by *Jobs/Events/Weddings*, or do you just use a folder marked *Wedding photos*? If you are using keyword metadata to extensively catalog all the photos you take, it really should not matter which folder your photos live in because you can search for everything just by the metadata. Therefore, you could argue that organizing imports by date offers a more consistent approach to folder organization for those who regularly apply keywords to all their photos.

File Handling panel

The File Handling panel (Figure 2.9) is where you decide how the imported photos should be managed. The Render Previews menu allows you to decide how previews should be rendered during the import process. The default setting here is Minimal, which will import photos as quickly as possible without devoting resources to the building of previews just yet. The Embedded & Sidecar option makes use of any previews embedded in the original image or sidecar file. This can help speed up the import process from a camera card and let you see some kind of image preview right away, but the previews may only offer a rough guide to image appearance. You can also force Lightroom to build Standard previews as the files are imported, or choose 1:1, which will go the whole nine yards and force a full-sized preview (this can really slow down the import times). Fortunately, Lightroom always prioritizes importing the photos first before proceeding to render the finer-quality previews. Of these four options, I reckon Embedded & Sidecar makes the most sense, because although the previews may not be accurate as you import raw files, this will still be the fastest way to get some kind of preview showing during the import process.

It should be noted that Lightroom is able to import all the supported raw file formats plus RGB, Lab, CMYK, and grayscale images saved using the TIFF, JPEG, or PSD file formats. Non-raw images can be in 16-bits or 8-bits per channel mode, but PSD files must be saved from Photoshop with the Maximize Compatibility option switched on (**Figure 2.10**). If there are no compatibility problems, everything should import successfully. If there are files that Lightroom cannot process or that are already in the catalog (and you have the Don't Import Suspected Duplicates option checked), you'll encounter a feedback dialog like the one shown in **Figure 2.11**.

Secondary backups

For all copy imports, you can specify a secondary folder to copy the images to. Check the Make a Second Copy To check box and then click on the menu list next to it to specify a backup folder. The backup option is, therefore, extremely useful

	Preferences	
General Interface File Handheig Performance Cursors Cu	 File Saving Options Image Previews: Always Save Image Previews: Always Save Icon Full Size Macintosh Thumbnail Windows Thumbnail Append File Extension: Always Iways Isour Case Save As to Original Folder File Compatibility Camera Raw Preferences If refer Adobe Camera Raw for Supported Raw Files Ignore EXIF Profile Tag Ask Before Saving Layered TIFF Files Never Maximize PSD and PSB File Compatibility Adobe Drive Recent File List Contains: 10 files 	OK Cancel Prev Next

Figure 2.10 To ensure that your layered Photoshop format (PSD) files are recognized in Lightroom, make sure you have the Maximize Compatibility option switched on in the Photoshop File Handling Preferences before you save any layered PSD files via Photoshop. If you ever find that you are unable to import PSD files into Lightroom, try switching on this option in Photoshop and resave the PSDs so that you overwrite the originals.

ome import operations were not performed	L.
The files already exist in the catalog. (11)
1W8A0622.CR2	C
1W8A0623.CR2	c
1W8A0624.CR2	
1W8A0625.CR2	C
1W8A0628.CR2	C 100 C 1
1W8A0629.CR2	c
1W8A0630.CR2	
▶ The files use an unsupported color mo	de. (31)

Figure 2.11 If there are files that can't be imported into Lightroom, you'll see the warning dialog shown here, which lists the files that couldn't be imported and the reasons why.

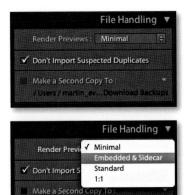

Figure 2.9 This shows a full view of File Handling panel options (top) and the Render Previews options (bottom).

Jsers / martin ev... Down

NOTE

The backup copy images are always stored in their original file state with no Develop settings or metadata settings applied to them and without converting to DNG (if you happened to choose the Copy as DNG option). when importing photos from a camera card, because you never know when a hard disk failure might occur. If you copy the original camera files to a separate backup drive at the import stage, as shown in **Figure 2.12**, the chances of losing all your camera files due to disk failure or human error will be greatly diminished.

After you have renamed and edited the master selection of images and have backed up these images in their modified state, you'll no longer need to keep the initial backup copy files. But nonetheless, it is a wise precaution at the camera card import stage to temporarily keep more than one copy of each master file that's stored on the system.

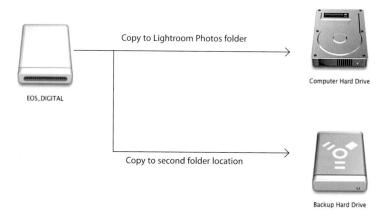

Figure 2.12 This diagram illustrates the standard Lightroom file handling backup procedure where you can assign a Second Copy folder to save backup files to at the time of import.

File handling limitations

The pixel limit is 65,000 pixels per side. This means that where the widest dimension of an image exceeds this value, it cannot be imported into Lightroom. But 65,000 pixels should be enough to satisfy most users.

You can import Grayscale, CMYK, and Lab mode images and these can be previewed and adjusted in Lightroom, but when you do so, the edit calculations are carried out in and exported as RGB only. Lightroom 3 does, indeed, now support importing CMYK photographs and makes it possible to edit them in the Develop module (via an internal RGB conversion), but I don't recommend that you do so. Basically, it is best to simply use the Library module to manage your CMYK images and not take them anywhere near the Develop module. Even so, I am sure many photographers will now appreciate being allowed to manage all their image assets (including their CMYK originals) in Lightroom and have the ability to export them in their original format. Also new to Lightroom 3 is support for video files. For more on this topic, please refer to page 64.

File Renaming panel

If you want to manage and track your image files successfully, it is important to rename them, ideally at the import stage (although you can always select Library \Rightarrow Rename Photos to do this later). The File Renaming panel (**Figure 2.13**) has a Template menu containing several file renaming templates that are ready for immediate use. For example, if you select the Custom Name – Sequence template, you can enter text in the Custom Text field and the imported files will be renamed using this text followed by a sequence number starting with the number entered in the Start Number box. The Custom Name (x of y) template numbers the imported files using a sequence number (x) followed by a number for the total number of images in the sequence (y). The Custom Name – Original File Number option preserves and uses the sequence number that was added by the camera. Meanwhile, the sample filename at the bottom of the File Renaming panel gives an advance indication of how the chosen renaming will be applied to the imported files.

If you choose the Edit option from the bottom of the Template list, it opens the Filename Template Editor (**Figure 2.14**). This allows you to customize and save your own File Naming template designs using tokens or data descriptors such as Date and Sequence. In the Figure 2.14 example, I clicked the Insert button next to the Custom Text item in the dialog to add a Custom Text token at the beginning of the File Naming template. Next, I went to the Additional section and added a

	Filename re	mplate Editor
Preset:	custom+date+sequence	:e
Example:	_090818_0001.dng	
Supervised and the second	n Text _ Date (YY) DD) _ Sequence # ((
Image Nam	e	
	Filename	insert
Numbering		
	(Import # (1)	(Insert
	(Image # (1)	insert
	Sequence # (1)	t Insert
Additional		
	Date (YYYY)	i Insert
Custom		
	Custom Text	Insert
		Cancel Done

Figure 2.14 The Filename Template Editor.

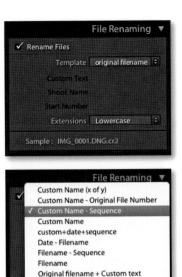

Original filename + custom text

Shoot Name - Original File Number

original filename

Edit

Shoot Name - Sequence

Shoot name+date+sequence

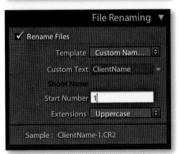

Figure 2.13 The File Renaming panel is shown here with the default filename renaming template in use (top), the full Template menu list visible (middle), and a Custom Name–Sequence renaming template selected (bottom).

TIP

The Rename Files switch allows you to quickly switch the file renaming settings on or off. series of Date format tokens. I clicked on the Insert button to add each of these one by one to the template. Then I went to the Numbering section and added a four-digit Sequence number token. This template was then saved and added to the File Renaming template list.

For an initial import of images, you may well want the numbering to start at 1, but if you are adding files to an existing shoot, you may want to set the numbering to consecutively follow the last number in the current image sequence. Lightroom readjusts the numbering sequence automatically whenever you add imported images to an existing folder. However, there is also a school of thought that it is sometimes better to utilize the original camera-assigned sequence number. For example, if you use the Custom Name - Original File Number template, you will end up with files where the sequence number uses the original image file number, and the sequence numbers will keep rolling over from one job to the next. So instead of all your imported images always being numbered from say, 1 to 500, you will end up with a much broader distribution of sequence numbers. This can make it easier to narrow an image selection based on a sequence-number-only search. In other words, if a known client orders a photo giving you just the last four numbers and nothing else, the chances are good that there won't be many other photos in your library with that exact same four-digit number. If, on the other hand, you keep resetting the numbers to start from 1 before each job, the chances are good that on every shoot you do, you will have photos with file numbers in the 0001-0100 range.

Renaming catalog images later

Images can also be renamed any time after you have imported them into Lightroom. You can make a selection of images in the Library module using the Grid or Filmstrip and select Library \Rightarrow Rename Photos (alternatively, you can use the **F2** keyboard shortcut). This opens the Rename Photos dialog shown in **Figure 2.15**, where you can use the File Naming menu to select a custom file renaming scheme. Or, you can choose Edit from the File Naming menu and create a new template using the Filename Template Editor (Figure 2.14).

		Rename 207 P	inter a second s
File Naming:	Custom+	date+sequence	
Cus	tom Text:	Client	Start Number: 1
Example:	Client09091	7_0001.dng	Cancel OK

Figure 2.15 In the Rename Photos dialog shown here, I selected a pre-created custom file renaming scheme from the File Naming menu, entered custom text that would be used during the renaming, and set the Start Number to "1."

Apply During Import panel

The Apply During Import panel (**Figure 2.16**) lets you choose the Develop settings and metadata information that you wish to apply to the photos as they are imported into Lightroom.

The Develop Settings menu lets you access all of the Develop settings you currently have saved in the Develop module Presets list. This is extremely useful because it means you can instruct Lightroom to apply a favorite Develop preset to new photos as they are imported. For example, in Figure 2.16, I selected one of the default Lightroom settings: General – Auto Tone. I find this Develop setting useful if I want to auto tone adjust all the raw capture photos as they are imported into Lightroom.

Sensible folder and file naming can certainly make it easier to retrieve images later, but as your library grows, you will begin to appreciate the benefit of using keywords and other metadata to help track down your images, especially when searching a large catalog collection of photographs. The Library module offers a number of ways to search for a specific image or group of images. For example, the Library module Filter bar can help you search for files using criteria such as Date, Camera, or File Type. This method of searching requires no prior input from the user, of course, but in the Apply During Import panel, you can add custom metadata and keywords to your photos as they are imported, thereby ensuring that such informational data is present in your files right from the start. Next to the Metadata item is a pop-up list that allows you to access any pre-saved metadata templates (see pages 140-143 for more about working with metadata templates). Or, you can click New to open the Edit Metadata Presets menu shown in Figure 2.17 and create a brand new metadata template. Admittedly, the dialog is rather tiny here, so do check out the above page reference if you want to see the preset dialog contents more clearly. Metadata presets are particularly useful where you wish to add common information that conforms to the International Press Telecommunications Council (IPTC) standards. This can include information such as your contact details and image copyright status.

The Keywords section can be used to add shoot-specific metadata, such as the name of a location or a common descriptive term for the photos you are about to import. For help and advice on how to apply keywords, I suggest you read up on the keywords metadata section of this book in Chapter 4. There you will learn about the best ways to organize and apply keywords. Note, though, that once you have an established keyword list, as you begin to type in a keyword, Lightroom has the ability to auto-complete your entries by referring to the current Keyword List panel contents. Basically, adding metadata at the time of import can greatly assist you later when conducting searches for specific images. Also, the metadata information entered at this stage will be applied to any derivative files that are created from the master photos.

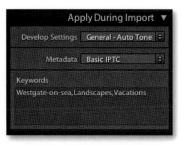

Figure 2.16 The Apply During Import panel.

reset: Basic IPTC (edited)		(LISEI)
🖲 Basic Info		
Copy Name		70
Rating		ø
Label		0
Caption		0
F 🗌 IPTC Content		
Headline		70
IPTC Subject Code		10
Description Writer		10
Category		10
Other Categories	[70
🕫 🗹 IPTC Copyright	122	
Copyright	© Martin Evening	1
Copyright Status	Copyrighted	
Rights Usage Terms	Licensed usages only	1
Copyright Info URL	www.martinevening.com	ø
F IPTC Creator		
Creator	Martin Evening	1
Creator Address	Chambers Lane	
Creator City	London	1
Creator State / Province	London	M
Creator Postal Code	NW10] 🗹
Creator Country	UK	1
Creator Phone	+44(0)2084500000	REEEE
Creator E-Mail	martin@martinevening.com	V
Creator Website	www.martinevening.com	1
Creator Job Title	Photographer	M
🔻 🖃 IPTC Image		
Date Created		0
Intellectual Genre] 0
Scene		8800
Location		0
City	London	1
State / Province	London	1
Country	UK	1
ISO Country Code	UK	Ø
🕫 🖃 IPTC Status		
Title		70
Job Identifier		10
Instructions		10
Provider	Martin Evening	1
Source	Martin Evening Photography Ltd	1

Figure 2.17 You can use the Metadata Preset dialog to creaté Metadata presets that you can then use to apply to all newly imported images. The information sections shown here all conform to the standard IPTC format that is recognized throughout the industry.

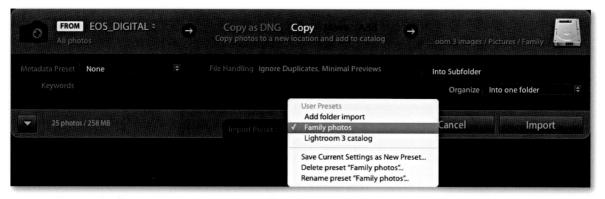

Figure 2.18 The Import Presets menu.

Import Presets menu

It has taken me nine pages so far to describe how to configure the Import dialog panels and determine how your photos are imported, but fear not, because it is possible to save regular import settings as presets! The Import Presets menu (Figure 2.18) is at the bottom of the Import dialog, and if you choose Save Current Settings as New Preset, this adds the current Import dialog configuration as a new import preset. For instance, let's say that when you shoot certain types of subjects, you are in the habit of always placing the imported files into a specific root level folder in a particular way, such as always doing a straightforward copy import, in which photos are organized into one folder at the same root level, using the same file naming and handling and applying the same metadata. For these types of imports, it makes sense to configure the Import dialog settings once and then go to the Import Presets menu to create a new custom user import preset. Even if the import setting needs vary slightly each time, accessing a preset and then tweaking it still ensures greater consistency between one import and the next and can save you time. Maybe all you need to do is change the name of the subfolder you are downloading to or apply different keywords. Either way, import presets are the way to go. Another crucial benefit is that once you have created a few custom import presets, you can, most of the time, work with the Import dialog using the minimal view mode.

Planning where to store your imported photos

Unless you have an expensive, high-capacity RAID server, you probably won't have the storage capacity to keep all your catalog photos on a single drive. My work setup includes three large-volume disk drives that are dedicated to storing the digital negatives and derivative files that make up the Lightroom catalog. It doesn't matter too much how the files are organized, but what I find useful is to keep all the Lightroom image data on these drives only rather than on the drive that's used by the operating system, such as the *Pictures* or *My Pictures* folders. By keeping them separate, it will be easier to transfer the drives to a different computer, if necessary.

Converting to DNG

The Convert to DNG feature is useful for converting raw files to the DNG format, which you can do by going to the Library menu and choosing Convert Photos to DNG (**Figure 2.19**). I always prefer to convert my raw photos to DNG at the end of a photo shoot rather than convert them at the import stage. When I am busy in the studio, this can easily save an hour or more of computer processing time, which is important because, as we all know, time is money. Lightroom also lets you delete the original raw files after successfully converting them to DNG, which is useful if you wish to convert everything to DNG and simultaneously remove the raw originals. By doing this, you can avoid ending up with duplicate raw versions of your images. You can also choose to embed the original raw file in the DNG image. Now, this option does provide the flexibility of reverting to the original raw file format state, but the downside is that you end up with DNG files that are twice the size of the original. Mostly, I would say it is safe to leave this option unchecked: Convert everything to DNG and delete the raw originals as you do so.

ource Files		
Only convert Raw files		
Delete originals after su	ccessful conversion	
NG Course		
ONG Creation		
File Extension:	dng	•
Compatibility:	Camera Raw 5.4 and later	•
JPEG Preview:	Medium Size	•
	Embed Original Raw File	
		Cancel OK

Figure 2.19 The Convert Photos to DNG dialog.

Updating DNG files

The DNG file format has been around for several years now and has been widely adopted as a preferred format for archiving raw camera files. For all its benefits, one problem has been the inability to update the JPEG preview. This was not necessarily a problem if you were using DNG in Bridge or Lightroom, since the preview was referenced by the file preview cache and rebuilt when you transferred a DNG file from one Lightroom/Bridge setup to another. But this approach was less convenient when working with other DNG-aware programs such as iView Media Pro. To get around this problem, you can go to the Metadata menu and choose Update DNG Previews & Metadata. This does two things: It updates the metadata the same way as the Save Metadata to Files command does, and it rebuilds the JPEG preview contained within the DNG file.

NOTE

The DNG (Digital Negative) format is an Adobe-devised format for archiving raw capture files. While it is possible to convert other file formats such as JPEG to DNG, you really want to use this feature only for converting actual raw files to DNG, so it is best to leave the "Only convert Raw files" option selected (see Figure 2.19).

NOTE

Should you keep the original raws? It all depends on whether you feel comfortable discarding the originals and keeping just the DNGs. Some proprietary software, such as Canon DPP, is able to recognize and process dust spots from the sensor using a proprietary method that relies on reading private XMP metadata information. If you delete the original .CR2 files, you won't be able to process the DNG versions in DPP unless you chose to embed the original raw file data, since this allows you to extract the raw originals.

When files are converted to DNG, the conversion process aims to preserve all the proprietary MakerNote information that is contained in the raw original. If the data is there, external, DNG-compatible software should have no problem reading it. However, there are known instances where manufacturers have placed MakerNote data in odd places, such as alongside the embedded JPEG preview, which is discarded during the conversion process. Basically, the DNG format is designed to allow full compatibility between different products, but this, in turn, is dependent on proper implementation of the DNG spec by third parties.

NOTE

The Loupe view mode (button circled in Step 1 below) is available when importing photos from a camera card or from a folder. This allows you to check photos more easily before you import them into Lightroom and check for things like sharpness. In Loupe view mode, you can use the spacebar to toggle the preview between a "zoom to fit" and a close-up zoom view.

Adding photos from a folder to the catalog

Let's now look at a simple import workflow in which all I wanted to do was add photos from an existing folder to the Lightroom catalog. As I explained earlier, the Add import method is the quickest and most efficient way to import existing folders of photos into Lightroom.

Importing photos using the Add method is also the best way to build a Lightroom catalog from scratch. If you are setting up Lightroom for the first time and you have all your images neatly structured in, say, your *My Pictures* folder, all you have to do is choose Add, select the topmost folder (the root directory), make sure the Include Subfolders option is checked, and click Import. This will import all the photos in one go, and the folder directory on your computer will be mirrored in the Lightroom Folders panel.

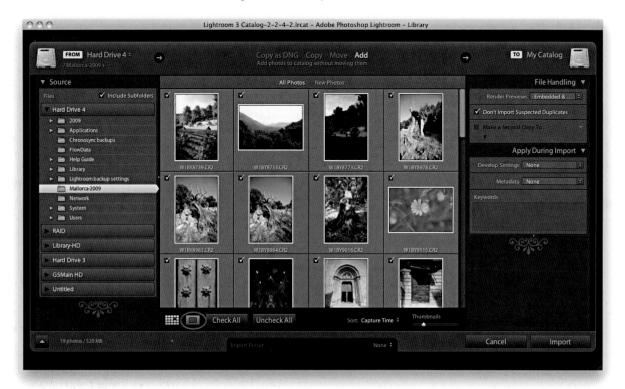

1. In this example, I clicked on the Import button in the Library to open the Import dialog shown here. I selected the *Mallorca-2009* folder from the Source panel and chose the Add option from the Workflow bar. You'll notice how when the Add option is selected, only the File Handling and Apply During Import panels remain visible and active in the right panel section. Note that you'll need to check the Include Subfolders option if the folder you are importing from contains subfolders and you want their photos to be included in the import.

Preset Name:	Add folder	
	Cancel	

2. Before going ahead with the import I decided to save the settings that were applied in Step 1 as an import preset. For example, in the File Handling panel, I thought it wise to choose Embedded & Sidecar previews and not to import duplicates. In the Apply During Import panel, I though it best to leave everything here set to None, since I didn't wish to overwrite or add to any of the existing metadata.

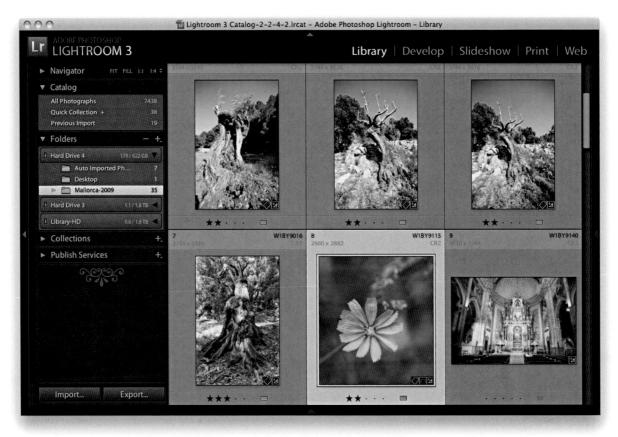

3. I then clicked on the Import button so that the photos would all be imported using the settings configured in Step 1. As you can see, the Folders panel in the Library module showed that the *Mallorca-2009* folder had been added to the Lightroom catalog.

Importing photos via drag and drop

In previous editions of this book, I showed how it is possible to drag photos from Adobe Bridge to an alias of Lightroom in the Favorites panel. That particular import method is redundant since we now have a browser in the form of the Import dialog Source panel. However, there are a couple of other ways you can initiate importing photos into Lightroom. One way is to simply drag and drop files from a camera card or a folder of images from the Finder/Explorer/Bridge to the Library module content area. This method will open the Import dialog with the dragged folder as the source and allow you to decide how the new images are to be imported. Or, if the Import dialog is already open, you can also use the dragand-drop method described here.

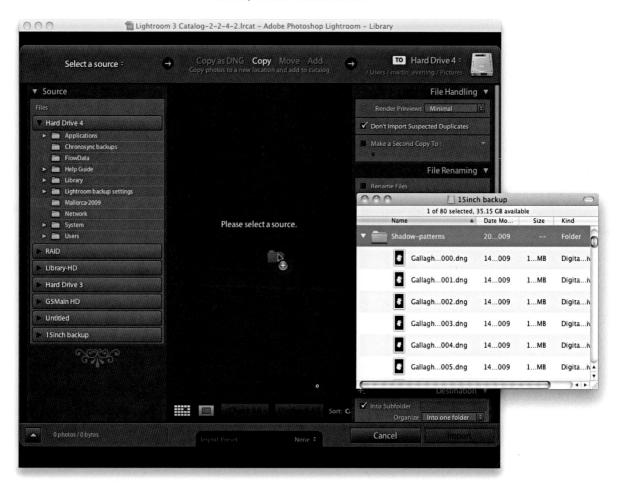

1. To carry out a drag-and-drop import, I opened the Import dialog, located the images I wanted to import, and dragged them across to the content area as shown here.

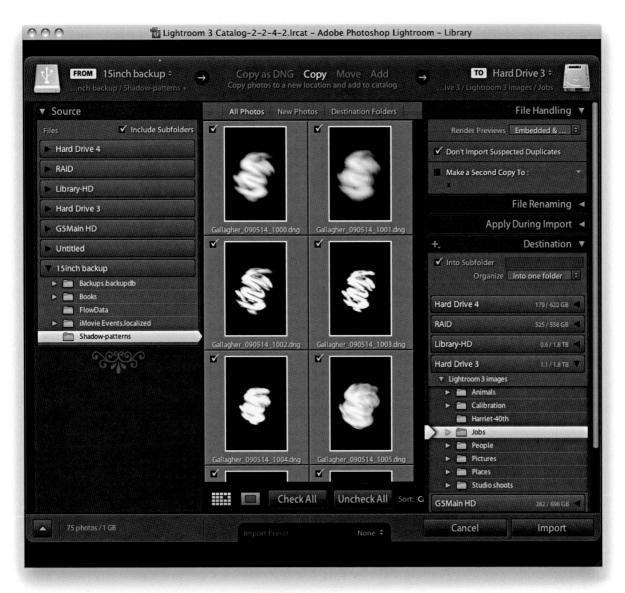

2. This drag-and-drop action established the dragged folder as the source. From here on, the steps used were exactly the same as for any other import. The drag-and-drop step simply bypassed the need to spend time navigating the Source panel. All I had to do was decide how I wanted the new images to be imported. In this example, I wanted to copy the photos from a remote hard drive, keeping the photos in their original folder, copy them to the *Jobs* folder on my main computer, and preserve the embedded and sidecar previews.

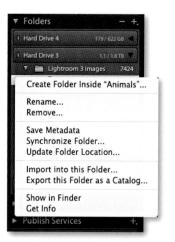

Figure 2.20 The contextual menu for the Folders panel, showing the "Import into this Folder" menu item.

Importing to a selected folder

You may often find yourself working with a folder of images and wish to import more photos to this same folder. You could go to the Import dialog and manually locate the relevant folder, but there is now an easier way. While you have the folder highlighted in the Folders panel, right-click (or use the Ctrl key with an old-style Mac mouse) to access the contextual menu shown in **Figure 2.20** and select "Import into this Folder." This launches the Import dialog with that folder preselected as the destination folder.

Importing video files

If the camera you are shooting with supports shooting video, the camera movie files can be imported into Lightroom along with the regular image files (see **Figure 2.21**). Once imported into Lightroom, they will be distinguished apart from the regular image files by a movie frame icon (**Figure 2.22**), which if you click on this, launches an external movie playing application.

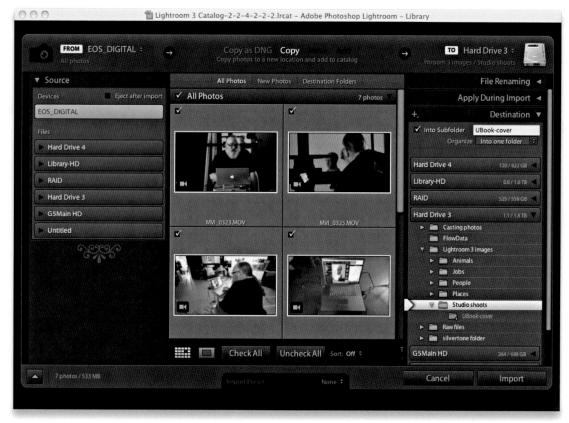

Figure 2.21 This shows an example of a card import that includes video files.

Auto imports

If you go to the File menu and choose Auto Import \Rightarrow Auto Import Settings, this opens the dialog shown below in **Figure 2.23**. In the Watched Folder section, you can choose a folder to drag and drop the photos you wish to auto import; in the Destination section, you can choose the folder you wish to import the photos to in the Lightroom catalog. The remaining sections can be used to determine how the files will be named as they are imported and also whether to apply any specific Develop settings or IPTC or keywords metadata on import. Finally, you can select appropriate options for generating the initial previews.

The Auto Import feature is incredibly useful. After you have configured the Auto Setup settings once and checked the Enable Auto Import box, you are all set to add photos to the catalog by simply dragging and dropping them to the designated watched folder. This, therefore, offers you a way to guickly import photos, bypassing the Import Photos dialog completely. Once the photos have arrived in the Destination Lightroom folder, you can always move them to a new folder location

Auto Import Settings

Fnable Auto Import

Figure 2.23 This shows the Auto Import Settings dialog. As you can see, the Watched Folder I referenced here was located on the Desktop to which I could easily drag and drop any images I wished to quickly add to the catalog.

Watched Folder: /Users/martin evening/Desktop/LR3 watched Choose ... Destination Move to: /Users/martin evening/Pictures Choose. Subfolder Name: Auto Imported Photos File Naming: IMG_0001.DNG -File Naming: Filename Information -Develop Settings: General - Auto Tone -Metadata: None Keywords IN AND -Initial Previews: Embedded & Sidecar Cancel ОК URB WATCHIER

Figure 2.22 Imported video files are distinguished in the Library Grid, Loupe view, and Filmstrip by a movie icon, which also indicates how long the clip lasts. Clicking on this icon launches whatever default external movie playing program you have installed.

Downloadable Content: www.thelightroombook.com

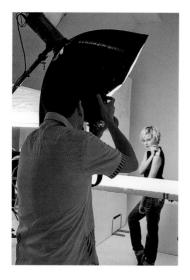

Importing photos directly from the camera

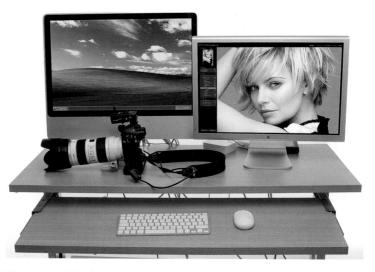

Figure 2.24 This shows the computer setup that I normally use when shooting in tethered mode in the studio using the Canon EOS 1Ds Mark III camera.

NOTE

Here is an interesting technology that has been in development for a while and has just recently come to market: Eye-Fi is about to introduce a product called Eye-Film, which is a media card incorporating 802.11b/g Wi-Fi and 1 GB of Flash storage. Eve-Film will come in the form of an SD card. (A Compact Flash Type-II adapter will allow digital SLR users to put these in cameras without an SD slot.) When you start shooting, the card transfers photos from within your camera to any computer with Wi-Fi support. With Eye-Film, the originals remain on the card and are transmitted to the computer. So far, only specific camera models are supported. For more information, go to www.eye.fi.

It is now possible to set up Lightroom to work directly in tethered shooting mode (**Figure 2.24**). This means that photographs shot on the camera can be brought quickly into Lightroom, bypassing the need to import the photos from the card. Tethered shooting via Lightroom also allows clients to see the images appear as previews in the content area as you shoot (if you think this will help). I also find tethered shooting can be useful on model castings because it allows me to individually update the keywords or captions right after each photo has been shot.

Connecting the camera to the computer

To shoot in tethered mode, you obviously need to be able to connect your camera to the computer. Ideally, you want the fastest connection possible. Most professional digital SLRs offer either a FireWire (IEEE 1394) or a USB 2.0 connection and these should offer a fast enough interface and buffer speed so that you can import the capture files at about the same speed as you can with a fast camera memory card—in some cases, quicker. The only downside is that you must have your camera connected to the computer via the appropriate cable, which can restrict the amount of freedom you have to move about without pulling the cable out or, worse still, pulling a laptop computer off the table!

Another option is to shoot wirelessly. At the time of writing, wireless units are available for some digital SLR cameras. These will allow you to transmit images directly from the camera to a base station linked to the computer. Wireless shooting offers you the freedom, up to a certain distance, to move about without the restrictions of a tethered cable. But the current data transmission speeds with some cameras are a lot slower than those you can expect from a FireWire or USB 2.0 connection. Rapid shooting via a wireless connection can certainly work well if you are shooting in JPEG mode, but not if you intend shooting raw files only. Of course, that may all change in the future. For example, with Nikon equipment, you can shoot wirelessly via PTP/IP or FTP. It appears, so far, that PTP/IP is better and should rival FireWire, since PTP/IP is able to transfer files much faster due to the compression that's built into the transmission.

Lightroom tethered shooting

The ability to establish a tethered connection via Lightroom should mean that your photos can be imported more quickly because the tethered process imports the photos directly to the destination folder. The one downside is that the tethered connection process is mostly one-way. Lightroom enables camera capture files to be imported into Lightroom and can read the camera settings data, but unfortunately, you can't use the Tethered Shoot control panel to interact with the camera, other than to use the shutter release button to fire the camera shutter. For studio photographers like myself, who shoot people, this isn't necessarily going to be a huge problem since you are always going to have your hands on the camera anyway. For studio photographers, where the camera is static on a tripod, I can see this being more of a disappointment. What you have to bear in mind here is that providing reverse communication with each unique camera interface has proved a lot harder than enabling tethered download communication with the currently supported cameras. Multiply this work by the number of cameras supported by Camera Raw, and you'll get some idea of the scale of the problem. Personally, I am pleased with the progress that has been made to get us to the point where Lightroom can download images quickly and flawlessly.

The tethered shooting feature in Lightroom 3 has initially been provided for a select number of Canon and Nikon digital SLR cameras, but these also come with their own software solutions for importing photos via a tethered connection. One of the advantages of using such dedicated tethered capture software is that you can control the camera settings remotely via a computer interface. This can be particularly useful where it would otherwise prove awkward to reach the camera. If this sounds like a more appealing solution, then you might want to explore using such software in conjunction with Lightroom. If you go to the book's Web site, you can download the sample instructions I have provided there for working with the Canon EOS Utility program in conjunction with the Canon EOS 1Ds Mark III camera. Basically, I show how Lightroom is able to appropriate the tethered shooting component of the camera communication software and, from there, directly take over the image processing and image management via the Auto Import dialog. Although these instructions relate to Canon software, you should be able to translate this to working with other cameras and camera software setups.

NOTE

To get your camera to tether successfully with the computer, you may also need to install the necessary drivers for the camera you are using. In most cases, the drivers are already part of the system and you shouldn't experience any problems. For example, with Mac OS X and Windows XP, I have never had any difficulty connecting any of the Canon EOS cameras. With Windows Vista, the driver options are so far limited to allowing a narrower range of camera models that can connect directly.

Downloadable Content: www.thelightroombook.com NOTE

While the File menu can be accessed via all the Lightroom modules, the Tethered Capture option can only be activated via the Library module.

New Catalog Open Catalog	☆業O		and the second second
Open Recent	•		
Optimize Catalog			
Import Photos Import from Catalog	습 兆		
Tethered Capture		Start Tethered Capture	
Auto Import	۹.	Hide Tethered Capture Window	жT
Export	企業E	New Shot	企業7
Export with Previous	て企業E		TERMETER
Export with Preset	⊳		
	Open Recent Optimize Catalog Import Photos Import from Catalog Tethered Capture Auto Import Export Export with Previous	Open Recent Optimize Catalog Import Photos Import from Catalog Tethered Capture Auto Import Export 企業E Export with Previous て企業E Export with Preset	Open Recent ▶ Optimize Catalog Import Photos Import from Catalog ☆ ೫I Tethered Capture ▶ Auto Import ▶ Export ☆ ೫E Export ☆ ೫E Export with Previous ℃ ☆ ೫E Export with Preset ▶

1. To initiate a tethered shoot session, I went to the File menu and selected Tethered Capture

→ Start Tethered Capture.

Session Name:	Studio session
	Segment Photos By Shots
Naming	
Sample:	Studio session-105.DNG
Template:	Session Name - Sequence
Custom Text:	Start Number: 17
Destination	
Location:	/Volumes/Hard Drive 3/Lightroom 3 images/Studio shoots Choose
Information	
Metadata:	UK Basic IPTC
Keywords:	Camilla Pascucci > Makeup artists,Harriet Cotterill > Clothes stylists, James Pearce > Hair stylists,MOT,Sofia > Models

2. This opened the Tethered Capture Settings dialog shown here, where I was able to configure the desired tethered import settings. I used the default "Studio session" text for the Shoot Name and clicked Segment Photos By Shots. In the Naming section, I chose a suitable file naming template. In the Destination section, I set the destination folder location to *Studio shoots*. In the Information section, I selected a Metadata preset to add on import, along with relevant keywords for the shoot. I then clicked OK to confirm these Settings.

nitial Shot Name:	Shot 1
	Cancel OK

3. Because I had chosen to segment photos by shots, the Initial Shot Name dialog appeared next. Here, I needed to enter a name for the photo shoot that was about to take place. To keep things simple, I called this shoot Shot 1 and clicked OK.

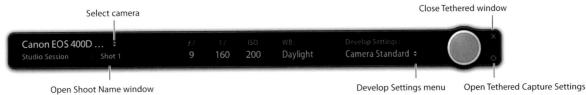

4. This opened the Tethered Shoot control panel, where, after I had switched the camera on, the camera name appeared in the top-left section. If more than one camera is connected to the computer, you can click the pop-up menu to choose which camera to import from. You will notice that the camera data displayed here is informational only, and the settings will have to be adjusted on the camera itself, although you can use the big round shutter button to take photographs remotely.

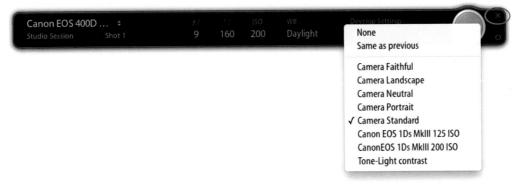

5. You can also click on the Develop Settings pop-up menu to select an appropriate Develop setting. In this step, I chose a pre-saved setting that would apply a Camera Standard profile to the photos as they were imported. As long as the Tethered Shoot control panel remained active, I could shoot pictures with the selected camera and these would be automatically imported into Lightroom. I could hide the panel using ℜT (Mac) or Ctrl T (PC), or quit by clicking the Close button (circled).

TIP

When you shoot using the tethered mode, it is useful to see new images appear at the top of the content area as they are imported. To enable this feature, choose View ⇔ Sort ⇔ Descending. You may want to switch the sort order back to Ascending for normal editing. If the Ascending/ Descending toggle action appears to be broken, it may be because you have a Custom sort order selected. Also, make sure the Sort order option is set to Import Order or Capture Time. 6. As I started shooting, the capture images began to appear in the Lightroom catalog, where I had adjusted the sort order so that the most recently shot images were shown first (see sidebar tip). You will notice that these photos appeared in the following folder directory: *Studio shoots/Studio Session/Shot 1*. To understand the hierarchy employed here, you will need to refer back to the sections that I have highlighted in steps 2 and 3. *Studio shoots* was the selected master Destination folder for the tethered shoot images "Studio Session" was the default name used in the Shoot section, and Shot 1 was the name given to this first series of shots. At this point, I could prepare for a second shoot by opening the Initial Shot Name dialog via the Tethered Shoot control panel (see Step 4) and enter a name for the next set of shots (or use the ﷺ ☆ Shift) T [Mac] or Ctrl ☆ Shift) T [PC] shortcut). One last thing I should mention here is that when shooting with a Canon camera, the captured files are also saved to the memory card, but if you are using a Nikon camera, the capture images won't be saved to the card.

Speedier tethered shooting

The main reason for choosing to shoot tethered is that it can help make the import process smoother and faster. However, a number of factors can affect the overall tethered shoot import speed. The first thing you need to consider is the camera interface. Professional digital SLR cameras should boast a faster buffer capacity and data transfer rate compared to budget digital SLRs. Early pro cameras, like the Canon EOS series, used a FireWire interface, whereas more recent cameras now use USB 2. Both are capable of providing reasonably fast data transfers, but the actual download speed may be compromised by two further factors. One is the speed of the operating system's FireWire/USB drivers, and the other is how well the software is able to optimize the interface connection. In the various reports I have read and the personal testing that I have done myself, it is clear that difference. You also have to consider whether you are going to shoot raw or JPEG and the likely size of the capture files.

When I carry out a speed test, I usually time how long it takes to download a burst sequence of ten captures and build a full set of initial previews. I then divide the total number of megabytes for all the captures by the time taken to fully download them. This gives me a rough idea of how fast the tethered shooting speed is in terms of the number of megabytes per second to download the files from the camera and build the initial previews. My previous experiences with the Canon EOS Utility were quite interesting: I discovered that running EOS Utility plus Lightroom via Windows XP on my Intel Macintosh was around four to five times faster than running the EOS Utility plus Lightroom via Mac OS X 10.5 on the same computer. More recently, I have found that with the later versions of the Mac OS X system, the speeds are more comparable, and if anything, the Mac OS X download speeds are now faster. For example, using a Macintosh with a 2.8 GHz Intel chip and 4 GB of RAM running Windows XP, I have been able to achieve download speeds of up to 8.4 MB per second when capturing images via EOS Utility and auto importing them into Lightroom 3. Using the same hardware running Mac OS X 10.5.7, I have been able to achieve download speeds of up to 9.6 MB per second. These are perfectly respectable download speeds. However, when capturing images directly via Lightroom 3 using the new Tethered Capture feature, I have found I can download images at speeds of up to 10.8 MB per second using the Mac OS X 10.5.7 system. This is in line with what one would expect. Having the ability to download images directly to the destination folder is obviously going to be faster than downloading the photos to a watched folder and then having to move them to a new folder location.

One note of caution here: Having a camera tethered to the computer can quickly drain the battery. If you find this to be the case, then remember to switch the camera off between shots. Another alternative is to use a DC power supply to power the camera while working in the studio.

NOTE

Capture One reportedly offers fast tethered shooting that meets the needs of professional photographers, while other software programs can only offer slow data transfer rates of just a few megabytes per second. It is also interesting to note how live demos of tethered shooting at trade shows have sometimes been deliberately carried out using cameras with low megapixel captures or been switched to capture in JPEG mode. These tricks have been done to achieve a seemingly impressive performance!

TIP

If you need to reconcile changes made to the folder contents at the system level, you can go to the Library module Library menu and choose "Synchronize folder." This forces Lightroom to scan the system folder to see if the contents match the associated Lightroom catalog folder and lets you update the Lightroom catalog, sync deletions, and import any photos that are missing in the current catalog.

How imported photos are organized

As you import photos into the Lightroom catalog, the folders will appear listed in the Folders panel, which is in some ways like a normal list tree folder view that you would find in a file browser program. However, there are some important differences to note here. The Folders panel only displays the folders of photos that have been explicitly imported into the catalog. The folders are primarily displayed by hard drive volume and in alphabetical order, showing the root folder first (such as My Pictures). These can be expanded to reveal any subfolders that are contained in the folder hierarchy. For example, Figure 2.26 shows a typical Folders panel view, which happens to contain three drive volumes. The Hard Drive 3 volume has a root level folder called Lightroom 3 images that contains several image subfolders. When you compare this with the operating system folder, you can see the exact same set of folders listed there as well. When working with the Folders panel, you can rename folders, change the hierarchy order, move files and folders from one location to another (see Figure 2.25), or delete them. Whatever you do in Lightroom is always reflected at the system level. One benefit of this approach is that you can more easily switch between working in Lightroom and a file browser program such as Adobe Bridge. However, if you rename a folder at the system level, or move the location of a folder, the link between the system folder and the Lightroom catalog folder is broken and the Lightroom catalog folder name will appear dimmed with a question mark. In these situations, you can easily restore the link by following the instructions in Figure 2.27 and click the question mark icon that appears in the thumbnail cell to restore the broken link. If a hard drive volume is off-line, the volume header will also appear dimmed and the off-line folders will again have a question mark (see Figure 2.27).

	Moving Files on Disk	
Lr	This will cause the correspondin proceed, neither this move nor a be undone.	g files on disk to be moved. If you ny change you've made prior to this can
	Don't show again	Cancel Move

Figure 2.25 If moving a folder via Lightroom means moving the files to a new disk location, Lightroom alerts you beforehand. You may see a further warning if there is not enough room on the destination drive.

Image management by metadata

Lightroom takes full advantage of the metadata already contained in the image files and any metadata that is added as you import your pictures into Lightroom. You can then use this information to make the searching for and grouping of images faster and easier to accomplish. In many respects, the way Lightroom manages the catalog is more like Apple iTunes in that it uses the image file metadata for the image organization and management. This process kicks in as soon as you import new images and are offered the chance to enter a new folder name and add custom keywords. These are all vital pieces of metadata information that help Lightroom keep track of the images in the catalog.

Figure 2.26 The Folders panel displays the folders for all the photos that have been imported into Lightroom. In the example shown here, the system folder view shows a Lightroom 3 images folder that is stored on Hard Drive 3. You can see how this folder and its subfolders are grouped identically in the Lightroom 3 images folder in the Library module Folders panel.

Figure 2.27 If for some reason the link between the images in a folder and the systemlevel source folder is broken, the Folder listing will appear dimmed and show a question mark, while the thumbnail cells will also display a question mark in the top-right corner of the cells. You can restore the links by clicking a thumbnail cell question mark. This displays the warning dialog shown here. Click the Locate button to relocate the original source photo on the computer. Correct the link for one image and you will find that all the other photos in the folder should relink, too.

3

Navigating the Library module

Tips for navigating the Catalog module and how to make refined selections of photos

In this chapter, we are going to take a first look at the Library module and, in particular, how to use the Library module controls to navigate the photos in your catalog. Lightroom uses fast image caching methods to build preview images of all your imported photos, and from there you can quickly navigate and view any of the pictures in the catalog. You can select individual images, zoom in and zoom out, see multiple selections of photos on the screen, and compare single images alongside others. Plus, I'll show how you can work with Lightroom using a dual-display setup.

Lightroom 3 has also managed to untangle the link between the user interface and cataloging tasks so that the user interface experience is now a lot smoother. This has resulted in faster scrolling in Grid view, faster switching from one image to the next in Loupe view, faster zooming to a 1:1 zoom view, faster module switching, and improved Develop slider module responsiveness. Plus, large catalogs should now be handled better.

We will also look at the tools you can use to refine your image selections, through the use of flags or by rating your images with stars to mark the pictures that you like most. From there, you can use the filtering tools in the Library module to make selections of specific photos or create shortlists of your favorites. You can then decide how you should handle those images that have been left unflagged or flagged as rejects.

TIP

You can use the 🗱 key (Mac) or Ctrl key (PC) in combination with a keypad number (1, 2, 3, etc.) to toggle showing and hiding individual panels. For example, Quick Develop = 1, Keywording = 2, Keyword List = 3, etc. You can also right-click to access the contextual menu options for the panels and use this to hide and reveal individual panels in any of the Lightroom modules.

NOTE

If you are working on a computer with a small display, you will be pleased to know that you can collapse both the Navigator and the Histogram displays. This can make quite a big difference when working with the right panel displays because it allows you to view and work more easily with the panels below. Note also that the other panels slide beneath as you scroll down the panel list. This, too, can be helpful for those who have limited screen real estate.

The Library module panels

When the Library module is selected, the contents of the catalog can be displayed in a Grid view, which provides a multiple-image view using a grid cell layout; Loupe view, which shows a magnified, single-image view; Compare view, which lets you compare two photos side by side; or Survey view, where all the photos in a current selection are displayed in the content area. The Library module controls are split between the left and right panels (Figure 3.1). The Catalog panel lets you view the contents of the entire catalog, a Quick Collection of images, or the Previous Import of images. Additional items may appear in the Catalog panel, such as Missing Photos, and these temporary collections can easily be removed via the contextual menu (see page 78). The Folders panel lists all the folders in the catalog in volume and alphabetical order, and only displays the folders of those photos that have been explicitly imported into Lightroom. You can use the Folders panel to select specific image folders, but as you will see, there are also other ways you can search and locate the photos in the catalog. The Collections panel allows you to select a group of photos from the catalog and save them as a named collection. However, unlike Folders, an individual image can exist in any number of collections. Lightroom also has the ability to create Smart Collections: These are collections that are created automatically based on custom rule settings (see page 180). You can also use the B key to add favorite images to what is known as the target collection. By default this will be the Quick Collection in the Catalog panel, but in Lightroom 3 you can now pick any collection as the target.

New to Lightroom 3 is the ability to publish collections of photos to sites such as Flickr. You can, therefore, now manage photos that have been published online and view feedback comments made via the new Comments panel (see pages 181–184).

The Filter bar, located at the top of the content area, provides a one-stop location for making refined photo selections based on text searches, ratings, and/or metadata. For example, you can filter the catalog based on a keyword search combined with a ratings filter, followed by a metadata filter based on which camera the photograph was taken with. The Quick Develop panel allows you to make basic Develop adjustments without having to switch over to the Develop module. The Keywording panel is where you go to enter or edit new keyword metadata; plus, you can select keyword sets including a Suggested Keywords set, which offers adaptable keyword suggestions based on your current photo selection. Keywords can be applied to images by dragging and dropping keywords onto selections in the content area, by dragging images onto keywords, or by making a selection and adding keywords via the Keywording panel on the right. Other metadata information, such as the camera's EXIF data, can be viewed via the Metadata panel, which offers several data list view options. You can use this panel to add custom IPTC data, such as the title, caption, and copyright information.

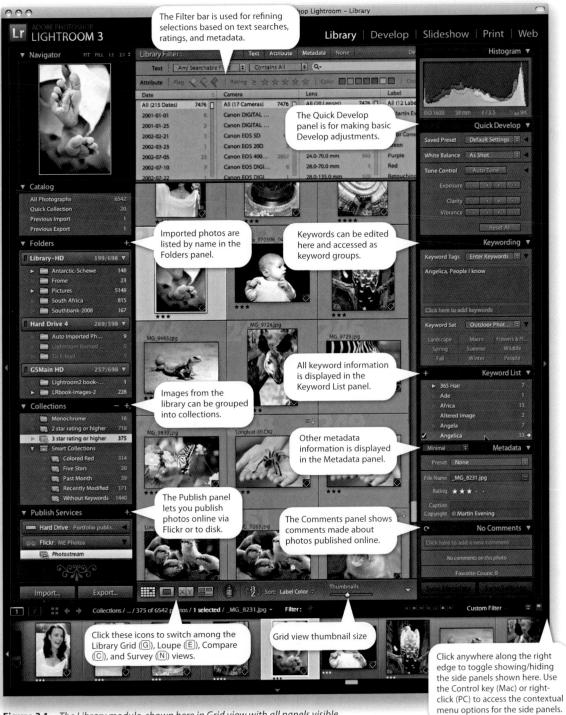

The Library module, shown here in Grid view with all panels visible. Figure 3.1

Figure 3.2 The Navigator panel.

Catalog	
All Photographs	51961
Quick Collection	300
Previous Import	
Previous Export as Catalog	41356
emove this Temporary	Collection
Missing Files	2599
missing riles	25

Figure 3.3 In the Library panel, you can select All Photographs (showing the total number of photos in the catalog), a current Quick Collection, or the most recently imported images from the Previous Import. Some of the items that appear in the Catalog panel are temporary collections and can be removed via a right mouse click and choosing "Remove this Temporary Collection."

Navigator panel

The Navigator panel (**Figure 3.2**) displays a preview of the currently selected image and offers a number of controls for zooming and scrolling the photo (see page 89). The Navigator panel will also update as you roll the mouse over the Folders or Collections panel lists. When you do this, it previews the first photo that appears in the folder, thus providing a visual reference to make it easier to locate the folder or collection you are looking for.

The Catalog panel

The Catalog panel displays summary information about the catalog. For example, the All Photographs option selects all the images in the catalog. It is important to always remember to select All Photographs if you want a filter search to include all photos in the catalog. I know it sounds silly mentioning this, but it's so easy to forget and then wonder why a search has turned up no results! Quick Selection allows you to select photos that have been added to the current Quick Selection, and Previous Import lets you access the most recently imported images. As you work with Lightroom, other items will appear on the list such as Missing Files. These are classed as temporary collections and can easily be removed: Right-click to access the contextual menu and click "Remove this Temporary Collection" (Figure 3.3).

The Library module Toolbar

The default Library module Toolbar contains the Grid, Loupe, Compare, and Survey view mode buttons, plus the Painter, Sort control and Thumbnail Size (**Figure 3.4**). But you can customize the toolbar by adding Rating, Flagging, Color labels, Rotate, Navigate, and Slideshow playback controls. (The Library module Toolbar can be customized individually for both Grid and Loupe views.) It is useful having the toolbar visible, but you can always use the T keyboard shortcut to toggle showing and hiding the Toolbar.

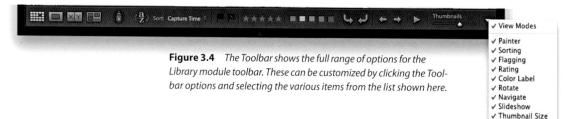

Folders panel

The Folders panel provides front-end management for all the folders that make up the Lightroom catalog. The one rule you have to bear in mind here is that there can be only one master version of an image in the Lightroom catalog. This means you can't make copies of the master image or assign images to more than one folder, but once images have been imported into the Lightroom catalog, they can be grouped into folders any way you like (as long as they are stored on the same volume). "Show photos in subfolders" is always on by default, but you can switch this off via the Library menu, as well as via the Folders panel drop-down menu (circled in **Figure 3.5**).

Any changes you make to the folder structure in Lightroom are reflected at the system level, and the system files and folders will, therefore, always correspond with the hierarchy of the Folders panel in Lightroom. Similarly, as you move folders around or rename them at the system level, these changes are recognized in the Lightroom Folders panel to the extent that if you alter a file or folder location at the system level, an already imported image in Lightroom displays a question mark icon. This indicates that there is a broken link between the catalog photo and the source file; to restore the link, you will need to click the question mark to relocate the missing image. Once this is done for one photo, all the rest will update automatically (see page 73). Figure 3.5 shows how imported folders are listed alphabetically in the volumes they are stored on. As well as rearranging the hierarchy of folders, you can freely move images from one folder to another, and the Volume header bars can be collapsed, making it easy to view the folders by individual volumes. See page 73 for more about the catalog/folders relationship.

Filter bar

The Filter bar (**Figure 3.6**) consists of a Text search section for searching by filename, caption, keywords, and so forth. The Attribute section duplicates the filter controls at the bottom of the Filmstrip, while the Metadata section lets you filter by various metadata criteria. The metadata search options reduce as you narrow the search criteria at each stage. On the downside, the Filter bar does waste quite a bit of space in the content area, but you can use the <u>N</u> keyboard shortcut to toggle showing/hiding the Filter bar. Also, note that if you hold down the <u>Shift</u> key as you click the Text, Attribute, and Metadata options, you can add these to the Filter bar display. <u>(Shift)</u>-click again to remove each one and return to a single option display.

Library Filter :		Text A	ttribute	Metadata None		Custom Fi	iter = 🎴
		Text Any Searchable Fie	id 🛊	Contains All 🔹 🤇	2.		
	Attr	ibute Play QQ	女女女女子:Cotor 日日日日日 i Copy Status 日日				
Date	H	Camera		Lens	State State State	Label	
All (215 Dates)	7476	All (17 Cameras)	7476	All (20 Lenses)	7476	All (12 Labels)	7476
2001-01-01	8	Canon DIGITAL IXUS	7	7.4-22.2 mm	2	© Martin Evening 2006	2
2001-01-25	2	Canon DIGITAL IXUS 400	2	10.0-22.0 mm	6	Blue	59
2002-02-21	1	Canon EOS 5D	48	12.0-24.0 mm	174	Color Correction Needed	2
2002-03-23	1	Canon EOS 20D	3	24.0 mm	4	Green	118
2002-07-05	23	Canon EOS 400D DIGITAL	2857	24.0-70.0 mm	943	Purple	11
2002-07-10	7	Canon EOS DIGITAL REB		28.0-70.0 mm	1	Red	366
2002-07-22		Canon EOS DIGITAL REB	, 81	28.0-135.0 mm	320	Retouching Needed	1

Figure 3.6 The Library module Filter bar.

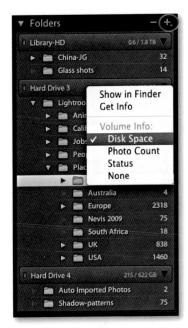

Figure 3.5 The Folders panel displays imported image folders by volume and in alphabetical order. The green light in the volume header indicates that a disk drive is connected and has ample spare storage space. If a disk drive is currently off-line, the volume name appears in black and if a folder name is dimmed, this means there are broken links to one or more of the images within that folder. The numbers displayed in the volume header bar here indicate the number of free GB of data alonaside the total GB capacity of a drive. You can right mouse click on the volume header bar to access the contextual menu shown here to change this display to reveal the Photo Count for the volume, the online/off-line status, or show None.

'	File Name
	File Base Name
	File Extension
	Copy Name
	Folder
	Common Attributes
	Rating
	Label
	Rating and Label
	Capture Date/Time
	Cropped Dimensions
	Megapixels
	Caption
	Copyright
	Title
	Location
	Creator
	Common Photo Settings
	Exposure and ISO
	Exposure
	Lens Setting
	ISO Speed Rating
	Focal Length
	Exposure Time
	F-Stop
	Exposure Bias
	Exposure Program
	Metering Mode
	Camera
	Camera Model
	Camera Serial Number

Figure 3.7 The label options available in Compact Cell Extras in the Library View Options menu.

Exploring the Library module

Grid view options

As new photos are imported, low-resolution previews will appear in the Grid view. If you selected the Standard-Sized Previews option at the import stage, the initial rendering may take a little longer, but you will get to see better-quality previews. If the camera used to capture the images has the camera orientation information embedded in the metadata, the thumbnail previews should correctly rotate to portrait or landscape mode accordingly. Otherwise, you can use the rotate buttons to rotate the images manually, or use **X**[] to rotate left and **X**[] to rotate right (Mac), or **C**trl [] and **C**trl [] (PC).

To open the Library View Options, go to the View menu, select View Options (or press III) [Mac] or Ctril [PC]) and choose Grid View (Figure 3.8). There are two modes for the Library Grid View: Compact Cells (Figure 3.9), which shows the thumbnail only and Expanded Cells (Figure 3.10), which displays the added options listed below. The "Show clickable items on mouse over only" option refers to the Quick Collection markers and rotation buttons. When this is checked, clickable items will be revealed only as you roll the mouse over a grid cell. When the "Tint grid cells with label colors" option is checked, this shades the entire cell border where a color label has been applied to a photo, and "Show image info tooltips" lets you see additional info messages when rolling over the cell badge icons.

30	Library View	Options			
	Grid View L	oupe View			
Show Grid Extras:	Expanded Cells				
Options					
Show clickable it	ems on mouse over	only			
Tint grid cells wi	th label colors				
Show image info	tooltips				
Cell Icons					
I Flags		Unsaved Metadata			
I Thumbnail Badge	es 🕑	Quick Collection Marke	ers		
Compact Cell Extras					
Index Number	Top Label:	File Name	•		
Rotation	Bottom Label:	Rating	•		
Expanded Cell Extra	5				
Show Header wit	h Labels:	Use	Defaults)		
Index Num	ber 🚺	File Base Name	•		
Cropped D	mensions 🛟	File Extension	•		
Show Rating Fool	er				
🗹 Include C	olor Label				
Include R	otation Buttons				

Figure 3.8 The Library View Options dialog.

If you want the image's flag status to appear in the cell border, then check the Flags option in the Cell Icons section. The Flag icons indicate if an image has been identified as a pick (🜒 or as a reject 🍘 (see pages 106–107 for more about working with flags). The Thumbnail Badges are the small icons you see in the bottom-right corner. Four types of badges can be displayed here. If you double-click the Keywords badge (
), this automatically takes you to the Keywording panel in the Library module, where you can start adding or editing keywords linked to this particular image. If you double-click the Crop badge (III), this takes you to the Develop module and activates the Crop overlay. If you double-click the Develop settings badge (図), this also takes you directly to the Develop module, and if you click the Collections badge (
), a drop-down menu appears allowing you to select from one or more collections the photo belongs to. Let me also point out a useful shortcut here: Alt –double-clicking in a grid cell takes you directly to the Develop module, and Att-double-clicking a photo in the Develop module takes you directly back to the Library Grid view. Check the Unsaved Metadata option if you wish to see an alert in the top-right corner when a photo's metadata is out of sync with the main catalog (this is discussed later in Chapter 4). If a photo has been added to a Quick Collection, it will be identified in the Grid view with a filled circle Quick Selection Marker in the top-right corner. You can also click inside this circle to toggle adding or removing an image from a **Ouick** Collection.

Figure 3.9 shows an example of a Compact Cell view (which is the default view when you first launch Lightroom). This particular cell view has the grid cell Index Number (the large dimmed number in the cell background) displayed in the Top Label section, along with the File Name (selected from the **Figure 3.7** list). The Bottom Label section has room for the Rotation buttons, plus one other custom item from the Figure 3.7 list. When Rating is selected, the image rating is displayed, with five stars as the highest rated and no stars as the lowest. Although it is possible to assign star ratings by clicking on the dots in the grid cell area, a more common way to assign ratings is to enter numbers (1–5) or use the square bracket keys ([],]) on the keyboard.

Figure 3.10 shows an example of an Expanded Cells view. You can use the Show Header with Labels check box in the Expanded Cell Extras section to turn the header display options on or off. With the Expanded Cells view, there is room for two rows of information in the header, and you can use the four pull-down menus to customize what information is displayed here. You can also check the Show Rating Footer option to enable adding the Include Color Label and Include Rotation Buttons options. That concludes all the customizable options for the Grid cells, but note that pressing **(CShift)** (Mac) or **(Ctrl) (Cshift)** (PC) toggles showing and hiding all the items in the grid cells and you can use the **()** keyboard shortcut to cycle through the three different Grid cell views: Compact view with badges showing, and Expanded view with badges showing.

This is a flagged pick image.

Image rating status

Figure 3.9 Here is an enlarged view of a Library grid cell in Compact Cells mode.

Rotate thumbnail counterclockwise Rotate thumbnail clockwise

Figure 3.10 Here is an enlarged view of a Library grid cell in the Expanded Cells view. In this example, I deselected "Tint grid cells with label colors" and enabled Include Color Label in the Show Rating Footer options.

TIP

Some Macintosh users may experience problems navigating using the keyboard arrows. If so, go to the System Preferences and select Keyboard & Mouse > Keyboard Shortcuts. Where you see "Full Keyboard Access: In windows and dialogs, press Tab to move keyboard focus between," check the "Text boxes and lists only" button.

Library Grid navigation

The main way you browse the photos in the catalog is by using the Library module Grid view (**Figure 3.11**). You can navigate the Grid by clicking individual Grid cells or use the arrow keys on the keyboard to move from one cell to the next; plus, you can make the thumbnail sizes bigger or smaller by dragging the Thumbnails slider in the Toolbar, or use the + key and – key to increase or decrease the number of cells per row. As explained in Chapter 1, the Library Grid is displayed in the main content area, and the side panels can be hidden by clicking the outer-left or -right sidebar edges. This collapses the panels to the edge of the Lightroom window. The panels can then be revealed by rolling the mouse cursor toward either side of the window, or kept locked in place by clicking the sidebar arrow. An even easier way to manage the Library Grid view is to use the Tab key; this toggles displaying the content area with both side panels in view or hidden, enlarging the content area to fill the complete width of the display.

The selected thumbnail previews are shown in the Grid and Filmstrip with a light gray surround. Within a photo selection of two or more photos, there will always be a primary or "most selected" image (which is also displayed in the Navigator). You can also tell which image this is because in the Grid or Filmstrip, the primary selected image is the one that's shaded a slightly lighter gray than all the other selected thumbnail cells. A photo selection is a temporary collection of images, and selections can be used in many different ways. For example, you might want to make a selection and apply the same rating to all the selected images at once. Or you might want to select a group of images in order to synchronize the Develop settings. In these instances, you'll be synchronizing the settings to whichever is the most selected image in the Grid or Filmstrip. When making image selections via the Library Grid or Filmstrip, you can use the @Shift) key to make a contiguous selection of images—that is, a continuous selection from point A to point E. Alternatively, you can use the 🕱 key (Mac) or Ctrl key (PC) to make a noncontiguous (non-consecutive) selection of images, such as A, C, and E. You can also use the forward slash key ([/]) as a shortcut to deselect the most active photo in a Grid or Filmstrip selection. By using the 🕖 key, you deselect the most selected image in a photo selection; this removes it from the selection and makes the photo immediately to the right in the photo selection the most active.

You can reorder the photos that appear in the Grid view by dragging and dropping them. You can do this most of the time within a Folder or a Collection view of photos, but drag and drop will sometimes be disabled, such as when viewing a temporary collection in the Catalog panel, or when you have multiple folders or collections selected at once.

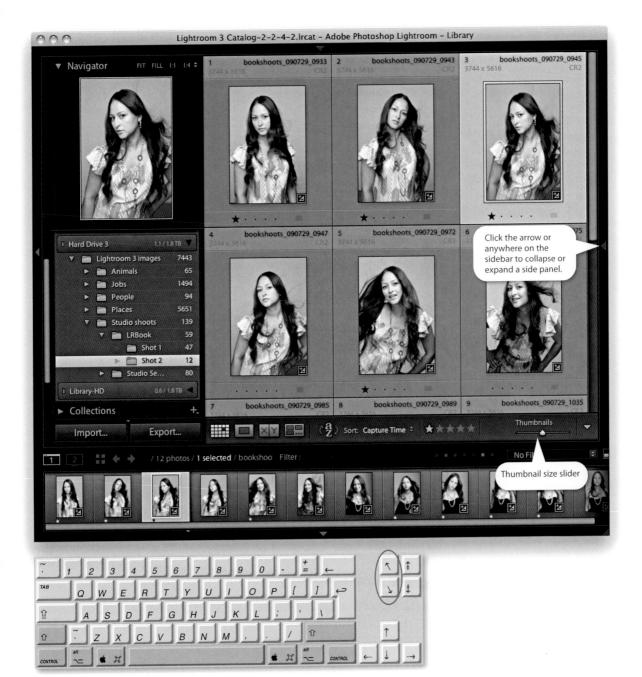

Figure 3.11 This shows the catalog contents displayed in Grid view. Note how this content area image selection (showing all the images in the Shot 2 folder) is duplicated in the Filmstrip below. You can navigate the Grid either by clicking an image in the Grid or Filmstrip, or by using the highlighted arrow keys on the keyboard to move from one image to the next. The Home and End keys (circled) can be used to jump to the first or last image in the Grid, and you can also scroll the Grid contents using the Page Up and Page Down keys.

NOTE

Here are some keyboard shortcuts for navigating between the Grid and Loupe views. The G key always takes you to the Library Grid view from whichever module you are currently in, and the E key always takes you to the Library module Loupe view. The $\mathbb{H}+$ (Mac) or $\mathbb{C}trl+$ (PC) key combination takes you from Grid to Loupe view and the $\mathbb{H}-$ (Mac) or $\mathbb{C}trl-$ (PC) key combination takes you from Loupe view back to Grid view.

Working in Loupe view

Lightroom offers two Loupe viewing modes: standard and close-up. The standard Loupe view either fits the whole of the image within the content area or fills the content area with the narrowest dimension (**Figure 3.12**). The close-up Loupe view can be set to a 1:1 magnification or an alternative zoomed-in custom view setting such as 2:1 or higher. The simplest way to get to the Loupe view is to double-click an image in the Grid or Filmstrip. If you have more than one photo currently selected, the photo you double-click fills the screen. The photo selection is still preserved in the Filmstrip, and you can use the left and right arrow keys to navigate through those photos. If you double-click the Loupe view image, you will return to the Grid view once more. In the accompanying sidebar notes, I have listed some of the other keyboard shortcuts for switching views.

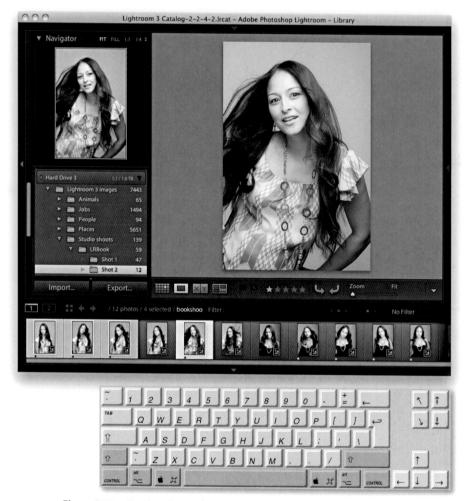

Figure 3.12 Here is an image shown in Loupe view. An active selection is visible in the Filmstrip. You can use the left/right arrow keys to navigate such a selection.

Loupe view options

The Loupe view options within the Library View Options (**#**J [Mac] or **Ctrl**J [PC]) let you customize what is displayed when you switch to the Loupe view. In **Figure 3.13**, I customized the Loupe View options for Loupe Info 1 to display an overlay in Loupe view showing the File Name, Capture Date/Time, and Cropped Dimensions. This information appears briefly when an image is first displayed in the Loupe view (**Figure 3.14**).

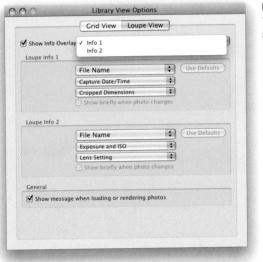

Figure 3.13 The Library View Options dialog showing the Loupe View settings.

Figure 3.14 Here is how the information is displayed for Loupe Info 1 when photos are viewed with the Show Info Overlay option checked. If the "Show briefly when photo changes" option is selected, the Info display appears and then fades out after a few seconds.

NOTE

The default setting will have the photo info appear briefly for a few seconds each time you show a new image in the Loupe view. You can also control the Loupe view options by using the # 1 (Mac) or Ctrl 1 (PC) shortcut to toggle switching the Loupe view information on or off. The 1 key on the keyboard can also be used to cycle between showing Info 1 and Info 2, and switching the Info display off.

NOTE

The View menu contains an item called Enable Mirror Image Mode. If this is selected, it will simply flip horizontally all the images in the library views. To turn it off, just select it from the View menu again. This option is intended to let you show people portraits of themselves the way they see their own reflection when looking in a mirror. However, when you check this option, it flips horizontally all the photos in the catalog—not just those in the current Library selection—so you'll need to remember to deselect it after you are finished!

Working with photos in both Grid and Loupe views

1. In the Grid view mode, you can make a selection of photos and the selection will be mirrored in the Filmstrip below.

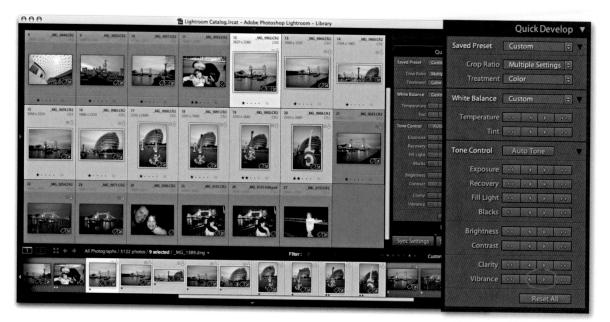

2. If you use Quick Develop to make Develop adjustments, these are applied to all photos in the Grid and Filmstrip selection. (The Quick Develop panel is ideal for such adjustments.) Here, I increased the Vibrance for all the selected photos.

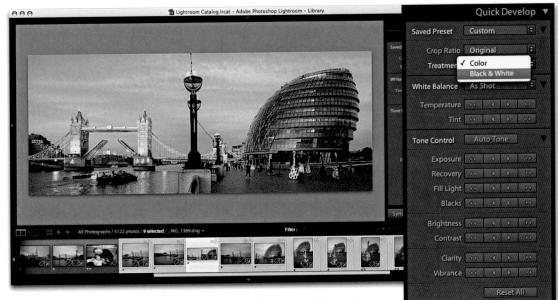

3. However, if you go to the Loupe view mode and apply a Quick Develop adjustment (such as convert to Black & White), this will be applied only to the current photo, even though the photo selection remains active in the Filmstrip. (You can use the ﷺ+left/right arrow keys [Mac] or [Ctrl]+left/right arrow keys [PC] to navigate from one photo to the next.)

4. Back in the Grid view, you can deselect a photo selection by clicking anywhere in the cell border area to deselect the other photos.

NOTE

In the Lightroom Interface preferences, the "Zoom clicked point to center" option provides a subtle difference in zooming behavior. When deselected, zooming in close fills the screen to best fit the content area. When it is selected, where you click is always centered on the screen.

Loupe view navigation

From the standard Loupe view, you can magnify the image preview in a number of ways. A further click will normally zoom in to a 1:1 magnification, centered on where you clicked with the mouse (see sidebar). Another click takes you back to the previous Loupe view. So clicking the photo shown in Figure 3.14, on the center of the face (in standard Loupe view), takes us to the close-up view shown in **Figure 3.15**. In Lightroom 3, you should also find that 1:1 view zooming is faster. This is because Lightroom now spends its time rendering just the portion of the image that you have selected to view in close-up instead of immediately rendering the whole image first.

You can scroll the photo by click-dragging the photo, but the Navigator panel (**Figure 3.16**) also offers an alternative way to navigate your photos. In the fullscreen Loupe view in Figure 3.15, the rectangle in the Navigator represents the area that is currently visible in the content area, relative to the whole image. You can

Figure 3.15 In Loupe view, you can scroll the image by dragging the rectangle in the Navigator, which indicates the area currently being magnified. You can also use the Zoom slider to quickly adjust the zoom level. If you can't see the Zoom slider, go to the Toolbar options (circled) and select Zoom from the list.

drag the rectangle to quickly scroll the image with a minimum amount of mouse movement. Finally, you have the Zoom view slider in the toolbar. This lets you magnify the image from a Fit to window view, right up to an 11:1 magnification.

Loupe zoom views

As I mentioned earlier, there are actually four different Loupe views and the Navigator panel displays a highlighted zoom view readout in the top-right corner of whichever one is currently in use. They are in order of magnification: Fit view, which displays a standard Loupe view, filling the available content area both horizontally and vertically; Fill view, which magnifies the standard Loupe view to fill the width of the available content area onscreen, cropping the top and bottom of the picture as necessary; close-up Loupe view, which offers a standard 1:1 view; and finally, a fourth close-up view with customized magnification levels. You can extend the close-up Loupe view range for this view mode by selecting a new zoom view from the Navigator fly-out menu (Figure 3.16). Overall, it's important to understand that the Loupe zoom essentially offers two zoom view modes: standard and close-up. You can use the Navigator panel to set the standard view to Fit or Fill, and the close-up view to either 1:1 or one of the custom magnified views. The zoom view modes you select via the Navigator panel also establish how Lightroom behaves when you use either a single click or Spacebar to toggle between the two zoom views.

Loupe view shortcuts

By now you'll have come to realize that there are umpteen ways to zoom in and out of an image between the Grid and Loupe view modes. I wouldn't even begin to pretend that it's easy to remember all the zoom shortcuts, so what I suggest you do is play with the various methods described here and just get used to working with whatever method you find suits you best. For example, you can use the (𝔅) + keys (Mac) or Ctrl + keys (PC) to zoom in progressively from the Grid view to the standard Loupe view to the magnified Loupe view. And you can use the 爰 keys (Mac) or Ctrl - keys (PC) to progressively zoom out again. You can use the **B**AIt keys (Mac) or Ctrl AIt keys (PC) with the + and - buttons to zoom in and out in gradual increments from the Grid view to a 11:1 Loupe view. You can also use the Z key to toggle directly between the Grid and close-up Loupe views. When you are in the close-up Loupe view, you can use Spacebar to toggle between the close-up and standard Loupe views. If you press the ${\Bbb Z}$ key again after this, you can now toggle between the standard and close-up Loupe views. I also find it useful to use the Return key to cycle between the grid and two different Loupe views. Press once to go from Grid view to standard Loupe view, press again to go to a 1:1 Loupe view, and press once more to return to the Grid view.

Figure 3.16 Here is a view of the Navigator panel, showing all the available custom Zoom view options. They can range from 1:4 (25 percent) to 8:1 (800 percent) and all the way up to 11:1. But as in the movie This Is Spinal Tap, I suspect the real zoom value is, in fact, closer to 10:1.

TIP

The close-up Loupe view is handy for comparing image details. You can navigate from one image to the next in a selection using the keyboard arrow keys, and inspect the same area of each image in close-up view.

Figure 3.17 The thumbnail and standard Loupe previews will start off looking pixelated and quite possibly flat in color. These will change appearance as the Lightroom settings kick in and render a Lightroom preview version that replaces the original preview. Note that the above behavior does also depend on which Camera Profile you have selected as part of the default import settings (see Camera Profiles in Chapter 6).

NOTE

The Auto Tone adjustment logic was updated for version 2 and has now been improved further in Lightroom 3. Lightroom now tends to do a better job estimating which Develop settings to apply when you select Auto Tone.

About the Lightroom previews

When you first import new photos, Lightroom makes use of whatever thumbnails are embedded in the file and uses these to populate the Library grid. Lightroom then automatically builds larger, standard-sized previews of the photos, which, depending on the camera default settings you are using, will usually cause the thumbnail to change appearance. In **Figure 3.17**, you can see a typical example of the change in appearance from a low-res, camera-embedded JPEG thumbnail to the Lightroom-generated preview.

Establishing the default Develop settings

Some people say they prefer the look of the camera-generated previews, and in some cases the camera-embedded preview may, indeed, look better. Often, it is because they have not yet established a suitable camera default setting. In the Lightroom preferences (**Figure 3.18**), you can click the "Apply auto tone adjustments" check box in the Presets section, which automatically applies Auto Tone adjustments every time you import a new set of photos. This usually produces a snappier-looking image (like the lower preview shown in Figure 3.17). The downside is that this default setting will then be applied to all newly imported photos, and the Auto Tone setting won't always work so well for all types of images, particularly those shot using controlled studio lighting.

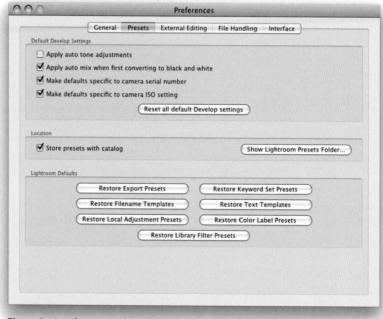

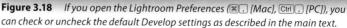

If you are working in the Develop module and you create a Develop setting that you feel is suited to the processing requirements of a particular camera, you can go to the Develop module Develop menu and choose Set Default Settings. This opens the dialog shown in **Figure 3.19**, where you can click the Update to Current Settings button to update the default settings for the camera model listed in the same dialog. But if, at the same time, you have "Make defaults specific to camera serial number" and "Make defaults specific to camera ISO setting" checked in the Lightroom Presets preferences (see Figure 3.18), clicking Update to Current Settings will make the default setting specific to the camera serial number and ISO setting. The combination of the Set Default Settings and Default Develop Settings preferences will, therefore, allow you to establish the default settings that are applied to all newly imported photos and how the previews look when they are first rendered by Lightroom as thumbnails and standard Loupe view previews.

Figure 3.19 When you select the Set Default Develop Settings option, you can update the default Develop settings for any camera. Depending on how the Lightroom Presets preferences have been configured, this action may apply the defaults to the camera type only, to a specific camera serial number, or to a combination of a specific camera body and ISO setting.

The initial preview building routine

Whenever you launch Lightroom, it initially loads all the low-resolution thumbnails, and within 30 seconds or so, starts running checks on the current catalog contents, checking the thumbnails in order of quality. Lightroom looks to see if any of the standard resolution thumbnails need to be rebuilt first before going on to build new previews for the images. At the same time, it checks existing thumbnail previews against their modification dates. If any file has been modified since the last time a preview was built, Lightroom rebuilds a new set of previews, starting with a standard preview, followed by the high-quality previews.

Preview size and quality

To set the standard preview size, choose File \Rightarrow Catalog Settings. This opens the Catalog Settings dialog shown in **Figures 3.20** and **3.21**. My advice here is to select a pixel size that is suited to the size of display you are working with. If you are working with Lightroom on a small laptop computer, then you probably won't

TIP

If you find you usually prefer the look of the standard, camera-embedded JPEG previews and want Lightroom to preserve the embedded-preview appearance, you can. If you go to page 340, you can read about how to select a Camera Standard profile in the Camera Calibration panel to simulate the look of a camera JPEG.

CALLS IN ALL HE - CALLER	General File	Handling	Metadata 👌		
review Cache					
Standar	d Preview Size: 10	24 pixels	•		
Р	review Quality: Me	dium	•		
Automatically Discard	i 1:1 Previews: Aft	er 30 Days	•		
Imp	ort Number: 46	Photos I	mported: 6	265	

Figure 3.20 For smaller-sized displays, there will be no need to set the Standard Preview Size any larger than 1024 pixels. Also, if hard drive space is at a premium, then set the Preview Quality to Low or Medium.

	General File	Handling	Metadata	
Preview Cache		1. Charles		
Standard	Preview Size: 20	48 pixels		
Pri	eview Quality: Hig	jh	•	
Automatically Discard	1:1 Previews: Aft	er 30 Days	•	
Impo	ort Number: 46	Photo	s Imported: 6265	
		, india.		

Figure 3.21 If you are working with a large screen such as a 30-inch dislpay, then set the Standard Preview Size to 2048 pixels. If you set the Preview Quality to High, this will ensure that the best-quality previews are generated and that they are archived using the ProPhoto RGB space.

need the standard-sized previews to be any bigger than 1024 pixels in either dimension. If you are using a 30-inch display, then it is better to select the largest preview size available. Since the preview pixel dimensions will also affect the size of the preview file cache, it makes sense to keep the cache down to a reasonable size. There is no point in making the standard previews unnecessarily large since this will simply consume more hard drive space than is needed. The preview quality determines how much compression is applied to the preview files. A Low Preview Quality compresses the previews more, at the expense of image quality, while a Medium setting uses less compression and produces larger, better-quality previews. The High setting applies the least amount of compression for the best image preview quality. Note that in Lightroom 3, all previews are now rendered using the Adobe RGB space.

When you point Lightroom at a particular folder, it will, as a matter of course, build standard-sized previews of all images; Lightroom does this in the background as and when it can. The process usually takes a while to complete, so not every image will have a preview available for use right away. The standard previews are generated quickly from the master file and now also include sharpening and noise reduction, but only if you are using Process Version 2010 rendering. Otherwise, the sharpening and noise reduction are skipped.

Generating the 1:1 previews

The 1:1 previews are generated last whenever you choose to zoom in on an image and inspect it close-up. If you need to prioritize building the full-size 1:1 previews, you can do so by going to the Library menu and choosing Previews \Rightarrow Render 1:1 Previews. This forces Lightroom to generate 1:1 previews for all the selected photos, which will be rendered with the sharpening and noise reduction included and at the same time regenerate the standard-sized previews.

Discarding 1:1 previews

The 1:1 previews are useful because they can speed up the time it takes to review images at a 1:1 zoom view, but they can also be costly in terms of taking up extra room on the hard disk. An option in the Catalog Settings File Handling section allows you to automatically discard 1:1 previews after a designated period of time. If you are not concerned about the *Catalog Previews.lrdata* file getting bigger and bigger in size, you can choose never to discard the 1:1 previews. If you go to The Library ⇒ Previews submenu, you can also choose Discard 1:1 Previews. This reveals the warning dialog shown in **Figure 3.22**, which alerts you to the fact that you are about to discard the 1:1 previews for all the selected photos. Note that if just one photo is selected, you will be asked if you wish to discard just that one image preview or all 1:1 previews in the current filtered folder/collection.

NOTE

If only one image is selected, Lightroom will ask if you wish to build previews for that one photo only or build all.

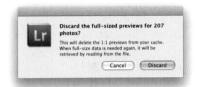

Figure 3.22 The Discard 1:1 Previews warning dialog.

NOTE

While it is possible to drag and drop photos in a Survey view to change the order they appear in, you will often find this a tricky process. This is because you will find yourself fighting with the Survey view mechanism that is designed to optimize the size and placement of photos on the screen.

Working in Survey view

If you have a multiple image selection active, you can view all the selected photos at once by clicking the Survey view button in the Library module Toolbar, or you can switch to Survey view by pressing the \mathbb{N} key (from any of the Lightroom modules). Whenever you are in Survey view, the content area is used to preview the selected images as big as possible. The relationship between the Survey and Loupe view is the same as that between the Grid and Loupe view. So, if you double-click an image in Survey view, you are taken to the standard Loupe view, and double-clicking the photo takes you back to the Survey view again.

Figure 3.23 shows a Survey view of all the photos that are currently selected in the Filmstrip. (I'll discuss the Filmstrip a little later in this chapter.) The arrangement and size of the individual previews dynamically adjust according to the number of photos you have selected and the amount of screen real estate that's available in the content area. So, depending on the number of photos you have selected, the orientation of the photos, and the physical size of the content area, Lightroom will adjust the Survey view display to show all the selected photos as big as possible. However, if you make a really large selection of photos and choose to view them in Survey view, there will be a cutoff point where Lightroom won't show any more than the first 100 or so photos, and you'll see a number in the bottom-right corner telling you how many more photos there are in the current selection not included in this Survey view.

The primary, or most selected, image is displayed with a white border, and you can navigate the photos displayed in the Survey view by click-selecting individual images or using the left and right arrow keys to navigate among them. You can remove photos from a Survey view selection by clicking the X icon in the bottom-left corner, or by (H)-clicking (Mac) or (CH)-clicking (PC) the photos you wish to deselect (either in the content area or via the Filmstrip). The image previews will then automatically resize to make full use of the screen space that's available in the content area. Note that removing a photo from a Survey view simply removes it from the selection and does not remove the photo from the catalog.

Personally, I find the Survey view to be a really useful tool for editing selections of photos, more so than the Compare view that's described over the next few pages. When I am working with clients, I find it most useful when I have a shortlist of shots and the client and I can view all the final candidate images on the screen at once, much in the same way we used to look through final photograph selections on a light box. For personal projects, I love the simplicity of how the Survey view allows me to get a quick overview of a final selection of pictures and gauge how they work alongside each other.

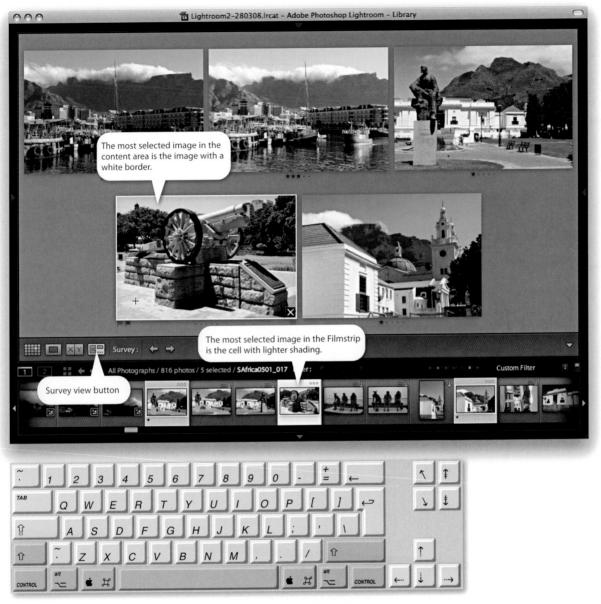

Figure 3.23 Shown here is an image selection made via the Filmstrip in the Library module Survey view. To navigate through the selected images, use the left and right arrow keys, shown highlighted above.

NOTE

If only one image is selected in the Grid when you switch to Compare view, whichever photo you selected immediately prior to the new selection becomes the new Candidate image. If you then highlight the Candidate image, Lightroom lets you cycle through all the images in the current folder/collection as you navigate using the arrow keys.

Working in Compare view

If you click the Compare view button in the toolbar, Lightroom displays the currently selected image as a Select image and the one immediately to the right in the Filmstrip as a Candidate image (**Figure 3.24**). In this setup, the Select image stays locked and you can use the keyboard arrow keys to navigate through the remaining photos in the selection to change the Candidate image view and thereby compare different Candidate images with the current Select. A white border indicates which image is active, and you can use the Zoom view slider to adjust the Zoom setting for either photo. When the zoom lock is switched on, you can lock the level of magnification and synchronize the zoom and scrolling across both image views.

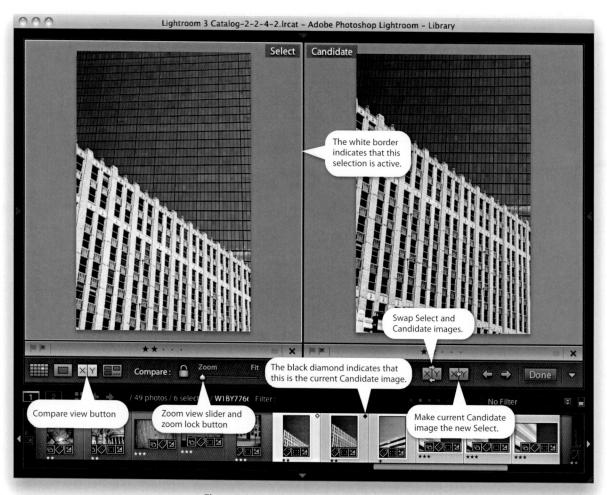

Figure 3.24 In Compare view, you can compare a Select image with various Candidate images and use the left and right arrow keys to navigate through alternative photos in the Filmstrip.

Compare view display options

If the Navigator panel is open, you can use it to navigate the Compare view display (**Figure 3.25**). Use a single click in the Navigator preview to zoom in to whatever the close-up zoom view level is, and then click-drag the zoomed-in rectangle to analyze different areas of the two images. Of course, you still have the lock button in the toolbar to unlock the zooming and scrolling for the two images in order to navigate each one separately. To return to the normal zoomed-out view, double-click anywhere inside the Navigator preview. When you have decided which image is the favorite Select, click the Done button to display the current Select image in a standard Loupe view.

NOTE

When using the Compare view mode to compare images side by side, you can also make the info overlay visible. To enable this, in the Library module, choose View ⇒ Loupe Info ⇒ Show Info Overlay. Or use the 注〔(Mac) or Ctri〔1 (PC) keyboard shortcut.

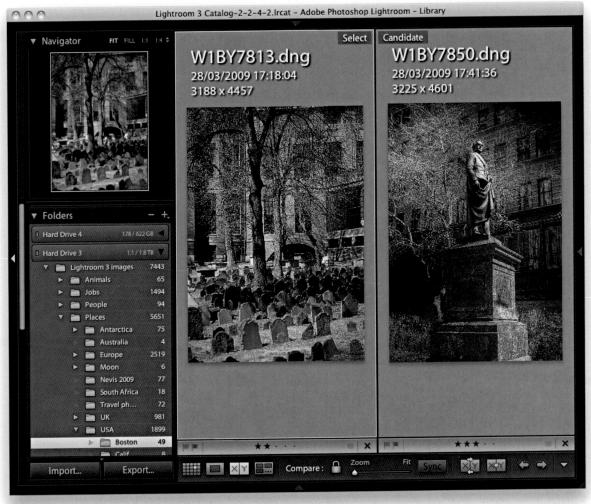

Figure 3.25 The Compare view with the Navigator panel and Loupe Info visible.

Compare view mode in action

The following steps show an example of the Compare view being used to edit a selection of photos made via the Filmstrip.

1. In the Filmstrip, you can tell which photo is the Select and which is the Candidate by the icon in the top-right corner. The Select photo (orange border) is indicated with a hollow diamond, and the current Candidate photo (blue border) is indicated with a filled diamond.

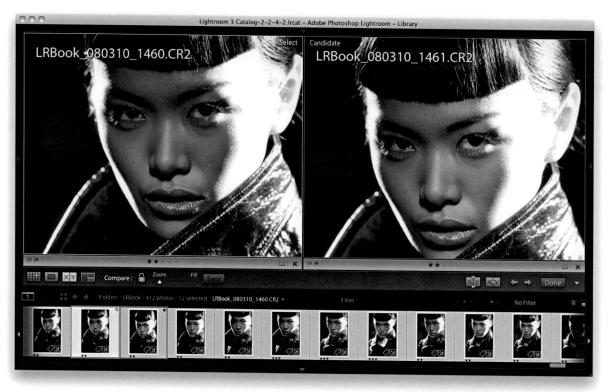

2. Here is an example of the Compare view mode in action. In this first screen shot, I have the photo highlighted with the orange border as the current Select and the photo highlighted with the blue border as the current Candidate.

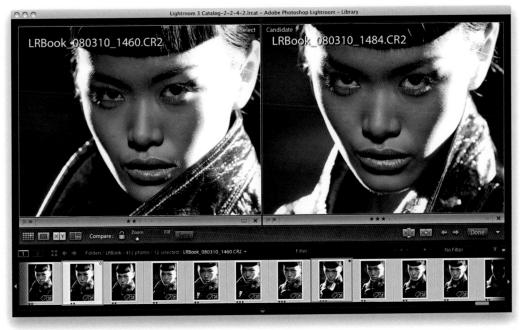

3. I proceeded to use the right arrow key to move forward through the Filmstrip selection comparing other photos with the original Select.

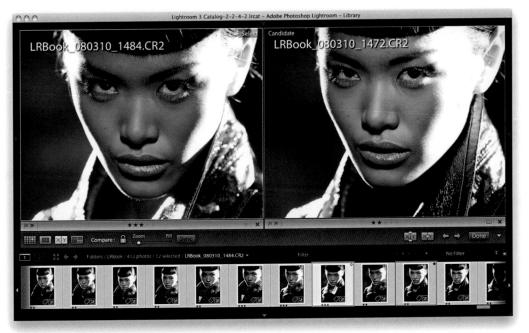

4. When I found a new photo that I liked more, I used the up arrow key to promote this Candidate photo to become the new Select and continued searching for alternative Candidate images.

Figure 3.26 In the Lightroom Interface preferences section is a Filmstrip section where you can choose to display ratings and picks, badges, and stack counts in the Filmstrip thumbnail cells.

Navigating photos via the Filmstrip

The Filmstrip is located at the bottom of the Lightroom window. You don't get to see the same amount of additional information in the Filmstrip as you can see in the Library Grid cells, although the Lightroom Interface preferences does have an option to "Show ratings and picks" in Filmstrip to make these two items appear at the bottom of the thumbnail cells in the Filmstrip (**Figure 3.26**). Plus, you can choose to display badges and stack counts for any stacked photos (see page 120).

Basically, the Filmstrip is always accessible as you move between modules in Lightroom; it provides a secondary view of the library contents (**Figure 3.27**). Therefore, when working in the other Lightroom modules, the Filmstrip offers an overview of the currently filtered photos in the catalog (**Figure 3.28**). As with the Library module Grid view, the Filmstrip lets you make selections of photos. Dragand-drop editing is possible via the Filmstrip, and any drag-and-drop changes you make will also be reflected in the Library module Grid view. Custom sort order changes such as these are also remembered whenever you save a selection of images as a Collection.

The Filmstrip allows you to navigate through your photos just as you can in the Library Grid view. For example, you can press the left or right arrow key to progress through the folder thumbnails one at a time, or hold down an arrow key to quickly navigate through the thumbnails and see the Loupe preview update as you do so. Or, you can drag the Filmstrip's slider bar to scroll even more quickly through the photos and make selections.

Figure 3.27 The Filmstrip sits at the bottom of the Lightroom Interface screen and is present in all the Lightroom modules. The Go Back/Go Forward buttons let you skip between the current and previous Lightroom views.

Figure 3.28 The Filmstrip allows you to view and work with the currently filtered photos in the catalog contents, which will remain accessible as you switch from one module to another.

✓ Show	₩F11
✓ Full Screen	企 第F11
Show Second Monitor Preview	飞仓器F11
✓ Grid	ΦG
Loupe – Normal Loupe – Live	ΦE
Loupe – Locked	☆器↩
Compare	ΦC
Survey	ΰN
Slideshow	℃分器↔
✓ Show Filter View	心/
Zoom In	
Zoom Out	☆ 第 −
Increase Thumbnail Size	
Decrease Thumbnail Size	

Figure 3.29 The Window ⇒ Secondary Display submenu.

Working with a dual-display setup

Let's now look at how you might use a dual-display setup. Figure 3.30 shows a secondary display Grid view (Shift) toggles showing/hiding a secondary Grid window). You have here the same controls as are found in the normal Grid view, including a menu list of recently visited folders, a thumbnails slider to adjust the size of the Grid display, and a Shift keyboard shortcut to show/hide the Filter bar. Figure 3.31 shows the secondary display Loupe view (Shift) toggles showing/hiding the secondary Loupe window), where there are three options in the top-right corner. The Normal mode displays the current image and updates whenever you make a new image active. The Live view updates as you roll the mouse over the photos in the main Grid view or the Filmstrip, which is handy if you want to inspect other photos up close without losing the current image selection.

Figure 3.30 This shows the main window (with the secondary-display button circled), plus a secondary Grid view window.

Figure 3.31 The secondary-display Loupe view window.

Figure 3.32 The secondary-display Compare view window.

By now, you will probably have caught on to the fact that all the keyboard shortcuts for the secondary display are just the same as those used for the normal display, except you add a ☆Shiff key to the shortcut.

NOTE

You have the same zoom controls in the secondary Loupe view window as you do in the Navigator panel, but you can set the Loupe zoom to a different magnification setting. This means that you can preview a photo in Fit to screen Loupe view on one screen while using, say, a 1:1 view on the other.

Figure 3.33 The Second Monitor Preview window allows you to preview and control remotely the content of the secondary display. For example, this would be useful if you wanted to control a display that was set up in a different location and wanted to use it to preview photos to clients.

But it also means that if you have the secondary display set to 1:1 view, you can run the mouse over the photos in a Grid view and use the 1:1 Loupe view as a quick focus checker. You should try this out—it is like running a large magnifying glass over a set of contact sheets! The Locked view option locks the Loupe view in place and does not update until you unlock from this view mode. This offers an alternative way for you to compare photos side by side, which leads us to the secondary Compare view mode shown in **Figure 3.32** (<u>A Shift</u>) toggles showing/hiding the secondary Compare window). The secondary Compare view shown here works just like the main Compare view and basically extends the scope of how you can carry out Compare view editing.

How to get the most out of working with two displays

Now let's look at a few examples of how a secondary display can be useful when you are working in Lightroom. On the facing page, I have suggested three ways that a secondary display can ease your workflow. Figure 3.34 shows how you can have a selection of photos in Survey view mode on the main screen and use the Compare view on the secondary display. With this arrangement, you can preview a Select image alongside a Candidate on the secondary display and choose alternative candidates by clicking on the individual photos in the main display in Survey view mode. In the Figure 3.35 example, you can see the Loupe view in use on the main screen with a Grid view on the secondary display. With this setup, you can have full access to the Grid and Loupe views at once, instead of having to rely on the Filmstrip. The one thing you can't have is two Grid views active at the same time. If you are in Grid view mode in the main window and you select the Grid view for the secondary display, the main window will automatically switch to a Loupe view mode. And finally, you can combine any module view on the main screen with a Grid, Loupe, Compare, Survey, or Slideshow view on the secondary display. In the Figure 3.36 example, I used the main screen to display a photo in the Develop module, where I was able to use the Develop tools to edit the photograph. Meanwhile, I had the current selection of photos displayed in the Survey view mode on the secondary display. With this kind of setup, you can use the secondary display to select photos from the Survey view (it doesn't have to be Survey mode; you could use Grid or Compare) and edit them directly in Develop, thereby bridging the gap when working with these two separate modules.

Note that the secondary display must be in full-screen mode for you to access the Slideshow option; otherwise, it will be hidden. You may want to use a secondarydisplay feature to control a display that's set up for clients to view picture selections. If the secondary window is active and in full-screen mode, you can go to the Window ⇒ Secondary Display menu and choose Show Second Monitor Preview (ﷺAtt ☆Shift)F11 [Mac], ⓒtri Att ☆Shift)F11 [PC]). This opens the control preview shown in Figure 3.33, which allows you to preview and control remotely the secondary-display content.

Figure 3.34 The Survey view used with the Compare view.

Figure 3.35 The Loupe view used with the Grid view.

Figure 3.36 A Develop module view used with the Survey view.

Use P to flag the pick select images. Use X to flag the reject images. Use U to undo the pick or flagged status. Use `` to toggle between a pick and unflagged status. Use # (Mac) or Ctrl T (PC) to increase the flag status. Use # (Mac) or Ctrl ↓ (PC) to decrease flag status.

TIP

Use #Ait A (Mac) or Ctrl Ait A (PC) to select all flagged photos.

Figure 3.37 From the Library menu, you can choose the Refine Photos command. This opens a dialog that informs you that if you proceed with this command, Lightroom will automatically mark the unflagged photos as rejects and mark the previously picked photos as unflagged. The intention here is help you make successive passes at the image selection editing stage and use flagging (in a rather brutal way) to narrow down your final picture choices. It's not an approach I would recommend.

Refining image selections

Rating images using picks and rejects

The next step in managing your images is to record which photos you like best by assigning ratings to them. Numbered star ratings are normally used to progressively mark the pictures you like best from a shoot. In the days of film, you would use a pen to mark the shots worth keeping with a cross and the ones you liked best with two crosses. These same editing principles can be applied when using the rating system in Lightroom to edit photos from a shoot. The flag controls on the toolbar provide an even simpler method for marking favorite and rejected photographs. (See Figure 3.37 to learn about the Refine Photos command.) You can then use the Filter controls in the Filmstrip (Figure 3.38) to selectively display your flagged selections. This simple binary approach allows you to mark the pictures you like with a flag by clicking the Pick flag button in the toolbar (or by using the P keyboard shortcut). You can then click the Filter Picks Only button in the Filmstrip to view the Pick images only (Figure 3.39). Meanwhile, you can use the Reject flag button (or use the X) keyboard shortcut) in the toolbar to mark an image as a reject (which will also dim the thumbnail in the Grid view). Likewise, you can use the Filter Rejects Only button to view the rejects only (Figure 3.40). This raises the question of what do you do with the reject photos. Some people suggest the rejects should then be deleted, but I strongly advise against this approach since you never know when a reject photo may come in use. Perhaps there is an element in the shot you may find useful later? The only photos I ever permanently delete are those where the flash failed to fire. Everything else I keep, but I do tend to filter out the rejects or unmarked photos, burn these to backup disks, and then delete them from the computer. Finally, you can use the U keyboard shortcut as a kind of undo command to mark a photo as being unflagged. You can, therefore, use the U keyboard shortcut as a means to remove the pick or reject flag status from any image. There is also an Unflagged Photos Only filter button in the Filmstrip, which allows you to view the unflagged photos only.

	Refine Ph	otos		
Lr	Refine the displayed photos This will cause the unmarked ph the marked photos.	? otos to be made rejected and will unmark Cancel Refine		
Filter:			Custom Filter	

Figure 3.38 Here is a close-up view of the Filmstrip filters. The flag buttons are cumulative, which means that you can click each to show or hide the flagged, unflagged, and reject photos. In this example, only the Flagged and Reject buttons are checked, which means all photos are displayed except for the unflagged images.

Figure 3.39 Use the flag pick (or press P or) to mark your favorite images. In the Filmstrip at the bottom, I clicked the Filter Flag Picks Only button to see my favorite picks.

Figure 3.40 Use the reject flag button (or press \times) to mark an image as a reject. To see the reject photos only, click the reject flag icon in the Filter options.

You can assign ratings to batches of images by making a selection in the Grid or Filmstrip and then assigning a rating using the appropriate keyboard shortcut.

TIP

When you are in Grid view, you can click the empty dots just below the thumbnail to apply a star rating. You can also adjust the star rating by clicking one of these stars and dragging with the mouse. Plus, clicking a star resets the photo's rating to 0. I don't recommend these methods because they're really fiddly, especially when using a large computer display with a fine screen resolution. All in all, the keyboard shortcuts offer the quickest solution for rating photos.

Rating images using numbered star ratings

The picks and rejects method is fine for making simple picture edits, but to my mind, the most effective way to rate your images is to use the keyboard numbers through s to assign a specific numbered star rating. Or you can use the right square bracket key () to increase the rating or the left square bracket key () to decrease the rating for an image (see **Figure 3.42**).

With the number rating system, you can assign star ratings that reflect a photo's importance. For example, you can use a 1-star rating to make a first pass selection of "pick" images and after that use a "1 star or higher" filter to view the 1-star photos only. (In **Figure 3.43**, you can see how I used the Filter rating control in the Toolbar to display only those images with a 1-star rating or higher in the content area.) You can then make a further ratings edit in which you assign higher star ratings to the very best photos. When you find yourself having second thoughts about photos you had rated previously, you can mark them with a 0-star rating to remove them from the current filtered view. To make things simpler, you can save a ratings filter as a filter preset. In **Figure 3.41**, I had a "3 stars or higher" filter active. I then went to the Custom Filter menu and chose Save Current Settings as New Preset and saved this as a "3 stars or higher" filter.

With Lightroom, you have the potential to rate your images on a scale from 0 to 5. I suggest you use a 0 rating for images that have yet to be rated or are unsuitable for further consideration, and use a 1-star rating for pictures that are not obvious rejects. During a second pass, I use a 2-star rating to mark the favorite images that are suitable for inclusion in the final selection. I may later use 3 stars to mark the final-choice images, but I prefer not to assign the higher star ratings too freely. The reason for this is that it leaves me some extra headroom to assign higher ratings later. At this point in time, I have a fairly large library of images that will surely grow over the next 10 to 20 years. I want to be careful as to how I allocate my 4- or 5-star ratings. These should be reserved for the very best shots.

Figure 3.41 You can use the Custom Filter menu to save a filter setting as a new custom preset. In the example shown here, I saved the current filter setting as a "3 stars or higher" filter.

Figure 3.42 The most convenient way to rate images is to navigate using the keyboard arrow keys and use the \bigcirc - \backsim keys to apply number ratings (use \bigcirc Shift + number to apply a rating and move to the next photo). Alternatively, use \bigcirc to increase a photo's rating or \bigcirc to lower the rating, and press \bigcirc to reset the rating to 0.

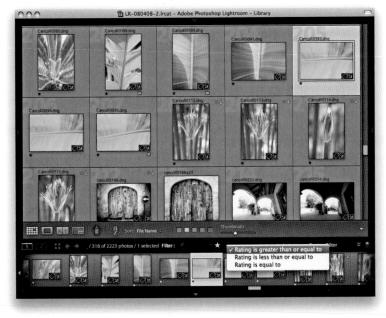

Figure 3.43 After applying initial ratings, you can use the Filter rating controls in the Filmstrip to narrow the selection to display the rated photos only. In this example, I chose to filter the photos with a 1-star rating or higher.

Edit Color	Label Set
Preset: Custom	
Red	6
Yellow	7
Green	8
Blue	9
Purple	and hand the paint
If you wish to maintain compatibility with lai both applications.	bels in Adobe Bridge, use the same names in
If you wish to maintain compatibility with la both applications.	
If you wish to maintain compatibility with labout applications.	Cancel Change
both applications.	Cancel Change
both applications	Cancel Change
both applications Edit Color I Preset: Review Status	Cancel Change

Color Correction Needed
7
Color Correction Needed
7
Color to Use
8
To Print
7
Provide its measure comparability with labels in Adde Bridge are the same name in
both applications
Cancel
Cancel
Change

Figure 3.44 If you go to the Metadata menu and choose Color Label Set ⇒ Edit, you can create and save your own custom interpretations of what the label colors mean or refer to. I suggest that you start by using the default Review Status set.

Working with color labels

In the previous sections, I've shown how flags can be used to mark photos as rejects or keepers and how star ratings can be used to assign levels of importance. Color labels, on the other hand, can be used in conjunction with these rating systems to segregate catalog photos into different groupings.

Rotate Left (CCW) Rotate Right (CW) Flip Horizontal Flip Vertical	ቻ[ቻ]		
Set Flag Set Rating	4		
Set Color Label Auto Advance	•	Red and Next Yellow and Next	
Set Keyword Change Keywords	¢ ⊮K	Green and Next Blue and Next Purple	企8 企9
Develop Settings	•	None	
Delete Photo Remove and Trash Photo Delete Rejected Photos	図 図第47 図第		

Figure 3.45 Here is a quick summary of the three main ways you can assign a color label. You can use the Photo \Rightarrow Set Color Label submenu, use the keyboard numbers from 6 to 9 (there is no keyboard shortcut for a purple label), or click on a label color in the toolbar.

You can assign color labels via the Photo \Rightarrow Set Color Label menu and choose a desired label color (**Figure 3.45**). Color labels can also be assigned by clicking a color label button on the Toolbar, or you can use keyboard numbers to assign labels as follows: red (6), yellow (7), green (8), blue (9). (Note that there is no keyboard shortcut available for purple.) If you hold down the Shift key as you press a keyboard number (6–9) this applies a rating and moves to the next photo. Finally, you can add a color label by typing in the name in the Color Label field of the Metadata panel.

Note that color labels are always specific to the color label set that's currently in use. The implication here is that when you use the color label filter buttons in the Filmstrip or Filter bar to filter according to a color label, the filter works only with the currently active color label set. So here's the problem: If you select a new color label set (**Figure 3.44**) and apply, say, a purple color label filter, this will only select the purple-labeled photos that were edited using *that specific color label set*. It won't select any of the purple-labeled photos that were edited using any other color label sets (where the color label text description does not match). So, if color label filters are not working as expected, check that you have the correct color label set active.

Lightroom and Bridge labels

If you use color labels in Bridge to classify your photos, the color label settings are preserved when you import them into Lightroom or modify a Lightroom imported image via Bridge. However, this does assume that the Bridge color label set matches the one used in your copy of Lightroom. The problem here is that Lightroom and Bridge both use two different default descriptions for the color labels, which can ultimately lead to metadata conflicts between the two programs. So while the color label "colors" may match, the text descriptions don't and this can lead to metadata confusion where neither program can read the labels fully. However, you can use the Label Color command on the Sort menu, shown in Figure 3.46, to overcome this. Lightroom also features two extra color label filtering options (Figure 3.47). For example, you can filter by Custom Label. This will filter out the photos with color labels like those in the previous scenario where the label color and label color text don't match. There is also a No Label filter option that allows you to quickly filter the unlabeled photos only. For more about sorting and how to deal with color label metadata conflicts, see page 197 in Chapter 4.

Figure 3.47 There are two extra color label filtering options: Custom Label and No Label.

Other labeling methods

While ratings can be used to indicate how much you like or don't like an image, color labels provide an overlapping means for classifying images into categories that have nothing to do with how you rate an individual image. For example, on a wedding shoot, you could use red labels to classify photos of the bride and groom, yellow labels for all the family group shots, and green labels for the informal style photographs. Peter Krogh, in *The DAM Book: Digital Asset Management for Photographers*, Second Edition (O'Reilly), describes how he uses color labels to assign negative ratings to his images. He uses red to mark images that have yet to be rated, yellow to mark the outtakes (which he doesn't want to delete yet, even though he won't use them), and green to mark images that definitely need to be trashed. He then uses blue and purple for making ad hoc temporary selections, such as when making a shortlist of Candidate shots to send to a client.

Figure 3.46 The Sort menu in the toolbar allows you to sort photos by the label color or by the label text description.

When a filter is in effect, you can use Library ⇒ Enable Filter to toggle it on and off, or better still, use the ﷺ L (Mac) or Ctrl L (PC) keyboard shortcut.

Filtering photos in the catalog

Now that you have edited your photos using a rating system of your choice, you can start using these ratings in conjunction with folder, keyword, and other selections to refine your image selections and retrieve the photos you are looking for more quickly.

The Lightroom image catalog can be thought of as having a pyramid-type structure in which the greatest number of images will have a 0-star rating, fewer images will have a 1-star rating, and even fewer images will have a 3-star or higher rating. Meanwhile, catalog image searches can be further filtered by first selecting a specific folder or collection. Or, you can choose to select all the photos in the catalog and combine a ratings search with a specific keywords filter via the Filter bar. **Figure 3.48** shows a schematic diagram that represents how image searches of the Lightroom catalog can be easily narrowed by adding these search criteria together. Whether you filter by folder, collections, or metadata in combination with a ratings filter, you can always quickly narrow a selection of images from a catalog to find the specific photos you are looking for.

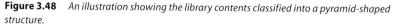

Three ways to filter the catalog

I will focus on metadata and metadata filtering in Chapter 4, but for now let's look at the filter options as they relate to flags, ratings, and color labels. **Figure 3.49** shows the Library module Library menu where you can filter by Flag, Rating, Color Label, or Copy Status. These options are identical to those found in the Filters section of the Filmstrip (**Figure 3.50**). For example, you could filter the photos displayed in the content area by choosing Library \Rightarrow Filter by Rating \Rightarrow 1 star and higher, to make only those photos with a 1-star rating or greater visible. Or, you could simply click the 1-star button in the Filmstrip and select the equal and greater than option to make only the 1-star photos or higher visible. The other way to filter catalog photos is to use the Filter bar, which is accessible from the top of the content area whenever you are in the Library Grid view. In the **Figure 3.51** example, the Refine section of the Filter bar was selected and a "1 star and higher" filter was applied to the photos in the Grid.

Figure 3.49 Here is a view of the Library module Library menu. In this example, the Library menu is being used to select photos with a 1-star rating and higher only.

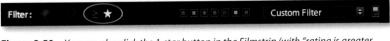

Figure 3.50 You can also click the 1-star button in the Filmstrip (with "rating is greater than or equal to" selected), to achieve the same filter result method.

Library Filter :	Text Attribute Meta	adata None	Custom Filter 🗧 🔒
	Rati (2 *) * * * *	Color	Copy Status

Figure 3.51 Alternatively, you can click the 1-star button in the Filter bar Refine section and select the "rating is greater than or equal to" filter option.

NOTE

When you are working in modules other than the Library module, the Library ⇔ Filters submenu shown in Figure 3.49 will appear in the File ⇔ Library Filters submenu instead.

Filtering photos via the Filmstrip

Now let's look at the top section of the Filmstrip in more detail and, in particular, consider how you can use the Filmstrip controls to filter images according to their rating, pick status, and label color (**Figure 3.52**). The Folder/Collection section displays the current folder path directory or collection name. Click anywhere here to view a list of recent sources such as a recently visited folder, collection, or favorite source. The Refined Filters section can be expanded or collapsed by clicking Filter (circled in red). The Filter section contains the "Filter based on flag status" selectors, which can filter by showing "all Picked images only," "all unflagged images only," or "all rejected images only" (click the flag icons again to undo these selections). To use "Filter based on rating," click on a star rating to filter the images and choose from one of the options shown in the pop-up menu (circled in blue) to display images of the same rating or higher, same rating or lower, and those photos equal to that rating only.

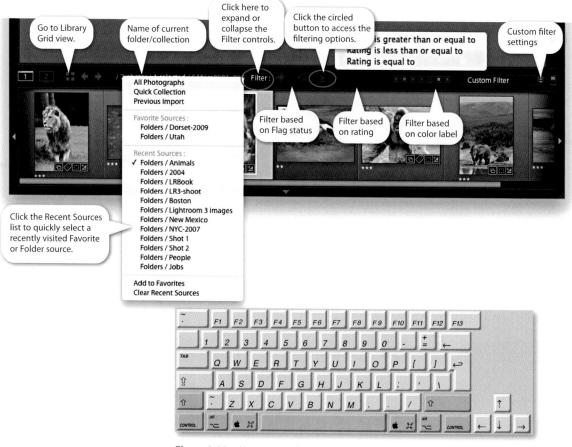

Figure 3.52 You can toggle between hiding/showing the Filmstrip by clicking the arrow at the bottom of the interface or by using the F6 function key. Use the left/right arrow keys to navigate through the photos shown in the Filmstrip.

Adding folders as favorites

You can now add folders as favorites via the FIImstrip source menu so that you can use this same menu to quickly locate favorite folders (see Figure 3.52). To save a favorite, go to the source menu and select Add to Favorites. The folder or collection will now appear in the Favorite Sources section at the top of the list.

Filtering flagged photos

The flag buttons in the Filmstrip can take a little getting used to. Start with all the flag buttons dimmed. Click the first pick flag (II) to filter the images to display the picks only. Click it again to turn off the filtering and reveal all the images. Click the second flag (II) to show the unflagged images only. Click it a second time to reveal all the images. Click the third flag, the reject flag (II), to display the rejects only. Click again to show all images. Now try clicking both the pick flag and reject flag buttons. This reveals both picks and rejects, but not the unflagged images.

Filtering options

If you click the icon to the left of the star rating symbols (see **Figure 3.53**), you can choose from one of the following options to decide what the filtering rule should be: "Rating is greater than or equal to," "Rating is less than or equal to," or "Rating is equal to."

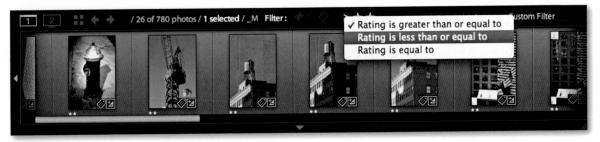

Figure 3.53 The Filmstrip rating menu options.

Creating refined color label selections via the Filmstrip

You can also use the Filmstrip buttons to create image selections based on the flag and color label status. If you hold down the 😹 key (Mac) or Ctrl key (PC) as you click any of the flag or color label buttons, instead of filtering the photos, you can create an image selection based on the buttons clicked. If you hold down the 😹 Ashift key (Mac) or Ctrl Ashift key (PC) as you click these Filmstrip buttons, you can add further photos to the selection. To remove photos from a selection, use ﷺ (Mac) or Ctrl Alt (PC) as you click the flag or color label buttons.

If you go to the Library menu, the Filters ⇒ Filter by Color Label submenu includes options to filter photos by No Label, to select all those photos that have no label status. There is also an Other Label option that will allow you to filter photos that have a label status not completely recognized by Lightroom. In other words, choosing File ⇒ Filters \Rightarrow Filter by Color Label \Rightarrow Other Label allows you to filter photos that have had their color labels edited in Bridge where the label text descriptions may not be currently synchronized with those used by Lightroom. (Refer back to page 111 for the reasons why Lightroom and Bridge sometimes have different ideas about what these color labels mean.)

New Collection New Smart Collection New Collection Set	жN	
New Folder	☆ 36N	
Find	ЖF	
✓ Enable Filters	ЖL	
Filter by Preset	- F	
Filter by Flag	•	
Filter by Rating	Þ	
Filter by Color Label		Red
Filter by Copy Status		Yellow
Filter by Metadata		Green
✓ Show Photos in Subfolders		Blue Purple
Refine Photos	₹¥R	Other Label
Rename Photo Convert Photo to DNG	F2	No Label Reset this Filte
Find Missing Photos Synchronize Folder		
Find Previous Process Version Previews	n Photos	
Previous Selected Photo	*⊷	
Next Selected Photo	3€→	
Plug-in Extras		

Figure 3.54 The Library module Filter by Color Label options.

Color label filtering

To filter photos by color label, you can go to the Filter by Color Label menu in the Library module Library menu (**Figure 3.54**), or use the color label buttons in the Filmstrip. (See **Figure 3.55** to learn how to customize the Library grid cell view.)

1. The color swatch buttons in the Filmstrip allow you to quickly make selections based on color labels. These buttons work independently: Click the red button to display all red label images. Then click the yellow button to add yellow label images. Click the red button again to remove the red label images from the filter selection.

2. In this example, you can see a collection of photos from a holiday trip in which a red color label was assigned to the food shots, yellow was used for the general detail shots, green for the town landscapes, and blue for the night sky pictures. At the moment, no filters have been applied and all images are visible in the Library module Grid view.

3. In this next screen shot, I clicked the red and green filter buttons in the Filmstrip, to filter just the red- and green-labeled photos.

4. In the color label filter swatch section of the Filmstrip, it is possible to <u>Alt</u>-click a color swatch to make an inverted color swatch filter selection. In this example, I <u>Alt</u>-clicked the Yellow swatch to display all photos except the yellowlabeled ones. Note: An inverted swatch selection excludes photos that have no color label.

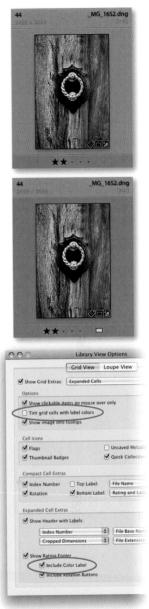

Figure 3.55 You can customize the Library grid cell view by pressing **H** J (Mac) or Ctrl J (PC), which opens the Library View Options. If you don't want to see the cell color tinted, then deselect the "Tint grid cells with label colors" option. Instead, click the Include Color Label check box in the Show Rating Footer section.

NOTE

You can find out more about working with virtual copies on page 384 in Chapter 6.

TP

You can also use the Find Previous Process version Photos Library menu item to create a temporary collection of Process Version 2003 photos (see Chapter 6).

Virtual copy and master copy filters

Most of the photos in the catalog will be master copy images. These are the original source files of which there can be only one version of each in the catalog. However, you can create virtual copy versions of the masters, which allows you to edit the virtual copy versions as if they were separate originals, but without having to create a physical copy of the master.

The Virtual copy and Master copy filters can, therefore, be used to filter the display to show or hide virtual copy photos only, and show or hide the master copy photos only. You can go to the Library module Library menu and choose Filter by Copy Status and choose Virtual Copies, Master Photos, or All Photos (see **Figure 3.56**). But it is far simpler to use the Virtual Copy and Master Copy filter buttons that are located in the Attribute section of the Filter bar.

	New Collection New Smart Collection New Collection Set	ЖN	
	New Folder	ΰ₩N	
	Find	ЖF	
	✓ Enable Filters Filter by Preset	жL	
	Filter by Flag	•	
	Filter by Rating	•	
	Filter by Color Label Filter by Copy Status		
	Filter by Metadata	•	All Photos Virtual Copies
	✓ Show Photos in Subfolders		Master Photos
	Refine Photos	₹₩R	Reset this Filter
	Rename Photos Convert Photos to DNG	F2	
	Find Missing Photos Synchronize Folder		
	Find Previous Process Version Previews	n Photos	
	Previous Selected Photo Next Selected Photo	# ← # →	
	Plug-in Extras	•	
brary Filter :	Text Attribute Metadata		THE REAL PROPERTY OF THE PROPERTY OF THE REAL PROPE

Figure 3.56 You can use Library \Rightarrow Filter by Copy Status \Rightarrow Virtual Copies to filter the catalog to display the virtual copy photos only or master photos only. However, it is probably simpler to use the Filter by Virtual Copy and Filter by Master Copy buttons that are shown circled here.

Subfolder filtering

The Show Photos in Subfolders filter (highlighted in Figure 3.56) lets you determine whether to include or hide the photos contained in subfolders. This menu item is also located in the Folders panel drop-down menu (see Figure 3.57).

To give you an example of how this works, in the Folders panel view in Figure 3.58, I have selected a folder called 2008 that contains 709 photos, of which 683 photos are contained in five subfolders. This means there are 26 photos floating around in the model castings folder that are not assigned to any of these five subfolders. If I deselect Show Photos in Subfolders in the Library menu, clicking the 2008 folder shows just these 26 photos and excludes showing the other 683 images that are contained in the subfolders.

Figure 3.57 The Folders panel showing the drop-down menu options.

Filter 41 IPG -All Photographs / 26 photos Figure 3.58 This view of the catalog shows a model casting images folder titled 2008 selected with Show Photos in Subfolders unchecked in the Library menu. You now only see the 26 photos contained in the root-level folder, instead of all 709 (which you would see in this filtered view if Show Photos in Subfolders had been checked).

T LR-080408-2.lrcat - Adobe Photoshop Lightroom - Library 000 Navigator Catalog W All Photographs **Ouick** Collection Previous Import Previous Export Folders Library-HD 199/698 🔻 709 2008 Casting-060308 114 Casting-190308 Casting-280408 84 Casting-Eylure 303 Casting-Mack. 104 Ade Antarctic-Schewe 148 Frome 5127 Pictures South Africa Southbank-2008 269/598 🖪 Hard Drive 4 G5Main HD 257/698 🔻 Custom Filter

Group into Stack Unstack Remove from Stack Split Stack	ቻር ትዝር
Collapse Stack	S
Collapse All Stacks Expand All Stacks	
Move to Top of Stack	∂ S
Move Up in Stack	<u></u>
Move Down in Stack	6]
Auto-Stack by Capture T	ime

Figure 3.59 The Photo \Rightarrow Stacking submenu, which can also be accessed via the contextual menu (right-click anywhere in the content area and navigate to Stacking in the menu list).

Auto-Stack by Capture Time				
ime Between Stacks:	0:01:00			
fore Stacks	Fewer Stacks			
1 stacks, 16 unstacked	Cancel Stack			

Figure 3.60The Auto-Stack byCapture Time dialog.

NOTE

There is a subtle addition to stack expansion behavior in Lightroom 3. If you single-click the stack badge in the Filmstrip or use the S key to expand a stack, it does so with the first photo in the stack selected. If you double-click or ①Shift]-click the Thumbnail stack button in the Grid view or Filmstrip, the stack expands with all the photos in the stack selected.

Grouping photos into stacks

Just as photographers used to group slides on a light box into piles of related photographs, Lightroom lets you group photos into stacks. You can do this manually by selecting a group of images from the Grid or Filmstrip and choosing Photo \Rightarrow Stacking \Rightarrow Group into Stack or by pressing #G (Mac) or Ctrl G (PC). From there, you can press \$ to Collapse Stack, so that all the stacked images are represented by a single thumbnail cell, and press \$ again to expand the stack. Note that the number of images in a stack is indicated in the upper-left corner of the cell and also in the Filmstrip, providing you have this option turned on in the Interface preferences (see Appendix A). If you need to unstack the stacked images, choose Photo \Rightarrow Stacking \Rightarrow Unstack or press #CshiftG (Mac) or Ctrl G (PC). You can also remove individual photos from a stack. Within a stack, select an individual image or the images you wish to remove and choose Photo \Rightarrow Stacking \Rightarrow Split Stack. This allows you to remove individual photos from a stack group while preserving the rest of the stack contents.

The easiest way to access the Stacking submenu is to right-click in the content area. This allows you to quickly access the Stacking submenu options from the main contextual menu (**Figure 3.59**). If you want to remove an image or selection of images from a stack, select the image or images first, and then use the contextual menu to choose Remove from Stack. Similarly, you can use this same menu to choose Collapse All Stacks or Expand All Stacks.

You can also choose which photo best represents all the images in a stack. If you are using stacks to group a series of related photos, it may be that the first image you shot in a sequence is not necessarily the best shot to represent all the other photos in the stacked group. You can expand the stack and select the photograph you like most in the series and use Shift[] to move that image up, or use Shift[] to move the image down the stacking order. Or, to make things simpler, just select the photo you want to have represent all the images in the stack and use the Move to Top of Stack command (Shift[S]).

Automatic stacking

My favorite feature in the Stacking menu is the Auto-Stack by Capture Time item. This allows you to automatically group a whole folder of images into stacks based on the embedded capture date and time metadata (**Figure 3.60**). On the facing page, I show an example of how to use the Auto-Stack feature to automatically group a series of image captures into stacks.

Note, too, that whenever you choose Photo \Rightarrow Create Virtual Copy, the virtual copy (or proxy) image is automatically grouped in a stack with the master image. (Virtual copies are also discussed later in Chapter 6.) And when you choose Photo \Rightarrow Edit in Photoshop, there is also a preference for stacking the edited copy photos with the originals.

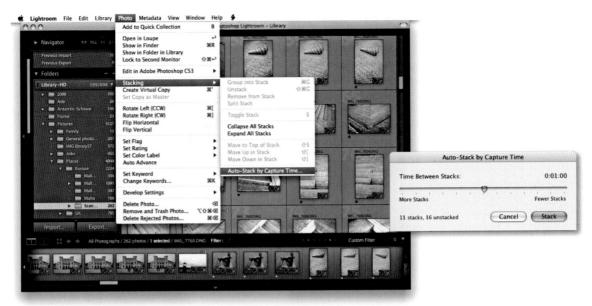

1. Here is a Library view of a folder of images where I wanted to auto-stack the folder contents. I went to the Photo ⇒ Stacking menu and chose Auto-Stack by Capture Time. I then adjusted the Time Between Stacks slider to group all the photos that were shot within a minute of each other.

2. The photos in the content area were now stacked, but the stacks remained expanded. To collapse a stack, click the badge icon in the top-left corner (which also indicates how many images are in the stack) and click again to expand the stack. You can also right-click to access the contextual menu and choose Collapse All Stacks.

NOTE

The general idea here is that you can use successive Add to Selection commands to build lots of different kinds of filter selections. For example, you can use the Select by Color Label menu to add yellow-label images to a red-yellow photo selection. You can also use the Select by Rating ⇒ Intersect with Selection menu to create selections of photos that have matching criteria only. To give you an example, you could use this method to select all the 1-star photos that have a red or yellow label. The Edit ⇒ "Select by" menu options can be used in this way to create any number of selection rules, which may be useful when managing large collections of photos.

NOTE

To repeat what was written on page 115, you can also use the Filmstrip buttons to create image selections based on the flag and color label status. If you hold down the 🕱 key (Mac) or Ctrl key (PC) as you click any of the flag or color label buttons, instead of filtering the photos, you can create an image selection based on the buttons clicked. If you hold down the 黑 合 Shift key (Mac) or Ctrl 合 Shift key (PC) as you click these Filmstrip buttons, you can add further photos to the selection. To remove photos from a selection, use # (Alt) (Mac) or Ctrl Alt (PC) as you click the flag or color label buttons.

Image selection options

The Edit menu contains a series of "Select by" submenu items. These let you make filtered selections of photos from the current catalog view.

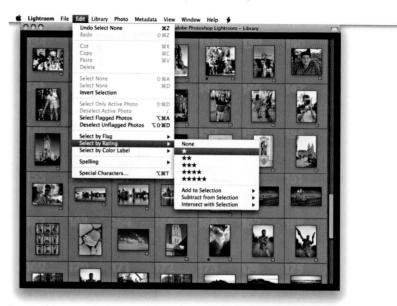

1. In this example, I went to the Edit menu and chose a "Select by" submenu item: Edit
⇒ Select by Rating
⇒ 1 star.

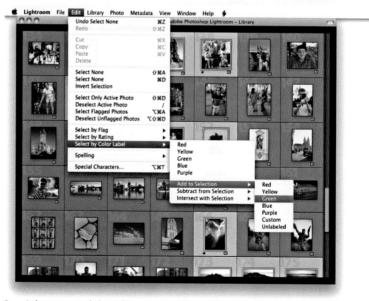

2. I then opened the Edit menu again and chose Select by Color Label \Rightarrow Add to Selection \Rightarrow Green.

Removing and deleting photos

After completing an image selection edit, you then need to consider what to do with the images that don't make it past a 0-star rating. Should you keep or delete them? I generally prefer not to delete anything since I never know when a rejected photo might still be useful. For example, there have been occasions when I have taken a photograph and not thought too much of it, only to discover later that it had a greater significance than I realized at the time I took it. If you press the Delete key, you will see the dialog shown in Figure 3.61. If you click Remove, this simply removes the photo from the Lightroom catalog, but the original file remains on the computer hard disk. If this is what you want to do and you wish to avoid having to go through the dialog each time, you can instead choose the Photo \Rightarrow Remove Photos from Catalog command, or use the Alt Delete shortcut. The other option is to Delete from Disk. This removes the photos from the catalog and also sends them to the system trash/recycle bin. Although the warning message says this process cannot be undone, the files are not completely deleted just yet. To permanently remove files from the hard disk, you still need to go to the Max OS X Finder and choose Finder ⇒ Empty Trash (∭@Shift)Delete Mac) or choose "Empty Recycle bin" (PC). You can also click Cancel to cancel the delete/ remove operation. The fact that the Delete command does not irrevocably remove files from your system provides you with a margin of safety in case you delete files accidentally—you can always rescue the deleted images from the trash and import them back into the Lightroom catalog again.

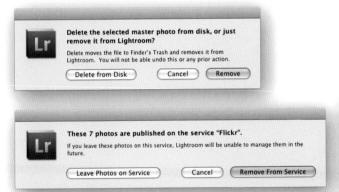

TIP

Earlier, we looked at working with the flag rating system and marking photos as rejects. Once you have marked photos as rejects using the reject flag or 🗶 keyboard shortcut, you can go to the Photo menu and choose Delete Rejected Photos or use the 🕱 Delete (Mac) or Ctrl Delete (PC) shortcut. With this command, you can send all your rejected photos directly to the trash, ready to be deleted.

TIP

On client jobs, I may shoot a hundred frames or more of each subject. After an initial edit, I separate out the 0-rated images, export them as DNG files, archive them to disk, and then remove them from the Lightroom library, leaving only the raw files with a 1-star rating or higher. For all other shoots, such as personal shots where the pictures are more varied, I delete only the obvious outtakes, such as where the flash failed to fire or a picture is badly out of focus.

Figure 3.61 The top-left dialog appears whenever you use the Delete command. The default option is Remove, which simply deletes the link from the Lightroom catalog. Click the Delete from Disk button if you are sure you want to remove the selected image from Lightroom permanently. If the photos belong to a published collection such as Flickr, you'll see the bottom-left dialog, where you can additionally choose to remove them from the catalog and leave or remove photos from the service as well. If you attempt to delete a whole folder from the Folders panel, you'll see the bottom-right dialog where you simply have the option to continue or cancel.

Remove the folder "/Volumes/Hard Drive 3/Lightroom 3 images/People"? This folder contains 64 photos.

If you continue, these photos will be removed from the Lightroom catalog but the folder and files will remain on disk.

(Cancel)

Continue

4

Managing photos in the Library module

How to use the metadata tools in Lightroom to manage your catalogs

Lightroom is designed to help you organize and catalog your images from the very first moment you import them. From there on, Lightroom provides a flexible system of file management that can free you from the rigid process of having to organize your images within system folders. Although Lightroom does still let you manage your photos by folders, it can also manage your images globally by letting you use metadata to filter your image selections.

A good example of how such a system works is to look at the way music files are managed on an iPod or by using iTunes. If you are familiar with importing music via iTunes, you know that it doesn't really matter which folders the MP3 files are stored in, so long as iTunes knows where all your music files are located. When you select a track to play on an iPod, you use metadata, such as the song title, album title, or genre to search for the music. Lightroom works in exactly the same way by encouraging you to add keywords and other metadata to your images either at the time of import or as you edit them in the Library module. Through the use of custom metadata and keywords, you can make image searching just as fast and easy as locating music on your iPod.

Working with metadata

With a folder-based organizational system, your file searching success will depend on your ability to memorize the folder structure of the hard drive and know where everything is stored. Anyone who is responsible for maintaining a large image archive will already be aware that this method of file management can soon become unwieldy. What is needed is a cataloging program that can help you keep track of everything. Therefore, the trend these days is to use file management by metadata, where you search for a file by searching its attributes instead of trying to remember which folders you put the pictures in.

As an image library grows, you will come to rely on the Lightroom Filter bar and Filmstrip filters to narrow selections of images. Some examples have already been given, such as the use of the Filmstrip filter to narrow a selection of photos and view only those images with ratings of 1 star or higher, 2-star images only, and so on. We have also looked at how to use the Folders panel to manage the image library. But the real power behind Lightroom is the database engine, which enables you to carry out specific searches and quickly help you find the photos you are looking for.

It is in no way mandatory that you follow all of the advice offered in this chapter, as each person will have his or her own particular image management requirements. You may, indeed, find that you just want to use the Folders panel to catalog your library images and that is enough to satisfy your needs. But one of the key things you will learn in this chapter is that the time invested in cataloging an image collection can pay huge dividends in terms of the time saved when tracking down those pictures later. The image management tools in Lightroom are far from being a complete asset management solution, but they do offer something for nearly everyone. Some people may find the cataloging tools in Lightroom will be fully accessible in other image asset management programs.

The different types of metadata

Metadata is usually described as being data about data that is used to help categorize information. For example, a typical cable TV system will allow you to search for movies in a variety of ways. You can probably search for a movie title using the standard A–Z listing, but you can also search by genre, release date, or even director. Lightroom also lets you organize your image files by metadata. For example, you can sort through images in various ways: by folder name, image rating, or favorite collections. By using the metadata information that is linked or embedded in the catalog photos, Lightroom is able to quickly search the database to help you find what you are looking for. This method of searching is far superior to searching by folder location or filename alone.

As I explained earlier, the way Lightroom uses metadata is fairly similar to the way a program like iTunes categorizes your music collection. For example, when you search for a music track on an MP3 player such as an iPod, instead of searching for specific tracks by opening named folders, you search for them using the metadata information that's embedded in the individual music files. In the case of MP3 files, when you buy a music track the necessary metadata information will already be embedded. But you can also use iTunes to automatically locate the metadata information for newly imported music CDs via an online database, or you can use iTunes to manually add or edit the tracks yourself.

The metadata used in Lightroom falls into several types. One type is informational metadata, such as the EXIF metadata that tells you things like which camera was used to take a photograph, along with other technical information such as the lens settings and image file type. In the case of Lightroom, most of the catalog information will have to be added manually by the person who took the photo-graphs. Custom metadata is, therefore, information the user adds manually, such as who is in the photograph, where it was taken, how to contact the creator of the photograph, and the rights usages allowed. Another type of custom metadata is keywords, which again you have to enter manually. Keywords can be used to categorize the photos in your catalog, and if you are skilled at keywording, this can help you manage your photos extremely efficiently, as well as improve sales if you are in the business of supplying photos to an agency.

It is true that you will need to spend time entering all this metadata information (although there are various tips coming up in this chapter that show you how to avoid repetitively entering this data for every single image). But the trade-off is that the time invested in cataloging your images in the early stages will reap rewards later in the time saved retrieving your files. In most cases, you need to configure essential metadata only once to create a custom metadata template. You can then apply this bulk metadata automatically to a set of imported photos. You can take metadata cataloging further and assign custom metadata information to individual images. It really depends on whether this is important for the type of work you do. Basically, the effort spent adding metadata should always be proportional to how useful that information will be later.

There is a lot of detailed content coming up in this chapter about how to apply, edit, and use metadata. I thought, therefore, that the best way to introduce this subject would be to provide first a quick example of how metadata can be used to carry out a search of the Lightroom catalog.

NOTE

Remember, there can only be one physical copy of each image in the catalog, and a catalog image can only ever exist in one folder (or else it's unclassified).

A quick image search using metadata

One of the key features in Lightroom is the Filter bar, which can be accessed at the top of the content area whenever you are in the Library Grid view mode. The Filter bar combines text search, file attribute, and metadata search functionality all in one. The following steps suggest just one of the ways you can use a metadata filter search to find photos quickly and save a filter search as a permanent collection. We'll be looking at keywords and collections later in this chapter, but for now let's run through a typical image search procedure and thereby demonstrate the usefulness of tagging your photos with keywords.

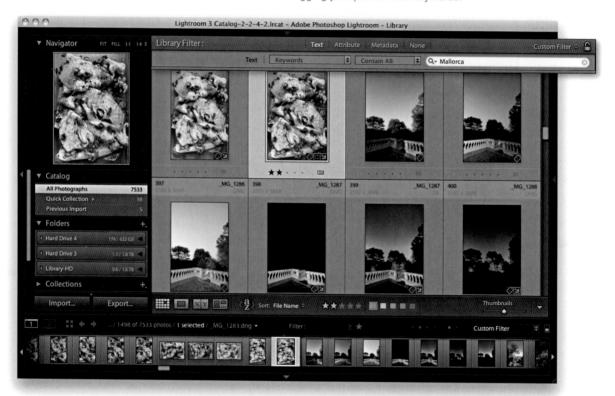

1. Let me begin by showing how you can search for photos quickly, without needing to refer to the folders that the images are stored in. In the example shown here, I wanted to search for photos taken in a town in Spain. Now let's say that I couldn't remember the actual name of the place I was looking for, but I did know that it was somewhere on the island of Mallorca. You need to be aware that the panels on the left define the source photos, and the Filter bar filters whatever is selected. To carry out a complete catalog filter search, I first selected All Photographs in the Catalog panel. I then went to the Filter bar, clicked the Text tab, set the text search criteria to Keywords, and typed *Mallorca*. This initial step filtered the entire catalog to display all photos that contained the keyword *Mallorca*.

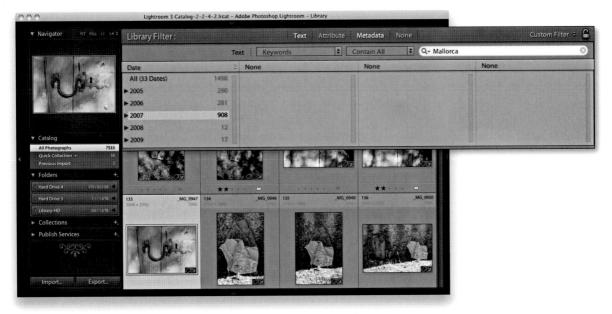

2. I have visited this island several times and taken over 1,700 photos there. To narrow the search, I clicked the Metadata tab. This revealed the Metadata search options, where I clicked the 2007 year date in the Date list.

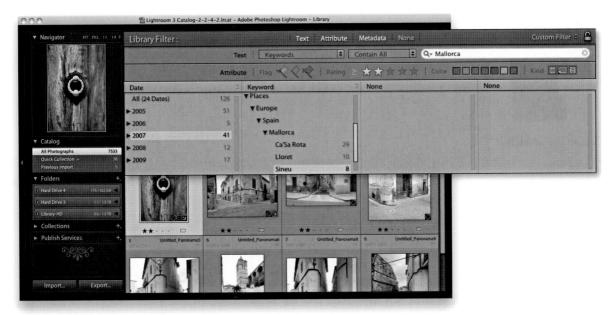

3. I could now see a narrowed set of keywords in the Keyword list next to the Date panel. As I expanded the Places keyword subfolders, I came across the keyword for the town of Sineu—that's the place I was looking for! I clicked the Attribute tab and then clicked the 2-star filter to narrow the selection further.

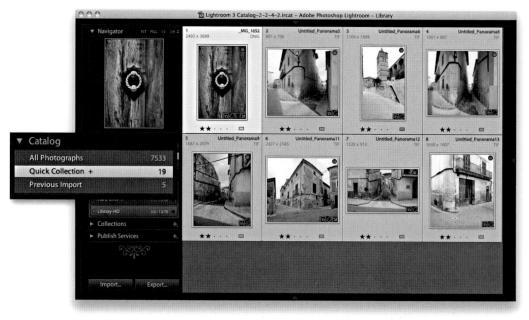

4. I hid the Filter bar (\square) , applied an Edit \Rightarrow Select All to select all of the photos, and pressed the \square key to add the selected photos to a Quick Collection.

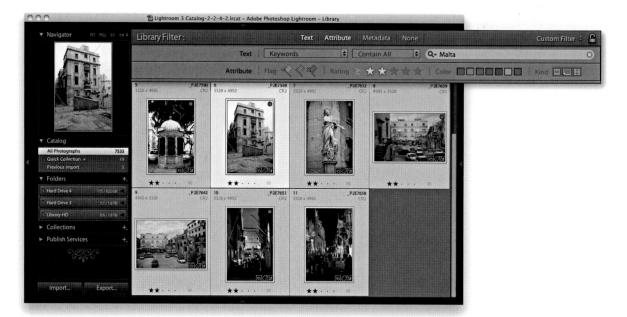

5. I pressed ① again to reveal the Filter bar and did a new search. This time, I used a text search for photos with the keyword *Malta* and with a rating of two stars and higher. I again chose Edit ⇔ Select All, and pressed B to also add these to the current Quick Collection as well.

Name:	Mediterranean Towns
Set:	Locations \$
🗹 Incl	ion Options ude selected photos Make new virtual copies

6. The Quick Collection now contained 23 selected photos and it was time to make this temporary collection more permanent. I chose Edit ⇒ Select All to select all of the photos, clicked the Add Collection button at the top of the Collections panel, selected the Create Collection option, and titled this new collection *Mediterranean Towns*.

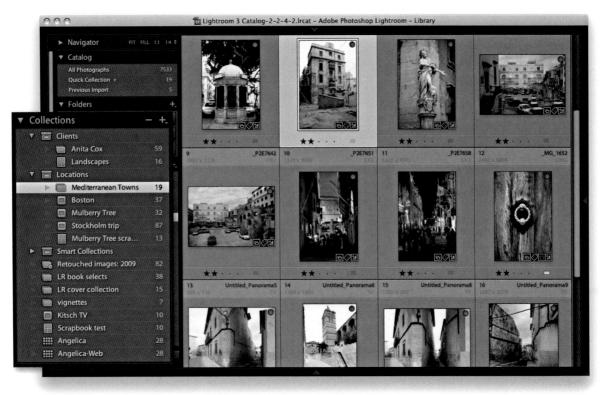

7. Here is the final stored collection, which represents the combined result of the two separate Lightroom catalog searches. This quick introduction by no means covers everything you need to know about metadata searches and collections. But it does at least give you a rough idea of how and why it is useful to use keywords to tag photos in the catalog and also why you don't necessarily need to be concerned with how the photos are actually stored in the system folders.

Default	Metadata 🔻
Preset	None
File Name	SAfrica0501_0164.TIF
Sidecar Files	xmp
Copy Name	
Folder	/Volumesuth Africa -
	Victoria & Albert Waterfront
Caption	View from Victoria & Albert Waterfront looking out across the harbour to Table Mountain in the distance.
Copyright	© Martin Evening 2005
Copyright Status	Copyrighted +
Creator	Martin Evening
Location	RSA
Rating	** • • •
Label	
Capture Time	16:02:40
	10 Jan 2005 🔤
Dimensions	4064 x 2704
Cropped	4064 x 2704
Exposure	1/500 sec at f / 7.1
Focal Length	
ISO Speed Rating	
Flash	
Make	Canon
Model	
	24.0-70.0 mm
an Allanarsan	

Figure 4.1 Here is the default view of the Metadata panel information, which shows just the basic file info metadata. The action arrow buttons that appear in the Metadata panel views provide useful quick links. For example, if you click the Folder button (circled), this takes you directly to a view of the folder contents that the selected photo belongs to.

Default All Plug-in Metadata	Meta	data 📲
EXIF EXIF and IPTC	IPTC	•
IPTC IPTC Extension	046.CR2	
Large Caption		
Location Minimal	ica	T T
Quick Describe	date	

Figure 4.2 The Metadata view options.

Metadata panel

Let's now look at the Metadata panel. **Figure 4.1** shows the default Metadata panel view, which displays a condensed list of file and camera information. At the top is the Metadata Preset menu with the same options as those found in the Import dialog Apply During Import panel (see page 140 for more about creating and applying metadata presets). Below this are fields that show basic information about the file such as the File Name and Folder. Underneath these are the Title, Caption, Copyright, Creator, and Location fields. These are all editable, and when you click in a blank field, you can enter custom metadata, such as the image title and copyright information. Below these are the image Rating and Label information, followed by the basic EXIF metadata items. This data is informational only and shows things like the file size dimensions, the camera used to take the photograph, camera settings, lens, and so forth.

Many of the items in the Metadata panel have action arrows or other buttons to the right of each metadata list item. These provide additional functions. For example, if you click the action arrow button next to the Folder name (circled in Figure 4.1), this takes you directly to a Grid view of the source folder contents.

Metadata panel view modes

If the Metadata panel in your version of Lightroom looks different from the one shown in Figure 4.1, this is probably because you are using one of the ten other Metadata panel layout views. If you click the view menu shown in Figure 4.2, this lets you access the alternative Metadata panel view options (Figure 4.3 compares some of the main Metadata panel view modes). Each photo can contain a huge amount of metadata information, so if you want to see everything, you can select the EXIF and IPTC view. But if you want to work with a more manageable Metadata panel view, I suggest you select a Metadata panel view more suited to the task at hand. For example, the EXIF view mode displays all the non-editable EXIF metadata, while the IPTC view mode concentrates on displaying the IPTC custom metadata fields only, and there is now also a new IPTC Extension view for displaying additional IPTC Extension data. The Large Caption view mode displays a nice, large Caption metadata field, which gives you lots of room in which to write a text caption. (The large caption space here does at least make the Caption field easy to target—click anywhere in the Caption field and you can start typing.) While you are in data entry mode, hitting *←*Enter) or *←*Return) allows you to add a carriage return in this field section instead of committing the text.

The Location panel mode offers a metadata view that is perhaps more useful for reviewing travel photographs. And finally, the Minimal and Quick Describe view modes are suited for compact Metadata panel viewing, such as when working on a small-sized screen or laptop.

EXIF	÷ M	etadata 🔻
Preset	None	
File Name	SAfrica0501_016	4.TIF 📃
Sidecar Files	xmp	
	South Africa	
Dimensions	4064 x 2704	
Cropped	4064 x 2704	
Date Time Original	10/01/2005 16:02	40 -
Date Time Digitized	10/01/2005 16:02	:40
Date Time	10/01/2005 16:02	40
Exposure	1/500 sec at f / 7	
Focal Length	70 mm	
Exposure Bias	0 EV	
ISO Speed Rating	ISO 160	
Flash	Did not fire	
Exposure Program	Normal	
Metering Mode	Pattern	國語語語語
Make	Canon	
Model	Canon EOS-1DS	
Serial Number	107498	建制的空电话制度
Lens	24.0-70.0 mm	
Artist	Martin Evening	

Location	Metadata 🔻	2
Preset	None 🗧	12101010
File Name Copy Name	SAfrica0501_0164.TIF	considerated a
	Nolumes/LiSouth Africa 🛶	
	Victoria & Albert Waterfront	
Caption	View from Victoria & Albert Waterfront looking out across the harbour to Table Mountain in the distance.	
Date Time Original	10/01/2005 16:02:40	
	10/01/2005 16:02:40	
	2005-01-10T16:02:40Z	
Location		111
	Cape Town	
State / Province		
Country		
Country ISO Country Code		Section 1
ISO Country Code		
ISO Country Code	🗧 Metadata 🔻	
ISO Country Code Minimal	ie Metadata ▼	
ISO Country Code Minimal Preset None File Name SAfric	ie Metadata ▼	
ISO Country Code Minimal Preset None File Name SAfric Rating * * Caption View f	Metadata Metadata more a second	
ISO Country Code Minimal Preset Nom File Name SAfric Rating * * Caption View Wate Narbo	Metadata Metadata Metadata	

Large Caption

Metadata

Figure 4.3 This shows most of the different Metadata panel view modes in Lightroom 3.

IPTC	€ Metadata ▼
Preset	Untitled Preset
File Name	SAfrica0501_0164.TIF
Metadata Status	Up to date
	Contact
Creator	Martin Evening
Job Title	Photographer
Address	Chambers Lane
City State / Province	London London
Postal Code	NW10
Country	UK
Phone	+44(0)20845120xxx
E-Mail	martin@martinevening.com
Website	www.martinevening.com
	Content
Headline	Victoria & Albert Waterfront
Caption	View from Victoria & Albert Waterfront looking out across the harbour to Table Mountain in the distance.
IPTC Subject Code	See newscodes.org for guidelines
Description Writer	Name of IPTC content creator
Category	
Other Categories	
	Image
Date Created	2005-01-10T16:02Z
Intellectual Genre	See newscodes org for guidelines
Scene	See newscodes.org for guidelines
Location	Victoria & Albert Docks
City State / Province	Cape Town
State / Province Country	Cape Town South Africa
ISO Country Code	RSA
	Status
	Victoria & Albert Waterfront
Job Identifier	Use own custom reference
	Use this field to add any special instructions, such as embargoes or other special instructions not covered by the rights usage
Provider	Name of person who should be credited
	Name of original copyright holder
	Copyright
Copyright Status	Copyrighted 🗧
Copyright	
Rights Usage Terms	
Copyright Info URL	www.martinevening.com 🛶
Quick Describe	📰 Metadata 🔻
Preset	None 🕒
File Name S	Africa0501_0164.TIF

	None	
File Name	SAfrica0501_0164.TIF	l
	xmp	ł
Copy Name		ł
Folder	/Volumes/Libs/South Africa	I
Rating	** • • •	
	4064 x 2704	ł
Cropped	4064 x 2704 🖼	ł
Capture Time	10/01/2005 16:02:40	ł
Camera	Canon EOS-1DS #107498	ł
	Victoria & Albert Waterfront	l
Caption	View from Victoria & Albert Waterfront looking out across the harbour to Table Mountain in the distance.	
Copyright	© Martin Evening 2005	
Creator	Martin Evening	1
Location	RSA	l

TIP

Jeffrey Friedl is an experienced software engineer and Lightroom enthusiast. He has added some useful pages to his Web site that include "Jeffrey's Lightroom Configuration Manager." This is a Web-based application that allows you to customize the Metadata panel items and fonts. To reach this page, go to http://regex. info/Lightroom/Config/.

General and EXIF metadata items

Let's now look in more detail at the items that can be displayed in the Metadata panel. **Figure 4.4** shows a complete list of what items you might see listed when using the EXIF and IPTC view mode. Many metadata items can be displayed here and most of them are fairly self-explanatory, but I've included explanations for those that are not so obvious, or that offer some interesting hidden tips and features. You might not see everything that's listed here when you compare this with what you are seeing on your copy of Lightroom; that's because certain items require the metadata to be present before it can be displayed. So, if you don't have an audio sidecar file attached or GPS metadata embedded in the file, you won't see such items listed in this panel view.

File Name

This displays the file name for the currently selected photo. If you need to change the name of a file, you can't do so directly in the content area, so you need to use this field in order to make any name changes. If you want to carry out a batch rename action, select the photos and click the button to the right to open the Rename Photo dialog.

Sidecar Files

The Sidecar Files item shows up whenever there is a sidecar file associated with an image. Sidecar files are always hidden from view, so this extra item in the Metadata panel lets you know if an .xmp sidecar is present or not.

Copy Name

The Copy Name field refers to virtual copy images made in Lightroom. Each virtual copy image can provide an alternative version of the original master (or negative as it is sometimes described in Lightroom). By making virtual copies, you can apply different crops or color treatments. But since virtual copies all refer to the same master, they all share the same root filename. Now, whenever you create a new virtual copy, Lightroom will label each new virtual copy as *Copy 1, Copy 2*, etc. But you'll most likely want to edit this name. To explain this further, please refer to **Figure 4.5**, in which an original DNG image has been selected and three virtual copies are associated with the master. (You can tell they are virtual copies because they have a turned-up page icon in the bottom-left corner.) In **Figure 4.6**, I renamed the Copy 2 photo (second one from the right) to *Black and white*, which brings us to the Go to Master action arrow (circled in Figure 4.6). If you have a virtual copy image selected in Lightroom, you can always locate the parent master photo by clicking this button. Virtual copy images can quite often end up being separated from the master. Because you may have assigned a different star

EXIF and IPTC	* Metadata	a 🔻	
Preset	None		
	SAfrica0501_0164.dng		Batch rename
Sidecar Files Copy Name		8	Go to Master
Folder File Size	/Users/martin_e Imported Photos 9.08 MB	5 +	Show this folder in Lightroom
	Digital Negative (DNG) Has been changed		Resolve metadata conflict
	_P 2E9628.wav		Play audio file
Rating	** • • •		
Label	Victoria & Albert Waterfront		
	View from Victoria & Albert		
	Waterfront looking out across the harbour to Table Mountain in the distance.		
	EXIF		
	4064 x 2704 4064 x 2704		Go to Crop mode in Develop module
Exposure	1/son sec at f / 7.1	-	
Exposure Bias Flash	0 EV Did not fire		
Exposure Program Metering Mode			
ISO Speed Rating	ISO 160		
Focal Length Lens	70 mm 24.0-70.0 mm		
	10/01/2005 16:02:40 10/01/2005 16:02:40	1 Star	 Filter photos in the content area to show those with the same date
	01/04/2008 23:11:33 Canon		
Model	Canon EOS-1DS		
Serial Number Artist	107498 Martin Evening		
Software GPS	Adobe Photoshop Lightroom 54°0'51" S 37°41'21" W		- Go to Google Earth
Altitude			
Creator	Contact Martin Evening		
Job Title	Photographer		
City	Chambers Lane London		
State / Province Postal Code			
Country	UK +44(0)208		
E-Mail	martin@martinevening.com		- Launch mail program and create new e-mail
Website	www.martinevening.com		- Go to Web site
Headline			
IPTC Subject Code Description Writer			
Category Other Categories			
Date Creater	Image 2005-01-10T16:02:40Z		
Intellectual Genre			
Scene Location	RSA		
City State / Province	Cape Town		
Country ISO Country Code			
Job Identifie Instruction			
Provide Source	r Martin Evening		
Copyright State	Copyright s Copyrighted ÷		
Copyrigh	t © Martin Evening 2005		
Rights Usage Term Copyright Info UR	s L www.martinevening.com	E.F.	 Go to Web site
Liguro A A	Ino Motadata papal c	nowingt	he FXIF and IPTC view mode

Figure 4.4 The Metadata panel showing the EXIF and IPTC view mode.

TIP

As you roll over the items listed in the Metadata panel, the tooltips now provide extended explanations of how to use each of the fields.

Figure 4.6 If you are inspecting a virtual copy image, its copy name will appear in the Copy Name field. Click the action button next to it to locate the master image.

Figure 4.5 Here is a view of a master photo with three virtual copies. The copy names are also shown in the Metadata panel, where you can edit them if you like.

rating to the virtual copy version, they may be grouped in a collection or removed from the master parent image. With this action button, you can quickly trace the master version of any virtual copy photo.

Metadata Status

If there is an issue with the metadata status of a catalog image, the Metadata Status item shows up to indicate that the metadata status is in the process of being checked (you'll see an ellipsis [...] in the Metadata Status field), or that the metadata for the photo has been changed. This message tells you that the metadata status is out of date. It could mean that the metadata, such as the metadata text, keyword, rating, or Develop setting, has been changed in Lightroom and has not yet been saved to the image's XMP space. Clicking the button to the right provides a quick answer (see **Figure 4.7**), as will a quick check to see if there is a warning icon in the photo's grid cell. Or, it could mean that the metadata has been changed by an external program such as Bridge and that you need to go to the Metadata menu in the Lightroom Library module and select Read Metadata from File. The ins and outs of metadata saving, XMP spaces, and Lightroom settings are quite a complex subject. For a more detailed explanation, please refer to pages 185–192 later in this chapter.

Lr	The metadata for this photo Save the changes to disk?	has been changed in Lightroom.
	Don't show again	Cancel Save

Figure 4.7 If a catalog photo's metadata appears to be out of sync, the Metadata Status item will appear in the Metadata panel to indicate it has been changed. Click the button to the right to reveal what needs to be done to get the metadata back in sync again. If there is no synchronization problem, the Metadata Status item will remain hidden.

Cropped photos

If a photo has been cropped in any way, the Cropped item will appear in the Metadata panel, showing the crop dimensions in pixels. If you click the action arrow next to it, this takes you directly to the Crop Overlay mode in the Develop module.

Date representation

Date Time Original and Date Time Digitized means the date that a photo was captured or was first created, while the Date Time field indicates the time the file was last modified. I have used **Figures 4.8–4.11** to explain the differences between these bits of metadata information.

Next to Date Time Original is the Go to Date action arrow (note that this applies only to digital capture images). Clicking this button filters the catalog view to show only those photos that have matching capture dates. To exit this filter view, use the $\Re L$ (Mac) or Ctrl L (PC) shortcut, which toggles the catalog filters on or off.

Date Time Original	13/01/2005 09:57:00	-
Date Time Digitized	13/01/2005 09:57:00	
Date Time	13/01/2005 09:57:00	

Figure 4.8 In the case of camera capture files that have not been converted to DNG, the Date Time Original, Date Time Digitized, and Date Time entries will all agree.

Date Time Original	04/06/2007 17:06:38	
Date Time Digitized	04/06/2007 17:06:38	
Date Time	06/06/2007 11:04:56	

Figure 4.9 Where a camera capture image has been converted to DNG, the Date Time entry reflects the fact that the file was modified and resaved in a different file format. In this case, a raw file was converted to DNG a few days after the time of capture.

Date Time Original	18/09/2006 12:23:34	-
Date Time Digitized	18/09/2006 12:23:34	
Date Time	27/02/2007 12:59:11	

Figure 4.10 Similarly, if I were to create an Edit copy as a TIFF, PSD, or JPEG version from the original, the Date Time would reflect that this version of the master image was created at a later date.

Date Time 12/06/2007 09:46:54

Figure 4.11 And if you import a photo that was originally created as a new document in Photoshop or was originally a scanned image, only the Date Time field is displayed, showing the date that the file was first created.

TIP

On the Mac platform, you can use a small application called BetterFinder Attributes to reset the Date Original and Date Time Digitized back to their actual times: www.publicspace.net/ ABetterFinderAttributes/. It works with a fair range of mainstream camera raw formats.

Capture time editing

If you know that the camera time and date settings are incorrect, you can address this by selecting Metadata ⇒ Edit Capture Time while working in the Library module. The Edit Capture Time dialog (**Figure 4.12**) allows you to amend the Date Time Original setting for an individual image or a group of images. If you are editing the capture time for a selection of images, the dialog preview displays the most selected image in the sequence and notifies you that the capture times for all the images in the current selection will be adjusted relative to the date and time set for this highlighted photo.

The Edit Capture Time feature is useful for a couple of reasons. One is that the internal clock on your camera may be wrong. For example, did you forget to set the internal clock correctly when you first bought your camera? For critical, time-sensitive work (such as GPS tagging via a separate GPS device), you may want to keep a regular check on your camera's internal clock to ensure that it is accurate. If this isn't the case, you can select the "Adjust to a specified date and time" option and reset the date and time accordingly.

When you travel abroad, do you always remember to set the camera for the correct new time zone? If you select the "Shift by set number of hours (time zone adjust)" option, you can compensate for the time zone differences for date and time entries that would otherwise be correct (unless, of course, you want the dates and times of all your captures to be recorded relative to a single time zone).

If you ever need to revert to the original embedded date and time, you can always select the "Change to file's creation date" option to reset everything back to the original capture date and time setting.

Modify the capture time stored in this image by entering the correct time adjustment below. Type of Adjustment
 Adjust to a specified date and time Shift by set number of hours (time zone adjust) Change to file's creation date
New Time
Original Time: 17/07/2007 09:35:16 Corrected Time: 17/07/2007 08:35:16
This operation cannot be undone. Cancel Change

Figure 4.12 The Edit Capture Time dialog.

Camera model and serial number

These items instantly tell you which camera model and specific serial number were used to take a particular photograph. If you shoot using more than one digital camera body or have photos in the catalog taken by other photographers using the same camera type, this data can prove really useful, especially if you want to track down exactly which camera was used. Let's say there is a problem with one of the cameras. There may be damage to the sensor or a camera focusing problem. Using this data, you can pinpoint which specific body is responsible.

Artist EXIF metadata

The Artist name EXIF metadata will only show up if you have uploaded it as a custom user setting to your camera. I work with the Canon EOS cameras and use the EOS Utility program (see **Figure 4.13**) to access the Camera Settings. This allows me to enter my name as the camera owner in the Artist EXIF data field. If you use a different camera system, the camera-supplied software will vary, but basically you should be able to do something similar to this by tethering the camera to the computer and using the utilities software that came with the camera to customize the camera settings (as shown below in Figure 4.13).

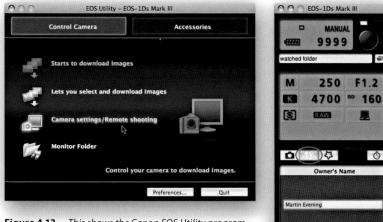

Figure 4.13 This shows the Canon EOS Utility program welcome screen. Click the Camera Settings/Remote Shooting option to open the Camera Capture window shown here, and then click the Setup menu button (circled) to set the owner name for the camera.

TIP

Check out the section on setting default camera-specific develop settings in Chapter 6 on pages 402–403.

TIP

Embedding your name as the owner in the camera settings seems like a pretty good idea. This ensures you get your name embedded in the capture file data even if you forget to add your name to the custom IPTC metadata. I have yet to hear of a case where a thief has been caught this way, using a stolen camera, but I am sure it may happen one day! Just remember that if you borrow someone else's camera or rent one, always check what the owner name metadata says. Once the owner metadata is embedded in the raw capture files, you won't be able to remove it so easily! If you are feeling brave though, the Artist EXIF metadata can be changed using an EXIF editor such as ExifTool by Phil Harvey (http://www.sno.phy. queensu.ca/~phil/exiftool/), but this is a command-line-based editor and, therefore, not particularly easy to use.

OK

IPTC	Metadata 🔻	
Preset	None 🗧	
File Name	_P2E9195.CR2	
	Martin Evening	
	Photographer	
Address	Chambers Lane	
	London	
State / Province	London	
Postal Code	NW10	
Country	UK	l
	+44 (0)208 451 xxxx	
E-Mail	martin@martnevening.com	
Website	www.martinevening.com	
Headline	Sassicaia 1968	l
Caption	Cabernet Sauvignon, 1968 vintage, Tenuta San Guido	
IPTC Subject Code	See newscode.org for guidelines	l
Description Writer	Name of IPTC content creator	l
Category	See newscode.org for guidelines	
Other Categories	See newscode.org for guidelines	
Date Created	2007-11-14	
Intellectual Genre	See newscode.org for guidelines	
Scene	See newscode.org for guidelines	l
Location	Willesden Green	
City	London	
State / Province	London	
Country	UK	
ISO Country Code	UK Status	
	Sassicaia	
Job Identifier		
	J1001 (use any custom job reference)	and the same
Instructions	Use this to add special instructions	
Provider	Whoever supplied image	
	Original copyright holder	10 M
	Copyright	
Copyright Status	Copyrighted ÷	
Copyright	© Martin Evening 2007	
Rights Usage Terms	Licensed usages only	
Copyright Info URL	www.martinevening.com	
		l

Figure 4.14 The Metadata panel in IPTC mode.

Figure 4.15 To select, add, or edit a metadata preset, go to the Preset menu near the top of the Metadata panel and click the menu list.

Custom information metadata

So far, I have mostly described the fixed, embedded camera metadata that is displayed in the Metadata panel. We are now going to look at working with custom metadata, which is data that is used to add image-specific information. This can broadly break down into information about the image such as the caption, headline, and location details of where the picture was shot. Also included is contact information about who created the photograph, such as your name, address, telephone number, e-mail, and Web site. This information can also include how the photo might be classified and what copyright licensing restrictions might be in force. As you start applying metadata to individual photos or groups of images, you gain the ability to differentiate them further and can reap the benefits of having a carefully cataloged image database. Applying such metadata now will help you in the future. Not only can it allow people to contact you more easily, but it can also help when you are working in Lightroom and want to make targeted image searches.

In Figure 4.14, you can see the Metadata panel in the IPTC view mode. You can see here that I have filled in the editable sections with examples of how you might use this panel to add descriptive information to a photo in the Lightroom catalog. You could, for example, select all the photos in a particular folder from the same shoot and start typing in custom information to categorize them. Most of the items in this panel, such as Creator, Job Title, and Address, are all pretty self-explanatory, and this is data you would probably want to apply to nearly every photo. However, the Headline and Caption fields can be used to add imagespecific information. The Headline field might be used to describe a photo shoot, such as Xmas catalog shoot 2009 or White-on-white fashion shoot, while the Caption field can be used to provide a brief description of a scene, such as Crowds lining the streets at local festival parade. These custom bits of information are essential when submitting images to a picture library, and are particularly useful when you take into account that the value of an individual image can be increased as more information about the photograph is added. But even with a small-scale setup, you may find it rewarding to methodically catalog your photographs with basic metadata information in the Contact and other IPTC sections.

Metadata presets

You certainly don't want to spend too much of your time repetitively entering the same metadata. This is where the metadata presets come in handy, because you can use them to apply the metadata information that you need to input on a regular basis. To create a new metadata preset, click the Presets menu shown in **Figure 4.15** and select Edit Presets, which opens the dialog shown in **Figure 4.16**. The fields in this dialog will be populated with any IPTC metadata that's already entered in the currently selected photo. So if you have applied custom metadata already, this will appear ready to use as a new preset. Or, you can use this as a basis for creating a new preset by editing the fields in this dialog. Next, click the Done button at the bottom to open the Save Changes dialog where you can select Save As to save these settings as a new metadata preset.

Metadata presets provide a useful way to batch-apply informational metadata either at the import stage or later via the Metadata panel. You might, therefore, find it useful to create several metadata templates for the different types of shoots you normally do. Let's say you are a sports photographer and are often required

NOTE

Even though the Lightroom Metadata panel may not be able to display all the items applied here, other programs may be able to.

Basic Info		
Copy Name	Copy 1	
Rating		
Label	© Martin Evening 2009	ø
Caption	Caption name	
IPTC Content		
Headline	Headline to describe content	Ø
IPTC Subject Code	See: newscodes.org for guidelines	M
Description Writer	Name of IPTC content creator (self, or whoever enters	Ø
Category	A now 'deprecated' item from the IPTC schema	Ø
Other Categories	A now 'deprecated' item from the IPTC schema	Ø
🛙 🗹 IPTC Copyright		
Copyright	© Martin Evening 2009	Ø
Copyright Status	Copyrighted	ø
Rights Usage Terms	Licensed usages only	Ø
Copyright Info URL	www.martinevening.com	Ø
F IPTC Creator		
Creator	Martin Evening	M
Creator Address	Chambers Lane	ø
Creator City	London	ø
Creator State / Province	London	V
Creator Postal Code	NW10 2RN	Ø
Creator Country	UK	Ø
Creator Phone		
Creator E-Mail	martin@martinevening.com	
Creator Website	www.martinevening.com	ø
Creator Job Title	Photographer	V
/ 🖃 IPTC Image		
Date Created		
Intellectual Genre	See: newscodes.org for guidelines	
Scene	See: newscodes.org for guidelines	V
Location	London	Ø
City	London	Ø
State / Province	London	Ø
Country	UK	Ø
ISO Country Code	GB	Ø
IPTC Status		
Title	Title of image	Ø
Job Identifier	J702 (use this section to apply own custom job codes)	ø
Instructions	Use this section to add special instructions that don't fit	ø
Provider	Martin Evening	1
Source	Martin Evening Photography Ltd	1

IPTC Extension Adminis	trative		
Image Supplier	0 items	Replace 🛟	V
Image Registry Entry	0 items	Replace	Ø
Max Avail Height	3200 pixels		V
Max Avail Width	4800 pixels		V
Digital Source Type	Original digital capture from a real life so	ene 🗘	Ø
IPTC Extension Artwork			
Artwork or Object in the Image	0 items	Replace	V
🛙 🗹 IPTC Extension Descript	ion		
Person Shown in the Image	Name of person		ø
Location Created	0 items	Replace 🛟	ø
Location Shown in the Image	0 items	Replace 🛟	V
Name of Orgad in the Image	Name of organization or company feature	d	V
Code of Orgad in the Image	Code from a controlled vocabulary for ide	ntifying	1
Event	Name or description of a specific event		ø
IPTC Extension Models			
Additional Information	Information about ethnicity or other facet	s of model	1
Age	Age of featured model at time photo was		1
Minor Model Age Disclosure	Age Unknown		1
Release Status	Limited or Incomplete Model Releases		1
Release Id	A PLUS-ID identifying each model release		ø
IPTC Extension Rights			
Image Creator	0 items	Replace \$	1
Copyright Owner	0 items	Replace \$	V
Licensor	0 items	Replace \$	1
Property Release Id	A PLUS-ID identifying each property release	se	1
Property Release Status	Unspecified	•	ø
🔻 🗹 Keywords			
Keywords	Camilla Pascucci, Harriet Cotterill, History	, Terry	ø
	Calvert, Yuliya, Zone		
Check All Check None	Check Filled	(D	one
Check An Check None	Check Pined	<u> </u>	me

Lr	Save changes as a	new preset?	
	(Don't Save	Cancel	Save As

Figure 4.16 Edit Metadata Presets dialog.

NOTE

Metadata presets are also available and editable via the Import Photos dialog. You, therefore, have the choice of applying metadata presets either at the import stage or via the Metadata panel section shown in Figure 4.15. to photograph the home football team whenever the team plays a game at the local stadium. You could save yourself a lot of time by creating a template with the name of the football team and the location information and applying this template every time you photograph a home game.

Editing and deleting metadata presets

If you want to edit an existing preset, first choose the preset you want to edit and then select Edit Presets. Apply the edit changes you want to make and click the Done button. This opens the Save Changes dialog again, where you will have to select Save As and choose a new name for the preset (it must be a new name you can't overwrite an existing preset). To remove a metadata preset, go to the Username/Library/Application Support/Adobe/Lightroom/Metadata Presets folder (Mac) or Local disk (C:)/Username/Application Data/Adobe/Lightroom/Metadata Presets folder (PC) and delete the preset. (Lightroom metadata templates will appear listed with the .Irtemplate suffix.)

IPTC metadata

The editable items you see listed in Figure 4.16 conform with the latest International Press Telecommunications Council (IPTC) standard file information specifications, used worldwide by the stock library and publishing industries. For help in understanding how to complete some of the advanced IPTC fields (such as IPTC Subject Code), I suggest you try visiting newscodes.org.

The items listed in the Metadata Presets dialog are not as comprehensive as those found in Photoshop, Bridge, or Expression Media, but they do conform to the IPTC metadata standard. Therefore, the metadata information you input via Lightroom will be recognizable when you export a file for use in these other programs. Conversely, Lightroom is able to display only the metadata information it knows about. It won't be able to display all the data that might have been embedded via Bridge or Expression Media. Should this be a cause for concern? For those who regard this as a shortcoming of Lightroom, it may well prove to be a deal breaker. But for others, the metadata options that are available will be ample. Figure 4.16 provides a useful overview and suggestions on how to complete the Basic and IPTC fields, and **Figure 4.17** shows a practical example of a partially completed metadata preset that would be suitable for everyday use.

It is not mandatory that all the listed fields be completed; just fill in as many as you find useful. For example, the IPTC Content section can be used to enter headline information and details of who wrote the description. Note that the Description Writer field refers to the person who entered the metadata information; this might be a picture library editor, your assistant, or a work colleague. This type of information is not something that you would necessarily want to add as part of a metadata preset. However, the IPTC Copyright section can list information about

reset: UK Basic IPTC		
🛡 📃 Basic Info		
Copy Name		
Rating	** · · ·	
Label		
Caption		
IPTC Content		
IPTC Copyright		
Copyright	© Martin Evening 2009	
Copyright Status	Copyrighted	• •
Rights Usage Terms	Licensed usages only	Ø
Copyright Info URL	www.martinevening.com	
IPTC Creator		
Creator	Martin Evening	
Creator Address	Chambers Lane	Ø
Creator City	London	Ø
Creator State / Province	London	
Creator Postal Code	NW10 2R	
Creator Country	UK	
Creator Phone	+44(0)2084512	
Creator E-Mail	martin@martinevening.com	Ø
Creator Website	www.martinevening.com	Ø
Creator Job Title	Photographer	V
IPTC Image		
🔻 🖃 IPTC Status		
Title		Θ
Job Identifier		0
Instructions		-
Provider	Martin Evening	V
Source	Martin Evening Photography Ltd	M
		Done

Figure 4.17 Here is an example of a metadata preset in which only some of the fields have been filled in and the corresponding check boxes selected.

who owns the copyright, plus Rights Usage Terms. The IPTC Creator section can also contain contact details such as your address, telephone, e-mail, and Web site. This information will most likely remain the same until you move premises or change e-mail accounts. Once you are done, you can save this template as a new basic metadata preset and apply it whenever you import new images into the catalog. This way, you can ensure that after each new import, all newly added photos will carry complete copyright and contact information.

NOTE

The IPTC Image section allows you to enter information that is more specific to the image, such as the intellectual genre. The remaining fields can be used to describe when and where the photograph was shot, job reference (such as a client art order), and so on. In Figure 4.17, you will notice that I did not enter data into all the fields, and for those that were empty, I deliberately left the check boxes deselected. This is because a selected check box is saying "Change this metadata." When you create a metadata preset, you will often want to devise a preset that is general enough to cover certain types of shoots but without including terms that will make a preset too specific. Also, if you create a metadata preset that is designed to add metadata to specific IPTC fields, you may not want to overwrite any of the other fields that contain existing, important metadata. Going back to the Figure 4.17 example, you will notice that I only checked the boxes that contained new preset metadata. Let's say I had an image where the caption, color label, and star rating information had already been added. If I applied the metadata preset shown in Figure 4.17 but with all the boxes checked, it would overwrite these existing metadata settings with zero values, thereby erasing the caption, color label, and star rating data. So when you create a new preset, it is always worth checking to make sure that you select only those items that you intend to change; otherwise, your metadata presets can soon start messing up the photos in the catalog rather than enhancing them. Of course, you can always edit an existing preset and deliberately set the preset to erase older metadata if you think that would be useful. The overall message here is to configure these presets carefully and always test them out to make sure that they are doing exactly what you expect them to do.

IPTC Extension metadata

Lightroom 3 has now added the IPTC Extension Schema for XMP, which is a supplemental schema to the IPTC Core. It provides additional fields with which to input metadata that can be useful to a commercial photography business. If you refer back to the example shown in Figure 4.16 on page 141, you will see brief explanations of how each of these new fields may be utilized. Basically, the new IPTC Extension schema can provide additional information about the content of the image such as the name, organization, or event featured in a photograph. It provides you with further fields to improve administration, whereby you can apply a globally unique identifier (GUID). It offers fields for precisely defining the licensing and copyrights of a particular photograph. For example, instead of just saying, "This photo is copyright of so and so," it allows you to specify the name of the copyright holder, as well as who to contact to obtain a license. This might well be a picture library or a photo agent rather than the photographer himself. The image supplier can also be identified separately. Again, it might be a photo library that supplies the image rather than the photographer directly.

Photographers who shoot people have the opportunity to record specific model information such as the age of the model, which might be particularly relevant if the model was classed as a minor at the time a photo was shot. You can also provide a summary of the current model release status. The same thing applies to photographs of private properties, where, under some circumstances, a property release may be required.

A more efficient way to add metadata

One of the things that continues to irk me about Adobe Bridge is that if you select a photo, make the Description field active in the Metadata panel, and enter new text, you have to press ←Enter to commit, select the next image, then re-target the Description field all over again to add a new description for the next photo.

Fortunately, this process is made a lot easier in Lightroom. **Figure 4.18** shows a Library Grid view of photographs that were taken at a model casting. I tend to shoot such model castings with the camera tethered to the computer and update the Caption field with the model's name and agency as I go along. In the screen shot shown here, you can see that the Caption field is currently active and I have typed in the model's details. Instead of hitting **←Enter** to commit this data entry, I can use the **E** key (Mac) or **C**trl key (PC) plus a right or left arrow to progress to the next or previous image. This step commits the text entry and takes me directly to the next photo. It also keeps the metadata field active so that I am now ready to carry on typing in new information for the next selected photo.

Figure 4.18 Here is an example of how to update the metadata for a series of photos without losing the focus on the field that's being edited in the Metadata panel.

Quick Describe	Metadata	V
Preset	None	۲
File Name	< mixed >	
Copy Name		-
Folder	/Volumes/Lis/World Trave	
Metadata Status	< mixed >	
Rating		
Dimensions	< mixed >	
Cropped	< mixed >	
Capture Time	< mixed >	t
Camera	< mixed >	
	< mixed >	
Caption	< mixed >	
Copyright	© Martin Evening	
Creator	< mixed >	
Location	< mixed >	

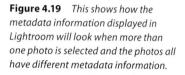

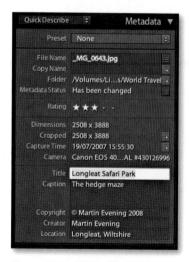

Figure 4.20 If Show Metadata for Target Photo Only is selected, the Metadata panel displays the information for the most selected (target) photo.

Metadata editing and target photos

If you have a group of photos currently selected and go to the Metadata panel, the metadata information will display <mixed> values whenever there are varied file attributes for the selected images (see the example shown in **Figure 4.19**). Only those values that are common to all the selected photos (such as the copyright information) will be displayed here. When you are in this "default" mode of operation, you can edit individual fields in the Metadata panel to update the metadata you wish to be common to all the selected files. So, for example, if you want to apply the same title to all the selected images, you can edit the Title field, which will update all the selected images so that they share the same data.

However, if Show Metadata for Target Photo Only is selected in the Metadata menu (**Figure 4.21**), the Metadata panel display will look like the version shown in **Figure 4.20**, where it will now be possible to read the metadata information for the most selected or target photo only, even though you may have more than one photo selected in Lightroom.

To show you how this feature might be used, in the **Figure 4.22** example, I had selected all of the photos from a folder in the catalog. The Metadata panel displayed the information for the photo that was the most highlighted (the target photo). By using the \mathfrak{B} + arrow keys (Mac) or Ctrl + arrow keys (PC), I was able to navigate from one photo to the next without deselecting the active photo selection and read the metadata information for each individual image as I did so.

With the Show Metadata for Target Photo Only mode, the one thing you need to be aware of is that you will now be able to edit the metadata only on a per-image basis. This is a good thing because it means that you can keep an image selection active and edit the metadata for each of the individual images but without losing the selection. However, a lot of people will be accustomed to making image selections and then using the Metadata panel to edit settings globally across a selection. So, just be aware that although this menu item can prove useful (for the reasons I have just described), you probably won't want to have it enabled all the time, as it can lead to confusion if you forget you have this option enabled.

Lightroom	File	Edit	Library	Photo	Metadata	View	Window	Help	\$
					Set Keyw Toggle S Enable Pa	hortcut	ortcut Keyword	٦	ひ 米 K
					Keyword Color Lat				*
					Show Me	tadata I	for Target	Photo C	Inly
					Copy Me Paste Me	tadata			ዕ ೫C ዕ ೫V

Figure 4.21 The Show Metadata for Target Photo Only menu item.

000	🖬 Lightroo	om2-280308.Ircat - Ado	be Photoshop Lightroom	- Library
4992 x 3772 JPG	338 x 4992 PG	2172.259 76 76 76 76 76 76 76 76 76 76 76	388 x 2592 JPG	Histogram ▼ Histogram ▼ ISO 400 11 mm f/13 1/400 Sec Defaults P Quick Develop ◄
157 _MG_9724 2592 x 3888 JPG	158MG_9729 3888 x 2592 JPG	159 _MG_9830 3888 x 2592 JPG	160 _MG_0241 3888 x 2592 JPG	Keywording ◀ + - Keyword List ◀
***	***	***	***	Default None S Preset None S File Name MG_0682-Edit-2.jpg F Copy Name Nolumes/LiWorld Travel R Metadata Status Has been changed Trite Stonehenge, Wiltshire
161	162	163 _MG_0554 2592 x 3888 JPG	164 _MG_0643 2508 × 3888 JPG	Caption Transformation and an and a second s
				Copyright Copyright & Martin Evening 2008 Copyright Status Copyrighted : Creator Martin Evening Location Wiltshire Rating ★★★★ Label Red Capture Time 17:06:48
★★★ · · 165 maze-02	★★★・・ 166 Longleatmaze-pano-2	★★★ · · 167 Longleatmaze-pano	★★★ · · 168 _MG_0682-Edit-2	Dimensions 3568 x 2378
105 x 1398 JPG	5483x 4146 JPG	8081 x 4146 JPG	3568 x 2378 JPG	Cropped 3568 x 2378 → Exposure 1/409 sec at / 13 Focal Length 11 mm ISO Speed Rating ISO 400 Fisab Did not fire Make Canon Model Canon EOS 4000 DIGITAL Lens EF-S10-22mm f/3.5-4.5 USM
169P2E9022-2 3926 × 3123 JPG	170P2E9022-3 3926 x 3123JPG	171 _P2E9022-4 3926 x 3123 JPG	172P2E9022-5 3926 x 3123JPG	Sync Settings Sync Metadata
T 2 4 4 I	/ 244 photos / 244 selec			Custom Filter

Figure 4.22 An example of the Show Metadata for Target Photo Only function in use. Note that although all the photos have been selected and the titles are different, you can now read the information for the most selected photo.

Mail and Web links

The E-Mail field also has an action arrow next to it, which implies that another Lightroom user viewing someone else's photo can send an e-mail to the creator by simply clicking on the action arrow. Lightroom then creates a new mail message using the default mail program on the computer and if the mail program is not currently running, Lightroom launches it automatically. Similarly, if you click the action button next to the Website field, this launches the default Web browser and take you directly to the creator's Web site link.

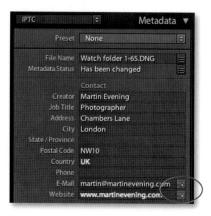

1. In this view of the Metadata panel, you can see the action arrow buttons next to the E-Mail and Website items.

000	New Message	C
\bigcirc		
Send Chat	Attach Address Fonts Colors Save As Draft	
To:	Martin Evening	
Cc:		
Bcc:		
Subject:		
≡ ▼ Account:	Martin Evening <martin_evening !<="" \$="" none="" signature:="" td=""><td>\$</td></martin_evening>	\$

2. When you click the E-Mail action arrow button, this automatically launches the default e-mail client program and prepares a new e-mail message, ready to be sent, using the e-mail address entered in the Metadata panel's E-Mail section.

Copyright status

The Copyright section also has an action arrow next to the Copyright Info URL, which, when clicked, takes you directly to the Web site link. Above that, there is also a Copyright Status field (see **Figure 4.23**), where you can set the copyright status as being Unknown, Copyrighted, or Public Domain. You can edit the copyright status via the Metadata panel, or go to the Metadata panel Presets menu, choose Edit Presets, and create a new custom metadata preset via the Metadata Presets dialog where Copyrighted is switched on by default (as shown in **Figure 4.24**).

I should write a word or two here about what the term *copyrighted* means. Strictly speaking, a copyrighted image is one that has been registered with the U.S. Library of Congress, and this is a term that applies to the United States only. So, if you say an image has been copyrighted, it has an explicit meaning in the United States that does not translate to mean the exact same thing to those photographers who operate outside of the country, where U.S. copyright laws do not apply. If you operate in the United States and use this field to mark an image as being copyrighted, then you should be aware of the precise meaning of the term and get these images registered. If you choose to use the Copyright field only to indicate this is your copyright, this statement should be clearly understood in nearly all countries and is all that you need to do to enforce your ownership rights.

reset: UK Basic IPTC-ALL	(edited)	
🖉 📃 Basic Info		
Copy Name		
Rating		
Label		
Caption		
F 🖂 IPTC Content		
Headline		0
IPTC Subject Code		
Description Writer		
Category		
Other Categories		0
🔻 🗹 IPTC Copyright		
Copyrigh	Unknown	
Copyright Status		
Rights Usage Term:	Public Domain	
Copyright Info URL	www.martinevening.com	Ø
▼ 🗹 IPTC Creator		
Creator	Martin Evening	
Creator Address	Chambers Lane	
Creator City	London	
Creator State / Province	London	Ø
Creator Postal Code	NW10	
Creator Postal Code	NW10	

Figure 4.23 You can set the Copyright Status by clicking the menu highlighted here in the Metadata panel.

Figure 4.24 The Edit Metadata Presets dialog, showing the Copyright Status options.

+ -		Keyword List	T
(Q.FI	lter Keywords		0
	ARCHITECTURE	(5
	Boats		5
	Buildings		5
	Details	1;	7
D	Food	1	
	History	68	3
	NATURE SUBJEC	TS	
	Flowers	21	
	plants		
	Cactus	e	5
	Seascapes	e e e e e e e e e e e e e e e e e e e	
	People		
	People I know		
	Places	789	
	Europe	1092	
	Italy		
	Norway	174	
	Bygdøy	peninsula 40	
	Oslo	134	
	Spain		
C	Test photos		
			10000

Figure 4.25 In this example, the Bygdøy peninsula keyword is a subset of Norway > Europe > Places and the Seascapes keyword is a subset of NATURE SUBJECTS.

Keywording and Keyword List panels

The most effective way to categorize your images is to label them with keyword information so you can use the Filter bar to carry out photo searches, either by typing in a specific text phrase (such as a keyword), or by carrying out a general, filtered metadata search.

You can add keyword metadata via the Import Photos dialog as you import your images, or you can add or edit the keywords later via the Keywording panel. **Figure 4.25** shows how I have sorted some of the keywords in my Keyword List panel into a hierarchy or keyword categories (also referred to as a controlled vocabulary). In the *Places* keyword category, there is a keyword subcategory called *Europe* and within that *Norway*, and within that *Bygdøy peninsula*. So the full keyword path here is *Bygdøy peninsula* > *Norway* > *Europe* > *Places*. Note how you enter keyword metadata in this order, placing the child keyword before the parent. This photo also contains the keyword *Seascapes*, which is a child of the parent keyword *NATURE SUBJECTS*, and the full keyword path here is *Seascapes* > *NATURE SUBJECTS*. You will find that it pays to establish a proper keyword hierarchy that suits the content of your library and give some careful thought as to how you wish to structure a controlled vocabulary.

Three ways to add new keywords

As I just mentioned, you can add keywords as you import images into the catalog (Figure 4.26) or add and edit keywords via the Keywording panel (Figure 4.27). You can also add keywords to the Keyword List panel in anticipation of the keywords that will be needed (Figure 4.28). Once such a controlled vocabulary has been set up, you can select an image you want to update, choose a keyword from the Keyword List panel, and click in the box to the left. This adds the chosen keyword to the selected photo (Figure 4.29). Whichever method you use, once a keyword has been added, it will from then on always appear listed in the Keyword List panel. But once the keywords are there, you can always rearrange them into a suitable hierarchy and, after a keyword has been created, Lightroom can then auto-complete keywords for you as you start typing in the first few letters for a new keyword entry. Apart from making it quicker to enter new data, this helps you avoid duplicating keyword entries through careless spelling or typos. Lightroom also auto-assigns the correct hierarchy. For example, the next time I might choose to add the keyword Seascapes, the Seascapes keyword will be automatically applied to the image using the keyword path Seascapes > NATURE SUBJECTS. I'll be coming back to this point later, but basically when you enter a keyword, Lightroom is able to auto-complete the keyword and at the same time knows to assign the correct keyword hierarchy. The only problem that arises is where a single keyword can have more than one hierarchy, but I'll come to this shortly.

FROM FCR-HS219bile Reader All photos	→ Copy as DNG Copy Move Add → Copy photos to a new location and add to catalog	TO Hard Drive 3 ÷
Metadata Preset Basic IPTC Reywords Boats,Buildings,History,Seas capes,Winter,Norway	File Handling Ignore Duplicates, Embedded & Sidecar Previews Develop Settings General - Auto Tone	✓ Into Subfolder Norway Organize Into one folder ₽
30 photos / 368 MB	Import Preset None +	Cancel Import

Figure 4.26 You can add keywords at the time of import. In this example, I entered the relevant keywords into the Keywords field. Lightroom offers to auto-complete a keyword if it recognizes that the word you are typing might belong to the keyword list.

Keywording 🔻	Keywording 🔻
Keyword Tags Enter Keywords 🔅 👻	Keyword Tags Enter Keywords 😜 💌
Boats, Buildings, History, Seascapes, Winter	Boats, Buildings Bygdøy peninsula, History, Seascapes, Winter
Bygdøy peninsula > Norway > Europe > Places	Click here to add keywords
Bygdøy peninsula > Norway > Europe > Places Keyword Suggestions	Click here to add keywords Keyword Suggestions

Figure 4.27 Alternatively, you can go directly to the Keywording panel and type in the keyword or keywords you wish to assign to a selected photo (in the box where it says, "Click here to add keywords"). In this example, I typed in "Bygdøy peninsula > Norway > Europe > Places" to add the keyword Bygdøy peninsula with the desired hierarchy.

Filter Keywords	Create Keyword Tag		
 ▼ Europe 1873 ▶ Malta 168 	Keyword Name:	Bygdøy peninsula	
Add this Keyword to Selected Photo Remove this Keyword from Selected Photo	Synonyms:		
Edit Keyword Tag		Keyword Tag Options	
Rename		Include on Export	
Create Keyword Tag		Export Containing Keywords	
Create Keyword Tag inside "Norway"		✓ Export Synonyms	
Delete		Creation Options	
Put New Keywords Inside this Keyword		Put inside "Norway"	
Use this as Keyword Shortcut		Cancel Create	
Export these Photos as a Catalog			

Figure 4.28 You can also add keywords in advance. In this example, I right-clicked the Norway keyword and chose Create Keyword Tag inside "Norway." This opened the Create Keyword Tag dialog. I then added "Bygdøy peninsula" as a child of Norway.

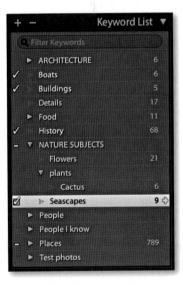

Figure 4.29 When you roll the mouse over a keyword in the Keyword List panel, a check box appears to the left of the keyword. If you click in this box, you can add a tick mark, which means the keyword is added to the currently selected image or images. If you click the arrow to the right of the keyword count number, Lightroom filters the catalog to show all photos that share the same keyword.

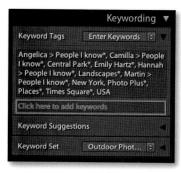

Figure 4.30 Keywords associated with a single image or group of images are listed in the Library module Keywording panel. In the example shown here, I highlighted all the images from the New York folder shown in Figures 4.32 and 4.33. The keywords marked with an asterisk indicate that these keywords apply to a sub-selection of images only. You can also add new keywords by typing them into the section that's highlighted above.

Figure 4.31 The Edit ⇒ Spelling submenu has options for checking spelling in Lightroom, including checking spelling as you type. This can help you avoid mistakes as you add new metadata. Note: This is available in the Mac version only.

Applying and managing existing keywords

The Keywording panel is located directly above the Keyword List panel and displays all the keywords associated with a specific image or collection of images. When you select an image in the Library module, you will see any keywords associated with the photo listed in this panel, each separated by a comma (there should be no spaces). As with the Import Photos dialog, you can add a new keyword by typing it into the space indicated in the Keywording panel, and Lightroom will attempt to auto-complete the entries as you type. If multiple images are selected, the Keywording panel displays all the keywords that are active in the image selection. Those keywords that are common to all images in the selection are displayed as normal, but those keywords that apply only to a sub-selection of the images will be marked with an asterisk (Figure 4.30). If you have a multiple selection of images and want to unify a particular keyword across all of the images in that selection, simply highlight the asterisk and press the Delete key. This ensures that all the selected images are now assigned with that keyword. If you want to change a particular keyword, you can always highlight it and type in a new word or press Delete to remove it completely from the selection.

You can apply keywords to photos in the catalog in a couple of ways. **Figure 4.32** shows how you can apply a keyword to a selection of images by dragging a keyword to the image selection. The good thing about this method is that it is easy to hit the target as you drag and drop the keyword. The other option is to make a selection first in the content area and then drag the selection to the keyword. In **Figure 4.33**, I selected the same group of images and dragged the selection to the keyword *New York*.

Auto-complete options

As you enter metadata for keywords and other editable metadata fields, it can save time to have the "Offer suggestions from recently entered values" option checked in the Metadata Catalog Settings (see Figure 4.70 on page 187), where you can also click the Clear All Suggestion Lists button to reset the memory and clear all memorized words. If you type in a keyword where there are two or more possible sources, Lightroom will offer these as choices, displaying, in this case, the full keyword path, such as *Salisbury* > *Wiltshire* > *UK* > *Europe* > *Places*, or *Salisbury* > *Maryland* > *USA* > *Places*, assuming both are logged as keywords. (See page 156 for more about how Lightroom handles implied keywords.)

Most of the time, auto-completion is a useful thing to have active. However, there are times when it can become a pain. For example, when I do a model casting and enter the names of models in the Caption field of the Metadata panel in the Library module, I don't find auto-completion particularly helpful. What is useful, though, with the Mac version is the ability to spell-check in Lightroom. The Edit \Rightarrow Spelling submenu in the Library module contains options to Show Spelling and Grammar, Check Spelling and Check Spelling as You Type (see **Figure 4.31**).

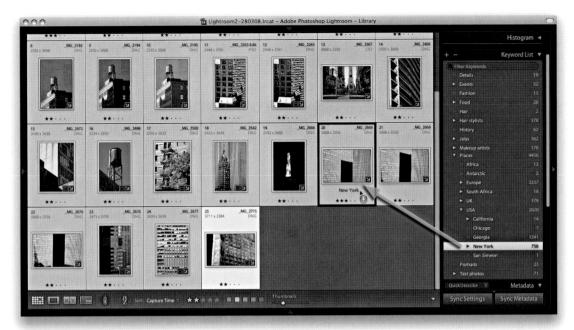

Figure 4.32 You can apply keywords to an image or selection of images by highlighting the images you want to apply the keyword to and then dragging a keyword from the Keyword List panel to the image selection.

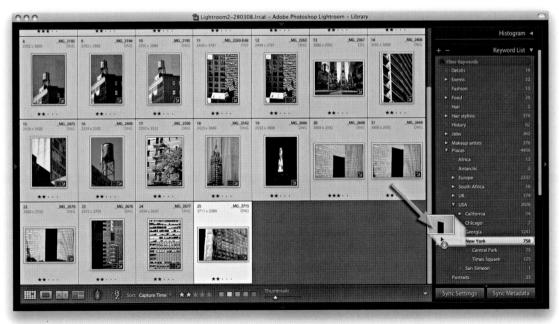

Figure 4.33 You can also apply keywords to an image or selection of images by highlighting them in the content area and dragging the selection to the relevant keyword in the Keyword List panel.

+ -	- K	eyword List	V
(0)	Filter Keywords		
Þ	365 Hair	7	
V	Clothes stylists	381	
	Bob & Joe	3	
	Harriet Cotterill	378	
	Details	22	
Þ	Events		
	Fall Foliage	3	
V	Hair stylists	389	
	Errol Douglas	5	
	Terry Calvert	382	
	History	62	
►	Jobs	543	
V	Makeup artists	419	1
	Camilla Pascuc	ci 414	
	Janet Francis		
	Shelley	2	
►	NATURE SUBJECTS	5 242	
Þ	People	142	
Þ	People I know	108	
	Photo Plus	31	
DHIR		active and the second	

Figure 4.34 Keywords can be used to categorize the images in ways that are meaningful to your business. In the Keywords panel view shown here, you can see how I am able to select images based on the personnel who worked with me on commercial jobs.

Removing keywords

It is easy enough to remove keywords. You can go to the Keyword List panel, select the keyword or keywords you want to delete, and click the minus button at the top of the panel. This deletes the keyword from the Keyword List hierarchy list and also removes it from any photos that have had that keyword assigned to them. Of course, if you remove a keyword via the Keyword List panel, you will only be deleting it from the Lightroom database. If the keyword metadata has already been saved to the file's XMP space, you may need to force-save the metadata change (the keyword deletion) back to the file's XMP space by choosing Metadata ⇒ Save Metadata to Files. By the same token, if keywords are removed using an external program, those keywords won't appear removed when you view the photo in Lightroom until you explicitly read the revised metadata back from the image.

As photos are removed from the catalog, keywords that were formerly associated with those pictures will consequently become unused. You can remove these by selecting and deleting as I have just described, or clear them from the Keyword List panel by going to the Metadata menu and choosing Purge Unused Keywords. Just so you don't remove these keywords by accident, a warning dialog will appear asking you to confirm this action.

Keyword hierarchy

It is important to plan not only your keyword list but also the keyword hierarchy by using a controlled vocabulary of keywords. The keyword list can be edited in the Keyword List panel by dragging and dropping the keywords in whichever way suits your needs best. It is possible to have several tiers of subcategories. For example, you could organize place name keywords in the following order: Town/City > State > Country > Places. When you are working in the Keywording panel, you can enter new keywords and assign a hierarchy by including a > character after the keyword, followed by the category. So if you wanted to add a new keyword called elephants as a subcategory of mammals, invertebrate, and ANIMALS, you would type elephants > mammals > invertebrate > ANIMALS. When you press Enter, you will see the *elephants* keyword appear as a new subset keyword in the Keyword List panel. There are a few things to point out here. One is that you always enter new keywords using the reverse path directory as shown here and in the previous examples. Second, once you have established a basic hierarchy, there is no need to type a complete path each time. In other words, once you have created the above path hierarchy, to add cat as a keyword you don't have to type cat > mammals > invertebrate > ANIMALS. All you'll need to type is cat > mammals. Lightroom knows how to complete the remaining hierarchy.

How you categorize library images is entirely up to you, but if you submit work to an external photo library, you will most likely be given guidelines on the acceptable keywords and categories to use when keywording photographs for submission. These guidelines are normally supplied privately to photographers who work directly with the picture agencies. But there are online resources that you can refer to that describe how best to establish and work with a controlled vocabulary. These ensure that the keyword terms you use to describe your images conform to prescribed sets of words universally used by others working in the same branch of the industry. When you get into complex keywording (and I do know photographers who assign images with 50 keywords or more), it is important to be methodical and precise about which terms are used and the hierarchy they belong to.

Keyword categories can also be used to catalog images in ways that are helpful to your business. For commercial shoots, I find it is useful to keep a record of who has worked on which shot. Some catalog programs let you set up a custom database template with user-defined fields. In Lightroom, you can set up keyword categories for the various types of personnel and add the names of individuals as a subset, or child, of the parent keyword category. **Figure 4.34** shows how I have created keyword categories for *Clothes stylists, Hair stylists,* and *Makeup artists*. Inside these categories, I created subcategories of keywords listing the people I work with regularly. Once I have established such a keyword database, Lightroom auto-completes the keyword metadata entry in addition to correctly placing the keyword within the established hierarchy. This type of organization is also useful for separating library images by job/client names. When the keyword names are in place, you should find it fairly easy to keep your catalog of images updated.

Keyword filtering

Because the Keyword List panel can grow to contain many thousands of keywords, you can make navigation simpler by typing the keyword you are looking for in the Filter Keywords section at the top of the panel. Even if you type just the first few letters or the keyword or keywords you are looking for, this can help narrow the selection of keywords to choose from. You can use this feature to check if a keyword exists in more than one place and edit the Keyword List accordingly.

You can also use the Keyword List panel to filter the photos that appear in the content area. As you roll the mouse over a particular keyword, you'll see an arrow appear next to the keyword count number. When you click on the arrow, this displays all the photos in the Lightroom catalog that contain this keyword, regardless of whatever photo filter view you have active.

Importing and exporting keyword hierarchies

You can create your own keyword hierarchy from scratch or import one that has already been created (such as the example shown in **Figure 4.35**). To import keywords into Lightroom, you'll need to do so from a tab-delimited keyword file.

ł		Keyword List 🔻
6	Fi	iter Keywords
		ACTION
		ANATOMY
		ANIMALS
		ARCHITECTURE 6
		ART
1		BUSINESS
		CLOTHING
		COLOR
		CONCEPTS
		DIRECTIONS
		DISASTER
		EDUCATION
Ċ		ENERGY
	>	ENVIRONMENT
	>	ETHNICITY
	>	EVENTS
(>	EXPRESSIONS
Î	>	GENDER
į	>	GOVERNMENT
1	2	HOLIDAY
1	>	LANDFORM
	>	LIGHT
	>	MEDICAL
1	Þ	MONTH
1	Þ	NATURE SUBJECTS
1	•	OCCUPATION
	Þ	OCEANS
		PETS
		PLANTS
	•	PRIVATE METADATA
		RELATIONSHIP FAMILY
		RELIGION
		SEASONS
		SPORTS
		SPORTS EQUIPMENT
		TIME OF DAY
		TRANSPORTATION
	•	TRAVEL
		TYPE
		WEATHER
		WEDDINGS
		WORLD LOCATION
		YEAR © 2007 D-65 KEYWORD LIST 0
		© 2007 D-65 KEYWORD LIST 0
igu	ire	4.35 This shows an imported

Figure 4.35 This shows an imported "D-65" keyword list, that was created by Seth Resnick for attendees of his D-65 workshops.

TIP

David Riecks runs a Web site with tips and guidelines on how to work with a controlled vocabulary at

www.controlledvocabulary.com.

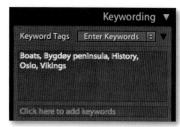

Figure 4.36 When Enter Keywords is selected in the Keywording panel, you can edit the keywords directly, but the implicit keywords will be hidden from view.

Figure 4.37 When Keywords & Containing Keywords or Will Export is selected in the Keywording panel, the implicit keywords will be made visible so that you can see a flattened view of all the keywords applied to a photo (but you won't be able to edit them).

Figure 4.38 In Enter Keywords mode, you won't always see the keyword hierarchy (as used when typing in a new keyword) unless there are identical keywords but with different parents. A tab-delimited file is a plain text file with a tab between each indented level in the text. Tab-delimited files are one way to import and place data that is arranged in a hierarchical format. In the tip to the left, you will see a link to David Riecks' ControlledVocabulary.com Web site, from which you can purchase a ready-made vocabulary that is compatible with Lightroom. To install this, download the file, launch Lightroom, and choose "Import keywords" from the Metadata menu. That's it—these keywords will be added to the Keyword List panel. Similarly, you can export a keyword hierarchy for sharing on other computer systems or catalogs by selecting Metadata \Rightarrow Export Keywords. (A keywords export is also saved as a text file using a tab-delimited format.)

Implied keywords

The Keywording panel lists keywords that have been applied explicitly to images in the Keyword List section. But as I mentioned, some of the keywords that you enter will already have implicit keywords associated with them. So if, in the future, I apply the keyword *Bygday peninsula*, it will automatically include the implicit keywords *Places, Europe,* and *Norway.* I don't have to type in *Bygday peninsula* > *Norway* > *Europe* > *Places* if there is already a keyword with such a hierarchy in the database. It should only be necessary to type in the first few letters (such as *Byg*), and Lightroom will auto-complete the rest. If the Keyword Tags menu is set to display Enter Keywords (**Figure 4.36**), you can edit the keywords in this mode, but the implicit keywords will be hidden (although they will, nonetheless, remain effective when conducting searches). If you select Keywords & Containing Keywords or Will Export (**Figure 4.37**), you will see a flattened list of keywords that includes the implicit keywords, but you won't be able to edit them in the Keywording panel when using these two modes.

When you enter a new keyword, you use the > key to signify that this keyword is a child of the following keyword (such as *Chicago* > *Illinois* > *USA* > *Places*). This establishes the hierarchy, and as I explained, when you use the Enter Keywords mode, all you will see is the first keyword; the parent keywords will be hidden. However, if you apply a keyword that is identical to another keyword where both have different parents, you will then see the full keyword path hierarchy appear in the Keywording dialog. To give you an example of why this is the case, take a look at **Figure 4.38**, in which you see the keyword *Camilla* repeated twice. This is because I can add the keyword *Camilla* in two separate contexts. On one level, *Camilla* is a makeup artist I work with, but she's also my wife (so I had better include her in the people I know!). This is why, when you type certain keywords, you'll sometimes see more than one keyword path suggestion. It also explains why, when you click (--Enter) to OK the choice, you may see a full keyword path directory in the Keywording panel rather than the single keyword (as in the Figure 4.38 example).

Keyword suggestions

If you expand the Keyword Suggestions section, this reveals a grid of suggested keywords. You can click any of the keywords displayed here to add it to the selected photo or photos. Lightroom adapts the list of keywords that are available for use based upon the keywords that are already in that image plus those photos that are close neighbors in terms of capture time. The suggested keywords are also prioritized based on how soon before or after the current photograph they were taken. The logic system that's used here works really well when trying to guess what other keywords you might like to add to a particular photograph. In **Figure 4.39**, the selected image had the keywords *New York* and *USA*. Lightroom was able to suggest adding the other keywords shown in the Keyword set list such as *Times Square, Central Park, Manhattan,* and *Architecture*. This is because all the other photos that had *New York* and *USA* as keywords *also* had one more of these other keywords assigned to them.

TIP

The more keywords you have in the source photo or neighboring photos, the more accurate the suggested keywords will be. The diversity of your keywording will also count. If all the keywords in a set of images are nearly identical, there is not much Lightroom can do when it comes to suggesting alternative keywords.

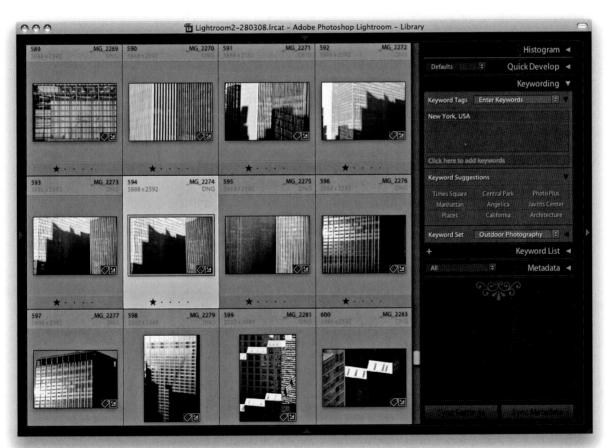

Figure 4.39 Here is an example of Keyword Suggestions in use. One photograph is selected here and the Keyword Set list adapts to display a list of keywords based on an analysis of the keywords assigned to similarly keyworded photos taken around the same time.

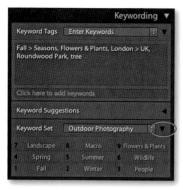

Figure 4.40 The Keywording panel shown here displays the Outdoor Photography keyword set. You can hold down the Alt key to preview the keyboard shortcut numbers and use the Alt key plus numbers shown here to quickly assign a Keyword Set keyword.

Keyword sets

The Keywording panel can also be used to display sets of keywords. When keywording certain types of photo projects it can save you a lot of time to have commonly used keywords quickly accessible. Keyword sets offer a quick method for adding commonly used keywords to selected images. To access a Keyword Set, click the disclosure triangle (circled in **Figure 4.40**) to reveal the Set section of the Keywording panel. This will normally display the Recent Keywords keyword set, which can be useful for most keywording jobs. Or, you can select one of the supplied Keyword Set presets such as Outdoor Photography, Portrait Photography, or Wedding Photography. In Figure 4.40, the *Outdoor Photography* Keyword Set had been selected, with suitable, outdoor keyword offerings such as *Landscape* and *Wildlife*. You can also use the Alt key plus a number as a shortcut for assigning Keyword Set keywords. If you hold down the Alt key, the number shortcuts will appear next to each keyword. So, for example, if I wanted to assign a *Flowers & Plants* keyword, I would use the Alt –9 shortcut (see also **Figure 4.41**).

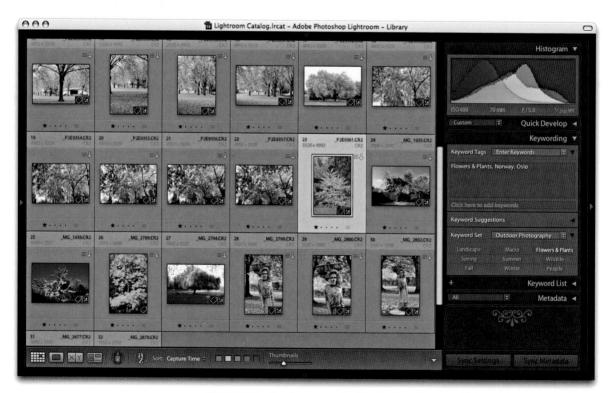

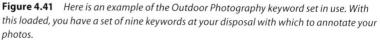

Creating your own custom keyword sets

If you have a lot of photos to edit from a specific trip, or if you regularly photograph certain types of events, you will most likely find it useful to create your own keyword sets for these types of shoots. To do so, follow these instructions:

Antarctic, Icebergs, Landscapes, Whaler's Bay	Edit Keyword Set		
	Preset: Antarctic		
Click here to add keywords	Keywords		
Recent Keywords	Antarctic	Drake Passage	Akademik Shokalskiy
intarctic Jutdoor Photography ortrait Photography Jedding Photography	Deception Island	Whaler's Bay	Half Moon Island
ave Current Settings as New Preset	Gerlache Strait	Icebergs	Landscapes
Delete preset "Outdoor Photography" Rename preset "Outdoor Photography"			

1. To create a custom keyword set, go to the Keyword Set section of the Keywording panel and select Edit Set. This opens the dialog shown here (using the current keyword set list), where you can edit which keywords you would use for quick access when keyword-editing a particular project. In this example, I created a keyword set that I could use when editing photographs taken in Antarctica.

	Keywording	T
Keyword Tag	s Enter Keywords 🔅	
Antarctic, Ice Whaler's Bay	bergs, Landscapes,	
	add keywords	
Keyword Sug	gesuons	
Keyword Set	Antarctic 🗘	
	8 Drake Pas 9 Akademi	
7 Antarctic	o prate ras o maderni	K
	5 Whaler's Bay 6 Half Moo	

2. After creating a new custom keyword set, go to the Metadata menu and check out the Keyword Set submenu to see the shortcuts listed for applying keywords. (These shortcuts are toggled.) The Keywording panel shown here now also displays the new custom keyword set. You can hold down the Alt key to preview the keyboard shortcuts and use the Alt key plus a number to quickly assign any of these keywords to selected photos.

TIP

In Keywords mode, you can enter more than one single keyword into the painter field. You will also notice in the Keyword List panel that the keywords entered will appear with a plus sign next to them (see the Keyword List panel view in Step 3 on the facing page).

cursor icon will change appearance depending on the mode you are using, to reflect the type of setting that is being applied.

The Painter tool

The Painter tool (also referred to as the spray can) is located in the Library module toolbar. It can be activated by clicking the tool, which floats it from its docked position in the Toolbar. You can also access the Painter tool by going to the Metadata menu and choosing Enable Painting, or use the \Re Att K (Mac) or Ctrl Att K (PC) shortcut. You can then select which type of settings you want to apply with the Painter tool (see **Figure 4.43**).

The Painter tool is ideal for those times when you want to repeatedly apply a keyword or combination of keywords to photos in the Library module Grid view. You can do this by clicking with the Painter tool on a photo you wish to edit, or you can click and drag over a number of photos at once. But that's not all: You can also use the Painter tool to paint using labels, flags, ratings, metadata, develop settings, rotation, or to set the target collection. It all depends on which mode you have selected in the accompanying Paint menu, and the Painter tool appearance varies according to which mode you have selected (see Figure 4.42 for examples of all the different cursor styles). As you can see, there are lots of potential uses for this tool-not just applying keywords, but other tasks such as painting with a saved Develop setting. With previous versions of the Lightroom Painter tool, some things (such as applying labels or ratings) had a toggle action where clicking or dragging over a thumbnail would either apply or remove data. Basically, it was all too easy to apply data and then undo it in a couple of keystrokes. With Lightroom 3, the toggle behavior has been removed and you now need to hold down the Alt key as you click in order to switch to eraser mode (\mathscr{A}) , which will undo a setting. Also, keep in mind that you have to be careful to target the thumbnail and not just the cell area. For jobs where you are constantly applying the same instruction, like "rotate this photo 90 degrees" or "apply this set combination of keywords," the Painter tool does have its uses, but it can often be much easier to just select the photos first and then apply a setting to all the photos in one step.

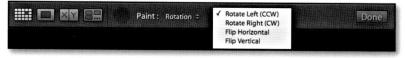

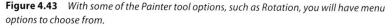

1. To work with the Painter tool, go to the Library module toolbar and click the tool icon to activate it (or use the **B**Att K [Mac] or **Ctrl**Att K [PC] shortcut). The Painter tool will undock itself from the Toolbar and replace the normal pointer cursor with the Painter tool icon as you move it within the Grid view area.

Paint: Keywords ÷	Antarctic, Icebergs, Landscap	Done
Set Keyword Shortcut		
Keyword Shortcut: Antarctic,Icebergs,Landscapes		
Cancel		

NOTE

When the Painter tool is set to Target Collection mode, it can be used to add photos to whatever is the current target collection. This is normally the Quick Selection in the Catalog panel, but you can change this to any other collection instead (see page 179).

2. You can enter the keyword or keywords you wish to apply in the empty field in the toolbar. (Lightroom again auto-completes the text by referencing previous or recently used keywords in the database.) Alternatively, you can choose Metadata ⇒ Set Keyword Shortcut, or use ﷺ(Alt Shift)K) (Mac) or Ctrl(Alt Shift)K) (PC) to open the Set Keyword Shortcut dialog and enter the keyword or combination of keywords in the dialog shown here.

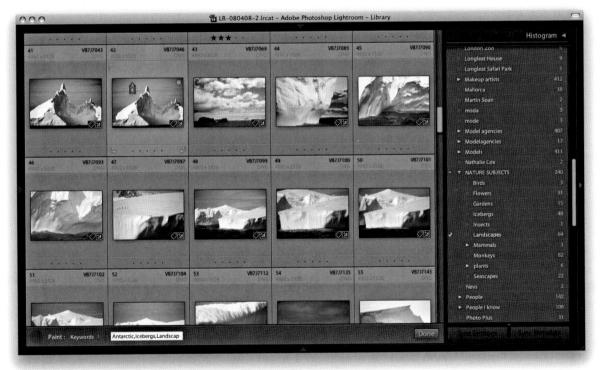

3. The Painter tool is now ready for use. Basically, you just click or drag with the Painter tool anywhere in the Grid view. In this example, I used the Painter tool to "paint" the keywords entered in Step 2. When you have finished using the Painter tool and want to switch out of "paint" mode, click in the empty area of the toolbar where the Painter tool normally lives, or use the **Alt** (Mac) or **Ctrl** (Alt) (PC) shortcut.

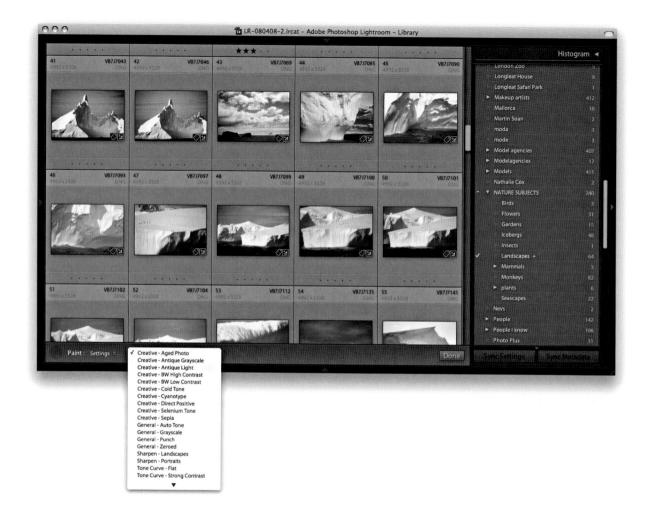

4. As was pointed out in the main text, you can use the Painter tool to apply things other than just keywords. In this example, the Painter tool is currently in Settings mode. When this mode is selected, you will see a menu list of saved Develop presets. If, on the other hand, you were to select Rotation, the menu would change to let you select a specific rotation or allow you to choose a painter setting that would flip an image. If Metadata is selected, the menu list will let you choose from pre-saved metadata templates. And, likewise, if Rating, Pick, or Label is selected, you are also offered another choice of settings to use.

Photo filtering and searches

So far, we have looked at how to manage images using folders to group the images in the catalog. Then we looked at how to rate images and separate the keepers from the rejects. Finally, we looked at how to add metadata information, including keywords to describe the image content, thus adding context, meaning, and ultimately more value to the pictures in the catalog. Now let's look at how to use the Library module tools to conduct image searches to find specific photos.

Filter bar

One of the key features in Lightroom is the Filter bar (see Figure 4.44), which can be accessed whenever you are in the Library Grid view mode. The Filter bar replaces the Find panel and Metadata Browser that were originally in Lightroom 1 and combines the best features of these two panels with the search functionality of the old Keywording Tags panel. The Filter bar is the main place to go for making refined filter selections of photos in the catalog (although you can still use the Filmstrip controls for filtering by ratings and labels). The Filter bar, therefore, rationalizes the filter controls in order to make the filtering process more centralized and flexible. One of the important things to note in Lightroom 3 is that filters are no longer automatically sticky. Previously, you might have visited a folder or collection, applied a filter, and then forgotten you had done so the next time you again visited that particular folder or collection. A lock button (circled in Figure 4.44) has now been added to the top-right section of the Filter bar so that you can instantly turn filters on or off, this now applies to all images in the catalog. For example, if you apply a "3 stars or higher" filter, this filter remains in force everywhere in Lightroom until you switch off the filter lock.

TIP

The most important tip of all here is to remember that the \\ key toggles the Filter bar visibility on or off. Another important tip is to use \(\Lambda)\) (Mac) or Ctrl\(\Lambda) (PC) to toggle the catalog filters on or off. Quite often, you will find yourself trying to work out where all your photos have disappeared to, and this is all because you forgot there was a filter active!

NOTE

To summarize, the left panels in the Library module contain the catalog source controls such as folders and collections. The Filter bar allows you to further filter the Left panel filter view and the right panels contain the catalog edit controls, such as the Quick Develop and Keywording panels.

Library Filter :		Text	Attribute	Metadata None		No Fi	lter 🗧 🔒
		Text Any Searcha	ble Field 😫	Contains All 🗘 Q-			
		Attribute Flag 🔨 🔇	🦿 🕴 Rating	12 ☆☆☆☆☆ 1 Ca	olor 🔲	Kind [
Date		Keyword	2	File Type		Camera	
All (218 Dates)	7876	Photographers	3	All (5 File Types)	276	All (1 Camera)	276
> 2001	16	V Places	854	Digital Negative (DNG)	268	Canon EOS-1Ds Mark II	276
> 2002	278	China	- 1	JPEG	1		
> 2003	72	▼Europe	1092	Photoshop Document (PSD)	1		
> 2004	39	► Norway	78	Raw	4		
> 2005	1596	▼ Spain	6	TIFF	2		
2006	749	W Mallorca	386				
2007	3510	Ca'Sa Rota	703				
2008	1596	Cancoll	276				
Unknown	22	Lloret	70				
		Senselles	344				
		Sineu	215				L

Figure 4.44 The Filter bar lets you filter the photos shown in the catalog using text, attributes (like those in the Filmstrip), metadata, or a combination of all three.

The Filter bar layout

There are three components to the Filter bar: Text, Attribute, and Metadata. These can be used to make a filter search of the entire catalog, or a subset of catalog images. This is an important point to remember, because if you want to conduct a search of the entire catalog, you must remember to go to the Catalog panel and select All Photographs first. This then allows you to carry out a global search. For speedier, targeted searches, make a sub-selection of photos first before using the Filter bar. It is so easy forget this important rule; many times, I go to the Filter bar with the intention of carrying out a global search yet forget that I have a sub-selection of photos active! So if a Filter bar search doesn't seem to be working properly, check that you have All Photographs selected. If you wish to undo a Filter bar search or toggle a Filter bar search on or off, use the Enable Filters shortcut: **(Mac)** or **(Ctrl L)** (PC).

Text filter searches

To carry out a text search you can choose Library \Rightarrow Find, click the Text tab in the Filter bar and click in the Search field, or you can use the XF (Mac) or Ctrl F (PC) shortcut to enable a text search and at the same time highlight the Search field in the Filter bar. From there, you can type in a text term that will be used to filter the photos in the current catalog view, looking for terms that match (Figure 4.45). The problem with this approach is that a general search for a term like ann could yield any number of matches-probably too many to be really useful. But there are ways you can limit a search and restrict the number of results you get when filtering the catalog contents. To start with, you can select an appropriate search target. Rather than search Any Searchable Field, which will mean searching everything, you can narrow the search target by choosing one of the following options: Filename, Copy Name, Title, Caption, Keywords, Searchable Metadata, Searchable IPTC data, or Searchable EXIF data. A Filename search is fairly obvious. I often search specifically by Filename using a Contains rule and type the filename I am looking for in the search field. I use this filter method when clients have made their final image selection and send me a list of filenames for the photos they wish me to retouch. All I need to do then is make a general selection of the client's photos and type in the last four digits of the selected filenames. This is usually enough to quickly locate each of the photos I am looking for. I discussed Copy Name more fully in the Metadata panel section earlier. Basically, you can use this to search the copy names that have been used for all your virtual copy images. All the other types of searches enable you to narrow the range of a text search to concentrate on the selected metadata type, such as Caption only or Keywords only. If you are unsure precisely where to search, the easiest option is to revert to using the more general Any Searchable Field approach, but as I have said, doing so might mean you end up with too many matches to choose from.

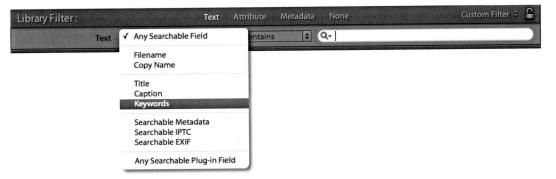

Figure 4.45 Filter bar text searches can be carried out by searching Any Searchable Field (as shown here) or by searching specific library criteria only, such as keywords, filenames, or captions.

Search rules

You can further limit a filter search via the Rule menu in the Text filter section (**Figure 4.46**). Here you can choose rules such as Contains. This carries out a search for text that partially matches anywhere in a text phrase. So, in the Figure 4.46 example, a search for *ann* could yield results such as *Ann*, *Anniversary*, and *Banner*. A Contains All rule looks for an exact match, such as *Ann*. The Doesn't Contain rule excludes files that match the text that's entered, while a Starts With rule could yield results where only words like *Ann* or *Anniversary* are filtered, and an Ends With search will yield results for anything ending with *ann* like *Portmann* or *ann*. These further search refinements can again make all the difference in ensuring that you have full control over the filtering process and that you don't end up with too many text filter matches.

Library Filter :	Tex	ct Attribute Metadata	a None	Custom Filter 🗢 🔒
	Text Any Searchable Field	Contains Contains All Contains Words Doesn't Contain	Q- ann	Click the X to clear the
		Starts With Ends With		current search term.

Figure 4.46 Here is an example of the Filter bar being used to search for a term that contains the letter sequence ann. You can use any of the rules shown here to further limit the search results and attain a more focussed filter result.

Combined search rules

If you click the search field icon circled in **Figure 4.47**, this opens a combined menu containing all the Search Target and Search Rules options. You can navigate this single menu to choose the desired settings. Note that if you click the X on the right, you can clear a text filter term and undo the current text filter.

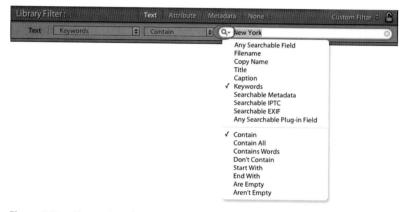

Figure 4.47 The combined Search Target and Search Rule menu.

Fine-tuned text searches

You could apply the Start With rule when searching, but it is handy to know that you can conduct a search for anything that begins with a specific search term by typing + at the beginning. If in my version of Lightroom, I were to type +*cape* in the search field, this would display photos with any keywords that begin with *cape*, such as *Cape Point* or *Cape Town*, and exclude keywords like *Landscape* (see **Figure 4.48**). Inverse searches can be made by typing an exclamation mark before the search term. If I want to search for keyworded photos that were shot on location but not include *Jobs, Europe*, or *USA*, I can type *Places !Europe !USA !Jobs* in the Find panel search field (also shown in Figure 4.48).

To further illustrate the points made here, you can use a search term like +cape to search for all terms that start with the word *cape* and combine this with *!USA* to also exclude any U.S. locations that start with the word *cape*. So you could end up with search results that included *Cape Town* in South Africa but excluded *Cape Canaveral* in Florida.

Library Filter : Text Attribute Metadata None	Custom Filter 🗧 🔒
Text Any Searchable Field 🗘 Contains 🗘 Q++cape	C
Library Filter : Text Attribute Metadata None	Custom Filter 🗧 🕻
Text Keywords Contain + Q- Places (Europe (USA Llobs	Ő

Figure 4.48 Examples of refined text searches using a + or ! in the search field.

Attribute filter searches

The Attribute filter tools are something that I touched on earlier in the previous chapter when discussing the Filmstrip filter controls. The Filter bar offers the exact same set of tools, except they can be accessed directly in the Filter bar alongside the other filter items (**Figure 4.49**). It is, therefore, simply a case of it being easier to integrate a refined filter search based on criteria such as the flag status, star rating, color label, or whether you wish to filter the master images or copy images only. Everything is the same here; you can click the buttons to apply a filter and click the star rating options to specify whether to filter for photos with a star rating that is the same and higher, the same and lower, or the same rating only.

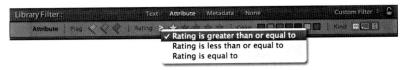

Figure 4.49 The Attribute section of the Filter bar showing the rating options menu.

Metadata filter searches

The Metadata section integrates some of the Keyword filter functionality of the Keyword List panel but goes further by allowing you to access a wide range of metadata attributes (not just keywords) and combine these to accomplish different kinds of metadata information searches. The Metadata filter section (**Figure 4.50**) provides customizable columns that can be adapted in an almost infinite number of ways to carry out different kinds of filter searches. In the example below, you can see how it is possible to combine a metadata search by date combined with a search that includes keywords, file type, and camera data criteria. Personally, I don't think there are that many instances where you would want or need to combine quite so many search criteria in a single search, but the functionality is there to allow you to do this (and more).

Date	3	Keyword	E	File Type		Camera	
2001	16	Model agencies	a 🗐	All (5 File Types)	2441	All (1 Camera)	833
2002	278	▶ Models	0	Digital Negative (DNG)	1510	Canon EOS 400D DIGITAL	833
2003	72	INATURE SUBJECTS	11	JPEG	63		
2004	39	> Objects	0	Photoshop Document (PSD)	10		
2005	1596	▶ People	0	Raw	833		
2006	749	People I know	31	TIFF	25	Drag the bottom bar to adjus	t the
2007	3510	Photo Plus	31			height of the Metadata lists.	
2008	1596	Photographers	1			The second secon	and succession
Unknown	22	▶ Places	810				

Figure 4.50 The Metadata section of the Filter bar.

NOTE

Not included in the Filter bar is an option to filter for images by process version. If you go to the Library menu you can select Find Previous Process Version Photos. This creates a temporary collection in the Catalog panel, which you can then filter using the Filter bar tools shown here.

Library Filter :	
✓ Date	
File Type	8
Keyword	A A
Label	2
Camera	0
Camera Serial Number	4
Lens	9
Flash State	6
Shutter Speed	
Aperture	9
ISO Speed	0
GPS Data	
Location	0
City	2
State / Province	
Country	
Creator	
Copyright Status	
Job	
Aspect Ratio	
Treatment	
Develop Preset	
None	
AND MADE IN COMPANY AND ADDRESS OF	

Figure 4.51 This shows the expanded list of options for a Filter bar Metadata search.

Metadata filter options

The Metadata section can be adjusted in height by dragging the bar at the bottom up or down. When the metadata panels are expanded in height, they can consume a lot of valuable space in the Grid view content area, which is a problem if all you are interested in doing is applying a filter using one panel only. This is another reason why it is important to remember the \Box keyboard shortcut, which toggles hiding and showing the Filter bar. It is unfortunate that the screen animation for this is rather jerky and slow compared to the speed with which the side panels and toolbar appear and disappear from the screen, but you do at least have the convenience to move the Filter bar out of the way when it is not needed.

The individual panels can be customized by clicking the panel name and selecting one of the many metadata search criteria that are available (**Figure 4.51**). Because you are able to customize the layout of the panels, this provides lots of opportunities for you to filter the catalog photos in different ways. Basically, you can use the figure 4.5hift or the figure (Mac) or Ctrl key (PC) to select more than one search term in a single panel. And because you can customize each panel by metadata filter type, you can have more than one panel used to filter by, say, Keyword (or whatever else it is you may wish to duplicate). The default view gives you four panels to work with, but you can customize this layout by clicking the button in the top-right corner of each panel (**Figure 4.52**) to either add extra columns (up to eight in total) or remove columns. Selecting multiple items within a single panel will add photos to a filter selection, while selecting items from other panels will "intersect" with the photo filter selection to further narrow a search.

1	File Type		Camera 🕏	(.=	5
596	All (5 File Types)	1596	All (5 Cameras)	1596	Add Column
1	Digital Negative (DNG)	33	Canon EOS 400D DI	29	Remove this Column
2	JPEG	707	Canon EOS DIGITAL	1	
2	Photoshop Docume	17	Canon EOS-1Ds Mark II	362	

Figure 4.52 Adding or removing a column in the Filter bar Metadata section.

Library Filter :	Text Attribute	Metadata None	Custom Filter 🗧
Keyword		Keyword	
Colorado	297	All (3 Keywords)	297
Colorchecker chart	4	* ARCHITECTURE	
Computers	21	▶ architectural detail	
Congo	185	* People I know	
Cookham	695	Jeff Schewe	
Copley Square	49	▼ Places	
Copra	5	▼USA	
Corfe Castle	132	▼ Colorado	
Courtenay	256	Georgetown	36
Courtney	524	Independence Pass	49
crab > crustacean	1	Leadville	23

Figure 4.53 In the first column, a metadata keyword filter was used to filter photos by keyword—in this case, "Colorado." In the second column, I used a secondary Keyword filter to filter by all keywords associated with "Colorado."

Metadata filter categories

The Date categories allow you to progressively filter by date. For example, you can search first by year date, and then expand the year folders to search by month and then by day.

The File Type section can be used to separate images by file format and make it easy for you to quickly filter out images, such as the PSD masters or the raw DNG images. The Keyword category is one that you will probably want to use all the time when searching the catalog, and in **Figure 4.53**, you can see an example where I used two Keyword filter columns to narrow a keyword search.

The Label category (**Figure 4.54**) almost amounts to the same thing as clicking a color label swatch in the Filters section of the Filmstrip. The main difference is that the Label filters used here allow you to distinguish between the color of a label and any text associated with that label. To understand what I mean by this, please refer to the section on sorting Color labels coming up on page 197.

Figure 4.55 shows an example of a Filter bar search that achieves the same filter result as the two-step approach described at the beginning of this chapter. The Filter bar search applied here was based on a 1-star filter for photographs taken from 2005 to 2007, using the keywords *Mallorca* or *Malta*, and a further keyword filter for photos with the keywords *Sineu* and *Valletta*.

The Camera section lets you filter by both camera model and serial number. Suppose, for example, you suspected that a fault was developing with one of your camera bodies. Inspecting the images by camera type can let you filter out the images that were shot using that specific camera. The Lens section (**Figure 4.56**) is great for filtering the catalog by lens type, which can be really handy when you are searching for, say, shots that were taken with an ultra-wide-angle lens. Flash State refers to whether the on-camera flash was fired. The Shutter Speed section allows you to filter photos according to the shutter speed the photos were shot at. Likewise, the Aperture section lists every aperture setting that has been used,

Label	
All (10 Labels)	5924
Blue	40
Color Correction N	2
Green	109
Purple	1
Red	304
Retouching Needed	1
Unedited metadata	151
yellow	2
Yellow	117
No Label	5197

Figure 4.54 The Color Label category allows you to filter labels by swatch color, as well as by the color label text description.

Library Filter :		Text	t Attribute	Metadata None	的設備還有限的		Custom Filter 🗧
Date	3	Keyword	3	Keyword	PI AND	None	
All (218 Dates)	7878	Malta	168	Valletta	168		
2001	16	Norway	79	▼ Spain	19		
2002	278	₩ Spain	19	₩ Mallorca	650		
2003	72	▶ Mallorca	650	Ca'Sa Rota	703		
2004	39	▶ Sweden	86	Cancoll	294 🗖		
2005	1596	South Africa	15	Lloret	70		
2006	749	▶ UK	731	Senselles	344		
2007	3510	▶ USA	800	Sineu	215		

Figure 4.55 By repeating the keyword across two or more panels, you have more flexible options when filtering by keyword to carry out OR- and AND-type searches. Here, I used the Shift key to make contiguous selections of Metadata items and the Rev (Mac) or Ctrl key (PC) to add discontiguous items to a filter list.

Lens	
All (20 Lenses)	7878
7.4-22.2 mm	2
10.0-22.0 mm	6
12.0-24.0 mm	174
24.0 mm	4
24.0-70.0 mm	1335
28.0-70.0 mm	1
28.0-135.0 mm	320
70.0-200.0 mm	741
70.0-300.0 mm	135
EF-S10-22mm f/3.5-4.5 USM	1269
EF15mm f/2.8 Fisheye	1
EF16-35mm f/2.8L II USM	81
EF24-70mm f/2.8L USM	374

Figure 4.56 *The Lens filter category.*

Develop Preset	
All (10 Develop Presets)	7878
Canon EOS 1Ds MkIII 125 ISO	1
Default Settings	7465
EOS1DsMkll calibration	1
General - Auto Tone	138
Sharpen - Landscapes	2
Sharpen - Portraits	1
Tone-Burn corners	1
Unavailable Preset	2
Unavailable Preset	39
Custom	238

Figure 4.57 The Develop Preset filter category.

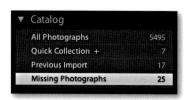

Figure 4.58 *Missing Photographs are shown.*

which might be useful for short-listing pictures shot at the widest lens aperture and, therefore, with the shallowest depth of field. With ISO Speed Rating, you can quickly filter the high ISO speed shots from all the rest, and the GPS filter allows you to filter according to whether GPS data is embedded.

The next few sections require that you have entered custom metadata in the catalog photos. The Location and Creator categories can be useful if you are in the habit of editing the associated IPTC fields via the Metadata panel. If so, you can quickly filter the catalog photos by any of the IPTC metadata items you see here. Location, City, State/Province, and Country all refer to the Location IPTC metadata used to describe where a photo was shot (you may use keywords to do this as well, of course, but only the IPTC data is referenced here). The Creator section filters the photos by the creator of the photograph. With some camera systems, you can configure the camera settings so that the creator name is always embedded at the capture stage for each and every shot. The Copyright Status and Job reference are also further examples of IPTC metadata that first has to be entered by the user.

The Aspect Ratio category lets you filter according to whether the photos are landscape, portrait, or square. Treatment refers to whether the photos are in color or have received a black-and-white conversion treatment via Lightroom (i.e., a photo that has been edited using the Black & White panel controls rather than a photo that has been merely desaturated using, say, the HSL panel Saturation sliders). And finally, the Develop Preset category (**Figure 4.57**), which filters according to the Develop module presets that may have been applied to the photos in the catalog, including those that have just had the default settings applied. This is a useful filter for tracking down photos that have had a particular type of treatment, such as a favorite grayscale conversion or split-toning technique. Are you looking for inspiration? You could select All Photographs to view the entire catalog and use this filter category to check out certain Develop setting from one of these filtered photos or make a note to apply this particular Develop preset to other images.

Locating missing photos

It is inevitable that photos in the catalog will become misplaced. This is where folders may appear grayed out in the Folders panel or individual files will show exclamation point badges. In either case, this indicates that the photos are either off-line or missing. It may be a simple matter of checking to reconnect a missing hard drive volume, or it could be because you have deleted or moved the original photos at the system level. If you need to locate all the currently missing files in the catalog, you can do so by going to the Library menu in the Library module and choosing Find Missing Photos. This gathers together all the missing files and groups them as an impromptu collection in the Catalog panel (see **Figure 4.58**).

Custom filter settings

We touched on working with custom filters in the previous chapter, where I showed how you can save custom filter settings via the Filmstrip. Such custom Filter settings are also accessible via the Filter bar, where you can save more detailed filter settings that make additional use of Metadata filter terms, which, in turn, can be accessed via the Filmstrip. In **Figure 4.59**, I created a filter search for photos that matched the keyword *Jobs* (to select all client job photos), where the File type was a PSD file (which is what I often use when editing retouched master images), that had a star rating of 2 stars or higher. I then clicked the Custom Filters menu to save this as a new preset setting, named it *Client select masters*, and clicked Create. I was then able to use this custom filter whenever I needed to access a shortlist of all my client retouched master images.

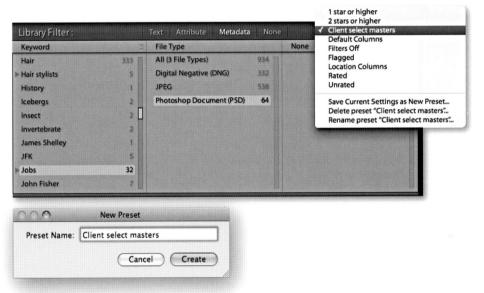

Figure 4.59 This shows the Custom Filters menu options, where you can save a Filter bar setting as a new preset.

Empty field searches

Let's go back now to the Text filter section of the Filter bar, where in the Search Target section you can choose to search by caption. In the accompanying Rules section, you will find rules such as Is Empty and Isn't Empty and, for keyword searches, Are Empty and Aren't Empty. The purpose of these rules is to let you search for photos where no caption or keywords have been added, or alternatively you can select only those photos that *do* have captions titles or keywords. (Note that when either of these rules is selected, the field search is overridden and the search field box dimmed.) Let's now look at how and why you would want to use an "Empty field" search. TIP

Color labels are specific to the color label set used. See page 110 in Chapter 3 for information on working with different color label sets.

No content searches

The idea of using Lightroom to search for nothing may sound strange, but trust me, there is method in such madness. The Is Empty and Are Empty rules can be used to filter out photos that have yet to be metadata edited. This housekeeping tip suggests a quick way to filter out all the photos that still need keywording or caption editing.

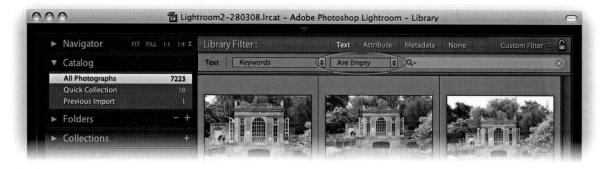

1. The Is Empty and Are Empty rules can be applied to keyword or caption searches only. For this example, I made a selection of All Photographs and made a Keywords, Are Empty Filter bar text search. This action filtered all the photos in the library that had yet to have keywords added.

reset: Review Status - (modified))
To Delete	6
Color Correction Needed	7
Good to Use	8
Retouching Needed	9
Unedited metadata	
If you wish to maintain compatibility with lo both applications.	abels in Adobe Bridge, use the same names in

2. Now, you can (if you like) apply a color label that can act as a semipermanent marker for all the photos in the catalog that have empty keyword metadata. To show you what I mean, I went to the Metadata menu and chose Color Label Set ⇒ Edit. I then selected the Review Status preset, and changed the purple label so that instead of saying "To Print" it said "Unedited metadata," since I felt it might make better use of this lesser-used label. I then saved this as a new color label set titled "Review Status – (modified)."

	Size P	

3. With the new color label set active, I applied a purple (Unedited metadata) label to the selected, empty keyword images.

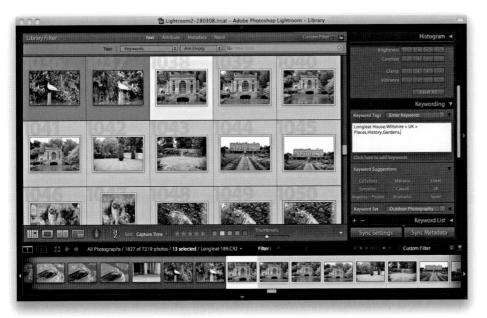

4. I only suggest the use of color labels as a helpful reminder. Here I am showing the photos that were selected at Step 1 (without the color label) and with the "Keywords are empty" filter in force. I could now add keyword metadata, and as I did so, the photos automatically removed themselves from the filtered selection.

Advanced searches

Let's finish this section with an example of a complex search where several different types of search criteria are combined together to create a precise, targeted catalog filter. All the tools you need to do this are located in the Filter bar, and the following step-by-step example will hopefully provide guidance and inspiration to help you get the most out of Lightroom's search abilities. Just to remind you once more: After a Filter search has been made, you can use **C** (Mac) or **C** (PC) to toggle switching the image filter on or off.

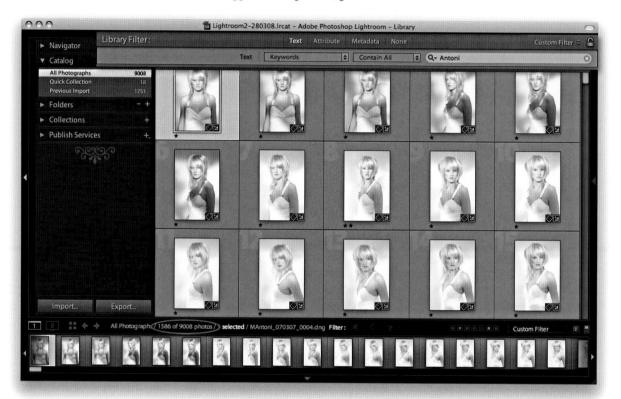

1. I first selected All Photographs in the Catalog panel. Then I went to the Filter bar, checked the Text tab, and chose to search by keywords only using the Contain All rule. I then typed in the name of one of my clients, *Antoni*, to initiate a catalog search for photos that were keyworded with the word *Antoni*. As I began typing in the first few letters, the search started narrowing the selection of images in the Grid to show all the photos where the keywords metadata contained this same sequence of letters. As you can see, the Filter bar search filtered the photos in the grid to show over 1,500 photos that had been shot for this client. This included everything—the raw files as well as the PSD masters. The next task was to whittle down this selection to something more specific.

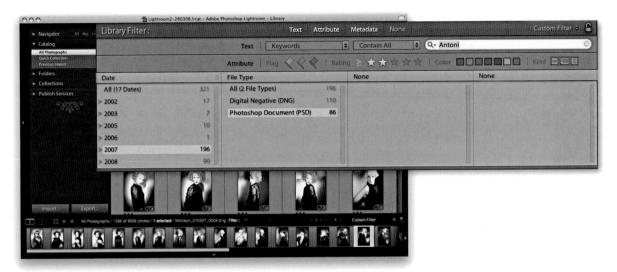

2. I clicked the Attribute tab and applied a 2-star filter to show only the 2-star or higher images. I also clicked the Metadata tab to reveal the Metadata filter options and used a Date panel to search for photos that had been shot in 2007 only. Finally, I used a File Type panel to search for the Photoshop Document (PSD) file types. This resulted in a filter selection that showed only the PSD file format photos that had been shot during 2007 that had been rated with 2 or more stars.

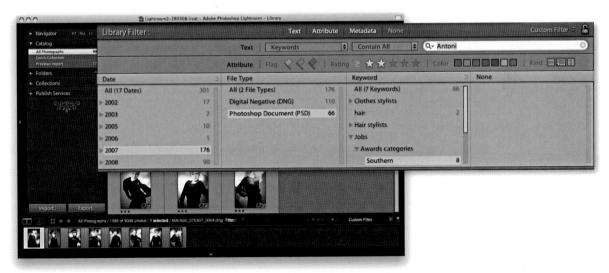

3. Even so, I still had 86 images to choose from. I used a Keyword panel to select *Southern*, which is an awards entry category keyword. This now filtered the catalog to show photos taken for the specified client that had been shot during 2007 that had a rating of 2 stars or more, that were PSD files only, and that also had the keyword *Southern* > *Awards categories* > *Jobs*.

Figure 4.60 To view a Quick Collection, click the Quick Collection item in the Photo Catalog panel.

	Save Quick Collection
ollection Name:	Seascapes
	Clear Quick Collection After Saving
	Clear Quick Collection After Sav

Figure 4.61 Press Halt B (Mac) or Ctrl Alt B (PC) to save a Quick Collection as a permanent collection to add to the Collections panel.

Quick Collections

When it comes to combining search results, it is good to familiarize yourself with the Collections features in Lightroom. A selection offers only a temporary way of linking images in a group, and as soon as you deselect a selection or select a different folder in the library, the selection vanishes. Of course, you can still choose Edit \Rightarrow Undo, or use the keyboard shortcut $\Re \mathbb{Z}$ (Mac) or $\mathbb{Ctrl} \mathbb{Z}$ (PC) to recover a selection, but the main point is that selections offer only a temporary means for grouping images together. If you want to make a picture selection more lasting, you can convert a selection to a Quick Collection by choosing Photo \Rightarrow Add to Quick Collection or by pressing the B key. Although note that in Lightroom 3 it is now possible to make other collections the "target collection" instead of the Quick Selection (see page 179). Any images that have been added to a Quick Collection will be marked with a filled circle in the top-right corner in both the Library Grid and Filmstrip views. Note that you can have only one Quick Collection at a time, but you can make further selections and keep adding fresh images to the Quick Collection. The other advantage is that a Quick Collection is always remembered even after you guit Lightroom—no saving or naming is necessary—and the images remain grouped this way until you decide to remove them from the Quick Collection.

Quick Collections can be accessed by clicking Quick Collection in the Catalog panel (**Figure 4.60**). You can also choose File \Rightarrow Show Quick Collection or use B (Mac) or \fbox{Ctrl} (PC) to display the Quick Collection images only (**Figure 4.62**) and use File \Rightarrow Return to Previous Content (or press B or \fbox{Ctrl} again) to return to the previous Library module view. With Quick Collections, you can make selections of photos from separate sources and group them in what is effectively a temporary collection. Quick Collections remain "sticky" for however long you find it useful to keep images grouped this way. If you want to save a Quick Collection as a permanent collection, you can do so by using Alt (Mac) or \fbox{Ctrl} (Alt B) (PC). This opens the Save Quick Collection. Once you have done this, it is usually good housekeeping practice to clear the Quick Collection, which you can do by choosing File \Rightarrow Clear Quick Collection or use Ctrl (Mac) or \fbox{Ctrl} (Ashift) (PC).

Collections

As I just explained, a Quick Collection can be converted into a collection, or you can convert any selection directly into a collection via the Collections panel. Whereas a catalog image can be assigned to only one folder at a time, you can use collections to create multiple references of the master photos. Collections are, therefore, useful for grouping images together from different folders in meaningful ways. For example, **Figure 4.64** shows a collection I made after filtering *UK* and *Travel* photos. As you conduct various catalog searches, you can

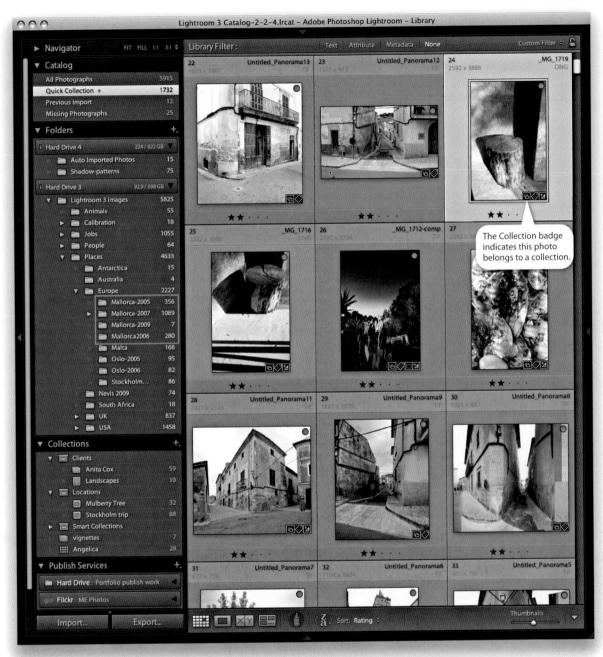

Figure 4.62 With Quick Collections, you can group images from different source locations (i.e., different folders) and then select Quick Collection to view all the selected images at once. In the example shown here, I have highlighted the source folder locations in the Folders panel for the photos that make up this current Quick Collection. Note the new Collection badge highlighted here. You can click this to go directly to a parent collection.

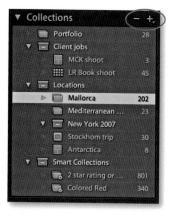

Figure 4.63 This shows the Collections panel, now common to the Library, Slideshow, Print, and Web modules with the different kinds of Collections icons that can be nested in Collections sets.

save the results as general collections (
). However, since the Collections panel is now accessible in the Slideshow, Print, and Web modules, you can also save module-linked collections. Figure 4.63 shows examples of the different collection types, which are distinguished by the Collection icon appearance: Slideshow (
), Print 🗐), and Web (🎟). The way this works is that you can create a modulespecific collection while working in any of the above modules, and have the collection be associated with the module where it was created. Figure 4.65 shows the Create Collection dialog for a Slideshow collection that was created within the Slideshow module, which then appears in all the other module Collections panels with the Slideshow collection icon (ID). When you click a module-specific collection, this selects the collection photos from the catalog (regardless of what filters are applied, what collection type it is, or which module you are in). But if you double-click a module-specific collection, it selects the photos from the catalog and takes you directly to the module the collection was created in. To give you an example of how this works, having created a Stockholm trip Slideshow collection, if I click this, it filters the collection photos that appear in the Grid and/or Filmstrip. If I double-click the Stockholm trip Slideshow collection, it filters the collection photos and takes me directly to the Slideshow module and previews them using whatever Slideshow settings happen to be associated with this particular collection. See also Figure 4.66, which explains how to rename collections.

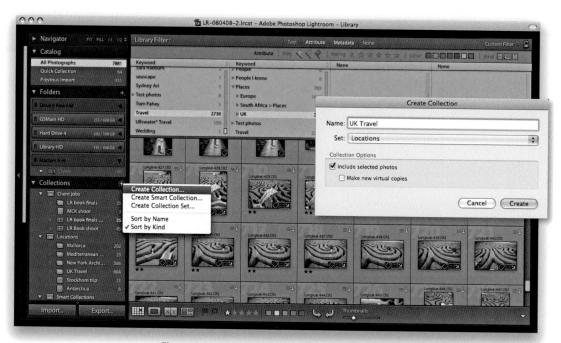

Figure 4.64 To create the collection shown here, I filtered the photos in the Library module to show photos that matched the keywords UK and Travel. I then clicked the Add Collection plus icon and chose Create Collection, which opened the dialog shown here, where I made this new collection a child of the Locations collections set.

Target collection

By default, the Quick Collection is always the target collection, but you can promote any other collection to be the target collection in its place and use the **(#Att) (Ashift) (Mac)** or **(Ctr) (Att) (Ashift) (PC)** shortcut to reset the Quick Collection as the target collection. You can assign a collection as a target collection by choosing Set as Target Collection via the contextual menu, as shown in Figure 4.66. When a collection has been promoted in this way, you'll see a + appear after the name. You can then select photos in the Library Grid or Filmstrip and press the **(B)** key to toggle adding/removing them to the target collection. (You'll see a message flash up on the screen to remind you which Collection the photo is being added to.) You can also use the Painter tool to select photos and add them to the current target collection (see page 161 for more about working with the Painter tool).

NOTE

You can't set a Smart Collection as the target collection.

Create Slideshow Create Collection Se	t	Name:	Stockholm trip
		Set:	None
Sort by Name ✓ Sort by Kind		Slidesh	ow Options
Mallorca	1732 //		ude selected photos
Mulberry Tree	32	0	Make new virtual copies
Stockholm trip +	86		Cancel Create
Smart Collections			
💼 vignettes	7		
III Angelica	28		

🕅 2 star ratings	
🔻 🛄 Locations	
T Ma Matt	51
Me Me	19
Stock	0
🖬 UK Travel	173
Portfolio	
QC collection	
🖬 VCs	

Figure 4.65 You can create a Slideshow collection by clicking the + button and choosing the Create Slideshow option. You can then enter a name and set location and choose to include photos from the Filmstrip. You can also add more new photos by dragging them from the Filmstrip to the collection in that module's Collections panel.

Create Collection Create Smart Collection Create Collection Set	
Set as Target Collection Rename	
Delete	Rename Slideshow Slideshow: Stockholm trip
Export this Collection as a Catalog Import Smart Collection Settings	Cancel Rename

Figure 4.66 To rename a collection, use a right mouse click to access the contextual menu and choose Rename. This opens the Rename Slideshow dialog shown here.

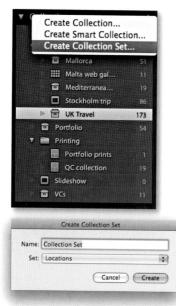

Figure 4.67 Click the + button in the Collections panel to choose Create Collection Set and create a new collection set in the Collections panel.

▼ Coll	ections	- +,
	Clients	
▼ 🖬	Locations	
	Mulberry Tree	
	🔲 Stockholm trip	88
V B	Smart Collections	
	🕞 Camera flash photography	
	Colored Red	386
	🕞 Five Stars	
	🕞 Past Month	
	Recently Modified	
	🕞 Without Keywords	872
à	Retouched images: 2009	82
	vignettes	7
	🗄 Angelica	28
	Angelica-Web	28

Collections sets

To help organize your collections, you can choose Create Collection Set. This adds a new collection folder (**□**) allowing you to create folder groups for your collections (as shown in Figure 4.63). These are container folders for managing hierarchies of collections. To add a new collection set, click the + button in the Collections panel header (**Figure 4.67**), or right-click anywhere in the Collections panel to access the contextual menu. Choose Create Collection Set, name the set, and drag and drop to manage the collections as you wish.

Smart Collections

Smart Collections can be used to establish rules for how photos should be grouped as a collection, and Lightroom automatically updates the photos that should be included in a Smart Collection. To do this, you need to click the + button or use the contextual menu to select Create Smart Collection. This opens the Edit Smart Collection dialog shown in **Figure 4.68**, where you can set up a series of rules to determine which photos will go into a particular Smart Collection. In this example, I used a Keywords filter to select photos with the keyword *Jobs*, a File Type filter to select TIFFs, and a Capture Date filter to select images that were captured throughout the year 2009. Note in the Match section that "all" was used. This means that photos will have to match the combined rules before being added. An "any" match can be used where you want to select photos that match multiple terms, but not exclusively so. You could create a Smart Collection with an "any" match to group photos that had both red labels and yellow labels taken in the date range of 2007–2008. In Lightroom 3, you can now even create smart collections based on whether the camera flash fired.

Keywords	following rules:	Jobs	-+
File Type	is	TIFF	-+
Capture Date	is in the range	2009-01-01	to 2010-01-01 - +

Figure 4.68 The Edit Smart Collection dialog and, to the left, the Smart Collection, as it appears in the Collections panel.

Publishing photos via Lightroom

The new Publish Services panel allows you to publish collections of photos to sites such as Flickr. When photos are published in this way, there remains a constant link between Lightroom and the hosting Web site so that any subsequent changes you make to a photo in Lightroom are propagated to the server hosting the images online. Here is how to establish a publishing link.

NOTE

At the time of writing, Flickr is the only external publishing site option that is available in Lightroom 3, but more will undoubtedly become available after Lightroom 3 ships.

ightroom Publishin	g Manager	
Hard Drive	▼ Publish Service	
Portfolio publish work	Description: ME Photos	▼ Publish Services +
Flickr ME Photos	V Flickr Account	Files on Disk: Portfolio publis
Flickr martin.evening	Logged in as Martin Evening (Martin Evening)	
	V Flickr Title	Flickr: Set Up
	Set Flickr Title Using: IPTC Title	
	When Updating Photos: Replace Existing Title	
	File Naming 0	Lightroom needs your permission to
	File Settings J)	upload images to Flickr. If you click Authorize, you will be taken to a web
	▼ Image Sizing	page in your web browser where you can log in. When you're finished, return to Lightroom to
	Resize to Fit: Width & Height Don't Enlarge W: 700 H: 700 pixels	complete the authorization.
	V Output Sharpening	
	Sharpen For: Screen Amount: Standard	
	▶ Metadata Iy	
	V Watermarking	
	Watermark: ME Copyright	The File Settings section also allows
	▼ Privacy and Safety	you to set a file size limit for the
	Privacy: O Private Safety: Safe B Family Hide from public site areas	photos you generate to go up on Flickr.
Add Remove	Public	

1. To start with, I clicked the Set Up button in the Flickr header in the Publish Services panel. This opened the Lightroom Publishing Manager dialog shown here (or, you can click the + button in the Publish Services panel and choose Manage Publish Connections). The first thing that's needed is a personal Flickr account. If you already have one, then click the Log In button and simply enter your Flickr account details. If you don't have an account, you'll be taken to the Flickr Web site where you can create a new account profile. Here, I configured the remaining Export settings in this dialog to establish what size I would like the large images to be and whether to add a watermark (see page 489–491). You can also set the privacy settings for your photostream images. Private means only your family and/ or invited friends will be able to see your photos, or you can make them publicly available. Plus, you will need to authorize allowing Lightroom to communicate with Flickr before completing this process.

NOTE

The Flickr Title section allows you to choose the current image filename or the IPTC Title field as the image title that appears on Flickr and, if the Title field is blank, substitute the filename anyway. You can also choose to update the image titles with each update, or leave as is. If you plan to use the Title field as the image title, this allows you to manage the image naming on Flickr via the Lightroom Metadata panel.

▼ Navigator FIT FILL I:I 4:I	Library Filter :		Text Attribute	Metadata No	one	Filters Off 💲
	5146 4960 x 3307	W1BY1696 DNG	5147 3218 x 3567	W1BY1705 DNG	5148 5616 x 3744	W1BY170
▼ Catalog All Photographs 5166	★★・・ 5149 4680 x 3744	• • • • • • • • • • • • • • • • • • •	★★・・ 5150 4982×3308	• W1BY1715 DNG	★★・・ 5151 5616 x 3744	• W1BY1741 DNG
Quick Collection + 0 Previous Import 32		36				
	IN A	6	int ,		Time t	
📁 Files on Disk: Portfolio publis <						
Flickr: martin.e	★★・・ 5152 M 3/44x5616	• 🗖	** · ·	• Mulberry_051-Edit	★★ · · · 5154 3744×5016	• W1BY1770-Edit-2
C		1	R	-		
Import Export		Y 🔜 🖓	Sort: Added O	rder ‡ Groupin	g: Off ≎	Thumbnail

2. I was now ready to start adding photographs to my Flickr photostream. I clicked the Flickr header in the Publish Services panel to expand the Flickr panel contents. This revealed the Flickr photostream, and it was now a simple matter of using the Library module to search for the photos I wished to add and then dragging and dropping these onto the photostream. Here, I selected a group of selected photos and dragged these across to my Flickr photostream in the Publish Services panel.

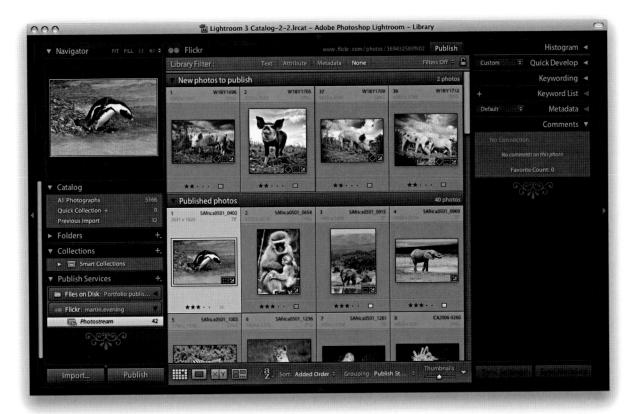

Having done that, I could now check the current status of my Flickr 3. photostream. In the example shown here, I had already uploaded some photographs to my flickr page and these appeared under the filter grouping labeled "Published photos." The photos that I had recently added in Step 2 showed up under the "New photos to publish" filter grouping. This meant that, although I had used Lightroom to assign these photos to my Flickr photostream, they had yet to be uploaded to the Flickr page. To do this, I needed to click the Publish button at the bottom of the screen. This instructed Lightroom to upload the photos to my Flickr page. As the photos were added, they emptied from the "New photos to publish" group and joined the "Published photos" group below. And there they would remain until I decided to do anything else to them. For example, if I were to edit the IPTC metadata or the develop settings for any one of these images, this would move the image out from the "Published photos" group and to a "Modified photos to re-publish" group at the top of the content area. This mechanism allows you to keep close tabs on which photos have been published and which ones have been modified in some way or have yet to be published. Lightroom, therefore, always keeps you informed whenever you need to update the photos to be published on your Flickr page.

NOTE

You can also publish photos to a hard drive directory on the computer. Why would you need this? Well, if you were designing a book, you could use the Publish panel to generate the resized TIFF files used in the book and publish these to the folder that's linked to by the page layout program. This means that if changes need to be made to any of the images, you can edit them in Lightroom and then simply republish them to generate new TIFF masters that remain automatically linked in the page layout program. You could also use this mechanism to maintain off-site backups of important original images.

Comments

lo Connection

Sean McCormack 6 days ago Elephants are actually one of my favourite creatures. The whole set look like you enjoyed yourself.

Favorite Count: 0

Having clicked the Publish button, I needed to wait a minute or two while 4. Lightroom rendered and uploaded the JPEG files to the Flickr server. Once this was complete, I could go to my Flickr page and check how the photostream appeared online. To do this, I used the contextual menu (right mouse clicked) in the photostream and selected Go to Published Collection. This opened my Flickr page directly via Lightroom. Those who are familiar with the way Flickr works will know how you can use the site to manage your photos into collections and click the italicized text that appears below each image to add descriptions. If your photos are made available for anyone to view (see Step 1 for more information on privacy settings). Once your photos are on view, anyone visiting these pages can add comments. Because Flickr and Lightroom are able to communicate with one another, as you browse the photos contained in the photostream, these comments are also updated in the Lightroom Comments panel. This allows you to see comment messages such as the one posted here by my friend and colleague Sean McCormack. The Comments panel also tells you how many times a photo has been marked as someone's favorite

Saving and reading metadata

Another pain point for newcomers to Lightroom has been the question of how to save images. In your very first computer lesson, you learned how important it is to always save your work before you close a program. Some Lightroom users have been confused by the fact that there is no "save" menu item—they wonder if they will lose all their work after they quit the program. There is no need to worry here because, in the case of Lightroom, your editing work is always saved automatically. Even if Lightroom suffers a crash or there is a power failure, you should never lose any of your data.

It is important to remember that as you carry out any kind of work in Lightroom whether you are adjusting the Develop settings, applying a color label or star rating, or editing keywords or other metadata—such edits are initially stored in the Lightroom catalog. For simplicity's sake, we can summarize these actions by grouping them under the term metadata edits. Whenever you alter a photo in Lightroom, you are not changing anything in the actual image file. This is because Lightroom is built around the principle that the imported images are the master negatives, which should never be edited directly. Lightroom, therefore, records the changes as metadata information, and these changes are initially stored at a central location in the Lightroom catalog. This is also the reason why Lightroom is much faster at searching images compared to a browser program like Bridge. You can add, search, and read metadata information more quickly because the metadata information is all stored in a database. However, it is possible to have the metadata information stored in the individual picture files as well. In the case of JPEG, TIFF, PSD, or DNG images, there is a dedicated XMP space within the file's header that can be used to store the metadata. With proprietary raw files, the metadata has to be stored separately, in what is known as an .xmp sidecar file.

The good thing about having all the metadata information stored in a single database file is that it is lightweight. When it comes to backing up essential catalog data to another hard drive, the backup process can take only a few minutes. On the other hand, saving metadata to the file can be seen as adding an extra level of security and allows the metadata entered via Lightroom to be shared when viewed in browser programs. But this security does come at a cost. When you export the metadata to the files, the whole file has to be backed up. Do this and all DNG, TIFF, PSD, and JPEG files will have to be copied as complete files during the backup process. What would otherwise take a few minutes can start taking hours to complete. Interestingly, you could argue that this is a good reason for not converting raw files to DNG, since backing up .xmp sidecar files is a lot quicker than backing up self-contained DNG files where the XMP metadata is embedded.

If you work on an image in the Lightroom catalog using another program, such as Photoshop or Bridge, and you make any changes to the metadata, the metadata edit changes are always made to the file itself. When such an image is opened via Lightroom, you have to decide whether the "truth is in the database" (the Lightroom catalog) or the "truth is in the file." I'll return to this question a little later.

Saving metadata to the file

For most of the time that you are working in Lightroom it should not really matter if the metadata information is stored only in the catalog. Of course, it feels kind of risky to trust everything to a single database file, but that is why Lightroom has a built-in catalog backup feature as well as a diagnostics and a self-repair function to help keep your catalog file protected (see **Figure 4.69**). Plus, I highly recommend that you back up your data regularly anyway. Despite all that, it is still important to save the metadata edits to the files so that the "truth is in both the catalog and the file." By doing this you can maintain better compatibility between the work you do in Lightroom and the work carried out using external programs.

	Corrupt Catalog Detected
	oom catalog "Lightroom Database" is corrupt and cannot be used or backed s repaired.
The repair op progress.	peration may take several minutes to complete and should not be interrupted while in
A message w	ith further instructions will be displayed when the repair process is complete.
See Adob	e TechNote Show in Finder Quit Repair Catalog
LR	The catalog "Lightroom Database" has been successfully repaired.

Figure 4.69 If Lightroom detects that the catalog database file has become corrupted, there is an option to Repair Catalog. But click the See Adobe TechNote button to read more about such file corruptions before you do so.

So what is the best way to save metadata to the files? If you go to the File menu and choose Catalog Settings, you will see the dialog shown in **Figure 4.70**, where there is an option called "Automatically write changes into XMP." In the first edition of this book, I recommended that you keep this option switched off. This was because it could affect Lightroom's performance. However, since the version 1.3 update, it has been OK to leave this switched on, because Lightroom now only automatically writes to the files' XMP space when it is convenient to do so, without affecting the program's performance. Checking this option ensures that all the files in the Lightroom catalog will eventually get updated. However, if you want to be sure that a file's XMP space gets

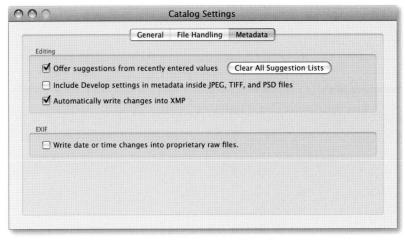

Figure 4.70 The Metadata Catalog Settings.

updated right away or you have "Automatically write changes into XMP" switched off, then you can use the Metadata \Rightarrow Save Metadata to Files command in the Library module or the Photo \Rightarrow Save Metadata to Files command in the Develop module. This forces an immediate export of the metadata information from the Lightroom catalog to the image file's XMP space. In practice, I recommend using the \Re (Mac) or Ctrl (S) (PC) shortcut anyway every time you wish to immediately update any metadata changes made to a photo or group of selected photos.

Tracking metadata changes

In order to keep track of which files have been updated and which have not, Lightroom does offer some visual clues. If you go to the View menu and open the View Options dialog (\textcircled [Mac], \bigcirc [PC]), there is a check box in the Cell Icons section called Unsaved Metadata. **Figure 4.74** shows the Library View Options dialog with the Unsaved Metadata option circled. When this is checked, you may see a "calculating metadata" icon (\textcircled) in the top-right corner of the Grid cells as Lightroom scans the photos in the catalog, checking to see if the metadata is in need of an update. You will also see this icon when Lightroom is in the process of saving or reading metadata from a file. If the metadata in the catalog and the file are in sync, the icon soon disappears. If there is a "metadata status conflict," you will see either a down arrow (**Figure 4.71**) or an up arrow (**Figure 4.72**). The down arrow indicates that the metadata information embedded in the photo's XMP space is now out of date compared to the current Lightroom catalog file and that now would be a good time to choose Metadata \rightleftharpoons Save Metadata to File (\textcircled [**F**[**S**] [Mac], \boxed [**PC**]).

Figure 4.71 When the Unsaved metadata icon is enabled in the Library View Grid options, the icon in the top-right corner indicates that the metadata status has changed. A down arrow indicates that Lightroom settings need to be saved to the file.

Figure 4.72 An up arrow indicates that settings have been edited externally and that the file metadata settings may need to be read in order to update the Lightroom catalog.

Quick Describe		Metadata	¥
Preset	None		0
File Name	_P2E3634.CR2		
Sidecar Files	xmp		
Copy Name			-
Folder	Molumes/libr.	Mallorca-2005	
Metadata Status	Has been chang	jed 📄	
Rating	*** · ·		
Dimensions	4992 x 3328		
Cropped	4992 x 3328		-
Capture Time	25/05/2005 00:50	5:49	→ →
Camera	Canon EOS-1Ds	Mark II #312116	5
Title			
Caption	Mallorca Villa		
Copyright	© Martin Evenin	g 2006	
Creator			
Location	CanColl Villa		

Figure 4.73 The Metadata Status item in the Metadata panel will also alert you if the file metadata is out of sync.

Concernation of the physical little			
	Grid View	Loupe View	
Show Grid Extras:	Expanded Cells		Ð
Options			
Show clickable it	ems on mouse ove	r only	
Tint grid cells wi	th label colors		
Show image info	tooltips		
Cell Icons			
🗹 Flags	<	Unsaved Metadata	
I Thumbnail Badg	25	Quick Collection Marke	ers
Compact Cell Extras			
Index Number	Top Label:	File Name	•
Rotation	Bottom Label	: Rating and Label	•
Expanded Cell Extra	s		
Show Header wit	h Labels:	Use	Defaults
Index Num	ber	File Base Name	•
Cropped D	imensions	File Extension	
Show Rating Foo	ter		
🗹 Include C	olor Label		
	otation Buttons		

Figure 4.74 The Library View Options.

In the Metadata panel (**Figure 4.73**) is an item called Metadata Status, which will say "Has been changed" if anything has been done to edit the photo metadata settings since the last time the metadata was saved to the file. This is basically telling you the same thing as the metadata status icon that appears in the Library Grid cells.

Choosing Save Metadata to File will make the metadata status icon in the Library Grid cells disappear, but if you are uncertain what to do, you can click the icon in the grid to open the dialog shown in **Figure 4.75**. This dialog asks if you want to save the changes to disk (better described as "Do you wish to confirm saving the metadata changes to the photo's XMP space?").

Lr	The metadata for this photo has been changed in Lightroom. Save the changes to disk?			
	Don't show again	Cancel Save		

Figure 4.75 This dialog will appear to confirm if you wish to save changes to disk.

The up arrow shown in Figure 4.72 indicates that the metadata information embedded in the image file's XMP space is out of sync and more recent than the current Lightroom catalog file. This will most likely occur when you have edited a Lightroom catalog file in Camera Raw and the externally edited image has a more recently modified XMP than the Lightroom catalog. To resolve this, choose Metadata \Rightarrow Read Metadata from file.

The other possibility is that a Lightroom catalog photo may have been modified in Lightroom (without saving the metadata to the file) and has also been edited by an external program, resulting in two possible "truths" for the file. Is the truth now in the Lightroom catalog, or is the truth in the externally edited file XMP metadata? If you see the icon shown in **Figure 4.76**, you can click it to open the dialog in **Figure 4.77** where you can choose either Import Settings from Disk if you think the external settings are right, or Overwrite Settings if you think the Lightroom catalog settings are the most truthful and up to date.

Lr	The metadata for this photo has How should Lightroom synchron	been changed by another application. ize this data?
	Import Settings from Disk	Cancel Overwrite Setting

Figure 4.77 The Metadata status conflict dialog.

XMP read/write options

Let's now take a closer look at what this XMP settings business is all about. The XMP space is the hidden space in an image document (such as a JPEG, TIFF, PSD, or DNG file) that the metadata settings are written to. In the case of proprietary raw files, it would be unsafe for Lightroom to write to the internal file header, so .xmp sidecar files are used instead to store the XMP metadata. The XMP metadata includes everything that is applied in Lightroom, such as the IPTC information, keywords, file ratings, flags, and color labels, as well as the Develop settings that are applied via the Quick Develop panel or Develop module.

In the Metadata section of the Catalog Settings (Figure 4.70), the "Include Develop settings in metadata inside JPEG, TIFF, and PSD files" option lets Lightroom distinguish between writing the Develop settings metadata to the XMP space for all files including JPEGs, TIFFs, and PSDs, or to raw and DNG files only. This is a preference that predetermines what gets written to the XMP space when you explicitly save the metadata to the file. The ability to save Develop settings with the file can be a mixed blessing. If you are sharing images that are exported from Lightroom as individual images (or as an exported catalog) with another Lightroom user, you will most definitely want to share the Develop settings for all the images that are in the catalog. But if you are sharing files from Lightroom

Figure 4.76 If there is a metadata status conflict where the settings have been modified both in Lightroom and another external program, you will see the warning icon shown here (circled).

NOTE

If you are working with the latest version of Lightroom and the latest version of Photoshop, everything will work seamlessly. If you are working with Lightroom 3 and an earlier version of Photoshop, such as CS3 or CS4, then there are limitations you need to be aware of. Edits carried out using Process Version 2010 in Lightroom 3 will not be recognized in versions of Camera Raw prior to version 5.7. For example, if you make adjustments using the new improved noise-reduction sliders, apply a postcrop vignette effect, and save the settings to the image, it will open in Photoshop CS3 but not as expected, since the post-crop vignetting won't be recognized. The Sharpening and Color Noise slider settings will register, but these won't use the latest Version 2010 processing and, therefore, won't recognize any of the new noise reduction settings. If opened in CS4 using a version of Camera Raw prior to version 5.7, you will also see incomplete Version 2003 Detail processing. However, postcrop vignettes will be recognized, but only the Process Version 2003 Paint Overlay style effect will be recognized. The Highlight Priority and Color Priority styles will default to the Paint Overlay style.

with Bridge CS4 or later, this can lead to some unexpected file behavior when you open non-raw files via Bridge. Basically, what will happen is that raw and DNG images that have had their Develop settings modified via Lightroom will open in Camera Raw via Bridge exactly as you expect to see them, since Bridge is able to read the settings that were created in Lightroom. However, where you have non-raw files, such as JPEGs, TIFFs, or PSDs, that have been edited using the Develop settings in Lightroom, and the Develop settings have been written to the files' XMP space, Bridge may now consider such files to be like raw files and open them via Camera Raw rather than directly in Photoshop. That's what I mean by mixed blessings. If you want Lightroom to retain the ability to modify the XMP space of non-raw files for data such as file ratings, keywords, and labels but exclude storing the Develop settings, you should uncheck the "Include Develop settings in metadata inside JPEG, TIFF, and PSD files" option. Do this and the Lightroom Develop settings for non-raw files will get written only to the catalog and they won't get exported to the files when you choose Save Metadata. But raw and DNG files will be handled as expected. On the plus side, you will never be faced with the confusion of seeing your non-raw images such as JPEGs unexpectedly default to open via Camera Raw when you had expected them to open in Photoshop. The downside is that if you modify a non-raw image in Lightroom using the Develop module, these changes will be seen only by Lightroom and not by Bridge. For these reasons, my advice is to turn off "Include Develop settings in metadata inside JPEG, TIFF, and PSD files." To help explain the settings and how they affect image files after being modified in Lightroom, I have summarized below how these options affect the way different file formats will be handled. Please note that these steps do assume that you are using Photoshop CS4 with Bridge CS4 (or later) and have updated Camera Raw to version 5.7 or later.

If a photo in Lightroom is modified using the settings shown in **Figure 4.78** with "Automatically write changes into XMP" and "Include Develop settings in metadata inside JPEG, TIFF, and PSD files" switched on, then all the adjustments that are made to the image will automatically be saved to the Lightroom catalog and also saved to the original image file. In the case of proprietary raw files, the XMP metadata will be written to an .xmp sidecar file and, when opened via Bridge, will (as you would expect) open via the Camera Raw dialog with the same Develop settings that were applied in Lightroom. In the case of DNG files, the XMP metadata will be written internally to the file and these, too, will open in Camera Raw. In the case of JPEG, TIFF, and PSD files, because you are including the Lightroom Develop settings in the export to the XMP space, they will default to opening in Bridge via the Adobe Camera Raw dialog.

If the "Automatically write changes into XMP" option is disabled, as shown in **Figure 4.79**, the metadata edits will now be saved only to the Lightroom catalog. If you were to open a JPEG, TIFF, or PSD image from Bridge that had been edited in Lightroom, it would open directly in Photoshop and not open via the Camera Raw dialog. But at the same time, any image ratings, metadata keywords, or other

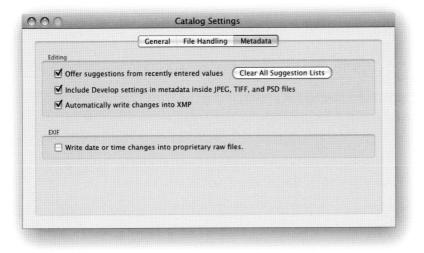

Figure 4.78 This shows the Catalog Settings where all the metadata editing options have been checked.

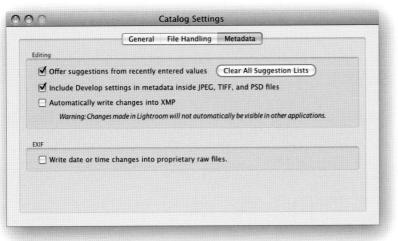

Figure 4.79 In this example, "Automatically write changes into XMP" has been disabled.

Figure 4.80 In this example, "Include Develop settings in metadata inside JPEG, TIFF, and PSD files" has been disabled. information that has been entered while working in Lightroom will not be visible to Bridge or any other external editing program either. (This assumes that you are not manually saving the metadata to the file, as described below.) In this example, the "Include Develop settings in metadata inside JPEG, TIFF, and PSD files" option is still switched on, so if you did want the metadata edits to be saved to the files' XMP metadata space, you would have to do so manually using a Save Metadata command (Imissi [Mac], Ctrinssi [PC]). But, in doing so, the problem with a Save Metadata command is that you would again be saving all the Lightroom settings to the files' metadata space (including the Develop settings), and we are back to the same scenario as in Step 1, where non-raw files may default to opening via Camera Raw, which is perhaps not what the customer wanted!

Now let's look at what happens when "Include Develop settings in metadata inside JPEG, TIFF, and PSD files" is disabled and "Automatically write changes into XMP" is switched on (Figure 4.80). Any edits made in Lightroom will automatically get saved to the Lightroom catalog as well as to the files' XMP metadata space—all the settings, that is, except for the Develop settings, which are saved to the proprietary raw and DNG files, but not to the JPEG, TIFF, or PSD files. In this scenario, all metadata information will be saved to all types of files (with the exception of the Develop settings not being written to JPEG, TIFF, or PSD files that have been edited in Lightroom). Proprietary raw and DNG files that have been edited in Lightroom will preserve their appearance when viewed in Bridge and open as expected via the Bridge Camera Raw dialog. But with JPEG, TIFF, or PSD files, the Develop settings won't be transferred, so they will open from Bridge directly into Photoshop without opening via the Camera Raw dialog. The downside is that such images may not always look the same in other programs as they did in Lightroom. It all depends on whether you want to use the Develop module to modify the JPEG, TIFF, or PSD images as you would do with the raw images. Overall, this is probably the most useful configuration because it preserves the informational metadata in non-raw files that have been modified in Lightroom and avoids non-raw files opening via the Camera Raw dialog when working in Bridge and Photoshop.

Where is the truth?

The main point to learn here is that the most up-to-date or "truthful" settings can reside either in the Lightroom catalog or in the files themselves. If you work only in Lightroom, the answer is simple: The truth will always be in the catalog. But if you adopt a more complicated workflow where the files' Develop settings and other metadata can be edited externally, the truth will sometimes be in the file. To summarize, the "Automatically write changes to XMP," Save Metadata to Files, and Read Metadata to Files options allow you to precisely control how the metadata is updated between the Lightroom catalog and the image files.

Synchronizing IPTC metadata settings

You will often want to apply or synchronize metadata settings from one photo to other photos in the catalog. To do this, make a selection of images and click the Sync Metadata button, which opens the Synchronize Metadata dialog (**Figure 4.81**). The check boxes in this dialog can help you select which items you want to synchronize. You can then click the Synchronize button to synchronize the IPTC metadata information (including the keyword metadata) in the most selected image with all the others in the selection. You can also select an image and press **(#AIT**<u>OShift</u><u>C</u>(Mac) or <u>Ctrl AIT</u><u>OShift</u><u>C</u>(PC) to use the "Copy Metadata settings" command and then use **(#AIT**<u>OShift</u><u>V</u>(Mac) or <u>Ctrl AIT</u><u>OShift</u><u>V</u>(PC) to paste those settings to another selected image or group of images.

	Synchronize Metadata			IPTC		Metadat
🖲 🗹 Basic Info			n	Preset	None	
Copy Name	Georgetown			File Name	< mixed >	
Rating	* * * * *				Has been chan	ged
Label		V			Contact	
Caption				Creator	Martin Evening	
					Photographer	
IPTC Content				Address	Chambers Lane	
🔻 🗹 IPTC Copyright				· · · · · · · · · · · · · · · · · · ·	London	
Copyright	© Martin Evening 2009		U	State / Province		
Copyright Status	Copyrighted	•		Postal Code		
Rights Usage Terms	Licensed usages only			Country Phone		000
Copyright Info URL	www.martinevening.com			E-Mail	martin@martin	evening.com
VIPTC Creator				Website	www.martinev	ening.com
Creator	Martin Evening			Sync Metada	uta Šv	nc Setting
Creator Address	Chambers Lane	Ø		Syncivietada	10a - 3y	nesetting
Creator City	London	V				
Creator State / Province	London	V				
Creator Postal Code	NW10	V				
Creator Country	UK					
Creator Phone	+44(0)20845100000	Ø				
Creator E-Mail	martin@martinevening.com	1				
Creator Website	www.martinevening.com					
Creator Job Title	Photographer					
▶ 🗹 IPTC Image			Ă.			

Figure 4.81 If you make a selection of images and click the Sync Metadata button in the Metadata panel (right), this opens the Synchronize Metadata dialog. Here you can check the individual IPTC items that you wish to synchronize with the other photos in the selection.

Figure 4.82 If the name of the folder linked to in the Lightroom Folders panel has been altered at the system level, the Lightroom folder will appear dimmed with a question mark above it. If you right mouse click on the folder, you'll see the options shown here. Choose Find Missing Folder, and then navigate to relocate the original, renamed folder.

Synchronizing folders

Some folder synchronization will happen automatically in Lightroom. For example, if you change a folder name in Lightroom, the system folder name should update too. But if the folder linked to in the Lightroom Folders panel happens to have been renamed at the system level, then you'll need to use a right mouse click to access the contextual menu shown in **Figure 4.82** to relocate the missing folder. Once this is done, Lightroom will quickly relink all the photos that are in that folder.

When it comes to synchronizing the folder contents, this requires an explicit Lightroom command to check and compare the folder contents in Lightroom with what's in the system folder. What sometimes happens is that you import a folder at the start of a project and as you continue working with that folder between Lightroom and Bridge (or in the Finder/Explorer), new subfolders get added, files may get moved into these subfolders, and some photos can get deleted or new ones added. All this can lead to a situation where the Folder view in Lightroom is no longer an accurate representation of what is in the real system folder.

The Synchronize Folder command, located in the Library menu, can be used to interrogate the system folder that the Lightroom folder refers to. **Figure 4.83** shows the Synchronize Folder dialog, which as you can see, provides initial information about what differences there are between the two, such as whether there are any new photos to import, whether any photos in the Lightroom catalog are missing their master images, and whether any metadata changes have been made externally where the Lightroom database will need to be updated.

If you check the "Import new photos" option in the Synchronize Folder dialog, you can choose to simply import and update the catalog. The default settings for the Synchronize Folder dialog automatically imports the files to the same folder as they are in currently. It does this without showing the Import dialog and without modifying the filename, Develop settings, metadata, or keywords. However, you

23 26	Synchronize Folder "Antarctica"
Lr	Synchronizing keeps your Lightroom catalog up to date with the latest changes you may have made to your photos in other applications.
	✓ Import new photos (60) ✓ Show import dialog before importing
	Remove missing photos from catalog (0)
	🗹 Scan for metadata updates
	Show Missing Photos Cancel Synchronize

Figure 4.83 The Synchronize Folder dialog.

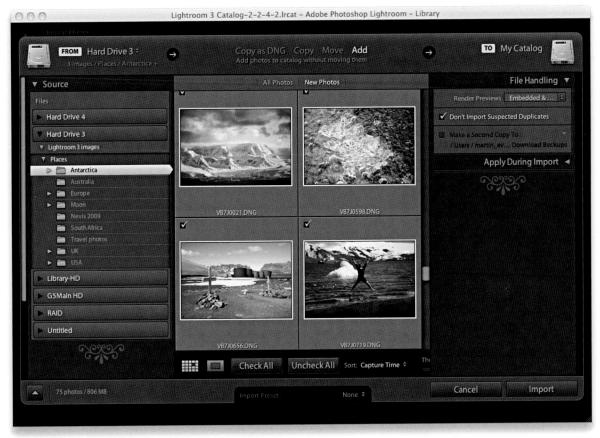

Figure 4.84 The Import Photos dialog, shown here ready to add new photos to the current catalog (where it always defaults to selecting the New Photos option).

can also choose "Show import dialog before importing," which will open the Import Photos dialog shown in **Figure 4.84**. The main reason for choosing to show the Import Photos dialog when synchronizing a folder is so that you can adjust any of the settings as you carry out an import and update the Lightroom catalog. Note that if you have removed any photos from the folder at the system level, Synchronize Folder can also remove these files from the catalog, thereby keeping the Lightroom catalog completely updated for new additions as well as any photos that are no longer located in the original system folder.

"Scan for metadata updates" works exactly the same as the "Read metadata from Files" option in the Library module Metadata menu (see page 189). For example, if you have edited the metadata in any of the catalog images in an external program such as Bridge or another program where the metadata edits you make are saved back to the file's XMP header space (or saved to an .xmp sidecar file), you can use the Synchronize Folder dialog to synchronize such metadata changes to the Lightroom catalog.

NOTE

The sort order is numerically sensitive. This means that Lightroom will reorder number sequences correctly: 1, 2, 3, 4, 5, 6, 7, 8, 9, 10, 11, 12, 13.... Previously, Lightroom would have reordered the numbers like this: 1, 10, 11, 12, 13, 2, 3, 4, 5, 6, 7, 8, 9.

Figure 4.85 *The Library module toolbar sort order buttons.*

Sorting images

You have the option of sorting images in Lightroom by Capture Time, Added Order, Edit Time, Edit Count (for sorting Edit versions of master images in the order in which they were created), Rating, Pick, Label Text, Label Color, File Name, File Extension, File Type, or Aspect Ratio. You can set the sort order by selecting the View menu and highlighting an item in the Sort submenu, but an easier method is to use the Sort drop-down menu in the Toolbar (Figure 4.85). Next to the Sort menu is the Sort Direction button, which allows you to guickly toggle between ordering the images in an ascending or descending sort order (Figure 4.86). For example, if you come back from a shoot with several cards full of images, there is a high probability that the order in which you imported the photos may not match the order in which they were shot. If the files are renamed at the time of import, you may want to correct this later by re-sorting the capture files by Capture Time and then apply a batch rename by selecting Library \Rightarrow Rename Photos. The descending sort order can also be useful when shooting in tethered mode, where you want the most recent images to always appear at the top of the filter view in the content area.

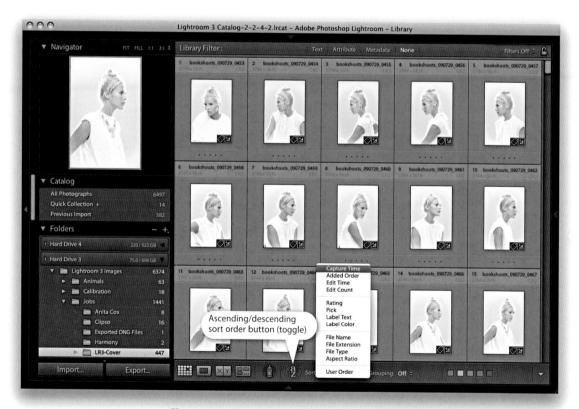

Figure 4.86 The image sort order is, by default, set to photo Capture Time. This is probably the most useful sort order setting. In the View menu, you can choose to sort the images by say, Added Order or by Rating.

Sort functions

If you are viewing a folder, a filtered folder view, or a collection, you can manually adjust the image sort order by dragging and dropping photos either in the Grid view or via the Filmstrip. Manually sorting the photos defaults the sort order menu to a User Order sort setting, and the User Order sort will remain in force after you have exited a particular Folder or Collection view. But as soon as you switch to any other sort order menu option, such as Capture Time, the previous User Order sorting will become lost. However, you should note that it is only possible to drag and drop photos in the Grid or Filmstrip view when a single folder view or a collection is selected. You cannot drag and drop grouped folder views or filter views that span more than one folder.

The Sort menu can also help resolve some of the possible contradictions in the way color labels are identified in Bridge and Lightroom. This is because instead of having a single sort option for sorting by color labels, there are, in fact, two options: sort by Label Color and sort by Label Text. The reason for this is as follows:

ted	6
Yellow	7
Green	8
Blue	9
Purple	
	with labels in Adobe Bridge, use the same names in

NOTE

Just to add further confusion, the implication of having more than one type of color label and text set at your disposal means that the Color Label Set choice determines which color labels are visible in Lightroom as color shaded labels.

Let me explain: If you use the default color label set shown at Step 1, all the color labels you apply will work as expected, with Grid cells appearing with shaded borders or color swatch tags in the cells. However, if you switch color label sets and use one that matches the Bridge set shown in Step 2, or an alternative set like the one shown in Step 4, all the color labels that you had applied previously will appear to have vanished. This is because you are using a new color label scheme. But if you use the filter method shown in Step 3, or look closely at the Label text status in the Metadata panel, you will still see evidence of the color label tags that you had applied previously. The moral of this story is to think carefully about how you intend to work with color labels and color label sets before you start carrying out any major editing work in Lightroom.

1. In Lightroom, the default color label set uses the following text descriptions alongside each label: Red, Yellow, Green, Blue, Purple. (To access the dialog shown here, go to the Library module Metadata menu \Rightarrow Color Label Set \Rightarrow Edit.) OK, this is not a particularly imaginative approach, but the label text that is used here did at least match the label text descriptions that were used in Bridge CS2 (as included with the CS2 Creative Suite). Note that the Lightroom dialog shown here says, "If you wish to maintain compatibility with labels in Adobe Bridge, use the same names in both applications." So far, so good. If you follow this advice, Lightroom can be compatible with the CS2 version of Bridge because both programs use identical color label text descriptions.

General	Labels	
Thumbnails Playback Metadata		nd Key to Apply Labels and Ratings
Keywords Labels	Select	26 + 6
File Type Associations	Second	¥ + 7
Cache Startup Scripts	Approved	# + 8
Advanced Output	Review	# + 9
output	To Do	
		Cancel OK

2. However, in Bridge CS3 and CS4, the Color Label text naming was changed to a new default setting. Shown here is how the default label text appears in the Bridge CS3/CS4 program's Labels preferences. If you install Bridge CS3 or later and use the default color label settings in both Bridge and Lightroom, the label text descriptions will differ. This has led to problems such as white labels appearing in Bridge CS3 or later where Bridge is unable to read Lightroom's color label metadata correctly. In these specific instances, Bridge can "see" that a color label has been applied, but it does not know how to interpret the metadata correctly. Bridge can read the color label text description and display this in the Bridge Filter panel, but it does not know how to apply the label color part.

3. Lightroom faces a similar problem in not knowing how to manage mismatched color labels where the label color and label description text differ. But at least in Lightroom, you can use the Custom Label filter (circled here in the Filter bar) to filter those photos that have a color label but where the text descriptions don't match the current color label set.

	6
Color Correction Needed	7
Good to Use	8
Retouching Needed	9
To Print	
To Print	with labels in Adobe Bridge, use the same n

4. If you were to choose an alternative color label set in Lightroom such as the Review Status set shown here, the problem between Lightroom and Bridge would persist because the descriptive terms used in both programs will again be different. Furthermore, subsequent Bridge updates have not necessarily managed to resolve this conflict, and the message remains the same. If you want to be absolutely consistent between applications when applying color labels, then make sure the color label text system adopted in both programs matches.

The sort by label text solution

If you edit a photo's color label setting in Bridge and then use the Lightroom Library module Metadata \Rightarrow Read Metadata from File command, a similar conflict can occur. But instead of showing a white label, Lightroom will not display any color labels in the Grid or Filmstrip views. However, if you go to the Metadata panel (**Figure 4.87**), you will notice that the Metadata panel does at least display the color label text data. This means that although Lightroom won't necessarily be able to display any of the color labels that might have been applied in Bridge, you still have a means to filter and sort them based on the color label text metadata. Therefore, the Sort by Label Color option allows you to sort photos by color labels that have been applied in Lightroom (and where the Bridge color label text matches). The Sort by Label Text option is a catch-all option that allows you to sort *all* color labeled photos regardless of whether the color label settings match in Lightroom and Bridge (but you'll still need to check the Metadata panel to identify the color label text).

On the subject of label colors and label color text, you might want to return to page 110 in Chapter 3, which discusses working with specific color label sets. It is important to note here that the Color Label filters can select only the color label photos that match the current, active color label set.

	1000		
283			
		r	
	1000		

Default		Metadata	V
Preset	None	R	
File Name	LRBook_080310_1	500.CR2	
Sidecar Files	xmp		
Copy Name			*
Folder	/Volumes/Libac	k collection -	
Metadata Status	Has been changed	ſ	
Title			
Caption			
Copyright	© Martin Evening		
Copyright Status	Copyrighted \$		
Creator	Martin Evening		
Location			
Rating	** • • •		
Label(Retouching neede		
Capture Time	18:06:10		
	10 Mar 2008		•
Dimensions	3744 x 5616		
Cropped	3744 x 5616		÷
Exposure	1/125 sec at f / 5.0		
Focal Length	160 mm		
ISO Speed Rating			
	Did not fire		
	Canon		
	Canon EOS-1Ds N		
Lens	EF70-200mm f/2.8	L IS USM	

Figure 4.87 The Metadata panel displays the color label information using the color label text data.

TIP

In a moment, we'll be looking at how to embed and use GPS metadata in Lightroom, where you can use the GPS metadata to find out exactly where a photo was taken. But audio note making can also offer a way to conveniently record the name of a site you have just photographed or record other useful information that you might want to include in a caption later, such as the date an important building was constructed.

Extra tips for advanced users

Audio file playback

It was thanks to Ian Lyons that I discovered this little gem. Lightroom can recognize and play back an audio sidecar file that is associated with a photo. The following steps show you how this would work using a Canon EOS 1Ds Mark II camera.

1. If your camera has the facility to record audio notes, you can do so as you review the pictures that have just been shot. The method will vary from camera to camera, but with this particular camera, you press the record button and speak into the microphone on the back.

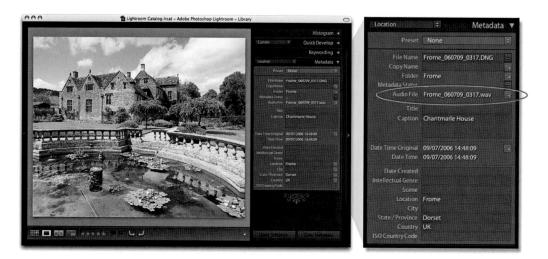

2. After importing the files to Lightroom, if an audio sidecar file is present, it will appear as a metadata item just below Metadata Status. All you have to do is click the action button next to the audio filename to play back and listen to the audio annotation.

GPS metadata and linking to Google Earth™

If you have GPS metadata embedded in an image file, Lightroom will let you link directly to the Google Maps[™] Web site and locate exactly where that photograph had been taken. But in order to pull off this trick, you will need to find a way to embed GPS metadata in your image capture files. This is not as difficult as you might imagine, since there are now quite a few GPS devices capable of capturing the GPS coordinates at the time of capture and then synchronizing the GPS data with your capture images via post-processing software. For example, according to John Nack's blog, JOBO AG has announced photoGPS, a \$155 device that sits in the hot shoe (the mounting point for a flash) of a digital SLR. Post-processing software synchronizes data captured by the device with the corresponding images. In the following steps, I have used an image with embedded GPS metadata to demonstrate how Lightroom can use such metadata to link to Google Maps as well as how to view the location using the Google Earth program.

NOTE

John Nack is product manager for Photoshop and Bridge and writes a blog called "John Nack on Adobe" (http://blogs.adobe.com/jnack). It is full of lots of interesting background information on what is going on at Adobe. It also offers off-topic posts such as links to interesting photography Web sites.

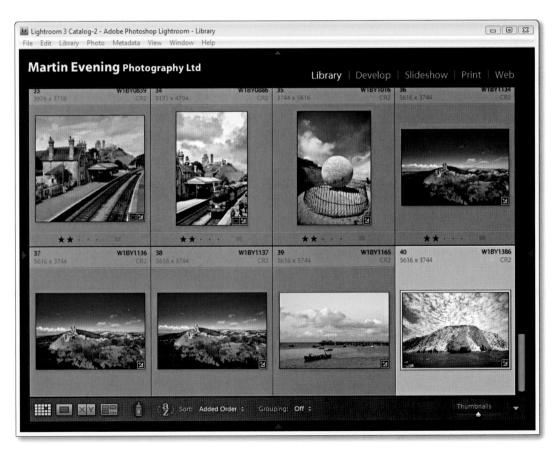

1. Here is a Library view of photographs shot around Dorset, including a highlighted photograph that was shot looking toward Ballard Point near Swanage, England.

** • • • •		** • • •			Histograr	n 🔺
17 616 x 3744	W1BY1136 CR2	38 5616 x 3744	W1BY1137 CR2		 Metadat 	a 🔻
				Preset	None	
				File Name	W1BY1386.CR2	
		Contraction in the second second		Copy Name		4
				Folder	Dorset-2009	
			Contraction of the second	File Size	26.87 MB	
				File Type	Raw	
and the				Metadata Status	Up to date	
Ven a	AND THE COM	1 Street	And the second	Metadata Date	26/07/2009 22:42:40	
				Rating	** · · ·	
We share the second		and the second sec		Label		-
**************************************				Title		
				Caption		
*** • **		*** • •				
9	W1BY1165	40	W1BY1386		EXIF	
616 x 3744	CR2	5616 x 3744	CR2	Dimensions	5616 x 3744	
				Exposure	1/1000 sec at f / 6.3	
				Exposure Bias	0 EV	
				Flash	Did not fire	
		Mar alla mar 19	Ball Star Call	Exposure Program	Normal	
		1. States	Strand Pro	Metering Mode	Pattern	
man The Martin	Marca and Sha	and the second of the	A THAT I WANTED	ISO Speed Rating	ISO 200	÷
Contraction of the second second	1 Sala	A CONTRACTORY	State of the second	Focal Length	13 mm	
and the second sec	and the second	TO NO	10.77	Lens	12-24mm	1 T
	The second second	- Alter	The Com	Date Time Original	25/07/2009 14:10:03	t
	ADE MORE THE REAL		the start	Date Time Digitized	25/07/2009 14:10:03	
the state of the s		a share and the	ALL OF	Date Time	25/07/2009 14:10:03	
				Make	Canon	
	2		The second se	Model	Canon EOS-1Ds Mark III	
				Serial Number	608248	Ť
				Artist	Martin Evening	
				GPS	50°37'49" N 1°55'59" W	
** • • • •		** • • •		Altitude		

2. In this Library module view, you can see the Metadata panel is in the All view mode. If GPS metadata is associated with a photograph in the catalog, the GPS coordinates are displayed with an action arrow Map Location button next to the item in the Metadata panel. Note: If no GPS data is associated with a selected photo, this GPS field remains hidden.

3. Clicking the Map Location button takes you directly to the Google Maps Web site, pinpointing exactly where the photograph was taken (providing you have a live Internet connection). If Google Maps allows, you may be able to zoom in to get a closer look at the location where the photograph was taken.

4. If you have the Google Earth program installed on your computer, you can copy and paste the GPS coordinates and use the program's extensive navigation tools to explore the scene where the photograph was taken. Here, I tilted the preview to show a ground-level view from where the photograph was shot.

TIP

Recording GPS metadata is not as straightforward as it sounds. First, the camera time setting must be accurate and match the computer system clock time setting. If they don't agree, the GPS points can end up being inaccurate.

Like many of the GPS devices out there, the AMOD AGL3080 has a rather low-sensitivity cell and can, therefore, fail to work when cloud cover is heavy or you are inside a building. Devices like this can also consume a lot of battery power and the batteries can die quite quickly, so it may be a good idea to consider using rechargeable batteries and to always carry a spare set when out on location. Having said that, I have found the AMOD to be reasonably good at conserving battery power.

Figure 4.88 The AMOD AGL3080 GPS Photo Tracker is a small, lightweight device which can be used to record GPS coordinates that can be read by the appropriate software. It is easily attached to a camera bag strap.

How to embed GPS metadata in a photo

OK, now that I have shown you how GPS metadata can be useful, let's see how you can capture and embed GPS metadata in a series of photos. Lightroom does not have any mechanism that will allow you to import or edit GPS metadata. In fact, it will only display the GPS field in the EXIF Metadata panel if GPS metadata is actually present in the catalog image files. The following steps show how I was able to import the GPX data from an AMOD AGL3080 unit (see **Figure 4.88**) and merge the GPX data with the camera-captured images. This small device can record the GPS coordinates of wherever the unit is, several times per minute, and record the GPS time-stamped trackpoints to a log file. When you get back to the computer, you'll need to use one of the suggested programs described here to read the GPS log data and merge the data with the imported photos.

There are a number of software solutions you can use, and when you purchase a GPS geotagging device, you may well find it comes with software that is supplied free for Mac or PC. The problem here is that many of these programs are designed to write GPS data to JPEG capture images only. What's really needed is software that can write GPS data to .xmp sidecar files, from which you can read the updated metadata via Lightroom. For this edition of the book, I thought I would update things by highlighting two popular programs: one that's suitable for PC users and one that's for Mac only.

GeoTagging with GeoSetter for PC

The following steps show how I used GeoSetter to tag raw images with GPS coordinates recorded using the AMOD GPS tracker device. GeoSetter is available free from www.geosetter.de/en/, but don't forget to make a donation if you find this software useful.

GPS1		1.11	Search		P
👌 Organize 👻 🏢 Vi	ews 👻 💭 Open 👻 🚛 Pri	AND AND ADDRESS OF A DR.		eran kontan menderi kana beran	2
Favorite Links	Name	Date modified	Туре	Size	1
Documents	GPS_20090723_060303	01/01/1980 01:00	Text Document	2,763 KB	k
More »	GPS_20090723_150657	01/01/1980 01:00	Text Document	1,351 KB	1
INIOTE #	GPS_20090723_165348	01/01/1980 01:00	Text Document	1,007 KB	
Folders	GPS_20090724_083322	01/01/1980 01:00	Text Document	3,899 KB	
roidel3	GDS 20000724 140651	01 /01 /1020 01 00	Tast Document	סע דכד	
GPS_20090	0723_150657 Date modified: 01	/01/1980 01:00			

1. I connected the AMOD GPS device via the USB cable that came with the unit. The AMOD device has room to store lots of GPS data, but it makes sense to back these up to the main computer as soon as you can. Once the GPS log files have been copied and backed up, it is safe to delete them from the device.

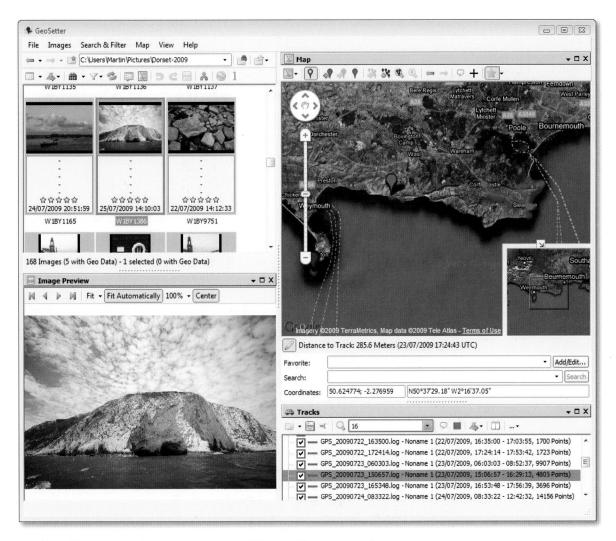

2. Next, I launched the GeoSetter program for Windows Vista. I targeted a folder of images and loaded the copied GPS files that were associated with this particular folder. (You can see here, outlined in red, some of the routes that were recorded by the AMOD GPS device.) Normally, you can select all of the photos from a shoot and add GPS data to all the selected photos, but in this instance, I wanted to show what happens when a single photo is processed. So I selected just the one photo shown here and used the Ctrl G command to add GPS data to the selected image.

nchronize with GPS Data Files			2
Synchronize with Tracks in Current Di	rectory		
Synchronize with Visible Tracks			
Synchronize with Data File:			
]	
Synchronize with a Directory containi	ng Data Files:		
C:\Users\Martin\Documents			
Assignment of Found Positions			
Interpolate Regarding Shoot Time V	/ith Last or Next Position		
aximum Time Difference between Take	Dates and Trackpoints [seconds]:	3600 🗢	
lime Adjustment			
while daylight saving time which you ha	we considered when adjusting the do		
while daylight saving time which you ha Please use 1 of the following 4 options	we considered when adjusting the do	ock of your camera.	
vhile daylight saving time which you have a very saving the second second second second second second second se	we considered when adjusting the do	ock of your camera.	
while daylight saving time which you have lease use 1 of the following 4 options Use Local Windows Settings	we considered when adjusting the do below to adjust the date time of your	ock of your camera.	
vhile daylight saving time which you ha Yease use 1 of the following 4 options Use Local Windows Settings Use this option when your images wer	we considered when adjusting the do below to adjust the date time of your e taken in the same time zone as spe	ock of your camera. r images:	
while daylight saving time which you ha Please use 1 of the following 4 options Use Local Windows Settings Use this option when your images wer Take Time Zone "+1:00 GMT Daylig	we considered when adjusting the do below to adjust the date time of your e taken in the same time zone as spe	ock of your camera. r images:	
while daylight saving time which you ha Nease use 1 of the following 4 options Use Local Windows Settings Use this option when your images wer Take Time Zone "+1:00 GMT Daylig Additional Time Adjustment	we considered when adjusting the do below to adjust the date time of your the taken in the same time zone as spe pht Time" over to Taken Date me settings and adjust the following v	ock of your camera. r images:	
while daylight saving time which you have lease use 1 of the following 4 options Use Local Windows Settings Use this option when your images were Take Time Zone "+1:00 GMT Daylig Additional Time Adjustment Take a look at your camera's date thi requires a properly adjusted Window	we considered when adjusting the do below to adjust the date time of your the taken in the same time zone as spe pht Time" over to Taken Date me settings and adjust the following v	ock of your camera. r images: cdfied in your Windows settings (+1:00 GMT Daylight Time). values until the same date and time is shown below as it is set on your camera (this	
while daylight saving time which you have lease use 1 of the following 4 options Use Local Windows Settings Use this option when your images were Take Time Zone "+1:00 GMT Daylig Additional Time Adjustment Take a look at your camera's date thi requires a properly adjusted Window	we considered when adjusting the do below to adjust the date time of your te taken in the same time zone as spe whit Time" over to Taken Date me settings and adjust the following v vs system clock): Seconds: Camera Da	ock of your camera. r images: cdfied in your Windows settings (+1:00 GMT Daylight Time). values until the same date and time is shown below as it is set on your camera (this	
while daylight saving time which you have a set of the following 4 options Use Local Windows Settings Use this option when your images were that the additional Time Adjustment Take a look at your camers's date this requires a properly adjusted Window Days: Hours: Minutes:	we considered when adjusting the dobelow to adjust the date time of your below to adjust the date time of your e taken in the same time zone as speent int Time" over to Taken Date me settings and adjust the following v vs system clock): Seconds: Camera Da int 0 (1) (Reset) 06/08/2002	ock of your camera. r images: cified in your Windows settings (+1:00 GMT Daylight Time). values until the same date and time is shown below as it is set on your camera (this ste Time:	
while daylight saving time which you have Nease use 1 of the following 4 options Use Local Windows Settings Use this option when your images wer Take Time Zone *+1:00 GMT Daylig Additional Time Adjustment Take a look at your camera's date thi requires a properly adjusted Window Days: Hours: 0 0 0 0 0 0	we considered when adjusting the dobelow to adjust the date time of your below to adjust the date time of your e taken in the same time zone as speent int Time" over to Taken Date me settings and adjust the following v vs system clock): Seconds: Camera Da int 0 (1) (Reset) 06/08/2002	ock of your camera. r images: cified in your Windows settings (+1:00 GMT Daylight Time). values until the same date and time is shown below as it is set on your camera (this ste Time:	
while daylight saving time which you have a set 1 of the following 4 options Wease use 1 of the following 4 options Use Local Windows Settings Use this option when your images were Take Time Zone *+1:00 GMT Daylig Additional Time Adjustment Take a look at your camera's date thi requires a properly adjusted Window Days: Hours: 0 + 0 + 0 + 0 +	we considered when adjusting the dobelow to adjust the date time of your below to adjust the date time of your e taken in the same time zone as speent int Time" over to Taken Date me settings and adjust the following v vs system clock): Seconds: Camera Da int 0 (1) (Reset) 06/08/2002	ock of your camera. r images: cified in your Windows settings (+1:00 GMT Daylight Time). values until the same date and time is shown below as it is set on your camera (this ste Time:	Ōk
while daylight saving time which you have Please use 1 of the following 4 options Use Local Windows Settings Use this option when your images wer Take Time Zone *+1:00 GMT Daylig Additional Time Adjustment Take a look at your camera's date til requires a properly adjusted Window Days: Hours: 0 ⊕ 0 ⊕ 0 ⊕	we considered when adjusting the dobelow to adjust the date time of your below to adjust the date time of your e taken in the same time zone as speent int Time" over to Taken Date me settings and adjust the following v vs system clock): Seconds: Camera Da int 0 (1) (Reset) 06/08/2002	ock of your camera. r images: cified in your Windows settings (+1:00 GMT Daylight Time). values until the same date and time is shown below as it is set on your camera (this ste Time:	
while daylight saving time which you have Please use 1 of the following 4 options Use Local Windows Settings Use this option when your images wer Take Time Zone *+1:00 GMT Daylig Additional Time Adjustment Take a look at your camera's date til requires a properly adjusted Window Days: Hours: 0 ⊕ 0 ⊕ 0 ⊕	we considered when adjusting the dobelow to adjust the date time of your below to adjust the date time of your e taken in the same time zone as speent int Time" over to Taken Date me settings and adjust the following v vs system clock): Seconds: Camera Da int 0 (1) (Reset) 06/08/2002	ock of your camera. r images: cified in your Windows settings (+1:00 GMT Daylight Time). values until the same date and time is shown below as it is set on your camera (this ste Time:	Ok Cancel

3. Here, you can see the Synchronize with GPS Data Files dialog. This allowed me to fine-tune the time settings before applying the GPS data. For example, I selected the Interpolate option, and GeoSetter read the previous and next trackpoints and calculated where between these two points the photo was most likely shot. Are you sure that the camera's time setting is accurate? You can compensate for any time difference between the time recorded by the GPS device and the time embedded by the camera's internal clock, whether there is a simple error of a few minutes or the time zone is incorrect.

Synchronize w	rith GPS Data F	iles	23
0		been found for all to continue with	
🖉 Show Syn	chronized Track	s in Map	
Yes	No	Cancel	Report

4. When I was happy with the synchronize GPS settings, I clicked OK. This opened the dialog shown here, where I could click Yes to apply the GPS data to the selected image.

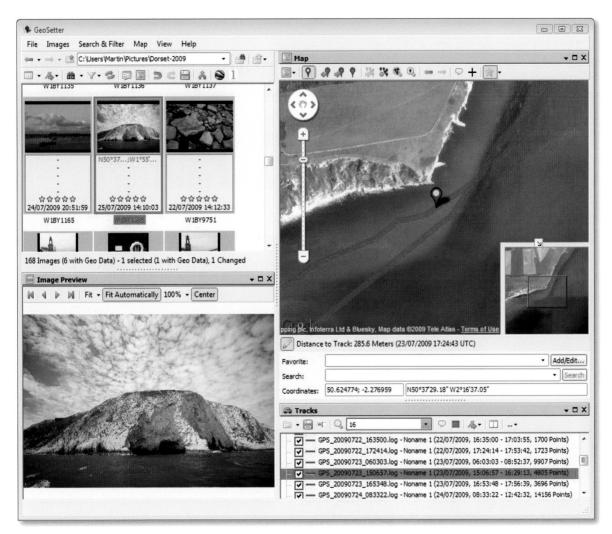

5. The GPS data had been synchronized in GeoSetter using the nearest trackpoint recorded by the GPS device, and you can see the GPS coordinates in red just below the image thumbnail. The estimated position the photo was taken from is also represented with a pin icon in the Map view panel section. At this stage, I needed to save the GPS data to the file's metadata so that the GPS coordinates could also be read by Lightroom. To do this, I highlighted the photo and used the [Ctrl]S command shortcut. Here you can see that I had to click OK in a dialog asking me to confirm that I wished to use the current system date zone setting.

Select Missing Time Zon	e	[2]
The image "W18Y1386.CR	2" contains date time values without a tim	e zone.
Due to the specification fo the time zone to use below	r date time values, a time zone is mandati v.	ory. Please select
Use System Setting (Use Following Time Zi	GMT Daylight Time (+1:00)) one:	
Parala and and a set	/ Apia	÷
(UTC-11:00) Pacific		

Please read the cautionary note on page 210 regarding metadata saves and EXIF lens data.

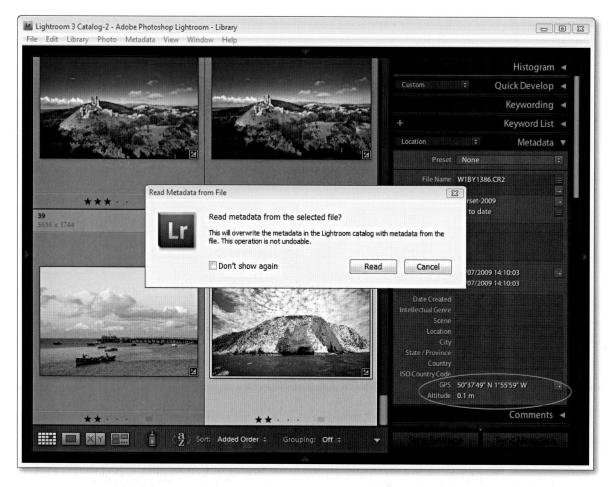

TIP

I recommend you consider carrying out a Metadata Save of all the images you are about to process before you open the files in GeoSetter (or the HoudahGeo program that's described in the next section). Select all the photos first and use ﷺS (Mac) or Cirl S (PC) to save the current file metadata settings. Then you'll be ready to process them in a GPS linking program. 6. I now needed to synchronize the file metadata in Lightroom. To do this, I went to the Library module and chose the Metadata ⇒ Read Metadata from Files menu option. At this point, Lightroom realized that this step might lead to a potential conflict in which, under some circumstances, you might end up overwriting important metadata information. For example, suppose you had edited one or more of your photos in Camera Raw via Photoshop or Bridge. If you were to choose to read metadata from files, this might mean overwriting some or all of the edits you had applied in Lightroom (see sidebar). In this example, I knew that it would be safe to read the metadata, knowing that all this would be the recently updated GPS metadata. Once this last step had been completed, the Map Location link appeared in the Metadata panel EXIF metadata list, and I could click the Map Location button (described on page 203) to view the Google Maps Web page.

GeoTagging with HoudahGeo for Mac

Mac users will find HoudahGeo (www.houdah.com/houdahGeo) is an easy geotagging program to work with. In demo mode, you can use this software to process up to five images at a time, but to batch process any more than this, you will need to purchase the full licence.

TIP

If, for any reason, you are unable to drag and drop as described here, you can use the HoudahGeo "Add images from files" button to manually add the photos instead.

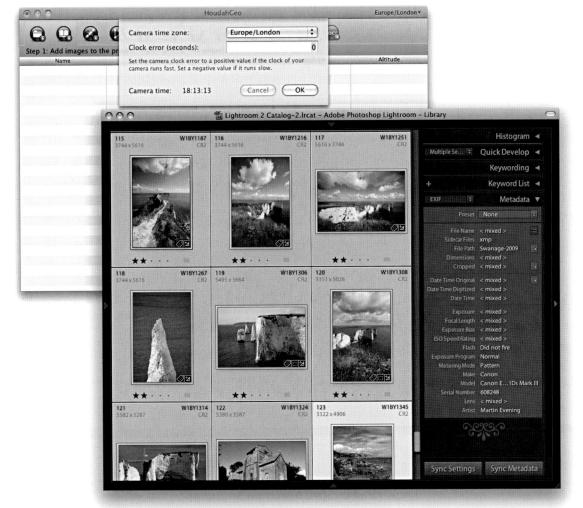

1. In this first step, I opened both HoudahGeo and Lightroom and, with the Library catalog in Grid view mode, simply dragged a selection of imported photos across to the main HoudahGeo window. At this point, it is worth cross-checking the time shown here with the time shown on your camera to make sure they are in sync and to compensate for any time difference so as to achieve a more accurate syncing of your photos with the recorded GPS data log.

TF

A note of caution here. Editing the EXIF metadata in either HoudahGeo or GeoSetter can cause problems for the EXIF lens data information. You'll also notice that the Lightroom metadata update procedure for HoudahGeo on the Mac is slightly different from that suggested for GeoSetter. At the time of writing, there is the potential problem that if you don't follow these particular steps correctly, you may inadvertently hose the Lens EXIF metadata. By this, I mean that EXIF data such as "EF 24-70mm f/2.8L USM" may become truncated to "24-70mm." This isn't necessarily the end of the world, but I mention it because later versions of these programs may address this bug and you may, therefore, need to revise the steps described here. I always suggest you practice with one selected image before you batch process a whole bunch of images. As I say, the rules may change with later versions of these software programs.

000	Hou	dahGeo	Europe/London*
000	Loading 15 track log file(s) .		
Step 2: Import trac	k logs and	Name and Andrews	
Name	Loaded 5	Stop	Altitude
W1BY9763.CR2	22/		-
W1BY9769.CR2	22/07/2009 14:27:24		
W1BY9772.CR2	22/07/2009 14:27:55		
W1BY9773.CR2	22/07/2009 14:28:18		
W1BY9776.CR2	22/07/2009 14:28:48		
W18Y9777.CR2	22/07/2009 14:28:54		
W18Y9787.CR2	22/07/2009 14:33:29		
W18Y9790.CR2	22/07/2009 14:34:23		and the second states
W1BY9813.CR2	22/07/2009 14:48:18		
W18Y9856.CR2	22/07/2009 16:14:07		CONTRACTOR OF STREET
W18Y9905.CR2	22/07/2009 17:01:50		
W18Y9906.CR2	22/07/2009 17:02:03		test at a state of the second
W1BY9915.CR2	22/07/2009 17:39:42		
W1BY9916.CR2	22/07/2009 17:40:17		STREET, SHARES
W1BY9917.CR2	22/07/2009 17:40:40		
W18Y9921.CR2	22/07/2009 17:41:31		and a literature
W1BY9926.CR2	22/07/2009 17:43:06		
W18Y9943.CR2	22/07/2009 17:58:21		Section Advicements
W1BY9945.CR2	22/07/2009 17:59:59		
W1BY9946.CR2	22/07/2009 18:00:02		Gin Karl Kataka Kataka K
W18Y9947.CR2	22/07/2009 18:00:06		
W18Y9948.CR2	22/07/2009 18:00:14		
W18V9969 CR2	72/07/2009 18:46:36		/

2. Here you can see a list of the camera files that had just been imported. I then clicked the "Load GPS data from file" button and browsed to locate the GPS log to link with the images. (I discussed copying the GPS logs from the GPS device on page 204.)

000			HoudahGeo		Europe/L	ondon 🔻
00		Export metadat	a for 132 (mage(s))	000	2	
Step 3: Export. Wri	te to EXIF	Selected images	inheogle Earl Uple	ad to Flickr or Locr.	The second secon	
Name W1BY0341.CR2	in the second	Geocoded imag	and the second distance.	S Longarde	Altitude	
	23/(26.300000	ŕ
W1BY0350.CR2	23/(Tag masters / o	riginals:		15.500000	
W1BY0358.CR2	23/0	Create copies:			15.500000	
W1BY0368.CR2	23/0				15.500000	
W1BY0373.CR2	23/(Always write XN	IP sidecar:		15.500000	
W1BY0396.CR2	23/6	Write:			18.100000	
W1BY0447.CR2	23/(Coordinates		7	8.422000	
W1BY0459.CR2	23/6	Altitude			-1.400000	
W1BY0484.CR2	23/6					
W1BY0511.CR2	23/4	City			CONSIGNATION OF THE OWNER	-
W1BY0514.CR2	23/6	Province / State	2	Ø Ø		
W18Y0523.CR2	23/4	Country			Constant and the second	1000
W18Y0545.CR2	24/6	Timestamp			-4.000000	
W18Y0546.CR2	24/4	Comment / Ca			-4.000000	
W18Y0556.CR2	24/6	Description / H	eadline		-4.000000	
W18Y0594.CR2	24/4	Artist		M	3,700000	
W18Y0610.CR2	24/6	Spotlight Comr	nents		3.700000	
W18Y0628.CR2	24/4				2,200000	
W1BY0643.CR2	24/6		-		2.200000	
W18Y0654.CR2	24/6	Reset	C	Cancel OK	-3.400000	
W1BY0687.CR2		/2009 10:46:19	50.610052	-1.961270	-3.400000	4
W18Y0701.CR2		/2009 10:54:38	50.610052			1
W18Y0702.CR2		/2009 10:54:38		-1.960950	-1.300000	ľ
WIDIU/UZ.CRZ	24/0/	/2009 10:54:43	50.610023	-1.960950	-1.300000	114

3. The unlinked image files remained colored orange, but the updated image files now appeared in black. At this stage, I needed to click the "Write EXIF/ XMP/IPTC tags" button (circled) to sync the GPS data with the image files. In this dialog, all I really needed to do was to ensure that the "Tag masters / originals" option was checked.

4. Meanwhile, in Lightroom, it was essential that I kept the exact same image selection active and chose Metadata ⇒ "Save metadata to file" ((IS)) before I went to the Metadata menu again and chose Read Metadata from Files. It appears that an initial "Save metadata" command is necessary to ensure that the HoudahGeo-edited data is updated to the files before you read from them again in Lightroom.

000	Lightroom 2 Catalog-2.In	cat - Adobe Photoshop I	ightroom – Library	C
				Histogram 🔺
The second	Car Martin Commen	THE PARTY AND	Custom +	Quick Develop 🔺
				Keywording 🖪
			+	Keyword List 🔺
*** • •	** · · · · · · · · · · · · · · · · · ·	** • • •	EXIF	Metadata 🔻
109 W1BY1155	110 W1BY1160	0 111 W		None
346573567 CR2	C270 H 3105 CR	2 5601x7769	Sidecar Files File Path Dimensions	W1BY1164.CR2 xmp Swanage-2009 5616 x 3744 5585 x 2919 →
			Date Time Original Date Time Digitized Date Time Leposure	24/07/2009 20:51:44 24/07/2009 20:51:44 24/07/2009 20:51:44 1/ ₂₅₀ sec at <i>f</i> / 7.1
			Focal Length Exposure Bias ISO Speed Rating	0 EV
★★··· 112 W1BY1164 5585 x 2919 CR2	★★・・・ # 113 W1BY118 3746 ⊭5616 CR		Flash	Did not fire Aperture priority
			Make Model Serial Number Lens Artist	Canon Canon E1Ds Mark III 608248 EF24-70mmf/2.8L USM Martin Evening 50°36'28°57'13° W-
** • • •	** · · ·	** • • •	- Synxishticat	

5. Finally, I checked to see if the metadata information had been updated correctly by selecting one of the images and checking the status of the Metadata panel. If the geotagging had been successful, I would have seen the GPS data appear directly below the EXIF Lens data and Artist items.

5

Working with catalogs

An explanation of the relationship between the Lightroom catalog and the way images are stored on the computer

What sets Lightroom apart from other raw image processing programs is its ability to manage the descriptive content of the image catalog. There is much to be said for keeping your images in a well-organized catalog system where they can easily be retrieved at a later date.

The Lightroom catalog plays a central role in everything that you do. As you import your photos into Lightroom, the catalog keeps track of where your photos are kept, as well as what information is associated with or stored in the photos themselves.

This chapter explains how your images are physically stored and referenced as well as how to share and manage the catalogs that you have created in Lightroom.

NOTE

There has been a tendency for some people to apply a Bridge-style methodology to working with Lightroom catalogs. It has sometimes been suggested that you should consider having one catalog for personal photographs, another for studio work, another for weddings, and so on. While this approach may seem to make sense because different catalogs can be used to segregate your photos into neat groups, it really is unnecessary. This is because it is much simpler to segregate your images when everything is contained in a single catalog.

About Lightroom catalogs

Since the very early days of managing documents on a computer, it has been common practice to organize files by placing them in separate system folders. This worked well enough when photographers were scanning in just a few images at a time and slowly building an image archive. But these days, photographers are typically capturing hundreds of new images every day. A folder system of management can work well enough for the person who is organizing the hierarchy of folders, but therein lies the weakness of such a system. As an image collection grows in size, you have to be extremely careful about how you plan your organization so that you know where all your files are when you want them. Suppose you were to fall ill and a co-worker needed to locate a specific image. How easy would it be for him or her to find this on your computer? In such situations, a cataloging system is required that can manage your images and keep track of where everything is stored. Several programs are available that can do this, including Microsoft Expression Media™ (formerly know as iView MediaPro). Lightroom does not have the full functionality of Expression Media, but it does offer a reliable method of cataloging your images from the moment they are brought into Lightroom.

The Lightroom catalog is the Lightroom image database file and it contains all the information that is used to manage the photos that are displayed in Lightroom. When you first installed Lightroom, a new catalog was created in the username/ Pictures folder (Mac) or the My Documents/My Pictures folder (PC). This folder contains the following: a Lightroom3. Ircat catalog file (the master catalog file that contains all the catalog database metadata) and a Lightroom3 Previews. Irdata file that contains the thumbnail previews. These two files store all the critical data that relates to the current Lightroom catalog. The most important of these is the Lightroom3. Ircat catalog file, which is why part of the catalog backup procedure is to create a duplicate backup version of the main catalog file and save it to the Backups folder (Figure 5.1). The catalog file is where all the latest metadata edit changes are written to, and since this happens on a continuous basis, the catalog file may benefit from being optimized from time to time. If you find Lightroom is running more slowly than expected, you may want to consider going to the File menu and choosing Optimize Catalog. This displays the dialog shown in Figure 5.2. Click the Optimize button to proceed. It may take a few minutes to complete the catalog optimization, but you should afterwards see an improvement in Lightroom's performance. Remember that you can also hold down the Alt key (Mac) or Ctrl key (PC) while restarting Lightroom to run an integrity check on the catalog file. This can be done to highlight any potential problems with the catalog file and initiate a repair if necessary. If for some reason the current catalog refuses to open and a catalog repair doesn't work, then you do have the option to replace the current catalog with the most recent one from the Lightroom catalog Backups folder.

0		room		\bigcirc
in in	Name	A Date Modified	Size	numin
¥	Backups	26/10/2009	198.2 MB	1
	2009-08-18 1159	18/08/2009	92.1 MB	
	Lightroom 3 Catalog-2-2.lrcat	17/08/2009	92.1 MB	
	2009-10-26 1547	26/10/2009	106.1 MB	
	Tightroom 3 Catalog-2-2-4 Previews.lrdat	a Today	1.48 GB	
	Lightroom 3 Catalog-2-2-4.lrcat	Today	107.7 MB	1
	Lightroom 3 Catalog-2-2-4.lrcat-journal	Today	2.6 MB	
	Lightroom 3 Catalog-2-2-4.lrcat.lock	Today	4 KB	
۲	Lightroom Settings	25/10/2009	160 KB	

Figure 5.1 The Lightroom folder contains the .Ircat catalog file. Also in here is a Backups folder that contains dated backups of the master catalog file.

Figure 5.2 The Optimize Catalog dialog.

Creating and opening catalogs

When you first install Lightroom, a default catalog will be created for you. If you are happy working with a single catalog, then there is no need to concern yourself with creating extra new catalogs and you can skip the next 16 pages. But let's start by looking at some of the reasons why you might want to work with more than one catalog and see if the following discussions are appropriate for your particular workflow.

If there is more than one person working with Lightroom on a single computer, each user might want to keep his or her own separate catalog. Let's say you and another family member share the same computer and are using Lightroom to archive and manage your own digital photos. In this case, you may definitely find it useful to each keep a separate Lightroom catalog of your work-it's a bit like working with separate user accounts on a computer. You may even wish to split personal work from professional work by keeping each in a separate catalog. Personally, I find it more convenient to keep everything in one place. It really doesn't bother me if personal and client photos are all stored in the same catalog. This is because the search functions in Lightroom make it very easy to filter and search for the photos I am looking for. But it is certainly the case that a professional photographer will be running Lightroom on more than one computer and may be forced to keep separate catalogs on each. Over the next few pages, I show you how to export selected contents from one catalog and import them into another, as well as how to export a complete catalog as a lightweight version of the original, so that you can keep a copy of the master catalog on a laptop without having to copy over the original master files as well.

TIP

To open an existing catalog, you can also double-click the *catalog.lrcat* file itself.

Creating a new catalog

To create a new catalog, choose New Catalog from the File menu. This opens the Create Folder with New Catalog dialog that's shown in **Figure 5.3**. What you need to do here is choose a disk location and type in the name you wish to give the new catalog. This creates a new folder with the new catalog inside it. Initially, all you'll create here is a new *.lrcat* file. A temporary *.lock* file will appear alongside the *.lrcat* file whenever the catalog is in use. This *.lock* file prevents other Lightroom users from accessing the same catalog file over a computer network.

Save As: Catalog-2			
Where: Pictures			
	Cancel Create)	
00	Catalog-2		
Name	A Date Modified	Size	Kind
Catalog-2.lrcat	 Date Modified Today, 15:29 	Size 872 KB	Kind AdobLibrary
Catalog-2.ircat Catalog-2.ircat-journal	 Date Modified Today, 15:29 Today, 15:29 	872 KB 24 KB	
Catalog-2.lrcat	 Date Modified Today, 15:29 	872 KB	AdobLibrary

Figure 5.3 When you create a new catalog, you will be asked to create a new folder and name the catalog.

Opening an existing catalog

To open an existing catalog, choose Open Catalog from the File menu. Alternatively, choose Open Recent and select a recently opened catalog from the fly-out menu (**Figure 5.4**). Note that whenever you create a new catalog or load an existing catalog, you must restart Lightroom in order to launch using the new catalog. This is because you can only have a single catalog open at a time.

New Catalog Open Catalog	☆ ₩O	
Open Recent		✓ Lightroom 3 Catalog-2-2-4.lrcat
Optimize Catalog		Catalog-2.lrcat
Import Photos Import from Catalog Tethered Capture Auto Import	쇼 ૠ I ►	
Export Export with Previous	企業E て合業E	

TIP

Should you suffer a computer crash while working in Lightroom and you experience problems when relaunching the program, it could be because a .lock file is still present in the Lightroom catalog folder. If this is the case, try manually deleting the .lock file via the system Explorer/ Finder. Do this and you should find that Lightroom relaunches as normal.

Exporting catalogs

If you can avoid having to use more than one catalog on your main computer, I recommend you do so. Most people are going to be fine using just one catalog for all their images, and the goal of good catalog management is to maintain a database of all your photos in one location. But let's say you are running Lightroom on a shared computer; individual users can maintain their own separate catalog to reference and manage the images they are interested in working with.

It is more likely that photographers will want to use this feature to export images from one copy of Lightroom and then import the catalog to another computer running Lightroom. To do this, you would make a selection of photographs via the Library module or the Filmstrip and choose Export as Catalog, which opens the dialog shown in **Figure 5.5**, where you can choose a location to save the catalog to. A catalog export will, at a minimum, always export the ratings and other metadata information. But if you want to export more than just this basic information, then click the "Export negative files" and "Include available previews" check boxes. Note that you can use the Export as Catalog feature only to create new, separate catalogs, and you can't simultaneously export and add to an existing catalog.

Exporting with negatives

If you export a catalog with the "Export negative files" option checked, this exports a copy of the current catalog contents that includes all the master photos—that is, all the raw files, JPEGs, TIFFs, or PSD image files that are in the catalog. In other words, Lightroom exports all of the catalog information along with the original master files.

NOTE

A catalog export is different from a normal file export. This is because a catalog export exports everything that is associated with the photographs in the catalog, such as the snapshots and virtual copy versions of the masters. When you include the negative files in an export, the master files are exported in their native, unflattened state. This means that all the Photoshop-edited files in the catalog are exported with the layers preserved.

	Export as Catalog	9	Export as Catalog	-
Save As:	Export-01		Save As: Export-01	
Where:	Desktop	•	Where: ወ Desktop	
Exporting a catalog with 4683 photos and 19 virtual copies.			Exporting a catalog with 75	photos.
	Export selected photo	s only	Export selected photo	s only
	Export negative files		Export negative files	
	Include available previ	iews	Include available previ	ews
	Cancel	Export Catalog	Cancel	Export Catalog

Figure 5.5 The Export as Catalog dialog appears whenever you choose to export photos as a catalog. This includes the option to export all the photos in the current Library module (left), or to export just the selected photographs in the current Library module/Filmstrip filter view (right).

Figure 5.6 A Catalog export in progress.

You can copy single folders or an entire catalog from one computer to another. Of course, if you are exporting the master "negatives" as you do so, the export process will slow down quite a bit and you'll see the progress bar indicator in the top panel of the Library window (**Figure 5.6**). I should also point out here that you need to have at least 200 MB of free disk space on your computer, which Lightroom uses as a temporary file storage directory when creating a new exported catalog.

Exporting without negatives

If you deselect the "Export negative files" option, you can export a catalog from your main computer that doesn't use up too much disk space and is lightweight enough to run from a laptop computer with limited free disk space. The advantage of this approach is that you can export a large catalog relatively quickly and use it to apply ratings and add keywords. The downside is that there are limitations as to what you can do in Lightroom when working with a catalog that is missing the master negatives. For example, you won't be able to make any adjustments in the Library module Quick Develop panel or the Develop module.

Including available previews

If "Include available previews" is checked, Lightroom includes all the Library Grid thumbnails, standard resolution Loupe views (in whatever form they are rendered) and 1:1 rendered views (if available) as part of the export. If you refer to the appendices, you can read in detail about how Lightroom goes through several stages of preview rendering. At a minimum, Lightroom will have thumbnail and standard-sized previews of each photo in the catalog. How detailed the previews are depends on whether Lightroom has had a chance to render them fully. You should at least see good-quality thumbnails, but if Lightroom has not had a chance to render proper standard-sized previews (at the pixel size you have set in the preferences), then the standard-sized/full-screen Loupe view previews may sometimes look pixelated because they are nothing more than enlarged thumbnail previews.

The "Include available previews" option is, therefore, more critical if you are exporting a catalog without including the master negatives. This is because once a catalog has been exported without the original negatives you won't be able to re-render the previews. Selecting "Include available previews" includes the previews in whatever state they are in. So you may, therefore, want to consider going to the Library menu in the Library module and choosing Previews ⇒ Render Standard-Sized Previews before exporting a catalog. And if you need to include full-resolution previews, then you might even want to choose the Render 1:1 Previews routine instead.

But there are some good reasons for not including previews. If you need to export a catalog that contains just the metadata edits so that you can sync these up with a master catalog, then deselecting "Include available previews" saves carrying out this unnecessary step and, therefore, makes the export process much faster.

If you click both the "Export negative files" and "Include available previews" check boxes, you will end up with an exported catalog that looks like the one in the folder shown below in **Figure 5.7**, where the catalog folder contains an *.lrcat* catalog file, a *Previews.lrdata* file that contains the thumbnails and preview image data, along with a subfolder containing the master negatives.

Figure 5.7 This shows a folder view of an exported catalog along with the previews file and Pictures folder.

Opening and importing catalogs

Now let's imagine you have transferred the exported catalog to another computer. If you choose File \Rightarrow Open Catalog, this opens the Open Catalog dialog shown in **Figure 5.8**, which asks if you wish to relaunch Lightroom. This is because Lightroom must relaunch before loading a new catalog. Or, you can choose Import from Catalog from the File menu, select the exported *.lrcat* file, and import it. If the catalog you are about to import excludes negative files, it will import directly. Otherwise, you'll see the Import from Catalog dialog shown in **Figure 5.9** on the next page, where you can choose to import the images by referencing them in their present location, or by copying to a new location and adding them to a current Lightroom catalog. Where image files already exist in the current catalog, you have the option to decide what gets preserved and what gets replaced during the import process. For example, in Figure 5.9, some photos already existed in the catalog, so in instances like this you have to decide what to do: Change nothing; change the metadata and Develop settings only; or change everything, including the negative files.

Figure 5.8 The Open Catalog relaunch dialog.

NOTE

Just to be clear, in the Lightroom Export Catalog dialog, the term *negative files* refers to the master photographs in the catalog.

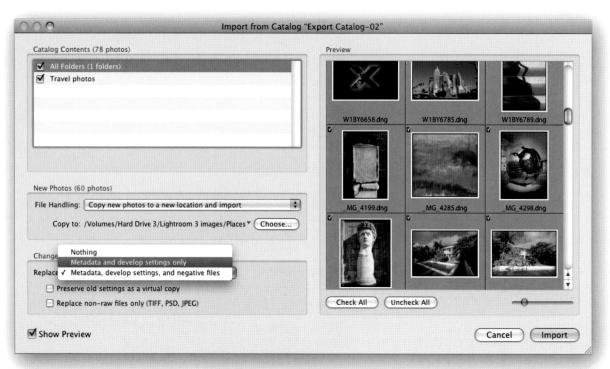

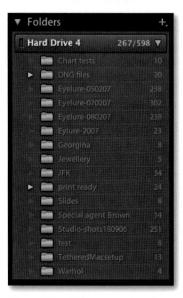

Figure 5.10 If the imported catalog excludes the master negatives, the folder names will appear dimmed in the Folders panel, because the source folders are effectively off-line.

Figure 5.9 This shows the Import from Catalog dialog, where of the 78 photos I was about to import, 60 were new photos. The New Photos section allowed me to decide how to handle importing these new images. This left 18 photos that were duplicate images, and in the Changed Existing Photos section, I could choose how to reconcile the mismatch between these and the photos that were already in the catalog. Here, I was about to select the "Metadata and develop settings only" option from the Replace menu so that this Import from a Catalog updated the metadata only.

Limitations when excluding negatives

As was pointed out in the previous example, you may encounter certain limitations when working with a catalog that has been exported without including the negatives. While you can edit most of the informational metadata, export the edited catalog, and reimport the information back into the main computer, that is about all you can really do. The Folders panel displays such catalog folders with the folder names dimmed because the links to the master folders will be considered off-line (see **Figure 5.10**). The Develop module will be accessible but inoperative: You'll be able to see which Develop settings have been used, but that is all. However, you will be able to use the Slideshow module to run slideshows (providing the pre-rendered previews are good enough) and use the Web module to generate Web galleries. But the Web module will constantly remind you that the "best available previews" are being used in place of the original masters. To be honest, this isn't always likely to be a problem. With the Print module, you'll have the ability to make Draft mode prints. But again, the print quality will always be dependent on the quality of the imported pre-rendered previews.

Changed Existing Photos section

The Changed Existing Photos section of the Import from Catalog dialog covers all eventualities. If you are worried about overwriting current Develop settings, you can ensure a safe catalog merge and choose "Preserve old settings as virtual copies" (especially if you choose to change "Metadata, develop settings, and negative files"). If you want to avoid overwriting any of the raw masters, you can select the "Replace non-raw files only" option, which can save time, since the raw files will not be overwritten and only the metadata edit settings will be imported to the catalog. As an extra security option, any photos that are exactly the same (i.e., share the same creation date) will not be imported or overwrite the originals. The steps on the following pages offer examples of how to configure the Import from Catalog dialog.

Export and import summary

You use the File \Rightarrow Open Catalog command to load individual catalogs, but Lightroom can run only one catalog at a time. There is nothing to stop you from utilizing multiple catalogs, but a single catalog is probably all you really need, even if you have a very large collection of photographs to manage. A catalog export is always a one-way process. You can create only new catalogs, and a catalog export can't add to an existing catalog. The File \Rightarrow Import from Catalog command is the mechanism used to import catalog information from a catalog and add it to an existing catalog. Depending on the catalog you are importing from, you can either import the complete catalog contents (images and metadata), or choose to simply update the metadata information (without importing any photos). There is an example coming up on pages 222–225 that shows how to export a catalog from a main computer, import it to a laptop, make some metadata edits to the catalog, and then reimport the revised catalog back to the original computer again.

Copying a catalog to another computer

If you are running Lightroom on more than one computer, there are bound to be times when you might wish to access the same photos across both machines. As I explained earlier, Lightroom works by explicitly importing master photos into the catalog and then keeps a record of where each file is and stores the information about the photos, such as the Develop settings and metadata within a central database (referred to here as the catalog). Once upon a time, you would have had to think in terms of creating duplicates of all your image files if you wanted to work with them on two or more computers stored in different locations. But cataloging programs like Lightroom don't need to access the original images in order for you to search for photos, make editing decisions such as image ratings, edit the metadata, or create slideshows. Lightroom can do all this by making use of the previews, so the master photos (or negatives as they are referred to here) don't always need to be present.

NOTE

The Adobe Photoshop Lightroom end-user agreement permits you to install Lightroom on a main computer and a secondary computer such as a laptop. This is because it is recognized that a lot of Adobe product customers regularly work on more than one computer. Another useful thing to know is that you can use a single Lightroom license to run a Mac and/or Windows version of the program. You don't need to buy a separate license to do this.

A catalog export and import in action

If you only need to export a subselection of images, make a selection of the photos you want to export from Lightroom and make sure you remember to click the "Export selected photos only" check box.

1. Over the next few pages, I wanted to show how you can use the catalog export and import features to copy a Lightroom catalog from a main computer over to a laptop computer. Here is a computer that holds the master catalog collection of photos, where all the master images are stored on an internal drive.

all and the	Export as Catalog	Export Catalog
Save As:	iMac-catalog	Exporting New Catalog
Where:	🔹 LaCie	Cancel
Expor	ting a catalog with 6466 photos and 31 virtual copies.	Cuncer
	Export selected photos only	
	Export negative files Include available previews	

2. My objective here was to export the entire Lightroom catalog to a removable hard drive so that I could then access it via a secondary computer. To do this, I made sure All Photographs was selected in the Catalog panel, and chose Export as Catalog from the File menu. I wanted to export the complete catalog, so I deselected "Export selected photos only." And because I wanted to export a lightweight version of the computer's Lightroom catalog, I deselected the "Export negative files" option. But I did keep the "Include available previews" option checked, because I needed to preserve these in the catalog export.

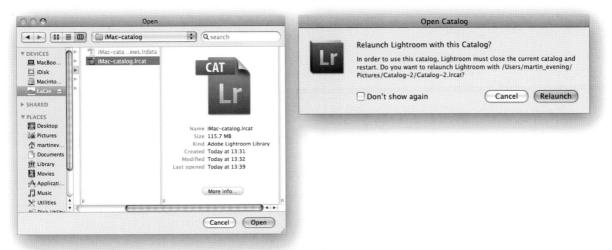

3. After I had exported the master catalog, I disconnected the removable drive from the main computer and reconnected it to a laptop computer. On the laptop, I launched Lightroom, chose File ⇒ Open Catalog, used the navigation dialog shown here to locate the exported catalog file on the removable hard drive, and clicked Open. This opened the warning dialog shown here, where I had to click the Relaunch button to restart Lightroom with Lightroom running from the new catalog.

4. After the new catalog had opened, I was able to access the exported catalog from the main computer via the laptop. In this instance, I was accessing the catalog from the removable drive. But I could just as easily have copied the exported catalog to the laptop drive and opened the catalog from there.

5. If you export a catalog without including the negatives (the master photos), there is only so much that you can do with it. I listed earlier what you can and can't do, but basically, you will still be able to navigate the catalog and edit the metadata. In this example, I edited various folders in the catalog, adding color labels, applying star ratings, as well as editing the keywords and other editable metadata.

Save As:	iMac edited-091109
Where:	💿 LaCie 🛟
Export	ing a catalog with 6466 photos and 31 virtual copies.
	Export selected photos only
	Export negative files
	Include available previews

6. After I had finished editing the catalog on the laptop, I was able to export the edits that had been applied on the laptop by creating a new export catalog. To do this, I chose File ⇒ Export as Catalog. I deselected "Export selected photos only" because I wanted to export all the images. Since I wanted to export only things like the ratings, color labels, and keyword metadata edits, I didn't need to check the "Export negative files" option (there were none to export anyway!). And because I was about to export back to the main library, there was no need for me to click "Include available previews" either.

n n n n n n n n n n n n n n n n n n n	ort from Lightroom Catalog	· OOO Import from Catalog "iMac-catalog"
< ►) (88	c-catalog 🗘 🗘 (Q search	Catalog Contents (6497 photos)
Devices Marrin E GSMain HD Hard Dri Hard Dri Disk Disk		All Folders (71 folders) Auto Imported Photos China-JG/China Tibet Disk 1 Glass shots Unchanged photos cannot be selected. Why? New Photos (none found)
Ubrary-HD LaCce ▲ Vertee Vertee Vertee Desktop Applicati	Name iMac-catalog.ircat Size 115.7 M8 Kind Adobe Lightroom Library Created Today at 13:31 Modified Today at 13:32 Last opened Today at 13:39	File Handling Add new photos to catalog without moving File Handling Nothing Change Metadata and develop settings only Replact Preserve old settings as a virtual copy
1 martin_e 1 Library Movies	u Cancel Choose	Replace non-raw files only (TIFF, PSD, JPEG) Show Preview Cancel Import

7. At this point, I needed to quit Lightroom so that I could disconnect the removable hard drive from the laptop and reconnect it to the main computer again. On the main computer, I opened Lightroom, running the original master catalog and chose File ⇒ Import from Catalog. I selected the laptop-exported catalog and clicked Choose. It was important here that in the Import from Catalog dialog I chose to change the catalog using "Metadata and develop settings only."

8. Finally, here is the master catalog on the main computer after I had merged the metadata edits from the laptop-exported catalog. As you can see, the color labels and ratings were updated and matched the changes that had been applied to the laptop-edited catalog.

NOTE

The merge catalog steps shown here let you synchronize metadata settings such as IPTC metadata, keywords, image ratings, and Develop settings adjustments from one catalog to another and back again. If you wish to share other Lightroom settings such as Develop presets or Print module templates, you will need to make sure you have opted to store the presets with the catalog (see page 603).

How to merge two catalogs into one

For most Lightroom users, one catalog is all you need. For example, I have one main catalog that is used to store everything that I import into Lightroom—work and personal projects alike. Basically, I keep all the current photo files from the last three to four years on two 2 TB internal hard drives. These files are then backed up to two large external disks, which are normally stored away from the computer for safe keeping. At the same time, I have a large collection of image files that are stored on an assortment of other hard drives. These are used to archive all the professional studio shoots that were worked on prior to three to four years ago, plus any other image files that I am unlikely to need in a hurry. I find there is no point cluttering up the main catalog with the image files that are mainly kept off-line. At the same time, I don't like having all those additional hard drives constantly powered up just so that once or twice a year I can access the files on them when I need to. Furthermore, there are an awful lot of duplicate version files in this archive that date back to pre-Lightroom days. The solution I have adopted has been to keep separate catalogs for these two setups. I find this also keeps the main catalog looking tidier and easier to manage.

But what if I wanted to work with the contents from both catalogs at once? There are times where it is not convenient to have to keep switching from one catalog to the other and I need to see everything that is on the system in one catalog. For example, I might want to reconcile the keywords between the two catalogs and I can do this kind of tidying up by working on a merged "uber" catalog. The following step-by-step example shows how I go about this, by merging the two catalogs into a single, merged catalog (see **Figure 5.11** below).

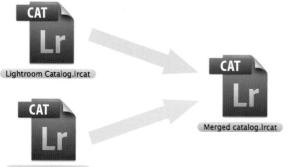

Off-line catalog.lrcat

Figure 5.11 In the following steps, I show how I created a master, merged catalog that could be used to interchange updates with two subcatalogs: my main Lightroom catalog and an archive catalog of off-line photos.

All Photographs	95397
Quick Collection +	99
Previous Import	3

TIP

Depending on the size of your catalogs, the Import from Catalog process can take a long time to complete. If all you want to do is update the metadata in the master/ merged catalog for a specific folder, make a few rating edits, or add some new keywords, then it will be quicker to save the metadata changes to the files directly. Leave out the "Don't import new photos" step (see Step 10) and relaunch Lightroom using the original subcatalog. All you have to do then is locate the folder or collection containing the files you had modified and choose Metadata ⇒ "Read metadata from file."

1. My main photo catalog is stored on internal drives that are backed up to the two external drives shown here. As you can see, there are over 95,000 photos in this catalog. They mostly comprise photos that have been taken over the last few years and other images I need to access regularly.

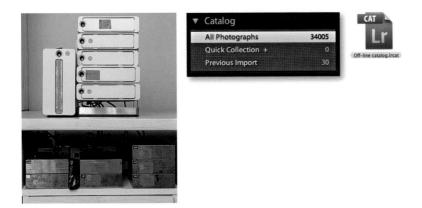

2. I also have a secondary off-line catalog that is used to manage the older image files, which are stored on a separate bunch of disks. These are mostly kept off-line and only switched on when I need to access the older data.

Save As:	Merged catalog	
Where:	Pictures	•

3. Let's now look at how I was able to merge the above two catalogs into a single catalog. To do this, I went to the File menu in Lightroom and chose New Catalog. This opened the Create Folder with New Catalog dialog shown here; I named it "*Merged catalog.*"

CAT	0.0	Me	rged catalog.lrcat – Adobe Photoshop Lightroom – Libr	ary	
Ir	▼ Navigator FILL	13 31 ¢ Library Filter:	Text Attribute Metadata None	Filters Off 🗧 🔓	Histogram 🔺
					Quick Develop 🔻
Merged catalog.Ircat					ed Pressi
					econoci
					Exposure
					Recovery Destination
					Blacks
<	▼ Catalog		Click the "Import" button to begin.		Brighmeis (2000) (2000)
	All Photographs Quick Collection +	0			Contrast
	Previous Import	0			Vibrance
100	► Folders	+.			Lenning Friday
- 7385	► Collections	+.			Keywording 🔻
	► Publish Services	+.		Key	word Tags 🔋 Enter Keywords 🗧 🔻
	Import		🖥 👘 Sor:: Capture Time 🗧 Grouping: Off 🗧		Contraction of the second s
1	El 🔶 🗄 🔶 All Pho	otographs / 0 photos -	Filter :		
		and the second second second second		the state of the s	The second state of the second second

4. When I clicked the Create button in the previous dialog, this required Lightroom to close down the current catalog and relaunch, opening with the newly created catalog, which to begin with contained no photos.

CAT	Import from Lightroom Catalog	O O Import from Catalog "Off-line catalog-2.lrcat"
1	Archive-catalog 🗘 Q search	Catalog Contents (34005 photos)
Off-line catalog.lrcat	V DEVICES Martin E GSMain HD RAID \triangleq Hard Dri Hard Dri Disk Untitled Name A Date Modified 2 Jan 2008 12:59 Coday, 11:11 Off-line catalPreviews.lrdata Today, 11:27 Today, 11:27	✓ All Folders (2036 folders) 34005 ✓ Masters A-H/A/Alan D ✓ ✓ Masters A-H/A/Alan D/Posters 1998 5 ✓ Masters A-H/A/Alan D/Posters 1999 1 ✓ ✓ Masters A-H/A/Alta Moda/1999/August 1999 1 ✓ ✓ Masters A-H/A/Alta
	iii Library-HD ▶ SHARED	File Handling: Add new photos to catalog without moving
	V PLACES	Changed Existing Photos (none found)
	Applicati Amplicati	Replace: Nothing \$
	Cancel Choose	Replace non-raw files only (TIFF, PSD, JPEC)
		Show Preview Cancel Import

5. I was now ready to merge the first catalog. I went to the File menu again and chose Import from Catalog. I used the first dialog shown here to select the catalog to import from (in this case, the Off-line catalog) and in the second dialog, under File Handling, chose "Add new photos to catalog without moving."

6. Here is how the Merged catalog looked after importing from the off-line catalog. At this stage, it was a mirror of the catalog that had just been imported.

Import from Lightroom Catalog	O O Import from Catalog "Lightroom 2 Catalog-2.lrcat"	CAT
(search	Catalog Contents (95397 photos)	
Name Backups Ughtroom Catalog Previews.Irdata Ughtroom Catalog.Ircat Ughtroom Metadata.Irdata	All Folders (643 folders) 95397 Auto Imported Photos 1 Casting photos/-Ms-C-collecion 24 Casting photos/2001/Models - men14.08.01 45 Casting photos/2001men14.08.01/Pictros 5 Casting photos/2001men14.08.01/Pictros 5 Casting photos/2001men14.08.01/Pictros 5 Casting photos/2001men14.08.01/Pictros 5 Casting photos/2001/models 15.10.01 75 New Photos (95397 photos) File Handling: Add new photos to catalog without moving Changed Existing Photos (none found) 6	Lightroom Catalog.Irca
Cancel Choose	Replace: Nothing Preserve old settings as a virtual copy Replace non-raw files only (TIFF, PSD, JPEC) Show Preview Cancel	

7. Here I repeated the same steps as shown in Step 5. I chose File \Rightarrow Import from Catalog, but this time I selected the main Lightroom catalog. In the Import from Catalog dialog File Handling section, I again chose "Add new photos to catalog without moving."

8. Here is how things looked after both catalogs had been imported into the one Merged catalog. I could now do things like edit the keywords for the combined catalogs, make changes to the ratings and labels, and also edit the Develop settings (providing the photos were accessible online).

9. Back in the original Lightroom catalog, here is how one of the folders looked before the catalog had been imported and edited in the Merged catalog.

O O O Import from Lightroom Catalog	Import from Catalog "Merged Catalog-2.lrcat"
< ► :: :	Catalog Contents (129402 photos)
DEVICES Martin E Martin E CSMain HD RAD Hard Dri Disk Disk Unitled Ubrary-HD	All Folders (352 folders) 129402 Hard Drive 3/Casting photos/-Ms-C-collecion 24 Hard Drive 3/Castingodels - men14.08.01 45 Hard Drive 3/Castingmen14.08.01/Pictros 5
	New Photos (3300 photos) File Handling: Don't import new photos
LaCie ▲ ShareD PLACES Sektop ▲ Applicati ▼	Replace: Metadata and develop settings only Preserve old settings as a virtual copy Replace non-raw files only (TIFF, PSD, JPEG) Photos that are the same in both libraries will not be imported.
Cancel Choose	Show Preview Cancel Import

10. With the original Lightroom catalog open, I went to the File menu and chose Import from Catalog. Here, I selected the Merged catalog as the source and, most important of all, in the File Handling section, I chose "Don't import new photos." In the Replace section, I chose "Metadata and develop settings only." These settings ensure that you don't import all the photos from the other catalog and that only the metadata edits get imported back to the original catalog.

11. Here is how the same Lightroom catalog folder looked after the recently edited changes in the Merged catalog had been updated to the main catalog.

d catalog.ircat

NOTE

One of the most common questions asked in the Lightroom forums is "Why is Lightroom running so slowly?" There can be many reasons for this. It can sometimes be due to the fact that people have had high expectations of how many images they can manage on a computer system that isn't powerful enough or does not have enough RAM to allow them to work efficiently. The best solution to this problem is to back up the catalog and check the Optimize Catalog option. Or, you can go to the File menu and choose Optimize Catalog. This can often lead to an improvement in Lightroom's performance.

General Catalog Settings

The Catalog Settings can be accessed via the Lightroom menu. There is a prominent link button in the Lightroom General Preferences that says "Go to Catalog Settings." Or you can use the Alt, (Mac) or Ctri Alt, (PC) keyboard shortcut to open the Catalog Settings dialog. This is a three-part preferences dialog. **Figure 5.12** shows the General Catalog Settings. The Information section provides some basic information about the current catalog file, and if you click the Show button, this reveals the current location of the catalog in the Finder/Explorer.

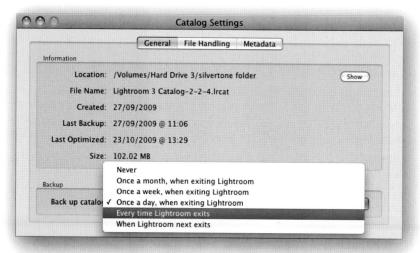

Figure 5.12 The General Catalog Settings.

Backing up the catalog file

In the "Back up catalog" menu, you can choose how often you wish to create a backup of the master catalog file. This now includes options to schedule the backup procedure to take place after you have quit Lightroom rather than at launch time. I strongly advise you to select one of these options since it provides an extra level of built-in backup security that may well prevent you losing valuable catalog data information.

When you select a "Back up catalog" option, the Back Up Catalog dialog appears each time you are due to carry out a scheduled backup (**Figure 5.13**). You can click the Choose button to select the location where the backup catalog file should be stored, and you can select the option to test the integrity of the catalog before backing up. There is also a further option that allows you to optimize the catalog after backing up. If any problems are found with the catalog, you then have the opportunity to replace the current (corrupt) database with the previously backed-up catalog copy file.

Settings for the catalog "Lightroom 3 Catalog-2-2-4" indicate it should be ba	ked up each time it is closed.
Note: This only backs up the catalog file, not the photos refe	renced by it.
Backup Folder: /Volumes/Hard Drive 3/silvertone folder/Backups	Choose)
Also: 🗹 Test integrity before backing up	
Optimize catalog after backing up	
(Chin Maur
(Skip Now Backup

Figure 5.13 The Back Up Catalog dialog that's shown here will appear according to the settings you choose in the General section of the Catalog Settings. For example, I have these configured to show the Back Up Catalog dialog each time I quit Lightroom.

As they say, there are only two types of computer users: those who have experienced loss of essential data and those who are about to. On at least one occasion, I have been grateful for having backed up the Lightroom catalog file and needed it to replace a corrupted catalog (in fact, as I type, this happened to me today just a few hours ago). If this happens to you, go to the Lightroom folder (which is usually stored in the user's *Pictures* folder), open the *Backups* folder, and then open the most recently dated folder, which will contain an *.lrcat* catalog backup file. Note that each time you back up the Lightroom catalog, Lightroom creates a new backup copy of the *.lrcat* catalog file and stores it in a new, dated backup folder. To replace a corrupted catalog, you just need to copy this backup file to the root-level Lightroom folder, replacing the corrupted one, and restart Lightroom. When Lightroom relaunches, it will do so using the last backed-up version of the catalog. Over time, you may accumulate a lot of backup folders, so it makes sense to cull the older ones as they become too out of date to be of any practical use.

It is also a good idea to go to the File Management preferences and switch on the "Automatically write changes into XMP" option. This causes Lightroom to push the metadata information such as the Develop settings and other metadata information into the individual images (or sidecar files). This means that the image files will also contain a backup of most (but not all) of the information that is stored in the central Lightroom catalog file. So, even if the replacement backup catalog file is a little out of date, you still have an opportunity to read the metadata settings from the files themselves to recover data that might otherwise seem to have been lost.

TIP

I have provided only a simple overview of how to devise a suitable backup strategy. If you would like to find out more about how to manage your image collection, check out *The DAM Book: Digital Asset Management for Photographers,* Second Edition (O'Reilly Digital Studio, 2009), by Peter Krogh.

Backup strategies

A mirrored RAID system can be essential in a mission-critical environment to ensure continuity of data access (see Appendix B). But this does not amount to the same thing as having a fail-safe backup strategy. For that, you need to perform scheduled backups to a secondary set of drives, which should be stored in a safe location such as a fire-proof safe or somewhere off-site. In a simple office setup, you could use one drive on the computer to hold the main Lightroom image catalog and a duplicate external drive of similar capacity to make regular, scheduled backups to. With this kind of setup, it is important that the backups are scheduled manually. If a problem such as an accidental file deletion or a directory corruption were to occur on the master disk, you can rectify the problem by copying data from the backup drive. And because you are keeping the data on a separate drive, it can be stored in a separate location away from the main computer. For added security, I suggest using two external backup drives and just keep swapping over the backup disk that's connected to the computer and the one that's kept off-site. As long as the files are stored on read/write disk media, they may still be vulnerable to accidental erasure or a virus attack that could infiltrate the backup drives. To reduce the risk further, you could make DVD copies of your files and keep these in an appropriate storage location. Of course, it would be a pain to have to reload all the data from DVDs again, but writing data to DVD does at least ensure that the data is free from virus attack or human error. Also, keep an eye out for newer media systems such as Blu-ray that are bound to become more affordable and practical for storing larger amounts of data on single disks.

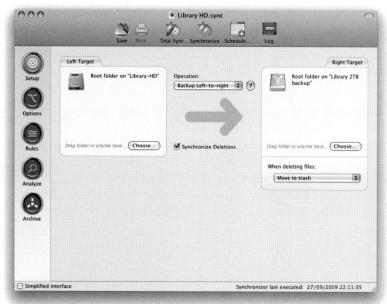

Figure 5.14 The ChronoSync backup program interface.

Backup software

You can use various programs to carry out data backups. On the Macintosh platform, I like to use ChronoSync from Econ Technologies (www.econtechnologies.com) because it is simple to use and effective at synchronizing all the files on a backup disk with the master disk (Figure 5.14). I make regular backups of all the drives on my system. Whenever I want to back up any data, I simply switch on a backup drive and run the backup process. I have the settings configured so that ChronoSync first compares all the data on the Left Target disk (the drive I want to back up) with the Right Target disk (the drive I want to store the backup data on) and copies all the newly added files. I also have the Synchronize Deletions option checked, so that file deletions on the master disk are applied to the data on the backup disk. At the end of a synchronization, I empty the Trash and the backup is complete. Setting up the backup drives and copying all the data does take a long time the first time around, but thereafter, if you carry out regular backups (like once a day or every few days), the backup procedure won't take nearly so long (see sidebar, though). If you are in the habit of leaving on your computer and drives overnight, you can always schedule the backups to occur in the early hours of the morning.

Time Machine backups (Mac)

One of the key features of Mac OS X 10.5 and higher is Time Machine, which allows you to make automatic backups of your data while you work and to retrieve any lost or overwritten data. While this backup method can work fine for most computer application data, up until now it has never been a suitable method for backing up the Lightroom catalog. This is because the backing up should always be done as a complete process while Lightroom is not in use; otherwise, Time Machine could easily create a corrupt Lightroom catalog backup. Lightroom 3 now marks an open catalog file as "being in use" and to be excluded from a Time Machine backup while Lightroom is running. This, therefore, prevents Time Machine from backing up the catalog while it may be in an incomplete state or in the process of being modified. When Lightroom guits, it takes the catalog off of the exclusion list. This means that Time Machine can still create backups of the Lightroom catalog, but only while Lightroom is not in use. Note that if you want to restore the Lightroom catalog from a Time Machine backup, you must make sure that Lightroom is not running with that catalog open before allowing Time Machine to make a backup.

The catalog/folders relationship

One way to appreciate the relationship between the Lightroom catalog and the system folders is to look at the various ways Lightroom can interact with the system folder structure.

NOTE

Because your Lightroom catalog will most likely consist of tens of thousands of metadata and preview files, this can have unintended consequences. For example, it can actually take a long time for some backup software or virus checking programs to process such a huge number of individual files, even though the file sizes may be quite small.

TIP

If you are running out of space on a particular drive, you can simply move the folders and files to a new hard disk and Lightroom can keep track of them at the new drive location. But note that the catalog images cannot be stored on a network drive or stored on a read-only data disk. People often ask how using a Lightroom catalog is different from using the finder or a browser program to locate images. I point out that with a system folder/ browser setup, you usually need to know exactly where everything is kept in order to successfully retrieve something. A well-organized photographer might keep his or her photos archived on disks by date, alphabetical order, or a combination of both. In order to retrieve photos from such a system you need to have personal knowledge of how the photos are stored: which folders are on which drives and how the subfolders are organized. Of course, if you have already added metadata to your images in the form of IPTC metadata or keywords, you can use the search command in a program like Bridge to help find the photos you are looking for. But the bottom line is that such searches will be easier if you use a dedicated cataloging program like Lightroom to manage the metadata contained in the image catalog.

Folder organization is also limiting because you are tied to viewing your photos in strictly segmented groups. What I mean by this is that you can use a browser to view a folder that contains photos that were shot for a particular client on a particular day, but it is less easy to view all the photos that were ever shot for that client, or all the photos that were shot during a particular month. Browsers can be made to do this, but Lightroom is designed to do it faster. Once you get used to being freed from the constraints of a browser navigation system for carrying out multilevel searches, the underlying folder structure becomes less relevant.

If you were starting from scratch and used only Lightroom to manage your photographs, there would be no need to focus too much on how the folders were organized or named, since everything in the catalog can be managed fast and efficiently by referencing the metadata information. However, there are reasons why this ideal is not always possible. If you are not so organized and forget to add metadata to your photos, then it can be useful to rely on the folder names to help locate desired pictures. Also, if you work in tandem with a browser program such as Bridge, it is always faster to search by folder in Bridge than it is to rely on metadata searches. For crossover workflows that rely on Bridge and Lightroom, it can be important to know where your images are stored and locate them by folder as well as by metadata.

If you are comfortable searching by metadata and using features like Lightroom collections, does it really matter if you know which folder the images came from? Well, yes and no. In the future, we may see our computer systems place less importance on the folder structure and encourage us to use metadata to group and organize all our files. We are seeing that happen already. But when it comes to organizing and maintaining legacy folders that contain precious data, it is hardly surprising that photographers wish to know how to manage and access everything using tried and trusted methods. This is why it is useful to appreciate the interrelationship between the catalog and the system folders they refer to. Over the next few pages, I show you how to keep both in check.

Adding new folders

Here are the steps required to add a new folder within the Lightroom Folders panel.

1. To create a new folder inside another, click the plus icon in the Folders panel header (circled) and choose Add Subfolder. Or, right mouse click on a specific folder and choose Create Folder Inside *name of folder*. In this case, I created a new folder inside *Animals*. Here, I named the new subfolder *Lions*, and because I had a selection active, I was able to check the "Include selected photos" option.

2. After clicking the Create button, this created the new subfolder called *Lions* within the parent folder *Animals*.

₹ F	olde	rs		
D H	ard Di	rive 4		222/622GB
0 H	ard Di	ive 3		91.07 698 GB 👎
v	0	Lig	htroom 3 images	5894
	V	-	Animals	54
		ļįt-	Lions	10
	Þ		Calibration	18
	Þ	0	Jobs	1055
	•	-	People	64
	Ÿ.		Places	4703
		Þ	in Antarctica	75
			🦳 Australia	4
		Þ	Europe	2228
			Mevis 2009	75
			💼 South Africa	18
		Þ	📄 ик	838
		•	USA	1465

Lightroom folders and system folders

If you rename a folder in Lightroom, the corresponding system folder is renamed. And if you move a folder location in the Folders panel, such changes are mirrored at the system level, too. However, Lightroom is unable to automatically detect new images that have been added to a system-level folder. To do this, you must use the Synchronize Folder command from the Library menu.

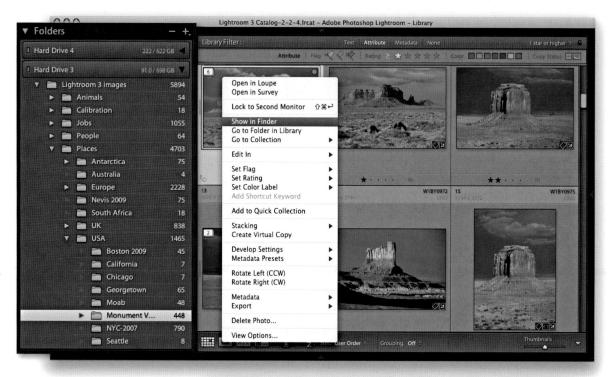

000	Monument Valley			
Name	🖾 USA	herein	Size	Kind
🗰 W1BY0960.dng	Places	4	22.6 MB	Digita
W1BY0961.dng	Lightroom 3 images		22.5 MB	Digita
W1BY0962.dng	Hard Drive 3	.9	20.7 MB	Digita
W1BY0963.dng		.9	21.3 MB	Digita
M1BY0964.dng	Martin Evening's Mac Pro	:0	21.9 MB	Digita
W1BY0965.dng	27 Septem 2009, 19	27 Septem 2009, 19:20		
W1BY0966.dng	27 Septem 2009, 19	:20	23 MB	Digita
W1BY0967.dng	27 October 2009, 10:0	03	23.8 MB	Digita
🛎 W1BY0968.dng	27 October 2009, 10:0	03	24.1 MB	Digita
W1BY0969.dng	27 October 2009, 10:0)3	22.1 MB	Digita.
M1BY0970.dng	27 October 2009, 10:0)3	21.1 MB	Digita.
			terrer ages segments	14 +

1. Here is a view of the Folders panel in Lightroom and the associated system folders, where I selected a photo that resided in the *Monument Valley* folder and used a right mouse click to reveal the contextual menu shown here and then chose Show in Finder (shown in Explorer on a PC).

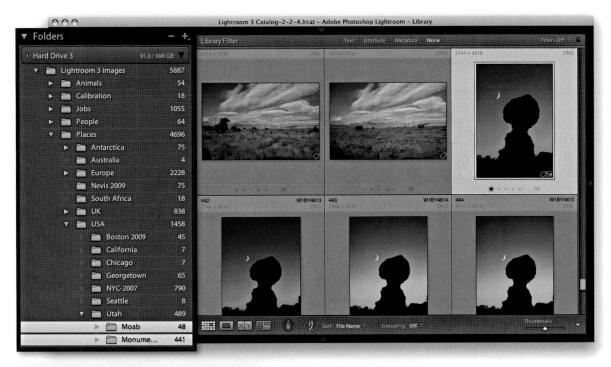

	Create Folder		
Folder:	Utah		
	Folder Options		
	✓ Put inside "USA"		
	Include selected photos		
		Cancel Create	
000	2	of 10 selected, 91.06 GB available	
Na		Date Modified	Size
▶ 🛄 Bo	ston 2009	11 October 2009, 10:32	
► 🕅 Ca	lifornia	22 October 2009, 13:51	
▶ 🗐 Ch	icago	22 October 2009, 13:46	
▶ 🛄 Ge	orgetown	23 October 2009, 11:54	
Mis	sc	Today, 07:59	
> DO NO	2007	22 October 2009, 13:50	
-	'C-2007 attle	Today, 07:53	

V Utah

N LOUIS

2. In Lightroom, I created a new folder called *Utah*, as a child of the *Places/USA* folder. I then moved the *Monument Valley* and *Moab* folders inside the new *Utah* folder. As you can see, the added subfolder and movement of the other two folders into the new subfolder is mirrored at the system level.

Today, 07:57

27 October 2009, 22:05

Kind Folder Folder Folder Folder Folder Folder

Folder

You can change the name of a folder by selecting it in the Folders panel and choosing Rename from the contextual menu.

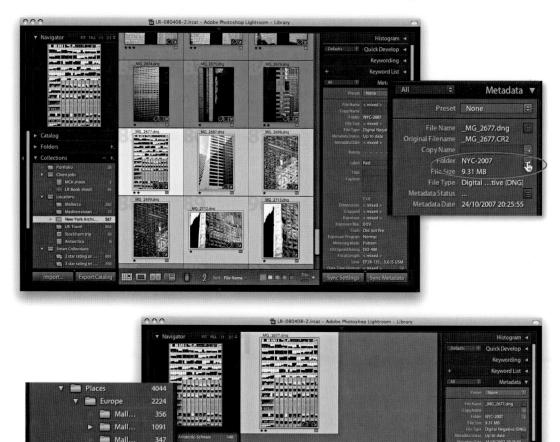

Finding the link from the catalog to a folder

1. With Lightroom, you are free to organize and sort your photos in ways that are not directly dependent on your knowing the underlying folder structure. For example, here I am looking at a collection of photos with a common New York Architecture theme where the photos have all originated from different folders. If I click the Folder Action button in the Metadata panel, this takes me to a Folder filtered view in Lightroom for the most-selected photo.

🚱) Sort: File Name

Malta

Scan...

NYC-..

- World Travel

-

Import...

168

781

244

. .

0	ta LR-080408-2.h	cat - Adobe Photoshop Lightroi	om – Library	9	0	100 DN	YC-2007	C
r Navigator an an an an a					CS-lähtte-GD	< > 88 🗮 🖽 🗘	Q Q	
Navigator	*				F	Name	Date Modified	
Telen pulses				±A.	1	MG_2672.dng	23 October 2007, 16:40	0
and I will the state	MG 2667.dng	MG_2668.dng	MG 2669.dng	MG 2670.dng		_MG_2673.dng	23 October 2007, 16:40	
and a state of a state of	Historia A	NAS POSE OF A				MG_2674.dng	23 October 2007, 16:40	0
					CHARLES HORK CON	_MG_2675.dng	23 October 2007, 16:40	0
Frank washing			Shift and shift	A Designed	Uliousy-GD	MG_2676.dng	24 October 2007, 20:25	5
And a state of the state						m _MG_2677.dng	24 October 2007, 20:25	5
Teastal I and a second second		all the second s			(Persona)	_MG_2678.dng	23 October 2007, 16:40	0
EXC.					0	MG_2679.dng	23 October 2007, 16:40	
						MG_2680.dng	23 October 2007, 16:40	
		MG 2675.dng	.MG. 2676.dng	M5 2677 dpg	isanto -	MG_2681.dng	23 October 2007, 16:40	0
Antarctic-Schewe 148	MG_2674.drig			MG 2677.dng	(SAUD)	MG_2682.dng	23 October 2007, 16:40	0
Frome 23				south the state of the		MG_2683.dng	23 October 2007, 16:44	0
v m Pictures 5126			Barris Barris	B Later	1	MG_2684.dng	23 October 2007, 16:41	0
Family 13					r r	MG_2685.dng	23 October 2007, 16:4	1
▶ 🗰 General photo 207	Strate and			ATT COLLEGE CAR		MG_2686.dng	23 October 2007, 16:4	1
MG libraryST 372				The second secon	watchise folitiar	MG_2687.dng	23 October 2007, 16:4	1
🕨 📷 Jobs 🛛 455	のなるとのないである。				autorios seases	MG_2688.dng	23 October 2007, 16:4	1
v 🗰 Places 🛛 4043		(CON)	(CEE	ALL RANGE OF	() (property)	MG_2689.dng	23 October 2007, 16:4	1
 Europe 2224 Mail., 356 	* 🖸	* 🛛	** 🖸	** 0	100	_MG_2690.dng	23 October 2007, 16:4	1
Mall 1091	MG: 2687.dng	MG 2//98.ong	MG 2000 deg	A MARY OF AN ADDRESS OF A DESCRIPTION		_MG_2691.dng	23 October 2007, 16:4	1
📷 Mall., 347			国際地位の形式	MG 2712.dng	AUXINI STATE	(and the spectrum concernment of the)	4
Malta 168	Trans Market			A PERSONAL PROPERTY AND	Bridge C53 alias	1 of 868 selected	1, 153.8 GB available	
► 🖿 Scan				- ARECAN				-
▶ 🖮 UK 795								
V 🖬 USA 780				(CONNEL	1			
> 🔜 NYC 780				NEW STREET				
 World Travel 244 		Present Contraction	ALCONTRACT OF					
Import Export		9 Sort: File Name :	Thumbnails		Andeles Urginessenn allins			
201200300 Carol Facility and the second second	Bastron and and and and an and a strong and a		Carlo Car	en de la companya de	74076			

🖺 🕼 🕃 💻 🛊 🛜 🐠 Wed 15:36:04 🧕

2. If I want to see where the photo actually resides at the operating-system level, I can choose Photo \Rightarrow Show in Finder (Mac) or Show in Explorer (PC), or use $\Re R$ (Mac) or Ctrl R (PC), to reveal the image file in a new Finder/Explorer window. But there is another way, one that allows you to link back to Bridge: You can simply drag and drop a photo from the content area to a Bridge program alias/shortcut.

3. When you do this, it opens the folder the photo belongs to in a new Bridge window, and the selected photo is highlighted.

6

Develop module image editing

A definitive guide to working with the image processing controls in the Develop module

One of the most powerful features in Lightroom is the image processing engine and the way the image adjustment processing is deferred until the time you choose to edit in Photoshop or export an image. This method of image processing actually originated in the early days of computer imaging, when deferred processing was adopted by programs such as Live Picture and xRes as a means to speed up the image editing. Computers were a lot slower back then, yet it was possible to manipulate large image files in real time (with as little as 24 MB of RAM memory) and defer the image rendering process to the end of a photo edit session.

Of course, these days, you can edit large images in no time at all in Photoshop. But one of the key advantages of Lightroom is that you can apply a crop, spot the image, make localized adjustments, tweak the color, do some more retouching, readjust the crop again, and so on, all without ever touching the pixels in the original photograph. In a conventional pixel editing workflow, the pixels are always modified in a consecutive sequence of steps. When you work in Lightroom, no restrictions are placed on the order in which you do things, and the edit changes you make in the Develop module are applied only when you output a photo as a rendered file, such as a PSD, TIFF, or JPEG image.

NOTE

A master file in Lightroom is treated as a digital negative. Any operations you carry out in Lightroom that alter the image, including the retouching, are stored as saved instructions. The other benefit of this approach is that the image pixels are eventually rendered in a single processing step.

Image editing in Lightroom Smarter image processing

The Lightroom image processing engine is notable for a number of reasons. First, the Adobe engineers have made Lightroom simple to use—there are no color management settings, color space issues, or profile warnings to worry about.

Just because the image processing is simpler doesn't mean it is inferior, as these changes have been made without compromising the quality of the image processing. A digital image is made up of nothing more than a series of numbers. and during the image editing process, those numbers are changed to new numbers. The Lightroom image processing engine ultimately reduces all of its pixel calculations into a single calculation by the most direct route possible to produce a mathematically purer result, in which any image degradation is minimized. Actually, there is quite a lot of juggling going on, including mode changes and image blending, but the essential point is that everything you do will eventually be applied as a single calculation. Another advantage of the Lightroom image processing engine is that you have full access to all of the image controls when working with JPEG, TIFF, and PSD images, just as you have when working with raw camera files. You can use any of the image controls available in the Lightroom Develop module such as the White Balance, Exposure, and Tone Curve controls to process any imported image. Lightroom does not use layers, but it does recognize and import layered images (as long as the backward compatibility option was switched on when you saved your files in Photoshop). If you need to do any kind of layering work, it is quite easy to choose the Edit in External Editor command, continue processing the image in another program, and save the results back to Lightroom in the form of an edited copy version of the original master image.

Lightroom uses a single RGB workspace to carry out all its image calculations, and the space used is similar to the ProPhoto RGB space that was originally specified by Kodak. It uses the same coordinates as ProPhoto RGB, but has a gamma of 1.0 instead of 1.8. By using a 1.0 gamma, the Lightroom RGB workspace is able to match the native 1.0 gamma of raw camera files, so its wide gamut can contain all the colors that any of today's digital cameras are capable of capturing. For these reasons, the Lightroom RGB workspace is ideally tailored to the task of handling the color processed data from the raw camera files. Concerns about banding in wide-gamut color spaces have perhaps been a little overrated, since it is really quite difficult to pull apart an image in ProPhoto RGB to the point where you see gaps appearing between the levels. Suffice it to say, the Lightroom RGB space uses a native bit depth of 16-bits per channel, which means that Lightroom is able to process up to 32,000 levels of tonal information per color channel. Since a typical digital camera is capable of capturing up to 4,000 levels per color channel. it is probably true to say that the Lightroom RGB workspace can safely handle all of the tone and color information that's been captured by any digital camera.

Camera Raw compatibility

The Lightroom Develop module works with the same Camera Raw engine that's used in Photoshop and Bridge to apply all the image adjustments. However, it is only possible to maintain absolute compatibility between the Lightroom Develop module and the Camera Raw engine used by Photoshop and Bridge if you are using the latest versions of both programs. This is because Adobe only provides updates to Camera Raw and Lightroom within the lifetime of each full product version. As new cameras are released, Adobe will provide further, free Lightroom updates, which will mainly include Camera Raw updates that allow you to read raw files from the latest digital cameras. You can usually count on an update being released roughly every three or four months. So, for example, if you purchased Lightroom 2.0, you would have had free access to all the incremental updates (i.e., Lightroom 2.1 through 2.7). And if you purchased Photoshop CS4, you would have had access to all the Camera Raw updates from version 5.0 through 5.7. Once a product is replaced by a new full version, such as Lightroom 3.0, the upgrade path for the previous Lightroom version comes to an end. If you wish to carry on receiving updates, your best option will be to upgrade to the next full version (in this case, Photoshop CS5). After all, Lightroom 3 does contain new Develop module features, and you can hardly expect Adobe to allow you to keep upgrading for free-there does have to come a cutoff point. However, there will be no problem in supplying Lightroom 2 edited files to a Lightroom 3 user, and a Lightroom 2 user will also mostly be able to read Lightroom 3 edited files—everything that is, except for any Lightroom 3 adjustments that Lightroom 2 can't understand, such as the new color noise reduction or Post-Crop vignettes.

A bigger problem is how to maintain compatibility between Lightroom and older versions of Photoshop (and, therefore, older versions of Camera Raw). Customers who choose not to upgrade Photoshop at the same time as they upgrade Lightroom should only be slightly disadvantaged. Basically, Photoshop CS4 users will find that there is a free Camera Raw 5.7 update that allows them to read (nearly) all the adjustments made in Lightroom 3 edited files, via Camera Raw. This means Photoshop CS4 users will be able to open raw images that have been edited in Lightroom 3 via Camera Raw and see their images appear the same as in Lightroom 3 (except for any auto lens or perspective corrections). Camera Raw 5.7 will have the benefit of the new demosaic processing, but you won't be able to edit any Process Version 2010 or other settings that would effectively be new to Camera Raw in Photoshop CS4, nor will you be able to update an image from Process Version 2003 to Process Version 2010. Earlier versions of Camera Raw (prior to 5.7) won't be able to recognize Lightroom settings that are new to Lightroom 3. However, when choosing the Edit in Photoshop command, Lightroom always uses its own internal Camera Raw processing engine to render a TIFF, PSD, or JPEG image, so in this respect there won't be any limitations when working with Lightroom 3 and older versions of Photoshop.

NOTE

Lightroom 3 does now allow you to import CMYK images and edit them in the Develop module, although understand that these edit adjustments are taking place in RGB and any export you make from Lightroom (except for export original) will result in an RGB output. While on one level, this gives you more control to fine-tune the look of your CMYK images, this could lead to problems if the original source CMYK files are opened directly via Photoshop (because the Lightroom adjustments won't be seen). Also, it's not really ideal to use a program like Lightroom to edit your CMYK files in this way. The best route would be to go back to the raw or RGB original, make your adjustments there, and then create a new CMYK output from that. You can do this in Lightroom by using the Export dialog to create, say, a TIFF output and incorporate a CMYK conversion Photoshop droplet action as part of the Export process routine (see page 494 in Chapter 9).

NOTE

Smart Objects that have been opened via Lightroom 3, which use Process Version 2010 or other new Lightroom 3 settings can also be viewed via Camera 5.7, but again, you won't be able to edit those settings that are effectively new to Camera Raw in Photoshop CS4.

NOTE

The Process Version 2003/Version 2010 distinction applies only to the sharpening, noise reduction, recovery, and fill light adjustments, since these particular settings are the ones that are common to both Process Version 2003 and Process Version 2010 image settings. Therefore, it is possible to use the brand new Grain Effect adjustment on a Process Version 2003 image without having to update it to Process Version 2010.

Process versions

For the first time since the introduction of Camera Raw, Adobe has been obliged to add the concept of process versions to the Camera Raw processing. This has happened because Lightroom 3 has seen the introduction of new processing features that have had a major impact on the overall raw conversion process—in particular, improvements to the sharpening and noise reduction, which affects the total appearance of the image rather than just one aspect of the raw processing. Because of this, there are now two process versions you can choose from when editing your photos—and this will apply not just to raw files but also to DNG, TIFF, JPEG, and PSD images, too. When you go to the Develop module and edit a photo that's previously been edited in an earlier version of Lightroom, it will use Process Version 2003 and an exclamation point button appears in the bottom-right corner of the content area to indicate that this is an older process version image. Clicking this button updates the file to Process Version 2010, which then allows you to take advantage of the latest sharpening and noise reduction features. Or, you can go to the Settings menu and choose Update to Current Process to update multiple photos to the latest Process Version 2010. You can also go to the Settings \Rightarrow Process submenu and choose which process version you wish to work with, which allows you to revert to the previous Process Version 2003 should you wish to do so. Whenever you choose to update to the latest process version you will see the dialog shown in Figure 6.1. This warns you about the consequences of updating and allows you to select a Before/After view if desired. I think you will mostly be fine choosing the "Don't show again" option and clicking Update. By default, all new files that are imported into Lightroom 3 use the latest Process Version 2010. Also, if you go to the Library module Library menu, you can choose Find Previous Process Photos to create a temporary collection of Process Version 2003 photos in the Catalog panel.

There is one trade-off to bear in mind here: The fact that the Process Version 2010 rendering is more sophisticated has also increased the amount of processing time that is required to render individual images. This may, in some circumstances, result in longer output processing times such as during an export, but the good news is that this won't affect the overall catalog performance in Lightroom 3.

Lr	Certain effects active in this photograph will be updated for Lightroom 3 and may result in slight visual changes. You may elect to preserve the original settings, or update this image to the current process.					
	Review Changes via Before/After					
	Don't show again					
	(Update All) Cancel Update					

Figure 6.1 The process version Update Process warning dialog.

Steps for getting accurate color Calibrating the display

The color management system in Lightroom requires no configuration, since Lightroom automatically manages the colors without your having to worry about profile mismatches, which color space the image is in, or what the default workspace is. There may be problems with missing profiles, but this applies only to imported files where a conscious decision has already been made to not colormanage an image. Apart from these rare instances, you can rely on Lightroom to manage the colors perfectly from import to export and print. However, you do need to give special consideration to the computer display and ensure that it is properly calibrated and profiled before you can rely on it to judge the colors of your images. This is because you want the display to show as accurately as possible what you are likely to see in print. Calibrating and profiling the display is essential, and it does not have to be complicated or expensive. So, if you want to get the colors right and avoid disappointments, you should regard the following pages as essential reading.

Choosing a display

The choice of display essentially boils down to which type of Liquid Crystal Display (LCD) you should get. As with all things in life, you get what you pay for. Since the display is what you will spend all your time looking at when making critical image adjustments, it is pointless to cut corners, just as it is pointless to scrimp on buying anything but the best-quality lenses for your camera. There are different classes of LCDs, from the budget-priced screens (such as those used on laptop computers) to large professional LCDs, which offer a high degree of color accuracy and wide color gamut, such as the EIZO ColorEdge CG301W and the NEC MultiSync LCD3090W-BK-SV. Both of these displays are easy to calibrate and profile; plus, the large 30-inch screen size means that they are comfortable to work with.

Calibrating and profiling the display

The only truly effective way to calibrate and profile a display is to use a colorimeter or spectrophotometer. It is possible to buy a good device along with the necessary software package for under \$250. You can spend up to \$1,000 on a good-quality display plus calibration package, or spend even more on a professional calibration kit that also allows you to measure and build custom print profiles. But if all you want to do is calibrate and profile the display, these more expensive devices don't offer any significant advantages over what a basic colorimeter device can do. Having said that, some software packages can help you build better profiles using the same basic hardware profiling kit.

NOTE

You don't need to be concerned with RGB workspaces or profiles when working in Lightroom. Raw files don't have profiles, and the color management of these files is handled by the internal raw processing engine, which incorporates its own calibration adjustments.

In the case of pixel images imported into Lightroom, the profile recognition is handled automatically. The image file you are working on in Lightroom can be any color space and will be color managed accordingly, provided the image has an embedded profile. If the image you are working on has no embedded profile, the situation is the same as with any other software program, and a guess has to be made as to what the colors in the file actually mean. Whenever Lightroom encounters a file with a missing profile, it assumes the image to be in an sRGB color space. There are no warning indications in Lightroom other than the appearance of the image itself. So, if the colors of a particular image you see in Lightroom don't match your expectations, it could be due to an image having a missing image profile. To prevent this from occurring in the first place, I suggest that you check your Photoshop Color Settings and ensure that you have the color management switched on so that Photoshop always embeds a profile in the files that are saved from it. The easiest way to do this is to choose a General Purpose color setting or, better still, one of the Prepress color settings in the Color Settings dialog.

Figure 6.2 I normally use the X-Rite Eye-One Photo to calibrate the displays I use at work.

There are two steps to a profiling process: The first step is to calibrate the display to optimize the screen brightness and contrast, as well as set the desired white point and gamma (**Figure 6.2**). The second step involves measuring various color patches on the screen, where the measurements made from these patches provide the source data to build a profile. On some of the advanced displays, there may be controls that allow you to adjust the brightness and contrast of the display and possibly some color controls for setting different white points and fine-tuning the color output. These settings can be adjusted during the calibration process to optimize the performance and neutralize the display before making the profile measurements. Most LCD displays have only a brightness control that adjusts the luminance of the backlight on the screen. So, when running through the preliminary calibration steps, there is often nothing you can adjust, other than the brightness, and you simply skip the steps where you are unable to make any adjustments to the display.

White point and gamma

Apart from asking you to adjust the hardware settings, the calibration software will ask you to choose appropriate white point and gamma settings before you proceed to build the profile. On an LCD display, it won't be possible to manually adjust the white point the way you could with a cathode ray tube (CRT) display. While you can set a specific white point for an LCD, such as 6500K, doing so may well compromise the display's performance, so it is usually best to select the native white point for the LCD you are calibrating.

Matching white balances

The above advice may seem at odds with how you think a display should be calibrated, since you might imagine the ideal situation would be to aim for a standard white point of, say, 6500K. People often assume the goal should be to match the white balance between different displays and viewing light sources. For side-by-side comparison this can help, but the fact is that human vision is adaptive, and our eyes always evaluate colors relative to what is perceived to be the whitest white. In reality, our eyes are constantly compensating and can accommodate changes in white balance from one light source to another. You can edit an image on a display using a white point of 7000K and check the results with a viewing box that has a white balance of 5500K, as long as the two are a reasonable distance apart.

Whether you are using a Mac or a PC, the gamma should ideally be set to 2.2, since the 1.8 gamma Macintosh option is really there only for quaint historical reasons. In fact, the Macintosh 1.8 gamma dates back to the very early days of Macintosh computers, long before color displays and ICC color management was universally adopted. Back then, it was found that the best way to get an image viewed on a Macintosh screen to match the output of an Apple black-and-white

laser printer was to adjust the gamma of the monitor to 1.8. These days, Adobe programs like Photoshop and Lightroom always compensate for whatever monitor gamma is used by the system to ensure that the images are displayed at the correct brightness regardless of the gamma that was selected when calibrating the display. Setting the gamma to 1.8 instead of 2.2 lightens the interface but has absolutely no impact on the lightness of the images that are displayed in Lightroom. These will be perceived as being displayed at the same brightness regardless of the monitor gamma. If you are using your computer mainly for image editing work, it is best to use a gamma setting of 2.2, as the image tones will be more evenly distributed when previewed on the display.

Steps to successful calibration and profiling

The performance of your display will fluctuate over time, so it is advisable to update the display profile from time to time. LCDs fluctuate a lot less than CRT displays used to, so you'll probably only need to re-profile once every month or so.

For accurate calibration, you first need to decide whether you want to buy a basic device for calibrating the monitor display only or a more advanced device that allows you to create your own custom print profiles. (I use the X-Rite Eye-One Photo.) The following steps show how the Eye-One Match 3.6.2 software can guide you through the calibration and profiling process with either the Eye-One Photo or the more affordable Eye-One Display 2 calibrator. Prior to doing a calibration or making any measurements, you should make sure the calibrator head and white tile are clean. Also, ensure that the screen surface is clean and free of dust. The following steps walk you through the process.

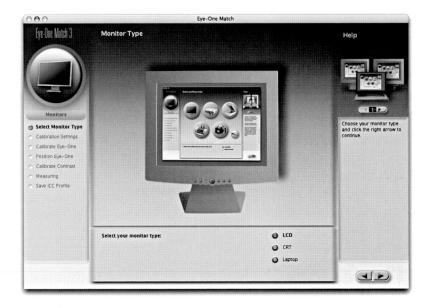

1. This first screen asks me to identify the type of display I want to calibrate and profile. The decision made here will affect the recommended settings shown in the next dialog. 2. In the previous dialog, I identified the monitor as being an LCD-type display, and the settings shown here are those recommended for a desktop LCD. Since you cannot physically adjust the white point of an LCD, it is best to select the Native White Point option. This particular software recommends that a luminance of 140 candelas m² is ideal when calibrating and building profiles for a desktop LCD, but this is not an absolute figure. Ideally, one should use a luminance between 110 and 140 for a desktop LCD.

3. I was now ready to place the calibrator on the screen and start the calibration process. To measure an LCD, you must use a counterweight attachment to carefully hang the calibration device over the screen. The Eye-One Match software can auto-detect the location of the calibrator so it knows exactly which section of the screen the calibrator should take its measurements from.

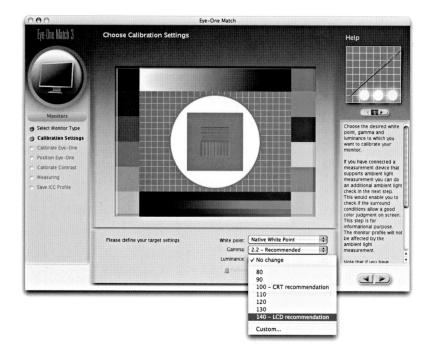

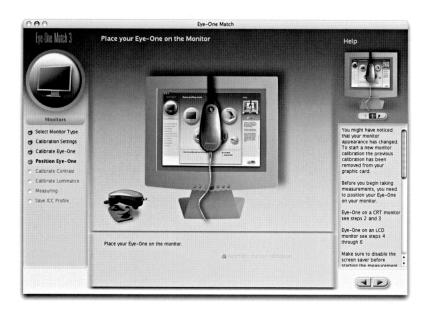

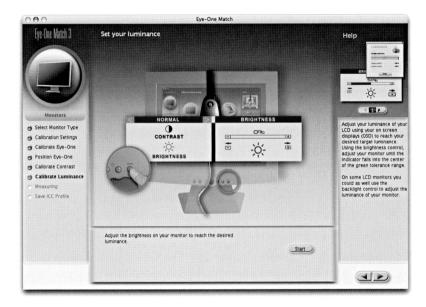

4. I couldn't adjust the contrast on the LCD I was using, but I could use the computer operating system brightness controls to adjust the brightness of the display so that the measured brightness matched the desired, target setting. I then clicked the Start button to initiate the profiling steps.

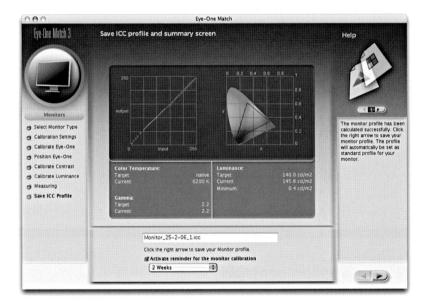

5. A series of color patches flashed up on the display. The calibration device measured these and used them to build the display profile. The profile measurement process usually takes a few minutes to complete, so you'll need to make sure that your screen saver doesn't kick in while the calibration is underway! For example, the energy conservation settings on an LCD laptop in battery-power mode may automatically dim the display halfway through the profiling process, which can adversely affect the results of the profile measurement. One way to ensure that this does not happen is to keep the mouse cursor moving every 30 seconds or so (outside of the area being measured of course) until the process is complete. At this stage, you can click to save the monitor profile that has been generated, so it will automatically be configured as the new display profile.

	Q	uick	Dev	elop
Saved Preset	Def	ault S	etting	js 🗘
Crop Ratio	Orig	jinal		¢
Treatment	Colo	or		¢
White Balance	Cus	tom		٢
Temperature	রব	4	•	DD
Tint	44	4	Þ	BIB
Tone Control	Au	to To	ne	
Exposure	ৰৰ	4	Þ). D
Recovery	40	4	Þ	ÞÞ
Fill Light	44	4		D D
Blacks	বর	٩	Ø	Did
Brightness	4.0	J	Þ	0D
Contrast	4 4	٩	Þ	00
Clarity	40	4	Þ	DD.
Vibrance	44	•	Þ	ð þ
		R	eset /	411

Figure 6.3 The Quick Develop buttons are laid out with arrows indicating how you can increase or decrease an adjustment. Note that in order to see all the controls shown here, you will need to click the expansion arrows on the right. To restore an adjustment to its default setting, click the name of the adjustment. The Auto Tone button applies an automatic adjustment to the Exposure, Recovery, Fill Light, Blacks, Brightness, and Contrast, whereas the Reset button resets everything back to the Lightroom default settings.

NOTE

Unlike the Histogram panel in the Develop module, the Histogram panel in the Library module features an animated transition when adjusting the values in the Quick Develop panel.

Quick Develop panel

Before I tackle the main controls in the Develop module, I thought it would be best to kick off with an introduction to the Quick Develop panel in the Library module (**Figure 6.3**). This panel provides all the essential image adjustment controls that are found in the Develop module, such as the White Balance, Exposure, Recovery, Fill Light, Blacks, Brightness, Contrast, and Vibrance, but it obviously doesn't require that you leave the Library module to carry out any of the above basic develop adjustments. One of the main differences with Quick Develop is that Quick Develop adjustments are always applied relative to the current Develop settings. For example, if I select a number of images that already have different Exposure settings, I can use the Exposure buttons in Quick Develop to make those photos relatively lighter or darker (as opposed to synchronizing all the photos with the same Exposure value).

The other main advantage is that you can apply Quick Develop adjustments to multiple images that have been selected in the Grid view or Filmstrip. Using Quick Develop is the same as working in the Develop module, except you don't have quite the same degree of control as you do in the Develop module. Quick Develop is, therefore, ideal for making first-pass edits, where you want to do most of your work in the Library module without having to switch back and forth to the Develop module to apply the image adjustments. Having said that, it is important to keep in mind here that the Library module previews are not as accurate as those displayed in the Develop module. This is due to the fact that Lightroom calculates the previews for the Library module differently from the way it does for the Develop module. When you edit a photo in the Develop module, the image preview shows the photo being processed directly through the Lightroom Camera Raw engine, and the edited image is updated and rendered live in the content area. When you edit a photo using the Quick Develop controls in the Library module, the Loupe view preview is updated using whatever settings have been established in the Catalog Settings File Handling section. This mechanism is suited for generating and storing a decent preview cache for fast Library module browsing, but it is not quite so ideal for assessing Develop settings adjustments.

Quick Develop controls

To use Quick Develop, go to the Library module and choose a photo, or make a selection of several photos. You are now ready to use the Quick Develop panel controls. One way you can do this is to click the Saved Preset list shown in **Figure 6.4**, and choose a default setting or a previously saved preset as your starting point. By clicking the arrow buttons in the Quick Develop panel, you can increase or decrease the tone adjustments. The single-arrow icons increase or decrease a setting by small amounts, and the double-arrow icons increase or decrease by larger amounts; these will simultaneously update the settings in the Basic panel of the Develop module.

Color controls

The Treatment menu section lets you decide whether to process an image in Color or Black & White. To be honest, I think it is better to memorize the \heartsuit shortcut as a means for toggling between the Color and Black & White modes and rely on the Treatment menu more as an indicator of which mode a photo is in.

Next, we come to the White Balance options, which include the Temp and Tint controls. If you are shooting with a camera set to Auto White Balance mode, or you were using a white balance that was correct for the lighting conditions at the time of shooting, you will probably want to leave this set to As Shot. Otherwise, you can click the White Balance menu (also shown in Figure 6.4) and choose one of the preset settings listed there, or select the Auto setting, and Lightroom will try to calculate an optimized White Balance setting for you (or use the ****Shift)** [Mac] or **Ctrl Shift** [PC] shortcut). In the Temperature section below, as you click the arrow buttons to the left, the image becomes incrementally cooler, and as you click the arrow buttons to the right, the image will appear warmer. The Tint buttons apply a green/magenta bias. Clicking the left arrows will make a photo greener, and clicking the right buttons will make it more magenta. The single-arrow buttons produce small shifts in color, and the double-arrow buttons produce dolor shifts.

Auto Tone control

In the Tone Control section, we have an Auto Tone button (**(H)** [Mac] or (**Crr**) [U] [PC]) that applies an automatic correction to the following Develop module settings: Exposure, Recovery, Fill Light, Blacks, Brightness, and Contrast. This action can be undone by clicking the Reset All button at the bottom of the panel (or you can use the **(H)** [Mac] or (**Ctri**) [Shift] [PC] shortcut). An Auto adjustment can sometimes make an instant improvement, or it may not do much at all because the tone adjustments were close to being correct anyway. It is ridiculous to expect an automatic function such as this to perform flawlessly every time, but for the most part, I find that Auto Tone works well most of the time, especially since the Auto Tone logic has been improved with each subsequent version of Lightroom. Even if Auto Tone does not produce perfect results, what it does produce can often be a useful starting point for applying further Quick Develop edits.

Other Tone controls

With the following tone and color controls, I advise you to start by adjusting the Exposure amount first, because the Exposure is critical for determining the clipping point for the highlights and overall brightness. Each click of an Exposure single-arrow button is equivalent to a 0.33-unit shift in the Develop module, whereas each click of a double-arrow button is equivalent to a 1.0-unit shift. Once you have set the Exposure, you can adjust the Recovery, if necessary. This is because a Recovery adjustment can be used to counteract the effect of an Exposure

Figure 6.4 The Quick Develop panel showing the Saved Preset and White Balance menu lists. The preset list displays all default and all saved develop settings. See "Saving Develop settings as presets" on page 394.

	Q	uick	Dev	elop	T	
Saved Preset	Cus	tom		¢	V	
Crop Ratio	Orig	ginal				
Treatment	Cold	or	12213122	\$		
White Balance	As S	ihot		e	7	
Temperature	ৰব		D	DD		
Tint	বব	Q	D	DD		
Tone Control	Au	to To	ne			
Exposure	44	<	Þ	00		
Recovery	44	<	Þ	00		
Fill Light	44	<	D	20		
Blacks	00	4	Þ	00		
Brightness	বব	4	D	22		
Contrast	00	4	D	00		
Sharpening	বব	4	Þ	DD		
Saturation	বব		D	00		
		Reset All				

Figure 6.5 The Quick Develop panel view with the Alt key held down, to make the Saturation and Slider controls visible.

adjustment to preserve critical highlight detail. A single-arrow click is equivalent to a 5-unit shift in the Develop module, and a double-arrow click is equivalent to a 20-unit shift. Fill Light is a shadow lightening adjustment that allows you to brighten the shadows to reveal any hidden shadow detail. A single-arrow click is equivalent to a 5-unit shift in the Develop module, and a double-arrow click is equivalent to a 15-unit shift. The Blacks controls the shadow clipping. With the Blacks button, a single-arrow click makes 1-unit shifts, and a double-arrow click shifts 5 units. Brightness and Contrast are fairly self-explanatory, but note that these adjustments are applied *after* Exposure, Recovery, Fill Light, and Blacks, which is one reason why I suggest you apply the Exposure adjustment *before* you adjust the Brightness. A single-arrow click on the Brightness and Contrast buttons is equivalent to a 5-unit shift in the Develop module, and a double-arrow click is equivalent to a 20-unit shift in the Develop module, and a double-arrow click is

The Clarity adjustment adds localized contrast to an image. Adding clarity can make a picture look "clearer" rather than "sharper," because it is increasing the midtone contrast to make the midtone areas stand out more. Most photos can benefit from a small clarity adjustment, and I explain why and how to make the most of Clarity later in this chapter. The Vibrance adjustment is similar to the Saturation control in the Develop module, but it works by applying a nonlinear adjustment that brightens the duller colors without oversaturating the already saturated colors. With both Clarity and Vibrance, a single-arrow click is equivalent to a 5-unit shift in the Develop module, and a double-arrow click is equivalent to a 20-unit shift.

If you hold down the Att key (see **Figure 6.5**), the Clarity adjustment switches to show Sharpening. In Att key mode, the Sharpening controls in Quick Develop are equivalent to making Sharpening Amount slider adjustments in the Develop module Detail panel. Although you don't have access to the other three sharpening sliders, you can still make an initial sharpening adjustment before you get around to fine-tuning the other settings later. If you hold down the Att key, the Vibrance adjustment switches to show Saturation, which can be used to apply standard, linear saturation adjustments. With both Sharpening and Saturation, a single-arrow click is equivalent to a 20-unit shift.

The Reset All button (**B**(Shift) **R** [Mac] or **Ctrl**(Shift) **R** [PC]) resets all the Develop settings that have been applied to a photo (not just those that have been applied via Quick Develop) to their default import settings. This action resets the Develop settings to a zeroed or default state, so use this button with caution.

A typical Quick Develop workflow

The following steps provide a brief overview of how you can use the Quick Develop controls to edit multiple photographs in the Library module.

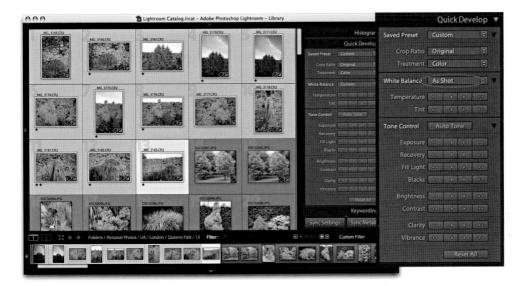

1. These daylight photographs were shot with a digital camera in raw mode and imported using the Default tone and color and As Shot White Balance setting. In this first step, I made a selection of all the photos that I wished to adjust.

90	1	Lightroom Catalog.lrc	at - Adobe Photoshop L	ghtroom - Library			Quick Dev	elop
MG 3165 CR2	≕{} 5.3166CR2	≡§ MG_3167.CR2	MG_3170.CR2 = [].	MG_3171.CR2 =0	Histograi Ouick Develo	Saved Preset	Custom	¢
		milited	atta	-	Saved Preset Custom	Crop Ratio	Original	•
	100				Crop Ratio Original	Treatment	Color	e e
	MG 3175.CR2 = 0.		*	* MG 3178CB2 =0	White Balance Custom	White Balance	Custom	÷
=D	MG 3175.CR2 = 5	MG_3176.CR2	MG 3177.CR2		Temperature Collection	Temperature	0000	
122		A Start Start			Tint	Tint	30 V V	00
·	012	*	() Z		Exposure	Tone Control	Auto Tone	
=9	* ≡§	=ß	0500001.000	DSC02092.IPG	Fill Light 🔤 👘 👘	Exposure	00 0	22
MG 3181.CR2	G_3162.CR2	MG_3183.CR2			Blacks	Recovery	00 0 0	
1	and faller and		State and	Save we	Contrast Contrast	Fill Light	10 1 1	36
*		*		(E)	Clarity Free Free States	Blacks	40 A B	
OSCO2094JPG			DSE02094.4PG		Vibrance Reset All	Brightness		×2
	C02095.PG	DSCROPPING	20 20	DSC02092JPG	Keywordin	Contrast	90 A B	- 55
		TRACT			Sync Settings Sync Metac	Clarity	64 8 B	55
2 #1 + + Fo	iders / Personal Photos	/ UK / London / Queens Park	713 Filter: 🕂	2	Custom Filter	Vibrance		- ×
							Reset	AII
		betticace	And the second sec	• Stored and Stored and Store	The second s	Contraction of the local division of the loc		Constanting of the

2. I first wanted to cool the colors in the selected photos, so I clicked the double-arrow button (circled here) to make all the photographs appear bluer.

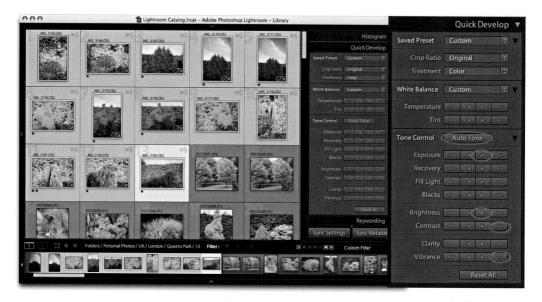

3. I now wanted to apply some tonal edits, so I clicked the Auto Tone button followed by the Exposure, Brightness, Contrast, and Vibrance buttons (circled here). This combination of adjustments improved the appearance of all the photos.

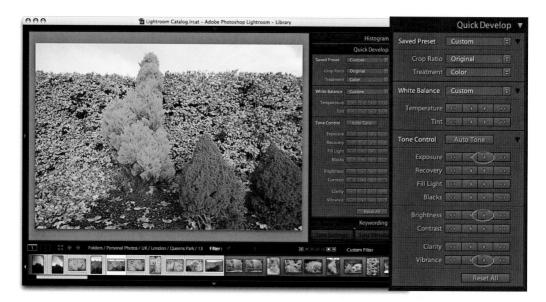

4. However, when looking at the photos grouped together I noticed two pictures in the middle of the selection that needed to be lighter than the others. There was no need to deselect the current photo selection. I double-clicked one of the photos to work in Loupe view, where the Quick Develop controls could be applied one image at a time. Here, I added more Exposure, Brightness, and Vibrance.

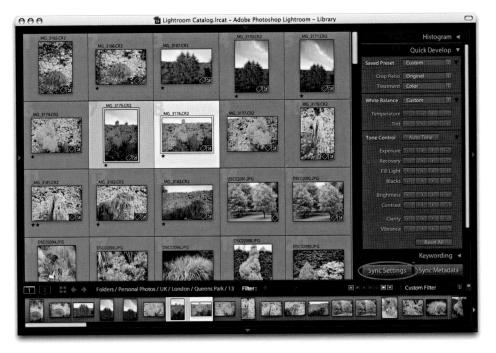

5. This took care of that one middle photo. I clicked the cell border of this image to deselect all the photos in the selection (except for that photo) and used a <u>Shift</u>-click to reselect this recently edited image and the photo next to it. I then clicked the Sync Settings button at the bottom.

White Balance	Treatment (Color)	Lens Corrections	Spot Removal
 Basic Tone Exposure Highlight Recovery Fill Light Black Clipping Brightness Contrast Tone Curve Clarity Sharpening 	Color Saturation Vibrance Color Adjustments Split Toning Local Adjustments Brush Graduated Filters Noise Reduction C Luminance C Color	 Lens Profile Corrections Chromatic Aberration Lens Vignetting Effects Post-Crop Vignetting Grain Process Version Calibration 	Crop Straighten Angle Aspect Ratio

6. This opened the Synchronize Settings dialog, where I clicked the Check All button to select all settings. I then clicked the Synchronize button to synchronize the settings across the two photos that were selected in Step 5.

Figure 6.6 The Quick Develop crop menu options contain a list of presets. You can add to this list by clicking Enter Custom to add up to nine new custom crop proportions to the list.

Quick Develop cropping

The Crop Ratio menu options (**Figure 6.6**) can be used to apply a preset crop ratio that trims photos evenly on either side. Image cropping is something that you usually want to carefully apply to each photograph individually, but I would say that having a quick way to change the aspect ratio of a bunch of pictures might be more useful for someone like a school photographer who wants to quickly prepare a set of portraits using a fixed aspect ratio setting. You can also create your own Custom Aspect Ratio crop settings for use in the Quick Develop panel (**Figure 6.7**). In **Figure 6.8**, I selected the 8.5 x 11 proportional crop and applied this to the selected photograph.

Aspect Ratio:	8.50]×	11.000
C	Cancel) (ОК

Figure 6.7 The Enter Custom Aspect Ratio dialog.

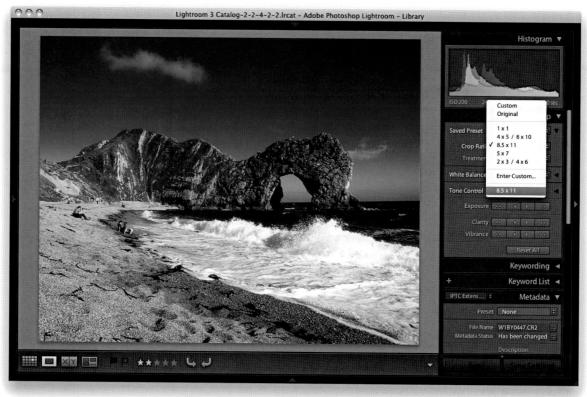

Figure 6.8 Shown here is a photograph to which I applied an 8.5 x 11 proportional crop to a landscape image that originally had a 2:3 aspect ratio.

Synchronizing Develop settings

The Sync Settings button at the bottom of the right panel section lets you synchronize all the Develop image settings and not just those that have been applied via the Ouick Develop panel (Figure 6.9). If you have a group of images selected and you want the settings to match the most selected image, just click the Sync Settings button, which calls up the Synchronize Settings dialog, shown in Figure 6.10. By the way, the most selected image will be the one most highlighted in the grid and will also be displayed in the Navigator panel. Notice that the Synchronize Settings dialog contains selectable options for all the different Develop settings. If you have just imported a collection of images and this is the first time you are editing these photos, select Check All so that all the image setting attributes are synchronized. In the early stages of a catalog photo edit, this is probably the easiest option to choose because no Develop edits will have been applied to any of the other pictures yet. If you are synchronizing photographs and it is likely that some of the images may have been individually adjusted, you probably won't want to override these settings when you carry out a synchronization. In these instances, it is better to make a careful selection of only those settings attributes that you want to see synchronized and leave all the other settings as they were. When you are done, click the Synchronize button at the bottom to synchronize the image settings so that they all match the most selected image.

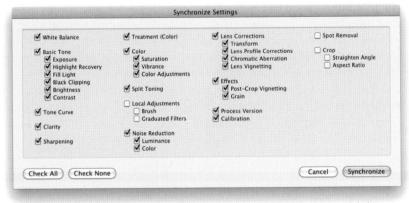

Figure 6.10 When you click the Sync Settings button in the Quick Develop panel, this opens the Synchronize Settings dialog shown here.

Quick Develop							
Saved Preset	Defa	ault Se	tting	s 🗘			
Crop Ratio	Orig	Original 🗘					
Treatment	Colo	or		¢			
White Balance	As S	ihot		¢			
Temperature	44		Þ	9.0			
Tint	44		Þ	DD.			
Tone Control	Au	ito Toi	ne				
Exposure	বব		Þ	00			
Recovery	00	•	D	ØØ			
Fill Light	90	<	Þ	00			
Blacks	44	<	Þ	DD			
Brightness	বব	4	Þ	66			
Contrast	90		Þ	DD			
Clarity	বর	٩.	Þ	DD			
Vibrance	44	4	D	DD			
		R	eset /	MI]			
Sync Setting	s	Syn	ic Mi	etada	ta		

Figure 6.9 The Sync Settings button can be used to synchronize all Develop module settings, not just those that have been applied via the Quick Develop panel.

TIP

The Local Adjustments, Spot Removal, and Crop settings are deselected by default. This is because you may not always want to synchronize these specific settings. For example, synchronizing the Spot Removal settings can be beneficial if you are syncing a selection of matching shots in which you want to remove sensor dust marks that always appear in the same spot and the individual pictures don't vary too much. But if all the pictures are shots of different subjects, sharing the Spot Removal settings would just create a big mess (as well as overwriting any spotting work you had done already).

NOTE

JPEG capture has the advantage of offering faster capture burst rates and smaller file sizes. JPEG capture does make sense for people like busy news photographers, where speed and the compactness of the file size is essential for wireless shooting. JPEG is also perfectly fine for shooting fun photos on a digital compact camera. But for everything else, I recommend that you shoot in raw mode whenever possible. Raw files are often not that much larger than a high-quality JPEG, and the raw mode burst rates on a typical digital SLR are usually adequate for all but the fastest sports shooters. Apart from that, it just doesn't make sense these days not to shoot in raw mode. Above all, Lightroom is designed to help you make the best possible photographs from the raw data captured by your camera sensor. Only by shooting in raw mode can you ever hope to achieve the highest-quality results.

Raw or JPEG?

At first glance, Lightroom appears to handle the processing of raw images and non-raw images as if they were the same. The fact that you now have more controls at your disposal to edit the color and tone in a JPEG-capture image, is, in one way, a good thing, but it would be dangerous to conclude from this that a JPEG image can now be considered equal to the quality of a raw capture. This section provides a brief summary of the differences between shooting in raw and JPEG mode.

A typical good-quality digital camera is capable of capturing up to 12-bits of data per channel, which equates to 4096 levels of information per color channel. This does not mean that every image you capture will contain 4096 levels in every channel—an underexposed digital photograph will have far fewer levels than this. But even so, you want to preserve as much levels of data as you can. It is claimed that the medium-format digital cameras and some of the more recent digital SLRs can capture as many as 14-bits of data or 16,384 levels per channel. Whether you can capture 14-bits or just 12-bits of data per channel, being able to record up to 4096 levels still means you have a lot of levels to play with.

A raw-capture file contains the direct raw data as captured by the sensor, without any pre-image processing applied to it. This is the major advantage of raw: When you shoot using raw mode, apart from the exposure and ISO setting, nothing else about the image processing will have been decided yet. A raw-capture file is really like a digital negative that has yet to be processed and, as such, is a master file with the potential to be edited in many different ways. Some photographers have found their initial encounters with raw images to be off-putting because some raw-capture images may appear dull and lifeless when they are first imported into Lightroom. But, in a way, this is a good thing because you want there to be room to expand the tones and add more contrast as you see fit. The controls found in Lightroom's Develop module can be used to interpret your master files in a variety of different ways, but they work best when they are used to edit raw images.

The alternative is to shoot using JPEG mode, where the camera automatically applies the image processing in-camera. This image processing can include things like setting the white balance, adjusting shadow and highlight clipping, applying a tone curve, removing noise, sharpening the image, and converting the raw data to an 8-bit RGB output space. JPEG mode also compresses the color data (while trying to preserve the luminance) to produce a compact JPEG-capture file, and all the image processing is managed by an onboard image processor inside the camera. The user has limited control over the JPEG processing beyond setting the white balance settings, sharpness, noise handling, and RGB output space before the pictures are shot. You can use the Develop module controls in Lightroom to enhance a JPEG photo's appearance, but there are limitations as to how much you can do before you start to see clipping and other artifacts appearing in your JPEG-edited photos.

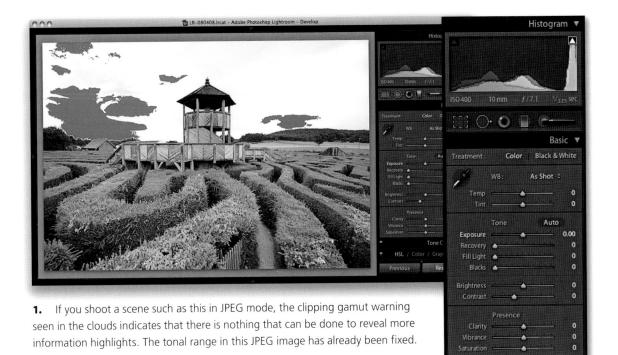

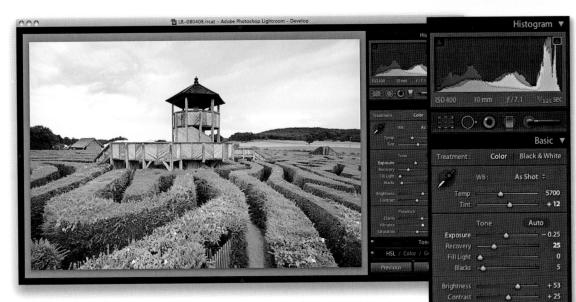

2. If the same image is captured in raw mode, a negative Exposure combined with a positive Recovery adjustment quickly reveals the highlight detail that the JPEG-capture version was unable to preserve. When you process a raw file, you potentially have more tone information to play with and, therefore, more flexibility when making tone and color adjustments in the Develop module.

+ 29 + 33

0

NOTE

The panels in the right section of the Develop module can be expanded by clicking the panel headers. If you Att -click an individual panel header, you put the panels into "solo" mode, which means that, as you click to select and expand a panel, this action simultaneously closes all the other panels.

TIP

You can reset the individual Develop settings at any time by doubleclicking the slider names.

NOTE

You can learn about Lightroom shortcuts by going to the Help menu and choosing the module help option at the bottom of the menu (or by pressing ﷺ?). In addition, there are shortcuts that will enable you to switch between individual modules. (These are the Mac shortcuts. PC users should use Ctri Alt plus the number).

 Image: Constraint of the select Library

 Image: Constraint of the select Develop

 Image: Constraint of the select Slideshow

 Image: Constraint of the select Print

 Image: Constraint of the select Web

 Image: Constraint of the select to the previous module

Also, G selects the Library module in Grid mode, E selects the Library module in Loupe mode, R selects the Crop Overlay mode, Q selects the Spot Removal tool, M selects the Graduated Filter, K selects the Adjustment brush and D selects the main Develop module again.

The Develop module interface

The Develop module provides all the controls photographers need for making adjustments and corrections to their images (**Figure 6.11**). The main controls are located in the right panel section. At the top are the Histogram panel and Develop Tools panel, and below that the Basic panel, which is where you make all your main image adjustments.

This is followed by a Tone Curve panel, which provides you with a more advanced degree of control over the image tones, allowing you to further fine-tune the Tone settings that have been set in the Basic panel. In the example shown here, the Tone Curve controls have been adjusted to apply the optimum contrast and brightness in both the sky and the rock (note the unusual tone curve shape). The Tone Curve features a Target Adjustment tool, which, when you click to activate it, allows you to move the cursor over the image, click an area of interest, and drag with the mouse to lighten or darken rather than have to drag the sliders. Similar target mode controls are available when making HSL and B&W panel adjustments. Note that the Tone Curve panel now also features a point curve editing mode.

Below that is the HSL / Color / B&W panel. The HSL tab section provides similar controls to the Hue/Saturation adjustment in Photoshop, as these allow you to adjust separately the hue, saturation and luminance components of an image. The Color tab section is similar to HSL, but with simpler controls (and no Target mode option). Clicking the B&W tab section (\boxed{V}) converts an image to black and white and lets you make custom monochrome conversions, creatively blending the RGB color channels to produce different types of black-and-white output.

The Split Toning controls can be used to colorize the shadows and highlights separately. (The Split Toning controls work quite nicely on color photos, as well as on black-and-white ones.) The Detail panel lets you add sharpness to imported images and has controls for suppressing the color and luminance noise in an image.

The Lens Corrections panel allows you to correct for global lens vignetting, as well as the chromatic aberrations responsible for color fringing. It now also offers auto lens corrections and manual transforms. The new Effects panel includes Post-Crop vignette sliders for applying vignette effects to cropped images with brand new Post-Crop vignetting options, plus Grain sliders for adding film grain effects.

The Camera Calibration panel allows you to apply custom camera profile or camera calibration settings that can compensate for variations in the color response of an individual camera sensor. Develop settings can be saved as custom presets. The left panel contains a selection of default presets to get you started, but it is easy to create your own presets using all or partial combinations of the Develop module settings. Notice that, as you roll over the list in the Presets panel, you'll see an instant preview in the Navigator panel, without having to click to apply an effect to the main image.

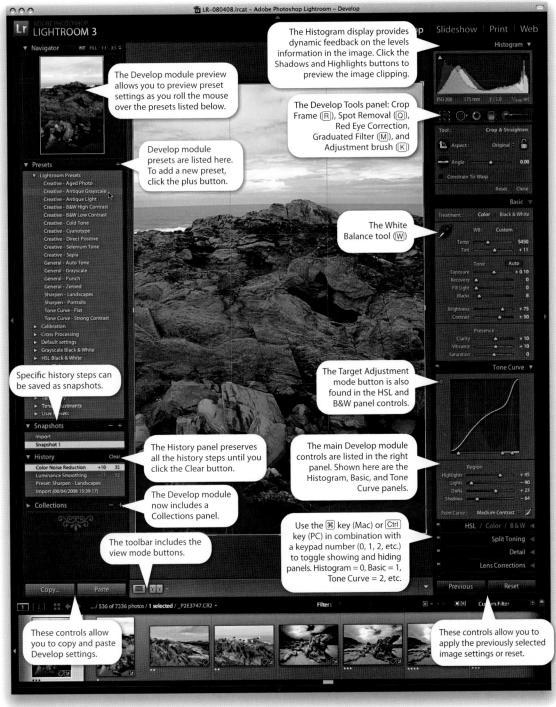

Figure 6.11 The Develop module interface.

NOTE

Dragging a handle moves the crop bounding box relative to its center. Dragging the cursor outside of the bounding box rotates the crop. Dragging the cursor inside the crop bounding box scrolls the image relative to the crop.

You can toggle the Constrain Aspect Ratio lock by pressing A.

NOTE

Now that Lightroom can apply lens profile corrections (see pages 330-333), this means that profilecorrected images will end up being warped to some degree. The same is also true for images that have been warped using the Manual transform controls. Normally, when you apply a lens profile correction, the crop is constrained to the warp bounds anyway. However, checking the Constrain to Warp option ensures that the crop bounds do not exceed those of the warped image content and, therefore, prevents the undefined padded gray areas from showing. For example, it is possible to adjust the Scale slider in the Lens **Corrections Manual section to reveal** the padded gray area. Checking the Constrain to Warp option here and in the Crop Overlay options snaps the crop overlay to the constraints of the warped image bounds.

TIP

In Lightroom 3, while you are in Crop Overlay mode, you can use the X key to rotate the aspect ratio. That is, you can change a current landscape aspect ratio crop to a portrait crop.

Develop module cropping

From any of the modules in Lightroom, you can press (R) to switch directly to the Crop Overlay mode in the Develop module. Or, if you are already in the Develop module, you can also click the Crop Overlay mode button in the Tools panel to activate cropping. Figure 6.12 shows a close-up view of the Crop tool panel controls. Once you are in Crop Overlay mode, a crop bounding box appears, initially selecting all of the image. As you drag the crop handles, the image and crop edges move relative to the center of the crop (Figure 6.13), and the areas outside the crop bounding box appear shaded. Dragging the cursor inside the crop bounding box scrolls the image relative to the crop, allowing you to easily reposition the photograph relative to the crop bounding box. If you hold down the [Alt] key, the crop bounding box can be made to resize relative to the crop box center. To reset the Crop Overlay, click the Reset button or press (#(Alt)(R) (Mac) or Ctrl Alt R (PC) and click Close to apply a crop and exit the Tools panel. Whenever you drag one of the crop handles to make a non-rotational crop, a dividing third grid overlays the image. These thin grid lines can be useful as an aid to composition. The photograph in Figure 6.13 has been cropped using the dividing third guides, although you can also choose other custom overlay options, which are shown on pages 269–271. You can use the Toolbar to have the overlays always on, off, or in Auto mode, where they are visible only when you drag one of the crop handles.

Rotating the crop

To rotate and crop an image at the same time, move the cursor outside the crop bounding box and click and drag. Alternatively, you can use the Straighten slider in the Tools panel, or the Straighten tool, to straighten a photograph. In either case, the image rotates relative to the crop bounding box (which will always remain level). You can also click the Crop Frame tool in the Tools panel (Figure 6.12) to activate it: Place the Crop Frame cursor over the photograph, and then click and drag to make a free-form crop (as you would with the Crop tool in Photoshop). When you have finished defining the crop, the Crop Frame tool returns to its docked position in the Tools panel.

Crop aspect ratios

When the Constrain Aspect Ratio box is checked, the current crop aspect ratio is preserved as you apply a crop. If no crop setting has been applied yet, the locked aspect ratio is locked to the current image proportions. So, if you check this box and drag any of the handles, such as a corner handle, the crop area matches the exact proportions of the current image. If you go to the Crop tool Presets list, you can select one of the aspect ratio presets in the list or choose Enter Custom, which opens the dialog shown in Figure 6.13. Here you can enter settings for a new custom aspect ratio setting and click OK to add this setting to the Crop tool Presets list.

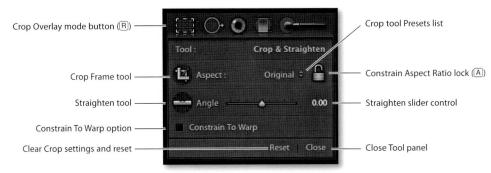

Figure 6.12 This shows a close-up view of the Crop tool panel controls.

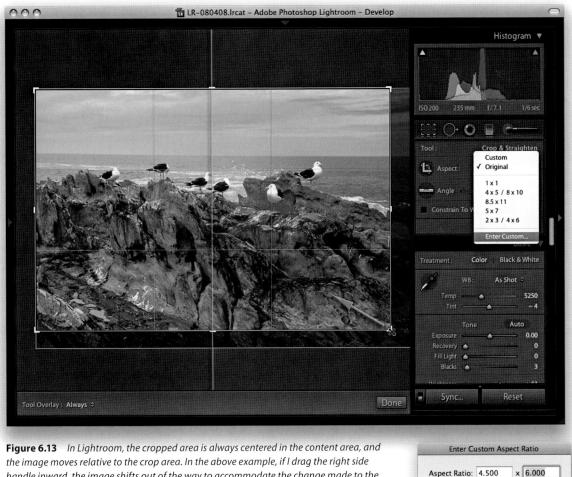

handle inward, the image shifts out of the way to accommodate the change made to the crop area and the center crop handles (aligned to the green line) will always remain in the center of the content area. You can select crop presets from the list shown here, or click Enter Custom, and create your own custom aspect ratio presets. Note that, in Lightroom 3, the Crop tool Presets list has been rationalized.

Cancel

OK

1. If you click the Crop Frame tool to select it, you can simply drag to apply a free-form crop to a photograph. Release the mouse, and the Crop Frame tool returns to its usual location in the Tools panel.

2. In this next step, I clicked the Crop Lock button to unlock the fixed crop aspect ratio. This allowed me to click a corner or side handle of the crop bounding box and drag to reposition the crop relative to the photograph.

3. I then clicked to select the Straighten tool and dragged it across the image to define a straighten angle. (You can also adjust the straighten angle by using the Angle slider in the Tools panel.)

4. You can also straighten a photograph by clicking anywhere outside the crop bounding box and dragging. As you do, a fine grid appears, and you can use the grid lines to help align the rotation to elements in the picture.

TIP

Don't forget that in addition to using the Photo ▷ "Rotate left" and "Rotate right" commands, you can also transform individual photos by choosing Photo ▷ Flip Horizontal or Flip Vertical.

Crop to same aspect ratio

There is also a contextual menu command and Develop module (S) keyboard shortcut that can be used to crop to the same aspect ratio. Basically, you can use this to take the current aspect ratio crop (such as in **Figure 6.14** below) and expand the crop boundaries to fit the frame and preserve the same aspect ratio.

Repositioning a crop

The Crop tool in Lightroom always restricts the cropping to within the boundary of the document. Unlike in Photoshop, you cannot drag the Crop tool outside the image document area to increase the canvas area. You can crop an image only within the confines of the photograph. So, however you drag or rotate the crop, you will always be applying the crop to the inside of the picture. When you click inside the crop bounding box, the cursor changes to show the Hand tool, which allows you to scroll the image relative to the crop. As you drag with the mouse, the crop box remains static and the image moves behind the crop (Figure 6.14).

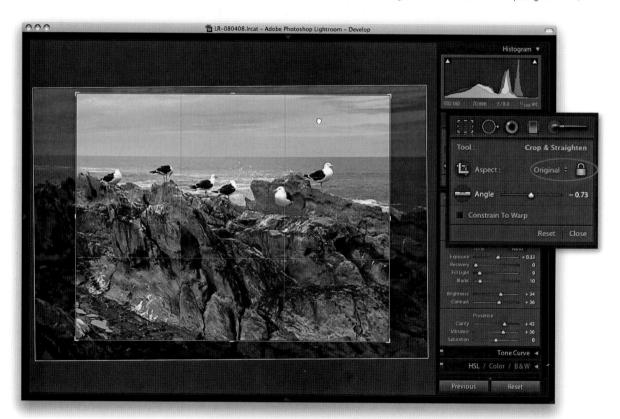

Figure 6.14 When the Crop Lock button is checked again, the crop bounding box is locked to the current aspect ratio. When you drag any of the bounding box handles, the current aspect ratio is the one that is applied. As you click the photograph inside the crop bounding box area, you can reposition the image relative to the crop.

Crop guide overlays

In the Tools \Rightarrow Crop Guide Overlay menu (**Figure 6.15**), you have six different crop guide overlays to choose from. These range from the simple Grid crop guide overlay shown in **Figure 6.16**, to other more exotic overlay designs. For example, I have included on the following pages the Diagonal crop guide overlay (**Figure 6.17**) and the Triangle crop guide overlay (**Figure 6.18**). So why should you want to use different crop guides? Cropping is partly about trimming away parts of the picture that are distracting and aligning straight edges, but it is also about creating a nice-looking, well-balanced visual composition with the picture content. The Thirds overlay provides a standard reference that you may already be used to seeing in certain camera viewfinder screens, while the Golden Ratio and Golden Spiral crop overlays offer new ways to preview a photo as you compose a crop.

Note that, regardless of the crop guide you choose, the Grid overlay design shown in Figure 6.16 appears whenever you rotate the crop by dragging with the cursor outside the crop bounding box. The Grid overlay is useful in these instances, since it can help you align the horizontal or vertical lines when straightening a photograph.

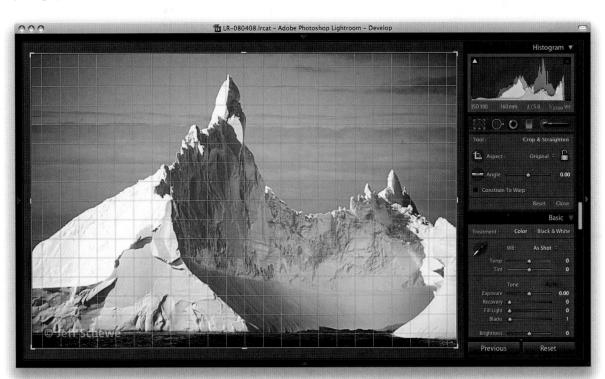

Figure 6.16 The Grid crop guide overlay.

Figure 6.17 The Diagonal crop guide overlay.

Figure 6.18 The Triangle crop guide overlay.

Crop guide orientation

It is also worth pointing out that the (i) keyboard shortcut can be used to cycle quickly through the crop guide overlays. You can also use the (Shift) is shortcut to cycle through the crop guide orientation for the individual crop overlay modes Triangle (two modes) and Golden Spiral (eight modes). In **Figure 6.19**, I have shown the Golden Spiral with an inverted overlay.

Figure 6.19 You can use the A Shift shortcut to switch the orientation of the Triangle and Golden Spiral crop guide overlays.

Cancelling a crop

You can also use the Esc key to revert to a previously applied setting made during a crop session. Let's say that the picture shown in Figure 6.19 had been cropped slightly on the left. If you were to alter the crop by adjusting the crop ratio or crop angle and then hit the Esc key, you would always be taken back to the original crop setting. If, on the other hand, you adjusted the crop, exited the crop mode for this photo, started editing photos in another folder, and returned later to this picture, the new crop setting would become the one that Lightroom reverts back to when you readjust a crop and then hit the Esc key.

Figure 6.20 The Tool Overlay menu options.

Automatic lens corrections

Some of the latest digital cameras, such as the Panasonic DMC-LX3, are capable of storing lens-corrected linear raw data that can be read and used to optically correct for things like geometric distortion. Ever since version 2.5, Lightroom has been able to read this data and use what are referred to as "opcodes" in the latest DNG specification that allow the lens correction processing to be applied at the raw processing stage rather than in-camera. In fact, the camera manufacturers were not willing to allow Adobe to provide Camera Raw Support for their cameras unless Adobe could respect this data and apply the lens corrections in Camera Raw. However, if you go to pages 324–327, you can read about how this capability has now been extended in Lightroom 3 to provide auto lens corrections for most camera body/lens combinations.

Tool Overlay menu

The Tool Overlay menu can be used to control the behavior of the crop guide overlays, but it can also be used to control the Spot Removal, Red Eye, Adjustment brush, and Gradient Filter. I'll be covering these in more detail toward the end of the chapter. But for now, let's just look at the Tool Overlay menu options.

The Tool Overlay options

The Tool Overlay options are accessed via the Tools menu (**Figure 6.20**). The tool overlays are the crop guides that appear inside a cropped area when using the Crop tool (as well as the Red Eye Correction ellipses, Spot Removal circles, Adjustment brush pin, and Gradient Filter pin markers). If you select the Always Show menu option, the tool overlays remain visible at all times. If you want to hide the tool overlays, select Never Show from the menu. When this menu option is selected, the overlays remain hidden, even when you hover over the image. But as soon as you start working with a tool, the tool overlay behavior automatically switches to Auto Show mode. The Auto Show mode only makes the tool overlays visible when you hover over the content area. In other words, the Crop overlay guides, Red Eye Correction circles, Spot Removal circles, Adjustment brush, and Gradient Filter pin markers disappear from view whenever you roll the mouse cursor outside the image area, such as to the top panel menu.

Another way to work with the tool overlay show/hide feature is to use the **Shift**(H) (Mac) or (Ctri(Shift)(H) (PC) keyboard shortcut, which acts as a toggle for switching between the Always Show and Never Show options. An easierto-remember (and more flexible) shortcut is the (H) key, which toggles between the Auto Show and Never Show modes or between the Always Show and Never Show modes (depending on whether you had Auto Show or Always Show selected first).

Histogram panel

When you are in the Develop module, the Histogram panel is displayed in the top-right corner. (There is also a Histogram panel in the Library module, but the histogram in the Develop module has more direct relevance when making Develop adjustments.) If you want to hide the Histogram panel, you can use the **(Hac)** (Mac) or **(Ctrl)** (PC) shortcut to toggle collapsing and expanding the panel. The Histogram panel provides you with information about the distribution of the levels in an image and also allows you to turn the clipping preview on or off, which can indicate where there might be any shadow or highlight clipping in the image. You can either roll over or click the buttons circled in **Figure 6.21** or press (J) to toggle displaying the clipping preview shown below. Blue indicates where there is shadow clipping, and red indicates any highlight clipping. The clipping warning triangles themselves also indicate which colors (red, green, or blue) are initially being clipped most, and the triangle colors will eventually change to white as all three channels become clipped.

If you are editing an imported JPEG, PSD, or TIFF image, the Lightroom histogram represents the tone range based on the file's native color space. If, however, you are editing a raw capture, there are no gamut constraints until you export the image as a JPEG, TIFF, or PSD file, at which point the gamut space limit will be determined by the choice of RGB output space. sRGB has a small gamut and many of the colors will be clipped when you export. Adobe RGB is a popular, commonly used color space, and ProPhoto RGB has the widest gamut of all. Incidentally, Lightroom uses a wide-gamut RGB space similar to ProPhoto RGB to do all the image calculations, and the histogram and RGB percentage readouts are based on this native Lightroom RGB space. To find out more about the Lightroom RGB space, please refer to Appendix B.

NOTE

Histogram information is useful only if you know how to interpret it correctly. For example, if you shoot using raw mode, the histogram display on a digital camera is misleading because it is based on what a JPEG capture would record, and the dynamic range of a JPEG capture will always be less than what is available from a raw file. If you are shooting raw, the only way to tell if there is any clipping is to inspect the raw image in Lightroom, or via the Photoshop Camera Raw plug-in. In other words, don't let the camera histogram unduly sway your judgment if you have good reason to believe you are shooting with a correct camera exposure.

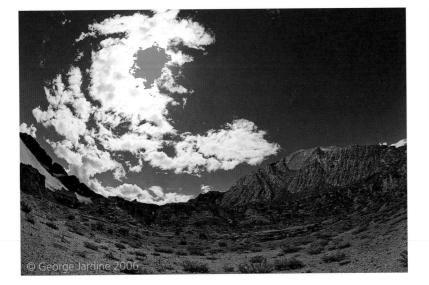

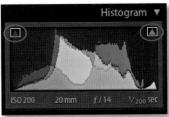

Figure 6.21 This shows the Histogram panel with the clipping warning triangles highlighted. You can see on the left an example of where a histogram clipping preview shows which areas are currently clipped in the shadows and the highlights.

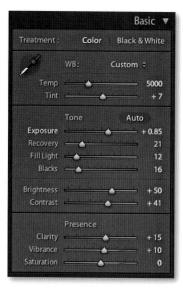

Figure 6.22 The Basic panel.

NOTE

If you are using Process Version 2010, you may notice a slight change in response for the Fill Light and Recovery slider settings. This has been brought about in order to overcome the tone inversions (or solarization) that was sometimes seen when applying extreme amounts of Recovery or Fill Light. On some of the worst-case images I have tested, the improvement here can be quite dramatic. Not all tone inversions can be prevented completely, but this is still a major improvement and a good argument for updating to Process Version 2010. However, when you do upgrade to Process Version 2010, you may sometimes need to revisit the Recovery and Fill Light sliders and readjust the settings.

Basic panel controls

If you have ever used the Adobe Camera Raw plug-in with Photoshop and Bridge, you'll already be familiar with some of the Basic panel sliders (see **Figure 6.22**). The Color controls include the Temp and Tint sliders in the White Balance tools (WB) section, which can be used to precisely adjust the white balance of a photograph. With these you can color-correct most images or, if you prefer, apply alternative white balances to your photos.

The Exposure slider sets the highlight point, determining where the image highlights get clipped, and it's also a primary tool for adjusting the overall brightness of an image. You may be aware that the Exposure slider is sometimes used as a negative exposure adjustment to rescue highlight detail. The problem here is that you can often end up setting the exposure a lot lower than is ideal and making the image darker than necessary. To address this, we have the Recovery slider, which is a highlight recovery control. It is not a tool for darkening highlights in the same way that the Fill Light can compensate for dark shadows. Rather, the Recovery slider can be used to let you bring back highlight detail without having to drag the Exposure slider too much to the left. My advice is to start with the Recovery set to 0, adjust the Exposure first (but without dragging the Exposure too far to the left), and use Recovery only when necessary to bring back important highlight detail. Note that if you hold down the Alt key as you drag the Recovery slider, you'll see a Threshold mode view of the highlight clipping.

The Blacks slider controls the shadow clipping, and although setting the shadows is not as critical as setting the highlights, you still need to be aware of how much is safe to clip when adjusting the Blacks slider. Meanwhile, Fill Light can be used to dramatically lighten the shadow areas. As with Recovery adjustments, I recommend you always adjust the Blacks before you add a Fill Light adjustment.

The Brightness and Contrast controls allow you to make basic adjustments to all the tones between the shadow and highlight clipping points. Note that increasing the contrast in Lightroom does not produce the same kind of unusual color shifts that you sometimes see in Photoshop when you use Curves. This is because the Lightroom/Camera Raw processing manages to prevent such hue shifts from occurring when you pump up the contrast.

Clarity can be used to enhance the midtone contrast and make pictures appear less flat.

At first, the Vibrance slider appears to be very similar to the Saturation slider. And it is, except that the Vibrance slider applies a nonlinear saturation adjustment. This means that less-saturated pixels get more of a saturation boost than the moresaturated pixels do. The advantage here is that colors can be given a saturation boost, but with less risk of clipping. Vibrance also contains a skin-tone protector that prevents skin-tone colors from being boosted and is, therefore, a useful alternative to the comparatively cruder Saturation slider.

Understanding camera exposures

A typical CCD or CMOS sensor in a digital camera is capable of recording over 4000 levels of information. If you are shooting in raw mode, the ability to record all these levels very much depends on a careful choice of exposure. The ideal camera exposure should be bright enough to record all the tonal information without clipping important highlight detail. This is because half the levels information is recorded in the brightest stop range. As shown in **Figure 6.23**, for each stop decrease in exposure, the number of levels that can be recorded is potentially halved. The upshot of this is that you do not want to deliberately underexpose an image, unless to do otherwise would result in the loss of important highlight detail. Deliberate underexposure can have a dramatic impact on the deep shadow detail, since relatively fewer levels are left to record the shadow information. **Figure 6.24** shows how you can easily lose detail in the shadow areas due to an underexposure at the capture stage.

As I mentioned earlier, if you are shooting raw, it is unwise to place too much emphasis on the camera histogram, since what you see here is based on a JPEG-capture view. It is best to either trust the exposure system in the camera to get it right or rely on the histogram in Lightroom. In practice, I do sometimes check the histogram as I am shooting, just to make sure that, at the very least, I am not underexposing, according to what the camera shows me. But I won't be particularly worried if this shows me a few signs of highlight clipping.

Figure 6.24 This image is divided diagonally. The top section shows the enhanced shadow detail using an optimum camera exposure setting, and the bottom section shows the same scene captured at minus two stops camera exposure and then processed to match the luminance of the normal exposure. Notice that there is more noise and less tonal information in the underexposed version.

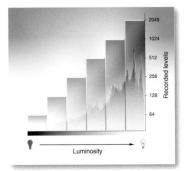

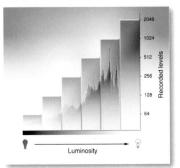

Figure 6.23 If you don't optimize the camera exposure, you may be missing the opportunity to record a greater number of levels via the sensor. The top diagram shows how a correctly optimized exposure makes maximum use of the sensor's ability to record the fullest amount of levels information possible. In the lower diagram, you can see how recording the exposure just one stop darker than the ideal exposure results in only half as many levels being recorded by the sensor.

NOTE

The image adjustment workflow described here is one that Adobe Camera Raw users have always worked with in the past, and the Basic panel controls in Lightroom mostly match the equivalent sliders in Camera Raw, which comes with Photoshop. If you see different slider options, this will be because you are using an earlier version of Camera Raw.

ΠP

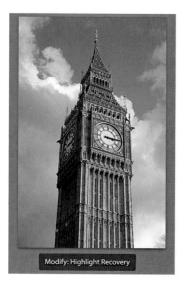

Basic image adjustment procedure

The main purpose of the Basic Develop controls is to allow you to make a firstpass adjustment to set the overall color balance and optimize the tone information in the source image, before making further fine-tuned adjustments in the remaining panels. It does not necessarily matter which order you apply the Basic adjustments in, but you will mostly find it best to work through them more or less from the top down. Usually, the main goal is to set the white balance first. If you can get this right, you'll usually find that all the other colors easily fit into place. Next, adjust the Exposure slider as you would when judging film exposures: Exposure can be used to compensate where a photograph initially appears too light or too dark, and it is always best to set the Exposure before you adjust the Brightness (we'll come to why later). You then set the Blacks slider to clip the shadows so that the darkest black just begins to get clipped. Once these first three steps have been applied to the source image, you should end up with a photograph that has a full contrast range from solid black to the lightest printable highlights. However, sometimes the Exposure and Blacks adjustments are not enough on their own. and it is necessary to use the Recovery and Fill Light sliders to bring out more detail in the highlight and shadow regions of a picture. When you have finished adjusting all these sliders, you can then fine-tune the image using Brightness and Contrast. Finally, the Presence group of sliders can be used to add Clarity (which can bring out more image contrast detail in midtone areas) and pump up the color saturation using Vibrance. Note that if you click the inside panel edge and drag, you can adjust the width of the side panels. Figure 6.25 shows the Develop panel in normal and expanded form. In this instance, a wider panel offers you more precise control when dragging the sliders.

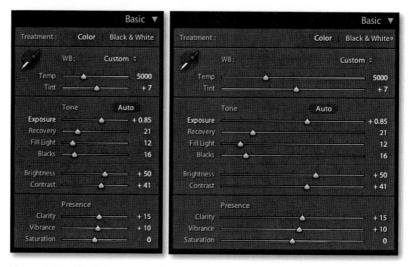

Figure 6.25 The Lightroom panels can be expanded by dragging the side edge. An expanded Develop panel offers greater precision when making image adjustments.

White Balance tool

The White Balance tool is located near the top of the Basic panel. You can activate the tool by clicking it or by using the W shortcut. This unlocks the tool from its docked location and allows you to click anywhere in the image to set a new white balance (**Figure 6.26**). The floating loupe magnifier provides an extreme close-up of the pixels you are measuring, which can really help you select the correct pixel reading. As you hover over an image, you will also see the RGB readout values for the point immediately beneath the cursor (see **Figure 6.27** on the next page), as well as at the bottom of the Histogram panel. These RGB readings are shown as percentage values and can help you locate and check the color readings. (If the RGB values are all close enough to the same value, the color can be regarded as neutral.) If the Auto Dismiss option is disabled in the Toolbar (see Step 1 below), all you have to do is click W to activate the White Balance tool and continue clicking with the tool until you find the right setting. You can then use the **Esc** key or the **W** key again to cancel working with the White Balance tool and return it to its normal docked position in the Basic panel.

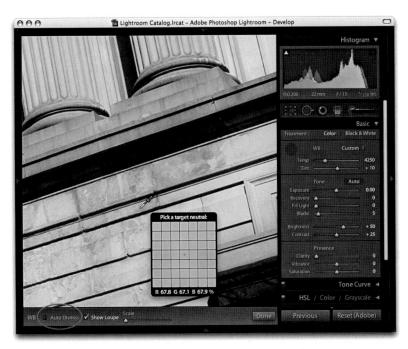

1. To make a white balance adjustment, select an area of the picture that should be neutral in color (but not a bright white area). The light gray stones in this photo are a perfect spot to sample from. If the Auto Dismiss box (circled) in the toolbar is checked, the White Balance tool automatically returns to its docked position in the Basic panel after a single click. If the Auto Dismiss box is unchecked, you can click and keep clicking with the White Balance tool until you are completely satisfied with the white balance adjustment that you have made.

TIP

You can also use the <code>MShiftU</code> (Mac) or <u>CtrlShiftU</u> (PC) keyboard shortcut to apply an Auto White Balance.

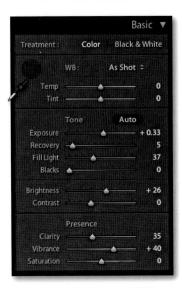

Figure 6.26 To activate the White Balance tool, click the tool to undock it from the panel.

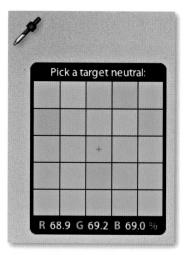

Figure 6.27 Instead of using the traditional 0 to 255 scale, the RGB readouts are given as percentages. You can determine the neutrality of a color by how close the readout numbers are to each other.

NOTE

Do we still need the 0 to 255 scale in the readout section? Some people say that they would like to see this as an option, but there are no truly valid reasons for doing so. The 0 to 255 scale has come into existence only because of the way the number of levels is calculated for pixel-rendered 8-bit images. In my view, the percentage scale makes it easier to interpret what the eyedropper readout numbers mean.

Pici	Pick a target neutral:	
	+	
R 82.6	G 83.7 B 87.9 %	

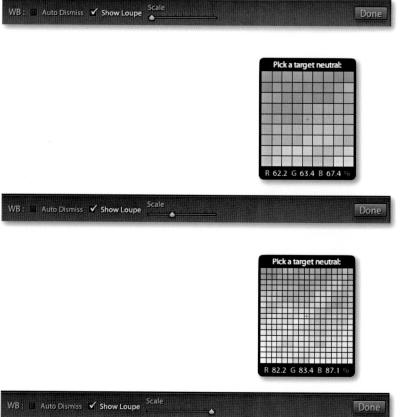

2. The Show Loupe check box allows you to toggle displaying the loupe that appears below the White Balance tool cursor. You can adjust the loupe scale setting by dragging the slider next to the Show Loupe item in the toolbar. This slider adjusts the sample grid pixel size, and dragging the slider to the right increases the number of pixels used when sampling a white balance point measurement. Increasing the pixel sample size can be beneficial if you want to aggregate the pixel readings more, such as when you're sampling a really noisy image and you don't want the white balance measurement to be unduly affected by the pixels that contain color noise or other artifacts.

White Balance corrections

In most shooting environments, once you have found the right white balance, all the other colors will tend to fit into place. You can help get the white balance right in-camera by choosing a fixed or auto setting. Or, you can use a white balance or color checker chart, like the one shown in Figure 6.28, as a preparatory step that will help you make a more accurate, measured reading later in Lightroom. A camera auto white balance setting may do a good job, but it really depends on the camera you are using, because even the best camera won't know how to handle every lighting situation it meets. In Figure 6.29, we see a scene where there were mixed lighting conditions. This photograph could be processed for either the exterior daylight or the tungsten lighting indoors, and each could be said to be correct. In situations like this, you can't always rely on the camera's Auto White Balance setting and you'll have to decide for yourself which setting works the best. This is where the White Balance tool can come in handy. The trick is to analyze the picture and look for an area in the scene that should be a neutral, nonspecular, textural highlight. You should try to select something that should be a neutral light gray, because if you click an area that's too bright, there may be some clipping in one or more of the color channels, which can result in a false white balance measurement and consequently make an inaccurate adjustment.

Figure 6.29 The white balance can be measured manually by selecting the White Balance tool (*I*) and clicking an area in the image that should be near white in color. This image shows two possible white balances: one measured for the indoor lighting (left) and one measured for the outside daylight (right).

Figure 6.28 Among other things, the X-Rite ColorChecker Classic chart is useful for taking white balance readings under the same lighting conditions as those you are about to shoot with. To take a white balance reading in Lightroom, click the light gray patch next to the white patch.

NOTE

It is tempting to assume that the grayscale patches in the X-Rite ColorChecker Classic chart shown in Figure 6.28 correspond to the full tonal range that you are trying to optimize using the Basic and Tone Curve panel controls. This is a dangerous assumption to make because, in a properly optimized image, the white and black patches rarely ever equate to the respective highlight and shadow points in the image. For example, the black patch in the ColorChecker is really a dark gray, and if you were to clip the shadows using this patch as your guide, you could end up clipping a lot of important shadow information.

Figure 6.30 The White Balance slider controls in the Basic panel allow you to manually adjust the white point in an image. The Temp slider adjusts the white point from warm artificial lighting conditions to cool daylight and beyond. The Lightroom slider represents this as a progression going from blue to yellow. The Tint slider allows you to fine-tune the white point for any green/magenta bias in the white point.

Understanding white point

The adjustments made using the White Balance slider controls in the Basic panel will have the greatest impact on the overall color appearance of an image (**Figure 6.30**).

The numbers used in the Temp slider refer to the temperature scale measured in degrees Kelvin, which in photography is commonly used when describing the color temperature of a light source. Artificial lighting, such as a tungsten lamp light source, is said to have a color temperature of around 2800 K to 3200 K, whereas average daylight is notionally rated as being 5000 K and overcast daylight is somewhere around 10,000 K. As a result, photographers often tend to describe higher-color-temperature lighting conditions as being "cooler" and lower-color-temperature lighting conditions as being "warmer," because most people equate blue colors with coldness and reddish colors with warmth (although, technically speaking, a bluer color temperature is actually hotter). The Temp slider scale allows you to set what "should be" the white point of the image based on the Kelvin scale. The key point to emphasize here is that the White Balance controls are used to "assign" the white point as opposed to "creating" a white balance. Some people get confused on this point because they assume that if 3200 K equates to tungsten-balanced film and 5500 K equates to daylight-balanced film, dragging the Temp slider to the right makes the image cooler and dragging to the left makes it warmer. In fact, the opposite is true, because you are using the Temp slider to assign a color temperature to the image. Dragging the slider to the right makes the image warmer and dragging to the left makes it cooler. Try thinking of it this way: If you have a photograph shot under average daylight conditions and assign a lower color temperature to the photo, like one more suited for tungsten lighting conditions, such as 3200 K, then naturally enough, the colors in the image will appear blue. The result you will see as a result of this experiment is exactly the same as using a tungsten-balanced film emulsion to record a daylight scene.

Tint adjustments

You don't always need to make Tint slider adjustments when color-correcting an image, and when you do, these can usually be quite minor, except for those situations where the light source emits uneven spectral wavelengths of light, such as when shooting under fluorescent lighting. It is always hard to set an accurate white point for these types of lighting conditions, but fluorescent lighting conditions usually require a heavy magenta tint bias to the white point in order to remove the strong green cast.

Creative white balance adjustments

Who is to say if a correct white balance is any better than an incorrect one? Before digital capture and the ability to set accurate white balances, photographers could choose only between shooting with daylight-balanced or tungsten-balanced film emulsions. Most photographers would simply accept whatever colors the film produced, although some professionals had the know-how to measure the color temperature and place filters over the camera lens to correct for color shifts in the lighting. With a digital camera, it is easy to set the white balance precisely. There may be times, such as when shooting catalog work, when it is critical to get the color exactly right from camera to screen. But you don't always have to obsess over the freedom to interpret a master raw file any way you like, and you can change the mood in a photograph completely by setting the white balance to an alternative, incorrect setting (**Figure 6.31**).

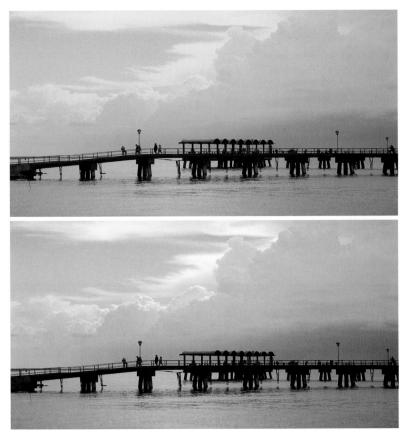

TIP

Warning! If you shoot using a studio flash system (not with a built-in flash) and have the camera set to auto white balance, there is a high probability that the white balance reading will be influenced by the tungsten modeling lights instead of the strobe flash.

Figure 6.31 Here is an image that's been processed using two different white balance settings. It is often largely a matter of personal judgment when deciding which version you prefer, since neither of these examples uses what could be described as a "correct" white balance.

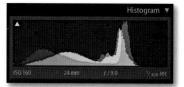

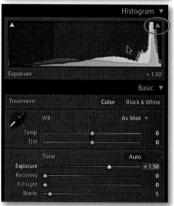

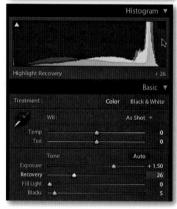

Figure 6.32 In the top histogram, the highlights need to be expanded to fill the width of the histogram. In the middle example, I adjusted the Exposure slider to make the image brighter, while keeping an eye on the highlight clipping indicator (circled) so as not to go beyond the clipping limits for the highlights. In the bottom example, I compensated with the Recovery slider to reduce the extreme highlight clipping, preserving more highlight detail but without compromising the exposure brightness adjustment.

Basic adjustments and the Histogram panel

You normally use the Exposure slider to set the overall image brightness, and the Blacks slider to adjust for the shadow clipping. These two Basic panel Tone adjustments can make the biggest difference in the appearance of an image. Get the highlights and shadows right, and you will often find that all the in-between tones look right, too. But while the Exposure slider should be seen as the key tool for controlling the brightness, it also acts as a highlight clipping control. This is where the Histogram panel becomes useful, because as you make an exposure adjustment, you can observe the image levels expanding to the right, just to the point where the highlights should begin to clip. Figure 6.32 shows how the levels were expanded as the Exposure was increased. But notice also how the highlight clipping indicator (the triangle in the top-right corner) lit up as I came within range of where the highlights were about to clip (the color indicates which colors are clipped). You can use the highlight clipping indicator as a guide to how far you can safely push the Exposure adjustment before clipping occurs; then you can use the Recovery slider to compensate for any unwanted highlight clipping. As you drag the Recovery slider to the right, the highlight end of the histogram compresses to recover the clipped highlight detail, and the highlight clipping indicator turns off at the optimum point where no more clipping occurs. As you experiment with these two slider controls, you'll soon discover how it is possible to use Exposure to set what looks like the best exposure setting for the image brightness (but within the range of clipping tolerance), and then use the Recovery slider to compensate separately for any highlight clipping.

The Blacks slider is a shadow clipping tool. For raw camera files, the default Blacks setting is 5. This should be about right for most images; you can set this lower if you like, but even with an underexposed image, it is unlikely you will want to set the Blacks below, say, 2 or 3. As you try to determine where best to clip the shadows, the shadows clipping indicator also lights up to indicate where any shadows point clipping is taking place. The Fill Light slider is not a shadow recovery control in the same way that the Recovery slider can be used to rescue the highlights, but it is ideal for lightening the dark tone areas, and it can certainly make quite a dramatic difference in photographs with heavy shadows. As you adjust the Fill Light, the clipping indicator again hints at the ideal range of settings to use. You can extend a Fill Light adjustment beyond this range, but overdoing it can produce unnatural-looking results if you are still using Process Version 2003, so I suggest you pay attention to what the clipping indicator is telling you. However, as was mentioned on page 274, using Process Version 2010 can really make a big improvement in the response of the Recovery and Fill Light sliders.

What's really cool is that the histogram is more than just an information display. You can also use it to actively adjust the four main Basic panel tone slider controls: Exposure, Recovery, Fill Light, and Blacks. As you roll the mouse over the histogram, you'll see each of these four sections highlighted in the histogram (Figure 6.33). And if you click and drag, you can actively mold the shape of the histogram and levels output by dragging with the mouse inside the Histogram panel.

The Brightness and Contrast controls are partly there for legacy reasons, because people have grown accustomed to working with them in the Adobe Camera Raw plug-in and are familiar with (and like) the image control that they give. In practice, I find myself still using both when making Basic panel adjustments, but I find that Brightness is the more useful of the two, because I often need to compensate the image brightness slightly after making an Exposure adjustment. Basic panel Contrast adjustments are great for making simple contrast tweaks, but the slider controls in the Tone Curve panel offer a more precise way of adjusting the contrast.

The overall objective with Basic panel editing is to adjust the raw (or pixel image) data to produce an image that is more or less correct for tone and color. The separation between the Basic and Tone Curve panels is there because the Tone Curve controls are designed to pick up where the Basic panel adjustments left off. It is important to understand this distinction, because in the Develop module processing pipeline, the image data is processed first through the Basic panel before being passed through the Tone Curve panel, where you can make fine-edit adjustments to the tone contrast in the image. We will be discussing the Tone Curve panel shortly, and we'll also take a look at a step-by-step example that shows how to process an image where the Basic panel controls were adjusted first before applying a fine-tuning Tone Curve adjustment.

Auto Tone setting

The Auto Tone (ﷺU [Mac] or ctrl U [PC]) can work well on a great many images as a quick-fix tone adjustment (see **Figure 6.34**). It automatically sets the Exposure, Recovery, Fill Light, Blacks, Brightness, and Contrast. From there, you can adjust any of the Basic panel sliders to manually fine-tune the adjustment. Auto Tone can also be included as part of a Develop preset, allowing you to import images with Auto Tone applied right from the start.

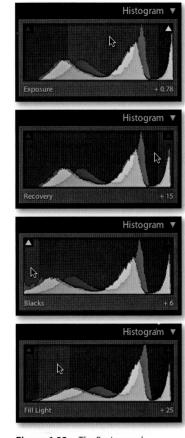

Figure 6.33 The Basic panel adjustments shown here were all achieved by clicking different sections of the histogram and dragging right or left to increase or decrease the setting represented by that particular section of the histogram. You can also doubleclick these areas of the histogram to reset the values.

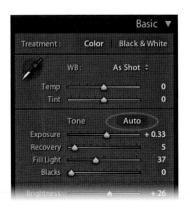

Figure 6.34 The Auto Tone button.

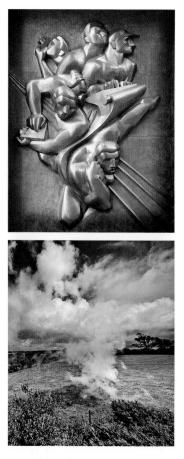

Figure 6.35 The top image mostly has reflective highlights that don't contain any detail. You would normally want to clip these highlights to achieve the optimum image contrast. In the lower image, the lightest areas are the clouds, and you would want to make sure that these nonreflective highlights did not get clipped.

Highlight clipping and Exposure Settings

The main objective when optimizing an image is to ensure that the fullest tonal range can be reproduced in print. With this in mind, it is vitally important that you set the highlights correctly. If the highlights become clipped, you will risk losing important highlight detail in the finished print. And if you don't clip them enough, you'll end up with flat-looking prints that lack sparkle.

When setting the Exposure slider, you need to be aware of the difference between reflective and nonreflective highlights, and how the highlight clipping you apply affects the way the image will eventually print. The two examples shown in Figure 6.35 help explain what these differences are. A reflective highlight (also referred to as a specular highlight) is a shiny highlight, such as the light reflecting off a glass or metal surface, and it contains no highlight detail. It is, therefore, advisable to clip these highlights so that they are the brightest part of the picture and are printed using the maximum, paper white value. In Figure 6.35, the metal sculpture has plenty of reflective highlights and we would want to make sure that these are clipped when making an Exposure adjustment. Nonreflective highlights (also known as nonspecular highlights) need to be treated more carefully, because they'll contain mostly important detail that needs to be preserved. Each print process varies, but in general, whether you are printing to a CMYK press or printing via a desktop inkjet printer, if the nonreflective highlights are set too close to the point where the highlights start to clip, there is a real risk that any important detail in these highlights may print to the same paper white as the clipped highlights.

Learning how to set the Exposure slider correctly is not too difficult. Basically, you just need to be aware of the difference between a reflective and nonreflective highlight, and the clipping issues involved. Most photos will contain at least a few reflective highlights, and in practice I use the highlight clipping preview (discussed on page 287) to analyze where the highlight clipping is taking place and toggle between the clipping preview and the Normal image preview to determine whether these highlights contain important detail. Alternatively, you can use the clipping gamut warning in the Histogram panel as a guide to when the highlights are about to become clipped. I usually adjust the Exposure and Recovery so that the reflective highlights to make sure that these are protected. To do this, I'll either nudge back a little on the Exposure slider or increase the Recovery slider so that the reflective highlights are a little less bright than the brightest white.

Setting the blacks

Setting the blacks is not nearly as critical as adjusting the highlight clipping. It really all boils down to a simple question of how much you want to clip the shadows. Do you want to clip them a little, or do you want to clip them a lot? I know some Photoshop books and tutorials instruct you to set the shadow point to a specific black value that is lighter than a zero black, but this advice is useful only if you are working toward a specific, known print output. Even then, this should not really be necessary, since both Lightroom and Photoshop are able to automatically compensate the shadow point every time you send a file to a desktop printer, or each time you convert an image to CMYK. Just remember this: Lightroom's internal color management system always ensures that the blackest blacks you set in the Basic panel faithfully print as black and preserve all the shadow detail. When you convert an image to CMYK in Photoshop, the color management system in Photoshop will similarly make sure that the blackest blacks are translated to a black value that will print successfully on the press.

On page 288, I'll be showing an example of how to use a clipping preview to analyze the shadows and determine where to set the clipping point with the Blacks slider. In this example, the objective will be to clip the blacks just a little so as to maximize the tonal range between the shadows and the highlights. It is rarely a good idea to clip the highlights unnecessarily, but clipping the shadows can be done to enhance the contrast. **Figure 6.36** shows a classic example of where the shadows in the image have been deliberately clipped. A great many photographers have built their style of photography around the use of deep blacks in their photographs. For example, photographer Greg Gorman regularly processes his black-and-white portraits so that the photographs he shoots against black are printed with a solid black backdrop. Some images such as the photograph shown in **Figure 6.37** may contain important information in the shadows. In this example, there is a lot of information in the shadow region that needs to be preserved. The last thing I would want to do here is clip the blacks too aggressively, since I might lose important shadow detail.

Figure 6.37 Here is an example of a photograph that contains predominantly dark tones. When adjusting this photo, it would be important to make sure that the blacks weren't clipped any more than necessary to produce good, strong blacks in the picture.

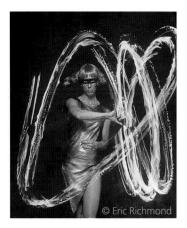

Figure 6.36 With this photo, I set the Blacks slider to 17 because I wanted to clip some of the shadows to black.

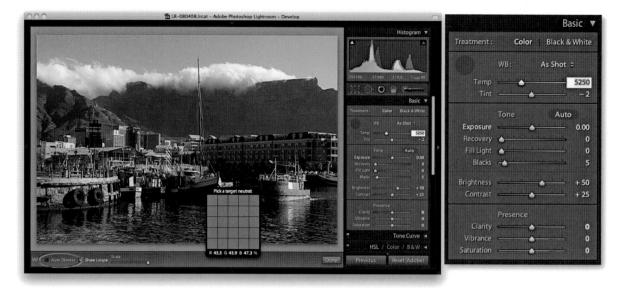

1. Here is a before image in which the Lightroom Basic adjustments have been set to the Lightroom defaults and the White Balance is using the As Shot White Balance setting (as recorded by the camera). I began by selecting the White Balance tool (()) and clicked the white paint work of one of the boats to select a nonreflective neutral color. Note that when the Auto Dismiss option is unchecked in the Toolbar, you can keep clicking to sample new white balance settings, and press the () key again to return the White Balance tool to the dock.

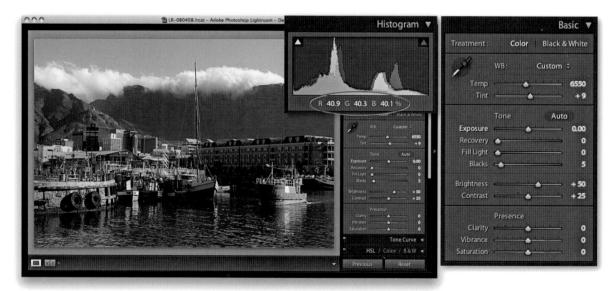

2. Here is the same photograph after I had applied a white balance correction. The RGB percentage readouts where I had clicked with the White Balance tool now showed a more neutral balance.

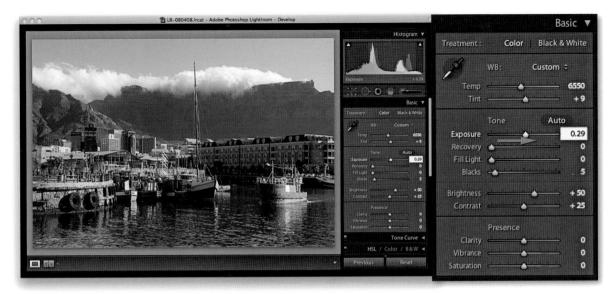

3. I then used the Exposure slider to expand the tonal range. In this step, I adjusted the highlight clipping point to lighten the image.

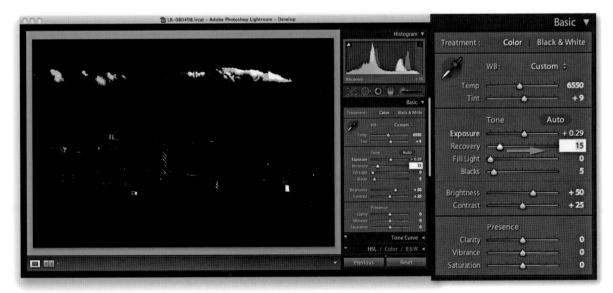

4. The Recovery slider can be used to prevent highlight clipping. If you hold down the Alt key as you drag the Recovery slider, you'll see a clipping preview that shows where the highlights are starting to get clipped. If the clipped highlights are specular (reflective) highlights, it is okay to clip them. But if they contain nonreflective highlight detail, it's best to nudge the Recovery slider more to the right to reduce such clipping. In this step, I adjusted the Recovery slider until I was confident that I had adequately preserved all the essential highlight detail.

5. Similarly, when you use the Blacks slider to set the shadow point in an image, you can again hold down the Alt key to see a shadow clipping preview that shows where the shadows are starting to get clipped. It is usually best to do what I did here and adjust the Blacks slider so that the shadows just start to clip.

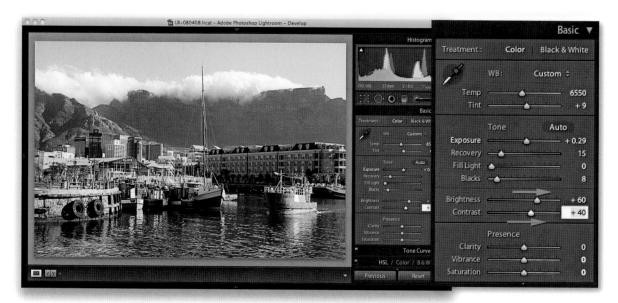

6. The Basic Develop controls usually allow you to make big enough improvements to the appearance of an image so that you won't always need to do much else to the photo. In this example, all I needed to do here was to add a little more overall Brightness and Contrast.

Vibrance and Saturation

The Vibrance and Saturation sliders can both be used to adjust the saturation in an image. The main difference between the two is that the Saturation slider applies a linear adjustment to the color saturation, whereas a Vibrance adjustment uses a nonlinear approach. In plain English, this means that when you increase the Vibrance, the less saturated colors get more of a saturation boost than those colors that are already saturated (see Figure 6.38). This can be a real practical benefit when you're applying a saturation adjustment to a picture and you want to make the softer colors look brighter, but you don't want to brighten them at the expense of losing important detail in the already bright colors. (In Figure 6.39, I demonstrate how a saturation boost can easily damage the color information in an image.) The other benefit of working with Vibrance is that it has a built-in Caucasian skin color protector that should filter out colors that fall within the skin color range. This can be useful if you are editing a portrait and you want to boost the color of someone's clothing, but at the same time, you don't want to oversaturate the skin tones. When it comes to adjusting most photographs, Vibrance is the only saturation control you'll ever really need. However, the Saturation slider still remains useful, since a Saturation adjustment can be used to make big shifts to the saturation, such as when you want to dramatically boost the colors in a photograph or remove colors completely (see the example shown in Figure 6.40).

Figure 6.38 In this example, the photograph on the left shows a normally corrected image and the one on the right shows a version where I applied a +100% Vibrance adjustment. This is an extreme adjustment, but as you can see, this boosted the subtle colors in the scene, without causing any unwanted clipping.

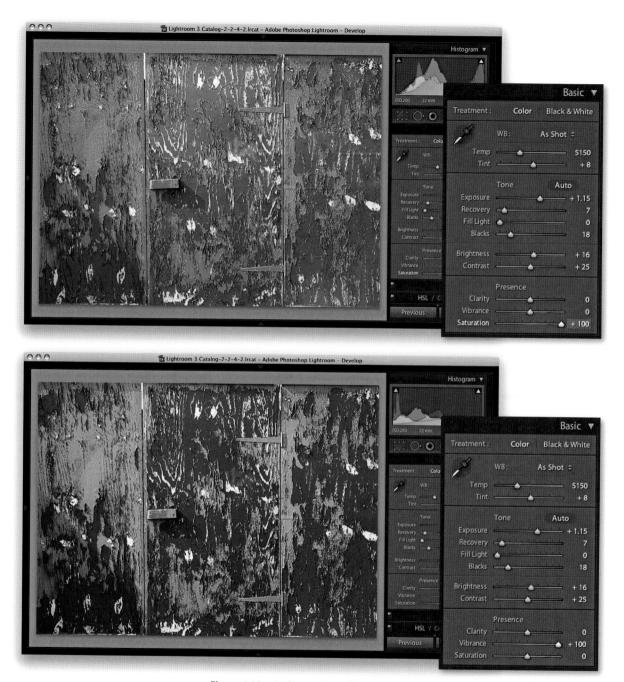

Figure 6.39 In the top screen shot, I increased the Saturation to +100%. A positive Saturation adjustment boosts all colors equally, and as you can see, there is a lot of clipping in the saturated blue colors. In the lower screen shot, I increased the Vibrance to +100%. This resulted in the colors appearing more saturated, but without oversaturating to the point where there was clipping of any of the color channels. Vibrance preserved more tonal detail.

Figure 6.40 In the top screen shot, I applied a Vibrance of -100%. As you can see, the effect is quite subtle. A negative Vibrance can be used to gently desaturate a photo. In the bottom screen shot, I reduced the Saturation to -90%, which produced a pastel version of the image, and if I moved the Saturation slider all the way to -100%, I would have ended up with a monochrome image.

NOTE

Clarity is a hybrid of two separate contrast-enhancing techniques. One is a local contrast enhancement technique, devised by Thomas Knoll, using a low amount and high radius setting in the Photoshop Unsharp Mask filter. The other is a midtone contrast enhancement Photoshop technique that was originally devised by Mac Holbert, which he used to bring out crisper detail in his landscape prints. I think most photographs can gain from adding a little bit of Clarity.

Clarity slider

The Presence section in the Basic panel includes the Clarity slider, which is essentially a midtone contrast adjustment. A Clarity adjustment cleverly applies an adaptive contrast adjustment that is similar to the low Amount/high Radius Unsharp Mask technique referred to in the accompanying sidebar note. The Clarity effect is achieved by adding wide halos to the edges in the photograph. Adding these halos builds up the contrast in the midtone areas based on the edge detail in the photograph. The net effect is that a positive Clarity adjustment boosts the apparent contrast in the midtones, but it does so without affecting the overall global contrast. Normally, you would want to start with a Clarity setting of around 10 and try not to overdo the effect too much. But as you increase the Amount, the halos get wider, strengthening the midtone contrast effect, which, in turn, makes the midtone areas appear more crisp. You can actually see the halos forming as you drag the slider left and right.

1. Here is a screen shot that shows a close-up 1:1 view of a photo. You don't have to necessarily view your images at 1:1 in order to evaluate Clarity adjustments, but a 1:1 view will allow you to evaluate the effect more clearly. A few basic adjustments were applied here using the Basic panel controls and the image was presharpened by adjusting the sliders in the Detail panel.

2. In this next screen shot, you can see how the wooden deck looked after I had set the Clarity slider to +100%. The reason I took the slider all the way to the maximum setting was in order to create the most dramatic difference between this and the previous screen shot. You can see much more contrast detail here in the grain pattern of the wood.

Using Clarity to decompress the levels

All image adjustments are destructive. One way or another, you will end up either expanding the tones in an image, which stretches the levels further apart, or compressing the tones by squeezing the levels closer together. For example, some Tone Curve adjustments flatten portions of the curve, and as you compress the detail in these areas, you consequently lose some of the tonal separation that was in the original image.

When you edit a raw image, there should be plenty of levels information waiting to be used. So, despite the apparent compression that may occur when you use the Tone Curve, this is where Clarity can be most beneficial. A positive Clarity adjustment can be used to expand these areas of flat tone and enhance the detail that's still lurking in the original capture image.

TP

You can also add Clarity to an image using the localized adjustment tools. Later, I'll be showing a few examples of how you can apply Clarity adjustments with the Adjustment brush.

Negative Clarity adjustments

A Negative Clarity adjustment does the exact opposite of a positive Clarity adjustment because it softens the midtones, and it does so in a way that produces an effect not too dissimilar from a traditional darkroom diffusion printing technique (see **Figure 6.41** and **Figure 6.42**). The net result is that you can create some quite beautiful diffuse soft-focus image effects, which are particularly suited to black-andwhite photography. A negative Clarity adjustment is also a bit like being able to add a cloudy sky lighting effect to your landscape photos.

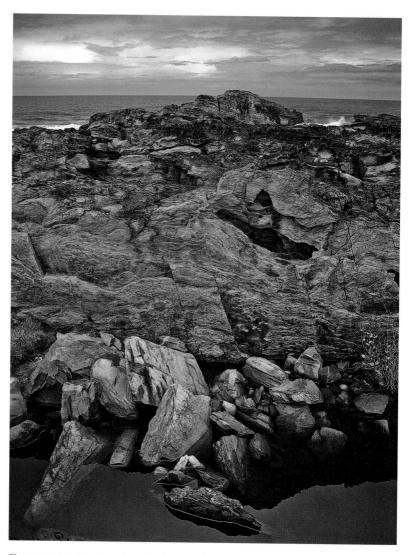

Figure 6.41 This shows how the photograph I was about to work with looked before I had applied a negative Clarity adjustment. It's a nice picture with lots of sharp detail, but it's also a good candidate image for this "pseudo" diffusion printing technique.

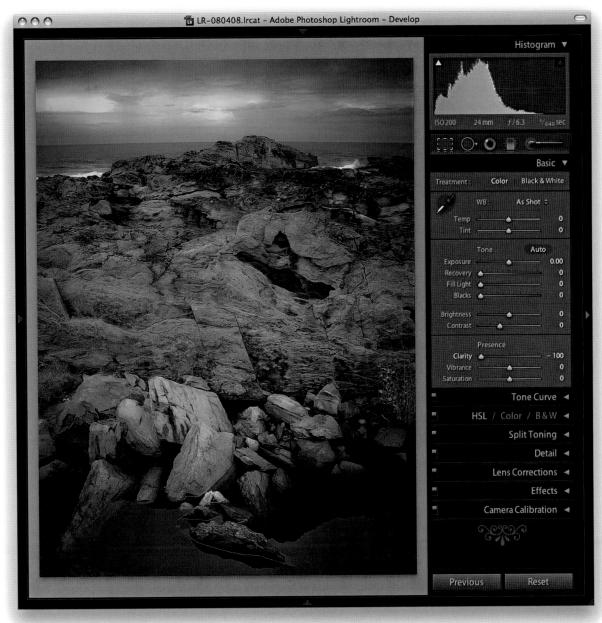

Figure 6.42 This screen shot shows the photograph in Figure 6.41 where I had applied a -100% Clarity adjustment in the Presence section. As you can see, the negative Clarity creates a kind of diffuse printing effect.

Correcting an overexposed image

Lightroom has the ability to reveal highlight detail that might otherwise be hidden. You can often recover seemingly lost highlight information by combining a negative Exposure adjustment with the use of the Recovery slider. It may be possible to use this technique on a JPEG image to darken the highlights, but the technique shown here really works best with raw images. This is because Lightroom is able to use all of the luminosity information that's contained in a raw file that is simply waiting to be discovered. In the accompanying example, I was able to recover one and a half stops of overexposure, but in some cases, it may be possible to recover as much as two stops.

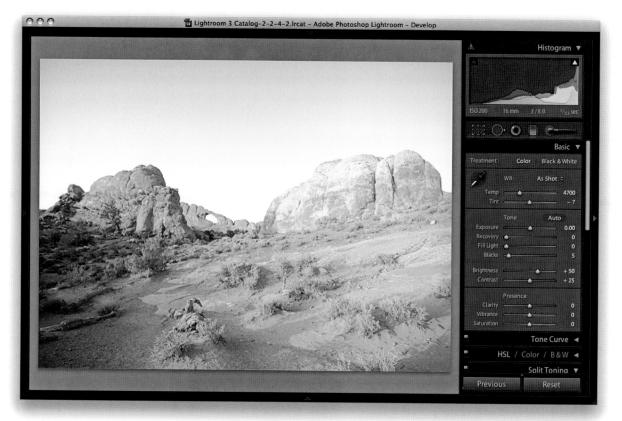

1. This overexposed photograph was initially processed using just the default Basic panel settings in the Develop module. The histogram shows severe clipping in the highlights, and you can see how there is not much detail in the sky or rocks. A histogram like this can appear disconcerting until you realize that there is more information contained in the image than there appears at first sight. Although Lightroom can work its magic on most images, it will have a limited effect on pixel-based images such as JPEGs or TIFFs. For best results, you can really use this technique only when processing raw images.

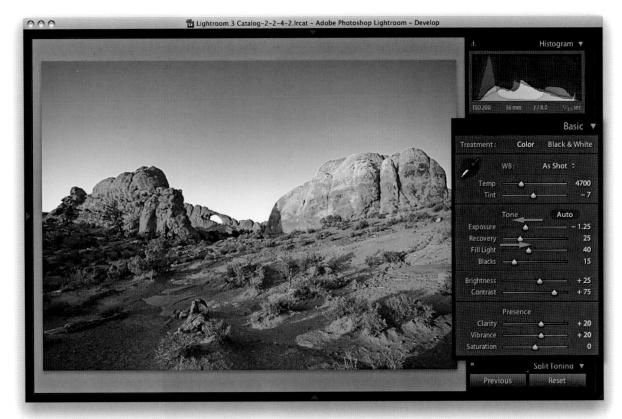

The main treatment for an overexposed photo can be achieved by applying 2. a negative Exposure adjustment. If you drag the Exposure slider to the left, you can effectively recover at least a stop or more of information, and maybe even as much as two stops. The downside is that you will usually end up making the overall image darker. But if, instead, you combine a negative Exposure adjustment with a positive Recovery adjustment, you'll get to see the highlight information that would otherwise be clipped, without having to over-darken the image. In the step shown here, I also adjusted the Fill Light, Blacks, Brightness, Contrast, Clarity, and Vibrance sliders, but the main lightness adjustment was achieved by using a negative Exposure adjustment plus Recovery. As I mentioned on page 275, it is often better to optimize the camera exposure to capture as much of the shadow detail as possible, without overexposing to the point where you are unable to process important highlight information. I will often ignore the camera or light meter readings and deliberately overexpose at the time of capture in order to record the maximum amount of levels information and use the combination of a negative Exposure and a positive Recovery adjustment when processing the image in Lightroom.

Correcting an underexposed image

Underexposed images represent a bigger problem because there will be fewer levels available to manipulate, particularly in the shadows. The Basic panel controls in Lightroom can be used to brighten an image and lift out the shadow detail. But it is important that you work through the Basic image adjustments in the correct order, as described in the following steps. When adjusting the tones in an underexposed photograph, you will notice that the Blacks slider is very sensitive and a small shift of the Blacks can make a really big difference in the brightness of the shadows. In the example shown here, I could have opened the shadows more by setting the Blacks slider to 1 or 2. But by setting the Blacks to 3, I was able to preserve more overall contrast.

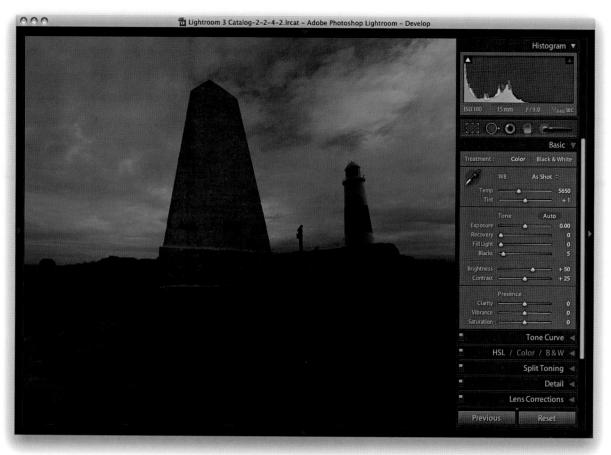

1. As with the highlight recovery method shown earlier, underexposure corrections should mainly be done by adjusting the Exposure slider first in order to set the highlight clipping. This should be followed by an adjustment to the Blacks slider, and then further adjustments to the remaining sliders.

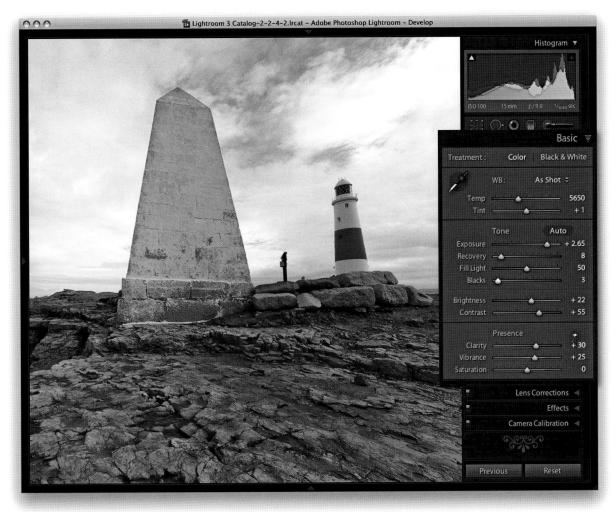

2. In this example, I dragged the Exposure slider to the right, which lightened the image considerably, while preserving all the information in the highlights. I then adjusted the Blacks slider so that the shadows were just clipped and used the Fill Light adjustment to radically lighten the dark shadow areas. I also used the Brightness and Contrast sliders to lighten the midtones and add more contrast depth. Finally, I added more Clarity and Vibrance. What you don't want to do here is adjust the Brightness slider before you adjust the Exposure slider. Although similar results can be achieved using this method, you will end up stretching the shadow tones far more than is good for the image, so for best results you should always apply the Exposure correction *before* you adjust the Brightness. The end result here is a photo that is usable, considering how dark it was before. However, lightening such a dark original has also amplified the noise, which is especially noticeable in the shadow areas.

NOTE

The Match Total Exposures command has now also been added as an option to the Library module Photo ⇔ Develop Settings menu.

Match Total Exposures

You can use this command to match the exposure brightness across a series of images that have been selected via the Filmstrip. Match Total Exposures calculates a match value by analyzing and combining the shutter speed, the lens aperture, the ISO speed at which the photos were captured, plus any camera-set exposure compensation. It then factors in all these camera-set values, combines them with the desired exposure value (as set in the most selected image), and calculates new Lightroom exposure values for all the other selected images. I find that this technique can often be used to help average out the exposure brightness in a series of photos where the light values were going up and down during a shoot, which is probably why the chief Lightroom architect, Mark Hamburg, also liked to describe this as a "de-bracketing" command.

So, to sum up, if you highlight an individual image in the series and select Match Total Exposures, the other images in that selection will automatically be balanced to match the exposure of the target image.

1. In this example, I made a selection of photographs in the Library module Grid view, where you can see that some of the photos in the sequence were more underexposed than others.

2. I selected the photo with the most correct-looking exposure and made this the most selected, target image. I then went to the Develop module and chose Match Total Exposures from the Settings menu ((**#Ait**) Shift) (Mac] or (Ctri (Ait) Shift) (M [PC]).

3. In this Library Grid view, you can see how the exposure appearance of the other photos was now more evenly balanced compared to the Library Grid view in Step 1.

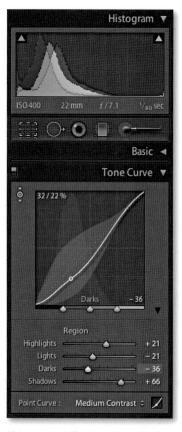

Figure 6.43 The Tone Curve panel controls are shown here with an adjustment in progress being made to the darks. Notice how the histogram in the Histogram panel is mirrored in the curve graph, and both are updated as you edit the Tone Curve controls.

Tone Curve controls

The Tone Curve controls offer a new approach to tone curve mapping, where the tone curve is modified through slider control adjustments. The reason the Tone Curve controls are presented in this way is to encourage people to make tone curve adjustments based on descriptive criteria. If you are used to working with the point-edit Curves dialog in Photoshop, the Lightroom method may appear restrictive at first, but the Tone Curve slider controls in Lightroom can often inspire you to create tone curve shapes that are guite unlike any of the curve shapes you might have applied when adjusting them using the traditional point curve method. The slider controls also recognize the fact that many photographers just don't get how to work the point curves adjustment in Photoshop. The Tone Curve sliders will, hopefully, make curves adjustments accessible to everyone. The good news is that you can still manipulate the curve graph directly by clicking a point on the curve and dragging up or down to modify that particular section of the curve. Best of all, you can also edit the curve by targeting an area of interest in the image directly. If you enable the Target Adjustment tool button, you can then click any part of the image and drag the mouse up or down to make the tones there lighter or darker. When you start using the Target Adjustment tool editing method to refine the tones in an image, you won't necessarily even need to look at the Tone Curve panel. You can also use the keyboard arrow keys: The up and down arrows can be used to increase or decrease the tone values. Holding down the Alt key as you adjust the values applies smaller incremental adjustments, and holding down the \bigcirc Shift) key as you adjust the values applies larger incremental adjustments. (Note that the left and right arrow keys are reserved for navigating images in the Filmstrip.) You can turn off the Target Adjustment tool by clicking the Target Adjustment tool button again, pressing [Esc], or using the [#[Alt] Shift][N] (Mac) or [Ctrl Alt Shift N (PC) shortcut.

In practice, people tend to select the Target Adjustment tool while in the Tone Curve panel, apply some adjustments, and then forget to switch it off. In previous versions of Lightroom, the Target Adjustment tool would continue to remain active when you switched to working in a different panel. So, instead of seeing the zoom or scroll icon, you would continue to see the Target Adjustment tool. Worse still, if you switched to working in, say, the HSL panel, it could get quite confusing since the HSL panel also has its own set of Target Adjustment tools to work with. Anyway, Lightroom 3 has addressed this problem by automatically deactivating the Target Adjustment tool as soon as you switch the focus to another panel.

The four main slider controls for controlling the Tone Curve are Highlights, Lights, Darks, and Shadows. The slider controls also provide a shaded preview of the range of shapes an individual Tone Curve slider adjustment can make. In **Figure 6.43**, I was in the process of adjusting the Darks slider. The gray shaded area represents the limits of all possible tone curve shapes I can create with this particular slider in conjunction with the other current slider settings. For those who understand curves, this provides a useful visual reference for how the curve can look. Plus, you can edit it by clicking anywhere on the curve and moving the mouse up or down to make that section of the tone curve lighter or darker. However, If you like using the on-image tone curve editing, and screen real estate is at a premium, you can collapse the Tone Curve sliders by clicking the arrow icon next to the Tone Curve graph and just work with the sliders only.

As mentioned earlier, the Basic panel is used to apply the main tone adjustments. It's important to understand that these are all applied upstream of any tone curve adjustments, so the Tone Curve is an image adjustment control that you always want to apply after you have made the initial Basic panel adjustments. The layout of the tools in both the Basic and Tone Curve panels are also influenced, to some degree, by the legacy constraints of the Adobe Camera Raw plug-in. For example, the Contrast control in the Basic panel is mainly there to provide a slider equivalent to the one found in the Camera Raw plug-in. So those people who prefer using the simpler Camera Raw method of adjusting contrast can continue to do so. But more important, it has been necessary to ensure that settings applied to an image via Camera Raw in Photoshop are also recognized (and made accessible) when the same image is opened via the Develop module in Lightroom. I mention all this as an explanation for the presence of the Point Curve menu at the bottom of the Tone Curve panel (Figure 6.44). In the early days of Camera Raw, some purists argued that the tone curve should always default to a Linear mode, and if you wanted to add contrast, it was up to you to edit the curve how you wished. Meanwhile, almost every other raw converter program was applying a moderate amount of contrast to the curve by default. The reason for this was because most photographers tend to like their pictures having a more contrasty and film-like look as a standard setting. Consequently, the Adobe Camera Raw plug-in has evolved to offer three choices of curve contrast with Medium Contrast as the default setting. So, the Point Curve menu in the Tone Curve panel (not to be confused with the point curve editing mode discussed on pages 304–305) is mainly there to allow you to match up raw files that have been imported with legacy Camera Raw settings. The Medium Contrast curve applies more of a kick to the shadows to make them slightly darker and lightens the highlights slightly (which you can see by looking at the shape of the curve). The Point Curve options are, therefore, nothing more than a curve shape setting; they can be used as a starting point when making further edits to the tone curve, and they're mainly there for compatibility reasons.

The tone range split points at the bottom of the tone curve allow you to restrict or broaden the range of tones that are affected by the four Tone Curve sliders (**Figure 6.45**). Adjusting each of the three tone range split points enables you to further fine-tune the shape of the curve. For example, moving the dark tone range split point to the right offsets the midpoint between the Shadows and Darks adjustments. These adjustment sliders are particularly useful for those instances where you are unable to achieve the exact tone localized contrast adjustment you are after when using the Tone Curve sliders on their own (see also page 314).

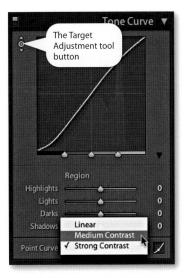

Figure 6.44 *The Point Curve menu offers a choice of three curve settings.*

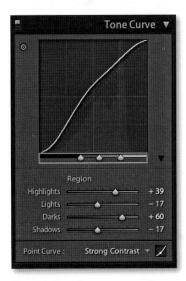

Figure 6.45 *The tone range split point controls.*

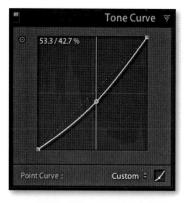

Figure 6.46 *The Tone Curve in point curve editing mode.*

NOTE

You can save the entire Tone Curve as a preset, including the point curve adjustments, but you can't save the point curve settings separately from the parametric curve settings.

Point curve editing mode

Lightroom 3 now allows you to edit the Tone Curve the same was as you can using the point curve editor in Camera Raw (or the Curves adjustment in Photoshop). To switch to the point curve editing mode, click the button circled in Step 1 below. In this mode, you can click the curve to add a new point and drag up or down to modify the curve shape. The before/after value of the point that's being moved is shown in the top-left corner of the editor view as a percentage value. Note that when selecting an existing curve point to click and move, you have to be within a few pixels of a point on the curve, left or right (or you can be anywhere above or below it). It can also help here to hold down the Alt key, as you make point curve mode Tone Curve adjustments. This reduces the sensitivity of mouse tracking movements, and you have to move the mouse ten times as far for the same amount of change to be applied to the Tone Curve. You can also click to select the Target Adjustment tool. As with the parametric editing mode, you can use up or down movements to make the corresponding area on the selected region of the curve lighter or darker.

Unlike the Adjustment panel in Photoshop or the point curve mode for the Tone Curve panel in Camera Raw, Lightroom does not provide modal, keyboard focus when editing the tone curve points. What this means is that you can't use the Delete key to delete a selected point. To remove a point, you need to either use a right-click to open the contextual menu to delete a point on the curve, or doubleclick a point to delete it.

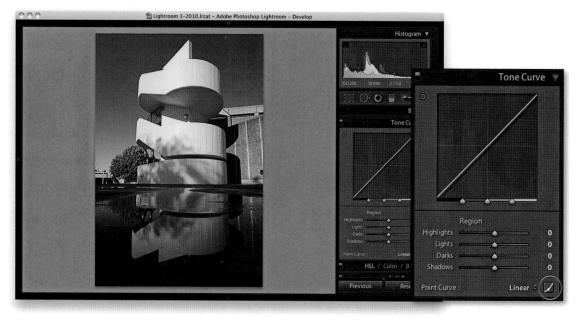

1. Here, I started with a photo to which I had applied a Linear curve. I clicked on the point curve button (circled) to switch to the point curve editing mode.

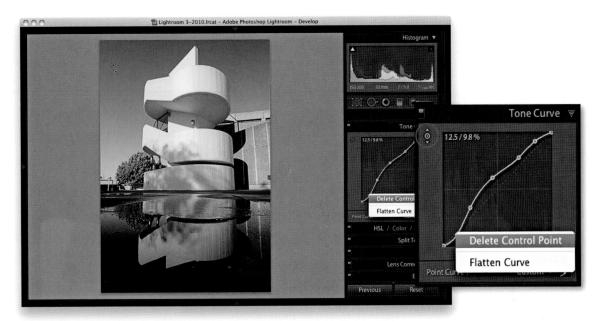

2. I then selected the Target Adjustment tool from the top-left corner (circled) and clicked to add new points to the Tone Curve, dragging up or down to modify the shape of the curve. I was also able to use the contextual menu to delete selected curve points or flatten the curve.

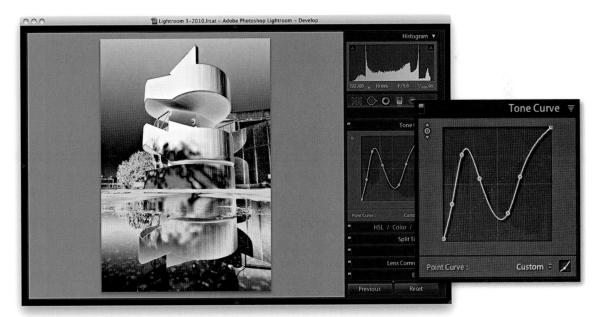

3. This screen shot shows the image in black-and-white mode and also shows how it is possible to use the point curve editor mode to either invert the tones in an image or apply a solarized-type look to a photo.

TIP

The Target Adjustment tool can also be activated by going to the View Target Adjustment submenu, or by using the following shortcuts: Press ∰ Alt Shift T (Mac) or Ctrl Alt Shift T (PC) to enable the Tone Curve Target Adjustment tool and use [Esc] or ∰ Alt Shift N (Mac) or Ctrl Alt Shift N (PC) to turn off the Target Adjustment tool.

The Tone Curve zones

The Tone Curve zones are evenly divided between the four quadrants of the tone curve. In the following step-by-step example, I wanted to show a series of tone curve adjustments in which each of these zones is adjusted. To emphasize how the Tone Curve zone sliders operate, I have highlighted the active quadrants with a green color to accentuate these zone regions and show which areas of the curve are being adjusted. If you want to reset the Tone Curve settings, you can do so by double-clicking the slider names in the Tone Curve panel; plus, you can also reset the Tone Curve adjustments by double-clicking the adjusted region within the Tone Curve itself.

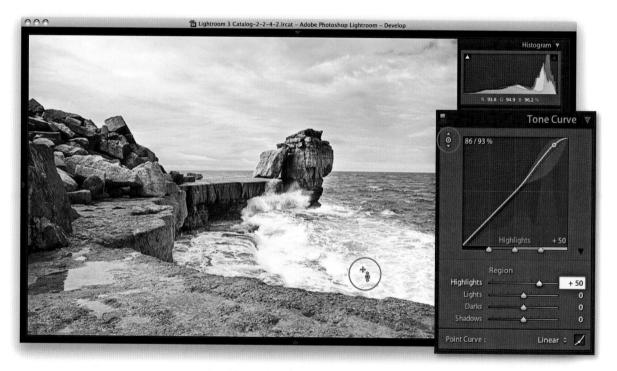

1. I began by adjusting the Highlights slider to make the brightest portion of the image lighter and set the Highlights to +50. This could be done in a number of ways: I could drag the Highlights slider in the Tone Curve panel to the right, or make the Highlights field active and use the up arrow key to increase the value. If I wanted, I could click anywhere in the green-shaded section of the Tone Curve and drag the curve upward, or click this portion of the curve and use the up arrow key on the keyboard to lighten the highlights. But in this instance, I clicked the Target Adjustment tool button (circled) to make it active, moved the cursor over the image, and hovered over a highlight area on the sea spray. I then clicked and dragged upward to lighten the tones in this selected portion of the curve. Note that you need to drag the mouse up to lighten and down to darken.

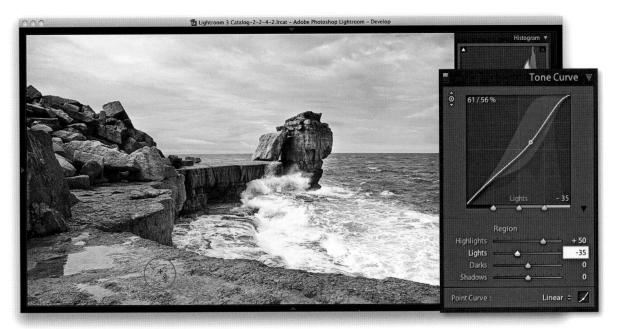

2. Next, I wanted to concentrate on darkening the tones within the Lights zone of the curve. I placed the cursor over the rock in the foreground and this time dragged downward with the mouse.

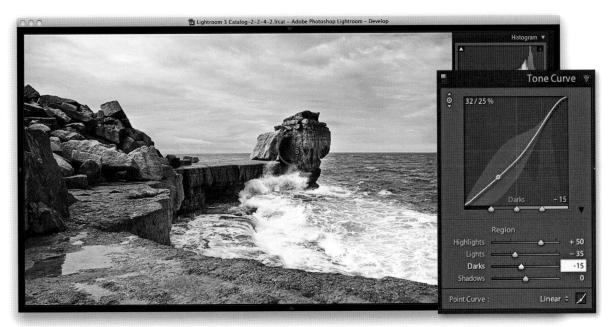

3. I then moved the cursor over one of the shaded area of the rock pillar and dragged the mouse downward. If you are using the arrow keys, you can use the <u>Alt</u> key to apply small incremental shifts and the <u>Shift</u> key to apply bigger shifts.

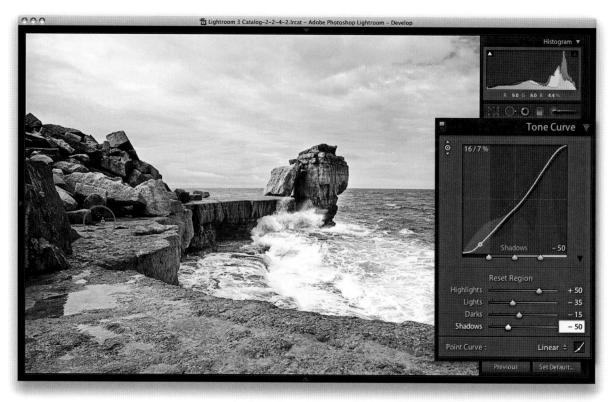

4. Finally, I adjusted the Shadows, which I did by placing the cursor over the shadow area circled here and dragged the mouse downward to darken. If you compare the finished step here with where I started, you can see that the combined Tone Curve adjustments have managed to increase the image contrast, but in a more controlled way compared to using the Basic panel Contrast slider on its own.

Combining Basic and Tone Curve adjustments

So far, I have shown how Tone Curve adjustments can be applied in isolation. But you would more typically work using a combination of both Basic and Tone Curve adjustments. Over the next few pages, I have provided a step-by-step example in which the Basic panel adjustments are applied first in order to correct the white balance, recover lost highlight detail, and improve the overall contrast in the photograph. This is then followed by Tone Curve adjustments to fine-tune the tonal balance and bring out more detail in the highlights and shadows. You can do a lot to improve the appearance of a photograph by making just a few Basic and Tone Curve adjustments. Through careful use of these adjustment controls, it is possible to edit the tones in a picture so that you won't always have to apply localized adjustments in order to achieve a good-looking image.

00		cat – Adobe Photoshop Lightroon			Histogram 🔻		
				150400 50mm			Basic
	Sector of the		-	E = 2	Treatment :	Color	Black & Whit
ALL		and a second		WB:		WB:	Custom 🗧
MA MALINA	and the	Just -		Temp	Temp		570
110 111	A. W. S.	The loss of		Tone	Tint		
	1 Berl	A A		Exposure Recovery		Tone	Auto
	ANA	PR	k a target neutral:	Eill Light A	Exposure		0.0
a state and	Record		and the second s	Brightness	Recovery	<u> </u>	
min The second	and a file	ATTONNESS CONTRACTOR		Presence	Fill Light		
	a de la companya de l		207 A 10000	Clarity Vibrance	Blacks		
	· ·	The second s	7 G 59.1 B 55.8 %	Saturation	Brightness		<u>ل</u> +5
					Contrast		<u></u>
			State and and and a	Previous		Presence	
		<i>õ.</i>		Energy Provident State	Clarity		<u>i i i i</u> ,
					Vibrance		<u> </u>
		c 1. 1 * 1 *	Savalan asttings h		Saturation	ALL REAL PROPERTY.	

1. Here is a raw image where just the default Lightroom Develop settings had been applied. I first corrected the As Shot White Balance by selecting the White Balance tool and rolling the cursor over an area that I wanted to make neutral.

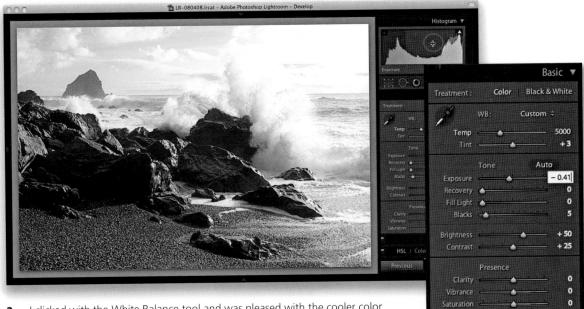

2. I clicked with the White Balance tool and was pleased with the cooler color temperature setting this gave me. I then proceeded to darken the Exposure setting, which I did by clicking on the midsection of the histogram. I held down the mouse button, and dragged to the left.

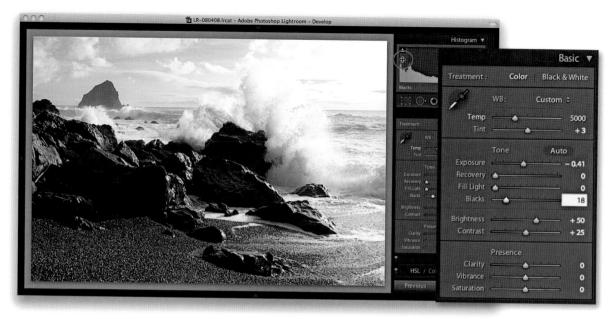

3. The Exposure slider can be used mainly to get the image brightness right, without having to worry too much about highlight clipping. Next, I adjusted the Blacks slider to set the shadow clipping point. I clicked on the shadow end of the histogram graph and again held down the mouse button, and dragged to the left. (Dragging to the left in the histogram increases the amount of clipping in the blacks.)

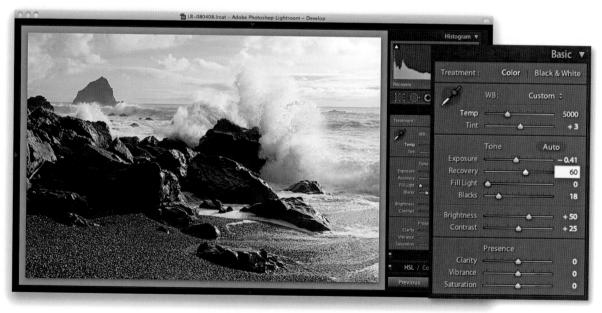

4. In this step, I applied a Recovery setting of +60, which helped prevent the highlights from becoming too clipped.

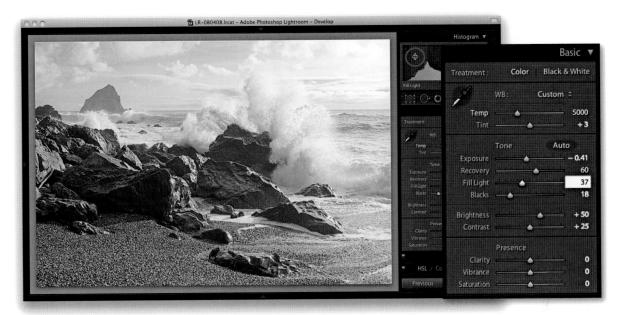

5. I wanted to preserve as much shadow detail as possible, so I clicked on the Fill Light zone of the histogram and, while holding down the mouse button, dragged the mouse to the right to add more Fill Light in the shadows.

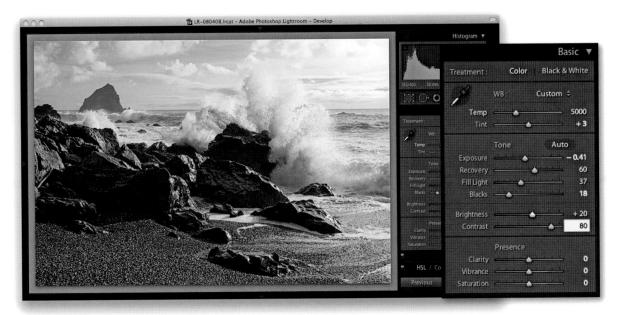

6. At this point, I could have completed all the Basic panel tone edits by reducing the Brightness and increasing the Contrast to achieve what could be considered an acceptable finished result.

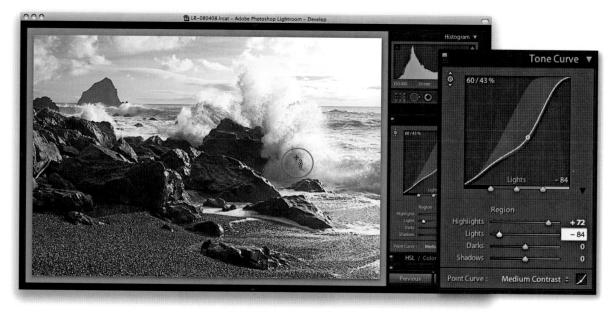

7. Instead of using Brightness and Contrast, I reverted back to the settings used in Step 5. I opened the Tone Curve panel and used the Tone sliders to improve the brightness and contrast. With the Tone Curve panel in Target Adjustment mode, I clicked on the clouds and set the Highlights to +72. I then clicked on the shaded spray and dragged the Lights down to -84. Notice how the steep curve increased the contrast in the Lights and Highlights zones.

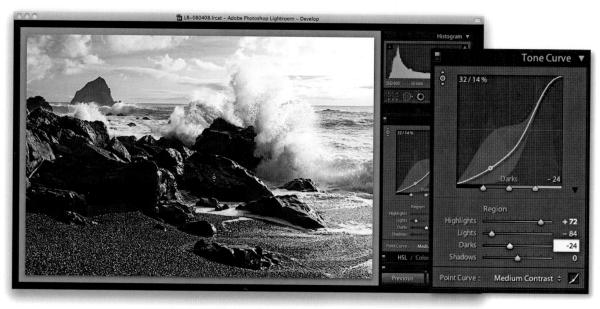

8. I then clicked on the rocks and dragged downward to take the Darks zone down to -24%.

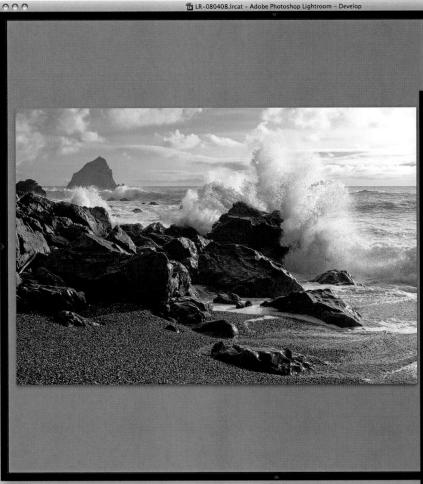

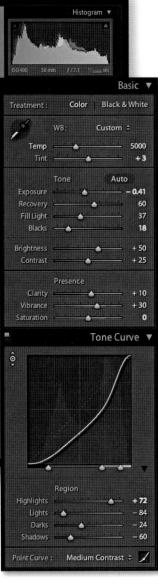

9. In this final version, I rolled the mouse over the rocks and dragged downward to darken the Shadows zone to -60%. At this stage, I had completed all the main Tone Curve adjustments, and the image now looked more promising than it had at Step 6. But the Tone Curve editing didn't end there: I clicked the split point sliders and dragged them to fine-tune the curve shape and achieve the exact tone mapping I was after. Finally, I added some Clarity and Vibrance. If you compare the version shown here with the one in Step 6, the earlier version is perfectly acceptable, but the Tone Curve panel provided me with almost the complete control I needed to shape the curve any way I liked, using just the four Tone Range controls plus the split point adjustment sliders.

TIP

You can always double-click the tone range split points if you need to reset them to their default settings.

Tone range split point adjustments

The tone range split points are located at the bottom of the Tone Curve panel. Note that in **Figures 6.47**, **6.48**, and **6.49** I have shaded green the areas of the tone curve that are being targeted and added guide lines to indicate how the split points have been set.

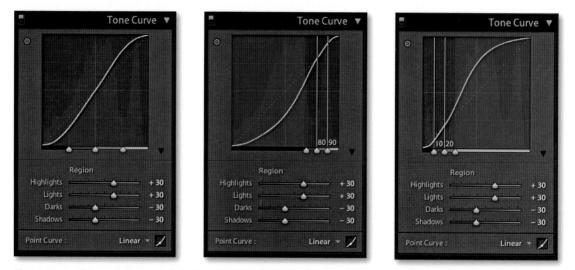

Figure 6.47 The screen shot on the left shows an S-shaped tone curve with the tone range split points in their normal positions, with equal spacing for the Shadows, Darks, Lights, and Highlights zones. The middle example shows the Shadows zone set to its widest extent, compressing the other three zones. The example on the right shows the Highlights zone set to the widest point allowed.

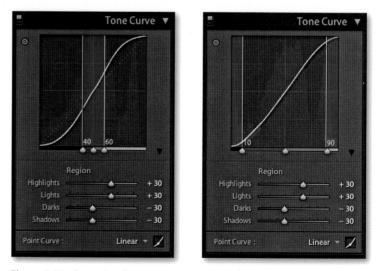

Figure 6.48 By moving the two outer tone range split points in closer, you can increase the midtone contrast; you can reduce the contrast by moving them farther apart.

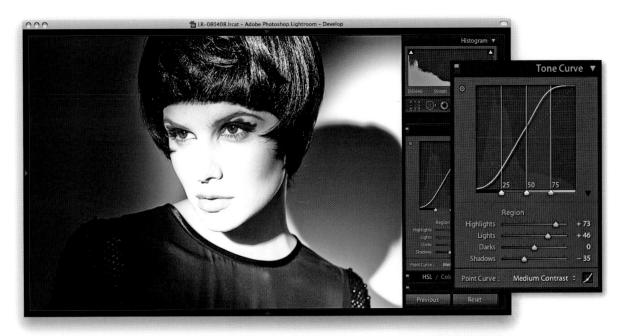

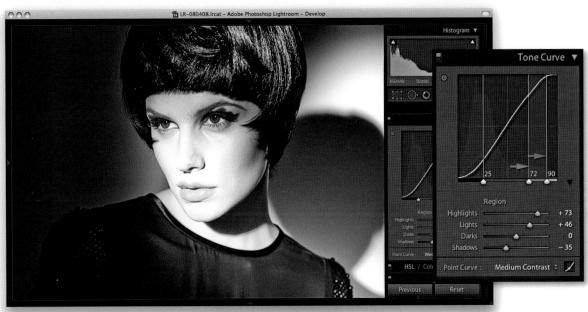

Figure 6.49 These two screen shots show a photograph where the Tone Curve zone settings have been adjusted to fine-tune the Tone Curve contrast. In the top screen shot, the tone range split points are in their default positions and the Tone Curve zones are evenly divided. In the lower screen shot, I moved the middle and outer-right sliders to the right, which compressed the width of the Lights zone, thereby increasing the contrast in the Lights zone area and revealing more tone detail in the face.

ł	HSL /	Color / B&	Wÿ
Hue Satu	uration	Luminance	All
0	Hue		
Red			0
Orange	Contractor Descent		0
Yellow			0
Green			0
Aqua			0
Blue			0
Purple			0
Magenta	Transfer and	• <u>•</u>	0

Figure 6.50 The HSL / Color / B&W panel with the HSL mode selected.

	HSL /	Color	/ B	& W 🔹	112
] All	
	Red				
Hue		<u> </u>	<u>.</u>	0	
Saturation				0	
Luminance				0	

Figure 6.51 *The HSL / Color / B&W panel with the Color mode selected.*

NOTE

Mark Hamburg and Thomas Knoll were pretty pleased with the way the color sliders broke with the traditional additive and subtractive primary color slider controls. The colors chosen here provide a more practical range of color hues to work with. They are the ones that more usefully match the colors that people most often want to adjust.

HSL / Color / B&W panel

The HSL / Color / B&W panel is an all-in-one panel for making fine-tuned color adjustments and black-and-white conversions. The HSL component (see **Figure 6.50**) is kind of equivalent to the Hue/Saturation dialog found in Photoshop, except in Lightroom you can apply these types of adjustments to raw photos and not just pixel images (although you can also do this in Photoshop using Camera Raw). It should be considered a color adjustment tool for those situations where you need to target specific colors in order to fine-tune the color adjustments. Essentially, you have three color adjustment sections for controlling the Hue, Saturation, and Luminance over eight color band ranges with Target Adjustment tools available for each. The Color section of this panel (see **Figure 6.51**) provides a more simplified version of the HSL controls with button selectors at the top for choosing the desired color band to edit, with Hue, Saturation, and Luminance sliders below. The B&W section is for carrying out monochrome conversions, which I'll be discussing separately in Chapter 7.

The sliders in the Hue section control the hue color balance; they allow you to make subtle (or not so subtle) hue color shifts in each of the eight color band ranges. For example, if you were to adjust the Green Hue slider, dragging to the right makes the greens more cyan, while dragging to the left makes the greens more yellow. The sliders in the Saturation section control the color saturation. Dragging a slider to the right increases the saturation, while dragging to the left decreases the saturation to the point where, if all the Saturation sliders were dragged to the left, you could convert the whole of the image to black and white. The Saturation slider controls apply a nonlinear saturation-type adjustment (similar to what the Vibrance slider does). This means that, as you increase the saturated pixel values are increased relative to the already more-saturated pixel values in an image. The sliders in the Luminance section can darken or lighten the colors in the selected color ranges, and do so in a way that manages to preserve the hue and saturation.

If you click the All button, the panel expands, giving you access to all the sliders at once. As with the Tone Curve panel, the HSL controls can be applied using a Target Adjustment mode. Select an HSL section such as Hue, Saturation, or Luminance, and click the Target Adjustment tool button to activate it. You can then click an image and drag up or down with the mouse to adjust the colors targeted by the cursor. You can also use the following shortcuts to enable the different HSL Target Adjustment modes: Hue, **#**Alt Shift (Mac) or Ctrl Alt Shift(H)(PC); Saturation, **#**Alt Shift(S) (Mac) or Ctrl Alt Shift(S)(PC); and Luminance, **#**Alt Shift(L) (Mac) or Ctrl Alt Shift(L)(PC). You can turn off the Target Adjustment tool by clicking the Target Adjustment button again, pressing **Esc**, or using the **#**Alt Shift(N) (Mac) or Ctrl Alt Shift(N) (PC) shortcut. Also, bear in mind that the new Target Adjustment tool behavior in Lightroom 3 means that the Target Adjustment tool is deactivated whenever you switch to working in a new panel.

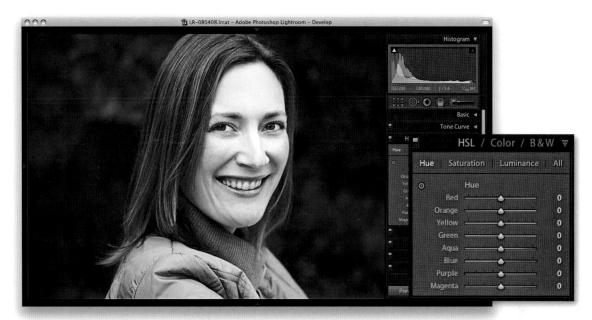

1. If you shoot a lot of skin tones, you might consider creating a custom camera calibration for such work (see page 340). But if you shoot a mixture of subjects with the same camera profile, you can also use the HSL panel Hue section to compensate for reddish skin-tone colors.

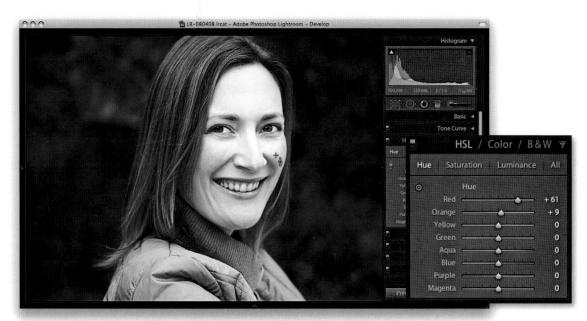

2. In this example, I went to the Hue section and activated the Target Adjustment tool. I then clicked on a skin tone area in the picture and dragged the mouse upward to make the skin tones less red and more yellow.

Selective color darkening

At first glance, the HSL controls in Lightroom appear to work the same as those used in Photoshop's Hue/Saturation dialog, but if you experiment a little further, you will notice some distinct differences. For example, the Lightroom Hue slider adjustments are somewhat tamer than their Photoshop cousins. The Saturation sliders respond more or less the same as they do in Photoshop, but the most marked differences are revealed when working with the Luminance controls. You may have noticed that when you adjust the Lightness slider in the Photoshop Hue/Saturation dialog, the adjusted colors tend to lose their saturation. To selectively darken a color in Photoshop, you generally have to search for a magic combination of Saturation and Lightness in order to achieve the desired result. But the Lightroom sliders really do respond the way you would expect them to, and they provide you with complete control over the luminance of any color range, as shown in the accompanying steps.

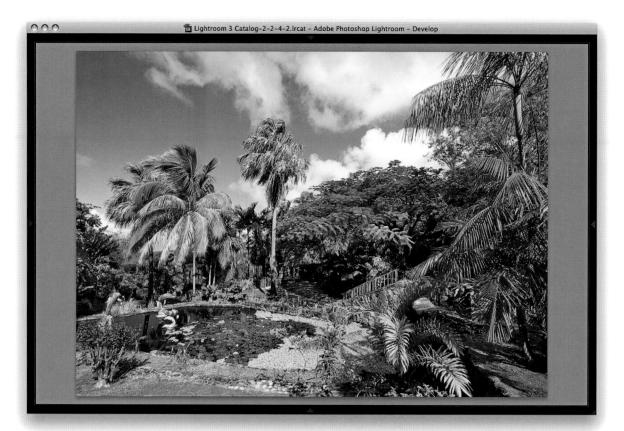

1. The challenge here was to simulate the effect of a polarizing lens filter and darken the blue sky without affecting the tonal balance of the other colors. If working in Photoshop, it would have been tricky to find the exact Saturation and Lightness values that would have made the blue sky go darker.

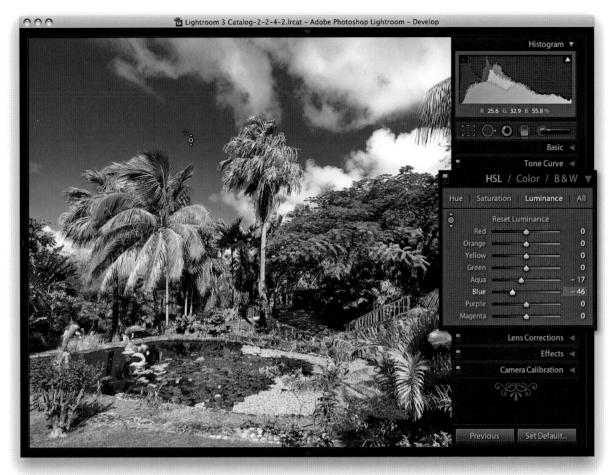

2. To darken the blue sky colors in Lightroom, I enabled the Target Adjustment mode in the Luminance section of the HSL panel, clicked an area of blue sky, and dragged downward. As you can see, this mainly reduced the Blue slider luminance and successfully added more contrast between the sky and the clouds.

False color hue adjustments

There is still some room to go crazy and do things like turn blue skies purple, but the hue adjustments in Lightroom are definitely more constrained. To create more extreme hue shifts, you will want to shift more than one Hue slider at a time. For example, you could create some Develop settings in which all the Hue sliders are shifted by equal amounts. On my computer, I have created a series of hue-shifted Develop settings. In the first, all the Hue sliders are shifted +30; in the second, they are shifted to +60; and so on. I suggest this as one way to create creative hue shift coloring effects (see the **Figure 6.52** example on the next page).

	HSL / (Color / B&	&W ₩
Hue Sat	uration	Luminance	All
0	Hue		
Red			- 90
Orange	404-44	<u>, , , , , , , , , , , , , , , , , , , </u>	- 90
Yellow			- 90
Green			- 90
Aqua			- 90
Blue			- 90
Purple		<u></u>	- 90
Magenta		<u> </u>	- 90

Figure 6.52 This shows an example of an even –90 Hue color shift applied across all the hue values.

Using the HSL controls to reduce gamut clipping

The camera you are shooting with is almost certainly capable of capturing a greater range of colors than can be shown on the display or in print. But just because you can't see these colors, doesn't mean they're not there!

In the Figure 6.53 example, you can see a photograph of one of the Window arches in Arches National Park, Utah, which was shot at sunset when the rocks appeared at their reddest. At first sight, there doesn't appear to be much detail in the rocks, but this is only because the computer display is unable to show all the information that is actually there in the image. By using the HSL panel Luminance controls to darken the red, orange, and yellow colors, I was able to bring these colors more into the gamut of the computer display so that they no longer appear clipped. Of course, the real test is how would these colors print? If you are working with a standard LCD, it will probably have a color gamut similar to an sRGB space. In fact, many photographers are viewing their photos on displays with a color gamut that's smaller than most modern inkiet printers. The display I work with has a gamut that matches 98 percent of the Adobe RGB color space and is. therefore, capable of displaying more colors than a standard LCD. In this respect, a good-quality professional display can allow you to see more color detail, which can certainly help when making evaluative adjustments such as in the example shown here. The downside is that having more colors to view on your display means that you can end up seeing more colors than an inkjet printer can print. This is where soft proofing can help you accurately pre-visualize what the final print will look like. However, this is something that can so far be done only in Photoshop. But maybe we'll see this feature in Lightroom, too, one day.

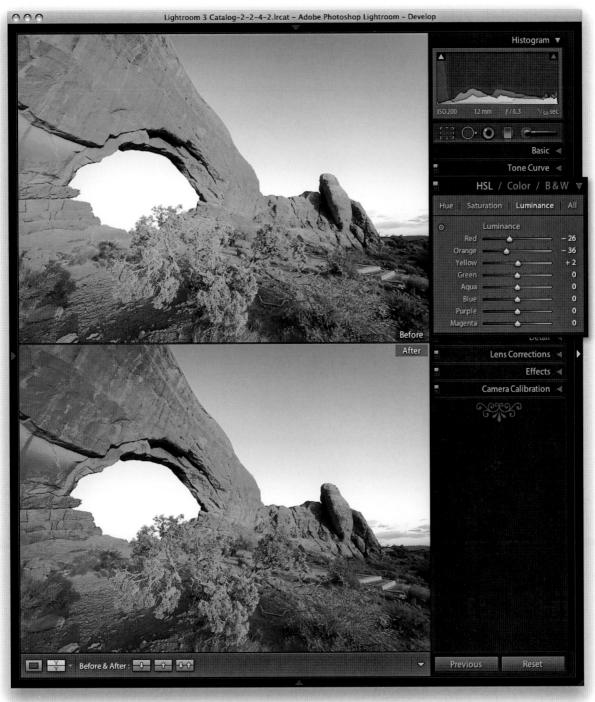

Figure 6.53 This shows an example of a Luminance HSL adjustment being used to selectively darken the red, orange, and yellow colors that initially appeared clipped.

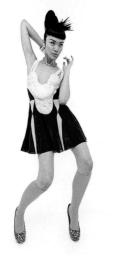

Figure 6.54 The vignette controls can also be used to compensate for light falloff in a studio shot.

Lens Corrections panel

Lens vignetting is a problem that's commonly encountered with wide-angle lenses and is particularly noticeable if the subject you are photographing contains what should be an even shade of tone or color. For example, you'll become more aware of such lens vignetting problems when you are photographing a landscape with a large expanse of clear blue sky, or you are photographing a subject against a plain, light colored backdrop. It is in these types of situations that you are more likely to notice a darkening of the image toward the corners.

The Lens Corrections panel (formerly known as the Vignettes panel) consists of two sections. The Lens Vignetting section contains the Amount and Midpoint sliders. By adjusting these two controls, you can usually find an optimum setting that will correct for the light falloff in a photograph, such as in the landscape photograph example shown on the right. Most of the correction is done by first adjusting the Amount slider, followed by a fine-tuning adjustment made using the Midpoint slider to balance the vignette adjustment from the center to the edges. With these two slider controls, you should be able to precisely correct for unwanted lens vignetting in almost any photograph. Once you have found the setting that is right for a particular lens, you might want to save this Lens Corrections panel setting as a preset that can be applied to other pictures that have been shot using the same lens.

The Lens Vignetting Amount and Midpoint sliders can also be used to compensate for the light falloff in studio lighting sets. In **Figure 6.54**, you can see an example of a studio shot in which the model was photographed against a white background using a wide-angle lens. Although I tried to light the background and foreground as evenly as I could, there was inevitably some light falloff toward the edges of the frame. In situations like this, it can be useful to adjust the Lens Vignetting sliders so that the darker corner edges of the frame are lightened slightly. Here, I would adjust the first photo in a series to get the Lens Vignetting balance right and then copy the Lens Corrections setting across all the remaining photos that were shot using this particular lighting setup.

Just as you can use the Lens Vignetting sliders to remove a vignette, you can use them to apply a vignette. I often like to use the Lens Vignetting sliders to deliberately lighten or darken the corners of a photograph. This is also something that you can achieve using the Post-Crop vignettes in the Effects panel. I'll be discussing these controls a little later, along with the new Lightroom 3 Post-Crop vignetting options.

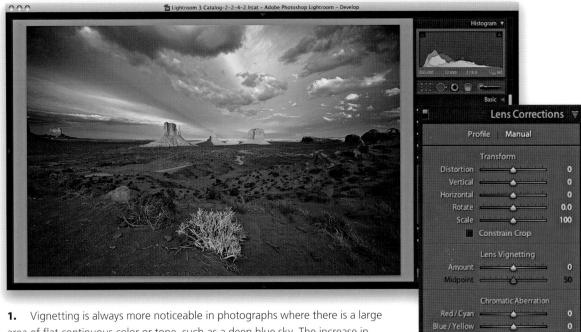

1. Vignetting is always more noticeable in photographs where there is a large area of flat continuous color or tone, such as a deep blue sky. The increase in darkness toward the corner edges is quite noticeable here.

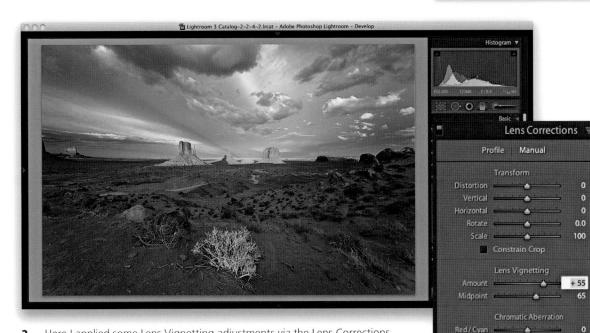

Here I applied some Lens Vignetting adjustments via the Lens Corrections 2. panel, in which I used a positive Amount setting to lighten the corners and finetuned this anti-vignetting adjustment by tweaking the Midpoint slider.

Blue / Yellow 📥

0.0

100

+ 55

65

Figure 6.55 The Lens Corrections panel controls include the Chromatic Aberration sliders.

Chromatic aberration adjustments

Chromatic aberrations are caused by the inability to focus the red, green, and blue light wavelengths at the same distance along the optical axis. As a result of this, where some color wavelengths are focused at different points, you may see color fringes around the high contrast edges of a picture. This can be particularly noticeable when shooting with wide-angle lenses (especially when they are being used at wider apertures), where you may well see signs of color fringing toward the edges of the frame.

The sensors in the latest digital SLRs and medium-format camera backs are able to resolve a much finer level of detail than was possible with film. As a consequence of this, any deficiencies in the lens optics can be made even more apparent. To address these problems, some camera companies have designed "digital" lenses that are specially optimized to provide finer image resolution and, in the case of non-full-frame-sensor cameras, lenses that are optimized for a smaller sensor chip. However, many of the lenses in common use today were computed in the days of film, when the film emulsion focus distance was different for each wavelength. Digital lenses, on the other hand, are specially optimized to take into account the fact that the filtered sensors on a typical digital SLR CCD all now lie in the same plane of focus. However, one exception to this is the Foveon chip, where the CCD sensors are placed in layers and it could be argued that lenses computed for film are more appropriate for this particular type of sensor.

Where lens aberrations are a problem, the Chromatic Aberration sliders in the Lens Corrections panel (Figure 6.55) are able to address and correct for such optical lens deficiencies. The Red/Cyan and Blue/Yellow Chromatic Aberration sliders are able to correct such lens problems by very slightly expanding or shrinking one of the RGB channels relative to the other two. So, if you adjust the Red/ Cyan slider, the red channel expands or shrinks relative to the green and blue channels. If you adjust the Blue/Yellow slider, the blue channel expands or shrinks relative to the red and green channels. If you hold down the Alt key as you drag the Chromatic Aberration sliders, you will see a more neutral color image in which the color fringe edges are easier to detect. As with other panel controls, such as the Detail panel, you must inspect the image at an actual pixels view size in order to gauge these adjustments correctly. In particular, you will need to scroll the image to carefully examine the corner edges where the color fringing will be more obvious. As I just mentioned, these problems are more common with wide-angle lenses, so you may find you want to share the lens correction settings made for one image across others shot using the same lens (as long as they were all shot with the same lens at the same focal length and lens aperture).

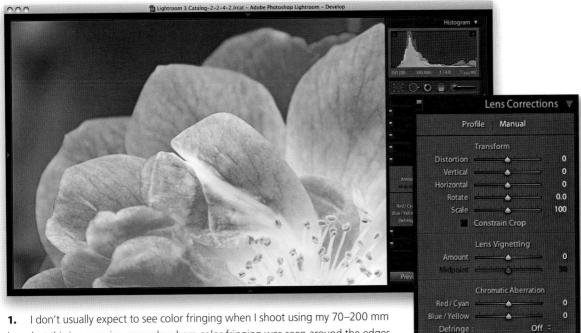

1. I don't usually expect to see color fringing when I shoot using my 70–200 mm lens, but this is a genuine example where color fringing was seen around the edges of the bright pink flower petals.

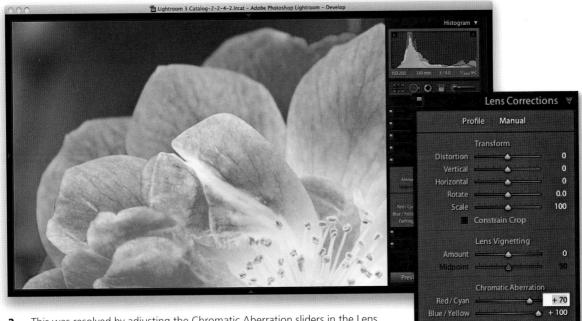

2. This was resolved by adjusting the Chromatic Aberration sliders in the Lens Corrections panel. Here, I adjusted the Red/Cyan and Blue/Yellow sliders to reduce the blue/purple fringe.

Defringe controls

The Chromatic Aberration section also features two automatic defringe controls. The first one is called Highlight Edges, which is able to correct for the color fringing that you sometimes see in extremely burned-out highlight areas. This type of color fringing can be caused by extreme light exposure hitting the camera sensor, which can overload individual photosites with too many photons. In turn, this can create problems in the demosaicing process. The Highlight Edges Defringe option, therefore, carries out a different kind of calculation in order to correct the magenta fringing that is sometimes seen around the highlight edges. I have to say that this correction is really subtle. It was not easy to find a photograph where I could show any difference between the before and after. Even then, I confess I had to cheat here and ended up showing a Lightroom 2 example. The new demosaic process in Lightroom 3 is so good that you are unlikely ever to need or benefit from using the Highlight Edges adjustment. So **Figure 6.56** below is included to show you the type of photograph that might benefit from a Highlight Edges Defringe adjustment. In practice, I doubt you'll ever need it.

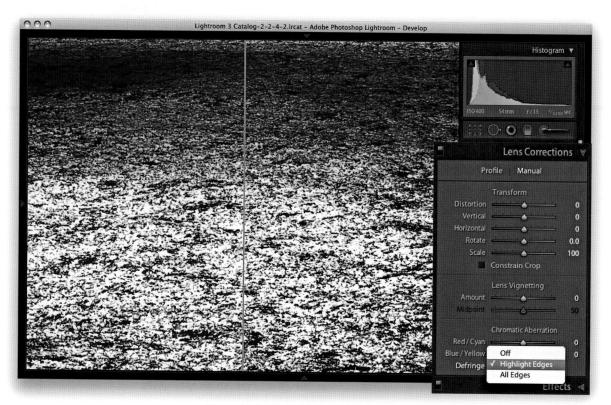

Figure 6.56 The Highlight Edges Defringe command can be used to autocorrect color fringing in the extreme highlights. Here you can see a close-up view of a photograph of the sunlight reflecting off the sea. The left half shows an uncorrected preview, and the right half shows a preview with the Highlight Edges correction enabled.

All Edges corrections

The All Edges correction also offers a rather subtle autocorrection, but I do find that this option can be useful should you encounter an image where it is proving tricky using the manual sliders alone to remove chromatic aberration fringing. If you ever experience problems trying to remove chromatic aberration, you may find this can help clean up the edges further and remove all traces of color fringing.

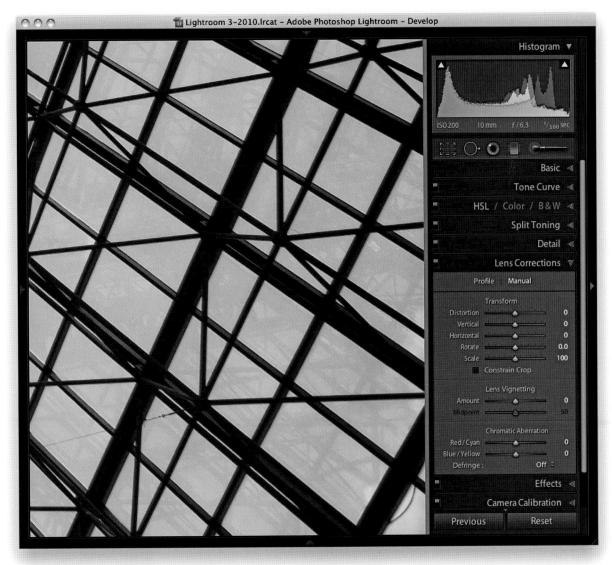

1. Here is a close-up view of a photo that had problems with color fringing toward the corner edges of the frame.

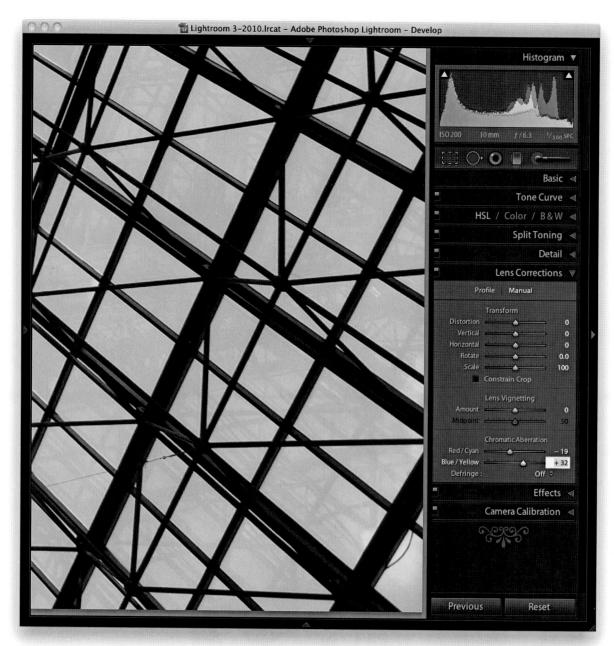

2. This photograph mainly required the use of the Chromatic Aberration sliders in the Lens Corrections panel to remove the color fringes. In this example, I set the Red/Cyan slider to –19 and the Blue/Yellow slider to +32. This seemed to be the optimum setting to use, but there was still a little bit of fringing around the high-contrast edges that I couldn't quite get rid of completely.

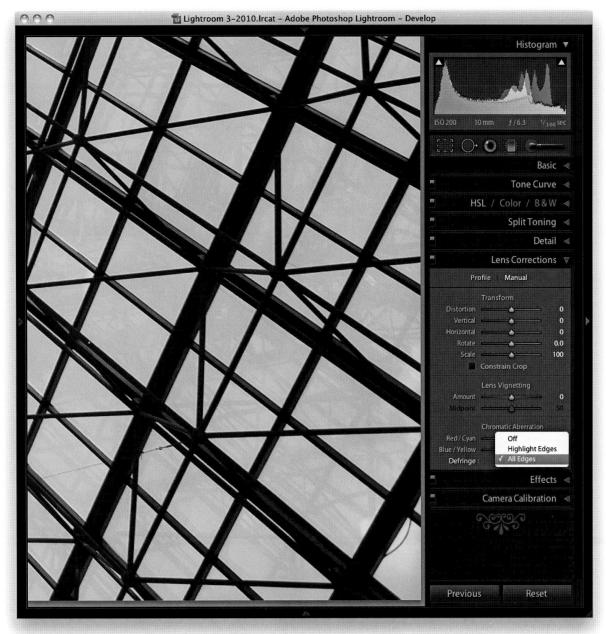

3. In this step, I selected the All Edges Defringe option. The difference between this and the previous screen shot may appear quite subtle, but when I compared the before and after by toggling the effect on and off, I was able to see a distinct improvement. I, therefore, like to look upon the All Edges Defringe setting as a way to clean up the edges that the Chromatic Aberration sliders on their own are unable to treat.

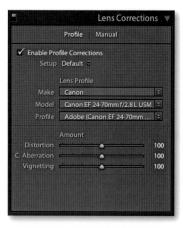

Figure 6.57 The Lens Corrections panel showing the Profile tab options, with the Enable Profile Corrections box checked.

NOTE

It is important to appreciate here that some camera systems capture a full-frame image (therefore, making full use of the usable lens coverage area for many lenses), while compact SLR range cameras mostly have smaller sensors that capture the image using a smaller area of the lens's total coverage area. The Adobe lens profiles are built using a camera that has a full-frame sensor, meaning that, from a single lens profile, it is possible to automatically calculate the appropriate lens correction adjustments to make for all other types of cameras where the sensor size is smaller.

Images that are missing their EXIF metadata cannot be processed using the Enable Profile Corrections feature. However, by saving Lens Profile Corrections settings as Develop presets, it is kind of possible to apply such adjustments.

Automatic lens corrections

I began this section on the Lens Corrections panel by showing you how to use the manual correction sliders because this seemed the best way to introduce you to what these controls do and why you would need to use them. When you use Lightroom 3, you will notice that the Lens Corrections panel defaults to showing you the Profile tab mode, shown in Figure 6.57, which now allows you to apply instant auto lens correction adjustments. This can be done with any image, providing there is a matching lens profile in the lens profile database that was installed with Lightroom 3. If the lens you are using is not included in the camera lens profile database, you will need to use a custom lens profile. I'll come on to this shortly, but assuming there are lens profiles available in Lightroom 3 for the lenses you are shooting with, it should be a simple matter of clicking the Enable Profile Corrections box to apply an auto lens correction to a selected photo. When you do this, you should see the Make of the lens manufacturer; the specific lens Model and lens Profile (which will most likely be the installed Adobe profile) appear in the boxes below. If these don't respond, then you may need to proceed to first select the lens manufacturer brand from the Make menu, then the lens Model, and finally, the preferred lens Profile.

An auto lens correction will consist of three components: a Distortion correction to correct for the barrel or pin-cushion geometric distortion, along with the Chromatic Aberration and Vignetting corrections that I have just described on the preceding pages. The Amount sliders you see here allow you to fine-tune an auto lens correction. So, for example, if you wanted to allow an automatic lens correction to automatically correct for the chromatic aberration and lens vignetting, but not correct for, say, a fish-eye lens distortion, you could drag the Distortion slider all the way to the left. On the other hand, if you don't believe an auto lens correction to be strong enough, you can easily increase the correction amount by dragging any of these sliders to the right.

The default option for the Setup menu is Default. This instructs Lightroom to automatically work out what is the correct lens profile to use based on the available EXIF metadata contained in the image file, or use whatever might have been assigned as a "default" lens corrections to use with this particular lens (see below). The Custom option appears only if you choose to override the auto-selected default setting, or you have to manually apply the appropriate lens profile. As you work with the automatic lens corrections feature on specific images, you will also have the option to customize the Lens Corrections settings and use the Setup menu to select the "Save new Defaults" option. This allows you to set new Lens Corrections settings as the default to use when an image with identical camera EXIF lens data settings is selected. As I mentioned above, in this instance, the Setup menu will also show Default as the selected option in the Setup menu.

Accessing and creating custom camera lens profiles

If you don't see any lens profiles listed for a particular lens, you will have two choices. You can either make one yourself using the Adobe Lens Profile Creator program, or locate a custom profile that someone else has made. The Adobe Lens Profile Creator program is available free from http://labs.adobe.com, along with full documentation that explains how you should go about photographing one of the supplied Adobe Lens Calibration charts and generate custom lens profiles for your own lenses. It really isn't too difficult to do yourself once you have mastered the basic principles. If you are familiar with what's new in Photoshop CS5, you will be aware that Photoshop also has the auto lens correction feature included within the updated Lens Corrections filter and that it is very easy to access shared custom lens profiles that have been created by other Photoshop customers (using the Adobe Lens Profile Creator program). Unfortunately, the Lens Corrections panel in Lightroom doesn't provide a shared user lens profile option, so whether you are creating lens profiles for yourself or wishing to install supplied lens profiles, you will need to reference the directory path lists shown in the sidebar opposite. Once you have added a new lens profile to the Lens Correction or LensProfiles folder, you will need to guit Lightroom and restart before any newly added lens profiles appear listed in the Automatic Lens Corrections panel profile list.

Perspective corrections

In the Manual tab section of the Lens Corrections panel, we have the Transform controls. The Distortion slider can be used to apply geometric distortions independent of the Distortion slider in the Profile tab section. The Vertical slider can be used to apply a keystone correction to the converging verticals in a photograph, such as when the camera has been pointed up to photograph a tall building. The Horizontal slider can similarly be used to correct for horizontal shifts in perspective, such as when a photo has been captured from a viewpoint that is not completely "front on" to a subject. The Rotate slider allows you to adjust the rotation of the transform adjustment (which is not the same as rotating the image). While it is possible to use the Rotate slider here to straighten a photo, you should mainly use the straighten tool in the Crop Overlay mode (R) to do this. However, in the example shown on pages 332–333, I did end up using a combination of a Crop Overlay rotate (which isn't included as a step here) and Lens Corrections panel Rotate adjustment to achieve the ideal combined rotation. Finally, the Scale slider allows you to adjust the image scale so that you can zoom in or out. As you reduce the Scale amount, the outer image area will appear as an undefined gray padded area (see Step 3 on page 333). Although Lightroom does not offer any options for filling in this border (as you have with the Lens Corrections filter in Photoshop), there are still ways you can do this in Photoshop itself when retouching a rendered pixel image that's been exported from Lightroom.

NOTE

Lightroom and Camera Raw should use lens profiles that have been generated from raw-capture files. This is because the vignette estimation and removal should be measured directly from the raw linear sensor data rather than from a gamma-corrected JPEG or TIFF image.

NOTE

Custom lens profiles created via Adobe Lens Profile Creator 1.0 should be saved to the following locations: Library\Application Support\Adobe\Camera Profiles\ Lens Correction\1.0 (Mac), C:\Program Files\Common files\ Adobe\Camera Profiles\Lens Correction\1.0 (Windows 32-bit), C:\Program Files (x86)\Common Files\Adobe\Camera Profiles\Lens Correction \1.0 (Windows 64-bit), C:\Documents and Settings\ All Users\Application Data\Adobe\ CameraRaw\LensProfiles\1.0 (Windows Vista/XP).

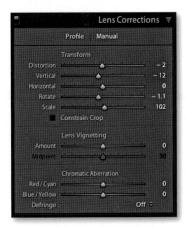

Figure 6.58 The Lens Corrections panel showing the Manual tab options, with Transform adjustments applied to an image.

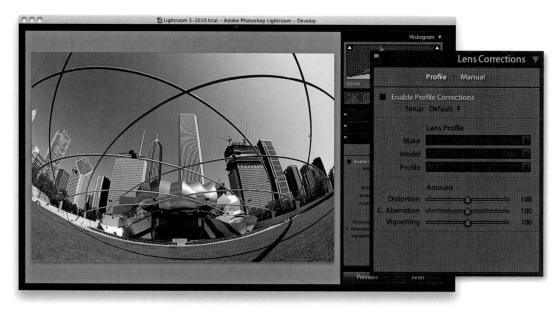

1. In this initial step, you can see an example of a photograph that was shot using a 15 mm fish-eye lens, where there is a noticeable curvature in the image.

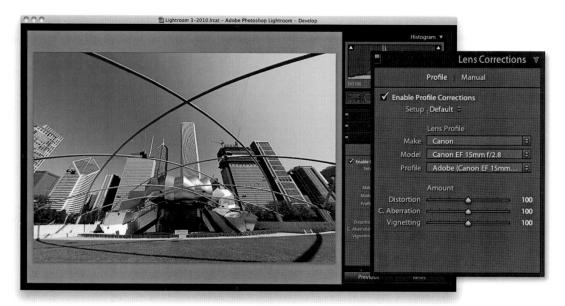

2. In the Lens Corrections panel, I simply checked the Enable Profile Corrections box to apply an auto lens correction to the photograph. In this instance, I left all three Amount sliders at their default 100 percent settings. If I wanted to, I could adjust these sliders to apply more, less, or no adjustment. For example, I could have chosen to apply a 50 percent Amount Distortion correction with a 0 percent Vignetting correction.

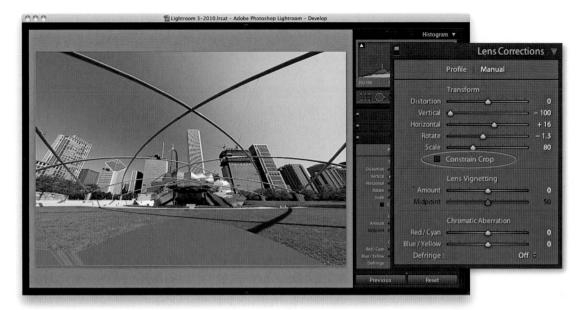

3. Next, I clicked the Manual tab in the Lens Corrections panel so that I could adjust the Vertical transform slider to correct for some of the keystone distortion in this photo. I also adjusted the Horizontal slider to center the two overhead poles. Finally, I rotated the transform adjustment –3 clockwise and adjusted the Scale slider in order to zoom out slightly and reveal more of the image content.

NOTE

See the sidebar on page 264 for information about the Constrain Crop option (circled in Step 3).

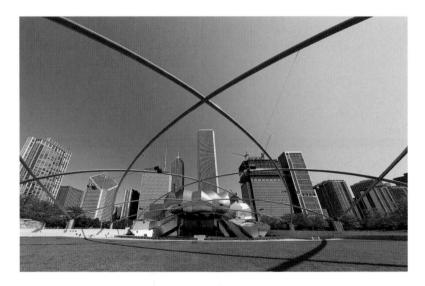

4. Finally, I opened the photo in Photoshop CS5 and used the new Content-Aware Fill feature to fill in the gray space at the bottom. If you are interested in seeing how this was done, I suggest watching the movie that's on the book's Web site. Downloadable Content: www.thelightroombook.com

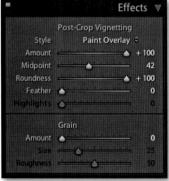

Figure 6.59 This shows the Effects panel controls. At zero Roundness, the vignette shape matches the proportions of the cropped image. At +100, the Roundness slider makes the post-crop vignette more circular. At a 0 setting, the Feather slider allows you to apply a harsh edge to the vignette edge.

Effects panel

Post-Crop vignettes

The Post-Crop vignette controls in the Effects panel (see **Figure 6.59**) can do more or less the same thing as the Lens Corrections sliders, except these adjustments are applied relative to the proportions of the cropped photograph. But note that whenever you use the Crop Overlay mode to edit a crop setting, the vignette effect is temporarily disabled. The Amount and Midpoint sliders work the same as those found in the Lens Corrections panel, while the Roundness slider allows you to adjust the shape of the vignette relative to the proportions of the image (see Figure 6.59). Meanwhile, the Feather slider allows you to soften or harden the vignette edge. For example, in Figure 6.59, I applied a Feather amount of 0 to the vignette, which applied a hard edge to the vignette.

In Lightroom 3, you now have access to the new Post-Crop options, plus a Highlights slider, which I'll come onto shortly. To inspire you, I have applied four different Post-Crop vignette settings to the book cover photograph (**Figure 6.60**). The main thing to point out here is that the Post-Crop sliders work just as well on uncropped images, and the ability to apply both a Lens Correction and a Post-Crop vignette means that you can also experiment using different combinations of these two settings when editing a cropped photograph. For example, in the bottom-right image in Figure 6.60, I combined a negative global Lens Correction with a positive Post-Crop vignette in Paint Overlay mode.

Post-Crop vignette options

I have so far shown just the Paint Overlay setting which is the name now given to the standard Post-Crop vignette that was incorporated into previous versions of Lightroom. When first introduced, some people were quick to point out that the Post-Crop vignetting wasn't exactly the same as a Lens Correction vignette effect. You can see for yourself in the Figure 6.60 examples how the Paint Overlay vignette applies a soft-contrast, hazy kind of effect. This wasn't to everyone's taste (although for some images I quite liked the look it created). Consequently, Lightroom 3 now offers two new additional post-crop editing modes that do closely match the normal Lens Correction edit mode, yet offer extra scope for adjustment. Where people were once inclined to use the Lens Correction sliders as a creative tool (because the Post-Crop effects were a bit wishy-washy), they should now think of the Lens Correction sliders as being for lens corrections only and the Post-Crop Vignetting sliders as being designed for adding different kinds of vignette effects.

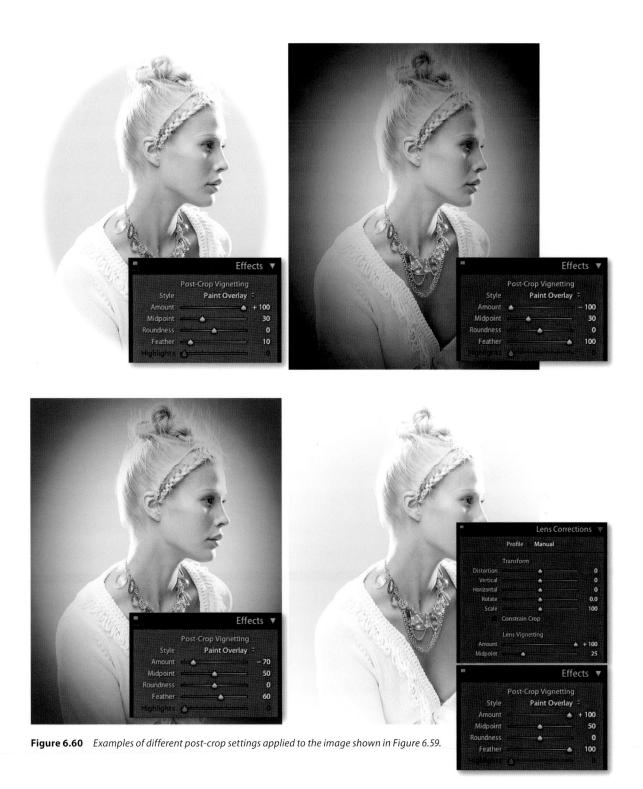

Figure 6.61 Here you can see an example of a lightening Post-Crop vignette adjustment in which the Color Priority mode was used (top) and the Highlight Priority mode was used (bottom).

In the Paint Overlay example below (see **Figure 6.62**), the post-crop effect blends either a black or white color into the edges of the frame, depending on which direction you drag the Amount slider. With the two new Lightroom 3 modes, the effect produced is much more similar to a Lens Correction effect since the darkening or lightening is created by varying the exposure at the edges. **Figure 6.61** shows an example of the two new vignettes in use where a positive Amount setting was used to lighten the corners of a photo. Of the two, the Color Priority is usually the gentler, as this applies the Post-Crop vignette after the Basic panel Exposure adjustments, but before the Tone Curve stage. This minimizes color shifts in the darkened areas, but it can't perform any highlight recovery. The Highlight Priority mode tends to produce more dramatic results. It applies the Post-Crop vignette prior to the Exposure adjustment, has the benefit of allowing better highlight recovery, but can lead to color shifts in the darkened areas.

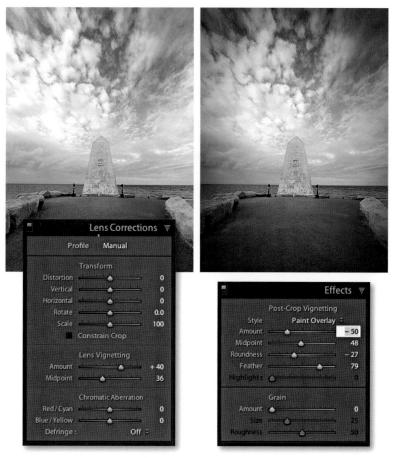

Figure 6.62 In this example, I took an image that had been shot with a 12 mm wide-angle lens and initially applied a Lens Correction adjustment to correct for the lens vignetting that was evident at the corners of the photo, and then cropped the bottom of the photograph (left). I then applied a Paint Overlay Post-Crop vignette using the settings shown here (right).

Figure 6.63 shows examples of these two new vignette effects being used to apply darkening vignettes. You will notice that there is also a new Highlights slider that can further modify the effect. But note that the Highlights slider is only active when applying a negative Amount setting—as soon as you increase the Amount to apply a lightening vignette, the Highlights slider is disabled. As you can see in the right-hand example in Figure 6.63 below, increasing the Highlights allows you to boost the contrast in the vignetted areas, and the effect is only really noticeable in subjects that feature bright highlights. Here it had the effect of lightening the clouds in the corners of the image, taking them more back to their original exposure value. In these examples, the difference is quite subtle, but I find that the Highlights slider usually has the greatest impact when editing a Color Priority post-crop vignette.

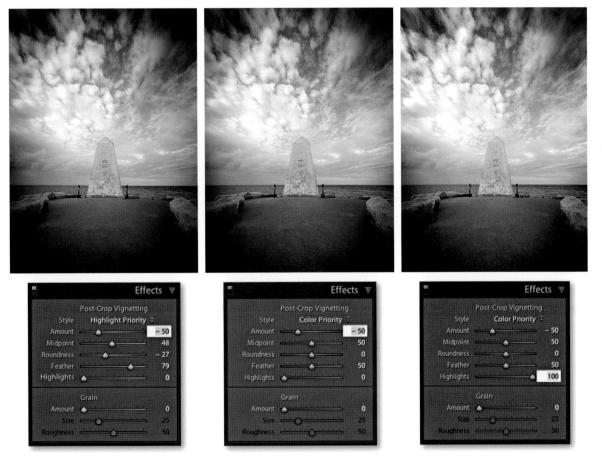

Figure 6.63 Here I have shown further examples of the same image processed using the two new Post-Crop vignette settings. On the left is an example of a Highlight Priority vignette; in the middle, a Color Priority vignette, and on the right, a Color Priority vignette with the Highlights slider set to 100 percent.

Adding grain to images

The Effects panel also contains new Grain effects sliders which can be used to give your photos a traditional film-like look. However, you may need to apply quite strong settings if you want the grain effect to be noticeable in print. The thing is, if you apply the grain effect to a typical digital camera capture image at a 1:1 view and then make an 8 x 10 print, the effect will mostly be lost due to the downsizing of the image data. If such images are downsized to appear on the Web, then I doubt you'll notice the grain effect at all. **Figure 6.64** shows a toned black-and-white photograph in which I added a heavy grain effect, and **Figure 6.65** shows a 1:1 close-up of the same image where you can compare the before and after views. As you can see, the grain sliders can be effective at simulating film grain, but doing so will also soften the image detail. I, therefore, can't help wondering what is the point of adding a grain effect to a digital photo? Isn't the lack of grain the main reason why most of us prefer to shoot digitally?

However, if you have a photo that suffers from noticeable image artifacts, you use the Grain effects sliders to add small amounts of grain to help hide these so that a final print can withstand close scrutiny. As my friend and late colleague Bruce Fraser used to say, "In the case of photographers, the optimum viewing distance is limited only by the length of the photographer's nose." Having said that, it is worth pointing out here that photographers often have false expectations that what they see on the screen will be an accurate representation of what they'll see in print. It is certainly possible to fret needlessly about what you see on screen at a 1:1 or a 200 percent view when the micro detail you are analyzing is about to become lost during the print process. Therefore, any tiny artifacts you see at a 100 percent view or higher aren't really worth stressing over. Yet it still troubles people when they see this. So, having the ability to dial in some added grain does allow you to add a fine amount of micro detail noise to a photo and blend the problem artifacts with the rest of the image. But in all honesty, while adding a subtle grain effect can, indeed, make your photos look better at 1:1 and help hide any residual luminance noise, you are still only creating the illusion that the image has been improved, and this won't actually have much bearing on the sharpness of the final print, unless of course, the problem is so severe that it is an absolute necessity.

The same can be said about the quest for perfect noise reduction. Although some camera reviewers talk about the noise they've seen in the high ISO captures, it's not always possible to see this noise reproduced in print, except where the photos have been printed blown up. So much has been done to improve the quality of high ISO capture, especially with the latest Nikon and Canon digital SLR cameras. Plus, the work of third-party software products (and now Adobe) have also allowed us to keep digital capture noise to a minimum. The main point I am trying to make here is not to over-obsess about trying to remove every single trace of noise when analyzing your images in close-up. The Grain sliders may appear as if they can do some good, but they won't always be strictly necessary.

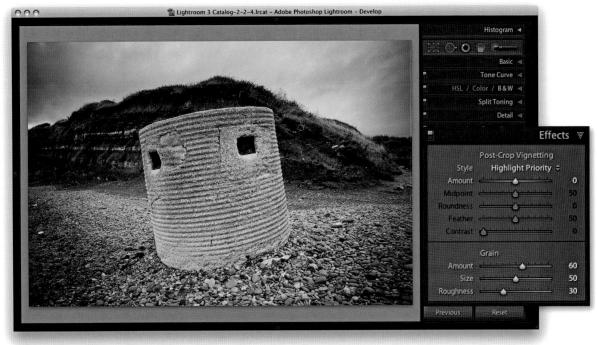

Figure 6.64 This shows a full-frame view of a photo where I applied a grain effect.

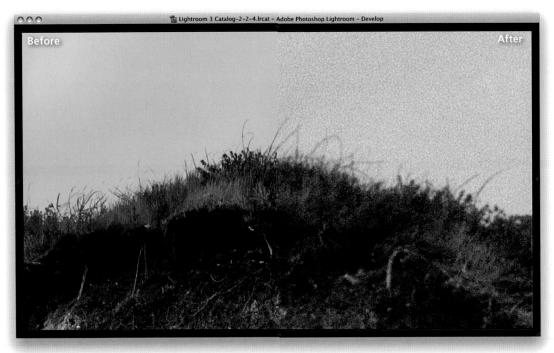

Figure 6.65 This shows a before and after close-up view of the photo shown in Figure 6.64.

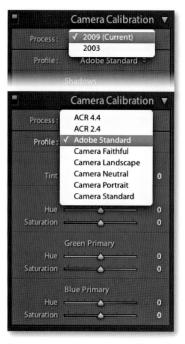

Figure 6.66 The Camera Calibration panel controls showing the process version options (top) and the camera profile options (bottom).

NOTE

The ACR profile version number indicates which version of the ACR plug-in was used to create the profile associated with the camera that shot the image and is there for information purposes only. There have been a few cases in which Adobe has decided that the profiles created for some specific cameras in earlier versions of the Adobe Camera Raw plug-in could have been improved upon, and this is where you may see extra ACR profile options listed. As I mentioned in the main text, Adobe Standard is now the best one to select, but for legacy reasons, the older versions are still made available.

Camera Calibration panel

The Camera Calibration panel (**Figure 6.66**) allows you to select the most appropriate camera profile to use as a starting point for your subsequent Develop module adjustments. To start with, you will notice that there is a menu that allows you to choose which process version to apply to the images. (You can also do this via the Settings \Rightarrow Process menu.)

Camera profiles

Below this is the Profile menu, from which you can choose a suitable camera profile to use as a starting point for your subsequent Develop module adjustments. Since the release of Lightroom 2, the camera profiles have been updated for most camera makes, and Lightroom ships with a collection of custom camera profiles for most of the cameras that are supported by the Camera Raw database. The Adobe Standard profile (shown selected in Figure 6.66) is now the recommended default, because it is more color accurate than previous camera profiles such as the ACR 4.4 profile or older. You can still access these other profiles, of course, since they need to be kept for legacy compatibility reasons (see sidebar note).

One of the things that bugged Lightroom users in the early days of the program was the way the initial previews for raw files would change appearance as soon as the previews were updated in the program. This was due to the fact that the embedded preview for a raw file would be based on a standard camera JPEGprocessed image. In other words, the JPEG previews that appeared when you first imported raw photos from a card showed a color rendering that was identical to a JPEG captured with the same camera. A lot of photographers were inclined to think, "Hey, I quite like the way those images look," only to find that Lightroom would proceed to redraw the previews using its own interpretation of the images. If you happen to be fond of the JPEG look and would prefer that Lightroom keep the colors the same on import, you can do so by selecting the Camera Standard profile from the Profile list shown in Figure 6.66, as this will match the default sRGB JPEG look. The alternative profiles you see listed here are designed to match the color response for specific JPEG camera looks that may be associated with a particular camera. If you were editing a photo shot with a Nikon camera, the alternative profile options would probably show: Mode 1, Mode 2, and Mode 3. The thing to stress here is that there is no right or wrong way to process an image at this stage, since any color interpretation is really just a starting point, but if you want your raw photos to match the "look" of one of the camera JPEG settings, you can now do so (see Figure 6.67).

The Camera Raw conversions in Lightroom are the result of many years of painstaking work. For each camera that is supported by Camera Raw, two sets of profile measurements were used to record the camera sensor's color response under controlled daylight-balanced and tungsten-balanced lighting conditions. Using this data, it has been possible to extrapolate what the color response should be for all white balance lighting conditions that fall between these two setups and beyond. Over 250 different cameras are supported by Adobe Camera Raw (ACR) and Lightroom, and in some instances several camera samples were tested to obtain a representative average set of measurements. Other times, only one camera model was actually used. But in all cases, it is clear that the measurements made by the Camera Raw team can only ever be as good as the camera or cameras from which the measurements were made (and how representative these were of other cameras of the same make). At the same time, the sensors in some cameras can vary a lot in color response from camera to camera, and this variance means that although a raw file from your camera may be supported by Lightroom, there is no guarantee that it will be exactly the same in color response to the raw files from the cameras that the Adobe team evaluated.

TIP

Try using the Develop Presets panel to save "Calibration only" presets for each of the available camera profiles. You can then either roll the mouse over the presets to preview the outcome in the navigator or click through the list to quickly compare the different camera profile renderings.

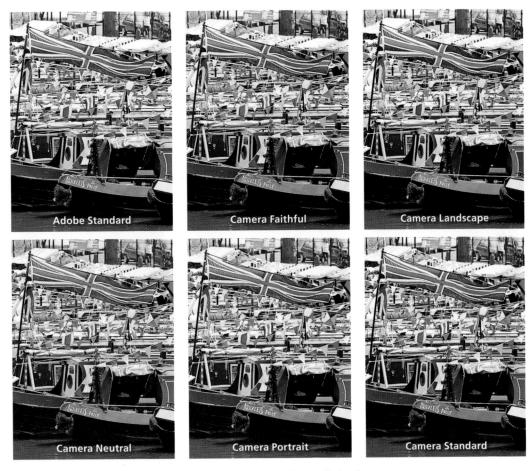

Figure 6.67 Here you can see examples of different camera profiles applied to the same image. The top-left image shows the Adobe Standard profile being used, while the bottom-right version uses the Camera Standard profile. This would be the one to choose if you wished to match exactly the appearance of the camera JPEG.

DNG Profile Editor.app

Figure 6.68 The DNG Profile Editor program can be downloaded for free from http://labs.adobe.com.

NOTE

The X-Rite ColorChecker chart is available as the full-size version or as a slightly cheaper mini version. Both are well-suited for creating custom camera profiles.

TIP

If you wish to produce a superaccurate camera profile to match those created by Adobe, you can do so by photographing the target ColorChecker target twice: once using 6500 K balanced lighting and again using 2850 K balanced lighting. DNG Profile Editor allows you to read both captures independently (see Step 3) and thereby build a camera profile that can adapt to subjects shot between these two measured white points and extrapolate beyond to calculate the profile response under different white balance lighting conditions.

How to create a custom calibration with DNG Profile Editor

In the quest to produce improved Adobe Standard profiles, Lightroom engineer Eric Chan used a special utility program called DNG Profile Editor to help reevaluate the camera profiles supplied with Camera Raw and, with this, produced the revised Adobe Standard profiles. You can get hold of a copy of this program by going to http://labs.adobe.com and doing a search for DNG Profiles. At the time of writing, it is currently in version beta 2 and can be downloaded for free (see **Figure 6.68**). There are a number of things you can do with this utility, but I think its main strength is that you can use it to create custom calibration profiles for the sensor in your camera. As I just mentioned, while the default camera profiles may be quite accurate for different individual cameras, there may still be a slight difference in color response between your particular camera and the one Adobe evaluated. For this reason, you may like to run through the following steps to create a custom calibration for your camera sensor.

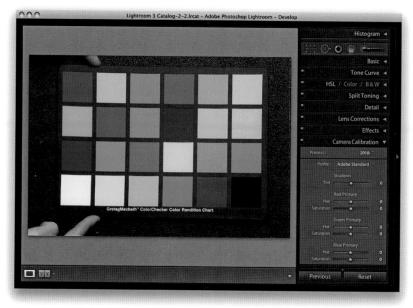

1. The first thing you need to do is to take a photograph of an X-Rite ColorChecker chart. I suggest you shoot this against a plain dark backdrop and make sure that the chart is evenly lit from both sides. It is also a good idea to take several photos and bracket the exposures by two-thirds of a stop either side. This is because if the raw original isn't correctly exposed, you'll see an error message when trying to run the DNG Profile Editor. The other thing you'll need to do is convert the raw-capture image to the DNG format, and then go to the Develop module, select the Adobe Standard profile as your starting point (don't apply any other Develop adjustments), and use **HSS** (Mac) or **Ctriss** (PC) to save the Lightroom-edited metadata to the DNG file.

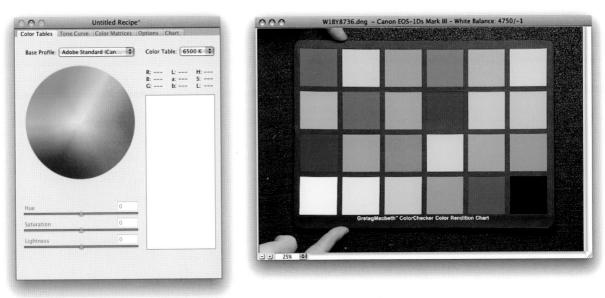

2. The next step is to launch DNG Profile Editor. Once launched, go to the File menu and choose File
⇒ Open DNG Image. Now browse to locate the DNG image you just edited and click Open. The selected image appears in a separate window, and you can see that the base profile is using the Adobe Standard profile for whichever camera was used to capture the ColorChecker chart.

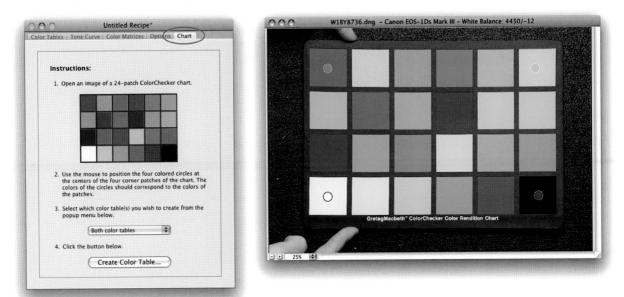

3. Now click the Chart tab and drag the four colored circles to the four corner swatches of the chart. If you are measuring just the one chart, select the "Both color tables" option before clicking on the Create Color Table button.

O Untitled Recipe			
Color Tables Tone Curve Color Matrices Options Chart			
Base Profile: ColorChecker	Color Table: 6500 K		
· · ·	R: L: H: B: a: S:		
	G: b: L:		
•	-		
		Export DNG Camera Profile	
		Save As: Canon EOS-1Ds Mark III calibration.dcp	
	-	Where: CameraProfiles	
Hue 0		(Cancel) (Save	
Hue 0 Saturation -1			
Lightness			
<u> </u>			

4. The camera profile process will take less than a second to complete. Once this has happened you can then go to the Edit menu and choose File ⇒ Export *name of camera* Profile, or use the ﷺE (Mac) or Ctrl E (PC) shortcut. Next, rename the profile as desired.

	Camera Calibration	T
Process :	2010 🕏	
Profile :	Canon EOS-1Ds Mark III calibration 🗧	
Tint Hue Saturation	Shadows Red Primary	0 0 0
Hue Saturation Hue Saturation	Green Primary	0 0 0

5. Custom camera profiles are saved to a default user folder but won't appear in the Camera Calibration Profiles list until after you have quit and restarted Lightroom. Once you have done this, you'll be able to select the newly created camera profile and apply it to any photographs shot with this particular camera.

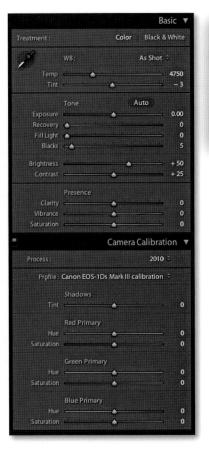

6. If you want, you can go to the Develop module and make sure that all the Develop controls are set to the default neutral settings, the White Balance is set to As Shot, and in the Camera Calibration panel, the relevant Camera Profile is selected. You can then go to the Develop menu and choose Set Default Settings. This ensures that the custom camera profile is now applied by default to all newly imported raw photos from this particular camera. (See also pages 402–403 for details on how to save the Camera Calibration profile setting as part of a Camera default setting and link default settings to ISO values.)

Creative uses of the Camera Calibration panel

There isn't much need now for the Camera Calibration sliders, since all you have to do is select an existing camera profile or create one specifically for your camera. However, I do still find these additional color adjustment controls useful, especially if you want to produce false color effects, so I have shown some examples of this in **Figures 6.69** through **6.72**. I have also discovered that the Camera Calibration controls can be useful for fine-tuning black-and-white conversions. (To read more about this, go to page 429 in the following chapter.)

NOTE

Before there was DNG Profile Editor, the best way to create a custom Camera Calibration was to use the Photoshop ACR Calibrator script created by Tom Fors (which was available via his Chromaholics Web site). Now that camera calibration can be carried out so much more speedily with DNG Profile Editor, the script is no longer applicable, but it is much to Tom's credit that he once managed to provide a viable solution for photographers who wished to calibrate their cameras.

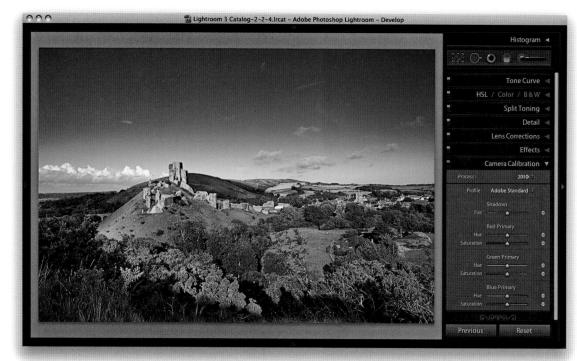

Figure 6.69 This shows a standard version of an image, using the Adobe Standard Camera Profile, but with zeroed Camera Calibration panel sliders.

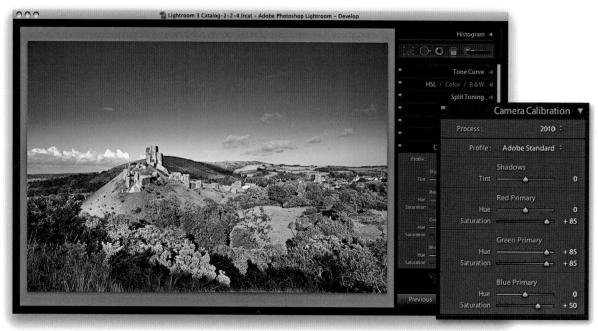

Figure 6.70 This shows a vivid color setting, created using the Camera Calibration sliders.

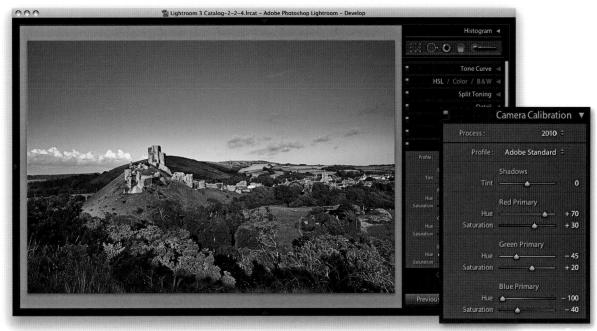

Figure 6.71 To create this color infrared effect, I used the settings shown here. (You may also want to reduce the Vibrance slightly.)

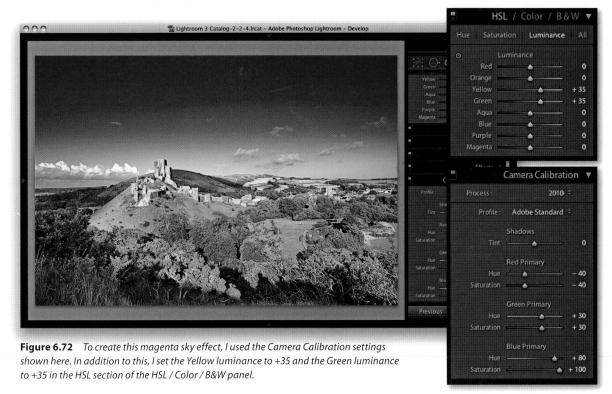

Assessing your images Comparing Before and After versions

While you are working in the Develop module, you can simultaneously compare the before and after versions of any photograph you are working on. This allows you to compare the effect of the Develop settings adjustments, as they are applied to the image. To view the before and after adjustments, click the Before/After view mode button in the Toolbar, and then click the disclosure triangle (circled in **Figure 6.73**) to select one of the four Before/After viewing modes from the fly-out menu. These viewing modes let you display two identical views of the currently selected image. You can choose a Left/Right view to see a horizontal side-by-side Before and After preview, or you can choose a Top/Bottom view to see a vertical side-by-side Before and After preview. Meanwhile, the Split

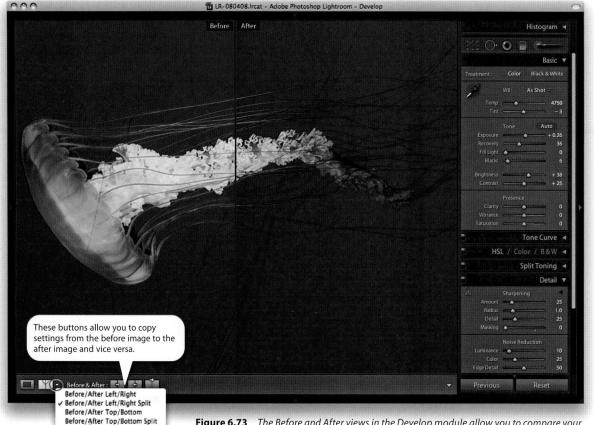

Figure 6.73 The Before and After views in the Develop module allow you to compare your Develop adjustments with a previous version of the image. The Before/After Left/Right Split option allows you to compare side-by-side before and after versions in the preview area.

The Before/After comparison

viewing modes

views divide the preview in half, displaying a Before view on the left and an After view on the right (or a Before view on top and an After view below [see **Figure 6.74**]). Alternatively, you can repeat clicking the Before/After button to cycle through all the available views. You can also use the Y key to toggle the standard Left/Right view mode on or off, press Alt Y to toggle the standard Top/Bottom view mode on or off, and use Shift Y to toggle between a Split screen preview or side-by-side previews. Pressing D returns to the default full-screen preview in the Develop module. While you are in any of the Before/After view modes, you can zoom and scroll the image to compare your adjustments with the before version.

TIP

You can switch between the before and after versions in the Develop module by going to the View menu and choosing Before/After ⇒ Before Only. Or, use the backslash key (①) shortcut to quickly toggle between these two viewing modes.

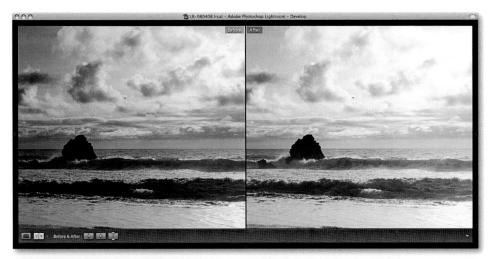

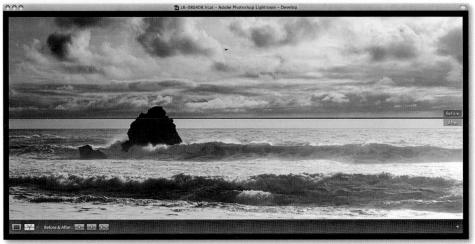

Figure 6.74 These two screen shots show you the two main viewing modes for comparing before and after versions of an image. The top screen shot shows a photograph in the Before/After Left/Right, side-by-side preview mode, and the bottom screen shot shows the Before/After Top/Bottom Split preview mode.

DE

The Copy After's Settings to Before keyboard shortcut is #Alt_Shift) (Mac) or Ctri_Alt_Shift) (PC). The Copy Before's Settings to After keyboard shortcut is #Alt_Shift) (Mac) or Ctri_Alt_Shift) (PC).

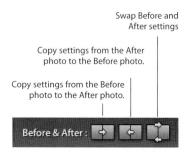

Figure 6.75 The Copy settings buttons only appear at the bottom of the Develop module when either the Left/Right or Top/Bottom view modes have been selected. The buttons shown here are those for when the Left/Right view mode is selected.

Managing the Before and After previews

When you edit an image in one of the Before/After viewing modes, you can make umpteen adjustments via the Develop module and at all times be able to compare the revised, After version with the Before version. Just to clarify here, the Before version view uses either the Develop settings that were applied when the photo was first imported into Lightroom or the last assigned Before state. When you click the "Copy settings from the After photo to the Before photo" button, you are assigning a new Before state to the Before version view.

Let's suppose that you want to make the current After version view the new Before. You can do this by clicking the "Copy settings from the After photo to the Before photo" button. This updates the Before image view with the After image settings. What you are effectively doing is making a snapshot of the settings at a certain point in the Develop adjustment process, which lets you make further new adjustments and compare these with a new Before version. Let's say at this point that you continue making more tweaks to the Develop panel settings, but you decide that these corrections have not actually improved the image and the interim Before version view was actually better. You can reverse the process by clicking the "Copy settings from the Before photo to the After photo" button. Basically, the Before and After compare mode controls (**Figure 6.75**) let you take a snapshot of an image mid-correction and compare it with whatever settings you apply subsequently. The following steps illustrate one such workflow.

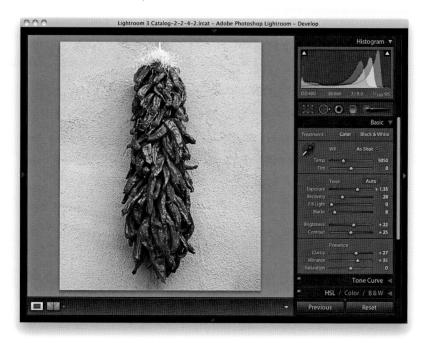

1. This screen shot shows a photo in the Develop module Loupe view with the image settings that were applied at the import stage.

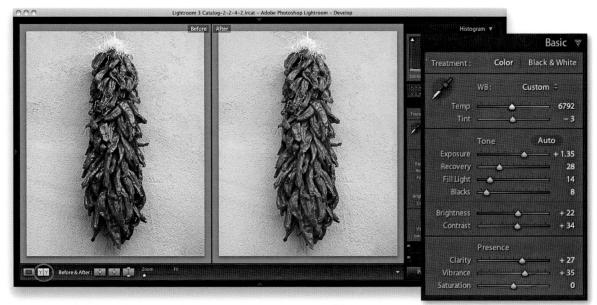

2. I clicked the Before/After view YY button (you can also use the Y keyboard shortcut) and began to adjust the image by altering the white balance so that the modified After version was warmer in color.

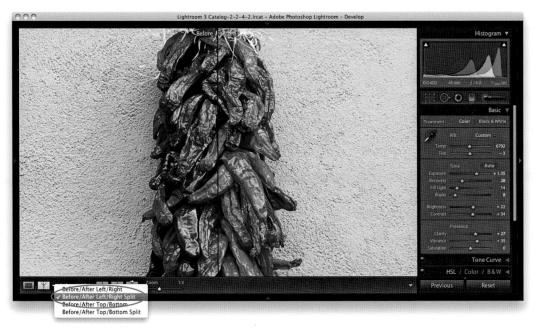

3. I went to the Before/After viewing mode menu and switched view modes, selecting the Before/After Left/Right Split view. I magnified the image to display the photo at a 1:4 zoom view.

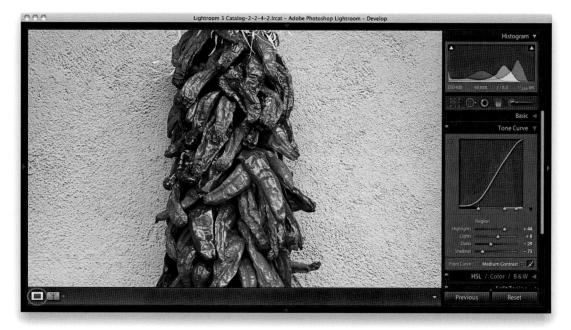

4. I clicked the Develop module Loupe view button to switch out of the Before/ After view mode so I could work on the photo in a normal full-screen view.

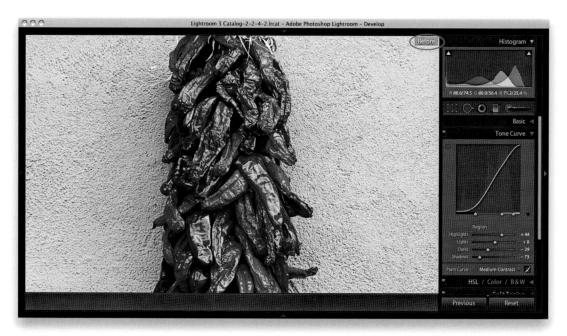

5. While working in the Develop module, you can easily compare the current Develop settings with the Before version, using the () keyboard shortcut. This switches to show the Before view. Press () again to revert to the After view.

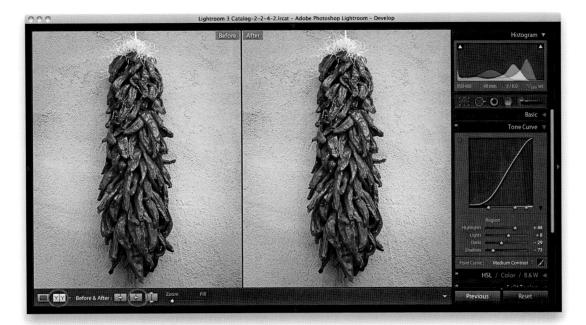

6. I then clicked the Before/After view button again (or you can use the Y shortcut) and clicked the "Copy After's settings to Before photo" button ((ℜ(AIL)Shift)) [Mac] or (Ctrl (AIL)Shift) [PC]) making the current version the new Before setting.

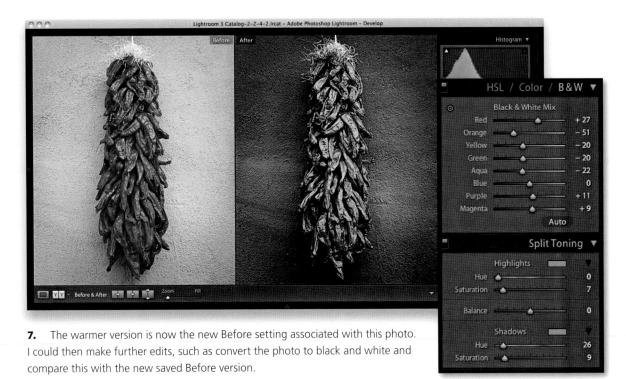

THE ADOBE PHOTOSHOP LIGHTROOM 3 BOOK 353

Figure 6.76 The retouching tools are all located just below the Histogram panel in the Develop module. From left to right: Spot Removal, Red Eye, Graduated Filter, and Adjustment brushes. This screen shot shows the Spot Removal tool panel options.

NOTE

So why the tool shortcut change for the spot removal tool? The previous shortcut was N, which someone suggested stood for the "nuke" tool! The revised tool shortcut, Q, doesn't stand for anything, it was just one of the few remaining keys left that hadn't been used for anything else. The reason for this change is to provide a new shortcut that can allow you to switch to Spot Removal mode from any module in Lightroom (previously, the N shortcut worked only from within the Develop module. If used elsewhere, it would select the Library module Survey view.

Image retouching tools

The retouching tools in the Develop module (**Figure 6.76**) can be used to retouch a photograph in Lightroom without actually editing the pixel data. When you work with the Spot Removal, Red Eye Correction, Adjustment Brush, or Graduated Filter tools, these actions are recorded as sets of instructions, and the pixel image data in the original master file remains untouched. It is only when you choose to export a file as a TIFF, JPEG, or PSD, or carry out an "Edit in external editor" command, that the retouching work is physically applied to the exported image.

Spot Removal tool

The Spot Removal tool ((Q)) has a Clone mode and a Heal mode. In Clone mode, the Spot Removal tool copies and repairs from a sample area but doesn't blend the result with the surrounding pixels. It does so using a soft-edged selection. This is the most appropriate mode to work with when removing spots that are close to an edge. For all other retouching work, I suggest you use the Heal mode, which blends the results of the retouching with the image information that is just outside of the area you are trying to repair. The Heal mode is nearly always successful at hiding blemishes because of the way it invisibly blends the healed area with the surrounding pixels.

To work with the Spot Removal tool, you can start by adjusting the Size slider in the Spot Removal tool options (Figure 6.76) so that the Spot Removal cursor matches the size of the areas you intend to repair. A quicker method is to use the square bracket keys on the keyboard. Click or hold down the 🗍 key to make the Spot Removal circle size bigger, or use the 🔲 key to make the spot size smaller. Next, locate the spot or blemish you wish to remove, click it with the Spot Removal tool, and set this as the target. If the cursor size is large enough. you'll see a small crosshair in the middle of the cursor circle; you can use this to target the blemish you want to remove and center the cursor more precisely. Then drag outward to select an image area to sample from. This will be used to repair the target area. At this stage, you'll notice that the original (target) circle cursor disappears so that you can preview the effect of the spot removal action without being distracted by the spot circle. A linking arrow also appears to indicate the relationship between the target circle and sample circle areas (Figure 6.77). When you have finished applying a spot removal, the target circle remains as a thin, white circle on the screen for as long as the Spot Removal tool is active in the Develop module. You can quit working with the tool by clicking the Close button (circled in Figure 6.76) or by pressing the Q key.

Because Lightroom is recording all these actions as edit instructions, you have the freedom to fine-tune any Clone and Heal step. For example, you can click inside a Spot Removal circle to reactivate it and reposition either the target or the sample circles. If you click the edge of the target cursor circle, a bar with a bidirectional

arrow appears, and you can click and drag to adjust the size of both the target and sample circles. Another way to work with the Spot Removal tool is to click and drag with the 😹 key (Mac) or Ctrl key (PC) held down. This allows you to define a different spot size each time you drag with the tool; the sample circle will auto-pick anywhere that surrounds the target circle area. When using this method of spotting, the sample selection may appear quite random, but Lightroom is intelligently seeking an ideal area to sample from. (This is similar to the logic used by Photoshop's Spot Healing Brush.) You can also use the On/Off button at the bottom of the Spot Removal tool options (circled in Figure 6.77) to toggle showing and hiding the Spot Removal tool circles, and the Reset button can be used to cancel and clear all the current Spot Removal tool edits.

In Figure 6.77, I have illustrated several of the ways you can work with the Spot Removal tool. On the next page is a detailed summary of the Spot Removal tool behavior discussed so far, as well as information on how to manage the Tool Overlays behavior.

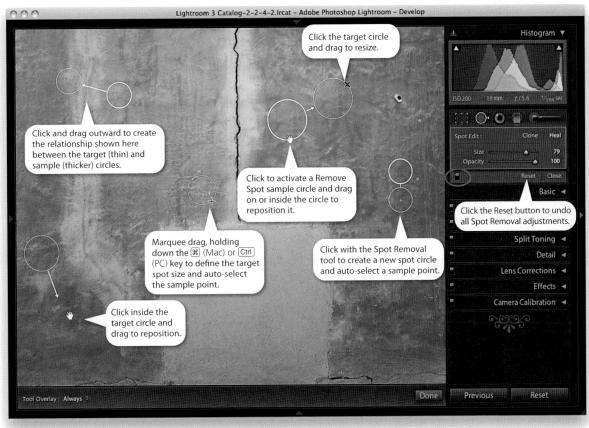

Figure 6.77 This screen shot shows a combined series of snapshots taken of the Spot Removal tool in action to illustrate the different ways you can work with this tool.

NOTE

Dust marks are the bane of digital photography, and ideally you want to do as much as you can to avoid dust or dirt getting onto the camera sensor. I have experimented with various products and found that the Sensor Swabs used with the Eclipse cleaning solution from Photographic Solutions, Inc. (www.photosol.com), are reliable products. I use these from time to time to keep the sensors in my cameras free from marks. It is a bit scary when you first try to clean a sensor. Just remember to follow the directions and don't use too much solution on the sensor swabs, because you don't want to drench the sensor surface with cleaning solution.

Clone or Heal

In Clone mode, the Spot Removal tool copies the pixels using a feathered circle edge. In Heal mode, the Spot Removal tool copies from the sample area and blends the copied pixels with those around the edge of the target circle area. You can also use the Clone/Heal buttons in the Tool options panel to change the Spot Removal mode for any Spot Removal circle. Another important thing to be aware of is that if you simply click with the Spot Removal tool in Heal mode (or **(Hac]** or **(Ctrl)** [PC] drag with the mouse), rather than just drag to set the sample point, the Spot Removal tool behaves like the Spot Healing Brush in Photoshop and Photoshop Elements. That is to say, when you click with the Remove Spot tool in Lightroom, it uses a certain amount of built-in intelligence to auto-select the best area to sample from.

Click and drag

One of the standard ways to work with the Spot Removal tool is to place the cursor over the area you want to remove, center the cursor using the crosshair, and then click with the mouse and drag outward to determine the placement of the sample circle. As you do this, the preview area inside the target circle is updated as you drag to set the sample circle. The target circle itself is hidden while you drag so that you won't be distracted by the cursor circle remaining onscreen as you work with this tool. Note here that the visibility of the crosshair is dependent on the size of the brush cursor, the zoom ratio that's currently applied, as well as the size of the image.

Resizing the Spot Removal circles

You can edit the Spot Removal circles by adjusting the size slider in the Spot Removal tool options (Figure 6.76), and you can also use the square bracket keys to adjust the circle size of the cursor before creating a new spot: Use the left bracket (①) to make the circle size smaller and the right bracket (①) to make the circle size bigger. The Spot Removal circles always remain fully editable. You can select an individual circle and use the Spot Removal slider to readjust the size. Or, you can click the edge of a target circle and drag to resize. Note that as you click and drag, the thin circle cursor conveniently disappears, which allows you to see more clearly the effect the circle resizing is having on the photo.

Repositioning the Spot Removal circles

If you click inside a target Spot Removal circle, the thin circle disappears and changes to show a hand icon. This allows you to drag and reposition the spot circle so that you can readjust the target position. You can also click on or inside a sample circle and drag to reposition the sample area relative to the target circle so that you can select a new area to sample from.

Tool Overlay options

The Tool Overlay options can now be accessed via the Develop module Toolbar (**Figure 6.78**), as well as via the Tools menu. These options refer specifically to the Spot Removal tool, Red Eye Correction tool, Adjustment brush, and Graduated Filter tool. If you select the Auto option, the Spot Removal circles become visible only when you roll the cursor over the preview area. If you select the Always option, the Spot Removal circles remain visible at all times. When the Selected option is chosen, only the active Spot Removal circle is shown and all others are hidden. When the Never menu option is selected, all the Spot Removal overlays remain hidden, even when you roll the mouse cursor over the image. But as soon as you start working with the Spot Removal tool, the tool overlay behavior automatically switches to Auto Show mode. I think the most convenient way to work here is to operate in Auto mode and use the H keyboard shortcut to toggle between the Auto and Never overlay modes. This toggle action allows you to work on an image without always being distracted by all the spot circle overlays.

Figure 6.78 The Tool Overlay options in the Develop module Toolbar.

Undoing/deleting Spot Removal circles

Use **B**[Z] (Mac) or **Ctrl**[Z] (PC) to undo the last spot circle. To delete a Spot Removal circle, click to select it and then hit the **Delete** key. And to remove all Spot Removal circles from an image, click the Reset button in the tool options panel.

Auto source point selection

If you simply click with the Spot Removal tool, Lightroom automatically chooses the best area of the photo to sample from. As long as you don't try to edit the sample point (by manually dragging the sample circle to reposition it), the spot circle will remain in "auto-select sample point" mode. So, if you carry out a series of spot removals using, say, the Heal mode, and you always click with the tool rather than drag, you will then be in a position to synchronize the Spot Removal adjustments more efficiently. If you synchronize a series of photos in this way, Lightroom auto-selects the best sample points in each of the individual synchronized photos. This does not guarantee 100 percent successful spot removal for every image that's synchronized this way, but you may still find this saves you time compared to retouching every photo individually one by one. (See the Synchronized spotting and Auto Sync spotting examples shown on pages 358–359.)

TIP

The H keyboard shortcut toggles the Tools overlay view between Auto and Never and the 슈Shift H keyboard shortcut toggles the Tools overlay view between Selected and Never. ΠP

If you have made a selection of images via the Filmstrip (or in the Library Grid view), you can also use the <u>Cmd Shift</u>(S) (Mac) or <u>Ctrl Shift</u>(S) (PC) shortcut to open the Synchronize Settings dialog.

Synchronized spotting

One of the best things about the Spot Removal feature is that you can continue to edit the tones and colors in the photograph and the spotting adjustments will update accordingly. You can also synchronize the settings in one image with others from the same sequence; this includes synchronizing spot removals. So if you get the spotting work right for one image, you can synchronize the spot removal work across all the other selected photos. There are two ways you can do this. One way is to work with the Spot Removal tool on one photo and synchronize the spotting with the other photos later. Or, you can Auto Sync a selection of photos and update all the selected images at once as you are retouching the most selected photo.

1. I first made sure that the photo that had all the spotting work done to it was the most selected in the Filmstrip (the one with the lighter gray border). I then clicked the Sync button.

White Balance	Treatment (Color)	Lens Corrections	Spot Removal
Basic Tone Exposure Highlight Recovery Highlight Recovery Hill Light Black Clipping Brightness Contrast Tone Curve Clarity	Color Saturation Vibrance Color Adjustments Split Toning Local Adjustments Brush Graduated Filters	Transform Lens Profile Corrections Chromatic Aberration Lens Vignetting Effects Post-Crop Vignetting Grain Process Version Calibration	Crop Straighten Angle Aspect Ratio
Sharpening	 Noise Reduction Luminance Color 		

2. This opened the Synchronize Settings dialog, where I made sure only the Spot Removal check box was checked. When I clicked the Synchronize button, Lightroom synchronized the Spot Removal settings across all the selected photos.

Auto Sync spotting

1. An alternative method is to make a selection of photos and hold down the key (Mac) or Ctrl key (PC). This changes the Sync button to an Auto Sync button. Click this button to set the photo selection to Auto Sync mode.

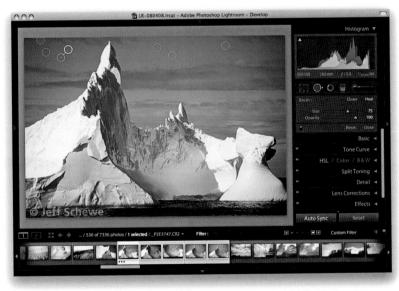

2. You can then edit any of the selected photos and *all* the Develop settings are automatically synchronized to the target photo. Here, I used the Spot Removal tool in Heal mode to remove dust marks from the photo in Step 1, and the Spot Removal settings were automatically applied to all the photos in the selection. When finished, I clicked the Auto Sync button to revert to the standard Sync mode behavior.

NOTE

Copying the Spot Removal settings or working with the Auto Sync feature can work better on some image series than on others. In the example shown here, I was careful to use the Spot Removal tool in Heal mode by clicking only to remove the dust spots (rather than clicking plus dragging). This is because when you synchronize in Heal mode with a click-only action, the click "heal" instruction automatically selects the best area to clone from. The net result is that, for each heal clone spot, Lightroom will clone from wherever it thinks is the best portion of the picture to sample from and do so differently for each individual image. It won't work perfectly in every instance, and it may be necessary to review each image afterward to fine-tune the clone source points (with Auto Sync disabled). But on the whole, Auto Sync cloning can still save you time when repetitively cloning out spots from areas such as skies or plain studio backdrops.

Figure 6.79 The Red Eye Correction tool cursor design.

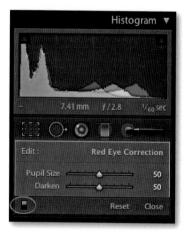

Figure 6.80 The Red Eye Correction tool panel options.

TIP

You can use the On/Off button at the bottom of the Tool options (circled in Figure 6.80) to toggle showing and hiding all Red Eye Correction tool edits. Plus, you can use the Reset button to cancel and clear all the current Red Eye Correction tool edits.

Red Eye Correction tool

There are many ways you can prevent red eye from happening. You can use a flash gun where the flash source is not so close to the lens axis, or on most compact cameras, you can set the flash to an anti-red-eye mode. But for those times when you can't do this, the Red Eye Correction tool can correct photographs in which the direct camera flash has caused the pupils in people's eyes to appear bright red.

To use the Red Eye Correction tool, place the cursor crosshair in the middle of the pupil and drag outward to draw an ellipse that defines the area you wish to correct. (The Red Eye Correction tool cursor is shown in Figure 6.79.) Lightroom automatically detects the red eye area that needs to be repaired and fixes it. You don't have to be particularly accurate, and it is interesting to watch how this tool behaves even if you lazily drag to include an area that is a lot bigger than the area that you need to define with the Red Eye Correction tool cursor. Lightroom always seems to know precisely which area to correct, because the cursor shrinks to create an ellipse overlay representing the area that has been targeted for the red eye correction. After you have applied the tool to a photo, the Red Eye tool options will appear below in the Tools panel selection (Figure 6.80). These options allow you to adjust the sliders to fine-tune the Pupil Size area you want to correct and decide how much you want to darken the pupil. You can revise the Red Eye removal settings by clicking on a circle to reactivate it, or use the Delete key to remove individual red-eye corrections. If you don't like the results, you can always click the Reset button in the tool panel options to delete all the Red Eye Correction retouching and start over.

This feature raises an interesting question: If you know Lightroom can repair red eye so neatly, do you really need to use the anti-red-eye flash mode? What I propose here may sound like a lazy approach to photography, but bear with me. In my experience, the anti-red-eye flash mode often kills the opportunity to grab the most spontaneous snapshots. There is nothing worse than seeing a great expression or something special going on between a group of people in the frame, and then having to wait a few seconds for the camera to get up to speed, firing a few pre-flashes before taking the full flash exposure. These days, I prefer to shoot using the normal flash mode and let Lightroom fix any red-eye problems that occur.

Adjusting the cursor size

Before applying the Red Eye Correction tool, you can adjust the size of the cursor by using the square bracket keys. Use the left bracket (①) to make the cursor size smaller and the right bracket (①) to make the cursor size bigger. To be honest, the cursor size doesn't always make much difference because, big or small, once you click with the tool, you can drag the cursor to define the area you wish to affect. The cursor size is probably more relevant if you are going to be clicking with the Red Eye Correction tool rather than dragging.

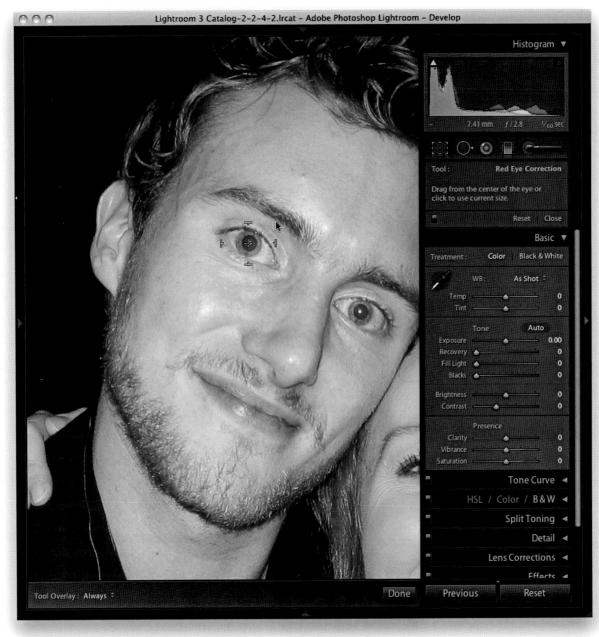

1. Here is an example of the Red Eye Correction tool in action. In this screen shot, you can see that I selected the Red Eye Correction tool and dragged the cursor over the eye on the left, moving from the center of the pupil outward. Alternatively, I could simply have clicked on the pupil using the Red Eye Correction tool. Either method would have worked here.

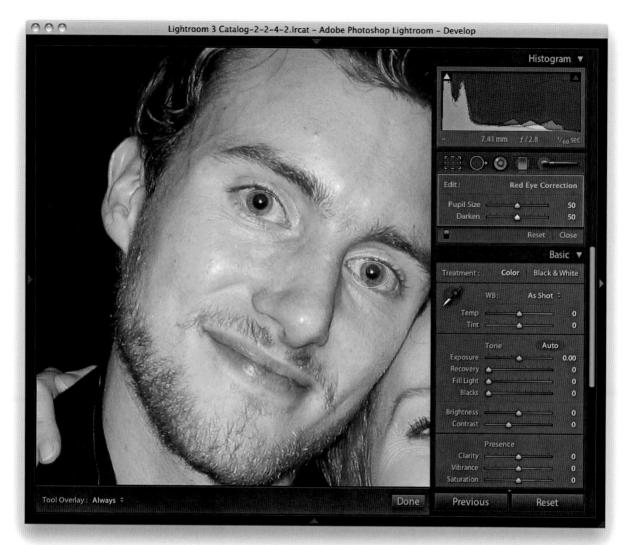

2. After I released the mouse, the Red Eye Correction tool ellipse overlay shrank to fit the area around the eye. As I just mentioned, you don't have to be particularly accurate with the way you define the eye pupils. In this screen shot, you can see that I first applied a red-eye correction to the eye on the left before correcting the eye on the right. Notice here how the first ellipse overlay has a thinner border and the current ellipse overlay is thicker, indicating that this one is active. When a red-eye ellipse is active, you can then use the two sliders in the Tool options to adjust the Red Eye Correction settings. Use the Pupil Size slider to adjust the size up or down for the area that is being corrected. Next to this is the Darken slider, which you can use to fine-tune the appearance of the pupil. I tend to find that the Lightroom autocorrection (using settings of 50) works fine in most instances.

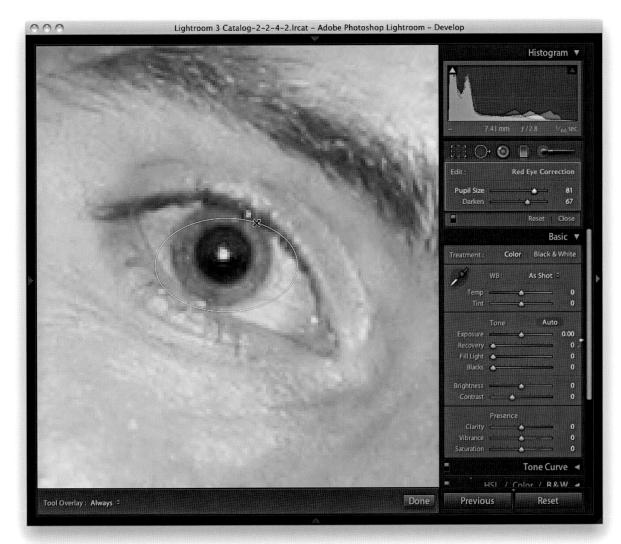

3. If you then move the mouse over to the edge of an ellipse and drag to resize the area, or drag from inside to reposition the ellipse, the behavior is quite different from what happens when you try to edit a Remove Spot circle. When you drag the overlay edge to resize a Red Eye Correction overlay, this allows you to fine-tune the shape and size of the red-eye adjustment. You know how it is said that there are no layers in Lightroom? Well, this is so far the first example of what you could call a Lightroom layer. The benefit is that you can get the Red Eye Correction tool coverage to match the eye pupil precisely. If you need to redo a red-eye correction adjustment, the best thing to do is to make an ellipse overlay active, hit the Delete key to remove it, and apply the Red Eye Correction tool again.

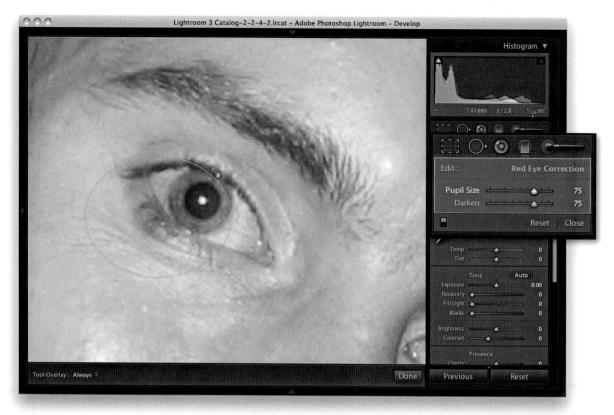

4. All will become even clearer if you hold down the mouse over the ellipse circle and drag the ellipse overlay away from the pupil. Basically, the ability to resize the shape of the red-eye correction and reposition it provides you with a lot of scope to fine-tune any Red Eye Correction adjustment.

Localized adjustments

Let's now take a look at the Adjustment brush and Graduated Filter tool. These are more than just tools for dodging and burning, because you have a total of seven effects to choose from, not to mention dual brush settings and an Auto Mask option. Just like the Spot Removal and Red Eye Correction tools, the Adjustment brush and Graduated Filter tool are completely nondestructive. There is no need for Lightroom to create an edit copy of the master image first. (If that is what you want to achieve, then you can always use the Edit in Photoshop command discussed in Chapter 9.) The unique thing about these tools is that when localized adjustments are applied to an image, the adjustments are saved as instruction edits that are automatically updated as you make further Develop module adjustments. You can even synchronize localized adjustment work across multiple images using the Sync Settings command. Note that the Adjustment tool layouts have changed in Lightroom 3, so read on to find out what's new.

Initial Adjustment brush options

When you first start working with the Adjustment brush (K), the panel options will look like those shown in Figure 6.81 or Figure 6.82. To begin with, you will be in New mode, ready to create a fresh set of brush strokes, but first you need to choose a paint effect: Exposure, Brightness, Contrast, Saturation, Clarity, Sharpness, or Color. In Figure 6.81, the Exposure effect was selected, where a positive value can be used to lighten, or a negative value to darken-these are your basic dodge and burn tool settings. But you can use any combination of sliders here to establish different types of localized adjustment effects and save these as custom settings, which can be accessed via the Effect menu (circled in Figure 6.82). If you want a simpler interface to work with, click the disclosure triangle next to the Effect drop-down menu to collapse the slider options. In Figure 6.82, there is just an Amount slider, and whatever effect settings you have selected in the Effect menu are now controlled by this single slider. You can expand the Adjustment brush options by clicking the disclosure triangle again. If you hold down the Alt key, Effect will change to show Reset (Figure 6.83). Click this to reset all the sliders to 0 and clear any currently selected color. Or, you can hold down the (Alt) key and click an Effect slider name to reset everything except this slider setting. Below this are the Brush settings, where you have three sliders. The Size slider controls the overall size of the brush cursor (Figure 6.84), or you can use the \square and \square to make the cursor bigger or smaller. The reason the cursor has two circles is to show the hardness of the brush. The inner circle represents the core brush size, while the outer circle represents the feathering radius. As you adjust the Feather slider, the outer circle expands or contracts to indicate the hardness or softness of the brush. Or, you can use [☆Shift] [] to make the brush edge harder or [15 Shift]] to make it softer. The Flow slider is kind of like an airbrush control: By selecting a low Flow setting, you can apply a series of brush strokes that successively build to create a stronger effect. You will notice that as you brush back and forth with the Adjustment brush, the paint effect gains opacity. (If you are using a pressure-sensitive tablet such as a Wacom, the flow of the brush strokes is automatically linked to the pen pressure.) The Density slider at the bottom limits what the maximum brush opacity can be. At 100 percent Density, the flow of the brush strokes builds to maximum opacity, but if you reduce the Density, this limits the maximum opacity for the brush. In fact, if you reduce the Density and paint, this allows you to erase the paint strokes back to a desired Density setting, and when Density is set to 0, the brush acts like an eraser. The A and B buttons allow you to create two separate Brush settings so that you can easily switch between two different brushes as you work. To exit the Adjustment brush tool options, you can click the Close button, click the Adjustment brush button at the top, or press [K].

Now let's look at how to work with the Adjustment brush. Where you first click adds a pin marker to the image. This is just like any other overlay, and you can hide it using the \mathbb{H} key (or use the View \Rightarrow Tool Overlay options discussed earlier

Figure 6.81 *The full Adjustment brush options.*

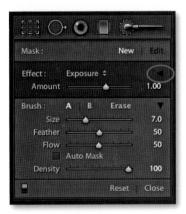

Figure 6.82 The Adjustment brush options in compact mode.

Figure 6.83 When you hold down the All key, Effect will change to show Reset. Click this to reset all the Effects sliders.

Figure 6.84 *The Adjustment brush cursor.*

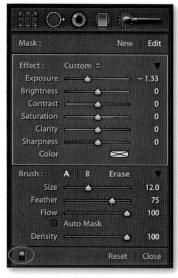

Figure 6.85 This shows the Adjustment brush panel Edit options. (Note as you scroll the other panels that these slide beneath the tool options.)

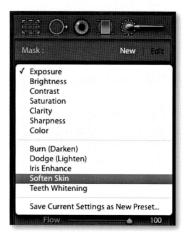

Figure 6.86 The Effect settings menu.

to govern the show/hide behavior for these overlays). The pin overlay is, therefore, like a marker for the brush strokes you are about to add and can later be used as a reference marker when you need to locate and edit a particular group of brush strokes. The important thing to understand here is that you click once and start painting away on an area of the picture to form a collection of brush strokes. When you edit the brush strokes, you can adjust the effect slider settings for the group as a whole. So you can come back later and say, "Let's make this series of brush strokes a little stronger," or "Let's add more saturation, too." Consequently, you should create new brush stroke groups only when you need to shift the focus of your retouching from one part of the photograph to another. Therefore, always click the New button in the Adjustment brush's panel when you need to create a new (separate) group of brush strokes. You can use the On/Off button at the bottom (circled in **Figure 6.85**) to toggle showing/hiding all Adjustment brush edits.

Editing the Adjustment brush strokes

To edit a series of brush strokes, click an existing pin marker to select it; a black dot appears in the center of the pin. This takes you into Edit mode, where you can start adding more brush strokes or edit the current brush settings (Figure 6.85). If you didn't get the slider settings right when you were painting, you now have complete control to edit them. Also, as you edit a localized adjustment, you can click a pin marker, hold down the Att key, and drag the cursor left or right to decrease or increase the strength of an effect. When you are done editing, hit **+** Enter or click the New button to return to the New adjustment mode, where you can click the image and add a new set of brush strokes. As you work with the Adjustment brush, you can undo a brush stroke or series of strokes using the Undo command (**H** C [Mac] or **Ctri** C [PC]), and you can erase brush strokes by clicking the Erase button to enter Eraser mode, or simply hold down the **Att** key as you paint to erase any brush strokes.

Saving effect settings

As you discover combinations of effect sliders that you would like to use again, you can save these via the Effect menu (**Figure 6.86**). For example, you'll find here a preset setting called Soften Skin that uses a combination of negative Clarity and positive Sharpness to produce a skin smoothing effect (see page 371).

Adjustment brush and gradient performance

The Adjustment brush should work fairly smoothly even on large images. If you find that the brush performance is diminished, it might be because you have too many separate brush effects applied at once. Remember, each time you create a new adjustment effect, you greatly add to the computational processing required for each image. It is best to restrict yourself to adding as few adjustment groups as necessary, instead of adding too many new adjustment groups.

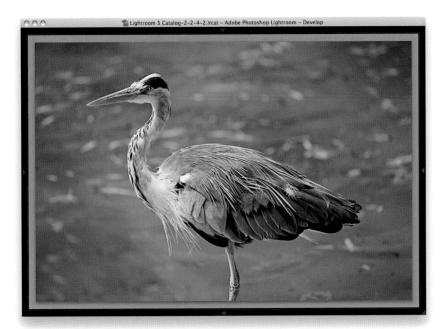

1. This shows a photograph where some Basic adjustments had been applied to set the highlights and shadows and optimize the contrast.

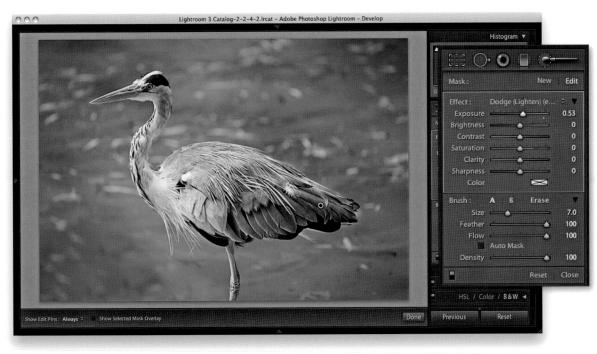

2. In this example, I used a modified Dodge (Lighten) effect to add a series of positive Exposure brush strokes to lighten the body of the bird.

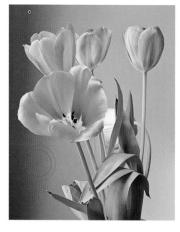

Figure 6.87 Often, all you need to do is to click an area of a picture with the color you wish to target and drag the Adjustment brush in Auto Mask mode to quickly adjust areas of the picture that share the same tone and color.

Automasking

The Auto Mask option cleverly masks the image as you paint with the Adjustment brush. It works by analyzing the area where you click with the Adjustment brush and applies the effect only to those areas that match the same tone and color. The paint strokes in a pin group don't have to all be based on the same color because the Auto Mask resamples continuously as you paint to calculate the mask. **Figure 6.87** shows an example of the Auto Mask feature in action, and the next exercise shows in detail how I was able to click the warm-colored backdrop and use successive strokes to paint just those areas that matched the backdrop color. The Auto Mask feature does appear to work remarkably well at autoselecting areas of a picture based on color. But, to fine-tune the edges, you may need to do what I did here, and switch back and forth with the Att key to erase those areas where the Adjustment brush effect spilled over the edges. Here I was able to neutralize all of the warm-colored backdrop without the brush adjustment bleeding into the flower petals or stems.

Note that you can also hold down the **#** key (Mac) or **Ctrl** key (PC) to temporarily switch the Adjustment brush into Auto Mask mode (or revert back to Normal mode if Auto Mask is already selected).

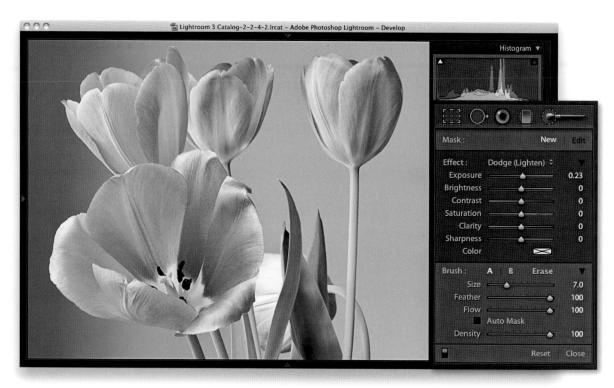

1. This shows the original photograph with a warm-toned backdrop. I began by clicking on the Adjustment brush to reveal the tool options.

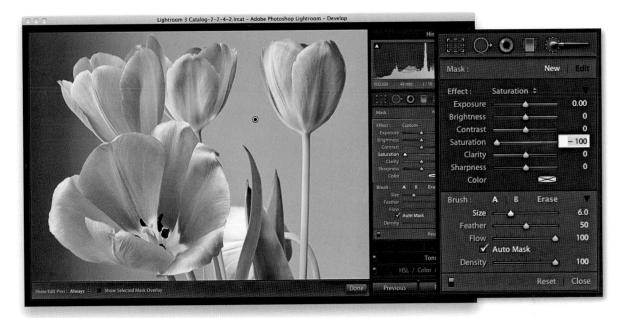

2. I selected the Saturation mode, set the Effect slider to –100% (to desaturate completely), and started painting. Because Auto Mask was checked, the brush only adjusted the backdrop colors.

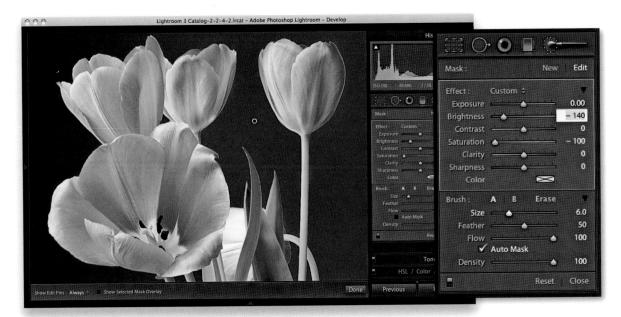

3. After finishing the main brush work, I switched to Edit mode, so that I could fine-tune the settings. In this example, I adjusted the Brightness, which meant I was easily able to darken the painted area as well.

NOTE

While the Auto Mask can do a great job at autoselecting the areas you want to paint, extreme adjustments can lead to some ugly artifacts appearing in parts of the image.

TP

Double-clicking the slider names resets them to 0, or to their default values.

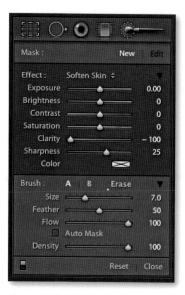

Figure 6.89 This shows the Soften Skin Adjustment brush setting that was used to work on the photograph shown in Figure 6.90.

Previewing the brush stroke areas

As you roll the cursor over a pin marker, you will see a temporary overlay view of the painted regions (**Figure 6.88**). This shows a colored overlay representing the areas that have been painted. You can also press () to switch the mask on or off and (

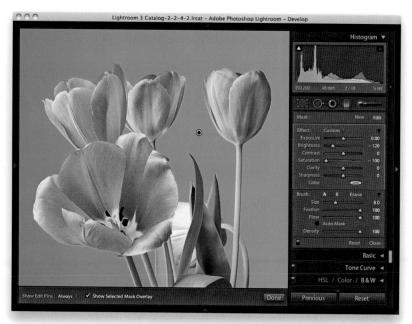

Figure 6.88 This shows an overlay view of the Adjustment brush stokes.

Beauty retouching with negative clarity

On pages 294–295, I showed an example of how you could use a negative Clarity adjustment on a black-and-white image to create a diffuse printing type effect. Meanwhile, a couple of Lightroom beta testers, Clicio Barroso and Ettore Causa, came up with the suggestion that you could use a negative Clarity effect as an Adjustment brush effect for softening skin tones. Personally, I have an aversion to the over-retouched look of some fashion beauty portraits, but the Soften Skin setting, which uses Clarity set to –100% and Sharpness to +25%, works really well as a skin-smoothing Adjustment brush. To illustrate how well this works, I used the Adjustment brush with the settings shown in **Figure 6.89** to create the After close-up view of the beauty photograph shown in **Figure 6.90**. I didn't need to use the Auto Mask mode; I just painted over the areas of the face that I felt needed softening. After applying the Soften Skin effect, I used the Spot Removal tool to clean up the photograph further, but most of the difference you see here was a result of using the Soften Skin effect with the Adjustment brush.

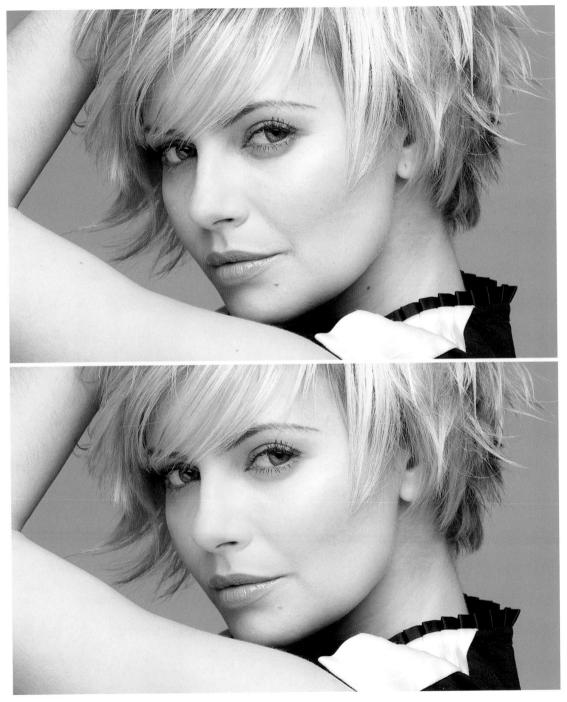

Figure 6.90 The top photograph shows the unretouched, Before image and the lower one shows the retouched version that was mainly edited with the Adjustment brush using the Soften Skin effect setting.

TP

You can use the color picker to sample not just from the ramp or preview image, but from anywhere on the Desktop. The trick is to click in the color ramp, hold down the mouse button, and drag the cursor to anywhere you would like to sample a new color from.

Hand-coloring in Color mode

The Color effect allows you to brush with color on your photographs and can be likened to working with the Brush tool in Photoshop using the Color blend mode. There are lots of potential uses for this tool: You could use it to make someone's hair a different shade of color or change the eye color, or you might want to cool an area of the picture such as in the Graduated Filter example shown later, where I used a blue Color Graduated Filter to make the sky bluer. In the example shown here, I started with an image that had been converted to black and white by desaturating the colors. The main thing to point out here is that I used the Adjustment brush in Color mode with Auto Mask selected. Although the previewed image was in black and white, it did not matter which black-and-white conversion method was used, since Lightroom always references the underlying color data when calculating the Auto Mask. The Auto Mask feature was, therefore, able to do a good job of detecting the mask edges based on the underlying colors of the flower heads, stems, and leaves.

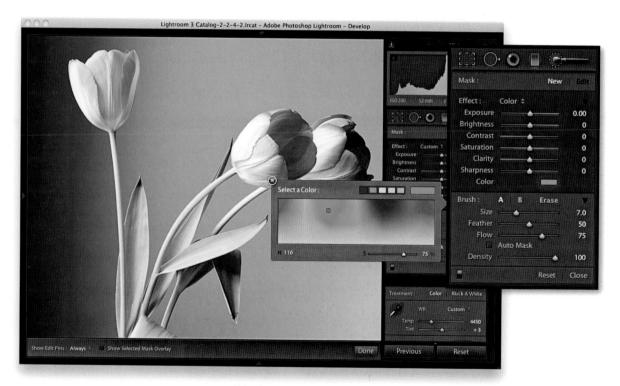

1. This photograph was converted to monochrome by desaturating all the Saturation sliders in the HSL panel. (You could also drag the Basic panel Saturation slider to 0, or convert to black and white in the B&W panel.) I selected the Color effect from the Adjustment brush tool options effect menu, clicked on the main color swatch to open the color picker shown here, and selected a green color to paint with.

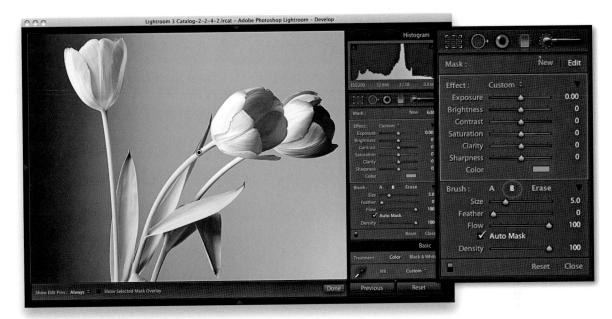

2. With Auto Mask checked, I brushed along the stems and leaves, switching between a broad brush A and smaller brush B.

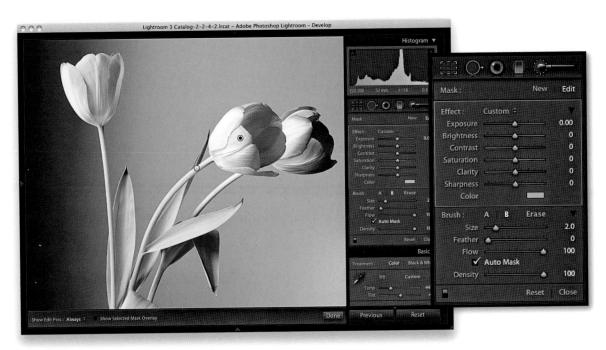

3. I pressed *HEnter* to OK these brush strokes and created a new set of paint strokes. This time I selected a yellow color and began painting the flower petals, again with the Auto Mask option selected.

TP

If you pump up the settings you are working with to produce a stronger effect than what is needed, you can see the results of your retouching more clearly. You can then use the Edit mode to reduce the Amount to reach the desired strength for the brush strokes.

Clarity and Sharpness adjustments

A positive Clarity Adjustment brush setting can be used to selectively paint in more midtone contrast. In the example shown here, I used a positive Clarity plus a positive Sharpness effect setting to bring out more detail in the rock surface. I definitely did not want to add more sharpening or clarity in the sky area, as this would have made the image noise more noticeable. So, I carefully painted the rock area only, avoiding the edges where the rock meets the sky.

Whenever you adjust the Sharpness slider in the adjustment tools to add more sharpness, you are essentially adding a greater Amount value of sharpness based on the other settings that have already been established in the Detail panel Sharpning section. A negative Sharpness setting in the 0 to -50 range can be used to fade out existing sharpening. Therefore, if you apply -50 sharpness, you can paint to disable any capture sharpening. As you apply a negative Sharpness in the range of -50 to -100, you start to apply anti-sharpening. This produces a very gentle lens blur effect, but you can always strengthen this by applying successive, separate Adjustment brush groups. I'll be showing a further example of localized sharpening in Chapter 8.

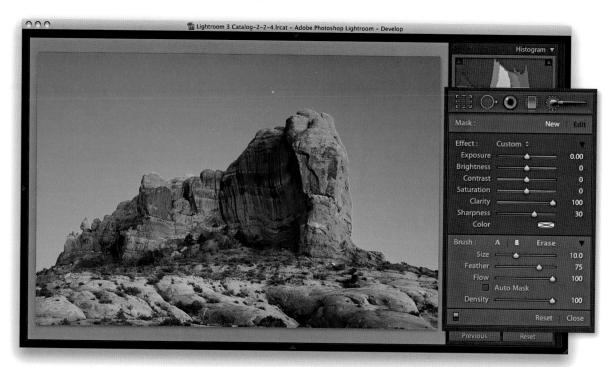

1. Here, you can see I selected the Adjustment brush tool and adjusted the effect settings to add +100% Clarity combined with +30% Sharpness. I then clicked on the image and started painting to apply the combined Clarity and Sharpness adjustment effect.

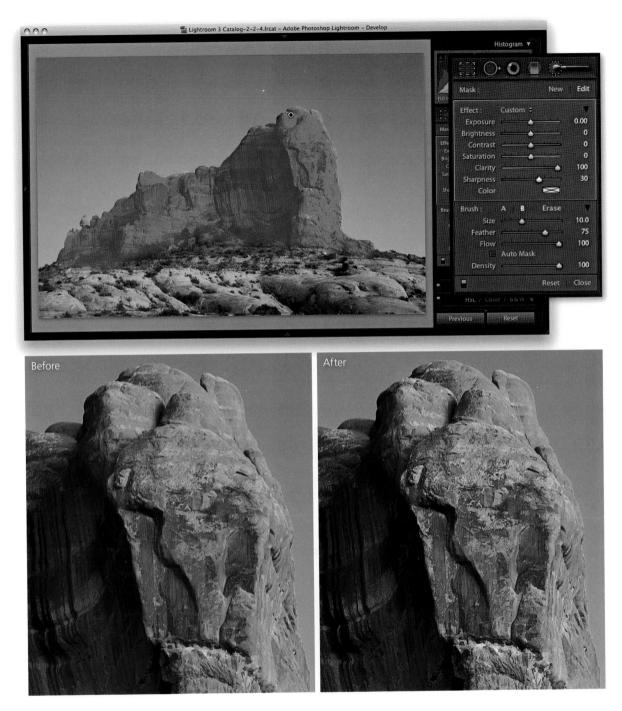

2. I applied this adjustment to the rock areas only, and you can see here an overlay view of the painted area (top) and close-up views below that show the Before and After versions.

Figure 6.91 This shows the Graduated Filter tool options in the compact mode.

Figure 6.92 This shows the Graduated Filter tool options in the expanded mode.

TIP

As you edit a localized adjustment, click the pin marker, hold down the <u>Ait</u> key, and drag the cursor to the left to decrease the strength of an effect or drag to the right to increase it.

TIP

In Lightroom 3, you can now also use the M keyboard shortcut to go direct from the Library module to the Graduated filter tool in the Develop module.

Graduated Filter tool

Everything that I have described so far about working with the Adjustment brush more or less applies to working with the Graduated Filter tool (M). The Graduated Filter tool (see Figures 6.91 and 6.92) allows you to add linear Graduated Filter fade adjustments. To use the tool, you click in the picture to set the start point for the Graduated Filter (the point with the maximum effect strength), drag the mouse to define the spread of the Graduated Filter, and release at the point where you want it to finish (the point of minimum effect strength). The Graduated Filter tool, therefore, allows you to apply linear fade-out adjustments between these two points. There is no midtone control with which you can offset a Graduated Filter effect, and there are no further gradation options other than a linear effect. A radial Graduated Filter would be nice, but we do at least have the Post-Crop vignette features in the Effects panel. If you hold down the (Alt) key, Effect will change to show Reset. Click this to reset all the sliders to 0 and clear any currently selected color. Or, you can hold down the Alt key and click an Effect slider name to reset everything except this slider setting. You can also double-click slider names to reset to 0, or to their default values.

Graduated Filter effects are indicated by a pin marker, and you can move a Graduated Filter once it has been applied by clicking and dragging the pin. The parallel lines indicate the spread of the Graduated Filter, and you can change the width of the filter by dragging these outer lines. If you want to edit the angle of a Graduated Filter effect, you can do so by clicking and dragging the middle line.

1. This shows how the photograph I started with looked after I had applied just the main Basic panel adjustments to optimize the highlights, shadows, and contrast.

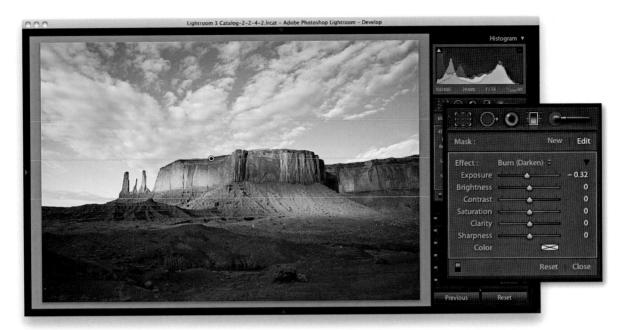

2. Here, I clicked the Graduated Filter tool to reveal the Graduated Filter options, selected a Burn (Darken) Exposure effect, and dragged the Graduated Filter tool from the middle of the sky downward.

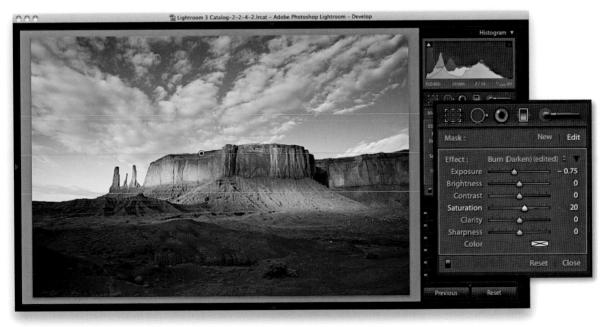

3. I then decided to strengthen the burn effect by setting the Exposure slider to -0.75 and boosted the Saturation slider to +20.

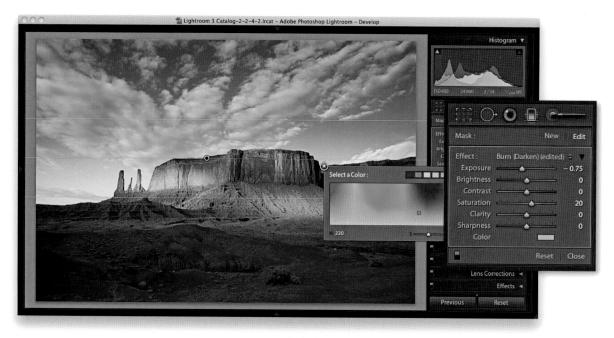

4. Next, I sampled a blue color to add a blue Color effect to the other effects settings. As you would expect, this made the sky appear bluer in color.

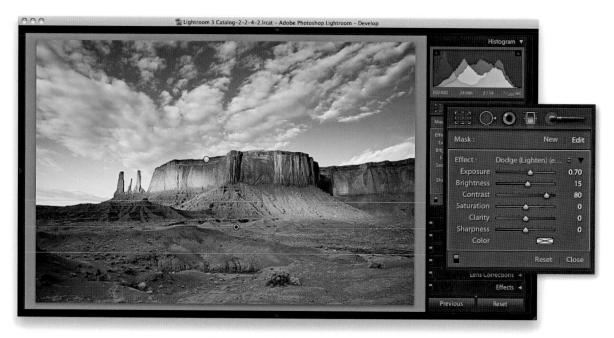

5. Lastly, I added a new Graduated filter to the foreground—this time a lighten Exposure effect that also included a Brightness and Contrast boosting adjustment.

History panel

Every step you apply in the Develop module is recorded as a separate history state in the History panel, which is located just below Presets and Snapshots (**Figure 6.93**). The History feature in Lightroom has the unique advantage over Photoshop in that the history steps are always saved after you quit Lightroom. You can return a year later to a photo and find that all the history steps are preserved from the time you first imported the photo to the last thing you ever did to that picture in the Develop module. The History panel is therefore useful because it allows you to revert to any previous Develop module setting, and you can access an unlimited. number of history states without incurring the efficiency overhead that is normally associated with Photoshop image editing and History. There are several ways you can navigate through a file's history. You can go to the History panel and click to select a history step, which will allow you to jump quickly to a specific state, or you can roll the cursor over the list of history states in the History panel to preview them in the Navigator panel and use this to help select the one you are after.

Figure 6.94 shows an example of how the History panel looked after I had made a series of Develop adjustments to the image. You'll also notice in Figure 6.90 that the numbers in the middle column show the number of units up or down that the settings were shifted, and the right column lists all the new setting values.

History		Clear
Contrast	+36	61
Sharpen Radius		0.9
Sharpening	+25	25
Clarity	+13	13
Vibrance	131	31
Brightness	+50	50
Contrast		25
Contrast	+17	17
Black Clipping	+6	6
Exposure	+0,42	0.42
Preset: General - Zer	oed	
Import (10/04/2008 1	2:29:57)	

Figure 6.93 In this close-up view of the History panel in Figure 6.94, you can see the original history state that was date stamped at the time of import. The subsequent history states are listed in ascending order.

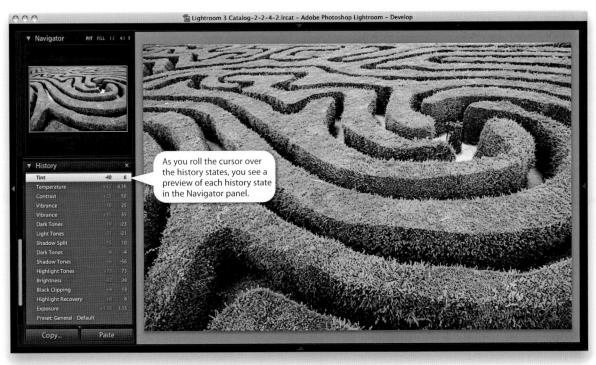

Figure 6.94 In this example, you can see that the sequence of steps applied to the image are recorded in the History panel and in the order in which they were applied.

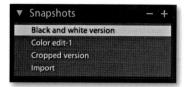

Figure 6.95 The Snapshots panel can be used to store saved history steps as variations.

Copy Snapshot Se	ttings to Before
Update with Curre	nt Settings
Delete	*

Figure 6.96 You can use the contextual menu to choose Update with Current Settings.

You can also select Edit \Rightarrow Undo or use ($\Re \mathbb{Z}$ (Mac) or $\mathbb{Ctrl} \mathbb{Z}$ (PC) to undo the last step. As you repeatedly apply an Undo, the history steps are removed from the top of the list one by one, but you can restore these steps by choosing Edit \Rightarrow Redo or use the $\Re \oplus \mathbb{Shift} \mathbb{Z}$ (Mac) or ($\mathbb{Ctrl} \oplus \mathbb{Shift} \mathbb{Z}$ (PC) shortcut. However, be warned that if you carry out a series of Undos in this way and then quit Lightroom, you will not be able to recover these history steps later. If you click the Clear button in the History panel, you can also delete all the history steps currently associated with a photo. Clearing the list of history steps is a useful thing to do if the number of history steps is getting out of control and you need to manage the history list better.

Snapshots panel

Another way to manage your history states is to use the Snapshots feature. Snapshots can be used to store significant history states as a saved image setting (**Figure 6.95**). It is often more convenient to use the Snapshots panel to save specific history states, as this can make it easier for you to retrieve history states that are of particular importance or usefulness, instead of having to wade through a long list of previously recorded history states from the History panel.

To use the Snapshots feature, select a history state that you want to record as a snapshot and click the plus button in the Snapshots panel. This creates a new untitled snapshot. If you like, you can name the snapshot and click Create to confirm (**Figure 6.97**). Snapshots are always arranged alphabetically in the Snapshots panel, and the preview in the Navigator panel will update as you roll the mouse over the snapshots in the list. To load a Snapshot, simply click the snapshot to select it. If you want to update the settings for a particular snapshot, you can do so via the contextual menu: Right-click a snapshot and select Update with Current Settings (**Figure 6.96**). This updates a snapshot with the current history state. You can, therefore, use the Snapshots panel to save multiple variations of a master photo, such as a color-enhanced or a black-and-white version of the original (**Figure 6.98**). To delete a snapshot, just click the minus button.

The Sync Snapshots feature in the Develop module Settings menu (see page 383) is particularly useful for updating previously created snapshots with new settings. For example, if you have just spent some time removing blemishes or cropping an image, it can be handy to use the Sync Snapshots command to update the Spot Removal and Crop settings in all the previously created snapshots.

	New Snapshot
Snapshot Name:	Cropped version 1
	Cancel Create

Figure 6.97 Click the + button to create a new Snapshot and name it.

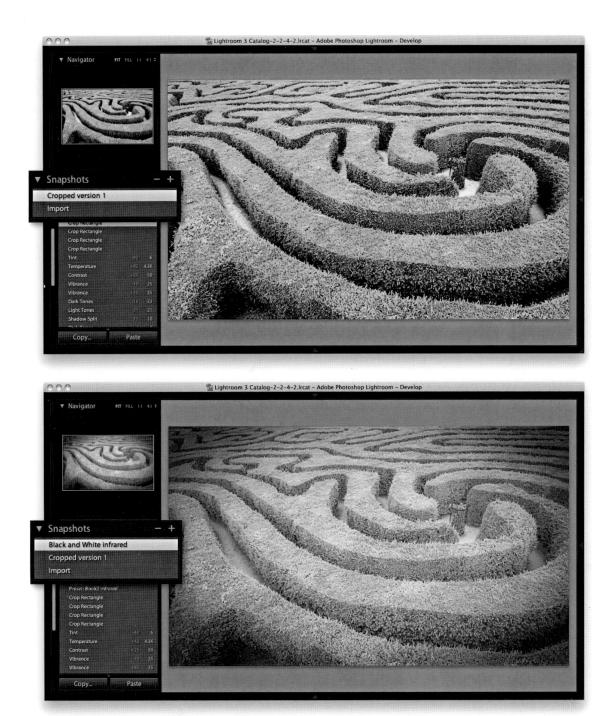

Figure 6.98 In the top screen shot, I saved a cropped version of the master image as a new snapshot and titled this "Cropped version 1." I then applied a "Black and white infrared" preset setting and saved this, too, as a new snapshot.

Synchronizing snapshots

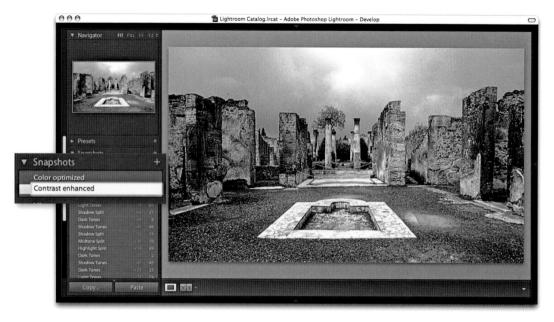

1. In this example, the current Develop settings were saved as a new snapshot.

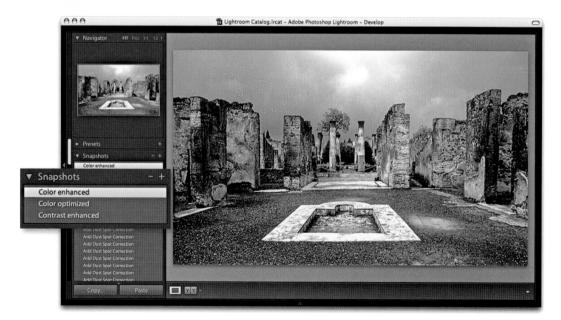

2. I continued editing the photo and saved a new "Color enhanced" snapshot. But you will notice that this snapshot now included a lot of spotting work, which had been carried out since saving the earlier snapshot.

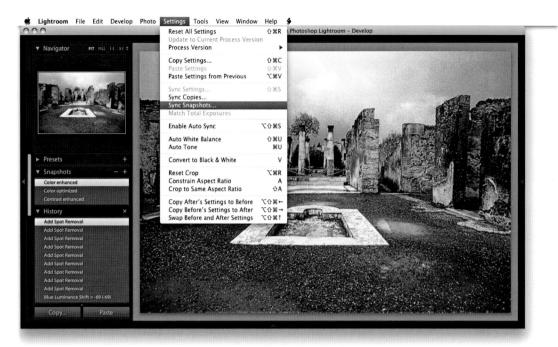

3. Whenever you make changes to the Develop settings and wish to update the remaining saved snapshots, go to the Settings menu and choose Sync Snapshots.

White Balance	Treatment (Color)	Lens Corrections	Spot Removal
Basic Tone Exposure Highlight Recovery Fill Light Black Clipping Brightness Contrast	Color Saturation Vibrance Color Adjustments Split Toning	Transform Lens Profile Corrections Chromatic Aberration Lens Vignetting Effects Post-Crop Vignetting Grain	Crop Straighten Angle Aspect Ratio
Tone Curve	 Local Adjustments Brush Graduated Filters 	 Process Version Calibration 	
Clarity	Noise Reduction		
Sharpening	Color		
heck All) (Check None	_		Cancel Synchroniz

4. This opened the Synchronize Settings dialog. I made sure only the Spot Removal option was checked and clicked Synchronize to update all the other snapshots in the Snapshots panel with the most recent Spot Removal settings.

Figure 6.99 Virtual copy images are automatically stacked with the master file. When viewing the Library Grid view or Filmstrip, you can tell which images are virtual copies by the turned-page badge in the bottom-left corner.

Easing the workflow Making virtual copies

In addition to making snapshot versions, you can also create virtual copies of your master photos by going to the Library module and choosing Photo \Rightarrow Create Virtual Copy (R) ' [Mac] or (\fbox{Crrl}) ' [PC]). This creates a virtual copy version of the master image that is automatically grouped in a stack with the master photo (see **Figure 6.99** and **Figure 6.100**). As the name suggests, you are making a proxy version of the master. It may look and behave like a separate photo, but is, in fact, a virtual representation of the master that you can continue to edit in Lightroom as if it were a normal image.

So, what is the difference between a virtual copy and a snapshot? Well, a snapshot is a saved history state that's a variation of the master. You have the advantage of synchronizing specific edit adjustments across all the snapshot versions but lack the potential to create multiple versions as distinct entities that behave as if they were actual copies of the master image. A virtual copy is, therefore, like an independent version of a snapshot, because when you create a virtual copy, you have more freedom to apply different types of edits and preview these edits as separate image versions. You could, for example, create various black-and-white renderings and experiment with alternative crops on each virtual copy version. **Figure 6.101** shows how you might use the Compare view mode to compare virtual copy versions of a photo alongside the master version (or you could use the Survey view to compare multiple versions at once). Virtual copies also make it possible for you to create collections that have different settings. For example, you

possible for you to create collections that have different settings. For example, you could use the Create Virtual Copy command to create black-and-white versions, as well as colorized versions from a master image, and then segregate these virtual copies into separate collections.

You also have the freedom to modify the metadata in individual virtual copy images. For example, you may want to modify and remove certain metadata from a virtual copy version so that when you create an export from the virtual copy, you can control which metadata items are visible in the exported file. Let's say you are running a location scouting service and send out images to clients that show the properties you recommend as photographic locations. You would normally store all the relevant metadata about the location such as the address and zip code, but you would want to remove such commercially sensitive information when distributing these images to prospective clients.

Making a virtual copy the new master

Once you have created one or more virtual copies, you can choose the Photo \Rightarrow Set Copy as Master command to make any virtual copy version of an image become the new master version (and make the old master version become a virtual copy).

Figure 6.100 As you make new virtual copies of a master file, these are automatically stacked with the original master image.

Figure 6.101 One of the advantages of having virtual copy versions of a master file is that you can explore applying different Develop settings and compare these against the original master.

Figure 6.102 When more than one photo is selected via the Filmstrip, clicking the Sync button (top, with an ellipsis) lets you synchronize images in that selection via the Synchronize Settings dialog. When you hold down the Alt key, the ellipsis disappears (middle), and clicking this button bypasses the Synchronize Settings dialog (and uses the last used Synchronize settings). The switch on the side also allows you to turn this mode on or off and makes this option more discoverable. Finally, you can hold down the X key (Mac) or Ctrl key (PC) to switch to the Auto Sync mode (bottom).

Synchronizing Develop settings

Now that we have covered all the main Develop controls, let's look at ways the Develop settings can be applied to multiple images. Whenever you have a selection of images active, the Previous button changes to show Sync (Figure 6.102), and clicking this button allows you to synchronize the Develop settings across two or more photos, based on the settings in the target (most selected) photo. In Figure 6.103, a number of photos have been selected in the Filmstrip. and if I were to click the Sync button, this would open the dialog shown in Figure 6.104, where you can then decide which settings are to be synchronized. Or, you can use the [#] (A Shift) (Mac) or [Ctrl (A Shift) (PC) keyboard shortcut to open the Synchronize Settings dialog. If you click the Check All button, everything here is checked, which, in some cases, is the easiest and most practical option. If you click Check None, you can then choose any subset of synchronization settings. Whether you choose to save everything or just a subset of settings, this will have important consequences for how the photos are synchronized. If you choose Check All, everything in the selected image will be synchronized. This might include the White Balance or Crop settings, and while these settings may be relevant for the target image, you won't always necessarily want to synchronize these across all the other photos. Sometimes you need to think carefully about which specific settings you should synchronize. If you don't, you may end up overwriting settings that should have been left as they were (although you can always recover a previous image version via the History panel on an image-by-image basis). For example, if your imported photos have the Camera Default settings applied for Sharpening, Noise Reduction, and Calibration, you will want to be careful not to overwrite these settings. Note that if you hold down the (Alt) key, the Sync button loses the ellipsis, and clicking the button now bypasses the Synchronize Settings dialog and applies a synchronization based on the last used Synchronize settings. Also in this mode you'll see a Set Default button, which allows you to set the current Develop settings as the new default settings for files shot with this particular camera, plus this specific serial number and ISO setting. What gets set here all depends on how the preferences have been configured (see page 402).

Auto Sync mode

If you 選 -click (Mac) or Cttl -click (PC) the Sync button, it switches to Auto Sync mode and stays as such until you click the Auto Sync button to revert back to Sync mode again. In Lightroom 3, you will notice a switch next to the Sync button. Clicking this has the same effect as switching you to Auto Sync mode, or you can use the \Re Shift Alt A (Mac) or Cttl Shift Alt A (PC) keyboard shortcut. In Auto Sync mode, you first make a selection of photos, and as you adjust the Develop settings for the most selected image, you'll see these adjustments propagated across all the images in the selection. Auto Sync, therefore, behaves a bit like a Quick Develop panel mode for the Develop module. Finally, there is the Reset button, which can be used to reset photos back to their Lightroom default settings.

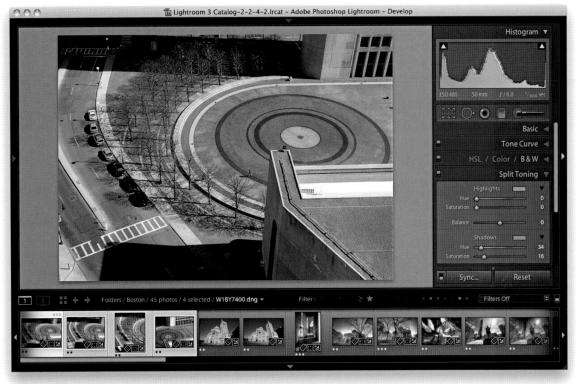

Figure 6.103 The Develop settings in the most selected photo can be synchronized with all the other photos in a selection by clicking the Sync button. The selected photos in the Filmstrip are indicated with a gray surround, and the most selected photo is the one with the lightest gray color.

White Balance	Treatment (Color)	Lens Corrections	Spot Removal
Basic Tone Exposure Highlight Recovery Fill Light Black Clipping Brightness Contrast	Color Saturation Vibrance Color Adjustments Split Toning Local Adjustments	Transform Transform Transform Lens Profile Corrections Chromatic Aberration Lens Vignetting Effects Yost-Crop Vignetting Grain	Crop Straighten Angle Aspect Ratio
Tone Curve	Brush Graduated Filters	Process Version	
Clarity		Cambration	
Sharpening	 Noise Reduction Luminance Color 		

Figure 6.104 In the Synchronize Settings dialog, use the Check All settings option with caution, since synchronizing everything may overwrite important Develop settings in the selected photos.

Lightroom and Camera Raw

As you are probably aware, Adobe Photoshop Lightroom and Adobe Camera Raw (as part of the Adobe Photoshop program) both share the same Camera Raw processing engine. This means that any development adjustments that are applied in one program can be recognized and read by the other. However, there are a few things you need to bear in mind here. Camera Raw development is mainly linked to specific versions of Photoshop. At the time of this writing, I anticipate that the launch of Lightroom 3.0 will coincide with a Camera Raw 6.1 update for Photoshop CS5. This will allow Photoshop CS5 users to access the latest auto lens corrections and perspective correction features that weren't included in the original Camera Raw 6.0 for Photoshop CS5. Therefore, full compatibility between Lightroom 3 and Photoshop CS5 is guaranteed. Meanwhile, Photoshop CS4 users will have been provided with a Camera 5.7 update. Now, although Camera Raw 5.7 for Photoshop CS4 has the ability to read most Lightroom 3 edits, no further functionality was added to this particular version of Camera Raw for Photoshop CS4. Camera Raw 5.7 does enable the new auto demosaicing enabled in Camera Raw 6 and Lightroom 3, and it can read all the new Camera 6 settings, including those that are specific to Process Version 2010. You just won't be able to edit those new settings, and you won't be able to use Camera Raw 5.7 to update from Process Version 2003 to Process Version 2010. Another key thing to point out is that the latest auto lens corrections and perspective correction settings applied in Lightroom 3 won't be readable in Camera Raw 5.7. The upshot of all this is that if you want Camera Raw to allow the same full editing as you have in Lightroom 3, you will at some point need to upgrade to Photoshop CS5.

Viewing Lightroom edits in Camera Raw

The main point to remember is to always save the metadata edits out to the files' XMP space if you want Camera Raw to be able to read the Develop adjustments that have been applied in Lightroom. If you don't do this, the edit changes you make in Lightroom cannot be read by Camera Raw. (But do take note of the points made above regarding Photoshop Camera Raw and Lightroom compatibility.)

Viewing Camera Raw edits in Lightroom

If you want your Camera Raw edits to be visible in Lightroom, you need to make sure that the image adjustments applied in Camera Raw are also saved to the file's XMP space. To do this, launch Bridge and choose Camera Raw Preferences from the Bridge menu. This opens the dialog shown in **Figure 6.105**, where you need to select "Sidecar .xmp files" from the "Save image settings in" menu.

Figure 6.105 To keep the Camera Raw edits in sync with Lightroom, you need to make sure that the Camera Raw settings are always saved to the sidecar .xmp files.

Keeping Lightroom edits in sync

If Lightroom detects that a file's metadata has been edited externally, it should display a metadata status conflict warning badge in the thumbnail cell (**Figure 6.106**). Clicking this badge opens the dialog shown in **Figure 6.107**. If you see no warning but have good reason to believe that the metadata has been updated, then choose Metadata \Rightarrow Read Metadata from files (in the Library module), or Photo \Rightarrow Read Metadata from file (in the Develop module). Alternatively, choose Library \Rightarrow Synchronize Folder (**Figure 6.108**). The Synchronize Folder command also runs a quick check to make sure that everything is in sync between Lightroom and any edit changes that may have been applied externally.

Figure 6.107 The metadata status change warning dialog.

Figure 6.106 When there is a metadata status conflict due to a photo's metadata having been edited externally, you'll see an exclamation point or upward arrow badge warning. This is assuming that you have the Unsaved Metadata option checked in the Library View: Grid View options (see page 80).

NOTE

If the Unsaved Metadata option is checked in the Library View: Grid View options and you have unsaved metadata changes in Lightroom, you will see a downward arrow in the top-right corner. If you have unsaved metadata changes in Lightroom and you also make external metadata changes, you will see an exclamation point. If the metadata is up to date in Lightroom and you make external changes, you will see an upward arrow.

Figure 6.108 The Synchronize Folder command can run a quick scan for updates.

Synchronizing Lightroom with Camera Raw

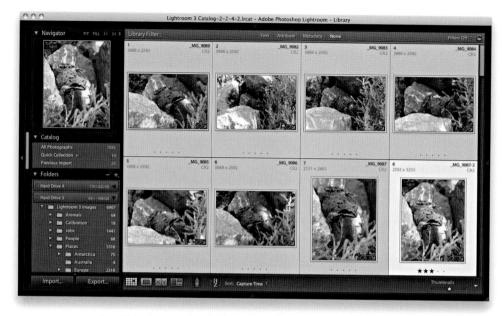

1. This shows a simple illustration of how to keep a set of photos in sync when switching between Lightroom and Camera Raw. This shows a selection of photos in Lightroom that have been optimized for the best tone contrast and color.

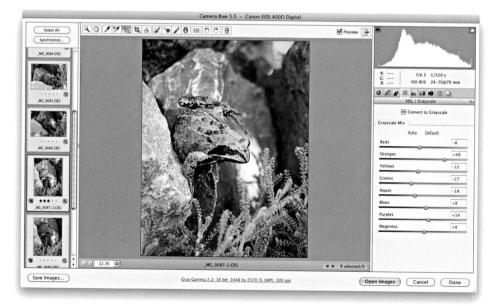

2. I opened the same photo selection in Camera Raw, converted one of the images to black and white, and synchronized this setting across all the selected photos.

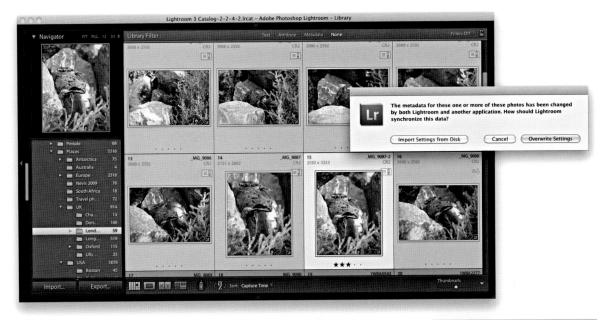

3. When I returned to Lightroom, the "out-of-sync" photos displayed a metadata status change warning icon with an exclamation point, indicating a metadata conflict. I clicked the warning icon and then clicked the Import Settings from Disk button in the dialog shown here to import the Camera Raw adjusted settings into Lightroom.

If you don't see a metadata status

warning where there should be (this can happen), then choose Metadata ⇔ "Read metadata from file."

		og-2-2-4-2.ircat - Adobe Photoshop	Lightroom - Library Metadata None	Filters Off :=
Navigator HT FILL ISI 33 *	Library Filter: MG_9089 3888 x 2592 CR2		3 MG_9083 3888 x 2592 CR2	
Catalog All Photographs 7031 Quick Collection + 14 Previous Import 25	5		7	8
¥ Folders - +. 1 Hard Drive 4 597/62200 - 1 Hard Drive 3 5407/60200 -				
				A DA
Places 5316 Places 5316 Antarctica 75 Australia 4 Europe 2318				***··
Import Export		C22 → Sort: Capture Time ÷		

4. The externally adjusted settings now appeared updated in Lightroom.

	Lightroom Presets
	Creative - Aged Photo
	E Creative - Antique Grayscal
	E Creative - Antique Light
	E Creative - B&W High Contra
	E Creative - B&W Low Contras
	🔲 Creative - Cold Tone
	E Creative - Cyanotype
	E Creative - Direct Positive
	🛅 Creative - Selenium Tone
	🔟 Creative - Sepia
	General - Auto Tone
	🗉 General - Grayscale
	General - Punch
	🗐 General - Zeroed
	Sharpen - Landscapes
	Sharpen - Portraits
	Tone Curve - Flat
	Tone Curve - Strong Contras
	Calibration
	Camera presets
Þ	Cross Processing
Þ	Default settings
	Grayscale Black & White
	HSL Black & White
	Hue Shifts
Þ	Imported Presets
•	Special effects
•	Split toning
•	Temporary
•	Tone adjustments
	User Presets

Figure 6.109 The Copy and Paste buttons are located in the bottom-left in the Develop module.

NOTE

If more than one photo is selected in the Filmstrip, the Previous button will change to say Sync. If you wish to override this behavior, you can do so by holding down the Shift) key, which reverts the button to the previous mode of operation. Lightroom then applies a copy of all the settings from the previously selected photo to the selected photos.

Copying and pasting Develop settings

Another way to synchronize images is to copy and paste the Develop settings from one photo to another (**Figure 6.109**). In the Develop module, select a photo from the Filmstrip and click the Copy button (or use the $\Re C$ [Mac] or Ctrl C[PC] shortcut). This opens the Copy Settings dialog shown in **Figure 6.110**, which allows you to specify the settings that you want to copy. Note that if you <u>Alt</u>-click the Copy button, you can bypass this Copy Settings dialog completely (or use $\Re Alt C$ [Mac] or Ctrl Alt C [PC]). So, if you had previously clicked the Check All button to check all the settings in the Copy Settings dialog, <u>Alt</u>-clicking the Copy button copies all settings without showing the dialog. Once you have copied the Develop settings, you can then select a photo or a selection of photos via the Library module Grid view or Filmstrip and click the Paste button to apply the current copied settings (or use the $\Re V$ [Mac] or Ctrl V [PC] shortcut).

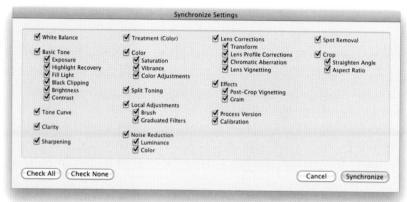

Copying and pasting settings via the Library module

When working in the Library module, you will need to use a different set of shortcuts: CShiftC (Mac) or $\fbox{Ctrl}ShiftC$ (PC) to copy the settings, CShiftV(Mac) or $\fbox{Ctrl}ShiftV$ (PC) to paste, and AltV (Mac) or $\fbox{Ctrl}AltV$ (PC) to apply the previous settings.

Applying a previous Develop setting

As you navigate the Filmstrip, Lightroom temporarily stores the Develop settings for each photo you click, thereby allowing you to apply a previous Develop setting to any photo. Note that when you are applying a previous Develop setting, there is no Copy Setting dialog. When you apply a Previous setting, it applies all the Develop settings from the previously selected photo.

1. Select a photo in the Filmstrip, and Lightroom automatically stores the Develop settings as a Copy All setting.

2. If you select another photo in the Filmstrip and click the Previous button, this pastes all the Develop settings from the previously selected photo.

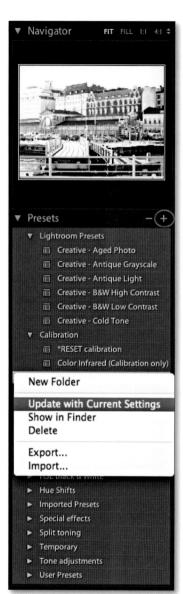

Figure 6.111 As you roll the cursor over the Presets list, the Navigator updates to show a quick preview of how the Preset settings will affect the image. You can update existing settings by holding down the Ctrl key (Mac) or right-clicking (PC) to reveal a contextual menu for the presets. Choose Delete or click the minus button to remove a selected preset from the list.

Saving Develop settings as presets

Copying and applying settings is useful in the short term, but if you create a setting that you are likely to reuse again, it is a good idea to save it as a preset. Figure 6.111 shows an expanded view of the Develop module Presets panel, in which you can see a list of custom preset settings. The Lightroom Presets folder is installed with Lightroom and has enough presets to help get you started, but you can add your own Develop presets by clicking the plus button at the top of the Presets panel. This opens the New Develop Preset dialog shown in **Figure 6.112**. where you can choose which settings you want to include in the preset. When you have decided which settings to check, give the preset a name, choose a folder location to save the preset to, and click the Create button to add it as a new preset to the list. This can be useful for all sorts of reasons. For example, it is a tedious process trying to access the different camera profiles listed in the Camera Calibration panel Profile drop-down menu. Rather than have to click through each one in turn to see what effect it has, why not create a Develop preset in which only the calibration setting is saved for each profile option? Do this and, as you roll the mouse over the list of presets, you get to see an instant preview in the Navigator panel, as shown in Figure 6.111.

	Black & White Calibration Camera pres Cross Proces	ets	
Preset Name	Default settin HSL Black & V Hue Shifts		
Folder	/ Special effect	ts	
A	Split toning		
Auto Settings	Tone adjustn User Presets	nents	
Auto T	User Presets		
🗌 Fill Lig	ie sure ight Recovery ght Clipping tness ast ve	Treatment (Color) Color Saturation Vibrance Color Adjustments Split Toning Graduated Filters Noise Reduction Luminance Color	Lens Corrections Transform Lens Profile Corrections Chromatic Aberration Lens Vignetting Effects Post-Crop Vignetting Grain Process Version Calibration

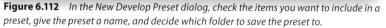

The default *Lightroom Presets* folder cannot be edited—you can't delete or add to the presets that are in this folder. But any new presets you do add are automatically placed in a folder called *User Presets*. If you want to organize your Develop settings better, I suggest you place your presets into different folder groupings. You will notice in **Figure 6.113** that I added a number of preset folders, which always appear listed in alphabetical order below the *Lightroom Presets* folder.

To add a new folder to the Presets list, right-click anywhere inside the Presets folder to open a contextual menu like the one shown in Figure 6.113, and choose New Folder, which opens the New Folder dialog (**Figure 6.114**). Give the folder a name, and it will appear added to the Presets list. You can now organize your presets by dragging them into the folders that you have just created.

Auto Tone preset adjustments

The Auto Tone option is potentially useful for those times when you want to include an Auto Tone adjustment as part of a preset. In some instances, this might be considered a useful item to include in a preset because you can get Lightroom to combine an autocorrection in combination with other types of Develop adjustments. On the other hand, because it can lead to different tone settings being applied to each image, this might not always produce the results you were after, (even though the Auto Tone logic has been improved in Lightroom 3). So, just be aware of this when you include Auto Tone in a saved Develop preset setting, and keep in mind that the results you get may sometimes be unpredictable.

The art of creating Develop presets

Lightroom Develop presets have proved incredibly popular. Lots of Lightroom users have gotten into sharing their preset creations. If you are looking for inspiration, visit Richard Earney's Inside Lightroom site (http://inside-lightroom.com), where there are lots of different presets that you can download and import into the Develop Presets panel. While it is possible to encapsulate a complete Develop module look in a single preset, it seems to me that the best way to use Develop presets is to break them down into smaller chunks. In my experience, the trick is to save as few settings as possible when you create a Develop preset. What we often see are Develop presets where the creator checks too many boxes and ends up with a preset that adjusts not just the settings it needs to adjust, but other settings, too. In many cases, it is not always obvious which settings a Develop setting is meant to be altering, and applying the preset may overwrite settings that it shouldn't. Or, the creator includes White Balance or Exposure settings that may have been relevant for the pictures the creator used to test the Develop setting with, but they are not necessarily suited for other people's photographs. In the following section, I have provided a guick guide on how to create neatly trimmed Develop presets.

Figure 6.113 You can use the contextual menu to import new presets. If you have been sent a Develop preset or have just downloaded one, use the contextual menu shown here to select Import and then locate the preset (or presets) you wish to add.

	New Folder
Folder Name:	Special Effects
	Cancel Create

Figure 6.114 You can also use the above contextual menu to add a new folder to the Presets list.

Creating a new Develop preset

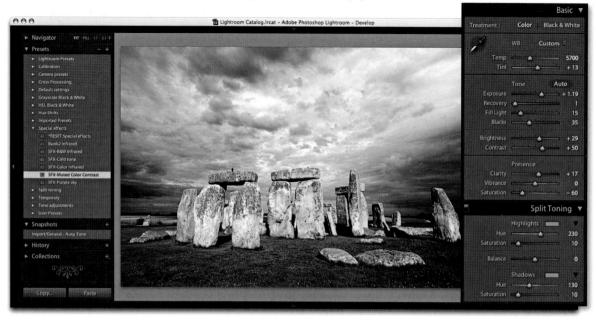

1. Here is a photograph that I had adjusted in the Develop module, where I wanted to save the current Develop settings as a new preset.

TIP

The most important lesson to learn here is this: Save only the settings that you need to save when creating a preset.

		New Develop Preset	
Preset Name:	Muted color o	ontrast	
Folder:	Special effect	ts	
Auto Settings			
🗌 Auto To	ne		
Settings			
🗹 Fill Li	ne sure ight Recovery ght Clipping tness ast	 ✓ Treatment (Color) Color ✓ Saturation Vibrance Color Adjustments ✓ Split Toning Graduated Filters Noise Reduction Luminance Color 	Lens Corrections Transform Lens Profile Corrections Chromatic Aberration Lens Vignetting Effects Post-Crop Vignetting Grain Process Version Calibration
Check All	Check None)	Cancel Create

2. I clicked the Presets panel's plus icon to open the New Develop Preset dialog and checked only those settings that were relevant for this effect. I named this preset setting Muted Color Contrast and saved it to the *Special effects* folder.

Understanding how presets work

Even with a Develop setting like the one described below in **Figure 6.115**, it can still get confusing, because the Develop preset is doing several things in one shot. It is raising the threshold for the black clipping point and boosting the contrast; plus, it is reducing the color saturation and applying a split tone color effect. Incorporating all these Develop adjustments into one preset has its disadvantages, because this can lead to messy situations like the one described in **Figure 6.116**.

TIP

The safest way to work with Develop presets is to apply a preset and then use XZ (Mac) or Ctrl Z (PC) to undo it before trying out another one.

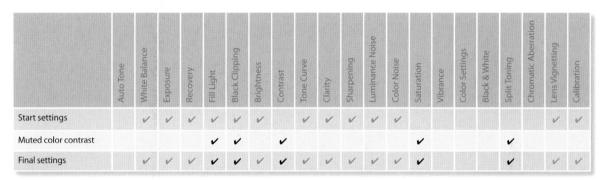

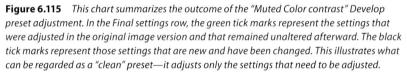

	Auto Tone	White Balance	Exposure	Recovery	FillLight	Black Clipping	Brightness	Contrast	Tone Curve	Clarity	Sharpening	Luminance Noise	Color Noise	Saturation	Vibrance	Color Settings	Black & White	Split Toning	Chromatic Aberration	Lens Vignetting	Calibration
Start settings		V	V	v	V	V	V		V	V	V	V	V							v	V
Camera simulation		~	~			~	~	~	~							~				~	
Split tone						~	~	~	~		~	~	~	~	~	~		~		~	
Infrared color effect		~				~	~	~	~												~
Final settings		~	V	V	V	~	~	~	~	V	V	V	V	V	V	V		V		v	~

Figure 6.116 This chart shows you what can happen when you apply a series of Develop presets. In the Final settings row, the green tick marks represent the settings that were adjusted in the original image version and remained unaltered at the end. The black tick marks again represent the settings that are new or have been changed. However, the red tick marks represent the settings that have changed cumulatively during the process of trying out different Develop presets (but which were not meant to part of the last applied preset). What this highlights is the fact that when "Infrared color effect" was applied as a Develop setting, some of the other Develop settings (that were not presets.

NOTE

The preset names must be unique. You can't have two separate presets called "Cool tone," stored in separate folders.

How to prevent preset contamination

As I mentioned earlier, one way I like to work with presets is to trim them down so that each preset performs a discrete task, such as a black-and-white conversion or a split tone coloring effect. That way, I find I have more options to combine different settings and prevent getting into a situation like the one shown in Figure 6.116, where the end result was a contaminated mess. For example, I may apply one preset to modify the contrast and another preset to apply a coloring effect. I then keep these presets stored in separate preset folders so that it is easy for me to locate all the presets that can be used for applying different black-and-white conversions or cross-processing effects. The **Figure 6.117** chart summarizes the steps that are described over the next few pages. You will notice how I added a series of presets to build a combined effect. Therefore, when applying different split tone effects I can click each of the presets in turn to see a full-screen view of what the end result will look like, but without fear of messing up any of the settings that have been applied already.

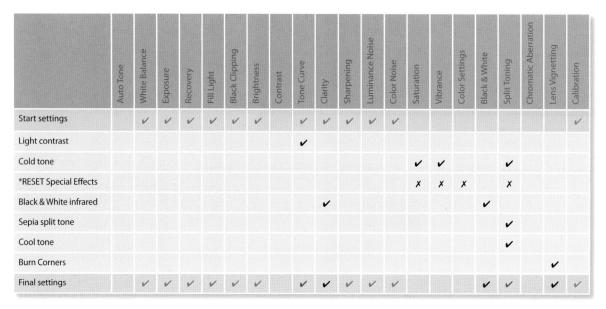

Figure 6.117 The alternative approach is to break down the Develop presets into smaller chunks so that you apply a sequence of Develop presets to build an effect. This chart summarizes the series of Develop preset steps that are applied in the step-by-step example that begins on the opposite page. The final settings include a couple of red tick marks where the settings have changed cumulatively, but this does not matter as much as in the Figure 6.116 example because the whole point is to build up the settings one step at a time. You will notice that I included a *RESET Special Effects step. This preset is designed to cancel out previous preset settings and, therefore, acts like a "clear settings" button. To illustrate this, I have used crosses to indicate that these items are returned to their default settings.

1. To begin with, I tried out some tone adjustment presets and selected a Light Contrast tone curve preset to apply a moderate contrast boost to the original color version of this image.

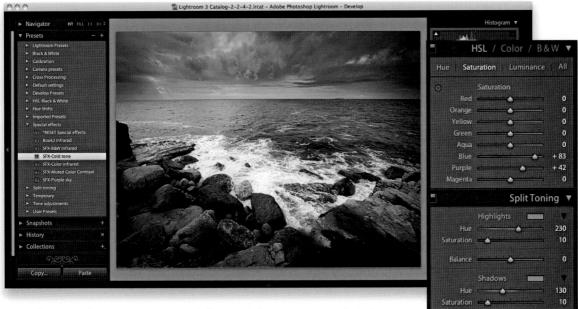

2. I also wanted to try out some special effects coloring presets, so I selected a "Cold tone" preset from my Special Effects preset folder. Should I wish to reset the preset settings used here and move on to try something different, I have included a RESET setting in each folder so that I can reset the relevant sliders to 0.

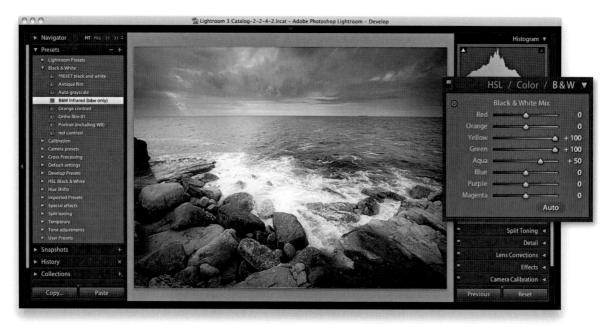

3. After resetting the "Cold tone" preset, I expanded the Black & White preset folder and applied a B&W Infrared preset to see what this conversion looked like.

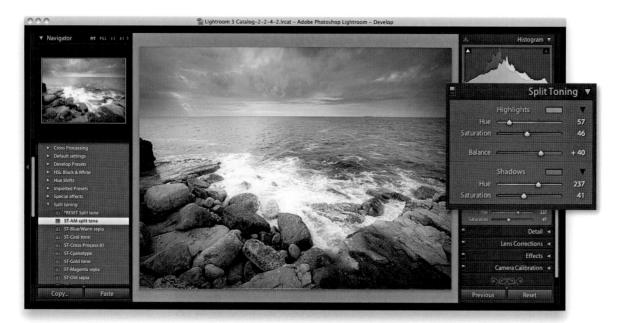

4. Next I went to the "Split toning" folder and tried different split tone presets. Note that if you have the Navigator panel open, you can hover the mouse over the preset list to preview each preset effect before applying.

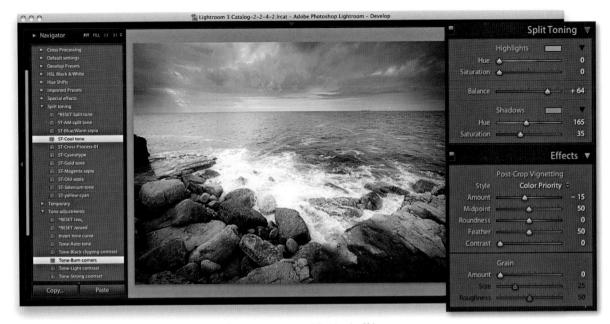

5. In the end, I opted for a "Cool tone" split tone preset and finished off by adding a Burn Corners preset from the "Tone adjustments" folder.

Reset settings

I will end this section by elaborating a little more on the use of the Reset preset settings such as the one referred to in Step 2. With the Develop preset folder structure I use here, I have added a preset to each folder that is named **RESET*. This is a preset setting that undoes any of the presets that have been applied in that particular folder. In the case of the Black & White folder, I have a preset called ***RESET black and white that switches from Black & White to Color mode. I created it by selecting a photo in color mode and creating a new preset in which I checked only the Treatment (Color) check box (as shown in **Figure 6.118**). For all the other preset folders, I similarly created presets such as a **RESET Split Tone* setting that uses zero Split Tone Saturation settings. The naming of these presets isn't critical; I prefer to use all caps so that the reset preset stand out more, and I place an asterisk at the beginning of the name so that the reset preset always appears listed first in each of the preset folders.

*RESET black &	white	
Black & White		
nt		
unce te une upte Recovery phr Clipping toess rast rve	Treatneent (Color) Color Color Adjustments Color Adjustments Split Tenring Cadaxetel Pitters Nose Reduction Luminance Color	Lens Corrections Lens Profile Corrections Lens Profile Corrections Corrections Lens Vapartting Ens: Vapartting Grain Process Version Calibration
	Black & White Black & White ance et uue uph Recovery pht	Back 6 Uhine N Sacc Share Sh

Figure 6.118 Here is an example of a preset that I created for converting a B&W setting back to Color mode again. All I had to do was select any Color mode image and save a preset with the Treatment (Color) box checked.

How to set default camera Develop settings

Any feature that saves you time is always welcome. Very often you will find that as you import pictures from a particular camera shot at a certain ISO speed, you end up needing to apply the same Develop settings. For example, if you shoot with more than one digital camera, you may want to create a custom camera calibration setting for each separate camera body. In addition to this, you may want to set different levels of noise reduction for specific ISO settings. You can do all this by creating camera default settings.

Folder: Camera presets Auto Settings Auto Tone Settings White Balance Treatment (Color) Basic Tone Color Exposure Saturation Highlight Recovery Saturation Black Clipping Color Adjustments Black Clipping Split Toning Contrast Graduated Filters	Lens Corrections
Auto Tone Settings White Balance Basic Tone Exposure Highlight Recovery Fill Light Black Clipping Brightness Color Adjustments Graduated Filters	Transform
White Balance Treatment (Color) Basic Tone Color Exposure Saturation Highlight Recovery Vibrance Fill Light Color Adjustments Black Clipping Split Toning Contrast Graduated Filters	Transform
 □ Tone Curve ☑ Clarity ☑ Clarity ☑ Sharpening ☑ Color 	 Lens Profile Corrections Chromatic Aberration Lens Vignetting Effects Post-Crop Vignetting Grain Process Version Calibration

1. One way you might go about doing this would be to gather a collection of sample photos that were shot with a particular camera and are representative of how the camera performs at different ISO settings. Then work on each photo to achieve the best Noise Reduction and Camera Calibration. As you do this, save the settings as new presets, but be sure to check only the items that are relevant for inclusion in the Develop preset settings, such as Noise Reduction, Process Version, and Calibration. You don't want to check any of the other items that are available here because you don't want a camera-specific Develop setting to affect more than the above Develop settings.

	Preferences
	General Presets External Editing File Handling Interface
Default Develop	Settings
Apply a	uto tone adjustments
Apply a	uto mix when first converting to black and white
Make de	faults specific to camera serial number
Make de	efaults specific to camera ISO setting
	Reset all default Develop settings
Location	
Store pr	resets with catalog Show Lightroom Presets Folder
Lightroom Defa	Restore Export Presets Restore Keyword Set Presets
	Restore Filename Templates Restore Text Templates
	Restore Local Adjustment Presets Restore Color Label Presets
	Restore Library Filter Presets

2. Go to the Lightroom Presets preferences and make sure that "Make defaults specific to camera ISO setting" is checked. It is important that you do this before proceeding to the next step. You can also check "Make defaults specific to camera serial number" if you want the settings to be camera-body specific.

	Change the default settings used by Lightroom and Camera Raw for
Ir	negative files with the following properties?
Bar B	Model: Canon EOS-1Ds Mark III
	Serial Number: 608248
	ISO Speed Rating: ISO 200
	Please note that these changes are not undoable.
Restore	Adobe Default Settings Cancel Update to Current Settings

3. Now go back to the photo you worked on in Step 1, and choose Develop \Rightarrow Set Default Settings. This opens the dialog shown here, where you need to click the Update to Current Settings button. Do this and Lightroom automatically makes this the default setting for all newly imported photos that match the same criteria of matching camera model, serial number, and ISO setting. But remember that you have created only what amounts to a default setting. If you were to choose a specific setting in the Import Photo dialog, or apply a Develop setting later that included Noise Reduction, Chromatic Aberration, Lens Vignetting, or Calibration subsettings, these settings would override the camera default setting values.

The art of black and white

How to achieve full creative control over your black-and-white conversions

I began my photographic career learning how to photograph and print in black and white. Since then, I have retained an enduring passion for black-and-white photography. In this respect, Lightroom does not disappoint because the Develop module tools provide the best environment I can think of to gain the most creative control possible from your color to black-andwhite conversions.

The techniques described in this chapter show you the three main ways to convert a photo to black and white; how to master the B&W sliders in manual, auto, and Target Adjustment mode; how to work with the White Balance sliders while in B&W mode; and how to use the HSL panel controls as an alternative approach to black-and-white conversions. I also show you how to achieve particular black-and-white styles, such as the blackand-white infrared look, as well as how to work with the Split Toning panel to colorize not just black-and-white images, but color photos, too.

NOTE

There is one other method of converting a color image to black and white that isn't covered in this chapter: using the Saturation slider. It is possible to convert an image from color to black and white by dragging the Saturation slider fully to the left. You can then modify the black-and-white conversion by adjusting the color controls such as the White Balance **Temperature sliders and Calibration** panel controls. This works, but in my opinion it is an unnecessarily convoluted approach when most of the controls you need are all there in the HSL/Color/B&W panel.

Black-and-white conversions

Black-and-white Develop controls

There are various ways you can convert a color image to black and white. You can click the Black & White button in the Basic panel, you can click B&W in the HSL / Color / B&W panel, or you can use the ♥ keyboard shortcut. Any of these methods immediately converts a photograph to black and white. (You can see the main panels associated with black and white conversions in Figure 7.1.) It is important to understand that when you make a black-and-white conversion, Lightroom is not actually converting a color image to B&W mode. Rather, it is creating a monochrome version of the original color image. Where the HSL or B&W panel controls are used to make a black-and-white conversion, Lightroom blends the grayscale information contained in the individual red, green, and blue channels that make up the composite RGB image. If you have ever played with the Channel Mixer controls or the Black & White adjustment in Photoshop, the B&W controls will probably appear familiar. In Lightroom, there are eight color slider controls to play with and these provide you with some nice, subtle controls over how the color component channels are blended in the conversion process. To make things a little easier, the B&W panel offers an Auto button that applies an automatic black-and-white conversion that is determined by the White Balance setting in the Basic panel. You can then further vary a black-and-white conversion by adjusting the Temperature and Tint sliders in the Basic panel.

When you switch to B&W mode, you have full control over the individual sliders, and these can be adjusted any way you like to create custom black-and-white conversions. The great thing about the Lightroom B&W panel is how the tonal balance of the image automatically compensates for any adjustments you make. Even so, it may still be necessary to revisit the Basic panel and readjust the tone controls such as the Exposure, Brightness, and Contrast sliders after you have applied a B&W panel adjustment.

In addition to working with the B&W panel sliders, you can use the HSL desaturate technique I describe at the end of this chapter. This provides you with even more scope to produce varied black-and-white conversions.

The Split Toning panel can be used to add split tone color effects to black-andwhite images and to produce different kinds of cross-processing effects with color originals. As always, favorite Develop settings can be saved as presets in the Presets panel, and a couple of black-and-white presets are there for you to play with. In Figure 7.1, I rolled the mouse cursor over the Creative – Selenium Tone preset, which updated the Navigator preview accordingly.

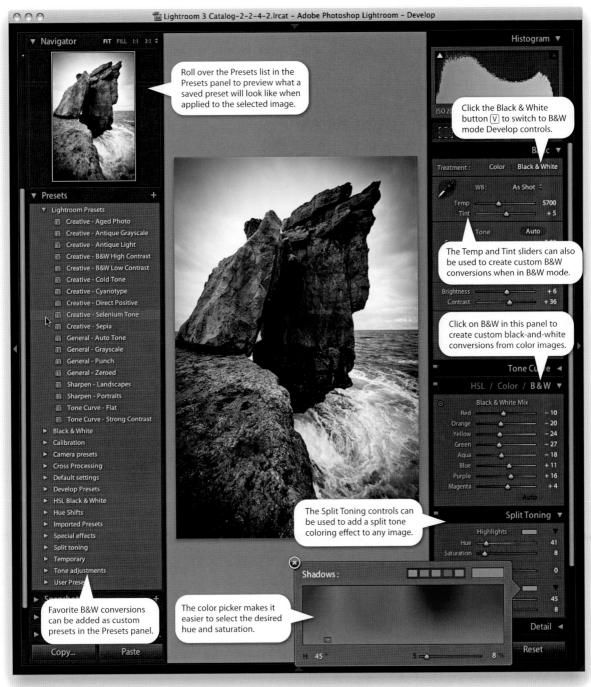

Figure 7.1 In this screen shot of the Develop module, I have highlighted the main blackand-white adjustment controls.

Figure 7.2 An RGB image consists of three grayscale channels that describe the red, green, and blue color information at the time of capture.

Black-and-white conversion options

In the early days of black-and-white photography, film emulsions were fairly limited in their color response. Most of these film emulsions were mainly sensitive to blue light only, which is why the skies in old photographs often appeared white, and why photographers could process their films in the darkroom using a red safe light. As film emulsion technology improved, panchromatic black-andwhite films began to emerge, and film photographers were able to creatively exploit the improved color sensitivity of these modern film emulsions. This next section shows you how to continue that tradition when working with digitalcapture images.

RGB color images, such as raw-processed digital captures, are made up of three grayscale images that record the luminance information of the original scene after it has passed through the red, green, and blue filters that overlay the photosites on the camera sensor. The color images you preview on the computer display are, therefore, composite images made up of these three RGB grayscale channels, which, when combined, produce a full-color image. **Figure 7.2** shows the individual red, green, and blue grayscale channels that make up an RGB image; here already you can see three quite different black-and-white interpretations of the original color photo. The B&W controls in Lightroom allow you to blend the three grayscale channels in various ways to produce different black-and-white conversion outcomes such as the examples shown in **Figure 7.3**. You will notice that there are actually eight B&W panel sliders you can use when carrying out a black-and-white conversion: Red, Orange, Yellow, Green, Aqua, Blue, Purple, and Magenta. Adjusting these sliders allows you to lighten or darken these respective colors in the color original when calculating the conversion.

How not to convert

Some photographers limit their black-and-white options unnecessarily, simply because they are unaware of the black-and-white conversion techniques that are available to them in Lightroom and Photoshop. For example, some people may set their cameras to shoot in a black-and-white JPEG mode. This restricts not only the tone adjustment options, but the black-and-white conversion options, too. The camera's onboard image processor decides, on the fly, how to blend the color channel information and produces a fixed black-and-white conversion. You are consequently left with no room to maneuver, because all the color data has been thrown away during the in-camera JPEG conversion process. Then there is the RGB to Lab mode method, in which you delete the a and b channels and convert the remaining, monochrome Lightness channel to grayscale or RGB mode. I suppose I'd better be careful of what I say about Lab mode editing because lately there has been a resurgence of interest in the Lab color space. Still, I don't believe there is anything to be gained from this approach because, yet again, you are throwing away all the color data rather than making use of it in the conversion.

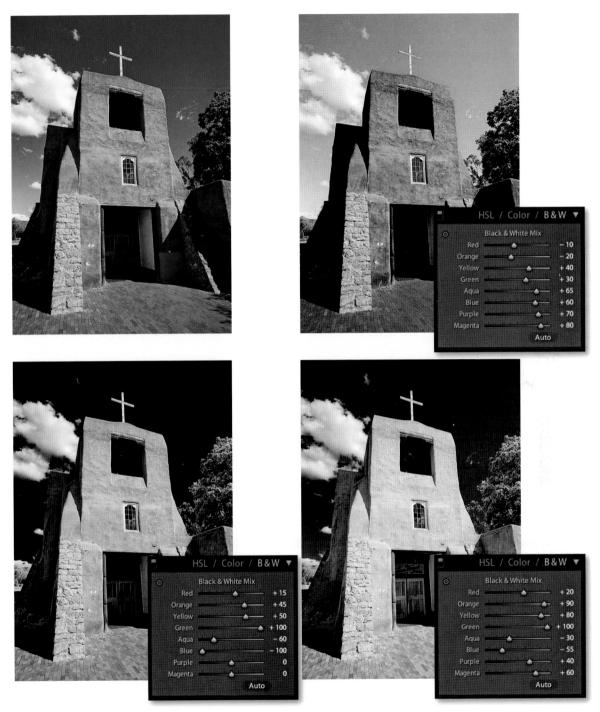

Figure 7.3 The B&W panel allows you to blend the color channel information in all sorts of ways to produce very different monochrome conversions from a color original.

Temperature slider conversions

Let's now look at how to use a black-and-white conversion in Lightroom to convert a color image (such as the one shown in **Figure 7.4**) to black and white. As just mentioned, one method is to click the B&W button in the Basic panel and adjust the White Balance settings. Figure 7.5 shows two possible black-and-white outcomes that can be achieved by dragging the Temp slider in the Basic panel and then clicking the Auto-Adjust button in the B&W section of the HSL / Color / B&W panel. The top version in Figure 7.5 shows a white balance with a warm bias. Notice how the red and yellow colors appear lighter when they are converted this way. When the Temp slider is dragged in the opposite direction, as shown in the bottom picture, the red and yellow colors look a lot darker. You can also adjust the Tint slider to vary the black-and-white conversion. A Tint slider adjustment wouldn't have much effect here in this particular photo, but there is an example coming up on page 419 where you'll see how a green Tint slider adjustment can be used to simulate an infrared look. In the next set of steps, we'll look at a further example of how to optimize a black-and-white conversion for a color portrait using just the White Balance and B&W sliders.

Figure 7.4 Here is a color original. Compare the monochrome conversions on the next page with the red, green, and blue colors in this photograph.

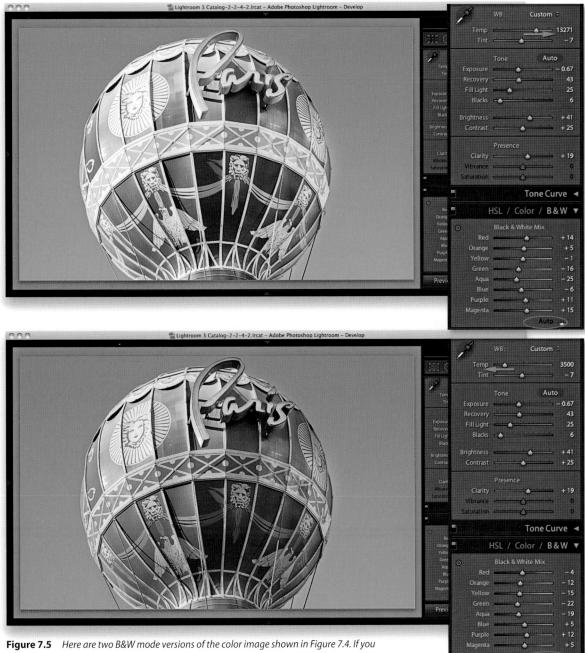

Figure 7.5 Here are two B&W mode versions of the color image shown in Figure 7.4. If you adjust the White Balance settings and then click the Auto button in the B&W panel, the B&W sliders will adjust accordingly. The top version shows a warm white balance temperature conversion followed by an auto black-and-white adjustment, and the bottom version shows a cool white balance temperature conversion followed by an auto black-and-white adjustment. Note the different outcomes in these two auto conversions.

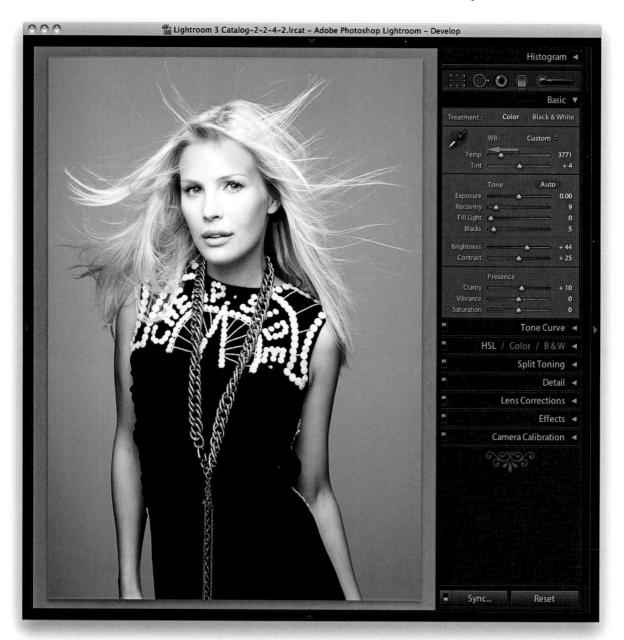

Auto B&W plus white balance adjustments

1. Let's look further at how the Black & White White Balance and Temp slider controls can affect a conversion. Here is a color photograph of the model used on the cover, in which I deliberately applied a blue color white balance. This works well as a color image, but let's see how it looks when converted to black and white.

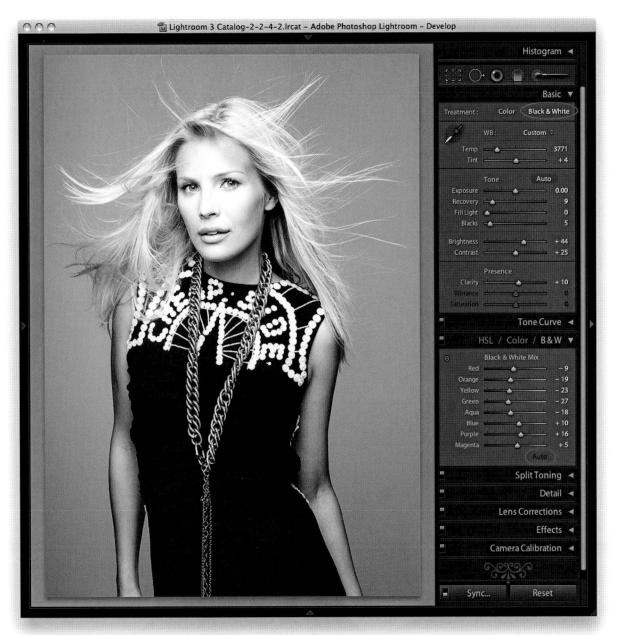

2. I clicked on the Black & White button in the Basic panel (circled) and then clicked the Auto button (also circled) in the B&W panel to apply an auto adjustment that was based on the current White Balance, Temp, and Tint settings. As default conversions go, this wasn't a bad starting point to work from.

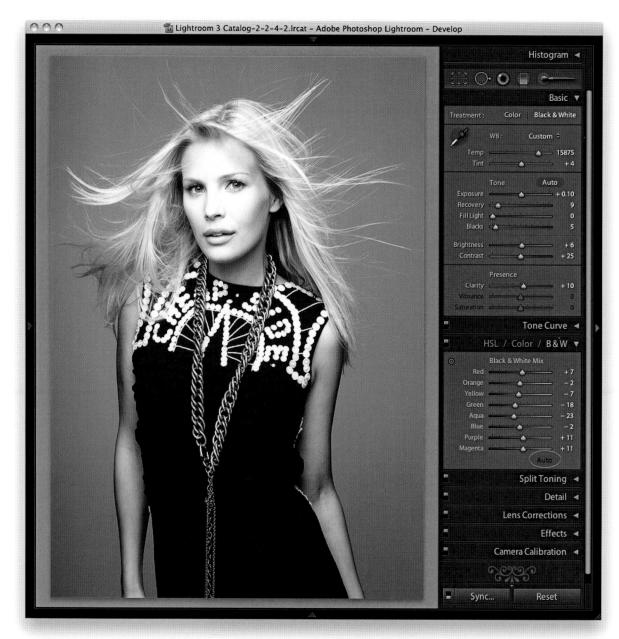

3. I then adjusted the Temp slider to find an optimum setting that would yield the best skin tone contrast and, as I did so, I clicked the Auto button each time, to update the B&W settings. I found that when the white balance was pushed to extremes I also needed to adjust the Brightness slider in the Basic panel to compensate for the B&W auto adjustment.

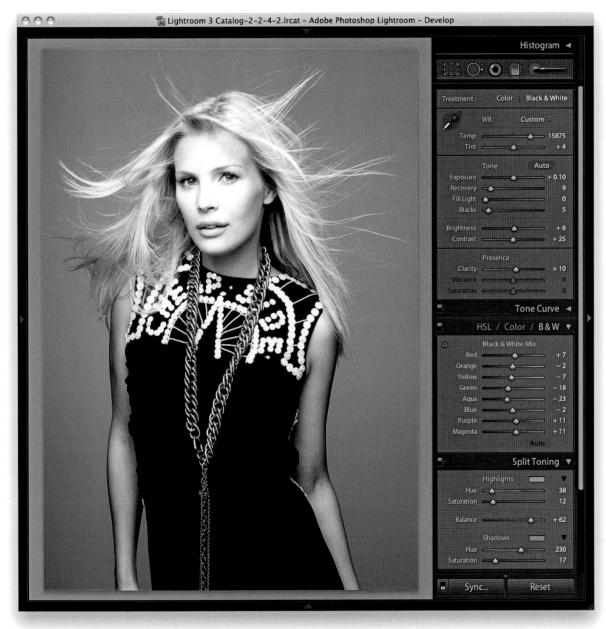

4. I also wanted to add some subtle color toning to the adjusted photo. So I used the Split Toning panel to add a warm highlight and a cool shadow split tone. (The Split Toning panel is covered later in this chapter.)

NOTE

Black-and-white adjustments are accessible and easy to work with. However, when you switch to B&W mode in Lightroom, this disables the Vibrance and Saturation controls, which is a shame since these sliders can also have an effect on the black-and-white conversion. But you can overcome this limitation by using the HSL desaturate technique that's described at the end of this chapter.

Manual B&W adjustments

Manually dragging the B&W panel sliders gives you almost unlimited freedom to create any number of different black-and-white adjustments. This is where the real fun begins, because you have complete control over how light or dark certain colors are rendered in the black-and-white conversion. The following steps show how I was able to improve upon the default Auto B&W panel setting, thereby maximizing the contrast in the sky and the clouds. Notice that I gave the Green, Aqua, and Blue sliders negative values because I wanted these colors to render darker. You can adjust the B&W sliders by dragging them, but you may well find it easier to use the Target Adjustment tool mentioned in Step 2 to edit the image directly. Remember, the black-and-white outcome is again influenced by the white balance setting, so it is often useful to experiment with different white balance adjustments as you search for the best combination, as shown here.

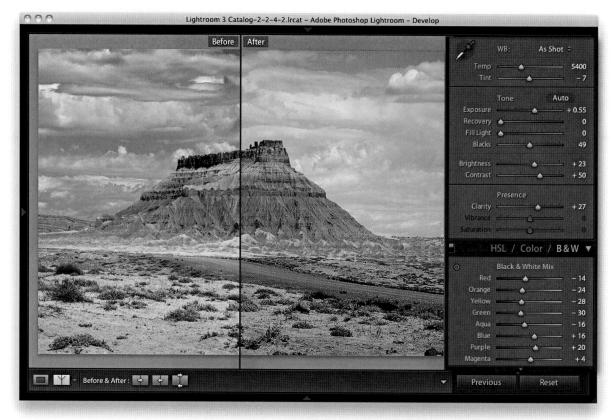

1. In this first step, the colors and tones were optimized using the Basic panel controls. This screen shot shows the color original alongside a black-and-white version that was produced using the Auto B&W setting. The default black-and-white conversion was nowhere near as dramatic as I would have liked.

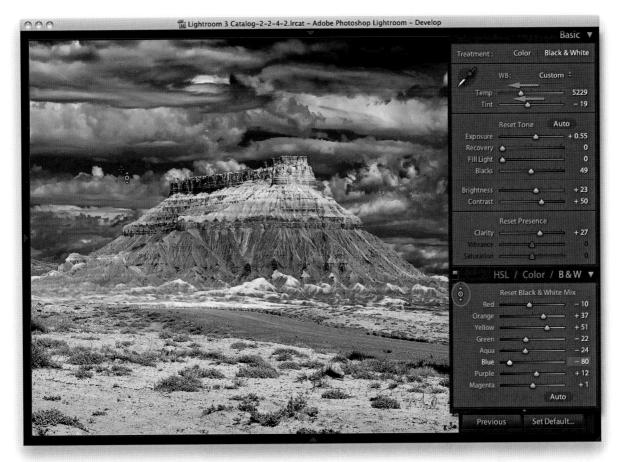

2. This second version shows the same image after I made some custom edits using the B&W sliders. I clicked the Target Adjustment tool button (circled), moved the mouse over the rock, and dragged upward to lighten the selected colors. I then moved the mouse over the sky and dragged downward to darken and add more contrast to the clouds. Notice that I also adjusted the Temp slider to make the white balance setting cooler and adjusted the Tint slider to make the white balance more green. This in turn also made the black-and-white-adjusted version look even more contrasty.

B&W slider tip

If you want to create dramatic black-and-white conversions, move the sliders farther apart and try moving two or more sliders in unison. In the above example, I moved the Green, Aqua, and Blues sliders to the left. This created the most dramatic tonal contrast based in the opposing colors of the warm rocks against a cloudy blue sky. The following section shows how to push Lightroom black-andwhite conversions to even greater extremes.

TIP

You can also use #Ait Shift (Mac) or Ctrl Alt Shift (PC) to enable the Target Adjustment tool in the B&W panel and use #Ait Shift (Mac) or Ctrl Alt Shift (M (PC) or Esc to turn it off again.

Black-and-white infrared effect

Now watch what happens when you take the White Balance settings to extremes before applying a black-and-white conversion. The following black-and-white infrared technique illustrates just one of the ways you can achieve a creative blackand-white conversion using Lightroom.

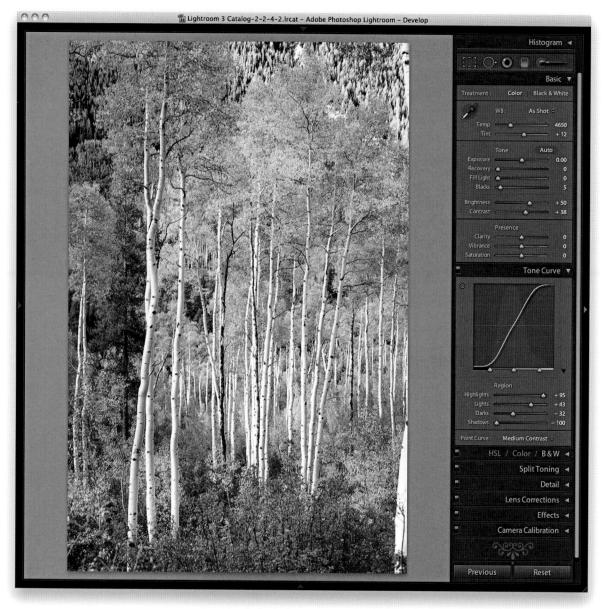

1. Here is the before version, which shows a nice mix of foliage—ideal for demonstrating a black-and-white infrared effect.

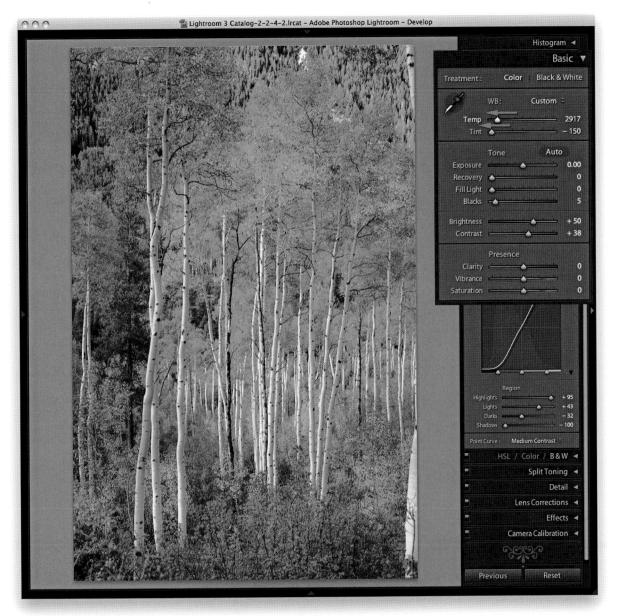

2. To create the fake black-and-white infrared look, I started with the image in Color mode, made the white balance temperature slightly cooler, and applied a full negative tint adjustment to the white balance to make all the green colors (i.e., the leaf foliage) as bright green as possible, without actually clipping any important areas of detail.

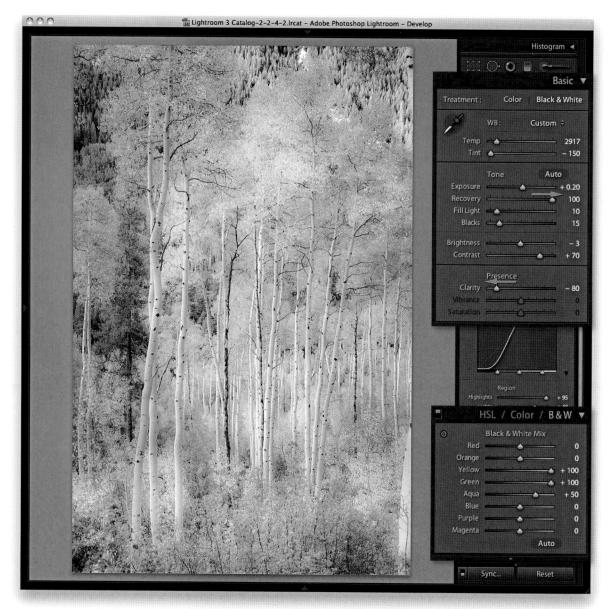

3. I then clicked the B&W button in the HSL / Color / B&W panel to convert the photograph to black and white. To get the full infrared look you see here, I set the Yellow and Green sliders in the B&W panel to +100% and the Aqua slider to +50%. I also adjusted some of the Basic panel settings. In particular, I set the Recovery slider to +100%, which helped me preserve some of the delicate tone information in the leaves. I set the Clarity slider to -80%, because this created a diffused printing effect that added a nice, soft glow to the photograph.

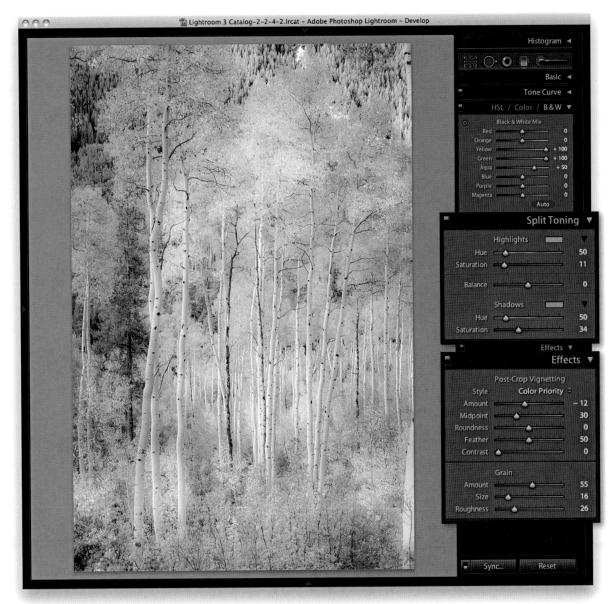

4. Finally, I went to the Split Toning panel to add a split tone coloring effect, and also added a Grain effect via the Effects panel. The settings shown here worked well for this particular image. If I wanted to apply this infrared effect to other photographs, I would need to save these settings as a custom preset. The main thing to remember is to lighten the greens by applying an extreme Tint slider adjustment in combination with the B&W panel settings shown here, apply a negative Clarity adjustment, and add a grain effect. The other tone settings will need to be fine-tuned on an image-by-image basis.

Figure 7.6 The Split Toning panel.

Figure 7.7 To access the color pickers, click on the swatches and click anywhere in the color ramp to sample a new color. The current selected color is the one with the thicker border.

Fine-tuning black-and-white images

Split Toning panel

As long as you have a good profile for your printer or you are using a printer and ink combination specifically designed for black-and-white work, it should be fairly easy to obtain a neutral gray print. It should not even matter how well your display is calibrated. If an image is in black and white, you should be able to produce a perfectly neutral gray print regardless of how neutral the photo looks on the display. If you are unable to achieve neutral black-and-white prints, there may be something wrong with your printer profiles. Or, if you're using an inkjet printer, the print heads may need cleaning. This is a good point to bear in mind. Often, I have gone to make a print and the colors have been distinctly off, and all because it had been several weeks since I had last used that particular printer. Usually, a quick nozzle clean is all that's required.

The Split Toning controls (Figure 7.6) are mainly intended for use on photos after they have first been converted to black and white, where you want to deliberately add some color to the otherwise neutral tones in the image. The Hue sliders can be used to adjust the hue color in either the highlights or the shadows, and the Saturation sliders can be used in conjunction with the Hue sliders to apply varying strengths of color. Note that if you hold down the Att key as you drag a Hue slider, you get a saturation-boosted preview that can help you see more clearly which hue color you are selecting without having to change the Saturation slider setting. In Lightroom, we have a color picker (Figure 7.7) that allows you to select the hue and saturation more easily in one step. To choose a color, click a swatch to open the color picker, and then click anywhere in the color ramp, or anywhere in the interface screen area even. Just click in the color ramp, and with the mouse held down, drag outside of the color ramp to anywhere on the screen. But remember, this only works if you keep the mouse held down as you drag. You can also save a new color swatch by Alt -clicking in the swatch boxes to the left of the main before/after color swatch box. You will notice that the color picker displays both the highlight and shadows color positions on the color ramp, so you can judge the relative positions of the two color sample points. There is also a slider at the bottom that you can use to adjust the saturation while keeping the hue value locked.

The Balance slider in the Split Toning panel lets you offset the balance between the shadow and highlight color toning and provides a really nice fine-tuning control for your split tone effects.

With the Split Toning controls in Lightroom, there are no hard-and-fast rules as to which color combinations to use. It can sometimes be useful to pick contrasting colors, such as a blue color for the shadows and a warm color for the highlight tones. The following two examples will give you an idea of what's possible.

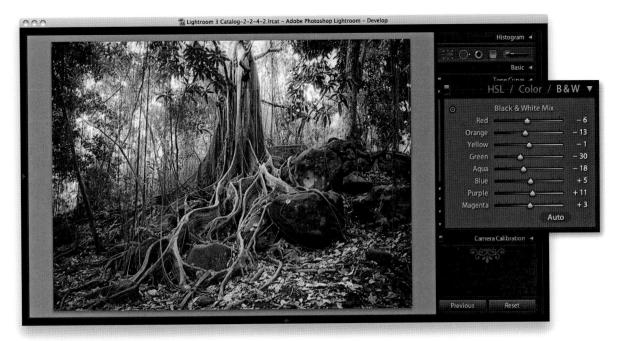

1. This photo was first converted to black and white using the B&W panel controls.

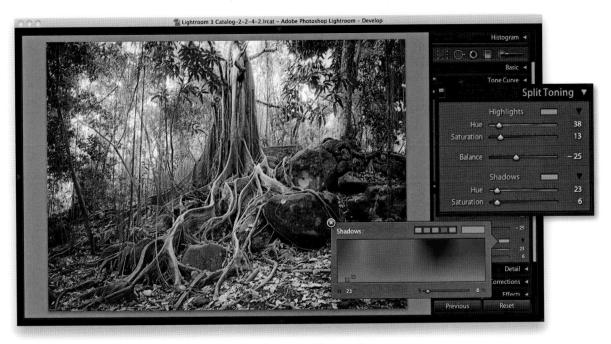

2. I then went to the Split Toning panel and used the color picker to select a warm sepia color for the highlights and a cool color for the shadows. Finally, I offset the split tone midpoint by adjusting the Balance slider.

Split-toning a color image

The Split Toning controls also work great on non-black-and-white-converted, color images. If you want to give your photographs that distorted color look, here's how you can create a cross-processed effect in Lightroom. It is really easy to vary the effects shown here and save successful color split tone effects as presets.

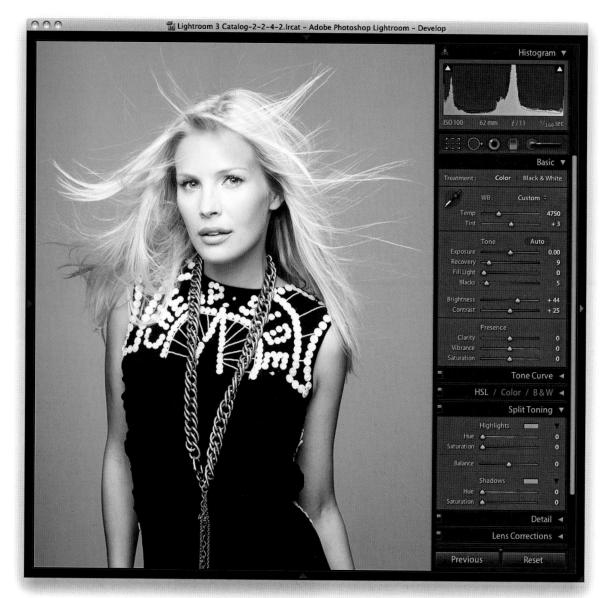

1. This is the same shot that was used to demo the Auto black-and-white conversion technique, except here I started with a neutral white-balanced version where I had applied only a few Basic panel adjustments.

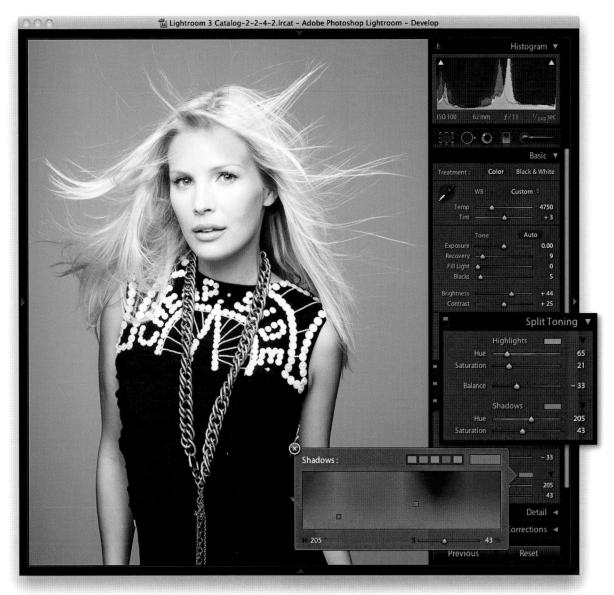

2. The color effect you see here was achieved using the Split Toning panel controls. In this example I tried to simulate a typical cross-processed film look, which I did by setting the highlights hue to yellow and the shadows hue to a cyan/blue color. I could have achieved a more subtle effect than the one shown here by reducing the Saturation amount for the highlights and the shadows, but the settings used here produced a fairly typical cross-processed look. You will notice that I also offset the Balance slightly to add more weight to the cyan/blue coloring in the shadows.

HSL	/ Color	/ Graysc	ale 🔻
Hue Sati	iration	Luminance	All
0	Hue		
Red			0
Orange			0
Yellow	<u>eren</u>	·	0
Green	-	<u>)</u>	0
Aqua	Contraction of the second		0
Blue	-		0
Purple	distant and		0
Magenta	-	State and the second second	0
o	Saturation		
Red	A		- 100
Orange	7		- 100
Yellow	X		- 100
Green	X		- 100
Aqua	X		- 100
Blue			- 100
Purple	自己自动相关的复数		- 100
Magenta		<u></u>	
0	Luminanc		
Red		<u>hini hi</u> n	+ 7
Orange			+ 21
Yellow			+ 58
Green		· · · · · · · · ·	+ 20
Aqua	<u> </u>		- 100
Blue			- 100
Purple			- 69
Magenta			-6

Figure 7.8 The HSL panel showing all controls with the Saturation sliders all set to -100.

HSL panel: Desaturated color adjustments

Lightroom offers another less obvious approach to converting color images to black and white. If you go to the HSL panel and drag all the Saturation sliders to -100, you can desaturate the color completely to create a black-and-white version of a photo. On the face of it, this would appear to be the same thing as dragging the Basic panel Saturation slider all the way to the left, but the key difference here is that the Saturation slider applies its adjustment upstream of all the other color sliders, thus rendering them inoperable (apart from White Balance, Color Noise, and Calibration). But the HSL desaturate method cleverly gives you full access to *all* the color controls in the Develop module, and this is where it can sometimes score favorably against B&W panel adjustments.

Here is how to get started. Go to the HSL panel and set all the Saturation sliders to –100 (as shown in **Figure 7.8**). That's it. Don't adjust the Luminance sliders just yet, as you'll be doing that later. For now, I suggest you follow the advice given in **Figure 7.9** and save this HSL setting as a new preset. At the end of Chapter 6, I suggested that you use folders to organize your develop presets, so my advice here is to save a setting like this to a dedicated folder for storing HSL black-and-white presets such as the HSL Black & White folder used in Figure 7.9.

Preset Name: HSL Graysc	ale
Folder: User Prese	its 🗘
Auto Settings	
Auto Tone	
Settings	
White Balance	Treatment (Color)
Basic Tone	Color
Exposure	Saturation
Highlight Recovery	Vibrance
Fill Light	Color Adjustments
Black Clipping	
Brightness	Split Toning
Contrast	
	Vignettes
Tone Curve	Lens Vignetting
	Post-Crop Vignetting
Clarity	
	Graduated Filters
Sharpening	
	Process Version
Noise Reduction	Calibration
Luminance	
Color	Chromatic Aberration
Grain	Transform
	Lens Profile Corrections
Check All Check Nor	Cancel Create

The HSL B&W method

With HSL black-and-white conversions, all you need to do is apply the preset that was saved in Figure 7.9 and then adjust the HSL panel Luminance sliders. Don't bother editing the Hue sliders—these will have no effect on the blackand-white conversion. The Luminance sliders can, therefore, be used to lighten or darken specific colors in the photo, just as you would when adjusting the B&W panel sliders. The Target Adjustment tool can also be used here. Click the Target Adjustment tool button to activate it, or use the **\mathbf{W}Att** Shift) (Mac) or Ctrl Att Shift) (PC) keyboard shortcut to switch to Target Adjustment mode and **\mathbf{W}Att** Shift) (Mac) or Ctrl Att Shift) (PC) to exit this tool mode behavior. (Figure 7.8 shows how the HSL panel might look after you have finished adjusting the Luminance sliders.) If you want, you can save an HSL black-and-white setting as a new preset, in which case you would click the plus button in the Presets panel and again use the same Develop settings shown in Figure 7.9 to create a new preset.

So far you might think this is a long-winded approach for producing exactly the same results as you can achieve with the B&W panel on its own. But as I mentioned earlier, when you work with the B&W panel, the Vibrance and Saturation sliders are unavailable and are shown grayed out. This is a shame, because when you use the HSL desaturate method, the Vibrance and Saturation sliders offer you a great deal of added control over the outcome of your black-and-white conversions. In HSL desaturate mode, the Saturation slider in the Basic panel can act like an amplifier volume control for the HSL Luminance adjustments. So, increasing the Saturation magnifies the HSL slider settings. The Vibrance slider offers a more subtle, fine-tuning control. But, interestingly, a Vibrance adjustment can sometimes appear to have an opposite effect to the Saturation slider, and decreasing the Vibrance can sometimes make certain colors (such as blue) appear darker when converted to black and white. This conversion method is perhaps more suitable for red contrast-type conversions where you might want to significantly darken a blue sky. I wouldn't say it is essential to use this approach in every case, because not all black-and-white conversions are likely to require this alternative method. But the following steps illustrate a typical example of a black-and-white conversion that might suit the HSL desaturate technique.

Camera Calibration adjustments

I have not mentioned this before, but you can also use the Camera Calibration panel sliders to apply further fine-tuned adjustments. Here, things get a little unpredictable, and it can be a matter of playing with the sliders and seeing what happens. But, even so, this method still offers more opportunities for experimentation that are otherwise lacking with the standard Lightroom black-and-white conversion methods.

NOTE

Some readers may be aware that I used to promote the HSL desaturate black-and-white conversion method as a way to beat noise creeping into your black-and-white conversions. However, since version 1.4, Lightroom black-and-white conversions have kept the Color Noise adjustment active, so you should no longer see this previously reported problem affect your normal B&W panel conversions.

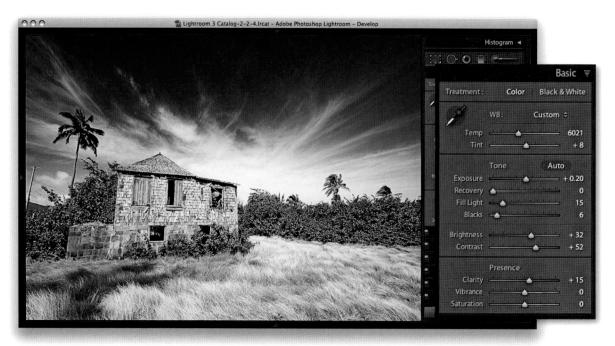

1. In this photograph, just a few minor adjustments were made to the settings in the Basic and other panels.

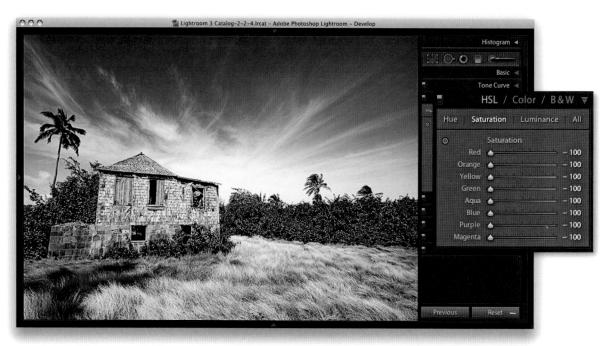

2. This shows how the photograph looked when converted to black and white with the HSL Saturation sliders all taken to –100. (I also added a Split Tone effect.)

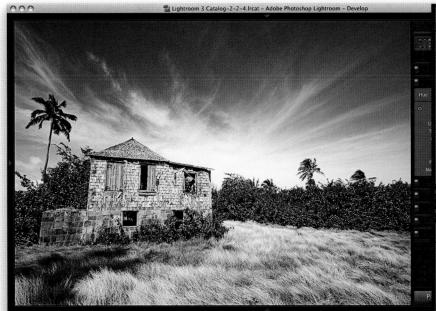

3. In the HSL panel, I used the Luminance sliders to adjust the black-and-white conversion mix, just as I would in the B&W panel; plus, I reduced the Vibrance.

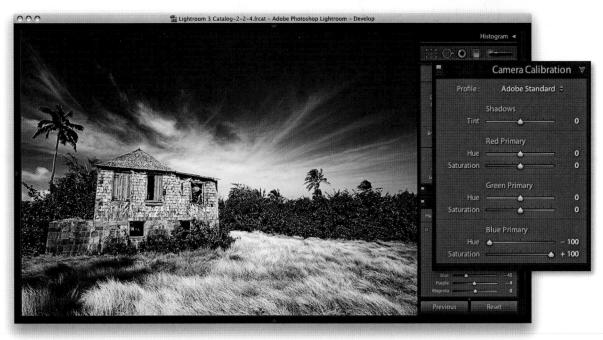

4. Finally, I went to the Camera Calibration panel and adjusted the Blue Primary Hue and Saturation sliders to add even more contrast to the sky.

K © 2006 Martin Evening 200 ISO | f/7.1 @ 1/500th Portsmouth, U Mik II | 70 mm | HMS Victory ion EOS 1Ds 1

RIEN

ati

1

5

Ø

1

10

1

1

P

4

11

1 R

Lar

П

4

AT .

12.00

P

anan

0

Na I

No. of Concerns

A

R

-

8

Sharpening and noise reduction

How to make full use of the capture sharpening and noise reduction controls in the Detail panel

Digital capture undoubtedly offers photographers the potential to capture finer detail than was previously possible with film. It is also important to understand that presharpening has always been an integral part of the digital-capture process. There are many reasons why it is necessary to presharpen an image. The process of converting the light information that hits the photosites on the sensor and subsequent digital data processing will result in an image with softer edge detail than would normally be considered desirable. It could be that the lens optics on your camera are not particularly sharp. Therefore, a little sharpening at the post-capture stage is usually necessary to produce an image that is sharp enough to look good on the display, but without being overly sharpened. If a photograph is sharpened too much at this stage, you may end up with artifacts that will be compounded only as additional adjustments are made to the image. Presharpening should, therefore, be applied to raw-capture images only and only in moderation. It is all about striking the right balance between compensating for the image softness in a raw file while avoiding the problems that can be caused by any over-sharpening at this preliminary stage.

This chapter emphasizes the importance of presharpening digital photographs and how to reduce image noise. I'll explain how the sharpening sliders in the Detail panel work and offer suggestions on which settings to use for sharper, clearer photos.

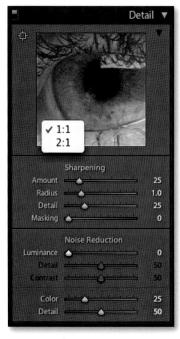

Figure 8.1 The expanded Detail panel includes a preview window that can be set to a 1:1 or 2:1 view via the contextual menu.

NOTE

Did you know that your sensor may have dead pixels? This is something that's guite common and you normally won't even be aware of it, since the raw processing is good at spotting problem pixels and removing them during the conversion. You may notice them briefly, though, when editing particularly noisy photos. For example, if you edit a photo that was shot at night using a long exposure, you may initially see a few brightly colored pixels appear always in the same spot before the Develop module finishes updating the preview.

Capture sharpen for a sharp start

Before discussing the new sharpening controls in Lightroom, I should briefly explain the principles behind capture sharpening and the difference between this and output sharpening.

The Unsharp Mask filter in Photoshop has been around since the very earliest days of the program and has not really changed much since then. As Photoshop has matured, our understanding of sharpening and how to best use the Unsharp Mask filter controls has improved and various techniques have evolved that cleverly use the Unsharp Mask filter to its best advantage. In his lifetime, author and Photoshop guru Bruce Fraser did the industry a great service with his research into Photoshop sharpening. His recipes for optimum sharpening, based on whether you were sharpening for input—that is, capture sharpening—or sharpening for output, have done a lot to improve our understanding of how to apply the most appropriate level of sharpening at each step of the image editing and printing process. It is also fair to say that Bruce's research and writing had an impact on the way some of the sharpening controls in Lightroom evolved. But more on this later.

Capture sharpening is all about adding sufficient sharpening to a photograph in order to correct for the inherent lack of sharpness that most digital images suffer from to a greater or lesser extent. If you shoot using raw mode, then your photographs will arrive untreated in Lightroom and they will most definitely need some degree of sharpening. If the photos you import have originated from a digital camera shot using the JPEG mode, then these images will already have been presharpened in-camera. The Detail panel sharpening controls in Lightroom are, therefore, intended for use with photographs that are raw originals or non-raw files that have yet to be sharpened (see the section "Default Detail panel settings" on page 435).

The main goal with input/capture sharpening is to correct for the lack of sharpness in an image. Capture sharpening is therefore something that you should evaluate on the display using a 1:1 view setting. Having said that, with images that use the latest Process Version 2010, the sharpening can now be previewed at lower display resolutions. This capability can sometimes give you a better idea of how the image will look when sharpened, but in no way does it provide you with an accurate means to preview the sharpening effect. This simply must be done at a 1:1 view and it is all about making the photograph look nicely sharpened on the display. At the same time, you don't want to over-sharpen, since that can lead to all sorts of problems later at the retouching stage in Photoshop. The Detail panel controls (**Figure 8.1**) are, therefore, designed to let you apply such sharpening in a controlled way so that only the edge detail gets sharpened and the flat tone areas are preserved as much as possible.

Improved Lightroom 3 raw image processing

Lightroom 3 now offers better demosaic processing, sharpening, and noise reduction. The combination of these three factors has led to much improved image quality from the Lightroom raw processing engine. It should again be noted that while sharpening and noise reduction can be applied to non-raw images, JPEG captures will have already undergone such a transformation and there is no way to undo what has already been fixed in the image. Therefore, the benefits will be fully appreciated only when processing raw images, although it should be noted that only those cameras that use the three-color Bayer demosaic method have been modified, and the demosaic processing for other types of sensor patterns, such as four-color shot cameras and the Fuji SuperCCD, has not been altered. However, additional improvements have been made in the demosaic processing for specific camera models. For example, improved green balance algorithms have addressed the problem of maze pattern artifacts seen with the Panasonic G1, which may also improve the image quality for some other camera models.

Let me try to explain what exactly has changed and how Lightroom 3 is now different. We can start by looking at the two image examples shown in Figure 8.3, where the top image shows a photograph processed using Lightroom 2 and the bottom one shows the same image processed using Lightroom 3: Process Version 2010. These photos have been enlarged to 400 percent so that you can see the differences more clearly. The first thing to point out is that the new demosaic process is now more "noise resistant," which means that it does a better job of removing the types of noise that we find unpleasant, such as color artifacts and structured (or pattern) noise. But, at the same time, it aims to preserve some of the residual, non-pattern noise, which we do find appealing. The underlying principle at work here is that colored blotches or regular patterns tend to be more noticeable and obtrusive, whereas irregular patterns such as fine, random noise are more pleasing to the eye. The new demosaic process does a better job of handling color artifacts (such as the example shown in Figure 8.2) and filters the luminance noise to remove pattern noise, yet retains some of the fine, grain-like noise. The net result is that Lightroom 3 is able to do a better job of preserving fine detail and texture.

The next component is the new revised sharpening. Sharpening is achieved by adding halos to the edges in an image. Generally speaking, the halos add a light halo on one side and a dark halo on the other side of an edge. To quote Lightroom engineer Eric Chan (who worked on the new sharpening), "Good sharpening consists of halos that everybody sees but nobody notices." To this end, the halo edges in Lightroom 3 have been made more subtle and rebalanced such that the darker edges are a little less dark and the brighter edges are brighter. They are there and you notice them in the way they create the illusion of sharpness, but you are less likely to actually "see" them as visible halos in a photo. Another thing that's been addressed is that when you select a Sharpen Radius within the 0.5 to 1.0 range, the halos are now narrower. Previously, these

NOTE

In order to speed up rendering times, the sharpening and noise reduction are disabled below a certain Fit to view preview size (Process Version 2010 only). This is dependent on the camera capture size.

NOTE

Some raw image processing programs apply sharpening in a clandestine way, giving the impression that their raw processing is somehow sharper than everyone else's. Other programs, such as Lightroom, don't hide the fact that there is a certain level of sharpening being applied and give you the option to turn sharpening off completely by setting the Amount slider to 0.

Figure 8.2 Color noise artifacts can be particularly noticeable when photographing shiny fabrics such as the example shown here. Improved demosaicing can remove these colored artifacts.

NOTE

You can download a layered version of this close-up view from the book's Web site.

www.thelightroombook.com

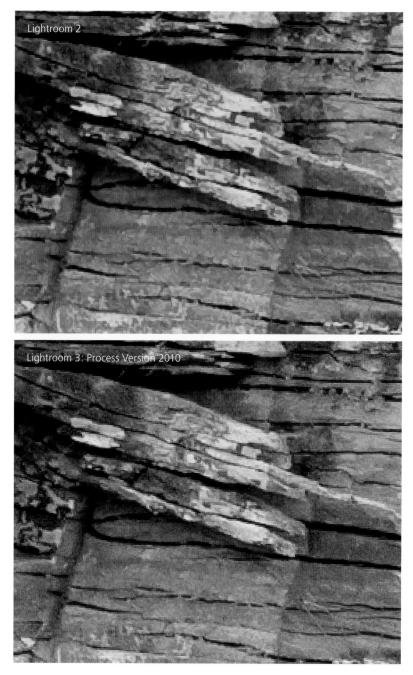

Figure 8.3 Here you can see a comparison between the demosaicing capabilities in Lightroom 2 (top) and Lightroom 3: Process Version 2010 (bottom). The sample image used here was shot with a Canon EOS 1Ds Mark III camera using an EF 24–70mm lens (24mm setting), ISO 800, f/7.1 at 1/200th second exposure. Shown here are close-up views at a 4:1 magnification in the Develop module (the full-frame version is shown top left).

were quite thick, and it should now be possible to sharpen fine-detailed subjects such as landscapes or fine textures more effectively. You'll also read later how the Detail panel Sharpen settings are now linked to the Sharpen mode of the Adjustment tools. This means you can use the Adjustment brush or Gradient Filter as creative sharpening tools to "dial in" more (or less) sharpness. Finally, we have the new noise reduction controls, which offer more options than before for controlling the luminance and color noise in a photograph.

Output sharpening

Output sharpening is something that is always done at the end, just prior to making a print, by using the Print Sharpening options in the Print module Print Job panel. But note that Lightroom does not allow you to see onscreen what the output sharpening looks like. The print sharpen processing is hidden from view, and the only way to evaluate print output sharpening is to judge the print. The amount of sharpening required at the print stage varies according to many factors, such as the print process, print size, print resolution, and type of paper used. Fortunately, Lightroom uses PixelGenius PhotoKit Sharpener routines at the print stage, so this is now all handled automatically. But I'm getting ahead of myself here. This section is all about the capture sharpening and what's new and special about the sharpening and noise reduction controls in Lightroom.

Default Detail panel settings

In Lightroom, the default behavior is to apply no Detail panel adjustments to an image unless it is recognized to be a raw capture. Raw capture images should always require some degree of sharpening and noise filtering, whereas JPEG captures already have had some level of sharpening and noise processing applied in-camera (see "Raw or JPEG?" on page 260). Other pixel images such as TIFFs and PSDs should not require any Detail panel processing either (unless you are working on an unsharpened scanned image). Basically, if a pixel image has already been sharpened, the last thing you want to do is add more sharpening after it has been imported into Lightroom. This is why the default sharpening is set to 0 for everything except raw images.

Sharpen preset settings

Perhaps the easiest way to get started is to use either of the two Sharpen presets found in the Develop module Presets panel shown in **Figure 8.4**. (These Develop presets are also available via the Library module Quick Develop panel.) All you have to do is decide which of these two settings is most applicable to the image you are about to sharpen. These can also be a useful starting point when learning how to sharpen in Lightroom. Start off by selecting one of these settings and fine-tune the Detail panel sliders based on the knowledge you'll gain from reading the remainder of this chapter.

NOTE

It could be said that even the film development process applies an unsharp masking effect. This is because the film development stage produces a slight edge contrast enhancement due to developer depletion in the higher-exposure areas.

V	Pre	resets +				
	V	Lightroom Presets				
		Creative - Aged Photo				
		Creative - Antique Grayscal	e			
		Creative - Antique Light				
		Creative - B&W High Contra	st			
		Creative - B&W Low Contrast	it			
		Creative - Cold Tone				
		Creative - Cyanotype				
		Creative - Direct Positive				
		Creative - Selenium Tone				
		Creative - Sepia				
		🛅 General - Auto Tone				
		General - Grayscale				
		💼 General - Punch				
		General - Zeroed				
		Sharpen - Landscapes				
		Sharpen - Portraits				
		Tone Curve - Flat				
		Tone Curve - Strong Contra	ist			
	Þ	Black & White				
		Calibration				
	Þ	Camera presets				
	D	Default settings				
	Þ	Develop Presets				
	Þ	HSL Black & White				
		Hue Shifts				
		Imported Presets				
	Þ	Special effects				
			Split toning			
	R	Split toning				
	Þ	Split toning Temporary				

Figure 8.4 The Develop module Presets panel contains two sharpening settings in the Lightroom Presets folder.

Sharpen – Portraits

As you read the rest of this section, it will become apparent what the individual sliders do and which combination of settings work best with specific photographs. But to start with, let's look at the two preset settings found in the Lightroom Presets subfolder. **Figure 8.5** shows a 1:2 close-up portrait of myself, shot by Jeff Schewe, where naturally enough, I chose to apply the *Sharpen – Portraits* preset. This combination of sharpening slider settings is the most appropriate to use for most portraits where you wish to sharpen the important areas of detail, such as the eyes and lips, but protect the smooth areas (like the skin) from being sharpened. You may wish to strengthen this setting by increasing the Amount, and you may also wish to increase the Masking slider if the skin tones are looking a little too "crunchy"—a higher Masking setting should help preserve the smooth tone areas.

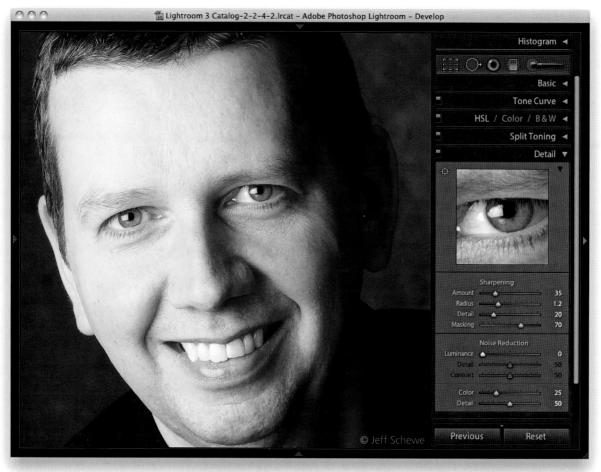

Figure 8.5 Here is an example of the Sharpen – Portraits preset in action.

Sharpen – Landscapes

The other preset setting you can choose is *Sharpen – Landscapes*. This combination of sharpening slider settings is most appropriate for subjects that contain a lot of edge detail. You could include quite a wide range of subject types in this category. In **Figure 8.6**, I used the *Sharpen – Landscapes* preset to sharpen the architecture photo shown. Basically, you would use this particular preset whenever you needed to sharpen photographs that contained a lot of fine edges.

The two preset settings described here provide you with a great way to get started and get the most from the new sharpening settings without having to understand too much about how the sharpening in Lightroom works or what the individual sliders do.

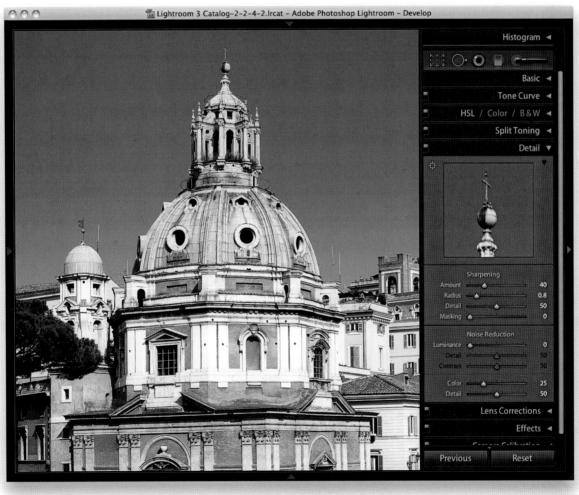

Figure 8.6 Here is an example of the Sharpen – Landscapes preset in action.

TIP

It is wonderful having tonal adjustment controls that allow you to pull more information out of the shadows, but because of this, Lightroom is more prone to emphasizing shadow noise problems. Many camera manufacturers are only too painfully aware of the problems of shadow noise and do their best to hide it by deliberately making the shadows darker in JPEG captures to help hide any shadow noise. Some camera manufacturer raw processor programs also apply a shadow contrast tone curve by default. If you use the Tone Curve controls in Lightroom to bring out more shadow information, just be aware that this may emphasize any shadow noise in the image. It is, therefore, always worth inspecting the shadows closeup after making such adjustments and checking to see if any Luminance and Color slider adjustments are needed to hide the noise (see pages 454-457).

Downloadable Content: www.thelightroombook.com

Sample sharpening image

To help explain how the individual sliders work, I have prepared a test image that has been designed to show some of the key aspects of Lightroom sharpening. You can download this image by going to the Lightroom book Web site and follow the steps that have been used here to demo how Lightroom sharpening works.

The **Figure 8.7** image was specially designed to demonstrate several key aspects of sharpening. The eye and surrounding skin texture allows you to see the effects of portrait-style sharpening where the objective is to sharpen detail like the eyelashes (but avoid sharpening the skin texture). Conversely, the patchy texture in the bottom-right corner allows you to test the ability to sharpen smooth texture content where you do want to emphasize the texture detail. The high-contrast detail content in the left section allows you to test the effects of sharpening on fine-detailed image areas, and the crisscross lines have been added to highlight the effects of the Radius slider adjustments. Remember, sharpening adjustments really need to be done at a 1:1 view or higher. You may find it helpful to view this particular image at a 2:1 or higher magnification in order to see the following adjustments more clearly.

Figure 8.7 The sample image that's used in this chapter can be accessed via the Lightroom book Web site.

Evaluate at a 1:1 view

If you are using Process Version 2010 rendering, it is now possible to preview the Detail panel sharpening and noise reduction effects at a Fit to Screen view. This is useful inasmuch as a downsampled, sharpened image will look nicer, but the only way to properly evaluate the outcome of a capture sharpening is to use a 1:1 view. When you go to the Detail panel, a warning triangle (circled red in **Figure 8.8**) appears if the selected photo is displayed at anything less than a 1:1 view. If you click on the warning triangle goes away. You can also click the Disclosure triangle that's circled blue in Figure 8.8 to reveal the Preview Target tool and Detail preview window (**Figure 8.9**). If you click to activate the Preview Target tool, you can click an area of interest in the image to see a close-up view displayed in the preview window. This, in turn, can be set to show a 1:1 or 2:1 view (as shown in Figure 8.1). You can use the Preview Target tool to quickly pinpoint other new areas of interest to display in the preview; plus, you can click and drag inside the preview window itself to scroll the Detail preview image.

Luminance targeted sharpening

The first things to say about Lightroom sharpening are that the sharpening is applied only to the luminance information in the photograph, and Lightroom always filters out the color content when sharpening. This is a good thing because sharpening the color information would enhance any color artifacts. In the early days of Photoshop, people sometimes converted an RGB image to Lab mode and sharpened the Luminosity channel separately. This technique allowed the user to sharpen the luminance information without sharpening the color content. Ever since version 3.0 of Photoshop, it has been easier (and less destructive) to sharpen in RGB mode and use the Luminosity blend mode to restrict the sharpening to the luminance information. Lightroom does a similar thing here: It filters out the color content when sharpening. For this reason, it can be useful to inspect the image in luminance mode when working with the slider. You can do this by holding down the Alt key as you drag the Amount slider in the Detail panel. Note that holding down the Alt key isolates the effects that all the other slider controls are having. But it should be noted that with Process Version 2003 images, the grayscale previews can't be accessed unless you are using a 1:1 view or higher.

The sharpening effect sliders

Let's start by looking at the two main sharpening effect controls: Amount and Radius. These sliders control how much sharpening is applied and how the sharpening is distributed. Don't forget, you can download the image shown in Figure 8.7 from the book's Web site, import it into Lightroom, and copy the steps described here.

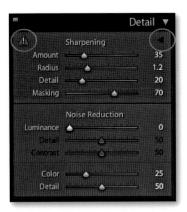

Figure 8.8 A warning triangle in the Detail panel (circled red) indicates that the image is currently being viewed at a lower than 1:1 view. If you click the disclosure triangle (circled blue) this expands the Detail panel to reveal the close-up preview and Preview Target tool, shown in Figure 8.9 below.

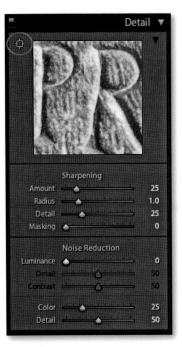

Figure 8.9 You can use the Preview Target tool (circled) to pinpoint the area you wish to preview .

Amount slider

The previews shown here and on the following pages were all captured with the Alt key held down as I dragged the Sharpening sliders.

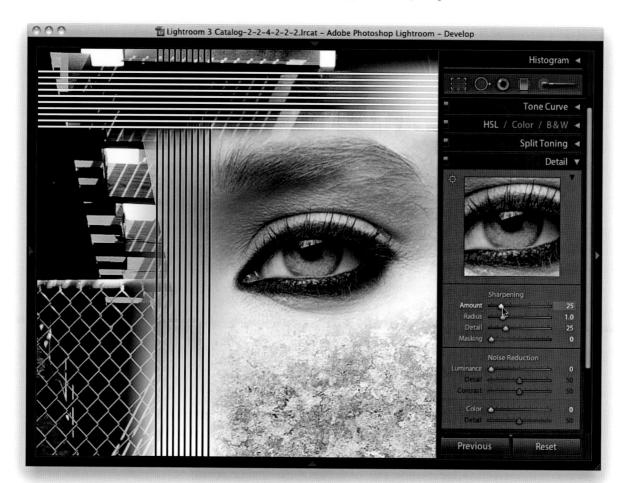

TIP

The Detail preview always shows a grayscale view when you drag with the Alt key, since the preview window displays a 1:1 or 2:1 regardless of the zoom setting for the main preview. Process Version 2003 images show a grayscale preview only at 1:1 or higher, while Process version 2010 images show a grayscale preview at all view magnifications. 1. The Amount slider is basically like a volume control. The more you apply, the more you sharpen the image. In this respect, it is similar to the Amount slider in the Unsharp Mask filter. The Amount range can go from 0 (which applies no sharpening) to a maximum sharpening setting of 150, where the slider scale goes into the red. The sharpening is somewhat excessive at 150, but there is a reason for that: You can use the sharpen suppression controls (described later) to dampen a sharpening effect. It is unlikely that you are ever going to need to set the sharpening as high as 150, but the extra headroom is available should you need it. In this example, you can see how the sample image looked using the default Amount setting of 25.

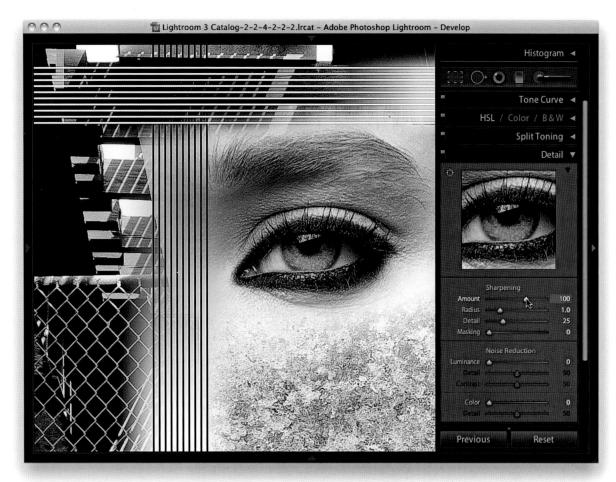

2. As you increase the Amount sharpening to 100, you can see how the detail in the image now looks a lot crisper. On its own, the Amount slider is a fairly blunt instrument to work with, but it is the ability to modify the distribution of the sharpening and ability to mask the edge halos that makes Lightroom sharpening so special. The important thing to remember here is not to overdo the sharpening. The intention is to find the right amount of sharpening to correct for the lack of sharpness that is in the original raw image and not let any sharpening artifacts become noticeable at a 1:1 view.

Radius slider

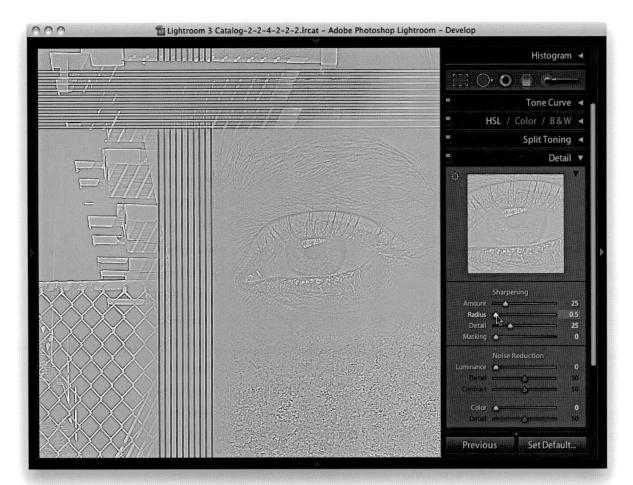

1. For this step and the next, I again held down the Alt key to isolate the effect that the Radius setting would have on the image. At the minimum Radius setting, you can see how a small Radius has a greater effect on the narrow edge detail, such as the wire fence, and has very little effect on the soft edge detail, such as the eye and eyelashes in this demo image. Notice also the effect that a small Radius setting has on the crisscross lines. This demonstrates that for high-frequency detailed subjects, such as architecture photographs or landscapes, you will often benefit from choosing a Radius setting that is smaller than 1.0. With Lightroom 3, the Radius edge values in the 0.5 to 1.0 range have now been recalculated to produce finer halo edges than was previously the case. This has resulted in narrower, razor-sharp edges when sharpening fine-detailed images with a low Radius setting. If you toggle between using Process Version 2003 and Process Version 2010, you should see quite a difference here.

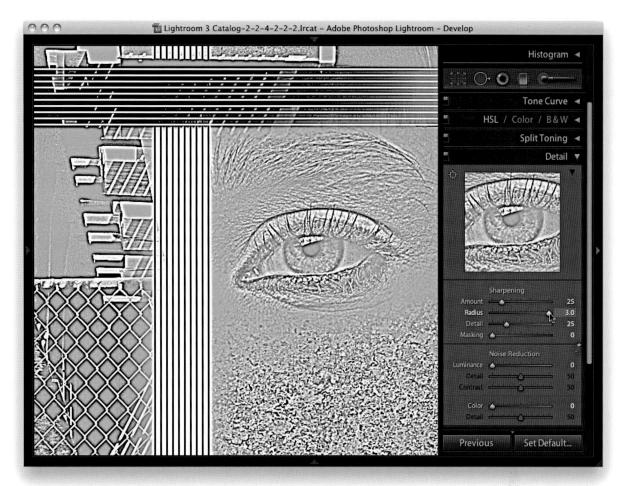

2. As you increase the Radius slider to its maximum setting, you will notice how the halo width increases to the point where the halos have less real sharpening effect on the fine edge detail. The sharpening around the wire fence area looks kind of fuzzy, but at the wider setting there is now more noticeable sharpening around the eyelashes and the eye pupil. For this reason, you will find it is usually more appropriate to select a higher than 1.0-size Radius when sharpening photographs that contain a lot of soft-edged detail, such as portraits. As I mentioned earlier, the halo edge calculation in Lightroom 3 has been rebalanced such that the darker edges are a little less dark and the brighter edges are brighter. They are there, and you notice them in the way they create the illusion of sharpness, but you are less likely to actually "see" them as visible halos in the image.

The suppression controls

The next two sharpening sliders act as dampening controls that modify the effect that the Amount and Radius sharpening settings have on an image.

Detail slider

The Detail slider cleverly suppresses the halos effect and thereby allows you to concentrate the sharpening on the edge areas. This, in turn, allows you to apply more sharpening with the Amount slider, adding sharpness to the edges, but without generating noticeable halos around them. A setting of 0 applies the most halo suppression, and a setting of 100 applies no halo suppression at all.

1. In this step, the Detail slider was set to 0. (I again held down the Alt key to preview in isolation the effect this slider adjustment was having.) When the Detail slider is at this lowest setting, nearly all the edge halos are suppressed. The combination of a low Detail setting and a medium to high Radius setting allows you to apply a strong sharpening effect to bring out details like the eye and eyelashes while suppressing the halos on the smooth skin tones.

2. When the Detail slider is raised to the maximum setting, all of the sharpening effect is allowed to filter through, unconstrained by the effect the Detail slider would otherwise have on the sharpening effect. When Detail is set to 100, you could say that the Amount and Radius sharpening settings are allowed to process the image to produce a sharpening effect that is similar to using the Unsharp Mask filter in Photoshop on its own without further filtering or masking. One of the minor changes in the new Lightroom 3 sharpening means that higher Detail slider settings now do more to exaggerate the highest possible edge detail in the image. This can result in the Lightroom sharpening now emphasizing more those areas with fine-textured detail (and noise). As a result of this, you may want to avoid setting the Detail too high if this is likely to cause problems, or you can increase the amount of Masking that's applied.

NOTE

If you compare the grayscale previews for Process Version 2003 and Process Version 2010 you should see quite a difference here, but you also need to take into account that the grayscale previews are showing each slider adjustment in isolation (except for the Amount slider). For example, what you don't see when you adjust the Detail slider is the combined effect this has with a Masking adjustment in force.

3. When the Detail slider is set to a midpoint value between these two extremes, we see how the Detail slider can be used to target the areas that need sharpening most. If you refer back to the sharpen preset used at the beginning, a lower setting of 20 is suitable for portrait sharpening because it does a good job of suppressing the sharpening over the smooth tone areas. A higher Detail setting will carry out less halo edge suppression and is, therefore, more suitable for emphasizing fine edge detail.

Interpreting the grayscale sharpening preview

This would be a good point for me to explain what the grayscale previews are actually showing us here. As I have already stated, if you hold down the Att key as you drag the Amount slider, you see an accurate preview of the cumulative effect that all the sharpening sliders are having on the Luminosity information in an image. But when you Att drag the Radius and Detail sliders, you are seeing a different kind of preview; with these, you are able to preview the sharpening effect in isolation.

What does this mean? The more experienced Photoshop users will understand better if I explain that this is a little (but not exactly) like the Photoshop sharpening technique where you apply the High Pass filter to a duplicate of the Background layer to pick out the edge detail and set the duplicate blend layer to Overlay mode. The High Pass filter turns most of the image a mid-gray, but when you set the layer to the Overlay blend mode, the mid-gray areas have no effect on the appearance of the photograph, while the lighter and darker areas in the Overlay blend mode layer build up the edge sharpness. The Radius and Detail [Att] mode previews are essentially showing you the edge enhancement effect as if it were on a separate sharpening layer (which, as I say, is like previewing a duplicate layer of the Background layer after you have just applied the High Pass filter). Basically, what these previews are showing you is an isolated view of the combined Amount, Radius, and Detail slider settings.

Masking slider

The Masking slider adjustment adds a final level of suppression control and was inspired by the late Bruce Fraser's Photoshop sharpening techniques. If you want to read more about Bruce's techniques for input and output sharpening plus his creative sharpening techniques, I highly recommend you check out *Real World Image Sharpening with Adobe Photoshop, Camera Raw, and Lightroom,* Second Edition, from Peachpit Press. This book was originally written by Bruce Fraser but has recently been updated by Jeff Schewe (see sidebar).

The basic concept behind the masking control is that you can use the Masking slider to create a mask that is based on the image content and that protects the areas you don't want to have sharpened. If you take the Masking slider down to 0, no mask is generated and the sharpening effect is applied without any masking. As you increase the Masking setting, more areas are protected. The mask is generated based on the image content; areas of the picture where there are high-contrast edges remain white (the sharpening effect is unmasked) and the flatter areas of the picture where there is smoother tone detail turn black (the sharpening effect is masked). The image processing required to process the mask is quite intensive, so if you are using an older computer, it may seem slow as the preview takes its time to update. On a modern, fast computer, however, you should hardly notice any time delay.

NOTE

The latest update to Bruce Fraser's book is titled *Real World Image Sharpening with Adobe Photoshop, Camera Raw, and Lightroom,* Second Edition, by Bruce Fraser and Jeff Schewe.

Masking slider preview mode

The Alt mode previews for the Masking slider shows a mask that limits the sharpening adjustment. The best way to interpret this preview is to imagine the preview of the sharpening adjustments as being like a sharpening layer above the image, and then think of the masking preview as a layer mask that has been applied to that imaginary sharpening layer.

1. In this example, I set the Masking slider to 55 and held down the <u>Alt</u> key to reveal the mask preview. At this midway setting, you will notice how the flatter areas of the picture are just beginning to get some mask protection, such as the skin tone areas around the eye. Let me mention again here that if you are using Process Version 2010, the <u>Alt</u> preview can be seen at all view settings. If you are using Process Version 2003, the <u>Alt</u> previews can only be seen if the image is viewed at 1:1 or higher.

2. As the Masking setting is increased to the maximum setting of 100, you can see how more of the flatter tone areas are now protected while the high-contrast edges are preserved. At this extreme setting, the Lightroom sharpening is applied only to the white mask areas. The black portions of the mask are completely protected and no sharpening is applied here. Generally, you set the Masking slider high for images that contain fine-detailed areas that you don't want to enhance (such as skin), and you set it low for images where you do wish to enhance the fine-textured areas. However, if you take into account the enhanced sharpening that can be obtained using the Detail slider, it would seem that most subjects can benefit from having a small amount of masking applied.

How to apply sharpening adjustments

Now that I have given you a rundown on what the individual sharpening sliders do, let's look at how you would use them in practice to sharpen an image.

1. For this first step, I adjusted the Sharpening sliders to provide the optimum amount of sharpening for the fine detail areas. I applied a Radius of 0.7, which added fine halos around the edge details (such as the wire fence) and a Detail of 70, which acted to limit the halo suppression. I applied an Amount of 33 to make the fine edge detail nice and crisp and set the Masking slider to 10, which meant that only a small amount of masking was used to mask the sharpening effect. I also adjusted the Luminance slider because most images, even those that have been shot using a low ISO setting, may benefit from some luminance noise reduction (see pages 454–457).

2. In this second example, I adjusted the Sharpening sliders to provide the optimum amount of sharpening for the soft-edged detail around the eye. I applied a Radius of 1.4 to build wider halo edges around the eyelashes, but at the same time, I used a Detail setting of 20 to suppress the edge halos. The Radius setting still has an effect on the sharpening, but the Detail slider is nicely suppressing the halo edge effect to produce a smoother-looking sharpening effect. I took the Masking slider all the way up to 85, so that I could target the sharpening on just those areas that needed sharpening most (that is, the details in the eye and eyelashes). You will note that the Amount was set to 45; this is a higher value than the default setting of 25, but this is because the sharpening was being substantially suppressed by the Detail and Masking sliders, so it was necessary to apply a larger Amount setting.

Creative sharpening with the adjustment tools

The golden rule when sharpening in Lightroom is to sharpen the images just enough so that they look sharp on the display, but not so sharp that you begin to see any sharpening halos. With some images, it can be tricky to find the settings that will work best across the whole of the picture, so this is where it can be useful to take advantage of the improved localized sharpening in Lightroom 3. Basically, whenever you adjust the Sharpness slider in the localized adjustment tools to add more sharpness, you are essentially able to add an increased Amount sharpness based on the other settings that have already been established in the Detail panel Sharpening section. All you have to do is follow the steps shown here: Select the Adjustment brush or Gradient Filter and increase the Sharpness amount. Basically, whatever setting you choose here can be used to add to the Amount of sharpening that's already applied to the image.

1. In this photograph, I do wish I had been paying more attention to the camera focusing, which had been left on auto and ended up focusing mainly on the foreground detail rather than selecting the appropriate hyperfocal distance between the foreground and the lighthouse. Still, this mistake did at least allow me to demo selective sharpening in Lightroom. To start with, I adjusted the sharpening sliders to obtain the optimum sharpness for the rocks in the foreground, but as you can see, the lighthouse still remained a little soft.

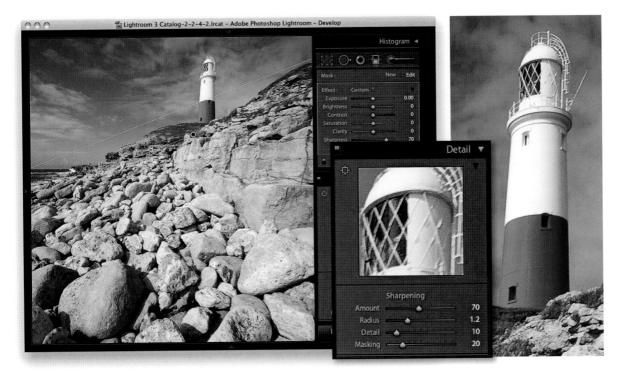

2. In this next step, I selected the Gradient Filter, set the Sharpness to +70 and added the gradient shown above. The objective here was to use the gradient to add more sharpness to the lighthouse in the distance. The setting amount for the Sharpness slider effectively added an extra Sharpness amount using the same Radius, Detail, and Masking settings as had already been applied in the Detail panel. I didn't need to use the Gradient Filter of course; I could just as easily have selected the Adjustment brush and used that to paint in the areas I wanted to see sharper in the picture.

Negative Sharpness

You can apply negative local sharpening in the 0 to -50 range to fade out existing sharpening. Therefore, if you apply -50 sharpness as a localized adjustment, this allows you to disable any capture sharpening. As you apply a negative Sharpness in the -50 to -100 range, you start to apply anti-sharpening, which is effectively a gentle lens blur effect. But you can, in fact, go beyond the +100/-100 limit set by the Sharpness slider by applying multiple passes of sharpness adjustments. In other words, you can keep creating new adjustment groups, each with a -100 Sharpness value. However, with multiple negative sharpness adjustments, the effect will eventually max out and won't become any more blurred beyond a certain point. In Lightroom, there isn't yet what you might call a true lens blur effect, but multiple-pass negative sharpness adjustments can still be effective.

NOTE

Remember that the new, improved noise reduction discussed here only applies to images processed in Lightroom 3 using the latest Process Version 2010 rendering. You can still apply sharpening and noise reduction adjustments to Process Version 2003 images, but you'll need to update these to Process Version 2010 in order to take advantage of the new sharpening and noise reduction processing.

TIP

If you are using Process Version 2003, you can only evaluate the noise reduction by inspecting the image at a 1:1 view or higher. If you are using Process Version 2010, the sharpening and noise reduction can be seen at lower viewing resolutions, but I would still recommend you use a 1:1 view in order to properly evaluate the sharpening and noise reduction.

Noise reduction

As I explained at the beginning of this chapter, the new Process Version 2010 demosaic processing does its best to filter out what can be described as pattern and color noise and carefully leaves just the random residual noise in the image. All digital captures contain an underlying amount of noise that's generated by the sensor, but it is only as the ISO is increased that the noise is amplified and, therefore, becomes more apparent to the eye. If you shoot with a good-quality digital camera at the standard ISO settings, you should be hard-pressed to see this noise. Not all cameras are the same, though, and some camera sensors are particularly prone to showing noise, especially at the higher ISO capture settings.

The new demosaic processing certainly does a better job of filtering out the good noise from the bad, but the thing to understand here is that it's not ideal that every trace of noise gets removed from the image. You might think this would be a good thing to achieve, but, in fact, you will end up with a photograph that, when you inspect the image detail in close-up, looks rather plastic and oversmooth in appearance. What the Camera Raw/Lightroom engineers determined was this: It is better to concentrate on eradicating the noise we generally find obtrusive, such as color and luminance pattern sensor noise (which is always a problem), but leave in the residual luminance noise that is free of ugly artifacts, yet retains the ultra fine grain-like structure that photographers might be tempted to describe as being "film-like." Having said that, extra help is sometimes required to further suppress the unwanted image noise, which can be characterized in two ways: as luminance and as color noise. This is where the Noise Reduction sliders in the Detail panel come in.

Luminance noise reduction

The Luminance slider in the Detail panel can help smooth out luminance noise, which is the speckled noise that is always present to some degree but is more noticeable in high-ISO captures. The default Luminance setting is 0 percent. You could try raising this to around 5 percent to 20 percent, but it shouldn't be necessary to go beyond 50 percent except in extreme circumstances. Jeff Schewe likes to describe the Luminance slider as "the fifth sharpening slider" because the sharpening process goes hand in hand with luminance noise reduction. Since noise reduction inevitably smooths the image, it is all about finding the right balance between how much you set the Luminance slider to suppress the inherent noise and how much you sharpen to emphasize the edges (without enhancing the noise). Improvements made since version 1.1 mean that Lightroom now does a much better job of reducing any white speckles in the shadows, and the luminance noise reduction has been further improved in Lightroom 3 to provide the smoothest luminance noise reduction possible.

The new luminance Detail slider acts like a threshold control for the main Luminance slider. The default setting is 50. When this slider dragged to the left, you will see increased noise smoothing. However, as you do so, important image detail may get treated as noise and also become smoothed. Dragging the slider to the right reduces the amount of smoothing and preserves more details.

Color noise reduction

Color noise is usually the most noticeable aspect of image noise, and the Color slider's default setting of 25 does a fairly good job of suppressing the color noise artifacts while preserving the color edge detail. If necessary, you can now take the slider all the way up to 100 percent. This would have once spelled problems for some types of images, but Lightroom 3 is better able to filter the color noise reduction so that you don't see the kinds of problems that are normally associated with applying too much color noise reduction. However, as you increase the Color noise slider this can result in color bleeding, or the fine color details in an image becoming desaturated. This kind of problem is one that you are likely to see only with really noisy images that contain fine color edge details, so most of the time it's not something you are likely to be concerned with, but where this is seen to be a problem the Detail slider can help. As you increase the color Detail slider beyond the default setting of 50, you'll notice how it preserves more detail and prevents the color edges from bleeding or becoming desaturated. Just be aware that as you increase the color Detail setting, this can lead to color speckles appearing along the preserved edges. To understand the effect this slider is having, you may want to zoom in to see a 400 percent view.

Noise reduction tips

I suggest you get to know your camera and how the sensor responds to different lighting conditions. Some cameras fare better than others in low-light conditions, and there will always be a trade-off between shooting at a medium ISO setting with a slower shutter speed and shooting at a high ISO setting with a faster shutter speed. Also, consider using a tripod or image stabilizing lenses as an alternative to shooting at the highest ISO setting. Where noise is a problem, I recommend using the Luminance sliders first to remove the fine luminance noise artifacts, followed by the Color sliders to remove the color noise. Note that setting the Luminance slider too high can make the image appear over-smooth, which can compromise the sharpness. Also, rather than tweak the Noise Reduction sliders on every individual image, you may find it worth following the advice on pages 402-403 in Chapter 6 about saving camera-specific defaults that include ISO-specific defaults. This can help automate the process of applying the appropriate amount of noise reduction for each image and avoid the need for multiple presets. Above all, don't be too paranoid about noise. There is no point in trying to remove every bit of noise, because the print process can be very forgiving.

NOTE

With the luminance Contrast slider, the default setting is 50. The smoothest results are achieved by dragging the slider all the way to the left. However, doing so can sometimes make the noise reduction look unnatural and plasticky. Dragging the slider to the right, therefore, preserves more of the texture contrast in the image, but at the same time, this can lead to increased mottling in some high-ISO images. It is worth pointing out here that the Contrast slider has the greatest effect when the luminance Detail slider is set to a low value. As you increase the luminance Detail, the Contrast slider has less impact on the overall Luminance noise reduction.

Color noise corrections

1. Here is a slightly underexposed photograph that was shot in a dimly lit hotel interior using a 1600 ISO setting. This image was a good candidate for demonstrating Lightroom 3 Process Version 2010 color noise corrections.

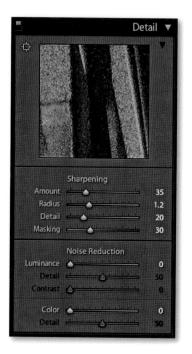

2. Here is a 4:1 close-up view of the above photograph (the area inside the red rectangle) before color noise reduction had been applied to the image.

3. In this step, I raised the Color noise reduction slider to 50 percent. This was enough to remove the color speckles, but it also had the undesired effect of causing the colors in the image to bleed.

4. To counteract this, I raised the Color and Detail sliders to 75 percent. As you can see, the color noise was removed and the edge detail was restored. I also applied the Luminance slider adjustments shown here to eradicate most of the luminance noise.

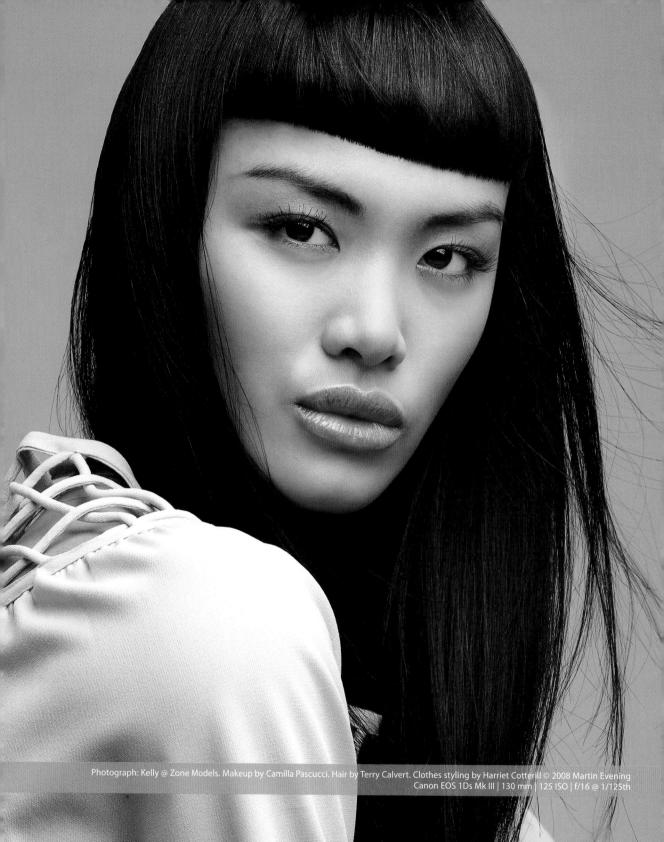

9

The Photoshop connection

How to get Lightroom and Photoshop to work together in harmony

The best way to understand the Lightroom/Photoshop relationship is to think of Lightroom as a program for managing and processing lots of images in the catalog and to think of Photoshop as the program where you are more likely to spend your time working on individual photographs one at a time.

Although there is a fair amount of overlap between Photoshop, Camera Raw, and Lightroom, it is clear that Photoshop will continue to remain the program of choice for serious retouching and layered image editing. The question then is, what is the most efficient way to work between these two programs? In this chapter, I will show you some of the various ways you can take photographs from Lightroom and edit them in Photoshop, as well as how to use the Export module to process single images or batches of photographs. I will also show you how to use the post-processing section of the Export module to integrate complex Photoshop routines as part of the export process.

Opening images in Photoshop

I have so far covered the image processing that can be done directly in Lightroom using the Develop module controls. Remember, all Lightroom edits are nondestructive, and the master photos are managed by the Lightroom catalog. These master images are always preserved in their original state, and there can be only one master version of each catalog image. If you want to edit a pixel image catalog photo outside Lightroom in an image editing program such as Photoshop, you can choose to edit the original or edit a new copy version. If you want to edit a raw image from the catalog, then Lightroom must generate a new pixel image copy.

The Edit in Photoshop options

Before you do anything else, you'll first need to go to the Lightroom Preferences and configure the External Editing preferences (**Figure 9.1**). Here, there are basically two ways to externally edit a Lightroom catalog image.

	General Presets	Extern	al Editing File Handling Interface
Edit in Adobe Photos	hop CSS		
File Format:	TIFF	•	16-bit ProPhoto RGB is the recommended choice for best preserving color details from Lightroom.
Color Space:	ProPhoto RGB	•	
Bit Depth:	16 bits/component	•	
Resolution:	300		
Compression:	None	•	
Additional External E	ditor		
Preset:	Save in CS4 as PSD		
Application:	Adobe Photoshop CS4.app	р	Choose Clear
File Format:	PSD	•	16-bit ProPhoto RGB is the recommended choice for best preserving color details from Lightroom. PSD can be less efficient than TIFF with
Color Space:	ProPhoto RGB	•	respect to metadata updates. When saving from Photoshop, please be sure to use the "Maximize Compatibility" option in Photoshop.
Bit Depth:	16 bits/component	•	Failure to do so will result in images that cannot be read by Lightroom.
Resolution:	300		
Edit Externally File Na	aming: IMG_0002-Edit.psd		
Template:	Custom Settings		•
Custom Text:			Start Number:

Figure 9.1 To change the external editing application, select Lightroom \Rightarrow Preferences, select External Editing, and go to the Additional External Editor section. Here, you can choose the File Format, Color Space, and Bit Depth options you want to use when creating an edit version of a master image in either Photoshop or an additional external editor program.

Edit in Adobe Photoshop

The main Edit in Adobe Photoshop command is in the Photo ⇒ Edit In menu (ﷺ) [Mac] or Ctrl E [PC]). If you use this method to open a raw image, it directly renders a pixel version of the master catalog image without showing an interim Edit Photo options dialog and without adding a copy version to the catalog. Lightroom opens it in whatever is the most recent version of Photoshop you have on your computer, and the opened image will display the same raw file extension as the master (e.g., NEF, CR2, or DNG). It is only when you choose File ⇒ Save in Photoshop that the file format and other settings configured in the External Editing preferences (Figure 9.1) come into play and the edited image is saved and added to the catalog. Basically, the Edit in Photoshop command provides you with a means to open Lightroom catalog images in Photoshop without generating new edit copy versions of the master each time you do so. You can open a raw file in Photoshop to see what it looks like and decide whether to save it. If you do save it, the default behavior is to automatically save the edit copy version to the same folder as the source image, using the save settings configured in the External Editing preferences and add it to the Lightroom catalog. If you prefer, you can use File \Rightarrow Save As to save the image to an alternative folder location without adding it to the catalog and, should you wish, save using a different file format.

If you open a non-raw image such as a TIFF, PSD, or JPEG in Lightroom using the **#E** (Mac) or **Ctrl E** (PC) command, you'll see the dialog shown in **Figure 9.2**, where the default option is Edit Original. This option is useful for editing layered masters or derivative versions of a master where you want to carry on editing the source photo and don't want to generate a new copy version. You can choose Edit a Copy if you want to create an edit copy of the file in its original state (ignoring any Lightroom adjustments that might have been applied). Plus, you can choose Edit a Copy with Lightroom Adjustments if you want to open a copy of a JPEG, TIFF, or PSD image with the Lightroom adjustments applied to it. So, if you had used the Lightroom Develop adjustments, this would be the option to choose.

Edit in additional external editing program

The other alternative is to open your images using the additional external editing program option, which can also be accessed via the Photo \Rightarrow Edit In menu ((\Re (Att(E) [Mac] or (Ctr)(Att(E) [PC])). This allows you to configure a specific program in which to open the images; this can be any pixel editing application, such as Adobe Photoshop Elements or Corel PaintShop Pro. Or, you could choose to open in the same version of Photoshop, but with different default file format options (see Figure 9.1). Whichever program you select here, it then becomes available as a menu option when you go to the Photo \Rightarrow Edit in Photoshop menu, just below the main Edit in Photoshop command (**Figure 9.5**).

What to Edit	
O Edit a Copy with Ligh	troom Adjustments
Apply the Lightroom adjustm	nents to a copy of the file and edit that one
🔿 Edit a Copy	
Edit a copy of the original file	
Lightroom adjustments will i	not be visible.
Edit Original	
Edit the original file.	
Lightroom adjustments will i	not be visible.

Figure 9.2 If you open a non-raw image using the main Edit in Photoshop command (IBE) [Mac] or Ctrl E (PC]), the Edit Original option will be selected, which opens the original pixel image without adding a copy to the catalog.

NOTE

The Edit a Copy with Lightroom Adjustments option allows you to open a pixel image from the catalog and apply any associated Lightroom adjustments, but when you're making a copy this will flatten any layers in the original pixel image. If the image you wish to open contains layers and you wish to preserve these layers, choose either Edit Original or Edit a Copy.

NOTE

One of the reasons why I prefer managing photos in Lightroom over Bridge is because the Lightroom policies are much clearer and the user always remains in full control over how such photos are opened from Lightroom. For example, if the Photoshop/Bridge Camera Raw preferences are configured with the TIFF or JPEG handling set to "Automatically open all supported TIFFs and JPEGs," then such images will open via Camera Raw rather than directly into Photoshop, which is potentially confusing.

Edit a Copy	with Lightroom Adjustments
	com adjustments to a copy of the file and edit that If Comoin loyers or ulpha channels
🔿 Edit a Copy	
Edit a Copy is n	nt applicable to now or Digital Negative files.
🔿 Edit Origina	1
	nat applicable to row or Digital Negative files.
Copy File Opti	ons
Copy File Opti File Format:	TIFF
File Format:	
File Format: Color Space:	TIFF
File Format: Color Space:	TIFF \$ ProPhoto RGB \$ 8 bits/component \$
File Format: Color Space: Bit Depth: Resolution:	TIFF 5 ProPhoto RCB 5 8 bits/component 5 300
File Format: Color Space: Bit Depth:	TIFF \$ ProPhoto RGB \$ 8 bits/component \$

Figure 9.3 If you open a raw image using the additional external editor option (*****[Alt E] [Mac] or Ctrl Alt E [PC]), the only available option is to edit a pixel-rendered copy using Lightroom adjustment.

What to Edit	
C Edit a Copy with Lig Apply the Lightnoom adjust The copy with not contain to	iments to a copy of the file and edit that one.
Edit a Copy Edit a copy of the original h Lightroom adjustments will	
Edit Original	
Edit the original file Lightroom adjostments wil	Inot be visible.
▶ Copy File Options	
Stack with original	Cancel Edit

The main difference here is that when you open a raw image using the "Edit in external editor" option it uses the Lightroom raw processing engine to render a pixel image copy of the catalog image, which is added to the catalog before opening it up in the selected program. So, when you use **(MAT)** (Mac) or **(Ctr) (Att) (**PC) to open a raw image, instead of seeing the photo opening directly, you will see the dialog shown in **Figure 9.3**. On the face of it, the only available option here is Edit a Copy with Lightroom Adjustments. But if you click the disclosure triangle at the bottom of the dialog, you can expand the Copy File Options and use these to override the file format, RGB space, and bit depth options set in the External Editing preferences. However, if you have selected a program other than Photoshop or Photoshop Elements as the external editor, the PSD file format option may not be available. You will also notice the "Stack with original" option, available at the bottom. This allows you to decide whether you want to automatically stack the newly created edit copy versions with the master image, which is something you can't do using the main Edit in Photoshop command.

When you open a pixel image such as a TIFF, PSD, or JPEG, the default option is Edit Original (**Figure 9.4**). This is almost exactly the same as choosing Edit Original in the dialog shown in Figure 9.2. The only difference is that the External Editing options allow you to open your catalog photos using a program other than the latest version of Photoshop on your computer. Likewise, if you choose one of the Edit a Copy options, these, too, will allow you to edit a copy version in the designated external editing program.

File settings options

The file settings options allow you to establish the default file format, RGB space, and bit depth to use when opening an image. There are two edit copy file format options: TIFF or PSD. The TIFF file format is the most versatile of the two, since the TIFF format always stores a flattened composite image and is able to save all Photoshop features such as layers, paths, and layer effects. The PSD file format is sometimes better because the time it takes to save and open a file means it is more efficient. But if you want Lightroom to recognize layered PSD files, you must make sure the Maximize PSD compatibility option is switched on first in the Photoshop File Handling preferences. The Color Space options are limited to ProPhoto RGB, Adobe RGB, and sRGB. The Bit Depth can be set to "16 bits/ component," which preserves the most tonal information (as much as Lightroom is able to). The "8 bits/component" option reduces the number of levels to 256 per color channel and allows you to create smaller edit files that are more compatible with applications other than Photoshop. (To find out more about the Color Space and Bit Depth options, please refer to page 604.) These settings are crucial for opening raw images, but with non-raw files, it is important to realize that the file settings options will be limited by the file properties of the master images. For example, if the source image is, say, an 8-bit sRGB JPEG, you aren't going to gain anything by exporting it as a 16-bit ProPhoto RGB TIFF.

hoto Metadata View	Window Help	
Add to Quick Collection	В	
Open in Loupe Show in Finder Go to Folder in Library	م RR	
Lock to Second Monitor	ΰ∺⊷	
Edit In	•	Edit in Adobe Photoshop CS5
Stacking Create Virtual Copies Set Copy as Master	► ⊮'	Save in CS4 as PSD Save in CS5 as PSD
Rotate Left (CCW) Rotate Right (CW) Flip Horizontal Flip Vertical	¥[¥]	Open as Smart Object in Photoshop Merge to Panorama in Photoshop Merge to HDR Pro in Photoshop Open as Layers in Photoshop
Set Flag Set Rating Set Color Label Auto Advance	* *	
Set Keyword Add Keywords	≱ ⊮K	
Develop Settings	•	
Delete Photos Remove Photos from Cat	N nol nole	

ΠP

You can use the Edit In options to open and edit multiple photo selections as well as single images.

Figure 9.5 Whichever program is selected as the Additional External Editor will appear listed below the main Edit in Photoshop command in the Photo \Rightarrow Edit in Photoshop menu and can be invoked using the \Re Alt E (Mac) or Ctrl Alt E (PC) keyboard shortcut. You can also select saved external editor presets.

Note that when you open a raw image using the main Edit in Photoshop command, it opens using the Color Space, Bit Depth, and Resolution settings configured in the External Editing preferences. However, the file format choice comes into play only when you choose to save the image from Photoshop. The default behavior is to save the file to the same folder as the original master, using the file settings options specified in the External Editing preferences, and add the image to the catalog. If you choose Save As from the Photoshop File menu, you can then override the default file format and save destination.

External editing filename options

Photos that have been edited externally and saved to the catalog will have *-Edit* appended to the original filename. The file naming applied here depends on how the External Editing preferences have been configured (Figure 9.1). If you do nothing and leave this set to Custom Settings, the photos will be renamed using the *-Edit* suffix. As you create more edit copies of the same image, these are appended with *-Edit-2*, *-Edit-3*, and so on. But you can choose any of the other file naming template options on offer here when deciding how the external edit copy photos should be renamed.

NOTE

When you open a Process Version 2003 image via Camera Raw 5.7 for Photoshop CS4, you would think that all Process Version 2003 settings would be fully compatible with all versions of Camera Raw 5. However, the Process Version 2003/Version 2010 distinction mainly applies to the sharpening and noise reduction adjustments (since these particular settings are the ones that are common to both Process Version 2003 and process Version 2010 image settings). It is, therefore, possible to use the brand new Grain Effect adjustment in Lightroom 3 on a Process Version 2003 image without having to update it to Process Version 2010. It is for this reason that you may see the warning dialog shown in Figure 9.6, even if the image is using Process Version 2003.

NOTE

The main thing to understand here when choosing an Edit in Photoshop command to open a raw image, is that Lightroom always wants to open that image using the Camera Raw plug-in contained in Photoshop itself. The reason for doing this is because the opened image can remain in an unsaved state until you decide to save it. This, therefore, gives you the option to close without saving. Where there may be compatibility problems because the version of Camera Raw for the version of Photoshop you are using is unable to interpret the Lightroom settings, you can always choose the "Render using Lightroom" option to override the default Lightroom behavior. The downside is, this always creates a rendered copy first; plus, you don't have the option to close without saving.

Camera Raw compatibility

When opening raw images, there is a further issue to take into account when choosing between the main Edit in Photoshop and Edit in external editor commands. The main Edit in Photoshop command opens raw images directly using Photoshop's own Camera Raw plug-in to read the Lightroom settings and carry out the raw conversion. What happens next will, therefore, depend on which Develop adjustments have been used to edit the photo and whether these are specific to Lightroom 3, as well as which version of Photoshop and Camera Raw you are using. With Photoshop CS5, all images will open as normal. If you use Photoshop CS4 with its most recent Camera Raw 5.7 update, most Lightroom 3 Develop settings will be read, although the 5.7 update won't add full Lightroom 3 functionality (for that, you will have to use Photoshop CS5). If you use Photoshop CS4 with an older version of Camera Raw, you will see the warning dialog shown in Figure 9.6. Here you can choose Open Anyway (maybe all the applied Develop settings can be read by an earlier version of Camera Raw). Or, you can choose "Render using Lightroom," where Lightroom will render an edit copy of the original and automatically add this to the Lightroom catalog. Essentially, you gain the ability to open a Lightroom 3 image in Photoshop CS4 with older versions of Camera Raw, but you lose the option to open the raw image in Photoshop and choose whether to save. Raw images may also open fine via Photoshop CS3. providing you have installed the most recent CS3 Camera Raw update and haven't applied additional develop adjustments that CS3 is unaware of, such as a negative Clarity, localized adjustments, or a Grain effect. Where a raw image does have "unknown" settings, you will see the warning dialog shown in Figure 9.7.

Lr	This version of Lightroom may require the Photoshop Camera Raw plug-in version 6.0 for full compatibility.
	Please update the Camera Raw plug-in using the update tool available in the Photoshop help menu.
	Don't show again Cancel Render using Lightroom Open Anyway

Figure 9.6 If you don't have the latest version of Camera Raw for Photoshop CS4, you will see this dialog when choosing the main Edit in Photoshop command from a raw image.

r	This version of Lightroom may require the Photoshop Camera Raw plug-in version for full compatibility.	on 6.(
	Camera Raw version 4.6 is the latest version available for Photoshop CS3. If raw file support fit camera was introduced after Camera Raw 4.6, the Photoshop integration features in Lightroom require Photoshop CS4 and the latest Camera Raw version S plug-in.	sr you
	The version of the Camera Raw plug-in currently installed is 4.6.	
	Don't show again Render using Lightroom Open Anyway Can	

Figure 9.7 If you are using Photoshop CS3, you will see this dialog when choosing the main Edit in Photoshop command from a raw image.

Creating additional external editor presets

Since you can use the additional external editor to configure different save options for different external image editing programs, it is handy to know that you can save external editor settings as saved presets. If you go to the Additional External Editor section of the External Editing preferences (**Figure 9.8**), you can configure different file save options for different external editor programs and use the Presets menu to save these as external editor presets. For example, you might find it useful to save export settings for both TIFF and PSD formats and for different pixel editing programs. Once you have done this, you will notice how the external editor preset settings will appear listed below the other Photo ⇒ Edit In menu items (**Figure 9.9**).

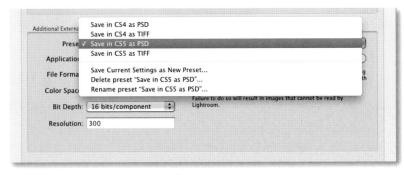

Figure 9.8 The Additional External Editor presets menu

Add to Quick Collection	В		
Add to Quick Collection	D		
Open in Loupe	د.		
Show in Finder	ЖR		
Go to Folder in Library			
Lock to Second Monitor	☆₩↩		
Edit In	•	Edit in Adobe Photoshop CS5 Edit in Adobe Photoshop CS5.app	B¥ B¥∵
Stacking	•	Euri III Auobe Photoshop C55.app	0.001
Create Virtual Copies	H '	Save in CS4 as PSD	
Set Copy as Master		Save in CS4 as TIFF	
Detete Lafe (CCM)	9.0 [Save in CS5 as PSD	
Rotate Left (CCW)	¥[Save in CS5 as TIFF	
Rotate Right (CW)	¥]	Open as Smart Object in Photoshan	
Flip Horizontal		Open as Smart Object in Photoshop	
Flip Vertical		Merge to Panorama in Photoshop Merge to HDR Pro in Photoshop	
Set Flag	•	Open as Layers in Photoshop	
Set Rating	•	open as Layers in Photosnop	
Set Color Label	•		
Auto Advance			

Set Keyword

Figure 9.9 This shows the Photo \Rightarrow Edit In menu with the additional external editor presets shown in Figure 9.8 added to the submenu list.

How to use the external editing options

Ordin . Com	with Lightroom Adjustments
	room adjustments to a copy of the file and edit that o of contain lavers or aloha channels.
C Edit a Copy	
Edit a Copy is n	of applicable to raw or Digital Negative files.
🖸 Edit Origina	al
Edit Original is	not applicable to raw or Digital Negative files.
V. Conv Eile Ont	
▼ Copy File Opti	and the second
Copy File Opti File Format:	and the second
File Format:	TIFF
File Format: Color Space:	TIFF ProPhoto RCB
File Format: Color Space:	TIFF
File Format: Color Space:	TIFF ProPhoto RGB f bits/component
File Format: Color Space: Bit Depth: Resolution:	TIFF ProPhoto RC8 16 bits/component 300
File Format: Color Space: Bit Depth:	TIFF ProPhoto RC8 16 bits/component 300
File Format: Color Space: Bit Depth: Resolution:	TIFF ProPhoto RC8 16 bits/component 300
File Format: Color Space: Bit Depth: Resolution:	TIFF ProPhoto RCB To bits/component To bits/com

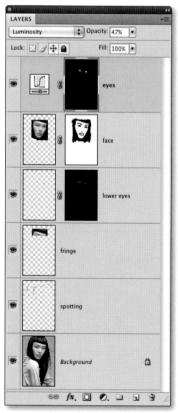

1. Here I selected a master raw image from the Filmstrip and used the Edit in External Editor command (**EAIT**) [Mac] or **CtrlAIT E** [PC]) to create an edit copy that could be edited in Photoshop. Notice that I checked the "Stack with original" option. This grouped the edited version in a stack with the original master.

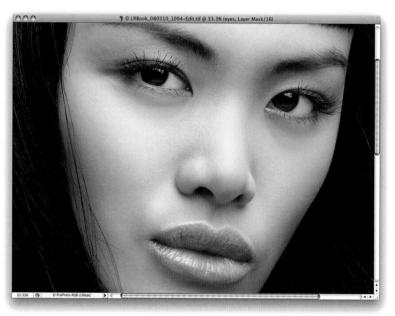

2. The edit copy of the original photograph opened directly in Photoshop, where I retouched the photo. When finished, I chose File \Rightarrow Save and closed the image.

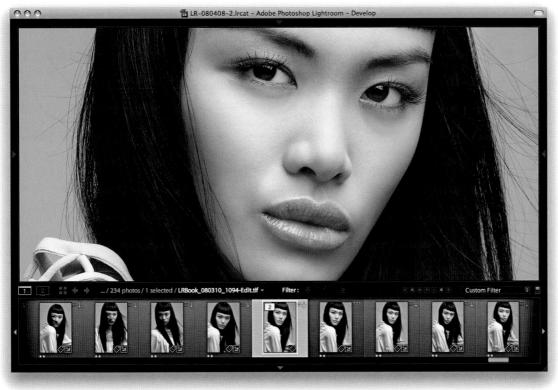

3. Back in Lightroom, you can see how the modifications made in Photoshop to the edit copy were reflected in the Filmstrip and main preview. The edit copy photo had been added to the same folder as the original and was highlighted in the Filmstrip, where you can see the selected image identified as number 2 of 2 images in the stack.

What to Edit	
O Edit a Copy with Light	room Adjustments
Apply the Lightroom adjustme	ents to a copy of the file and edit that one.
O Edit a Copy	
Edit a copy of the original file.	
Lightroom adjustments will n	ot be visible.
Edit Original	
Edit the original file.	
Lightroom adjustments will n	ot be visible.
Stack with original	(Cancel) (Edit

4. If I wanted to re-edit the image in Photoshop, I could use either **E** (Mac), **Ctrl E** (PC), or **E A t E** (Mac), **Ctrl A t E** (PC) to show the Edit Photo dialog, where I would choose Edit Original.

Photoshop as a sandwich filler for Lightroom

As you will recall, there are guite a number of ways you can use the Develop module in Lightroom to produce interesting black and white conversions or different types of color-processed looks. The question this raises is, when and where is the best time to apply such adjustments? Let's say you want to convert a photo to black and white, but you also wish to carry out a significant amount of retouching work in Photoshop. Should you convert the photo to B&W mode in Lightroom first and then choose to edit it in Photoshop? That could work, but once you have converted a photo to black and white in Lightroom and edited it in Photoshop, there is no opportunity to go back to the color original. Suppose, later on, a client decided that he didn't like the black-and-white look and wanted the color version instead? In my view, it is best to prepare your photos in Lightroom to what I consider to be an optimized image state, create an edit copy version to work on in Photoshop, and then apply the black-and-white or coloring effects to the Photoshop-edited image afterward in Lightroom. Of course, the major problem with this approach is that you don't get to see what the image looks like while you are working in Photoshop. However, the following steps suggest one way you can overcome this drawback and make this transition between Lightroom and Photoshop more fluid.

1. I started here with a raw image; alongside it is a virtual copy of this photo, which I had converted to black and white, and applied a split tone and post-crop vignette to create the alternate version you see here.

2. Now, if I wanted to edit this photo in Photoshop, I had two options here. I could select the virtual copy version and choose Photo ⇒ Edit in Photoshop, but as I just pointed out, this method would limit my options. In this example, my preferred approach was to first create an optimized color version of the raw photo and make a Photoshop edit copy based on this setting. To do this, I used the (#Alt)(E) (Mac), (Ctr)(Alt)(E) (PC) method.

White Balance	Treatment (Black & White)	Lens Corrections	Spot Removal
Basic Tone	🗹 Black & White Mix	Lens Profile Corrections	Crop Straighten Angle
Highlight Recovery	Split Toning	Lens Vignetting	Aspect Ratio
Fill Light Black Clipping	Local Adjustments	Effects	
Brightness Contrast	Graduated Filters	Post-Crop Vignetting	
Tone Curve	Noise Reduction Luminance	Process Version Calibration	
Clarity	Color		
Sharpening			

3. But how could I work on the optimized image in Photoshop *and* also see how it looked with the black-and-white effects? To address this, I selected the virtual copy, "effect" version of the image and then the newly created Edit Copy image and clicked the Sync Settings button. This opened the Synchronize Settings dialog, where I could synchronize the settings needed to apply the "effect" look.

NOTE

What to Edit

C Edit a Copy

C Edit Original

V Copy File Opti

File Format: TIF

Compression: No

Stack with original

Sedit a Copy with Lightroom Adjustments

4

Cancel Edit

When you follow this step, make sure that the virtual copy "effect setting" image is the one that is most selected. (It will have a lighter gray cell border.) This is important because you want to synchronize the effect settings from the "effect setting" image to the Photoshop-edited version.

4. Here you can see how I synchronized the Black & White, Split Toning, and Vignette adjustments from the virtual copy image on the right with the newly created Photoshop edit version on the left.

5. I continued editing the master image in Photoshop by choosing Photo ⇒ Edit in Photoshop and selected Edit Original. Each time I did this, it would open the original optimized image version and allow me to carry out the retouching work on a normal, full-color version of the photo.

6. Meanwhile, back in Lightroom, I could preview a combination of the Photoshop-edited image and the Lightroom applied adjustments. But I had to remember to keep saving the image in Photoshop in order to see the most currently updated version of the photo appear in the Lightroom window.

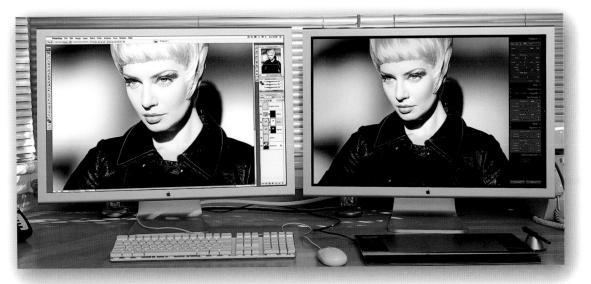

7. At this stage, I could simply toggle between the Photoshop and Lightroom windows to compare the two image previews. However, since I had the luxury of a dual-display setup, I was able to view the Photoshop image on one screen and the Lightroom window on the other.

TIP

With a dual-display setup, you may need to force the Lightroom screen view to update by clicking a photo next to it in the Filmstrip and then clicking the main photo again.

NOTE

It is hard to say whether this is a bug, but the "Merge to" and Open as Layers commands are available as menu items only when you are in the Library Grid view mode. However, if you are in the Library Loupe view or the Develop module, you can access these commands via the Filmstrip contextual menu.

NOTE

There is also a Photomatix Pro plug-in for Lightroom that allows you to export photos directly to Photomatix Pro and automatically reimport the processed images back to the catalog.

Extended editing in Photoshop

In addition to Lightroom letting you edit photos directly in Photoshop, you can also make use of Photoshop's extended editing features: Merge to Panorama, Merge to HDR, and Open as Lavers. These commands use the same settings as the Edit in Photoshop command and allow you to process images that have been selected in Lightroom, but without adding a new photo to the catalog. When you then choose File => Save in Photoshop, the default save location will be the same folder as the source images and the edit copy image is added to the catalog. The Merge to HDR method processes the selected photos and opens the Merge to HDR dialog in Photoshop, from where you can apply a Photoshop HDR to 16-bit or 8-bit conversion, edit the conversion settings, and save the processed image as a TIFF or PSD. The Open as Layers option places the selected photos as layers in a single Photoshop image. From there, you can auto align the layers and, if you have the Extended version of Photoshop, do things like convert to a Smart Object and run a Stack mode rendering process. To give you an idea of how the extended editing options can be useful, I have provided a few examples, starting with how to use the Merge to Panorama external editing option to create a panorama image via Photoshop from a selection of photos in Lightroom.

1. I started by making a selection of photographs in Lightroom that had been shot with the intention of creating a merged panoramic photograph. I went to the Photo menu in Lightroom and chose Edit In \Rightarrow Merge to Panorama in Photoshop.

	Photomerge	
Layout	Source Files	ОК
 Auto Perspective Cylindrical Spherical Collage Reposition 	Use: Files Browse W1BY4198.dng W1BY4201.dng W1BY4207.dng W1BY4207.dng W1BY4210.dng W1BY4213.dng	Cancel
	 ✓ Blend Images Together ✓ Vignette Removal ✓ Geometric Distortion Correction 	

2. This opened the Photoshop Photomerge dialog, where I selected the Auto Layout method and checked all the boxes at the bottom. I then clicked OK to proceed with the Photomerge.

3. Depending on the number of images and the size of the original files, it may take a while to process the panorama. But once completed, you should see a merged image like the one shown here with the component layers all masked.

TIP

It is usually best to select the Auto Layout Projection when creating a Photomerge, since this will automatically determine for you which is the best method to use. However, it doesn't always guess right, and for landscape Photomerges like this and the one shown on the previous page, the Cylindrical method usually works best.

TIP

To make this process simpler, I suggest recording the steps shown here as a Photoshop action. When you next use the "Open as layers in Photoshop" command, you can simply run the recorded action to replay all the recorded steps. You could also create actions that applied different levels of image resizing.

How to speed up extended editing in Lightroom

One significant disadvantage of processing panoramas or Merge to HDR shots via Lightroom is that you are always obliged to open the original images at their full size and there is no interim option that allows you to adjust the size (as you have with the Adobe Camera Raw dialog). If you are merging only a few photos as a panorama, this may not matter so much, but if you need to process a larger number of pictures, you might like to follow this tip that was suggested by Ian Lyons.

1. I selected the pictures that I wished to merge as a panorama and chose Photo ⇒ Edit In ⇒ "Open as layers in Photoshop."

		CONTRACTOR OF A	Normal	Opacity: 100%
Image :	Size		Lock 🖸 🥒	+ 🖨 🛛 Fill: 100%
Pixel Dimensions: 67.7M (was 1	20.3M)	ОК		18Y5200.dng
Width: 2808 pixels		Cancel	•	18Y5201.dng
Height: 4212 pixels	•	Auto	• M	18Y5202.dng
Document Size: Width: 75 percent	•		•	18Y5203.dng
Height: 75 percen			•	18Y5204.dng
Resolution: 300 pixels	inch 🛟		9 🖉 w	18Y5205.dng
Scale Styles			• 🖉 w	18Y5206.dng
Constrain Proportions				1BY5207.dng
Bicubic (best for smooth grad	ients)		9 💽 w	18Y5208.dng
			3-8 fx	00.033

2. This created a single image document in Photoshop with all the selected images added as layers. In Photoshop, I could then choose Image ⇒ Image Size and reduce the image to 75 percent of the original size (with Constrain Proportions checked). I then chose "Select all Layers": (#)Alt (A) (Mac) or (Ctrl (Alt (A) (PC).

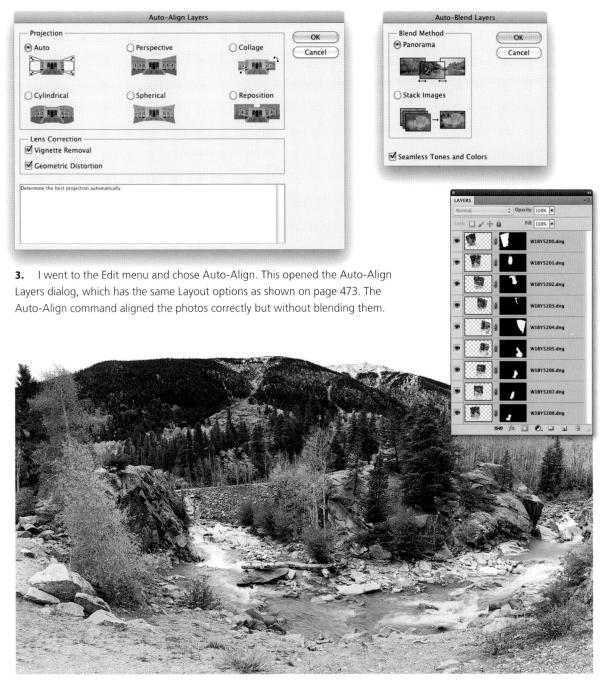

4. I then chose Auto-blend from the Edit menu, which blended the layers, adding a layer mask to each layer.

Opening photos as Smart Objects in Photoshop

1. Here you can see I had two photos selected in the Library module, where I wanted to merge these into a single composite image, yet retain the ability to edit the Lightroom Develop settings in Photoshop.

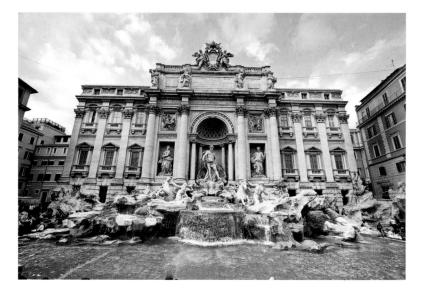

2. I began by selecting the photograph of the Trevi Fountain and chose Photo \Rightarrow Edit in Photoshop \Rightarrow Open as Smart Object in Photoshop. This created the Smart Object layer shown here, with a Smart Object icon ((Fi)) in the bottom-right corner of the layer thumbnail.

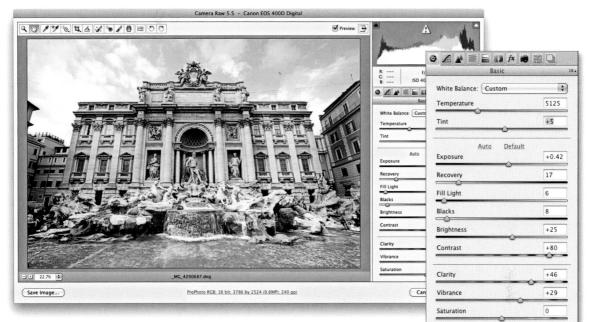

3. I double-clicked the Smart Object layer, which opened the Photo via Camera Raw dialog. This allowed me to edit the Develop settings. Here, I decided to crop and straighten the image and apply a warmer white balance.

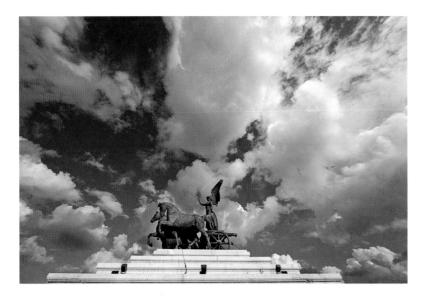

4. I then opened the second image as a Smart Object in Photoshop and dragged this over to the first document window, to add it as a new layer above the Smart Object layer of the Trevi Fountain.

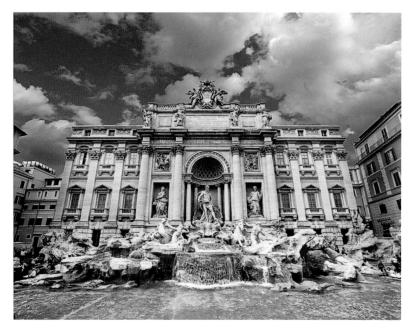

5. In Photoshop, I made a quick selection of the sky in the main photo and, from this, created a layer mask that could be applied to the new cloud sky layer.

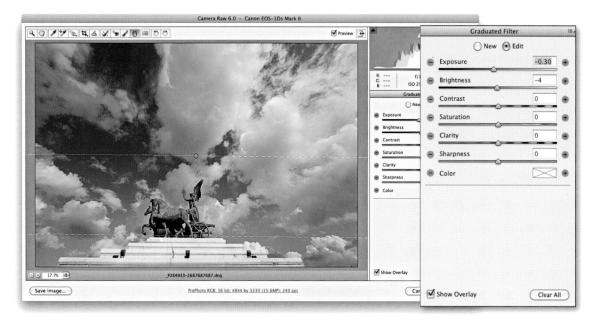

6. I was also able to open the cloud sky Smart Object layer again and revise the Develop settings via Camera Raw. Here I wanted the white balance to match better. I also wanted to introduce a gradient burn to the top of the sky.

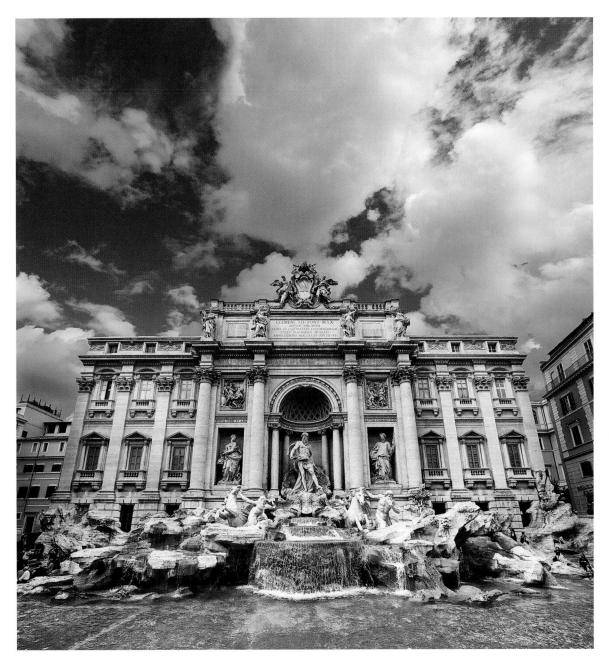

7. Here is the finished composite, where the two Smart Object layers preserved the source files in their raw states and remained fully editable via Camera Raw. All I did here was crop the image to reveal more of the clouds and edit the layer mask to improve the mask edges. With this technique, it always remains possible to open the Smart Object layers and continue editing the Camera Raw settings.

TP

You can use ﷺAlt Shift E (Mac) or Ctri Alt Shift E (PC) to bypass the Export dialog and carry out an export based on the last used settings.

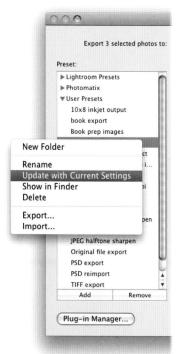

Figure 9.10 You can right-click to access the contextual menu and manage the export user presets.

NOTE

Overwrite WITHOUT WARNING is a risky option to select since the images that are likely to be affected are JPEG, TIFF, or PSD masters. Let's say you chose the For E-Mail preset. If this policy were selected, you could end up overwriting the original JPEG capture masters with low-resolution, heavily JPEG-compressed versions. Or, you might risk overwriting a layered TIFF or PSD with a flattened version of the original.

Exporting from Lightroom

The Export function lets you export single or multiple photos from Lightroom, allowing you to export copies of the master images as DNGs, flattened TIFFs, flattened PSDs, or JPEGs. But that's not all. You have full control over the exported file settings, such as where the files get saved to. You can also specify whether to incorporate a post-processing action and save export settings as custom presets, making it easy for you to create and use different export routines. To export photos, make a selection and choose File \Rightarrow Export or use \Re Shift E (Mac) or $Ctrl \Omega$ Shift E (PC) to open the Export dialog shown in Figure 9.12.

Export presets

The Export dialog has a Preset section that already contains a few preset export options to help you get started. For instance, The For E-mail setting can be used to export Internet-ready JPEG versions of the master catalog images. Other Lightroom presets include Export to DNG and Burn Full-Sized JPEGs. Plus, you can configure your own custom settings and add these to the User Presets list. The settings listed here can then be managed using the contextual menu, which also allows you to update a user preset setting (see **Figure 9.10**).

Export Location

The Export Location section allows you to export to the same source folder or to a specific folder. When the latter is selected, the folder location is remembered between exports, so you can regularly send your exports to locations such as the *My Pictures* folder. In the Figure 9.12 example, I had the For E-mail preset selected, which would automatically put the exported photos in a folder called *To E-Mail* on the Desktop. You can also check the Add to This Catalog option if you want to automatically reimport the exported photos back into the Lightroom catalog. The Existing Files menu (see also **Figure 9.11**) gives you several options. You can leave it set to "Ask what to do" when an existing file is encountered as an exported image is reimported back to the catalog, or choose from one of the following policies. If you select "Choose a new name for the exported file," this gives you the opportunity to rename the reimported image and create a new master image. You can also choose Overwrite WITHOUT WARNING; although, the use of all caps hints that this is potentially a risky policy to select. Or you can choose Skip, where Lightroom still exports the existing files, but skips reimporting them.

Figure 9.11 The Existing Files menu options.

Export To:	Hard Drive			
eset:	Settings:			
Lightroom Presets	Export Location		ni montini statema di su Tittadi	
Burn Full-Sized JPEGs	Funnet Te	Desktop		-
Export to DNG For E-Mail				
Photomatix	Folder:	/Users/martin_evening/Desktop		
User Presets		Vert in Subfolder: To E-Mail		
10x8 inkjet output		Add to This Catalog	to Stack: Below Orig	nal 🛟
book export Book prep images	Existing Files:	Ask what to do		
Burn as DNG	▼ File Naming		SHUTTERSTATE	
Convert to CMYK: Contact	Rename To:	Filename		
Export as DNG		(THENRING		and the second
Export CMYK TIFF 300ppi Export TIFFs	Custom Text:		Start Numb	er:
Export to same folder	Example:	LRBook-090729-0001.jpg	Extension	ns: Lowercase 🛟
JPEG A4 + halftone sharpen	▼ File Settings		en de la company de la comp	mainananinammanemaal
JPEG export	Format:	[IPEG	Quality:	50
JPEG halftone sharpen Original file export	Format.	Jrtu	Quanty.	
PSD export	Color Space:	sRGB (Limit File Size To: 1	00 K
TIFF export		Include Video Files	About Video File Sup	port
TIFF reimport		···········		
	▼ Image Sizing			
	🗹 Resize to Fit:	Width & Height	🗌 Don't Enlarge	
	W:	640 H: 640 pixels 🛟	Resolution: 72	pixels per inch
	1			
	♥ Output Sharpen	ing		
	Sharpen For:	Screen 🛟	Amount: Standard	••••••
	▼ Metadata			
		Minimize Embedded Metadata		
		Write Keywords as Lightroom Hiera	rchy	
		white Keywords as Eightrooth hiera	0 x 1 y	
	Watermarking			
	UWatermark:	Simple Copyright Watermark	Å V	
	V Post-Processing			
	After Export:	Show in Finder		
	Application:	Choose an application		 Choose
Add Remove				

Figure 9.12 The File \Rightarrow Export dialog is shown here with the For E-mail preset selected. You can configure your own custom export dialog settings and click the Add button (circled) to add these as new user presets.

NOTE

In Lightroom 3, the Export dialog now includes options to add exported images to the catalog and stack them either above or below the original, which I prefer to think of in terms of stacking "before" or "after."

Exporting to the same folder

If you select "Same folder as original photo" in the Export To box (**Figure 9.13**), this allows you to export a derivative version of a catalog photo, such as a full-sized TIFF version from a raw original, export the new photo to the same source folder as the original, and add it to the catalog. When this combination of settings is selected, you also have the option to stack the exported image either before or after the original. The Export dialog, therefore, provides you with a simple one-step solution for creating derivative versions of the raw masters and simultaneously adding them to the catalog.

xport Location			
Export To:	Same folder as original pl	hoto 🗘	
Folder:	(wherever each source pho	to is located)	
	Put in Subfolder:		
	🗹 Add to This Catalog	Add to Stack:	Below Original
Existing Files:	Ask what to do		

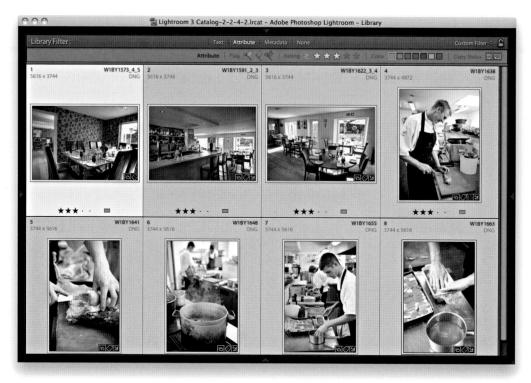

1. In this first screen shot, you can see here that I had filtered the photos in the catalog to select just the master raw, 3 stars or higher photos only.

Export To:	Hard Drive \$
♥ Lightroom Presets Burn Full-Sized JPEGs Export to DNG For E-Mail ▶ Photomatik ♥ User Presets 10×8 inkjet output book export Book prep images	Export Location Export To: Same folder as original photo Folder: Wherever each source photo is located) Our in Subfolder: FSD folder Ø Add to This Catalog Existing Files: Ask what to do File Naming W18Y1638.tif
Burn as DNG Convert to CMYK: Contact	V File Settings
Export as DNG Export CMYK TIFF 300ppi Export TIFFs Export to same folder JPEG A4 + halftone sharpen JPEG export	Format: TIFF Compression: None Color Space: ProPhoto RGB Bit Depth: 16 bits/component Include Video Files > About Video File Support
JPEG halftone sharpen Original file export	▶ Image Sizing 300 ppi
PSD export TIFF export TIFF reimport	Output Sharpening Sharpening Off Metadata Include Keyword Hierarchy
Add Remove	Watermarking No watermark Post-Processing Show in Finder

2. I used the Export command (\\mathbb{#\frac{D}{Shift}E} [Mac] or (\mathbb{Ctrl \frac{D}{Shift}E} [PC]) to export these eight photos with a custom "TIFF reimport" preset that used the same Export Location settings as those shown in Figure 9.13.

000	🔂 Lightroo	m 3 Catalog-2-2-4-2.lrcat	- Adobe Photoshop Lightro	oom – Library	
Library Filter :		Text Attribute	Metadata None		Custom Filter 💠 🤷
Listop inters			AND REAL PROPERTY AND ADDRESS OF ADDRES	승 승 Color DDDD	Copy Status
1 W18Y1573_4_5	2 W1BY1573_4_5	3 W18Y1591_2_3	4 W18Y1591_2_3	5 W18Y1622_3_4 5616 x 3744 DNG	6 W1BY1622_3_4
5616x3744 DNG		5616x3744 DNG		3616x3/44 DNG	
2 1020000		2		2	and the second s
			The second s	HI I ISA	A H BRAY
	The state	HER- LUIA	Les- Lung		
			DING	- ACH	
★★★ · · □□ 7 W18Y1638	★★★ · · □ 8 W18Y1638	*** · · 🖾 9 W1BY1641	★★★ · · □ 10 W18Y1641	★★★ · · □	★★★ · · □ 12 W18Y1648
3744±4972 DNG	8 W18Y1638	3744 x 5616 DNG	10 W (B1104) 1744 / 5615	3744 x 5616 DNG	3744 x 3616 TF
2		2	PA V	2	Astr.
122	1.2	331	331		
		2-2161	200		
Nº C	Nº.C	and the second s		A server 2	4-2
	1 Lo	DØ2	C	E COR	
*** • • ==	*** • =	*** · · =	*** • •	*** • =	*** • •
13 W1BY1655 3744 x 5616 DNG	14 W18Y1655	15 W18Y1663 3744×5616 DNG	16 W18Y1663		
2		2			
J. C.					
Title	Carl I	A COMPANY	Nº.		

3. Once the Export process was complete, I could see that the exported photos had been added to the catalog and stacked *after* the raw masters.

TIP

If you choose to export photos as JPEGs, Lightroom 3 now allows you to specify a file size limit for the exported JPEGs and auto-calculates the appropriate amount of JPEG compression that's required (see Figure 9.12).

File Naming and File Settings

If you want to retain the current naming, you can leave the File Naming section set to *Filename*, or if you wish to somehow differentiate the export processed images from the original masters, you can add a text string such as *_email* or *_foliocopy*. In the File Settings section, images can be exported using the JPEG, PSD, TIFF, DNG, or Original formats, and the file format options will adjust according to the file format you have selected. For example, in Figure 9.12, you can see the File Settings that are available for JPEG exports, and if you select the DNG format, you'll see the DNG options that are shown below in **Figure 9.14**.

TIFF options

When setting the TIFF options, I prefer to save uncompressed TIFFs. You can use ZIP or JPEG compression to make TIFFs smaller, but be warned that it can take up to ten times longer to save TIFF files that have been compressed this way.

Original format

Don't overlook the fact that you can export images from Lightroom in their original format. For example, when burning a DVD, it will be a lot quicker to export and burn photos to a disc by keeping them in their original format. After all, if your files are already converted to DNG, there is no point in asking Lightroom to convert them to DNG all over again. Likewise, now that Lightroom 3 supports managing of CMYK images and video files, you can use the Original format option only when exporting these types of files from Lightroom.

Saving non-raw files as DNG

Just as you can convert any supported proprietary raw file to DNG, you can also save non-raw files as DNGs. The only advantage of doing this is that the DNG file format can combine the XMP data with the pixel image information in a single file document. But the major downside is that, if you save JPEG images in this way, you will lose all the benefits of JPEG file compression; it's a bit like saving

File Settings	
Format:	DNG
	Compatibility: Camera Raw 5.4 and later
	JPEG Preview: Medium Size
	Embed Original Raw File

Figure 9.14 When DNG is selected in the Format box, you will see the DNG options shown here. These are the same options that you will find in the Camera Raw and DNG Converter Save options.

a JPEG image as a TIFF or PSD—you end up increasing the file size to that of a normal, uncompressed image file. It is also important to point out that saving a JPEG as a DNG does *not* convert a JPEG image into a true raw-format image. This is a misunderstanding that has cropped up before on some of the e-mail forums. It must be stressed that once you have converted a raw image to a TIFF or JPEG, there is no way of returning it to its raw state again.

File Settings

Up to this point, all the catalog files will have been edited using the Lightroom internal RGB space, but you can now select an output color space for the exported files by choosing from sRGB, Adobe RGB (1998), or ProPhoto RGB. If you are exporting the photos for photo editing, your choice will boil down to Adobe RGB or ProPhoto RGB. Adobe RGB is a safe general choice as it is a widely adopted space for general photo editing work in programs such as Photoshop. ProPhoto RGB is, in many ways, a better choice than Adobe RGB because the ProPhoto RGB color gamut is a lot larger than Adobe RGB and is more or less identical to the gamut of the native Lightroom RGB space. With ProPhoto RGB, you can guarantee inclusion of all the colors that were captured in the original raw file, whether your display is able to show them or not. For this reason, ProPhoto RGB is a favorite photo editing space for high-end print work where you want to preserve the maximum color gamut to achieve the best print results. The downside of using ProPhoto RGB is that you must view the files in a color-managed application in order to see the colors displayed correctly. If you view a ProPhoto RGB image in a program that does not recognize profiles (such as most Web browsers) or where the color management is switched off, the colors will look terrible. Adobe RGB files won't look so hot either if you don't color-manage them, but trust me, ProPhoto RGB images will look even worse! If you are familiar with the basic concepts of color management and are using Photoshop color management switched on, it will be safe for you to export using Adobe RGB or ProPhoto RGB. If any of the preceding information scares or confuses you, then perhaps you should stick to using sRGB. In fact, I would definitely advise choosing sRGB if you are exporting images as JPEGs for Web use or for client approval (especially if you are unsure how well the client's systems are color-managed), or if you are preparing pictures to e-mail to friends. For the time being at least, sRGB is going to remain the most suitable lowest common denominator space for Web work and general use.

The Bit Depth can be set to 16-bit or 8-bit. One of the reasons so many professionals advocate working in 16-bit is because you can make full use of all the capture levels in an image when applying your basic tonal edits. If you start out with an 8-bit image and carry out major edits, you'll end up needlessly throwing away a lot of data along the way. Keeping your images in 16-bit throughout helps preserve all the levels. In Lightroom (and this is true for any raw processor), you are making all your basic edits in 16-bit regardless of how you export them. So, at this stage, you will already have taken full advantage of all the deep-bit levels data

NOTE

You can never tell what the future may hold. There was a time when nobody could foresee a real need for deep-bit images. These days, film and video editors regularly rely on 16-bit or higher bit depths for special effects work. And new display technologies are emerging that can show deep-bit images on wide dynamic range displays. For this reason, I recommend that you export your Lightroom photos as 16-bit files in ProPhoto RGB.

The Resize to Fit options can be used to make the exported photos bigger or smaller. If you uncheck the Don't Enlarge check box, you can use the Resize to Fit settings to create output images with bigger pixel dimensions than the original. If the Don't Enlarge check box is selected, this resizes the photos to the desired output dimensions, but if the source photo is smaller than this size, it will output the photo at its native pixel size rather than try to make it bigger.

NOTE

I know some people still get confused by the file resolution setting. Basically, whatever resolution you set here has no bearing on the actual pixel file size. The Resolution box lets you specify the resolution for the image in pixels per inch or pixels per centimeter. in the original capture. Therefore, choosing 8-bit at this stage is not necessarily so damaging, especially if you have carried out all the major edit adjustments to the raw file in Lightroom. If you think 16-bits will help you preserve more levels as you perform subsequent editing work in Photoshop, and you feel the extra levels are worth preserving, the safest option is to choose 16-bit.

Image sizing

In the Image Sizing section (**Figure 9.15**), you have the opportunity to resize the exported photos (except where the DNG file format or Original image is selected in the File Format settings). There are various options here. If you check the Resize to Fit box, you can choose Width & Height to make the photos resize to fit within the values entered in the two boxes. If you select Dimensions, you can force the exported images to fit precisely within set dimensions (which may well change the aspect ratio of the exported images), or you can resize the photos along the long edge or the short edge only. if you have a selection of photos where some are landscape and others are portrait, you can specify a long edge or short edge dimension limit, and all photos will resize to the same long edge or short edge dimension constraints. Finally, the Resolution box allows you to set the number of pixels per inch or pixels per centimeter for the resolution.

	Export 10 Photos
Export To:	Hard Drive
reset:	Settings:
▼ Lightroom Presets Burn Full-Sized IPEGs	Export Location Desktop / JPEG A4
Export to DNG	File Naming SAfrica0501_0981.jpg
For E-Mail	V File Settings
Photomatix r User Presets 10x8 inkjet output book export Book prep images Burn as DNG Convert to CMYK: Contact Export as DNG	Format: IPEG Quality: 85 Color Space: sRCB Imit File Size To: 100 Include Video Files About Video File Support
Export CMYK TIFF 300ppi Export TIFFs Export to same folder	Resize to Fit: Long Edge 29.700 cm 2 Resolution: 300 pixels per inch 2
JPEG A4 + halftone sharpen	Output Sharpening Sharpening Off
JPEG export JPEG halftone sharpen	Metadata Minimize
Original file export	Watermarking Nowatermark
PSD export TIFF export	V Post-Processing
TIFF reimport	After Export: 300ppi sharpen
Add Remove	Application: Choose an application

Figure 9.15 Here is a view of the Export dialog in which you can see the File Settings and Image Sizing options. Note also that when the panels in the Export dialog are collapsed, the settings are summarized in the panel bar for quick and easy viewing.

When to interpolate?

There are no interpolation options in Lightroom. Instead, an adaptive method of interpolation is used in both Lightroom and Camera Raw. However, this still leaves the issue of when and where you should interpolate. There are still times when digital camera files may need to be made bigger in order to meet client requirements for blowup images. One of the questions that has arisen relates to capture sharpening. Is it OK to use the capture sharpening in Lightroom and interpolate the image up later when you need to create a bigger pixel-sized image? Or, should you switch off the capture sharpening in Lightroom, export at the bigger pixel size, and capture-sharpen afterward? Figure 9.16 shows the difference between these two approaches. The important thing to bear in mind here is that the capture-sharpening process is intended to sharpen a capture image in preparation for all types of uses. If the image you start with contains obvious artifacts, then any amount of sharpening and further interpolation is likely to enhance these defects. The objective should always be to capture-sharpen your photos just enough to make them visibly sharper, but without creating noticeable sharpening artifacts. So, although interpolating before capture sharpening sounds like a good idea, it doesn't actually help. I have come to the conclusion that the capture sharpening applied in Lightroom does not enhance any artifacts. It is appropriate to capture-sharpen the original raw image in Lightroom and interpolate up at the export or print stages.

NOTE

The Photoshop Image Size dialog offers a choice of interpolation methods when resampling an image. For example, it's recommended that you choose Bicubic Smoother when making an image bigger and Bicubic Sharper when reducing an image in size. Lightroom now uses an adaptive sampling approach that combines the Bicubic and Bicubic Sharper algorithms when downsampling an image and combines the Bicubic and Bicubic Smoother algorithms when upsampling.

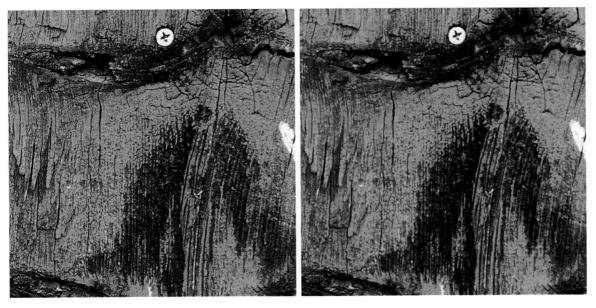

Figure 9.16 The left image was capture-sharpened in Lightroom and interpolated up at the export stage to twice the original file size. The right image was initially unsharpened and the exported version interpolated to twice the original size and then reimported and sharpened in Lightroom using settings identical to the ones used in the left version. These pictures are shown here at the 100% (doubled up) output size.

Photoshop author and digital imaging guru Bruce Fraser worked on the PixelGenius PhotoKit Sharpener plug-in for Photoshop alongside Mike Skurski and Jeff Schewe. Adobe worked with PixelGenius to bring the PhotoKit Sharpener technology into Lightroom. This included the inkjet and screen image sharpening that's available in the Print module and also in the Export dialog shown here.

Output sharpening

The Output Sharpening section (**Figure 9.17**) provides the same sharpening controls that are found in the Print module Print Job panel options. It should be stressed that these sharpening options are intended for applying sharpening for inkjet print output only. What this means is that, instead of using the sharpening controls in the print module to sharpen for print, you can use the Export dialog settings to sharpen a file for inkjet print output. For example, let's say you wanted to take photos from Lightroom and prepare them for printing in Photoshop or via a dedicated RIP. If you apply output sharpening at the Export stage in Lightroom, your files will be nicely sharpened and ready to print.

In the Sharpen For section, you can choose Screen output (such as for a Web page or external slideshow presentation) or choose between a matte or glossy paper inkjet output. I say "inkjet," but you can successfully use these output sharpening settings to prepare photos for other types of photographic printing such as a Fuji Frontiera continuous tone process. Note there are no sharpening options for halftone CMYK output, and you will still need to carry out this type of sharpening in Photoshop. The Amount settings include Low, Standard, and High. The Lightroom output sharpening is based on routines that were originally devised by Bruce Fraser; these were all coded with the Standard setting. The Low and High settings, therefore, allow you to make the sharpening effect weaker or stronger.

It is worth bearing in mind that you don't always need a high pixel resolution to get good results in print. Clients are often fond of quoting a 300 ppi resolution for everything from small newspaper photos up to billboard size posters! The truth is that 200 to 250 ppi is quite often all that you need for magazine reproduction, and more pixels doesn't always equate to better quality. Having said this, images that contain a lot of fine detail will benefit from being output for printing (or printed directly via the Print module) at a minimum resolution of 300 ppi. If you choose to upsample, Photoshop applies its adaptive upsampling routine that combines the Bicubic and Bicubic Smoother interpolation algorithms prior to applying the print output sharpening. As I say, this isn't necessary for all images—just those that contain a lot of fine edge detail.

Metadata

The Minimize Embedded Metadata option allows you to export images without including custom metadata such as keywords (**Figure 9.18**). This option can be useful if you want to keep the metadata information to a minimum or wish to hide the keyword metadata. Below this is the Write Keywords as Lightroom Hierarchy option. This is checked by default and ensures that keywords are always written to a file's XMP space so that the keyword hierarchy is preserved when the keyword metadata is previewed on another computer running Lightroom, where perhaps the keywords used are unknown or do not share the same hierarchy.

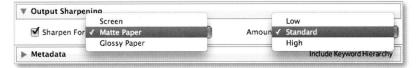

Figure 9.17 The Output Sharpening options.

▼ Metadata		
	Minimize Embedded Metadata	
	🗹 Write Keywords as Lightroom Hierarchy	
▼ Watermarking		
🗹 Watermark:	ME Copyright	

For example, let's say you have two computers that share the same controlled vocabulary—that is, they both share the same keyword hierarchy structure. If you were to export a photo from one computer and import it into the other, then the Write Keywords as Lightroom Hierarchy option wouldn't make any difference because the keyword hierarchy for the individual keywords would be recognized anyway. (Please note that I am talking about a normal export and import here and not about the Export/Import catalog command.) But if this option is unchecked and the second computer does not share the same information, the keywords will otherwise be output as a flat View list without a Lightroom-recognized hierarchy. So, if you happened to use a keyword hierarchy that used *California* > *USA* > *Places*, that hierarchy would be preserved as long as either the computer you were importing the photo to already knew this hierarchy relationship or the Write Keywords as Lightroom Hierarchy option had been checked. If it was not checked, the keywords would be exported as a flat list: *California*, *USA*, *Places*.

Watermarking

Previously, the Add Copyright watermark option in the Metadata panel would simply add a watermark in the bottom-left corner based on the copyright metadata applied to each image. It worked and was a useful feature to have, but the Watermarking section now allows more control over how watermarking is applied to your exported images (Figure 9.18). Over the coming pages you'll see two examples of how to add a watermark: You can create a text watermark, or you can click the Add Image button to select a suitable image graphic. In addition to placing a watermark at the time of export, you can also do so via the Print module Page panel and Web module Output Settings panel. Watermarks can also be edited by going to the Lightroom menu and choosing Edit Watermarks.

NOTE

Watermarks can be applied to all images except raw DNGs, since it isn't possible to add watermarks to raw images.

How to create new watermark settings

0	Watermark Editor	
Photo text	•	Watermark Style: 🖲 Text 🔘 Graph
		▼ Image Options
		Please choose a PNG or JPG image Choose
		Text Options
		Font: Myriad Web Pro
		Style: Bold
		Align: 💽 🛓 🗐
		Color:
		Shadow
o		Opacity: 80
C.Martin EV/	Selleta	Offset: 10
and a state of some of a	7	Radius:5
here as a		Angle: 60
		Watermark Effects
		Opacity: 33
		Size: 💌 Proportional
		60
		O Fit
		Inset
		Horizontal:
		Vertical:
		Anchor: OOO Rotate:
rtin Evening		888 4 4
		Cancel

1. To create or edit a watermark, go to the Lightroom menu and choose Edit Watermarks. Or, if you are already in the Export dialog, go to the Watermarking section and select Edit Watermarks. This opens the Watermark Editor shown here. If you are in Text mode, you can type in the text to use for the watermark and use the bounding box handles to adjust the scale of the text. Over on the right are the text and watermark options for setting the alignment, orientation, opacity, and color, plus you can also add a drop shadow and adjust the Radius and Angle settings to create a bevel and emboss type of effect. Once you are happy with the watermark settings, click the menu list at the top and choose Save Current Settings as a New Preset. The saved setting will now be available as a custom option such as in the Watermarking section of the Export panel (see Figure 9.18).

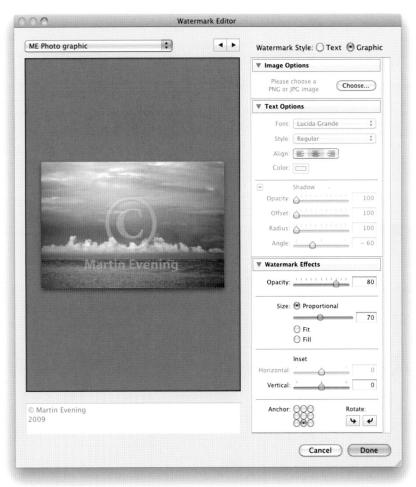

The logo shown here was designed using a type layer with layer effects set to a 50 percent opacity with a transparent background. The edited logo was saved as a PNG file.

2. Alternatively, you can click the Graphic button to open a PNG or JPEG image file and place this as your logo. There are no active settings here for adjusting a watermark graphic other than to fade the opacity, so you'll need to use Photoshop to edit such watermarks beforehand and create special effects like the rounded bevel edge seen here.

Post-Processing

The Post-Processing section in the Export dialog is a powerful feature. It lets you perform tasks such as showing the images in the Finder at the end of an export or instructing Lightroom to open the photos in Photoshop after exporting. You can even arrange for the exported files to be burned directly to a disc. These are the default options you have in the Post-Processing section, but if you read further over the next few pages, you can find out how to create Photoshop droplets (which are self-contained Photoshop action routines) and have these run at the post-processing stage of a Lightroom export.

TIP

It is also possible to drag and drop photos from Lightroom to a Photoshop droplet. Be warned though: Develop adjustments and other settings will not necessarily be transferred with the file if you drag and drop a file from Lightroom in this way.

Adding Export Actions in Lightroom

The post-processing options in the Lightroom Export module allow you to integrate Photoshop processing routines with Lightroom by adding them at the end of a Lightroom export. All you have to do is run through a sequence of Photoshop processing steps that you would like to see carried out at the end of an export and record these as an action. In the following few steps, I show an example of how to create a Photoshop action for converting RGB images to CMYK that includes the necessary pre-sharpening and profile conversion steps. This is just one example of a Photoshop routine that you might like to apply on a regular basis to photos that have been exported from Lightroom. By following the steps shown here, you can adapt this to record almost any type of Photoshop processing sequence.

1. Here I want to show you the steps you would follow to create a Photoshop droplet that could be placed in the Lightroom *Export Actions* folder so that it appeared as a selectable item in the Post-Processing section of the Export dialog. I started by opening an image in Photoshop and recorded a series of steps as an action. In this example, I set the opened image to the correct resolution, applied an automated sharpening routine for this resolution, merged the image, converted it to a specific CMYK profile, all before converting it to 8-bits per channel mode.

Save Droplet In			
	nartinevening::Adobe:Lightroom:Export Action	s:ConvertCMVX-Contact	OK
us main no.osers.in	a the verning Adobe. Eight oom. Export Action	is.convertentile contact	(Cancel)
Play			
Set: Droplet actions			
Action: CMYK output for Contac	t 🛊		
Override Action "Open" Command	ls		
Include All Subfolders			
Suppress File Open Options Dialog	gs		
Suppress Color Profile Warnings			
Destination: Save and Close			
Choose			
Override Action "Save As" Comma File Naming	nds		
Example: MyFile.gif			
Document Name	+ extension	(\$) +	
	(\$)+	(\$) +	
	(\$) +	\$	
Starting serial#: 1			
Compatibility: 🗌 Windows 🗹 Mac	c OS 📃 Unix		
Errors: Stop For Errors			

BOOPPI-halftone+CMYK

2. Having recorded the action, I was now ready to save it as a droplet. In Photoshop, I went to the File menu, selected Automate ⇒ Create Droplet, applied the settings shown here, and clicked Choose to save it to the Lightroom Export Actions folder (see Step 3). There was no need to establish an output folder in the Destination section, since I would be using the Lightroom Export dialog to determine where the exported files would be saved to, so I chose Save and Close.

000					Ex	xport Actions			0
				1 of 7	selecte	ed, 184.27 GB available			
Acrobat User Data	-	Ableton	10	Extension Manager2	1	Color Profiles	10	🐺 🐺 10x8_inkjet	▼ Preview:
Application Support		Ableton Live Engine	- 1	Flash CS3	- 1- 1	Develop Presets	- 1	300ppi sharpen	processo and a second
Applicatiobe/Acrobat	-	AddressBook	-	Flash CS4	- 1-1	Device Icons	-	300PPI-halftone+CMYK	D-
Assistants	-	Adobe	+	Fonts	- 1- 2	Export Actions		Adobe Lightroom alias	PC
audio Audio	-	BookSmartData	1	Lens Profile Creator	P	Export Presets	-	GMYK-A4	
Autosave Information	-	Calculator	-	Lightroom	•	External Editor Presets	-	ConvertCMYK-Contact	
Caches		ChronoSync	-	inguistics	1	Filename Templates	-	PK-presharpen	
Calendars	-	Console		CogTransport	- 1- 1	Filter Presets	- 11		
ColorPickers	-	Coriolis	-	Online Services	- Þ.[FTP Presets	ьU	J	•
Colors	-	CrashReporter		QuickTime		m 📖 Import Presets	-		Name 300PPI-halftone
ColorSync	-	DVD Player	+	Scripting.log		Keyword Sets	× .		+CMYK
Compositions	-	eSellerate	× [SING		Label Presets	ьĒ		Kind Application
Contextual Menu Items	P.	Eirefox	r II	Stock Photos CS3	- P-	Label Sets			Size 610 KB on disk Created 18/12/2008 11:53
Cookies	-	GarageBand	Þ	SwitchBoard	- P -	Lightroomegistration	1		Modified 18/12/2008 11:53
Documentation	×	Google Earth	•	TypeSpt	P 1	Lightroomegistration	E		Last opened 19/11/2009 14:06
Favorites	F A	GPSPhotoLinker	1.14	📓 Updater		Local Adjustment Presets	-	2.	Version 7.0
FontCollections	-	GridIron Software		Dpdater5	- F	Localized tion Presets	P 4		
E Fonts	-	🔛 HoudahGeo	-	Updater6	-	👖 📖 Metadata Presets	P II		More info

3. As I mentioned in the previous step, the Photoshop droplet needed to be saved to the Lightroom *Export Actions* folder. On a Mac, go to *Users/Library/ Application Support/Adobe/Lightroom/Export Actions*. On a PC, you will need to go to *Local Disk (C:)/Username/Application Data/Adobe/Lightroom/ Export Actions*.

reset:	Settings:
Lightroom Presets	V Export Location
▷Photomatix ♥ User Presets 10x8 inkjet output book export Book prep images Burn as DNG Convert to CMVK: Contact Export as DNG	Export To: Specific folder Folder: /Users/martin_evening/Desktop Put in Subfolder: CMYK TIFFs Add to This Catalog Add to Stack: Below Original Existing Files: Ask what to do
Export CMYK TIFF 300ppi	File Naming W1BY0150.
Export TIFFs	▼ File Settings
Export to same folder JPEG A4 + halftone sharpen JPEG export JPEG halftone sharpen	Format: TIFF Compression: None
Original file export PSD export	▼ Image Sizing
TIFF export TIFF reimport	Resize to Fit: Long Edge Don't Enlarge
	Output Sharpening Sharpening
	🔻 Metadata
	☐ Minimize Embedded Metadata ✓ Write Keywords as Lightroom Hierarchy
	▶ Watermarking No waterma
	V Post-Processing
	After Expor ✓ Do nothing Applicatio Show in Finder
Add Remove	
	Application Show in Finder Open in Adobe Photoshop CS5 Open in Adobe Photoshop CS4.app Open in Other Application
Add Remove	Application Show in Finder Open in Adobe Photoshop CS5 Open in Adobe Photoshop CS4.app Open in Other Application 10x8_inkjet
	Application Show in Finder Open in Adobe Photoshop CS5 Open in Adobe Photoshop CS4.app Open in Other Application 10x8_inkjet 300ppi sharpen
	Application Show in Finder Open in Adobe Photoshop CS5 Open in Adobe Photoshop CS4.app Open in Other Application 10x8_inkjet
	Application Show in Finder Open in Adobe Photoshop CS5 Open in Adobe Photoshop CS4.app Open in Other Application 10x8_inkjet 3000pi sharpen 3000Pi-halftone=CMYK Adobe Lightroom alias CMYK-A4
	Application Show in Finder Open in Adobe Photoshop CS5 Open in Adobe Photoshop CS4.app Open in Other Application 10x8_inkjet 300ppl sharpen 300Ppl =haircone + CMYK Adobe Lightroom alias

TIP

Even though this export setting was intended for converting photos to CMYK, the RGB space choice would have some bearing on the outcome. Either ProPhoto RGB or Adobe RGB would be a suitable choice since both spaces are capable of encompassing a typical CMYK gamut. I would not recommend selecting sRGB as an interim processing RGB space since the limited gamut of this space might actually clip some of the RGB colors before converting to CMYK. **4.** I was now ready to put the droplet action to use. In Lightroom, I selected the photos I wanted to process, and chose Export from the File menu to open the Export dialog shown here. In the Export Location section, I instructed Lightroom to create a new export folder called CMYK TIFFs. In the File Settings section, I selected the TIFF file format with the Compression set to None. It did not matter too much which RGB space was selected here because the output files would eventually be converted to CMYK, but I did choose to set the output color space to ProPhoto RGB, since this was pretty similar to the native Lightroom RGB space. In the Image Sizing section, I limited the output size to 30 cm along the longest edge and at a resolution of 300 ppi. Finally, in the Post-Processing section, I clicked the menu to select the droplet that I had previously saved to the *Export Actions* folder. Once I had done that, it was time to save these customized settings as a new preset. In the example shown here, I saved the Export settings as *Export CMYK TIFF 300 ppi*.

5. All I needed to do now was click Export, and Lightroom would export the images that had been selected in Lightroom as TIFFs, output them to the designated folder on the desktop that I had named CMYK TIFFs, and do so in the following sequence of steps.

The master Lightroom photos were rendered as pixel images using the ProPhoto RGB space and resized to fit dimensions of 30 cm along the longest edge at a resolution of 300 pixels per inch with the metadata information and keyword hierarchy preserved. These were initially saved as ProPhoto RGB TIFFs to the CMYK TIFFs folder that would appear on the Desktop. Once the initial export had been completed, the Photoshop post-processing kicked in. The exported TIFF files were then opened in Photoshop and the *Export CMYK TIFF 300 ppi* droplet action steps were applied to each of the images in turn, which were then saved back to the CMYK TIFFs folder, overwriting the original RGB TIFFs.

As you can see, there are a lot of processing steps going on here, which the Lightroom export process can manage automatically and do so much quicker than if you tried to do all this one by one to each individual image. The above folder shows the final six photos after they had successfully been exported from Lightroom as CMYK TIFFs, ready for delivery to the client for use in a page layout.

TIP

You can adapt the CMYK conversion action routine shown here for any publication. My recommendation would be to create separate droplet actions for different publications using the correct profile or CMYK setting for each. You can then build up different sets of user presets for each client.

A few enterprising individuals have started developing plug-ins for Lightroom. One such person is Jeffrey Friedl, who has written a number of Lightroom plug-ins that you can download via the following link: http://regex.info/ blog/lightroom-goodies. You may also wish to look at Timothy Armes' Photographer's Toolbox site at: www.photographers-toolbox.com/ plugins.php. There you will find links to his plug-ins such as Mogrify and Enfuse.

TIP

You may also want to click the Plug-in Exchange button at the bottom of the Lightroom Plug-in Manager (Figure 9.20) to search for more Lightroom plug-ins.

Export plug-ins

The Lightroom Export dialog allows the use of Export plug-ins, which can be downloaded from various third-party providers. To install a plug-in, click the Plug-in Manager button (circled) at the bottom of the Export dialog (**Figure 9.19**), which opens the Plug-in Manager, shown in **Figure 9.20**.

Export 3 selected photos to:	Hard Drive
reset:	Settings:
▼Lightroom Presets Burn Full-Sized JPEGs Export to DNG For E-Mail	Export Location
	Export To: Desktop Solder / Users/martin_evening/Desktop
 Photomatix User Presets 	Put in Subfolder: To E-Mail Add to Stack: Below Original
	Existing Files: Ask what to do
	File Naming 1W8A2809.jpg
	File Settings JPEG (50%) / sRGB
	V Image Sizing
	Resize to Fit: Width & Height Image W. 640 H: 640 pixels Image W. 640 H: 640 Resolution: 72 pixels per inch. 1
	Output Sharpening Off
	▶ Metadata Minimize
	► Watermarking
Add Remove	► Post-Processing Show in Finder

Figure 9.19 This shows the Lightroom Export dialog with the Plug-in Manager button circled.

0	Flickz Installed and running	🐺 Status	
0	Export to Photomatix Pro Installed and running LR2/Mogrify Installed and running	Path: /Applications/Adobe Lightroom 3 Beta.app/Contents/ Show in Finder Version: 3.0.621378 Status: This plug-in is enabled.	PlugIns/flickr.lrplugin
		▶ Plug-in Author Tools	No diagnostic messages
	Add Remove		

Figure 9.20 This shows the Lightroom Plug-in Manager dialog with several thirdparty plug-ins loaded.

Photomatix Pro export plug-in

The Photomatix Pro plug-in for Lightroom is only available to purchasers of the Photomatix Pro program. Instructions on how to install the plug-in are provided on the HDRsoft Web site, but you may need to go to the File menu and select "Plug-in manager" to check that the plug-in has been activated in Lightroom.

1. In this first step, I made a selection of grouped photos that had been shot using a five-exposure bracketed sequence, two EVs apart. Next, I used the Export Photo command: **#**ShiftE (Mac) or Ctrl ShiftE (PC).

hotomatix 🔹	
tings:	
File Naming	
Template: Original filename + custom text	•
Custom Text : HDR Start Number: 1	
Example: W1BY7622.tif	
File Settings	
Format: TIFF Compression: None	•
Color Space: ProPhoto BCB Sit Danth: 16 hits (component	•
	9
Image Sizing	1124
🗐 Resize to Fit: Width & Height 🗘 🗹 Don't Enlarge	
W: 1000 H: 1000 pixels	
1	ettings:

2. In the Export dialog, I selected the Photomatix Pro plug-in. Here I used a file naming template that would add the custom text *HDR* to the original filename. For the other settings, I selected ProPhoto RGB at 16-bits and clicked Export, which opened a second dialog, where I adjusted the settings and clicked Export.

NOTE

Photomatix Pro is available from www.hdrsoft.com. The standard version includes the export plug-in necessary for integrating Photomatix Pro with Lightroom.

	port 5 files to Photomatix Pro. ns to process the files.
O Blend exposure	S
Generate HDR i	mage
Reduce chro	omatic aberrations
Reduce nois	se
Attempt to	reduce ghosting artifacts
	ind movements
	bjects/people to Tone Mapping
Align images	to rone mapping
	horizontal and vertical shifts features
Export in color spa	ace: ProPhoto RGB
Handling of proce	ssed image
Automatically re	e-import into Lightroom library
Stack with fir	st selected photo
File name: W1BY	7622_3_4_5_6
Out	put format: TIFF 16-bit
	Cancel Export

Details Enh	ancer	Tone	Com	presso
Strength	1 1 1	I		93
Color Satur	ation	4	1	57
		*	. 1	+1
Light Smoo	thing		v	ery High
0 0) ()		0	
Microcontra		1	1	0
•	Tone se	ttings		
White Point	1 1 1	1 1	-0	5.650
Black Point	ттт	1 1		3.813
Gamma	<u>``</u> ``````````````````````````````````	1	[0.82
•	Color se	ttings		
•	Smoothing	settin	igs	
Micro-smo	othing	1 1		3
Highlights !	1 1 1 1 1 1 1) 	[₁ ,	,17
Shadows Sn	noothing	11	<u> </u>	,13
Shadows Cl	ipping	1 1	[,13
360° ima	age			
Reset: (Default		Oundo	Redo
Presets: (Custom		interioration de la composition de la composit	\$
Contraction	Proce	ss	Present at	

TIP

Whenever you create an HDR-to-LDR processed image and add this to the Lightroom catalog, I suggest you also consider adding an *HDR* keyword to the processed file. This will make it easier for you to locate all HDR processed images using a keyword search, or automatically group such photos through the use of Smart Collections.

3. Once the HDR image had been created, it opened in Photomatix Pro, where I was able to adjust the Tone Mapping settings shown on the left to get the desired HDR to low dynamic range (LDR) conversion. When I was happy, I clicked Process.

4. Here you can see the Lightroom Grid view again, where the HDR-to-LDR processed version appeared next to the original bracketed photos.

Exporting catalog images to a CD or DVD

If you want to export images to a CD or DVD, you can do so via the Export dialog. In Figure 9.23, I selected the Burn as DNG custom export setting, which uses the Files on CD/DVD Export plug-in and was configured to convert all the selected photos to DNG and burn them to a CD or DVD. With this setting, the photos are first converted to DNG and automatically placed in a temporary folder. Lightroom then launches the operating system disc burning utility (such as the one shown in Figure 9.21) and alerts you that Lightroom is ready to start copying the files to a blank recordable CD or DVD. If you have more than one CD/DVD burning device available, you can select which unit you want to use to burn the disc. Once you have done this, click Burn and you will see the Burn Summary dialog, where you can enter a name for the archive disc you are about to create (Figure 9.22). If there is not enough room to burn all the data on a single disc, Lightroom will inform you of this and enable a multi-disc burn session. In the example shown here. I needed to archive a total of just over 8 GB of data to disc. However, a single recordable DVD can hold a maximum of 4.3 GB of data, so in these circumstances Lightroom automatically divides the library export into batches of equal size (based on the space available on the first disc you inserted to record with) and proceeds to burn the data (and verify) to successive discs, appending each disc burn session with successive numbers. Once the burn is complete, Lightroom automatically deletes the temporary disc folder.

reset:	Settings:	
 ↓ Lightroom Presets Burn Full-Sized JPEGs Export to DNG For E-Mail ▶ Photomatix ♥ User Presets 10x8 inkjet output book export Book prep images 	File Naming Template: Filename Custom Text: untitled Example: W1BY5268.dng File Settings Format: DNG CONG CONG	Start Number: 1
Burn as DNG Convert to CMYK: Contact Convert to PSD and auto i Export as DNG Export CMYK TIFF 300ppi Export TMFFs	Compatibility: Camera Raw 5.4 and later 3 JPEG Preview: Medium Size 3 Embed Original Raw File	
Export to same folder	Output Sharpening	Sharpening Off
JPEG A4 + halftone sharpen JPEG export JPEG halftone sharpen Original file export PSD export	Metadata Minimize Embedded Metadata Write Keywords as Lightroom Hierarchy	
Add Remove	► Watermarking	

Figure 9.21 When you choose the "Burn the exported images to disc" option, you can select the device unit that should be used to burn the disc and click Burn.

	Burn Summary
Lr	You are about to burn the first disc out of 3 discs total.
	Lightroom will prompt you for the next disc after this disc finishes.
	Disc 1 Name: 2009-11-03-1
	442 images waiting to be burned Cancel Burn Continue

Figure 9.22 In this Burn Summary dialog, you can enter the name of the disc to be burned. If there is more data than can fit on a single disc, Lightroom automatically alerts you and sets up the CD/DVD burn procedure to a sequence of discs.

NOTE

With Llghtroom 3, there is no longer the need to create a desktop folder to temporarily hold the files about to be burned to CD/DVD. In the past, you had to remember to manually delete the folder contents after the burn was successfully completed.

NOTE

When you create DNG files, you can choose to add an uppercase or lowercase extension via the File Naming section.

uipit Rock, Portland Bill, Dorset © 2009 Martin Evening Canon EOS 1Ds MK III | 12 mm | ISO 200 | f/10 @ 1/50th

Printing

How to get perfect prints and work efficiently in the Print module

Digital printing has come a long way from the early days of Photoshop when few photographers were convinced that you could really produce a digital output from a computer to rival the quality of a photographic print. Graham Nash and Mac Holbert of Nash Editions were early pioneers of digital printing and the first people to demonstrate how inkjet technology could be used to produce print outputs from the computer onto high-quality art paper. In the intervening years, photographers have seen amazing breakthroughs in technology and pricing. These days, you can buy a photographic-quality printer for just a few hundred dollars. But, alas, many people still get beaten by the complexities of the operating system print dialogs and the inability to make print color management work for them.

Fortunately, the Print module in Lightroom can make your life much easier. Here you are able to see previews of how the photographs will be laid out on the page. You can set up batches of images in a print queue to produce high-quality prints, or work in draft print mode to quickly generate sets of contact sheets. Plus, the built-in print module sharpening means that you can get nicely sharpened prints without resorting to specialist sharpening routines in Photoshop. Best of all, once you have mastered how to configure your print settings, you can save these settings as part of a template for more reliable and consistent printing results. TIP

Remember that you can always use the Collections panel in the Library module to save a print collection with the print template settings.

Preparing for print

The Print module

The Print module (**Figure 10.1**) provides you with complete control over the print page layout and provides proper-sized previews of the images that have been selected for printing. Starting from the top right, the Layout Style panel offers a choice of print layouts: Single Image/Contact Sheet, Picture Package, or the new Custom Package. The Image Settings panel can be used to apply basic rules, such as how the selected image or images fill the cell areas, whether to rotate the images for the best fit, whether to zoom and crop the photos to fit a cell, or whether to add a stroke border.

The Layout panel can then be used to define the margins, grid layout, and cell size for the images. To help you get started, several templates are included for you to choose from in the Template Browser panel on the left, and you can preview the layout format in the Preview panel as you hover over the items in this list. The Template Browser print templates make it easy to switch print configurations and experiment with different page layout setups. Once you have settled on a template design, you can apply it to multiple images and then just click one of the print buttons to queue up a batch of images ready for printing.

The Guides panel lets you determine the visibility of various guides items, and the Page panel lets you add information to the print. Here, you can place your Identity Plate as a logo or as custom text, as well as add a watermark and other items like page numbers. If you are using the Print module to print contact sheets, you can also include additional file information below the print cells. Now, in Lightroom 3, you can also choose a custom page background color.

The Print Job panel lets you decide how the page or pages should be printed. (There is no need for an Image Resize dialog in the Print module, because the Page Setup options and Print Resolution in the Print Job panel are all you need to size an image correctly for print.) The Draft Mode Printing option is great for speedy print jobs, because it makes full use of the large JPEG previews that Lightroom has already rendered. As long as the previews have all been built, the print processing is virtually instantaneous. When Draft Mode Printing is disabled, Lightroom always processes the image data from the original master file, and you can decide which level of output sharpening to apply. For easy printing, you can use the Managed by Printer setting, or you can select a custom print profile and rendering intent. You can click the Page Setup button at the bottom to specify the page setup size and paper orientation and then click the Print Settings button to specify the print output settings, such as the paper media type and print quality. This is how things look on a Mac setup, but since version 2.1, Lightroom has shown a single Page Setup button on Windows systems. Basically, Windows print drivers allow you to access both the Page Setup and Print Settings options

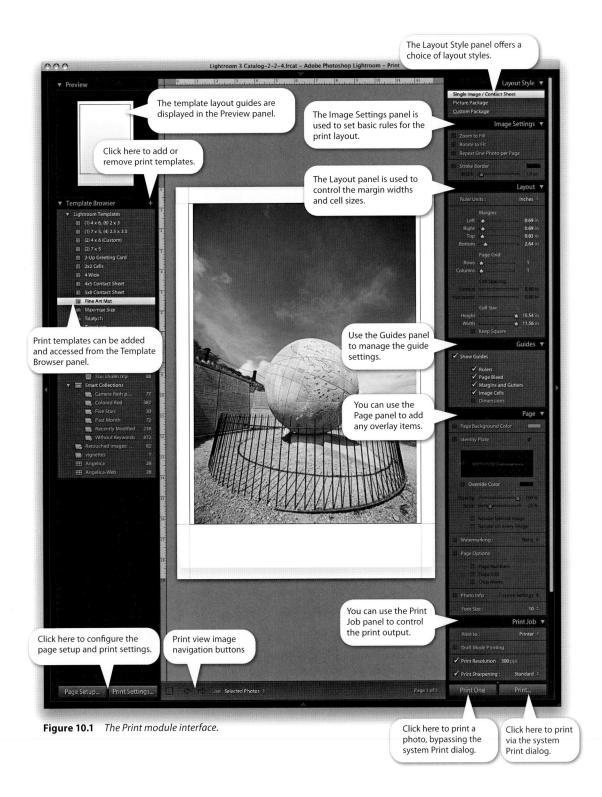

Figure 10.2 The Layout Style panel.

	Image Settings 🔻
V	Zoom to Fill
¥	Rotate to Fit
	Repeat One Photo per Page
	Stroke Border
	Width

Figure 10.3 The Image Settings panel, showing the cell policies and Stroke Border options.

from the one dialog. Both the Page Setup and Print Settings configurations can be saved as part of a print template, which can help reduce the number of opportunities for a print error at the operating system level. All you have to do then is click either of the Print buttons on the right to make a print. Basically, the Print button opens the system print dialog, which allows you to make further changes to the established print settings. But the Print One button is a safer option because if you are confident that the print settings are correct, it initiates the printing and bypasses the system print dialog altogether.

This provides a brief overview of all the main Print module panels and what they do. Let's now look at them in more detail.

Layout Style panel

This panel determines whether you use the Single Image/Contact Sheet, Picture Package, or Custom Package layout style. The selection you make here has a bearing on all the other panels displayed in the Print module (**Figure 10.2**). For example, if you select the Picture Package or Custom Package layout style, the remaining panel options will look different from those shown in Figure 10.1. Seeing as the Single Image/Contact Sheet layout is the one you are likely to use most often, I'll run through these panel options first.

Image Settings panel

The Image Settings panel (**Figure 10.3**) provides some elementary control over how the selected image or images fill the print cell areas. If the Zoom to Fill option is selected, the whole cell area is filled with the selected image so that the narrowest dimension fits within the widest grid cell dimension and the image is cropped accordingly. As you can see in the following steps, images that have been cropped in this way can be scrolled within the cells in the print layout. The Rotate to Fit option automatically rotates the images to fit the orientation of the print cells. For example, this option can be useful when printing a contact sheet of landscape and portrait images where you want each image on the contact sheet to print to the same size (see Step 3). The Repeat One Photo per Page option is applicable if the layout you are using contains more than one cell and you want the image repeated many times on the same page. For example, Step 4 on page 506 shows an example of a 2x2 cells template with this option selected.

A stroke border can be added to the outer cell area only and used to add a key line border to your photos. However, at lower print resolutions, the width of the stroke border may have to be adjusted to suit the print output. This is because narrow border lines may print unevenly, and you can end up with a line that is thicker on one side of the image than the other. Unfortunately, the only way to tell if this will be the case is to make a print and see what it looks like.

1. In this example, a *2x2 landscape* template was chosen and the Zoom to Fill option was checked. The images selected here filled each of the print cells.

2. Even with the Zoom to Fill option selected, there was room to change the image placement. If you click and drag a print cell preview (as I did with the bottom-right photo), you can scroll an image to obtain a better-looking crop.

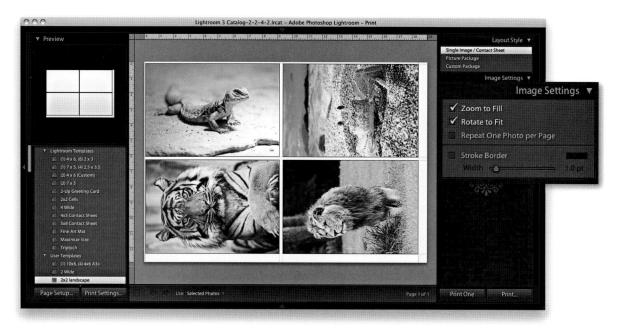

3. The Rotate to Fit option ensured that all images were rotated to best fit the cells. In this example, the three portrait-oriented images were rotated to best fit the landscape-oriented cells in the *2x2 landscape* print template.

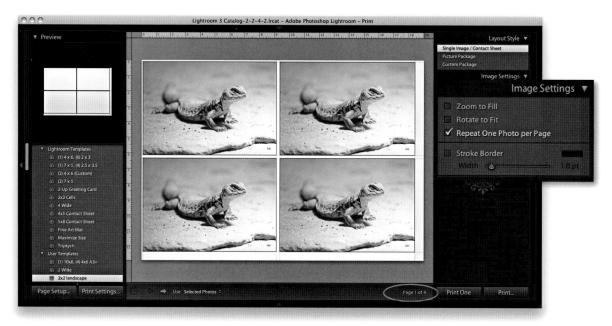

4. In this figure, I selected the Repeat One Photo per Page option. This made each image in the current selection populate all the cells per page layout. Shown here (circled) is page 1 of 4 pages.

Layout panel

The Layout panel lets you decide how an image (or multiple images) are positioned in a page layout, and scrolling through the Lightroom print templates in the Template Browser panel gives you a quick feel for how the layout controls work. Notice how the Layout panel settings in **Figure 10.4** relate to the page layout shown in **Figure 10.5**. Also note how the Margins settings take precedence over the Cell Spacing and Cell Size settings. Once the margins have been set, the Cell Spacing and Cell Size adjustments will adapt to fit within the margins.

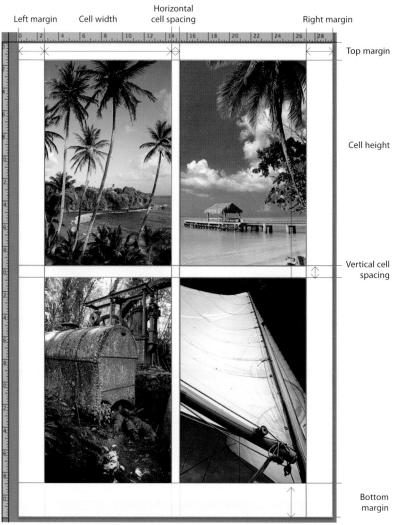

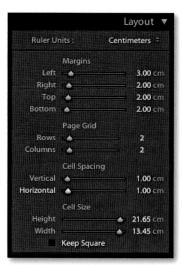

Figure 10.4 The Layout panel.

A quick way to adjust the margins or, indeed, any of these guides is to click the guidelines in the content area and drag them manually. Note that when you make layout adjustments using this method (or casually adjust the sliders in the Layout panel), the images will often auto-adjust in size as you make refinements. If it is essential that the images be a specific size on the page, it is best to use the Layout panel method because this allows you the most precise control over the image placement and layout measurements.

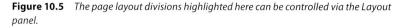

As you adjust the Page Setup settings to select different paper sizes, the Page Bleed area will vary and often appear asymmetrical. This is because some printers require a wider page bleed gap along the trailing edge of the paper as it comes out of the printer. With some applications, centering the print centers the image without allowing for the offset page bleed area; therefore, prints may still print off-center. With Lightroom, turning on the Page Bleed view lets you take into account the page bleed and adjust the margin widths accordingly. This ensures that your prints are always properly centered.

Margins and Page Grid

To place an image precisely on the page, the first step is to set the widths of the margins. If you want to center a photograph, make sure that the margins are set evenly and, most important, that the image is placed within the widest page bleed edge. Inside of the margins is the Page Grid area, which, when set to print a single cell, prints a single image on the page. If you want to print multiple images on each page, as shown in the previous two examples, you simply adjust the number of Rows and Columns. The Cell Size sliders determine the size of the print cell area. If the Cell Size sliders are dragged all the way to the right, the cell sizes expand to the maximum size allowed. But by making these smaller, you can restrict the printable area within the cell. However, note that the Cell Size adjustment is always centered within the Page Grid area set by the margins and that the margin adjustments always take precedence over the Page Grid area. Any readjustments made to the margins, therefore, have an effect on the cell size area. The Cell Spacing sliders are active only if the Page Grid is set to use two or more cells. If you refer back to Figure 10.4, you can see how I applied a 1 cm Vertical and Horizontal spacing to the 2x2 image layout.

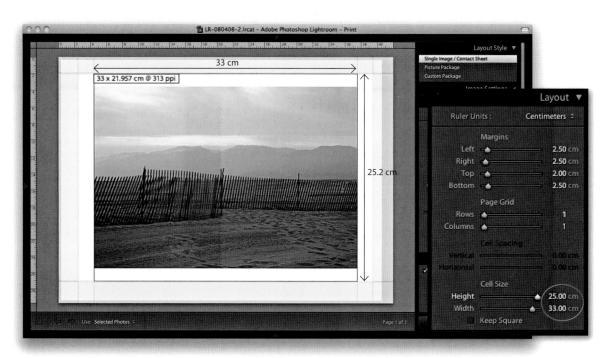

1. In this page layout, the margins (which are shaded pink) constrain the printable area by 2.5 cm left, right, and bottom, and by 2 cm on the top. The cell size is set to the maximum height allowed, which is 25.2 cm. But since the image width has been constrained to a 33 cm Width setting, the print image fills the width but does not fill the full height of the cell.

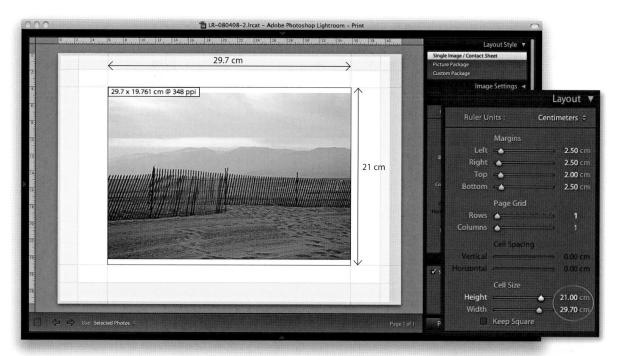

2. In this example, the margins remained the same, but the cell height and width sizes were reduced to an A4 metric size of 21 cm x 29.7 cm. Note also the Dimensions box in the top-left corner of the print cell. This indicates the actual print size and resolution (see below).

Guides panel

The Guides panel helps you plan a page layout. The rulers can be made visible by checking Rulers in the Guides panel (or use **#**(R) [Mac] or (Ctrl)(R) [PC] to toggle ruler visibility). The ruler units can be altered by clicking the Ruler Units menu in the Layout panel (Figure 10.6), where you can set them to inches, centimeters, millimeters, points, or picas. The Page Bleed displays a light gray shading to represent the non-printable areas, while the Margins and Gutters and Image Cells check boxes allow you to independently show or hide these items. When the Dimensions box is checked, Lightroom displays the print dimensions in the top-left corner of the cell. This shows the physical unit dimensions; if Print Resolution is deselected in the Print Job panel, it also shows the pixel resolution at which the file will print. Note it is recommended that you deselect Print Resolution in the Print Job panel and let Lightroom automatically calculate the pixel resolution for you. This is because Lightroom can auto-print-sharpen for any pixel resolution between 180 and 480 pixels. If the photo's image size exceeds these limits, a plus or minus sign appears, warning you to set an appropriate print resolution in the Print Job panel. Finally, the Show Guides check box displays or hides all of the previously mentioned Guides panel items.

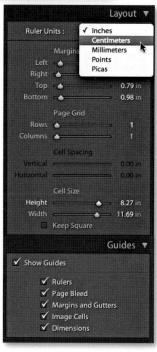

Figure 10.6 The Layout and Guides panels. Note that you can set the ruler units via the Layout panel.

TIP

Instead of printing a contact sheet from the Print module, you can always output it as a PDF document via the Print dialog (see page 532). Printing a PDF can be useful for several reasons. For example, with some printers, if you run out of ink during a print job where you are printing multiple pages and need to replace a cartridge, the printer will start reprinting again from page 1. Instead of clicking Print, you might want to generate a PDF and print the PDF via a program like Acrobat, where you can select which individual pages are printed. The other advantage of saving the print data as a PDF is that you can send a print document such as a contact sheet via e-mail for others to open via a PDF reader program on their computer or print remotely.

Multiple-cell printing

When the Single Image/Contact Sheet layout is set up to print using multiple cells, the Cell Spacing options in the Layout panel become active, letting you set the gap spacing between each cell. In **Figure 10.7**, I created a custom 3x3 contact sheet template in which the Cell Spacing was set to 0.5 cm for the Vertical and Horizontal spacing. The Cell Size and Cell Spacing settings are interdependent. So remember, if you adjust one setting, the other will compensate. Notice that for this contact sheet layout, the Keep Square option was left unchecked. For some contact sheet template designs, it can be useful to have this item checked because it ensures that landscape and portrait images are all printed at the same size on the page and are always printed upright without having to rotate the images for the best fit within the cells. In this case, it was not necessary to do so since all the photos were oriented the same way in portrait mode.

Multiple-cell print templates are ideal for generating contact sheet prints from large selections of images. Where more images are selected than can be printed on a single page, you'll find that the extra images auto-flow to fill more pages using the same template design and create as many print pages as necessary to complete the job. However, you do need to be aware that the Print Job settings will have a major impact on how long it takes to render multiple pages of images. For fast contact sheet printing, I suggest you always choose the Draft Mode Printing option in the Print Job panel. With this option selected, Lightroom renders the contact sheet images based on the high-quality preview images that already should have been generated. I say "should have" because this is something you may have to check before you click Print. Whenever a new batch of images is imported. Lightroom automatically generates the thumbnails followed by the standard previews for all the images. If you have just imported a large number of photographs into Lightroom, it may take a little while for Lightroom to generate all the standard previews, and until Lightroom has done so, Draft Mode Printing may result in some of the images appearing pixelated when they are printed out. This is because they will have been rendered from the low-resolution thumbnails only. It is, therefore, a good idea when you are in the Print module to carry out a guick preview of all the pages that are about to be printed and check whether the image previews look like they have all been fully processed. If you see an ellipsis warning indicator in the top-right corner, this means that Lightroom is still busy rendering the preview for that image. Having said this, it does seem to be the case now that because the Lightroom 3 catalog management is much faster than it was before you are less likely to encounter this problem and the previews can be accessed in the Print module more or less right away. Overall, I find that the Draft Mode Printing option in Lightroom is invaluable in the studio because the print rendering process can be so quick. The only limiting factor is how long it takes the printer to print out all the pages!

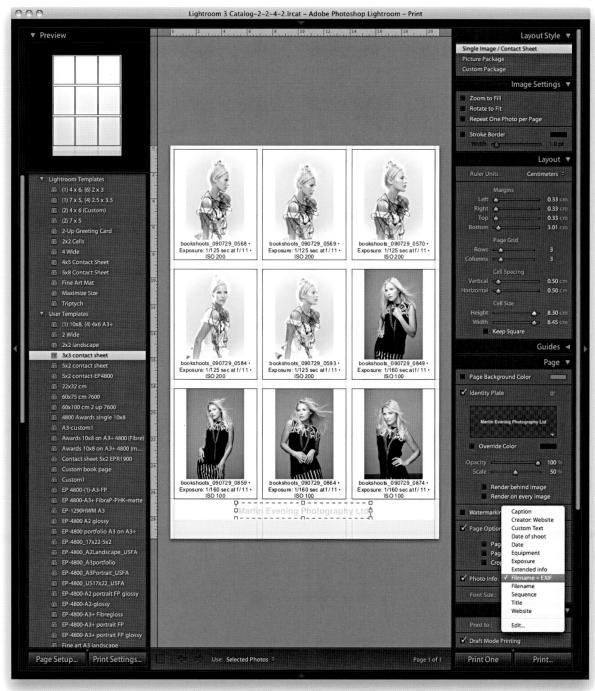

Figure 10.7 *Here is an example of a 3x3 contact sheet template showing the Layout panel and Page panel settings.*

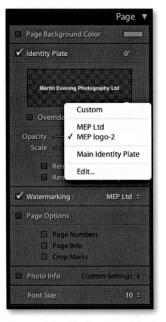

Figure 10.8The Page panel showingthe Identity Plate menu.

Page panel

The Page panel options determine which extra items are printed (Figure 10.8). The Page Background Color option allows you to choose an alternative backdrop color to print with. For example, you might want to choose black for a contact sheet image layout. When the Identity Plate option is selected, you can click in the Identity Plate preview to reveal the list of Identity Plate presets, and choose Edit to open the Identity Plate Editor dialog. Here, you can choose between adding a styled text name plate or a graphical logo. You can then use the Page panel controls to adjust the Opacity and Scale. In the following steps, I used the Scale slider to set the Identity Plate size to 90 percent, but you can just as easily do this by clicking and dragging the corner or side handles of the box. You can print an identity plate as big as you like, as long as the identity plate image has a sufficient number of pixels to print from. (On pages 514–515, I show how you can use a large graphical identity plate to overlay a photographic border.) Also, you can rotate the identity plate by going to the Rotate menu circled below. If you want to repeat your logo in a multiple grid cell layout, choose "Render on every image"; plus, there is a "Print behind image" option for placing large identity plate images in the background. The Watermarking section allows you to add a watermark as part of the print image. (Refer back to Chapter 9 for details on how to configure the new Watermark Editor in Lightroom 3.)

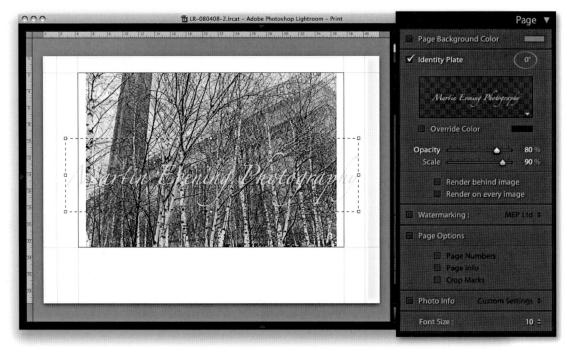

1. When the Identity Plate option is selected, the current Identity Plate can be added as an overlay. Click the rotate button (circled) to adjust the identity plate rotation option.

Identity Plate Editor	O O Colors O	Color	2.2
Use a styled text identity plate Use a graphical identity plate		Baic color:	·
Martin Evening Photography Zapfino Regular 24		Defen Caton Coke >> Of Cancel	Hur: 160 Red: 192 Sat 0 Green: 192 Color/Sold: Lum: 181 Blue: 192 Add to Cuntom Colors
Custom Cancel OK			

2. If you want to change the Identity Plate settings, click the downward triangle in the bottom-right corner of the Identity Plate preview in the Page panel and choose Edit This opens the Identity Plate Editor dialog, where you can choose an alternative font and font size. To change the font color, click the font color swatch (circled) and use the system color picker to choose a new color.

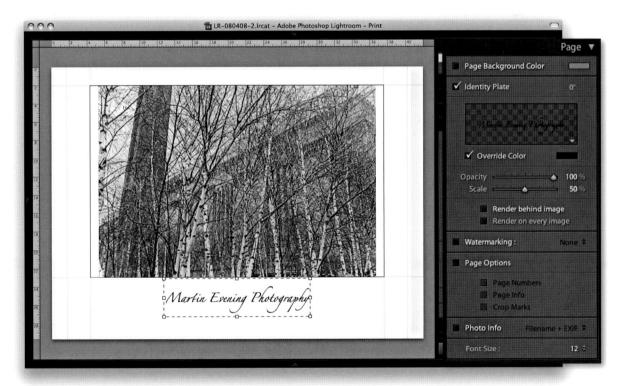

3. Now back to the Print module. I clicked the Identity Plate bounding box and dragged to move it downward, keeping it centered horizontally, and readjusted the scale to make the Identity Plate size smaller. The Identity Plate can also be nudged in small increments by using the arrow keys on the keyboard.

You can download the PNG mask border image used here from this book's Web site.

Downloadable Content: www.thelightroombook.com

How to add a photographic border to a print

It's not immediately obvious that you can add an image of any size as a graphical identity plate, since the preview area in the Identity Plate Editor is so small. This is because graphical identity plates that are intended for use in the Top panel should not exceed 57 pixels in height and the small preview space helps you judge the correct height to use here (see the warning message in Step 2). For print work and other identity plate uses, there is absolutely no reason why you should be limited by this constraint. You can add a graphic such as a scanned signature or company logo at any size you like, as long as they have a suitable number of pixels to reproduce smoothly in print. Thanks to my colleague Sean McCormack, I was shown the following technique for adding a photographic border to Lightroom print images via the Page panel. In the example shown here, I used a scanned photographic border image, but you can easily substitute other types of borders, or use the Paint tools in Photoshop to create your own!

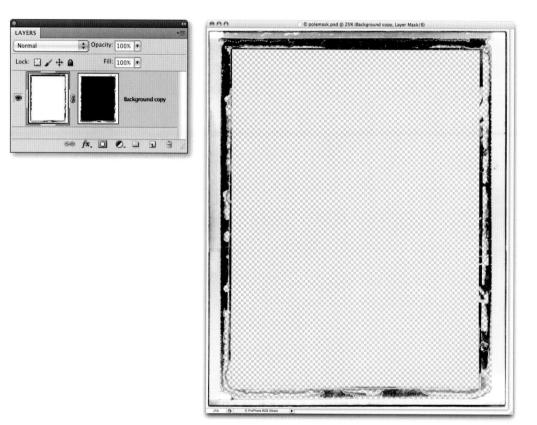

1. In this first step, I edited a photograph of a border in Photoshop. This picture is a scan of a Polaroid film border, where I created a mask of the center and the semitransparent border edges and hid them with a layer mask. I saved this master image as a flattened PNG file.

O O Identity Pla	e Editor	This file is very large (3592 x 4381). We
O Use a styled text identity plate 🖲 Use a graphical identity plat	•	recommend choosing a smaller file.
	an deneral fair than may be for the density of the second second second second second second second second seco	Cancel Use Anyway
Locate File	Clear Image	
Polamask-2	(Cancel) OK	

2. In Lightroom, I clicked in the Identity Plate preview area and selected Edit. This opened the Identity Plate Editor window, where I switched to the "Use a graphical identity plate" option, clicked the Locate File button to choose the recently saved PNG border file, and saved it as a new identity plate.

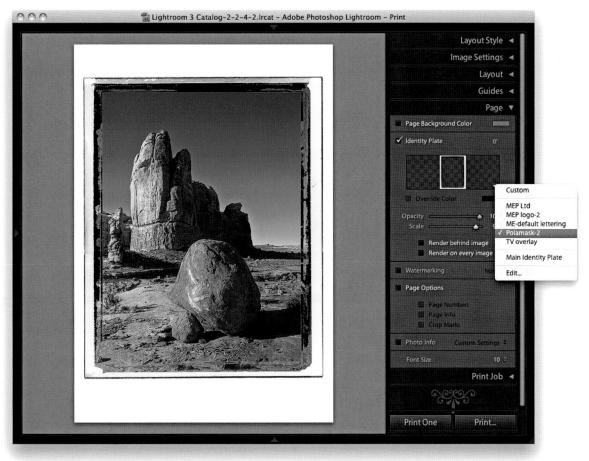

3. I selected the new Identity Plate setting in the Page panel and adjusted the scale to make the identity plate fit the edges of the photo.

The Sharpening info displays only the sharpening method (Standard, High, or Low) and doesn't tell you if the setting used was for glossy or matte media.

Page Options

The Page Options allow you to add useful extras. For example, I find the crop marks are handy for when I need to trim prints after output (although the cut guides described on page 521 can make this even easier). The Page Info item prints all the information relating to the print output—such as the sharpening, profile, and printer—along the bottom of the page. This can be useful if you are running tests to evaluate the effectiveness of various profiles and print settings. The Page Numbers option adds a number to the bottom-right corner of the page and is, therefore, useful if you need to keep the print outputs in a specific page order.

In **Figure 10.9**, I was about to print a photograph with a white background, so I added a thin black border (via the Image Settings panel) to frame the picture for me. You can choose a border width setting between 1 and 20 points, but if you are using the narrowest border width, make sure the print output resolution is at least a 300 pixels per inch.

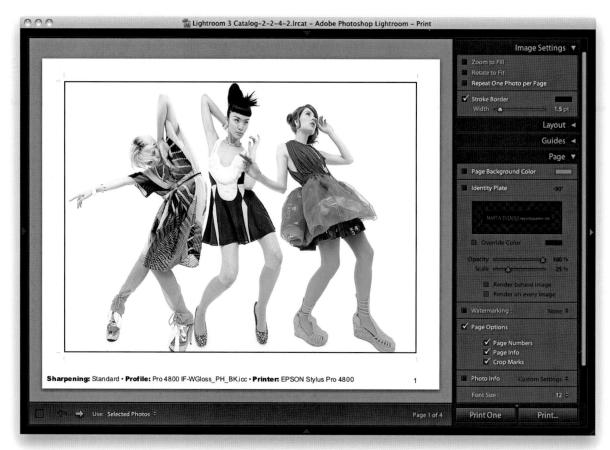

Figure 10.9 The Page panel Page Options.

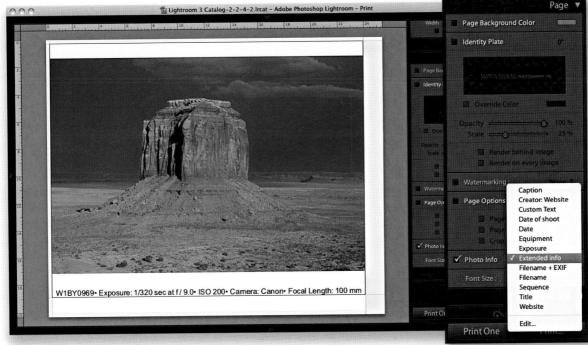

Figure 10.10 Photo Information can be added below each frame. In this example, I clicked the Photo Info menu in the Page panel to select a custom template that was created using the setup shown in Figure 10.11.

Photo Info

The Photo Info section lets you add photographic information below each frame (as shown in **Figure 10.10**), where you can click the menu to choose from a list of basic, commonly required items such as Filename or Date. If you choose Edit, this opens the Text Template Editor shown in **Figure 10.11**, where you can select tokens from the pop-up menus to add to the Photo Info display. You just click the Insert button to add a selected pop-up menu token to the Photo Info template design; plus, you can also add typed text in between the tokens, as shown in Figure 10.11. Once you are finished, go to the Preset menu at the top and choose Save Current Settings as New Preset; then click the Done button below. Once the Photo Info settings have been configured, you can simply select a preset from the Photo Info menu and choose an appropriate font size for the Photo Info text.

This feature has many practical uses, especially as there are many choices of photo information items that can be printed out below each picture. For example, if you are cataloging a collection of images, you may want to print contact sheets with all the technical data included. Or, if you are sending contact sheets to a client, you may want to include the filename, caption, and copyright information.

	Text Templa	e Editor	
Preset:	Extended info (edited)		
Example:	VB7J8442+ © Jeff Schewe+ 8	xposure: Yteos sec at f / S.6.	ISO
	me • Copyright • E seed Rating • Camera Length	oposure: Exposure • Make • Focal Length:	
Image Nan	N		
	Filename	insert)	
	Original filename	insert	
Numberin			
	[Image # (1)	(Insert)	
	Date (YYYY)	insert)	
EXIF Data			
	Exposure	(Insert	
	Dimensions	(Insert	
	Dimensions	t Insert	
IPTC Data			
	Title	(Insert	
	Caption	(Insert	
	Copyright	(Insert	
Custom			
	Custom Text	Insert	
			e ****

Figure 10.11 The Text Template Editor can be used to create custom Photo Info templates. Clicking Insert adds a new token. If you select an inserted token to make it active, you can choose a new token below and click Insert to replace it.

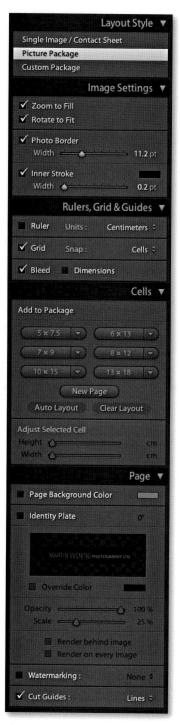

Figure 10.12 This shows the panel options for the Picture Package layout.

Picture Package and Custom Package panels

So far, we have looked at the Single Image/Contact Sheet options, but there is also a Picture Package engine mode that has its own set of configuration panels, as well as a few custom templates that can be accessed from the Template Browser panel. These can be readily identified by the bracketed numbers such as the (1) 4×6 , (6) 2×3 template that is shown selected in **Figure 10.13**. The purpose of the Picture Package templates is to enable you to produce multiple-sized photographs on a single page layout. For example, commercial portrait photographers may use this feature to produce multiple print variations on a single sheet of paper. Rather than be forced to print out two or more different print sheets that use different print sizes, you can produce all the different size prints you need on one sheet of paper.

Image Settings panel

Here you have the same Zoom to Fill and Rotate to Fit options as you have in the Single Image/Contact Sheet layout style mode. There is also a Photo Border slider for setting the border width inside each cell and an Inner Stroke slider that can be used to set the stroke border width.

Rulers, Grid & Guides Panel

The Ruler check box and Units options are identical to those discussed earlier, while the Grid check box allows you to switch the Grid display (the colored graph pattern) on or off. Next to this are the Snap options. Basically, you can customize the Picture Package layouts by dragging and dropping individual cells. The Snap options mean that you can choose to snap to the grid lines or other cells when adjusting the placement of the cells (or switch the Snap option off, if you prefer).

Cells panel

To create a new Picture Package layout setting, you need to select Picture Package in the Layout Style panel and click the Clear Layout button in the Cells panel. You can then add new cells to the blank Picture Package layout by clicking the cell size buttons. These range in size from 2×2.5 inches to 8×10 inches (or 5×7.5 cm to 13×18 cm, if using centimeter units).

You can stick with these default size recommendations or click the button options arrow and select Edit to create and add a new custom cell size (see **Figure 10.14**). As you click the cell buttons, new cells are added to the layout, and these are automatically placed to best fit the current Page Setup layout (**Figure 10.15**). To better arrange the cells, you can also try clicking the Auto Layout button, which rearranges the cells to find what would be the best fit for the page layout. Lightroom does so with a view to what would be the most efficient use of space, yet still allowing you to trim your photos easily with a paper cutter. As you try to

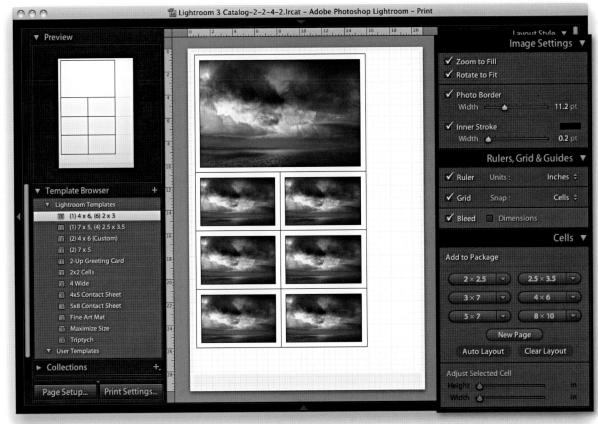

Figure 10.13 This shows an example of a Picture Package layout using the (1) 4 x 6, (6) 2 x 3 template.

squeeze in more cells, there will come a point when Lightroom may allow you to place one more cell, but this won't necessarily allow you to trim the pictures so easily. Even so, Auto Layout can otherwise be a useful paper-saving option. The alternative is to click a cell and manually drag it to a desired location on the page. This is where the Snap options can come in handy: They can help you align your cell images successfully. After this, you can use the Zoom to Fill, Rotate to Fit, and Photo Border options in the Image Settings panel to refine the layout and determine how the photos will fill the cell frames.

As you add more cells and there is not enough room on the page, new pages are added automatically (as shown in **Figure 10.16**). Alternatively, you can click the New Page button to manually add a new page and adjust the arrangement of the cells layout across two or more pages. If you want to delete a page, click the red cross in the top-left corner.

Figure 10.14 You can create new cell size settings by clicking a cell size arrow and selecting Edit. (The cell sizes shown here are using inches.)

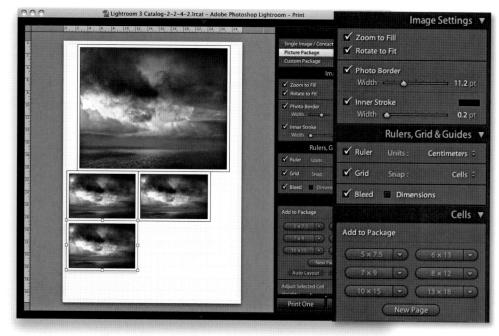

Figure 10.15 This shows a new Picture Package layout being created, where a new cell has been added to the current layout. You can click and drag to reposition the cell anywhere on the page layout.

COO 🛍 Lightroom	3 Catalog-2-2-4-2.lrcat - Adobe Photoshop Lightroom - Print	Cells 🔻
Control Extensis Control Control Extensis Extensis Extensis Extensis Extensis Extensis Extensis Extensis Extensis		Add to Package
		5×7.5 🔻 6×13 👻
		7×9 - 8×12 -
	10.	
		New Page Auto Layout Clear Layout
		Adjust Selected Cell Height Common cm Width Common cm
		Page 🔻
		Page Background Color
		✓ Identity Plate 0°
Differing Photography Ltdo		Martin Evening Photography Ltd
	-	Override Color

Figure 10.16 As more cells are added, they may overflow onto new pages. Or, you can click the New Page button to add new pages to a Picture Package layout.

Page panel

The Page panel now allows you to choose a custom background color when printing. This might be useful if, say, you wanted to print a set of contact sheet images with a black background. Below, you can add a custom identity plate to a Picture Package layout (as shown in Figure 10.16). One unique thing that's featured in the Picture Package mode is a Cut Guides option. When this item is checked, it adds cut guides to the print that can be in the form of crop marks at the edges or crop lines that intersect on the page. Now, although this feature is for Picture Package layouts, it also happens to be useful for single-image print layouts such as the example shown in **Figure 10.17**. This can makes it easier to trim prints to an exact size in cases where it is not easy to see where the print edge should be, such as in the example shown in Figure 10.9, where the background is all white.

TIP

It would be nice if the Single Image/ Contact Sheet layout had a Cut Guides option. But since it doesn't, you can use this workaround instead: First, figure out what the cell print area should be and add this as a new custom cell size. Add one cell only to the page, check the Cut Guides option, and choose the Lines option. When printed, you can use the lines to align the image on the paper cutter and trim your photos to produce perfectly trimmed borderless prints.

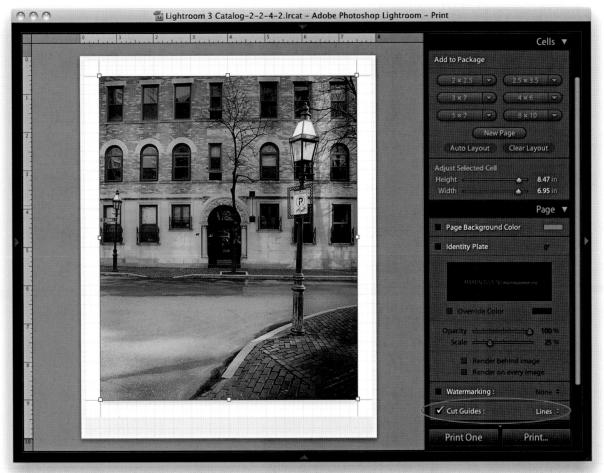

Figure 10.17 The Cut Guides option can be used to add crop trim guides to photos.

Downloadable Content: www.thelightroombook.com

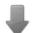

Custom Package layout

The Custom Package layout can be regarded as an extension of the Picture Package layout style. The main difference here is that, with Custom Package, you can create and save free-form layouts for placing selected, individual photographs on a page. In the following example, I have shown how you could use this layout engine to produce a scrapbook-style page, prepare for print, and save the layout for future use.

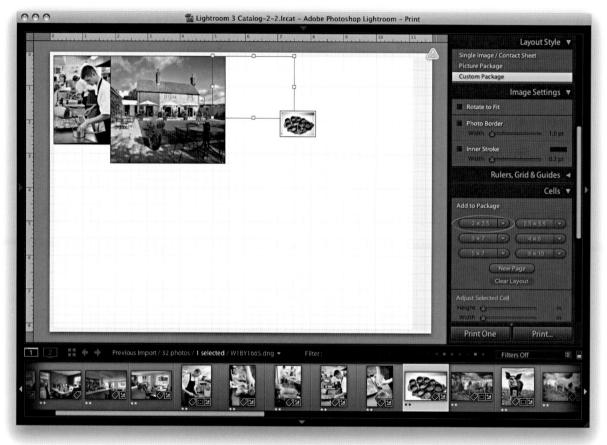

1. When the Custom Package option is selected, you can add frames to the layout in two ways. You can click the buttons in the Cells panel, such as the 2 x 2.5 cell circled here. Once you have done this, you can resize the cells as desired and drag photos from the Filmstrip into the layout cells. This provides you with a better indication of how the final custom package might look. Alternatively, you can simply drag any photo from the Filmstrip into the Custom Package layout to place it on the page.

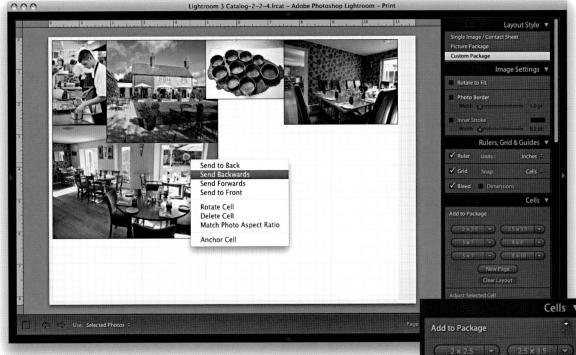

Once placed, you can edit the size and proportions of each cell by clicking to 2. select it and drag one of the handles to achieve the desired size and shape. You can also use the contextual menu (right mouse click a cell) to access the options shown here. These allow you to adjust the relative position of a cell, moving it either to the front or to the back of the Custom Package page layout. You can also select or check the Match Photo Aspect Ratio option to change the size of a cell in a pre-prepared Custom Package layout so that it matches the proportions of the placed photo. Or, you can use this menu to rotate, delete, or anchor a cell. If you click the New Page button (circled right), you can add extra pages to a Custom Package layout. Where an image is anchored, this allows you to keep an image locked to the layout design so that, as new pages are added to a layout, the anchored images appear automatically on each page in the same location. For example, this could be useful if you were designing a layout in which you needed certain images or logos to appear in the exact same place on each page. But bear in mind that the Custom Package layouts are limited to six pages at a time. Having said that, it is possible to create batches of Custom Package layouts and use the arrow keys in the Toolbar (see Figure 10.18) to navigate between them.

Page 7-11 of 11

Figure 10.18 The Toolbar shows here that Custom Package layouts are limited to six pages at a time and that you can use the arrows to move between sets of layout pages.

Agurt Selected Cell Add to Package 2 × 2.5 ▼ 3 × 7 ♥ 4 × 5 ♥ 5 × 7 ♥ New Page Clear Layout Adjust Selected Cell Height Notate Cell F Lock to Photo Aspect Ratio

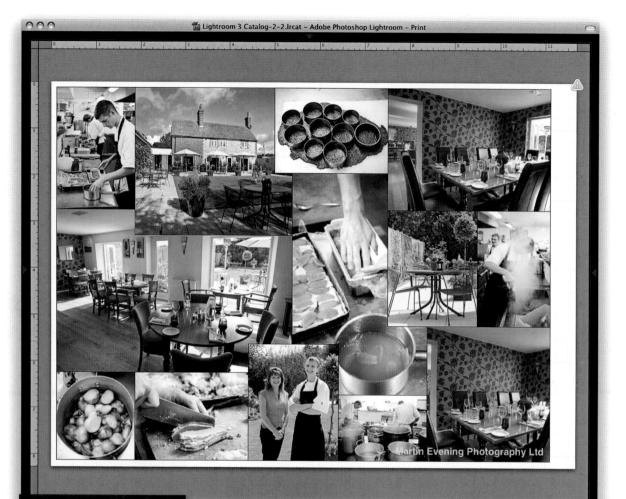

3. Here you can see an example of a completed layout in which I added enough cells to fill the whole of the printable area of the page. The black lines you see here are only guides; they won't show when the final print is made. You can also add an identity plate logo to the layout. Here I checked the Identity Plate option in the Overlays panel and adjusted the settings as shown on the left to add an identity plate in the bottom-right corner. Note that if you check the "Render on every image" option, this adds the identity plate to each and every image in the layout. By the way, these photographs were all shot at the Mulberry Tree restaurant in Kent, England, from a reportage shoot I carried out with my colleague Jeff Schewe.

4. Once I was happy with the Custom Package layout, I was able to save it as a custom user layout. I clicked the Add New Preset button (circled red) and named the preset as a new print template. This allowed me to access the template again in the future and use it with different collections of images, or edit as desired. It's also important to note that you can save specific template layouts with the photos used, which you can do by saving print collections. So, for example, where I had spent time carefully selecting and positioning the photos displayed in Step 3, I was able to click the Add Collection button (circled blue) and create a new print collections, which you can see added to the *Locations* folder in the Print module Collections panel. Such collections are preserved until you either edit and update a collection setting or choose Delete to remove them.

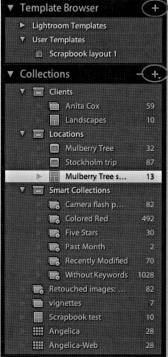

Page Setup

Before making an actual print, you first need to click the Page Setup button at the bottom of the left panel section or use the **B A Shift P** (Mac) or **Ctrl A Shift P** (PC) shortcut. This takes you to the Page Setup system dialogs for the Mac or PC operating systems, shown in **Figure 10.19** and **Figure 10.20**, respectively. The main aim here is to establish which printer you intend to use and enter the paper size you are about to print to, followed by the paper orientation: either portrait or landscape. The Paper Size options will most likely vary depending on which printer model you have selected, and the subsequent options will be restricted to the various known standard paper sizes that are compatible with that particular printer. However, if the size you want to use is not listed, it is usually quite easy to create a new custom page size. The main difference between the PC Print Setup dialog and the Mac dialog is that the PC dialog allows you to click the Properties button and go straight to the Print Settings section of the system Print dialog (which is why there is only a single Page Setup button).

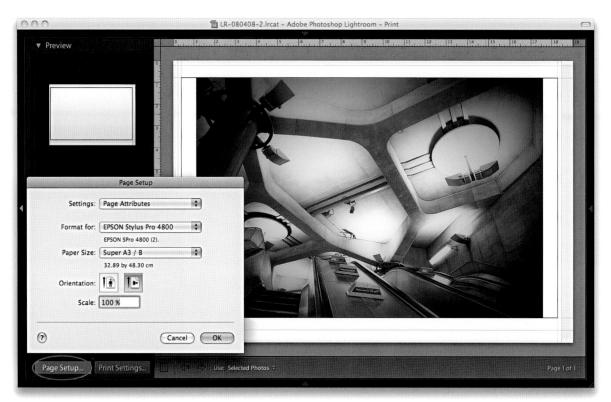

Figure 10.19 When you click the Page Setup button in the Mac version of Lightroom, you will see the Page Setup dialog shown here. You can then configure which printer to use, the paper size, and page orientation (portrait or landscape). The Scale box allows you to scale the size of the print output, but I advise you to leave the Scale set to 100% and use the Layout panel in the Develop module to scale the output size for the printed image.

Le Lightroom 3	Catalog-2-2 - Adobe Photoshop Lightroom - Print	
File Edit Prin	nt View Window Help	
▼ Previ	ew	<u>u u u u u</u>
Print Setup		
Print Setup		A
Name:	EPSON Stylus Pro 4800 Properties	
Status: Type: Where: Comment	Ready EPSON Stylus Pro 4800 USB002	4
Paper	Orientation	3
Size:	Super A3 / B 329 x 483 mm Portrait	
Source:	Manual Feed	
Help	Network OK Cancel	
Ć	Page Setup	Page 1 of 1

Figure 10.20 If you click the Page Setup button in the PC version of Lightroom, you will see the Print Setup dialog shown here, where you can choose a printer and set the paper size and orientation (either portrait or landscape). When you have done this, click OK to close the Print Setup dialog. You will notice that the PC Print version of Lightroom now features a single Page Setup button. This change was brought about in version 2.1. Basically, the Page Setup and Print Settings buttons opened the same dialog, so it makes sense to have just the one button here.

Print resolution

In Lightroom, there is no need to resize an image for printing. After you have configured the Page Setup settings, you can let Lightroom automatically set the print resolution by deselecting the Print Resolution box in the Print Job panel. When you do this, Lightroom either samples the image down or up in size to produce a print image with the right number of pixels to match the image dimension size that is a result of the Page Setup and Layout panel settings. It is only when the print resolution ends up falling outside the 180 ppi to 480 ppi range that you need to override the print resolution setting by checking this box and manually entering a value.

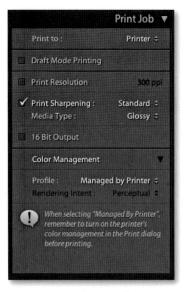

Figure 10.21 The Print Job settings panel.

Print Job panel

People often ask if Adobe could come up with a better print driver. But this is a problem that neither Adobe nor the printer manufacturers are able to resolve completely. This is because the print driver interfaces are dictated by the rules laid down by the computer operating system. Lightroom is able to ease the printing headache a bit by helping to lock down some of the settings, but whenever you click the Page Setup, Print Settings, or Print button, you are totally in the hands of the operating system and print driver.

Print job color management

The Color Management settings provide you with simple and advanced printing options. For the simple printing method, leave the Profile set to Managed by Printer (**Figure 10.21**) and click the Print Settings button to open the Print dialogs shown on the following pages. Basically, you need to check that the right printer is selected (the same one that's selected in Page Setup) and choose the appropriate print settings, such as the paper media type you are going to print with and the print quality. But most important, if you are using the Managed by Printer option, the ColorSync option must be checked in the Color Management section if you are on a Mac; if you are using the PC version of Lightroom, the ICM button must be checked in the Advanced Print Properties panel. After you have configured the relevant print settings, click Save to save these print settings changes.

The Lightroom printing procedure

Regardless of which print method is used, the printing procedure is essentially the same. You must first configure the Page Setup settings to tell Lightroom which printer you are printing to and the size of the paper you are using. Next, you configure the Print Settings to tell the printer how the print data should be interpreted. Then you can click the Print button (IMP [Mac] or [Ctrl P] [PC]). which takes you to the final Print dialog. Or, better still, use the Print One button (I Alt P [Mac] or [Ctrl Alt P [PC]), which bypasses the system dialog completely. The following steps show the settings that you would use for printing to an Epson R1900 printer. The print driver dialogs vary from printer to printer; some offer different driver interface designs and, in some cases, more options. It is unfortunate that there is no easier, universal way to describe the printing steps that you should use here. The thing is, the print drivers are designed by the printer manufacturers, which, in turn, have to work within the limits imposed by the different computer operating systems. Not even Microsoft and Apple can agree on a common architecture for the print driver settings. It may be helpful to know, though, that once you have configured the page and print settings, you can permanently save these as a print template. And because you are able to save the page and print settings, you can lock the correct print settings to a template and avoid having to configure the print driver every time you make a print.

Managed by printer print settings (Mac)

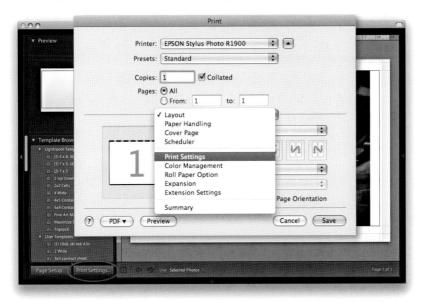

1. I clicked the Print Settings button ((#Alt) (Ashift) [Mac] or Ctri) (Alt) (Ashift) [PC]) to open the Print dialog, which is shown here with the full list of options for the Epson Stylus Photo R1900 printer. You'll often need to select the printer again here and make sure that it matches the one selected in the Page Setup dialog.

000	Print	
LT ADDREPHOTOSHOP LIGHTROOM 3	Printer: EPSON Stylus Photo R1900 € ▲ Presets: Standard € Copies: 1 € Collated Pages: ④ All From: 1 to: 1	now Print Web
Veruplate Browser Lightnoom Template () 4 × 4 (6 2 × 3) () 17 × 5 (6 2 × 3) () 17 × 5 (6 2 × 3) () 17 × 5 (6 2 × 3) () 27 × 5 () 20 Cells () 4 wold () 4 Context Sheet () The Art Mat () Macanza She () The Art Mat () Macanza She () The Art Mat () Macanza She () The Art Mat	Print Settings	No.
 User Templates m) (Dots, (4) 4vd A3+ Page Setup 	(?) (PDF • (Preview) (Cancel)	Save Puge Loft

2. In the Print Settings section, I selected the media type that matched the paper I was about to print with, chose the Color inks option, and set the print mode to Advanced, where I could select a high-quality print output setting.

NOTE

The simple print method outlined in these steps will work reasonably well for many photographers. While I appreciate that some of the more advanced drivers provide a greater range of options, I have offered here basic print settings that are common to most print drivers. Personally, I use the method described here only for Draft Mode Printing to make contact sheet prints.

There was a time when the canned paper profiles that shipped with most inkjet printers were good enough only for getting the colors to roughly match the colors seen on a calibrated display. The inkjet printers you are able to buy these days are a lot more consistent in the quality of print output they can produce, and the standard paper profiles that ship with these products are, therefore, a lot more accurate. So if you are using a printer without custom profiles, the simple print workflow outlined here should produce good results, although you will be locked into using the Perceptual rendering intent (see the "Rendering Intent" section, later in this chapter).

NOTE

Not all print drivers are compatible with applications such as Lightroom that can be installed as 64-bit programs. If some of the print settings appear to be crossed out, it may well be because the print driver needs to be updated to 64-bit, or there is no 64-bit driver available for certain older printers and you will have to run Lightroom as a 32-bit program in order to print.

NOTE

As you configure the Page Setup and Print settings, these are saved as part of the current print layout setup. If you proceed to save a print template, the Print settings will be saved along with all the other Layout settings. Later in this chapter, I show how to update an existing print template with the modified Print settings.

NOTE

When you use the printer color management shown here, the most important thing is to select the ColorSync or ICM color control option. There will sometimes be a further choice of Color Settings options. You definitely don't want to select Vivid, Charts and Graphics, or "No color adjustment." If offered the choice, select sRGB or, better still, Adobe RGB.

ADC		tr-080408	Pri	C.L. Data and the	ishop Lighti	room - P		and the second
-r Lic								Print Wel
▼ Previ	Printer: (EPSON S	tylus Pho	oto R19	00	\$		127
	Presets:	Standard	4		salahaja ay	•		
	Copies:	Consequences of the] ⊠ c₀	llated				411
_			1	to:	1			
	(Color Ma	anageme	nt		\$		_
• ue () Co	olor Controls olorSync ff (No Color Adjusi	tment)						
	PDF • Previe	2W)				C	Cancel Save	

3. Although there is sometimes a panel called ColorSync, don't confuse this with the Color Management section options. Here, I needed to click the ColorSync button to enable ColorSync color management. I then clicked the Save button to return to the Lightroom Print module.

Print Setup Printer Name: EPSON Stylus Photo R1900 Series Status: Ready Type: EPSON Stylus Photo R1900 Series Where: USB001 Comment: Image: Comment:	
Name: EPSON Stylus Photo R1900 Series Status: Ready Type: EPSON Stylus Photo R1900 Series Where: USB001 Comment:	2
Status: Ready Type: EPSON Stylus Photo R1900 Series Where: USB001 Comment:	
Type: EPSON Stylus Photo R1900 Series Where: USB001 Comment:	
Where: USB001 Comment:	
Comment:	
Den and the second s	
Paper Orientation	11.1480
Size: A3 297 x 420 mm 🔹 💿 Portrait	
Source: Sheet	
Source. Sneet	a all
Help Network OK Cancel	
The annual second se	THE REAL PROPERTY OF THE PARTY OF
Page Setup	Page 1 of 1

Managed by printer print settings (PC)

1. Here, I clicked the Page Setup button in the Print module. Note that the Print Setup dialog is the same as the one we saw earlier, in Figure 10.20. I now needed to click the Properties button to go to the Printer Properties dialog.

May Advanced Page Layout of M. Quality Option	aintenance	1
	Photo	
Beset Defaults Technical Support	Show Settings Cancel Help	Page 1 of 1

2. In the Printer Properties dialog, I selected the Best Photo print quality and the correct print media type. I then clicked the Advanced tab (circled).

Main 😵 Advanced 💮 Page Layo Paper & Quality Options	Color Management	<u>11. 19. 19. 12. 19. 14. 19. 11.</u>
Sheet Settings(0)	Color Controls	
Epson Premium Glossy 🔹	PhotoEnhance ICM	
Photo RPM 👻		
A3 297 x 420 mm 👻	Off (No Color Adjustment) ICM Mode	
Borders	Driver ICM (Basic)	
Orientation	Input Profile	TV AND
Portrait Q Landscape	sRGB IEC61966-2.1	ANT.
	Intent	WAR -
Print Options	Perceptual	TARASK AND
Reverse Order	Printer Profile	- And - Alexander
🕼 Gloss Auto 👻	EPSON Standard	The second s
✓ High Speed	Printer Profile Description	And the second s
🛄 Grayscale	SPR1900 Epson Premium Glossy	MALL & ALT
Edge Smoothing	Show all profiles.	
Custom Settings 🔹 Save Setting	Show this screen first	1.5%
Beset Defaults Technical Supp		

3. In the Advanced panel, I clicked the ICM Color Management button and set the ICM Mode to Driver ICM (Basic). In the Printer Profile section, I selected EPSON Standard so that the driver auto-selected the correct print profile. However, if the "Show all profiles" box is checked, you have the option to manually select a correct profile. I clicked OK to these settings and clicked OK once more, to return to the Lightroom Print module.

NOTE

When you buy a printer and install the print driver that comes with it, the installer should install a set of standard profiles for a select range of print media types that are designed for use with your printer. For example, if you purchase an Epson printer, the print driver installs a limited set of profiles for use with a specific range of Epson papers. If you want to add to this list, it is worth checking out the printer manufacturer's Web site and other online resources to see if you can obtain printer profiles that have been built for your printer. The alternative is to have custom printer profiles made by a color management expert.

There was a time when it was necessary to have custom print profiles built for each printer because of fluctuations in the hardware manufacture process. But these days, you can expect a much greater level of consistency. Hence, a custom profile built for one printer should work well when used with another printer of the same make.

TIP

Do not click the Print or Print One button in Lightroom until after you have configured the Page Setup and Print settings. You should use the Print buttons only after you have configured these other settings.

TIP

The most effective way to stop the system print preset settings from interfering with the Lightroom print settings is to click the Print One button. This ensures that the print output prints using the print settings established in Lightroom are not affected by any external factors.

TIP

On the Mac, you can click the PDF options and choose Save as PDF. Instead of making a print, this generates a PDF document from the print data, which can be used to print via another application, such as Adobe Acrobat. However, since we now have a Print to JPEG option, it is probably easier to use that option instead if your objective is to generate a print file that can be printed externally.

Print

After the Page Setup and Print settings have been configured, you need to send the print data directly to the printer. If you click the Print One button, Lightroom conveniently bypasses the system print dialog (see sidebar). Alternatively, you can click the Print button if you do wish to see the system print settings (**Figure 10.22** and **Figure 10.23**). The Printer model will be the same one you already selected. On the Mac, the Presets should be set to Standard. If Presets shows some other setting, reset it to Standard before clicking the Print button to print.

Printer: EPSON Stylus Photo R1900 • • • • • • • • • • • • • • • • • •	000	LR-080408-2.lrcat - Adobe Photoshop Lightroom - Print	
Printer: [PSON Stylus Photo R1900 • • • • • • • • • • • • • • • • • •	e	Print	Layout Style 🔻
Copies: I Collated Pages: All From: 1 to: 1 Layout Pages per Sheet: I Layout Direction: Z S VA Border: None Two-Sided: Off Reverse Page Orientation		Printer: EPSON Stylus Photo R1900	
Copies: 1 Collated Pages: All From: 1 to: 1 Layout Pages per Sheet: 1 Layout Direction: 2 S U N Border: None Two-Sided: Off Collated Reverse Page Orientation		Presets: Standard	Image Settings 🔺 Layout 🔺
Pages: All From: 1 to: 1 Layout Pages per Sheet: 1 Layout Direction: 2 5 4 N Border: None 6 Two-Sided: Off 0 Reverse Page Orientation	7		Guides « Page «
Layout Pages per Sheet: 1 Layout Direction: 2 Mage Directio			Page ∢ Print Job ▼ Printer
Pages per Sheet: 1 0 Market Pa	1	Layout	e Printing
Layout Direction: Z S 4 N Border: None C Two-Sided: Off C Reverse Page Orientation		Pages per Sheet: 1	
Border: None Magnetization Magnet		Layout Direction: Z S W N	e Glossy 5 put
Two-Sided: Off		Border: None	- Managed by Printer ÷
Reverse Page Orientation		Two-Sided: Off 🛟	instant Descriptions 2 Sections Managed by Printer
(?) PDF ▼ (Preview) (Cancel) (Print) Starter		Reverse Page Orientation	anagement in the Print dialog
		PDF Preview Cancel Print	12929/2
E to the set	📋 🤃 🗘 Use Sal		Print_

Figure 10.22 Clicking Print on the Mac reopens the system Print dialog. Make sure the Presets menu is set to Standard, and click Print.

ile Edit Print View 🗸	Adobe Photoshop Lightroom - Print Print	X	
	Printer Name: EPSON Stylus Photo R1900 Se Status: Ready Type: EPSON Stylus Photo R1900 Ser Where: USB001 Comment:		Layout Style 4 Image Settings 4 Layout 4 Guides 4 Page 4 Print Job 7 Printer 5 ning
	Print range All Pages from: 1 to: 1 Selection Help	Copies Number of copies: 1	9 200 9 Standard : Glooy 5 ent • Managed by Printer 5 ent by Printer 7 ent by Printer 7
	Calificated Photons C	Reperted a Rest Concern	Print_

Figure 10.23 Clicking Print on a PC reopens the Print dialog with the same settings. There should be no need to make any changes. Just click OK to print your image.

Printing modes

When you make a regular print output, Lightroom reads the image data from the original master file and resizes the image on the fly to match the print size specified in the page layout. This printing method ensures that you get the highest print quality possible, whatever the print size is. However, if you are processing a large number of images to produce a set of contact sheet prints, it can take a long time for Lightroom to read all the image data and resize the images. Whenever Draft Mode Printing is checked, Lightroom instead uses the image previews to generate the print files. The advantage of this approach is that the print processing time is pretty much instantaneous, which can make a huge difference in the time it takes to generate 10 contact sheet pages from a folder of 100 raw images. In draft mode, Lightroom uses whatever previews it has to work with. The Standard previews should be sufficient for most draft mode print jobs, so it might be worth visiting the Library module and choosing Library \Rightarrow Previews \Rightarrow Render Standard-Sized Previews before making a set of draft mode prints. Draft Mode Printing is perfect for any print job where speed is of the essence. For everything else (especially when you want to produce the highest-quality prints), you will want to deselect this option so that you can control the color management via Lightroom and apply the all-important print sharpening (see Figure 10.24).

Print sharpening

Photographic images inevitably appear to lose sharpness as a natural part of the printing process. To address this problem, it is always necessary to add some extra sharpening prior to making the print. Note that when Sharpening is selected in the Print Job settings, you won't be able to preview the sharpening effect, because Lightroom applies this behind the scenes to ensure that the picture looks acceptably sharp when printed. So, when you are working in the Lightroom Print module, the Sharpening options are essential if you want your prints to look as sharp as they do in the screen preview. Lightroom 2 introduced a completely new sharpening method for the print output, all thanks to Adobe working closely with PixelGenius to bring PhotoKit Sharpener routines to Lightroom. All you have to do now is enable the Print Sharpening option, indicate whether you are printing to matte or glossy paper, and choose Standard to apply the default sharpening. You can select Low or High if you wish to modify the standard strength setting.

Also, note that Lightroom automatically resizes the image data to the print size you have set in the Layout panel. As long as the print output image ends up falling within the range of 180 to 720 pixels per inch, there is no real need to use the Print Resolution option to interpolate the print data. In fact, you are advised not to, unless the image ends up falling outside of this resolution range. Basically, Lightroom can automatically apply the correct amount of sharpening on a sliding scale between 180 and 720 pixels per inch and it is best to let Lightroom work out the optimum pixel resolution and sharpening.

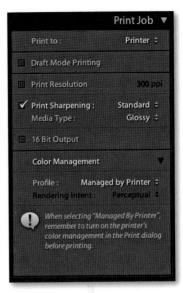

Figure 10.24 Here is the Print Job panel with the Print Sharpening set to Standard for glossy media.

NOTE

If you are making blow-up prints that contain high-frequency edge detail, it is worth checking the Dimensions display (see pages 502-503). If the output resolution falls significantly below 300 ppi, it may be worth using the Print Resolution box to manually set the resolution to 50 percent more than the native resolution. When you do this, Photoshop applies an adaptive upsampling routine that combines the Bicubic and Bicubic Smoother interpolation algorithms prior to applying the print output sharpening. This isn't necessary for all images—just those where the image contains a lot of fine edge detail. It is also worth pointing out here that the upper limit has been increased from 480 ppi to 720 ppi since Jeff Schewe discovered that some images could benefit from using a higher print output resolution.

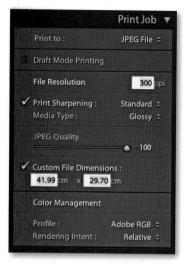

Figure 10.25 This shows the Print Job panel in Print to JPEG File mode. Notice how the File Resolution and Custom File Dimensions boxes have been highlighted, showing that these can be edited.

NOTE

I imagine some people will look at the Print to JPEG file feature and question why they have the option only to save a print file as a JPEG and not as a TIFF. Well, uncompressed print files can end up being very large. Truth be told, if you set the JPEG quality to the highest setting, or close to maximum quality, it is extremely unlikely that you will see the effects of JPEG compression in the resulting print file.

16-bit output

Image data is normally sent to the printer in 8-bit mode, but some more recent inkjet printers, such as the Canon IPF5000 are now enabled for 16-bit printing. You can take advantage of 16-bit printing as long as you are using the correct plug-in for the program you are working with; in the case of Lightroom you will need to make sure the 16 Bit Output box is checked. At the time of writing, I have not had a chance to see comparative tests between 8-bit and 16-bit printing. Some people who have tested such printers say the 16-bit printing option is overkill. Others claim they can see a difference. So, at this stage, I still can't say who is right. Given that 16-bit printing technology is now emerging, it does seem sensible to have this option available in the Lightroom Print module, but I don't think I am going to rush out and buy a new printer just yet!

Print to JPEG File

The Print to JPEG File option is available from the top of the Print Job panel and the JPEG file options are shown in **Figure 10.25**. This option was introduced by popular request because a lot of Lightroom customers were keen to have a way to produce image files directly from the Print module. As you have seen already in this chapter, it is really easy to set up contact sheet layouts and do things like add signatures or add an identity plate overlay as a custom photo border. With the Print to JPEG File option you can use the Print module to generate a JPEG image instead of sending the data to the printer.

In Print to JPEG mode, you have a Draft printing mode that can be used to quickly generate sets of contact sheet print files. For example, with a JPEG output file, you can send the file to another computer for printing. This is potentially useful for a number of reasons. For example, you can free up using the main computer while you let another computer manage the printing. Also, you can generate JPEG print files for others to share and print from, or you could output contact sheets from a shoot via the Print module and send these as e-mail attachments to a client or colleague so that he could run the prints off remotely. When you aren't in draft mode, you have access to the same sharpening controls as were discussed earlier. The JPEG quality slider allows you to control the degree of JPEG compression that is applied, and the File Resolution field can be edited to set a specific ppi resolution output. When the Custom File Dimensions box is checked, you can also edit the file dimensions (using the current ruler units) and proportions of the JPEG print files. In the Color Management section, you have a choice of the three main RGB output spaces: sRGB, Adobe RGB, and ProPhoto RGB, along with any other custom print profiles that you have loaded (see the next section on custom profile printing). You can then select the most suitable Rendering Intent option (which is discussed on page 538).

Custom profile printing

The Managed by Printer print method allows you to make prints where the color management is carried out by the print driver. If you are printing with a modern inkjet printer, you can expect to get good results using the Managed by Printer option, as long as the ColorSync or ICM option is selected in the print driver settings. However, if you want more control over how your images are printed or you want more options, you will be better off getting Lightroom to handle the printer color management. To do this, deselect the Managed by Printer option and select Other. This will open the Choose Profiles dialog, shown in **Figure 10.27**, where you can click the check boxes to enable the profiles that are relevant for your print workflow. Here you can choose canned profiles or custom profiles that have been specially made for your printer. **Figure 10.26** shows how I was then able to change the Color Management Profile setting so that, instead of using Managed by Printer, I could choose from a list of chosen printer profiles. This, in turn, offered me a choice of rendering intents for the print job (see page 538).

If you choose Lightroom to handle the printer color management, you must configure the print settings differently. For example, if you select a standard printersupplied profile, the Media Type selected in the print settings must match the selected profile, and if you select a custom print profile, you must ensure that the ensuing print settings match those used to generate the original print target. Most important, the ColorSync/ICM settings should be set to No Color Management, because you want to avoid double-color-managing the print image data.

9600 Somveivet SV1 Std V2.ICC	/Library/Colorsync/Profiles/7600 Somvelvet SV1 Std v2.icc
EP1290-HPAdvglossy	/Library/ColorSync/Profiles/EP1290-HPAdvglossy.icc
Epson1290-BI-HWM.icc	/Library/ColorSync/Profiles/1290-HWM.icc
HP9180-AdvG-010907	/Library/ColorSync/Profiles/HP9180-AdvG-010907.icc
HP91800-EpsonHWM	/Library/ColorSync/Profiles/HP91800-EpsonHWM.icc
HP9180_FP-SmoothHW-010907	/Library/ColorSync/Profiles/HP9180_FP-SmoothHW-010907.icc
HP9180_Fibraprint_glossy-F	/Library/ColorSync/Profiles/HP9180_Fibraprint_glossy-F.icc
HRag-7600-220107	/Library/ColorSync/Profiles/HRag-7600-220107.icc
Pictro-230606	/Library/ColorSync/Profiles/Pictro-230606
Pro 4800 IF-SCottonHW M_BK	/Library/ColorSync/Profiles/Pro 4800 IF-SCottonHW M_BK.icc
Pro 4800 IF-SCottonHW_PH_BK	/Library/ColorSync/Profiles/Pro 4800 IF-SCottonHW_PH_BK.icc
Pro 4800 IF-WGloss_PH_BK	/Library/ColorSync/Profiles/Pro 4800 IF-WGloss_PH_BK.icc
Pro4800 ARMP_MK	/Library/Printers/EPSON/InkjetPrinter/ICCProfiles/Pro4800.profiles/C
Pro4800 ARMP_PK	/Library/Printers/EPSON/InkjetPrinter/ICCProfiles/Pro4800.profiles/C
Pro4800 EMP_MK	/Library/Printers/EPSON/InkjetPrinter/ICCProfiles/Pro4800.profiles/C
Pro4800 EMP_PK	/Library/Printers/EPSON/InkjetPrinter/ICCProfiles/Pro4800.profiles/C
Pro4800 PGP	/Library/Printers/EPSON/InkjetPrinter/ICCProfiles/Pro4800.profiles/C
Pro4800 PGPP	/Library/Printers/EPSON/InkjetPrinter/ICCProfiles/Pro4800.profiles/C
Pro4800 PGPP170	/Library/Printers/EPSON/InkjetPrinter/ICCProfiles/Pro4800.profiles/C
Pro4800 PGPP250	/Library/Printers/EPSON/InkjetPrinter/ICCProfiles/Pro4800.profiles/C
Pro4800 PLPP	/Library/Printers/EPSON/InkjetPrinter/ICCProfiles/Pro4800.profiles/C
Include Display Profiles	

Figure 10.27. This shows the Profile list menu that you'll see when you click the Other option in the Print Job panel Profile menu.

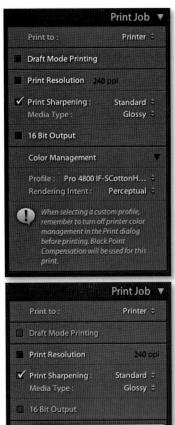

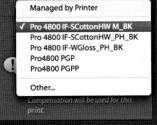

Figure 10.26 When you click the Profile menu in the Print Job panel, you can choose a custom profile from the pop-up menu. This can be configured to display only the profiles you wish to see. To edit the profile list, select Other and use the Figure 10.27 menu to check the profiles you want to see listed here.

NOTE

For those interested in knowing how the print color management is applied in Lightroom, the Adobe Color Engine (ACE) is used to carry out the conversions, and black point compensation is activated whenever Managed by Printer is deselected.

TIP

If you are using a custom profile generated from a print test target, always make sure you enter the exact same print settings as you used to print the target. You can then click Save to save these print settings.

Managed by Lightroom print settings (Mac)

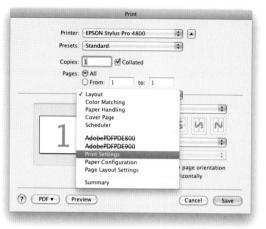

1. The steps outlined here are similar to those for the Managed by Printer procedure. I clicked the Print Settings button to open the Print dialog, which is shown here with the full list of settings options for the Epson 4800 printer.

Printer:	EPSON Stylus Pro 4800
Presets:	Standard
Copies:	1 Collated
Pages:	All From: 1 to: 1
	Print Settings
	Basic Advanced Color Settings
Page Setup:	Sheet :
	Manual Feed
Media Type:	Premium Glossy Photo Paper
Color:	Color
Color Settings:	
Print Quality:	SuperPhoto - 2880dpi
	Super MicroWeave
	High Speed Flip Horizontal
	Finest Detail

2. Once again, the Print Settings and Color Management sections are the most critical. Let's say I had selected the Epson-supplied 4800 Premium Glossy Photo Paper profile in the Print Job settings panel. I would need to ensure that the selected Media Type matched the profile chosen in Lightroom and that I had the correct, matching paper loaded in the printer (since the subsequent Print Quality settings would be governed by the choice of Media Type). Here, I selected the desired print resolution and print speed quality and set Color Settings to Off (No Color Adjustment). This ensured that the printer color management was disabled. I clicked the Save button and then clicked the Print One button to make a single print.

Managed by Lightroom print settings (PC)

1. When you click Print Settings in the PC Lightroom Print module, the main Print dialog opens. Here, I clicked the Properties button to open the printer properties dialogs shown in Step 2.

Current Settings	EPSON Stylus	Pro 4800 Properties		×
Main Media Type:	🔿 Main 🗊 P	age Layout 🦻 Utility		
Premium Glossy Photo Paper Print Quality Level: LEVEL 5 (Max Quality) Print Quality: SuperPhoto - 2880x1440dpi	Select Setting :	Current Settings		Save/Del
High Speed: On Color: Color Source: Manual Feed	Media Settings Media Type :	Premium Glossy Photo Paper		Custom Settings
Centered: Off	Color :	Color		Paper Config
Page Layout Orientation: Landscape Rotate 180°: Off Mirror Image: Off	Print Quality :	Max Quality	•	
Copies: 1 Size: A3 297 x 420 mm	Mode :	Automatic O Custom		
	Paper Settings	Off (No Color Adjustment)		Advanced
Job Settings: Off	Source :	Manual Feed	•	Printable Area
	Size :	A3 297 x 420 mm Borderless	•	User Defined
Color Correction Color Adjustment: Off (No Color Adjustm	Print Preview	Ink U	evels	
	Reset Default	рк \$(У)	C M Y	
Always show Current Settings.			ок	Cancel Help

2. In the Properties dialog, you can select the correct media type, set the Print Quality, and, in the Mode section, choose the Off (No Color Adjustment) option. I clicked OK to return to the Print dialog and clicked OK to save these print settings and return to the Lightroom Print module. I then clicked the main Lightroom Print One button to make a single print, bypassing the system print dialog.

NOTE

If you want to have custom profiles made for your printer, your best bet is to contact a color management consultant who will supply appropriate test targets and direct you on how to print a target from your printer. Please note that you cannot use Lightroom to print out such test target images. This is because target images are always unprofiled, and in the absence of an embedded profile, Lightroom automatically assumes an sRGB profile for the imported image and then converts the data from this assumed space to the native Lightroom RGB space as it is processed through the (non-draftmode) Lightroom pipeline.

To make a custom paper profile for your printer, you will need to print a target image via Photoshop CS4 or earlier, without color-managing the test image file and save the settings used to make the print (as described on these pages). When using the custom profile, make sure that the exact same settings are applied as you used to generate the test target. All you really need to know is that printer targets must be printed via Photoshop (where you can open a test target image file without color-managing it). But the system Print dialog will be the same as the one used by Lightroom. Remember to save the print settings so that the saved preset settings can be recalled when establishing the print settings for Lightroom to use.

The above advice is further complicated by the fact that the latest Mac OS X 10.6 operating system has presented certain problems here. However, Mark Dubovoy has posted a workaround on The Luminous Landscape (www.luminouslandscape.com) discussion forum.

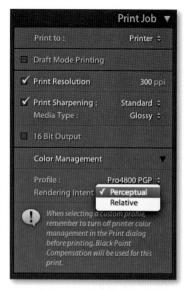

Figure 10.28 When you click the Rendering Intent menu, you can choose between Perceptual or Relative for the print output.

Rendering intent

Whenever you deselect the Managed by Printer option and select a custom print profile in Lightroom, you have two choices of Rendering Intent: Perceptual or Relative (**Figure 10.28**). Unfortunately, there is no way in Lightroom to preview what the outcome will be with either of these rendering intents. Therefore, you will have to decide which one to use based on your knowledge of what these rendering intents do, although you can always make a print using each and compare the printed results to see which you like best.

The Relative (also referred to as Relative Colorimetric) rendering intent maps all the colors in the source image to the nearest equivalent in-gamut color in the selected print profile print space; but at the same time, it clips those colors that fall outside the gamut of the print space. The Perceptual rendering intent maps all the colors in the source image to fit smoothly within the destination print profile space. When Perceptual is used, all color differentiations are preserved. So, the brightest colors in the source image map to the brightest printable colors in the print space, and all the other colors will be evenly mapped within the gamut of the print space. The difference between these two rendering methods is most obvious when comparing an image that contains bright, saturated color detail, such as a photograph of a flower. With Relative rendering, the brighter colors may get clipped, but with a Perceptual rendering you should see better preservation of detail in the bright color areas.

Some people may point out that the downside of Perceptual rendering is that it has a tendency to unnecessarily desaturate the colors in an image where there were no out-of-gamut colors in the first place. In these situations, a Relative Colorimetric rendering may produce a better result. Others argue that if the print does not look good when printed using a Perceptual rendering intent, it may be because you haven't fully optimized the image in the Develop module. Personally, I find both rendering intents to be useful. If the image is fairly standard without large areas of bright color detail, I often use Relative, especially if I am printing to glossy media with the wide-gamut inks found in the latest inkjet printers. However, some printers have a more limited gamut; this is especially true when printing to matte art papers using photo matte black inks. For instance, I have an older Epson 1290 printer that has a limited color gamut in the shadows compared to more recent printers such as the Epson 4800. Plus, if you compare a matte art paper profile for a printer like the Epson 7600 with a Premium Glossy paper profile for a printer like the Epson 2400, you will see a big difference in the color gamut size. With a Relative rendering intent, I may well see noticeable gamut clipping in the shadow areas, so I find I get smoother tonal renditions in the shadows if I use the Perceptual rendering intent when printing images with a lot of dark colors.

Saving a custom template

After you have set up the page layout design and configured the Page Setup and Print Setup settings, you can save the print setup (including all the print settings) as a custom template. In the Template Browser panel, click the plus button at the top of the panel header to add the current print setup as a template and give it a name (**Figure 10.29**). To delete a template, select the template name in the Template Browser and click the minus button.

As you update the layout or print settings relating to a particular template, you can easily update the settings by right-clicking the template name and choosing Update with Current Settings.

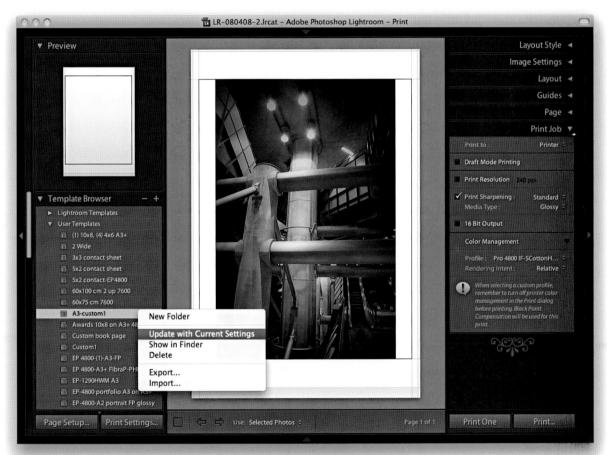

Figure 10.29 To save a print layout as a custom template, click the Add button just below the Template Browser and give it a name. You can update existing settings by holding down the Control key (for the Mac) or right-clicking (PC) to reveal the contextual menu and selecting Update with Current Settings.

FF

Presenting your work

Making use of the Slideshow and Web modules

Despite the popularity of print, it is interesting to speculate on just how few of the photographs we shoot actually end up being printed. There was a time when people would take their film to the local photo lab to be processed and every picture would be printed. These days, nearly everyone shoots using a digital camera and, instead of being shown prints, you are more likely to see people's photos when they are sent as e-mail attachments, placed on a Web site, or shown on a mobile device.

This final chapter is, therefore, all about how to present your photographs so that they can look their best when viewed on the screen. Lightroom's Web module lets you create instant Web sites of your pictures which can easily be uploaded to the Internet without having to leave Lightroom. But first, let's take a look at how to create smart-looking slideshow presentations that can be displayed on the computer or exported as selfcontained presentations for business or personal use.

NOTE

Whenever you launch an impromptu slideshow, the currently selected slideshow template is used.

The Slideshow module

The Slideshow module (**Figure 11.1**) lets you create onscreen presentations that can be played directly via the Slideshow module. The Options panel controls how the images are presented in the individual slide frames and offers the ability to edit the Stroke Border styles and image Cast Shadow options for the images.

The Layout panel here is similar to the Layout panel in the Print module and can be used to set up the margin widths for the slide frames.

The Overlays panel is also similar to the one in the Print module, where you can add elements to a slideshow template design, such as a custom identity plate, custom watermark, or rating information. When you enable the Text Overlays option, you can add custom text objects with full text editing control and optional drop shadows.

The Backdrop panel lets you set a backdrop color and color wash effect. Plus, you can choose to add an image from the Filmstrip as the backdrop.

The Titles panel lets you add slides at the beginning and end of a slideshow during playback, with the option to use the Identity Plate Editor to place saved custom text captions or graphics.

The Playback panel provides controls for playback duration, image fade, and randomize options, as well as the ability to add a music soundtrack to your slideshows.

As with most of the other modules, the Slideshow settings can be saved as a custom template setting via the Template Browser. Notice that, as you hover over the presets listed here, the Preview panel generates a quick preview using the current, most selected image in the Filmstrip selection as a guide to the slideshow template's appearance. The playback controls in the Slideshow Toolbar can be used to quickly switch to the Preview mode. This allows you to preview how the slideshow will look in the content area before clicking the main Play button; plus, you can initiate an impromptu slideshow while in the Library, Develop, or Print modules by using the <u>Crshift Enter</u> keyboard shortcut. Any time you want to exit a slideshow, just press <u>Esc</u>.

As I explained in Chapter 4, you can save slideshow image collections plus the Slideshow settings used as Slideshow collections via the Collections panel. This then allows you to quickly select Slideshow collections from the other modules. Slideshows can also be exported as self-contained PDF documents or as individual JPEG slide images for use in third-party slideshow presentations; plus, you can now export slideshows as movies. Just go to the Slideshow module Slideshow menu and choose one of the Export Slideshow options. Use **SJ** (Mac) or **Ctrl J** (PC) to export a PDF Slideshow, **SJ** (Mac) or **Ctrl Ashift J** (PC) to export JPEG slides, or **SJ** (Mac) or **Ctrl Att J** (PC) to export a movie.

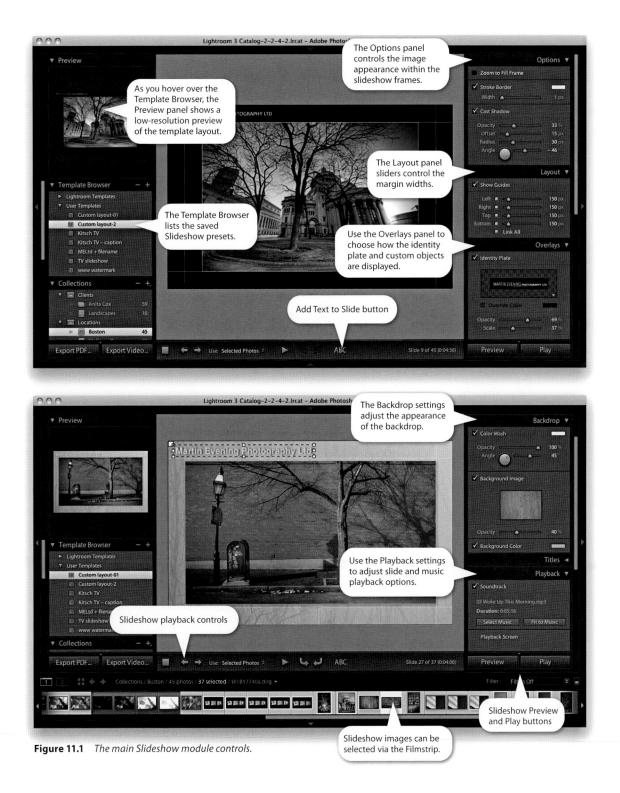

The slide editor view in the content area

The most selected image appears in the content area, which is used to display a slide editor view of the slideshow layout (**Figure 11.2**). You can change the image view by using the left and right arrow keys to navigate through the selected images in the Filmstrip. As adjustments are made to the Slideshow settings in the panels on the right, these changes are reflected in the slide editor view. The Toolbar provides preview playback controls and contains options for choosing which photos are displayed in a slideshow. You can choose from All Filmstrip Photos, Selected Photos, or Flagged Photos. As with other Lightroom modules, you can toggle showing and hiding the Toolbar using the T keyboard shortcut.

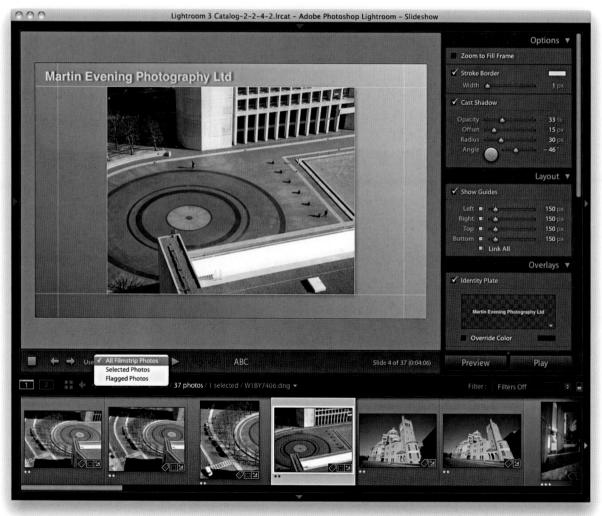

Figure 11.2 The Slideshow module showing a view of the slideshow layout in the content area and the Filmstrip below.

Layout panel

The Layout panel lets you edit the slide layout by specifying the margins for the image display. In **Figure 11.3**, the layout guides are highlighted in red, and you can adjust the margins by dragging the slider controls. Or, you can double-click the fields in the panel, enter a pixel value, and fine-tune this setting using the up and down arrow keys. A single arrow click increases or decreases the pixel dimensions by one unit, and a <u>(Ashift</u>)-click increases or decreases the pixel dimensions 10 units at a time. If you hover the mouse over one of the field boxes, you will see a scrubby slider; you can then drag the mouse right or left to increase or decrease a value. Notice that the unit dimensions have linking check boxes next to them. This means that when two or more boxes are checked, as you adjust one value, the other field values are linked. For example, in Figure 11.3, I checked the boxes for the left and right margins only. This meant that, as I adjusted the width for the right margin, the left margin was adjusted by the same amount. You can hide the slide layout guides at any time by unchecking the Show Guides box in the Layout panel or by pressing **(Shift)** (Mac) or **(Ctrl) (Cshift)** (PC).

NOTE

The proportions of the Slideshow view are always relative to and dictated by the proportions of the monitor display you are working on. This can have ramifications for how you export a slideshow. I will discuss how to address this in "Exporting a slideshow," later in this chapter.

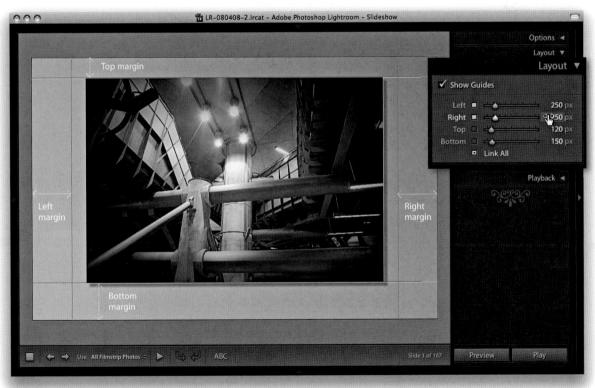

Figure 11.3 This shows the slide Layout panel controls. Note that as I rolled the mouse over the pixel size field, the scrubby slider became active, which allowed me to drag left or right to adjust the pixel size widths of the margins.

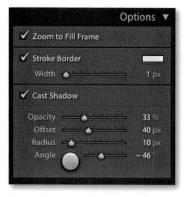

Figure 11.4 The Options panel.

Options panel

Now let's look at how the photographs are displayed within the slide frames. At the top of the Options panel (Figure 11.4) is the Zoom to Fill Frame check box. In the Figure 11.6 example, this option is deselected, and as you can see in the slide editor view, the slideshow photographs fit centered within the margins (as specified in the Lavout panel). If the Zoom to Fill Frame option is checked, the slideshow photographs resize and expand to fill the available space (Figure 11.7). You should be aware that when you select this option, the Zoom to Fill Frame setting automatically centers each image in the slideshow as it applies the necessary cropping to the picture. If you look carefully in Figure 11.7, you will notice that the cropped view is aligned to the bottom edge of the frame. This is because I clicked the slide preview image and dragged it upward to preserve the bottom edge of the photograph. This tweaking overrides the automatic cropping and is applied on a per-image basis. In other words, you can pre-edit a selection of pictures that are to be included in a slideshow and customize the cropping in each photo. Just be aware, though, that these adjustments are lost as soon as you make a new selection of images; it makes sense to spend time making custom tweaks to a slideshow presentation in this way only if your goal is to export the slideshow as a PDF presentation, as a movie, or as JPEG slide images. In these two examples, I also checked the Stroke Border option to add a light gray stroke to the slideshow frame images (the stroke border is always 1 pixel thick). If you want to change the stroke color, then double-click the color swatch to open the color picker dialog shown in Figure 11.5 below.

If you select the Cast Shadow option, you can add drop shadows behind the photographs. The Cast Shadow option applies a black shadow and, by adjusting the Opacity, Offset, Radius, and Angle sliders (or adjusting the angle wheel), you can customize the way the shadow effect looks. Notice that as you adjust the angle setting, the shadow preview temporarily hardens to a flat shape, but as you release the adjustment controls, the shadow is re-rendered in the slide editor view.

Figure 11.5 The Lightroom color picker dialog.

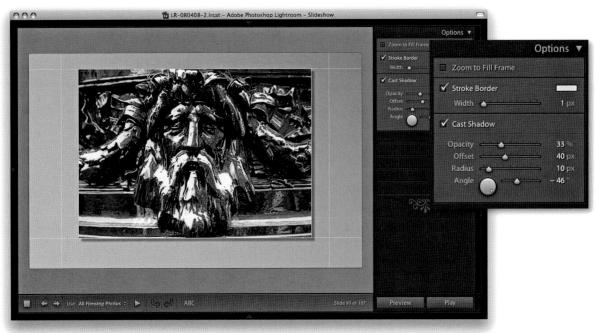

Figure 11.6 The Options panel is shown here with the guides visible but all other objects hidden. I left the Stroke Border option checked and applied a custom Cast Shadow setting.

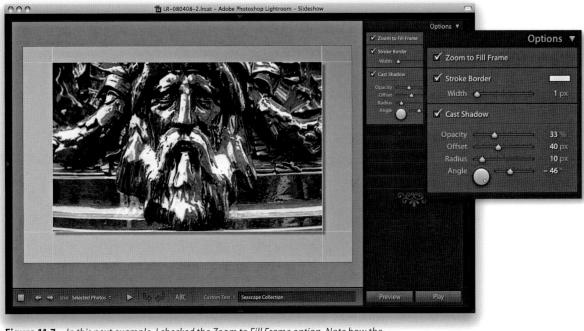

Figure 11.7 In this next example, I checked the Zoom to Fill Frame option. Note how the same image expands to fill the area within the frame margins.

NOTE

The new Watermarking option allows you to select a custom watermark setting such as was discussed in Chapter 9.

Overlays panel

Having established the layout margins and image placement, you can begin adding extra content to the slide frames. If you enable the Identity Plate option. you can select a custom preset template by clicking on the Identity Plate preview, and choose Edit from the drop-down menu to create a new one. The Opacity and Scale properties let you customize the identity plate appearance and decide whether you want the identity plate to be on top or placed behind each slide photograph. Once enabled, the identity plate can be repositioned by simply clicking and dragging it anywhere inside the slide frame area. In this respect, the identity plate is just like any other custom object. The Rating Stars options let you display the current image star rating, as well as set the color and scale size. As with all custom objects, you can scale each object by dragging a corner or side handle. The Text Overlays check box toggles displaying all other objects apart from the identity plate and ratings. For example, in **Figure 11.8**, this option is checked, which allows you to see a filename text object that I had placed centered below the image. The Shadow check box lets you apply a drop shadow effect to each overlay object and apply independent shadow settings to each. I will discuss working with text overlays shortly, but let's take a guick look at the Identity Plate options first (Figure 11.9 and Figure 11.10).

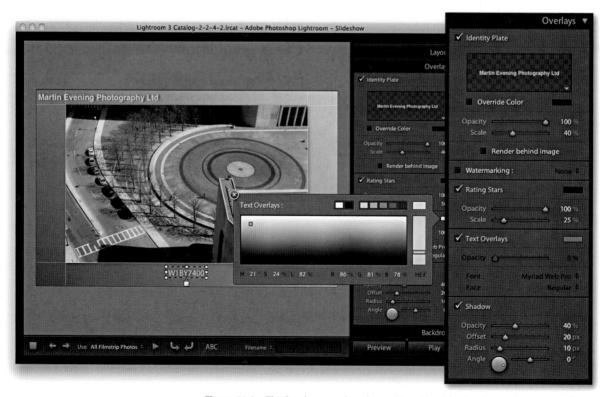

Figure 11.8 The Overlays panel can be used to add an identity plate, rating stars, and custom text objects with or without drop shadows.

Creating a custom identity plate

Overlays 🔻	Identity Plate Editor
✓ Identity Plate	
Martin Evening Photography Ltd	• Use a styled text identity plate O Use a graphical identity plate
✓ MEP Ltd Override Color MEP logo-2 ME-default letterin	Martin Evening Photography Ltd
Opacity 10 Polamask-2 Scale 11 Polamask-2 KB Book Credits	Helvetica Bold 18 🔹
Render behind image Main Identity Plate	ustom Cancel OK
Watermarking : No Edit	ustom
✓ Rating Stars	
Opacity 100 % Scale 25 %	Save Identity Plate As
Text Overlays	Cancel Save
Opacity 100 % Scale 25 %	me: MEP Ltd

Figure 11.9 To open the Identity Plate Editor, click the Identity Plate preview in the Overlays panel and choose a pre-saved Identity Plate setting or select Edit. In this step, I chose the "Use a styled text identity plate" option, modified the typeface, and saved it as a new identity plate preset.

Identity Plate Editor	Overlays 🔻
	✓ Identity Plate
O Use a styled text identity plate 💿 Use a graphical identity plate	MARTIN EVENING MOTOGRAMM UT
MARTIN EVENING photography ltd	MEP Ltd ■ Gverride Color MEP logo-2
Locate File Clear Image	Opacity ME-default lettering Polamask-2 Scale ME-default lettering Polamask-2 TV overlay LR3 Book Credits
MEP logo-2 Cancel OK	Render behind image Main Identity Plate
	Watermarking: Nor Edit
Save Identity Plate As	Opacity6 100 % Scale 25 %
Name: MEP Logo-2 Cancel Save	Text Overlays

Figure 11.10 Alternatively, you can choose the "Use a graphical identity plate" option and add a logo image for use as an identity plate.

NOTE

In the Overlays panel Text Overlays section, you can edit the individual text overlays, changing the font typeface, style, opacity, and color as desired.

TIP

To hide the Custom Text box, click the Add Text to Slide button a second time.

Adding custom text overlays

To add a custom text overlay, click the Add Text to Slide button (**Figure 11.11**), which opens a text box next to it in the Toolbar. At this stage, you can start typing to add custom text. After you press Enter), the text appears as a new text overlay in the Slide Editor view. You can add as many text overlays as you like and reedit them. If you click to select a text object in the Slide Editor view, you can edit the content by typing in new text. Plus, you can also click to open the text overlays menu and select an item from the list, such as Date or Filename (**Figure 11.12**). Or, you can choose Edit, which opens the Text Template Editor that is also shown in Figure 11.12 (or press **E**T [Mac] or **C**trl **T** [PC]). This allows you to add various metadata items as tokens. Just click an Insert button to add new tokens to a template design and combine these with custom text to create your own custom text overlays using different tokens, such as Date (Month, DD, YYYY). You can use the Rotate buttons on the Toolbar to rotate text overlays by 90 degrees, and to remove a text overlay, just click to highlight it and press **Delete**.

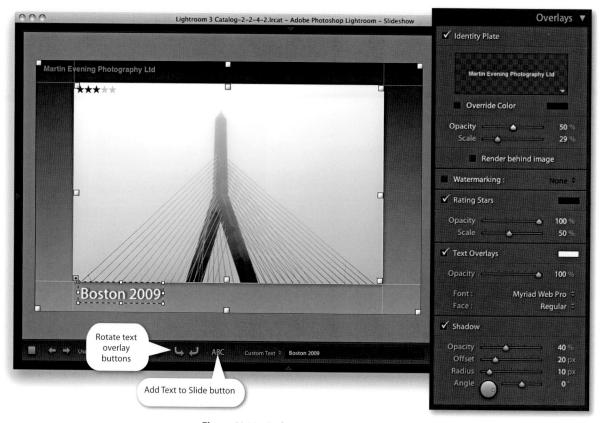

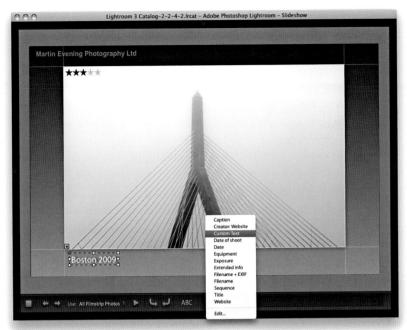

Preset	Custom Text (edited)	e provinsi and a provinsi sa
Example	Date of Shoot:January 12, 2005	
ate of S	hoot: Date (Month DD, YYYY)	9
Image Nai	ne	
	Filename	(Insert
	Original filename	(Insert
Numberin	9	
	Image # (1)	(Insert)
	Date (Month DD, YYYY)	(Insert
EXIF Data		
	Exposure	(Insert
	Dimensions	(Insert
	Dimensions	(Insert
IPTC Data		
	Title	insert)
	Caption	(Insert
	Copyright	(Insert
Custom		
	Custom Text	Insert

Figure 11.12 To add other types of text overlays, you can click the menu and select a text object preset, or click the Edit menu item to open the Text Template Editor and create a template design of your own.

	Text Template Editor			Text Template Editor	
Preset: (Example:	Date of shoot		Preset: (Example:	Website	
	ot: Date (Month DD, YYYY)		Creator	Website	
Image Name			Image Name		
	Filename 🚺	Insert		Filename	Insert
	Original filename	Insert		Original filename	Insert
Numbering EXIF Data	Image # (1) (2) Ø Date (MYMRD0) Date (MYMRD0) Date (MYMRD0) Date (MYMRD0) Date (MYMR0) Date (MYMR0) Date (MOMR0) Date (MYMR0) Date (MAMR0) Date (MYMR0)	Insert Insert Insert Insert	Dif Data	Title Caption Capyright Keywords Creator Data Creator Johns Creator Johns Creator State / Province Creator State / Province Creator Country Creator Country Creator Forsit Code Creator Country Creator Forsit	Insert Insert Insert Insert Insert
Custom	Copyright E	inser Done	Custom	Description Writer PTC Subject Code Intellectual Cenne Scene Location SG Country Code Headline City State / Province Country Job Identifier Instructions Provider Source Rights Lulage Terms Copyright Info URL	Insert Insert el Done

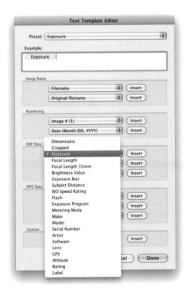

Figure 11.13 Here are some example views of the Text Template Editor. The Numbering token options (left) can be used to apply different date and time formats. The IPTC Data token options (middle) include items relating to the IPTC metadata (see Chapter 4). The EXIF Data token options (right) include items relating to the camera capture data.

TIP

When a text object is selected, you can scale it up or down in size by clicking the object and then dragging the text box handles. It is important to remember to make objects big enough so that they can be read easily on the screen.

Working with the anchor points

The anchor points serve as useful guides for the placement of text overlays within the slide editor view. You can use these points to help align a text overlay to the center or corner edges of the image, or to the entire Slide Editor frame. The anchor points of a text overlay normally link and snap to whichever Slide Editor anchor point is in closest proximity. As you click and drag a text overlay around the screen, the linking points jump to whichever anchor dock point is nearest. If you click inside the anchor point box, this locks the anchor position and highlights it yellow. You can then move the overlay around the screen with it locked to this anchor point (although the anchor points on the text overlay bounding box itself will jump to whichever point is closest to the locked Slide Editor anchor point). Instead of dragging, you can use the keyboard arrow keys to nudge the position of an overlay and use the (Shift) key to magnify the shift amount.

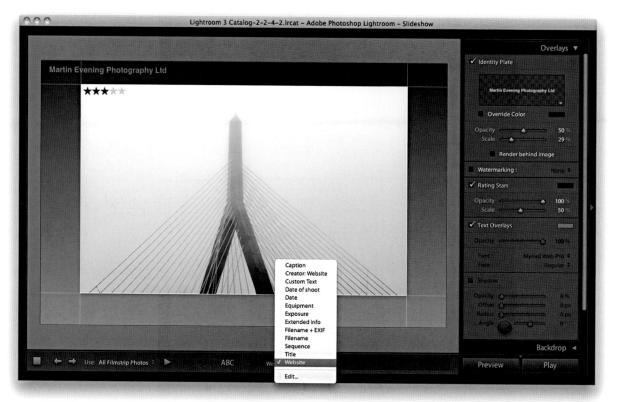

1. To add a custom text overlay, I clicked the Add Text to Slide button, which revealed the Custom Text options shown here, where I selected the Website token.

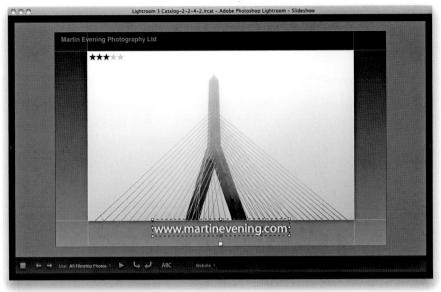

Overlays Martin Evening Photography Ltd Override Color -. Render behind image Watermarking : Rating Stars 100 % - Text Overlays -Myriad Web Pro Regular ✓ Shadow 20 DX -

2. The Website token displayed the URL shown here, and I used the Text Overlays options to set a font and type style for the overlay.

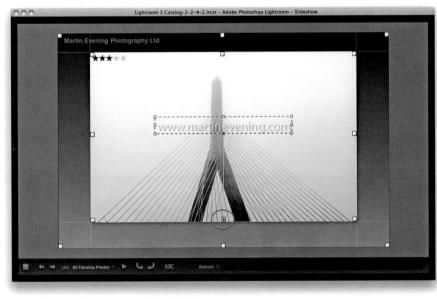

3. The text overlay could then be positioned in the Slide Editor view with the help of the anchor point guides. (Note that I have overlaid this particular screen shot with a map of all the available anchor points.) You can adjust the placement of a frame anchor point by clicking to select it and dragging it to a new position. Here, I placed the text in the middle of the frame. Finally, I set the text opacity to 40% and adjusted the Shadow section settings to create a watermark effect.

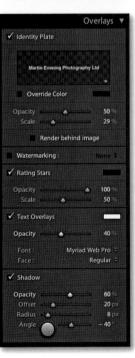

TIP

Don't forget that, as with all changes you make in Lightroom, changes made to the Slideshow settings and those made in the Slide Editor view can be undone using Edit ⊃ Undo or ⊮Z (Mac) or Ctrl Z (PC).

Backdrop panel

The Slideshow frame appearance can be modified via the Backdrop panel. The Color Wash controls are a nice refinement because you can set up different color scheme combinations using the Color Wash and Background Color swatches and adjust the Opacity and Angle sliders to fine-tune the effect; you can also place an image as a backdrop. The first time you check the Background Image option, you won't see anything happen, because you have to select a photograph from the Filmstrip first and drag it into the backdrop area (or Background Image preview area) for the background image to register. After that you can use the check box to toggle the backdrop image on or off. Notice how the Color Wash colors can be combined with the applied backdrop image and used to mute the backdrop image contrast. Whenever an image is applied to the backdrop, you still retain full control over the Color Wash Color, Background Color, and Color Wash settings, and you can mix them any way you like to achieve the desired look for the backdrop. Remember, also, that all the settings, including those in the Backdrop panel, can be saved as a template. So you can create Backdrop panel designs that use different background images and save these to the Template Browser panel. The following steps show how I went about creating a custom backdrop design for a slideshow.

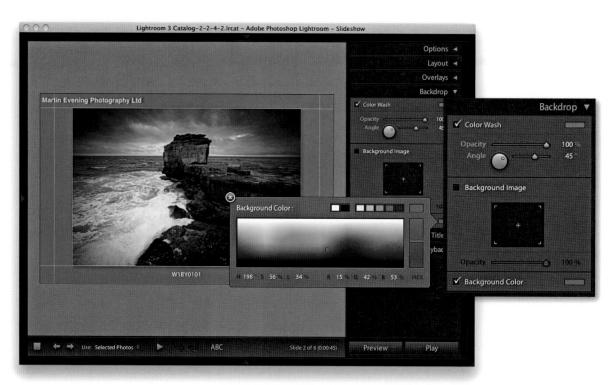

1. The default backdrop color for this template design was black, but when I checked the Background Color option, I could click the background color swatch to choose an alternative backdrop color.

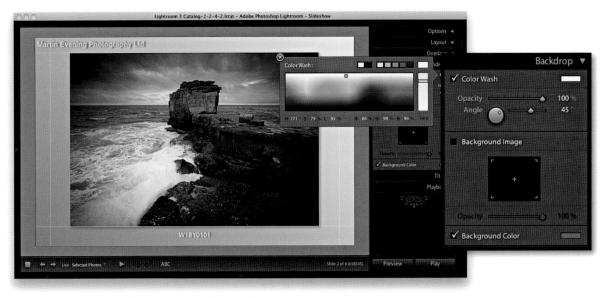

2. With the Color Wash option checked, I was able to introduce a secondary color to apply a gradient wash across the backdrop.

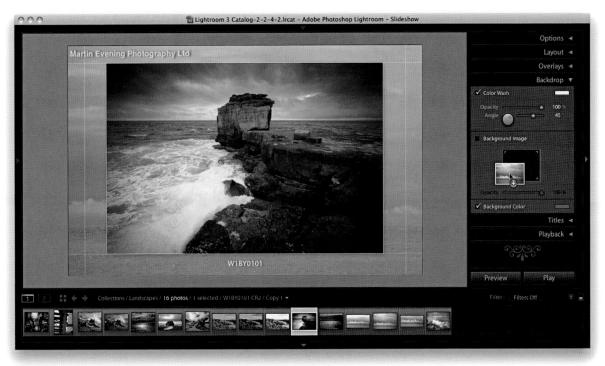

3. Finally, I added an image to the backdrop by dragging a photo from the Filmstrip into the slide Background Image preview area and adjusted the Background Image opacity.

NOTE

The two images used in the construction of this Slideshow layout can be downloaded from this book's Web site.

Downloadable Content: www.thelightroombook.com

How to create a novelty slideshow template

1. I devised the following steps to illustrate the potential Lightroom has for creating customized slideshow layouts. First of all, I used my Photoshop skills to create a cutout image of an old-fashioned television set on top of a table. I won't go into all the details about how I created this object, but I'd like to draw your attention to the screen area in the middle, which, although you can't see too well against the checkered transparency pattern, contained soft highlight reflections. (The insert image shows these more clearly against a black background.)

- Pixel Dime	ensions: 8.	28M	ОК
Width:	2080	pixels	Cancel
Height:	1392	pixels 💲 🕽	Auto
- Documen	t Size:		,
Width:	73.38	🖬 📬 🗍 🖉	
Height:	49.11	cm 🗘 🦉	
Resolution:	72	pixels/inch	
Scale Style	s		
Constrain	CTATION (1919) (111)		
Resample	Image:		

2. I went to the Image menu in Photoshop and used the Image Size dialog to resize the master image to the size shown here. This would be the maximum pixel size needed for slideshow presentations on a 30-inch display.

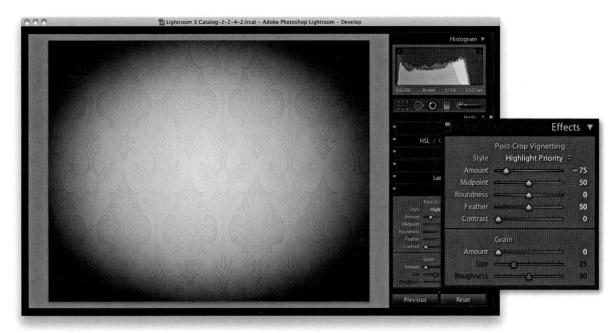

3. Meanwhile, I selected a backdrop photo in Lightroom, which, in this case, was a photograph taken of a wallpaper design. I used the Post-Crop Vignetting sliders in the Develop module Effects panel to darken the corners of this photo.

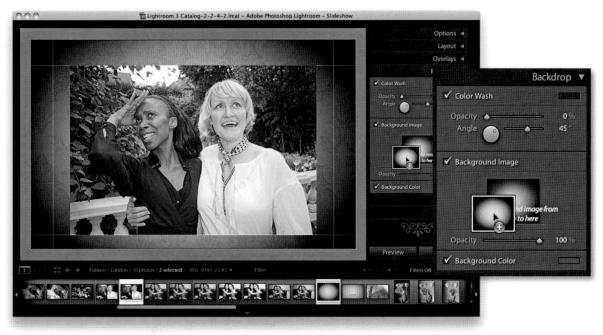

4. In the Slideshow module, I dragged the wallpaper photo from the Filmstrip to place it as a background image in the Backdrop panel.

Save Identity Plate As	1 Identity Plate Editor	
Name: TV overlay	O Use a styled text identity plate 🛞 Use a graphical identity plate	
(Cancel) (Save		
	(Locate File)	Clear Image
	Custom	Cancel OK

5. To load the foreground image that I had worked on in Photoshop, I clicked the triangle in the Overlays panel Identity Plate preview (circled in Step 6) and chose Edit. This opened the Identity Plate Editor shown here. I checked the "Use a graphical identity plate" option, clicked the Locate File button, and chose the image I had worked on in Photoshop. There was no need to worry about the image graphic exceeding the Preview window. I clicked OK to save this as a new Identity Plate setting.

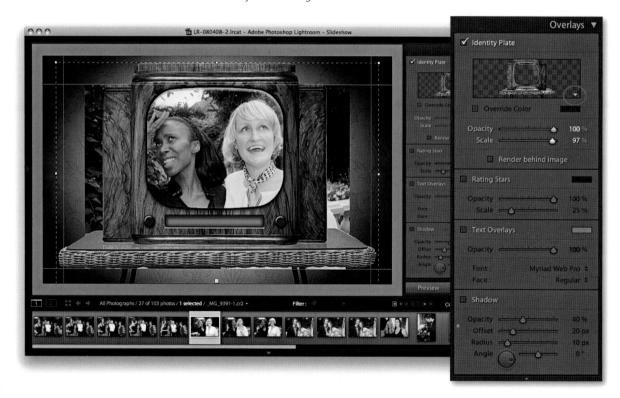

6. The identity plate image appeared as a new overlay where the photo selected in the Filmstrip appeared, sandwiched between the backdrop image and the identity plate overlay. The next step was to place and scale the identity plate image so that it almost filled the whole screen and was centered in the frame.

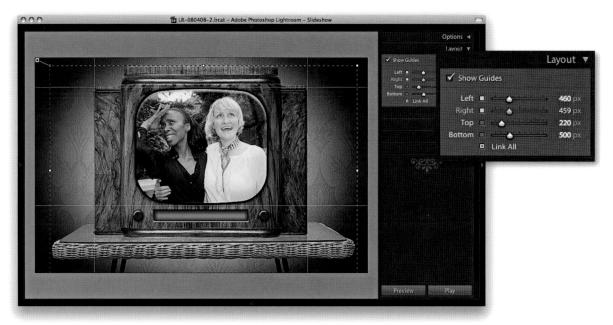

7. I then adjusted the Layout panel guides to position the photo frame so that the height of a landscape photograph just fit within the top and bottom of the TV screen area. I also set the left and right guides so that any extra narrow landscape photos would still fit the frame height.

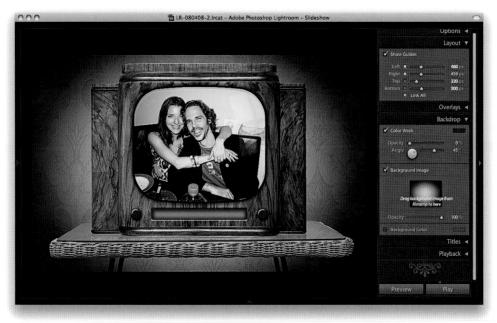

8. Here is a slide from the finished slideshow in which selected photos were played back via this television screen slideshow template.

ПĿ

The Identity Plate Editor dialog is rather limiting to work with, which is why I suggest that you are sometimes better off using a text editor program to format the text (such as in the example shown here).

Titles panel

The Titles panel allows you to add Intro and Ending screens to a slideshow presentation. You can add these screens using the Identity Plate Editor, as shown below. All you have to do is check the Add Identity Plate options to add a screen at the beginning and/or end of a slideshow. The Titles panel also offers a few extra controls so that you can scale the identity plate and override the color of the identity plate content, as well as set a background color.

C C C Lightroom 3 shoot credits.rtf	Identity Plate Editor
Styles E Styles	⊙ Use a styled text identity plate ○ Use a graphical identity plate
The Adobe Photoshop Lightroom 3 Book Photo Shoot Model: Sofia @ MOT	The Adobe Photoshop Lightroom 3 Book Photo Shoot
Make-up: Camilla Pascucci Clothes Styling: Harriet Cotterill	Helvetica 🛊 Regular 🛊 12 💌 🗆
Hair: James Pearce	Custom : Cancel OK
	Custom Cancel OK

1. To create an end credit screen, I used a basic text editor program to write the credits, where I made the first line bold, added carriage returns, and centered the text. I copied and pasted this into the Identity Plate Editor dialog and saved this as a new styled text identity plate.

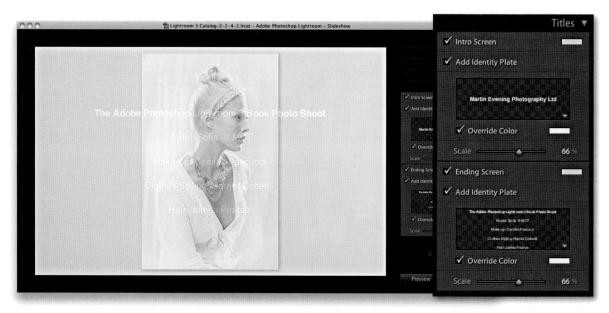

2. I then selected a standard identity plate company logo for the Intro screen and selected the credit list for the ending screen. This screen preview shows where the last image in the slideshow sequence faded to the ending screen credits.

Playback panel

When all the settings have been configured, you will be almost ready to start playing a slideshow. But before doing so, you need to visit the Playback panel (**Figure 11.14**) and set the times for the slides' duration and fades between each slide. If you want the slideshow to run at a fast speed, you can try selecting shorter slide and transition duration times. But bear in mind that the ability to play back at a faster speed is governed by the size of the master library image files and whether these have all been fully cached yet, not to mention the performance power of your computer. Should you be so inclined, you can check the Random Order option at the bottom to shuffle the play order or click Repeat to have the slideshow run in a loop. If Prepare Previews in Advance is checked, this can help ensure smoother playback without interruptions, waiting for images to be rendered fully on the display.

If the Soundtrack option is checked, you can click the Select Music button to select a music file to use as a backing sound track for your presentation. The track duration appears below, and if you click on the Fit to Music button, this auto-sets the exact slide duration required for all the images in the slideshow to play at an even pace from start to finish. It should also be pointed out here that, in previous versions of Lightroom, you could select an iTunes playlist directly from the Playback panel. While this was a convenient feature, it would work correctly only if iTunes didn't require yet another update, in which case you wouldn't notice the system warning dialog and the slideshow would play silently. This was a common cause for complaint and, as a result, it has been deemed safer to let users choose directly the sound tracks they wish to use. On the computer setup in my office, I maintain a complete MP3 music library and now use the Finder (as shown below in Figure 11.15) to select the music I wish to play in the background. Of course, only single-track files can be played this way, although you could conceivably use a third-party tool to convert a playlist of songs into a single audio file. Another thing to point out here is that you won't be able to play any iTunes files that are DRM protected. However, you can always upgrade such tracks to iTunes Plus, which removes the DRM restriction.

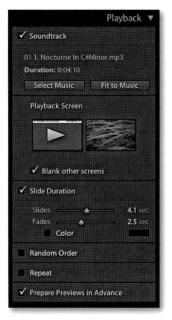

Figure 11.14 The Playback panel. (This panel view shows the dual monitor options for a two-display setup.)

NOTE

Music sound tracks can't be saved as part of a PDF Slideshow export, but you can save a music sound track with a video export. If a video is ultimately going to be published to a wider audience, you must ensure that you have the rights to use the music.

 ▲ ►) (# Ξ □ □ □ The Piani 	ist 🔹		Q search
V DEVICES Martin Evening's Mac Pro GSMain HD RAID Martin Evening's iPod Martin Evening's iPod DoS_DIGITAL Hard Drive 3 Hard Drive 4 Disk Unitiled	Album Artwork	Fietwood Mac Four Tops Foxy Brown Frank Sinatra Frank Sinatra Frantique Franz Ferdinand Freakpower Fred Neil Free Free Freederic Chopin	 Ø 01 1. Noct Minor.m Ø 02 2. Balla Minor.n
Library-HD			Cancel Choos

Figure 11.15 To select a sound track, click on the space shown in Figure 11.13, and then use the navigator to locate the desired sound track file from the music library on your computer.

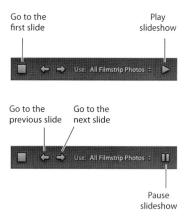

Figure 11.16 The Slideshow Preview mode playback controls, showing here the slideshow controls in both Play and Pause mode.

Preview and Play

You are now ready to play the slideshow (see **Figure 11.16**). To do this choose Slideshow \Rightarrow Run Slideshow, or click the Play button in the bottom-right corner, or press Enter to launch a full-screen slideshow using the currently selected slideshow template settings. When you switch to full Play mode, the display fades to black and then fades up to show the slides in sequence. To stop a slideshow, just press the Esc key.

If you just want to see a quick preview of a slideshow, click Preview next to the Play button (<u>Att</u>)<u>Enter</u>). This allows you to preview a slideshow within the content area. **Figure 11.17** shows a slideshow being previewed where the background is dimmed to black in the content area. The main advantage of running a slideshow in Preview mode is that slideshows typically start running a lot sooner (depending on the size of your slideshow images).

Navigating slideshow photos

While you are in Preview mode, you can interact with the slideshow using the navigation keys located on the Toolbar (see Figure 11.16 for descriptions of the

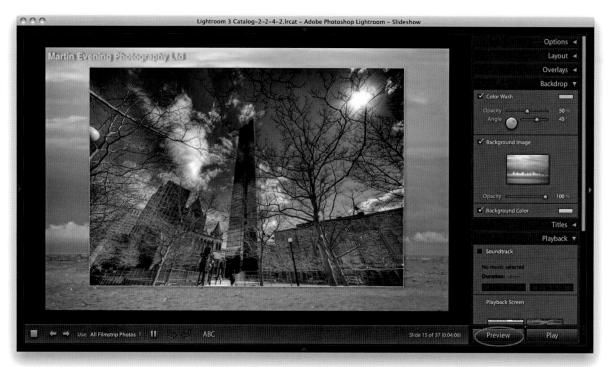

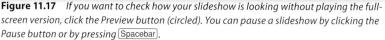

Toolbar buttons). You can also manually override a slideshow sequence by using the left and right arrow keys to go backward or forward through the sequence. Press (Spacebar) to pause a slideshow, and press (Spacebar) again to resume playing.

Slideshows and selections

There are Slideshow module options in the Toolbar (**Figure 11.18**), as well as in the Play \Rightarrow Content submenu (**Figure 11.19**), that determine which images are accessed from the Filmstrip when playing a slideshow (assuming more than one image is selected). If All Filmstrip Photos is selected, the slideshow plays all the photos in the current Filmstrip starting from whichever is the most selected or target image. If Selected Photos is selected, the Slideshow module plays only the selected images, and if Flagged Photos is selected, only those photos that have been rated as flagged images will be played.

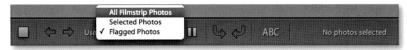

Figure 11.18 The Slideshow module toolbar showing the content options.

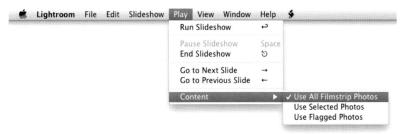

Figure 11.19 The Slideshow module Play menu showing the Content options.

Template Browser panel

When you have completed work on a slideshow layout design, you can select Slideshow \Rightarrow Save Slideshow Settings or use \textcircled (Mac) or \textcircled (PC) to quickly save the current slideshow settings (but without saving them as a template just yet). As you select other pre-saved templates and compare the look of different layouts, you can always go to the Slideshow menu and choose Revert Slideshow Settings, which instantly returns you to the last saved temporary slideshow layout.

NOTE

If you want to run an impromptu slideshow in any of Lightroom's modules, press (#)(Enter) (Mac) or (Ctr) (Enter) (PC).

Figure 11.20 The Template Browser plus template preview. Note: If you save a slideshow setting that includes a backdrop image, the backdrop image must be present in the library in order for the template to work.

NOTE

When you save a template that includes a specific backdrop image and, for whatever reason, that image is no longer available in the library, you may see an error warning in the preview. However, if you do select a template in which the backdrop image is missing from the library, Lightroom will most likely substitute the last used backdrop image.

However, after going to all the trouble of designing a slideshow layout with measured margins, identity plate, customized text objects, and a backdrop image, it makes sense to save it as a template that can be used again later. To do this, click the plus button in the Template Browser panel header and give the template a descriptive name. Figure 11.20 shows a template that I created on some of the earlier pages of this chapter that was saved as Custom layout-3. As you roll over the other template presets in the list, you will see a preview based on whichever is the most selected image in the Slide Editor view. As with the other Lightroom modules, you can remove a template by highlighting it and clicking the Remove (minus) button in the Template Browser panel. You can also update the settings for a particular template by right-clicking (also available as Ctrl)-click on a Mac) and choosing Update with Current Settings. There is no nesting capability built into the Template Browser panel, although to be honest it is not something that you are likely to need because there should be enough room to accommodate all the slideshow templates you might use. Don't forget that, as with the Print module, you can save Slideshow settings and the associated image selections as Slideshow Collections. These settings can then be accessed when working in the Library, Print, or Web modules.

You can also see how social and wedding photographers might find it useful to take a standard layout design and save variations of this template with alternative music playback settings to suit the music tastes of different clients, and how art photographers might like to create custom slideshows for exhibition displays on a large screen.

Exporting a slideshow

In addition to displaying slideshows, you can export slideshows from Lightroom. For example, you can export a self-contained slideshow in the Adobe PDF format, which can be played via the freely available Adobe Acrobat Reader or any other program capable of reading PDF files (such as Apple Preview). Or, you can export individual JPEG slides that can be placed as pages in presentation programs such as Microsoft PowerPoint or Apple Keynote. The Export buttons are positioned at the bottom-left of the screen and shown below in **Figure 11.21**. Normally, you will see two options: Export to PDF and Export to Video, but if you hold down the **Att** key, the Export to PDF button changes to say Export to JPEG, which completes the three export options available in Lightroom. (You can also access these via the Slideshow menu or use the keyboard shortcuts mentioned in the following sections.)

Figure 11.21 This shows the Export buttons in the bottom-left section of the Slideshow module. If you hold down the Alt key, Export PDF changes to Export JPEG.

Export slideshows to PDF

To export a PDF slideshow, choose Slideshow \Rightarrow Export PDF Slideshow, or press (#J) (Mac) or Ctrl J (PC). This opens the Export Slideshow to PDF dialog shown in Figure 11.22, where you can choose a destination to save the exported PDF to. Below this, you have the PDF export options, such as the Quality slider (which sets the amount of compression used), and the Width and Height sections (which let you determine how large you want the slideshow document to be). You need to take into account here the likely computer display size the exported slideshow will be played on. For example, most computers will be connected to a modern LCD that uses a wide-screen format ratio of something like 16:9. If you want to scale down the slide size but preserve the full slide area, the size dimensions must match the ratio of the current pixel width and pixel height of your display. However, to make life easier for you, the Common Sizes menu will be set to the current monitor display resolution. (Actually, the format of the slideshow slides will already have been influenced by the computer display you are working with.) If you click this menu, you can easily select a common monitor resolution size for other typical computer screens. The "Automatically show full screen" option determines whether the slideshow starts playing in full-screen mode when the person who receives the slideshow opens the exported slideshow PDF on his computer.

When you play back a PDF slideshow in Adobe Acrobat or Adobe Reader using the full-screen mode, the default view fills the entire screen. This is fine if you make the slideshow match the full-screen pixel resolution. However, if you want to play the slideshow at the actual pixel resolution, press **X**1 (Mac) or **C**trl **1** (PC) in Adobe Acrobat or Adobe Reader.

Save As:	Sample PDF]	•
Where:	Desktop	\$	
Quality:	90	Width:	1600
	Automatically show full screen	Height:	1200
	Common sizes:	1600x	1200 🛟
Notes:	Adobe Acrobat transitions use a fixed s Music is not saved in PDF Slideshows.	speed.	

Figure 11.22 The Export Slideshow to PDF dialog.

NOTE

Adobe Reader is a free PDF player program for Mac or PC. To download the latest version, go to www.adobe. com/products/acrobat and look for a link to download Adobe Reader. Only the latest versions of Adobe Reader are able to play a slideshow with transition dissolves, and even then, they will be of a fixed speed. The compression settings should be adjusted according to how you intend to use a slideshow. If a PDF slideshow is to be distributed by CD or DVD, use a full-screen size and best-quality compression setting. If you plan to send a slideshow by e-mail, then keep the pixel size and compression settings low enough so you don't send an attachment that is too large.

Export slideshows to JPEG

To export a slideshow to JPEG files, choose Slideshow \Rightarrow Export JPEG Slideshow, or press **#Shift** (J) (Mac) or **Ctrl Shift** (J) (PC). This opens the Export Slideshow to JPEGs dialog (shown in **Figure 11.23**), where, again, you can select the desired compression and screen size settings.

The Export Slideshow to JPEGs option is mainly useful if you wish to prepare individual JPEG slides that can then be incorporated into, say, a Microsoft PowerPoint or Apple Keynote presentation.

Save As:	Seascapes	
Where:	Desktop	
Quality:	90 Width:	1600
	Height:	1200
	Common sizes: 1600x	1200

Figure 11.23 The Export Slideshow to JPEGs dialog.

Export slideshows to Video

In the past, slideshows that contained music sound tracks could be played back only in Lightroom. Lightroom 3 includes the ability to export video files, so you can now export high-quality movie slideshows that include sound tracks (**Figure 11.24**). Also, by utilizing the H.264 movie format, it is possible to generate movie files that can be uploaded to any of the popular video sharing Web sites such as YouTube. You can also optimize video files to be played back on mobile media devices such as the Apple iPod Touch. However, this does raise the question of whether it is legitimate to do so, since one of the big problems facing the music industry has been the illegal sharing of music downloads.

To export a movie, go to the Slideshow menu and choose Export Slideshow to Video, or use the **#Att** (Mac) or **Ctrl Att** (PC) keyboard shortcut. Here is a summary of the various video output options, as described in the Information section of the Export Slideshow to Video dialog: **240** Provides H.264 video at

320x240 pixels at 30 frames per second, optimized for personal media players and e-mail. Such movies are compatible with QuickTime, iTunes, Adobe Media Player, and Windows Media Player 12. **320** provides H.264 video at 480x320 pixels at 30 frames per second. This is optimal for mobile devices (e.g., iPhone, iPod Touch, Android, etc.). **480** is suitable for small handheld devices, e-mail, or Web, while **540** is suitable for home media display (e.g., Apple TV). **720** provides medium-size HD quality, which can be used for online sharing (e.g., YouTube, Facebook, Blip.tv, etc.) and also for home media/entertainment (e.g., Apple TV or Windows Media Center). Finally, **1080P HD** provides high-bit-rate HD video at 1920x1080 pixels.

Figure 11.25 shows a screen shot of a time-lapse Lightroom movie export that was created by Sean McCormack, who also produced the modified Slideshow template that was used to create this 25 frames per second movie. You can watch the movie on this book's Web site and download the Slideshow template.

Save As:	Sample slideshow
Where:	Movies
Video Preset:	320 H.264 video at 480x320 pixels at 30 FPS. Optimal for mobile devices (e.g. iPhone, iPod Touch, Android, etc)

Figure 11.24 The Export Slideshow to Video dialog.

Figure 11.25 Here is an example of a slideshow movie that was assembled from a series of time-lapse photos and put together at a frame rate of 25 frames per second.

TIP

If you produce a Slideshow movie that includes original, unlicensed music, you can't expect to export such a movie and publish it to a wider audience. Even if you purchase an iTunes Plus track, this does not allow you to redistribute that track if it is used in a slideshow movie. Web sites such as YouTube will remove uploaded files that contain unlicensed music. So, if you plan to create a movie slideshow, make sure you have acquired the rights where necessary to use the soundtrack material. There are Web sites where you can purchase music for this type of usage, such as Getty's audio division at www.pumpaudio.com. Another solution is to check out Web sites or social networking pages for unsigned music artists and see if you can strike up some kind of reciprocal deal. Sometimes a band might be interested in letting you use its music if you let the band use your edited movie. Finally, Moby licenses some of his B sides and other unreleased material for free for noncommercial film usage. Check out www.mobygratis.com to read about the conditions for use and how to sign up.

Downloadable Content: www.thelightroombook.com

TIP

You can also obtain third-party Slideshow plug-ins, the best of which is SlideShowPro for Lightroom: http://slideshowpro.net.

TIP

Quite a few templates are provided in the Lightroom Web module to help get you started. With a little patience and practice, you can easily adapt these basic templates and customize them to create your own Web gallery design layouts.

The Web module

Photoshop has long had the ability to let you create Web photo gallery Web sites of your work. Yet it has often surprised me just how few photographers are using this feature, or even know that it exists. Web galleries are incredibly useful if you need to quickly publish a collection of images on a Web site. You can use them to show photographs from a shoot you are working on to get feedback and approval from a client. Or you can use Web galleries for fun, to share pictures with your friends and family.

The Web module in Lightroom can help you publish photo collections as Web sites with as little fuss as possible (**Figure 11.26**). The main difference between the Web module and the Slideshow module is that, although you have only a small amount of control over the Web gallery designs, there is more emphasis on being able to customize the content information. The Web module works by taking the catalog previews and building a Web site on the fly, as you adjust the Web module settings. What you see in the content area is not just a preview; it shows the Web gallery as it might look when viewed in a Web browser. And as you adjust the Web module panel settings, the changes you make are constantly updated. As with the Slideshow module, a Web gallery can be generated from a selection of images such as a collection, a filtered catalog selection, or a subselection of images made via the Filmstrip.

In the Layout Style panel, you can choose between a Flash Gallery, an HTML style, or one of the Airtight gallery layouts. The basic layout style you select affects the options that are subsequently made available in the remaining panels. In the Site Info panel, you can enter custom information such as the site name and your contact details. With the Color Palette panel, you can edit the color scheme for all the Web gallery design elements. While, in the Appearance panel, you can customize the appearance of the layout design for the HTML or Flash Gallery styles, decide how many rows and columns are to be used in the thumbnail grid, and set the thumbnail and preview image sizes. The Image Info panel lets you customize the content that appears beneath (or alongside) the individual gallery images and provides an opportunity to add multiple items of relevant data information. The Output Settings panel is used to set the image quality and output sharpening; plus, you can choose to add a watermark to the Web gallery images.

At this stage, you can either click the Export button to save the Web gallery to a named output folder or click the Upload button to upload the Web gallery to a server. Plus, there is a Preview in Browser button that lets you preview the Web gallery site in the default Web browser program. But before clicking the Upload button, you will need to use the Upload Settings panel to configure the FTP server settings for uploading a gallery to a specific server address. Finally, custom Web gallery configurations can be saved to the Template Browser panel.

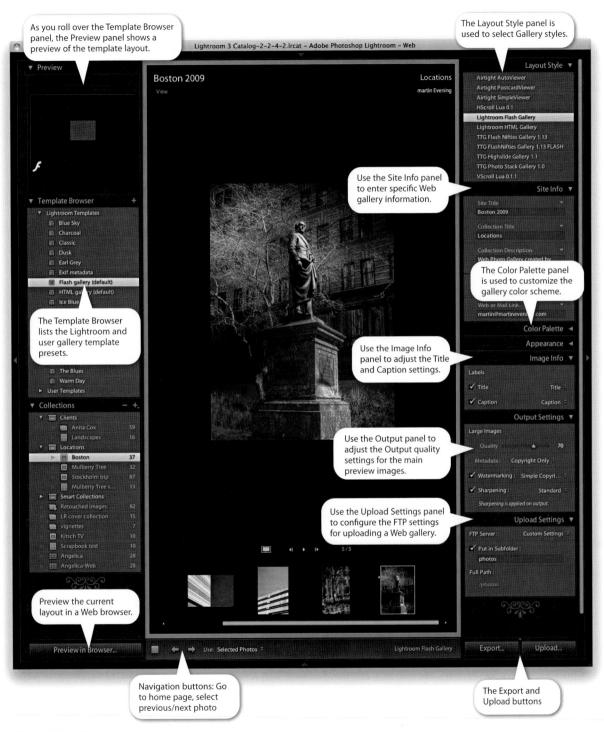

Figure 11.26 The Web module panels and controls.

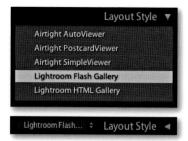

Figure 11.27 The Layout Style panel showing the expanded view (top) and compact view (bottom).

Figure 11.28 The About galler, window.

NOTE

When Photoshop first introduced the Web Photo Gallery feature, the site title would always default to "Adobe Web Photo Gallery," unless you entered a name for the banner. Try doing a Web search using the above term (inside quotation marks) and watch as you get half a million or more results revealing the private photo galleries of Photoshop users who forgot to name their Web galleries!

Figure 11.29 Adobe Flash Player Update warning dialog.

Layout Style panel

The Layout Style panel is located in the right-hand panel section and offers several choices of gallery styles, which can be selected from the list shown in **Figure 11.27**. Note that when the Layout Style panel list is compacted, you will see the name of the selected gallery layout style appear in the Layout Style panel header, from which you can access all the available layout styles via a pop-up menu list. If you go to the Web menu, you can select the "About layout gallery item" at the end of the menu list to open the window shown in **Figure 11.28**. This usually provides more information about an individual gallery layout style.

The Lightroom HTML and Flash galleries

The Lightroom HTML Gallery style is based on a classic HTML-coded template design that can be used to produce a simple Web gallery that has two viewing levels. Thumbnail images are displayed in a grid on the main index page. When you click one of the thumbnail cells, this takes you to a larger, single-image page view where there is room to include Title and Caption information above and below the photo. From there you can click the image to return to the index page thumbnail view again. Because the Lightroom HTML Gallery uses classic HTML code, it is probably the most compatible gallery layout style you can choose, as any visitor viewing a gallery created with an HTML gallery style will be able to access these pages. The custom options let you make some basic modifications, such as the size of the large image view, the metadata display options, and color scheme, but it is otherwise a fairly rigid gallery style.

The Lightroom Flash Gallery layout style builds galleries that use Adobe Flash (formerly Macromedia) code, which can render smooth, animated slide transitions between images. Flash-based Web sites are all the rage these days. They look cool and are a great way to present your images, but visitors to a site built using the Lightroom Flash Gallery style must have the latest Flash Player installed in order to view the Web gallery pages. In fact, when you select a Flash Gallery layout style, you may see a warning dialog indicating that you need to install the latest Adobe Flash Player (Figure 11.29). However, the Flash Gallery layout style does offer more options for customizing a gallery layout. For example, when a Flash Gallery layout style is selected, you have a choice of different layout modes, such as the Scrolling layout, where a large image is displayed in the main index page with the thumbnails below. Other options include a Paginated layout view, where the main image is shown on the right with paginated thumbnails on the left; a Left scrolling view, where the thumbnails run down the left side; and a Slideshow layout, where single images are displayed large in the window and you can view them as a continuous slideshow. The main differences between the HTML and Flash gallery layout styles can be seen over the next two pages.

Lightroom HTML Gallery layout

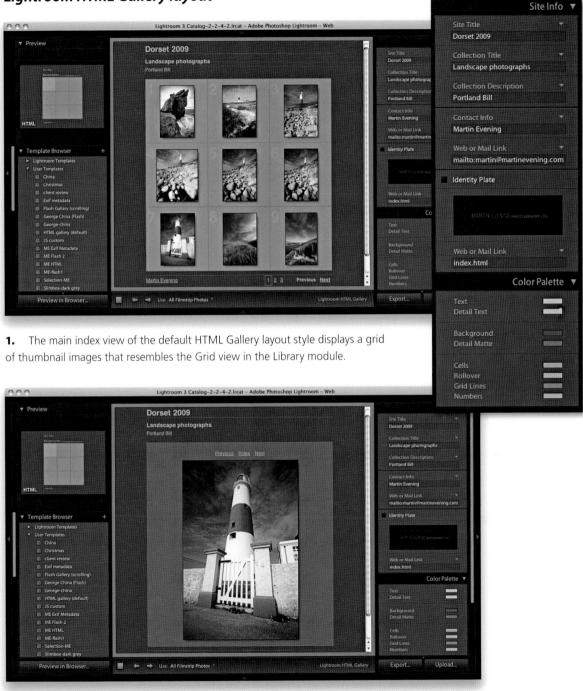

2. You can click a thumbnail to go to the main image view and then click the image to return to the index view again.

NOTE

Flash Gallery layouts offer four types of Web page layout: the Scrolling type layout (shown here), Paginated, Left scrolling, and Slideshow Only modes. Examples of these other layout designs are shown in Figures 11.49 through 11.52.

Lightroom Flash Gallery layout

1. The default Flash Gallery layout style displays a large image view with scrolling thumbnails at the bottom. You can click a thumbnail to select a new image, or click the Slideshow icon (circled) to go to the Slideshow View mode.

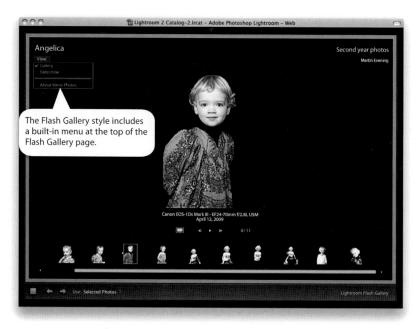

2. You can run the images in a slideshow autoplay mode or use the left/right arrow keys to navigate the Flash Gallery Web site.

Airtight AutoViewer gallery

Now that third parties have started constructing their own layout styles for Lightroom, it is possible to load additional gallery styles. For example, the Airtight layout styles have already been incorporated into the Lightroom Web module, and it is possible to install other layout styles, too, such as the Turning Gate galleries shown on page 576. As with the HTML and Flash gallery layouts, when you select one of these other layout styles, the Web module panel options will look different and reveal the custom options associated with each particular layout (**Figure 11.30**).

The AutoViewer gallery layout style creates a self-running slideshow Web gallery, for which you can adjust things like the frame size, padding, and slide duration, as well as the color of the background and the frames. In the Output Settings panel, you can adjust the size and JPEG quality for the gallery images. However, unlike with some of the other layout styles, you won't be able to fully appreciate how the resulting Web gallery works until you hit the Preview in Browser button. **Figure 11.31** shows a screen shot of how a finished gallery page looks when viewed in a Web browser program.

Figure 11.31 *This shows a Web browser view of the Airtight AutoViewer gallery layout style in action.*

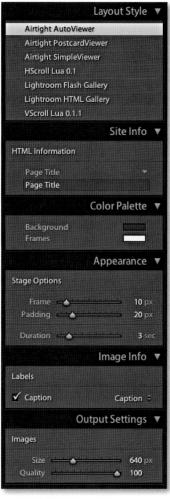

Figure 11.30 The Airtight AutoViewer gallery layout style panel options.

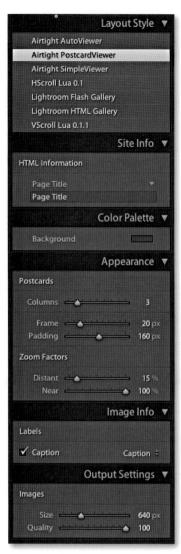

Figure 11.32 *The PostcardViewer gallery style panel options.*

Airtight PostcardViewer gallery

This gallery features a rather interesting use of Flash to create a scattered postcard layout. As you can see in **Figure 11.32**, the panel options allow you to set the number of columns to be used, as well as the zoom factors for the small thumbnails and large images. The **Figure 11.33** screen shots show a Web browser view of the gallery in use. When viewed via a Web browser, you can press the <u>Spacebar</u> to toggle between the thumbnail and large image view, and use the keyboard arrow keys to navigate from one image to the next.

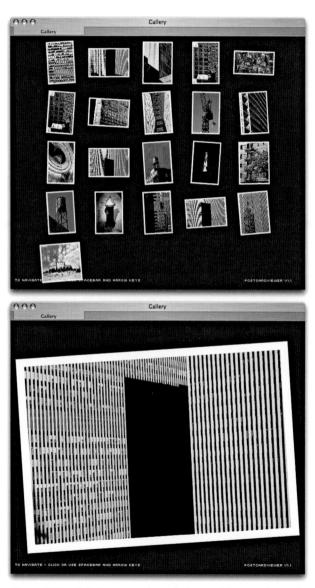

Figure 11.33 This shows two views of a PostcardViewer gallery style.

Airtight SimpleViewer gallery

The SimpleViewer gallery is fairly similar to the standard Lightroom Flash Gallery "paginated" layout, but it also offers a few nice touches, such as the ability to precisely control the thumbnails layout, where you can set the number of rows and columns in the Appearance panel and customize the image size and image quality, as well as the frame size and padding in the Output Settings. **Figure 11.35** shows the SimpleViewer gallery panel options, and **Figure 11.34** shows an example of how this gallery style looks when previewed in a Web browser. The large arrows make this Web gallery appear both functional and stylish.

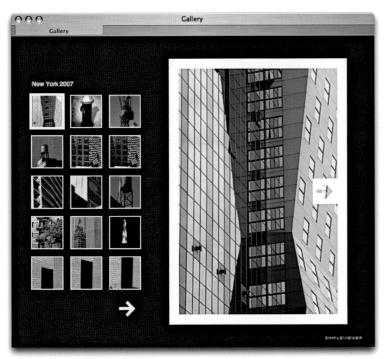

Figure 11.34 Here is a browser view screen shot of the SimpleViewer gallery. The arrow in the image view allows you to move from the current image to the next, while clicking on the arrow below the paginated grid jumps to the next batch of thumbnails.

Third-party gallery styles

Adobe has made it easy for third-party companies to create their own layout styles. Well, I guess it's only "easy" if you know how to code such things! This has led to a number of third-party companies and individuals creating their own brands of gallery layout styles, which, when loaded, take over the right-hand panels in Lightroom and allow you to customize these layout styles as you would when adjusting the others that I have just mentioned. My favorite Web gallery styles are those designed by Matthew Campagna of The Turning Gate (www.theturninggate.net), which can be downloaded from The Turning Gate

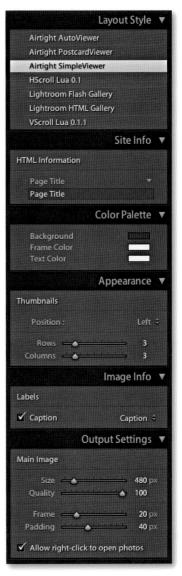

Figure 11.35 The SimpleViewer gallery layout style panel options.

NOTE

To access the gallery styles shown here, go to http://lr.theturninggate. net.

NOTE

Lightroom 3 now also allows thirdparty developers to use ActionScript 3 when developing gallery styles for Lightroom. Web site. I highly recommend you check these out, as they offer great additions to the Lightroom Web module. **Figure 11.36** shows a Lightroom Web module preview of a TTG Polaroid Gallery, and **Figure 11.37** shows a preview of the TTG Selection Gallery style.

Figure 11.36 The TTG Polaroid Gallery Type I 1.2 gallery layout style. With this Web gallery, the photos are cropped to a square format and placed in a Polaroid-style print border. The photos can then be dragged about however you like, and you can click an individual picture to see a larger view.

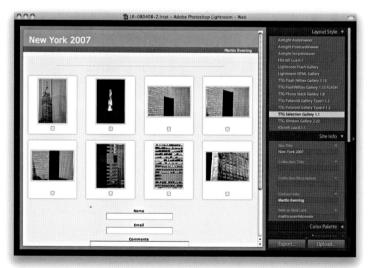

Figure 11.37 The TTG Selection Gallery 1.1 layout style has a lot of practical uses. A Web gallery created with this style allows visitors to the site to check the photos that they like, enter their names and e-mail addresses, and automatically send e-mails with any added comments to the e-mail address configured in the Site Info panel (see page 577).

Don't confuse Web gallery layout styles with the Web gallery templates that are saved to the Template Browser. To install a Web gallery layout style like The Turning Gate styles mentioned here, place the downloaded layout style in the following location: Username/Library/Application Support/Adobe/Lightroom/ Web Galleries (Mac), Users/Username/AppData/Roaming/Adobe/Lightroom/ Web Galleries (Vista PC), or Documents and Settings/username/Application Data/Adobe/Lightroom/Web Galleries (Windows XP). (On a PC, you will need to make sure that hidden files and folders are visible.) Remember to quit and restart Lightroom after you have installed a new layout style. Once you have done so, the newly added layout style appears listed in the Layout Style panel.

Site Info panel

The Lightroom gallery layout styles provide the core Web gallery structure, and the gallery style you select will affect the range of options available in the panels that appear below the Layout Style panel. These additional panels allow you to customize the Web gallery content, so let's start by looking at the Site Info panel (**Figure 11.38**). Here you can complete the various fields that are used to either describe or provide information about the Web gallery images.

The arrangement and purpose of the Site Info items is as follows: The Site Title is used as the main heading in the template design and when an HTML Gallery style is chosen, the Site Title also appears in the Web browser title bar. The Collection Title is like a subheading to the main title. For example, if you were preparing Web galleries of a wedding, the main title would probably be a general description such as "Jones wedding." You might then prepare several galleries with different collection titles: One gallery might be for the ceremony, another for the family groups, and another for the reception. In the Collection Description, you can write a slightly longer summary description of the Web gallery contents. When an HTML Gallery style is selected, this information appears just below the Collection Title header. If a Flash Gallery style is used, this information can be viewed only when visitors select View \Rightarrow About these Photos, as was shown in Step 2 on page 572. Note that this same built-in menu also allows visitors to switch from the Gallery to the Slideshow gallery mode, although they can probably do this more easily by clicking the **I** icon to the left of the slideshow controls.

You can enter your own name in the Contact Info box and use the Web or Mail Link box to enter a link that you want to have associated with the contact info. If you wish to add an e-mail link here, just type in your e-mail address. When you do this, the contact info appears at the bottom of the page (HTML) or in the top-right corner (Flash), and when a visitor clicks this link, it automatically launches his e-mail program and prepares a new e-mail that is ready to send with your e-mail address placed in the *To:* header. Alternatively, you can insert a URL that takes visitors to your Web site. There is no need to type in the *http://* at the beginning of the Web address—Lightroom automatically fills that bit in for you.

Figure 11.38 You can use the Site Info panel to add information relating to the gallery page. If you click the downfacing triangles, you can access the most recent list of data entries. Shown here is the HTML Gallery Site Info panel (top) and the Flash Gallery Site Info panel (bottom), which also includes the Identity Plate options.

	Color Palette 🔻
Text Header Text Menu Text	
Header Menu	
Background Border	
Controls Backgro Controls Foregrou	

Figure 11.40 The Color Palette panel for a Lightroom Flash Gallery.

TIP

You may also want to check out Adobe Kuler, which at the time of this writing is a Web-hosted application that enables you to explore, access, and share color harmonies. It is currently available as a free evaluation service and can be downloaded at http://kuler.adobe.com. Do check it out—it is a very cool service!

Color Palette panel

The Color Palette panel can be used to customize the gallery interface. The items in the Color Palette panel will appear different, depending on whether the Lightroom Flash Gallery or Lightroom HTML Gallery is selected. **Figure 11.39** shows a Color Palette panel in HTML Gallery mode, which shows the color scheme used in the Ice Blue HTML template design. In this particular example, the Text and Detail Text color is dark blue, offset against a light blue background with pastel colors of blue/lilac used for the thumbnail cells, cell frame rollover colors, cell frame numbers, and grid lines. Note that the Detail Matte color is that used as a matte backdrop for full-image page views, so you will have to inspect the HTML galleries in full-image page view mode to see the effect this is having on the layout.

Figure 11.40 shows an example of the Color Palette appearance when a Lightroom Flash Gallery style is selected. Here, I have shown the settings used for the Mossy Rock Lightroom Flash Gallery. In this example, the Text, Header Text, and Menu Text colors are all a light gray, and the Header, Menu, Background, and Border use different shades of green. The Header is the top bar that contains the site title and collection title, and the Menu is the bar that runs just beneath it. The Background is everything else in the background of the gallery layout, and the Border is the edging that defines both the main image and thumbnail list sections. Finally, the Controls Background and Controls Foreground colors determine the color of the Flash Gallery playback controls that appear at the bottom of a Flash Gallery layout.

Choosing a color theme

With so many color choices, which should you use? There is a definite art to picking the colors that work well together. The safest thing to do would be to select one of the gallery templates listed in the Template Browser, or stick to designing a layout that uses a neutral range of colors. Many photographers prefer to keep the color accent neutral since the presence of colors can be a distraction when evaluating color photographs. **Figure 11.41** shows the Color picker and how you can enter hexadecimal values to select Web-safe colors, while **Figure 11.42** and **Figure 11.43** show some of the Color Palette themes available in the Template Browser.

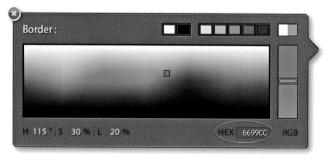

Figure 11.41 When choosing a color scheme for a Web gallery layout, you also enter hexadecimal (Web-safe) colors in the HEX edit box.

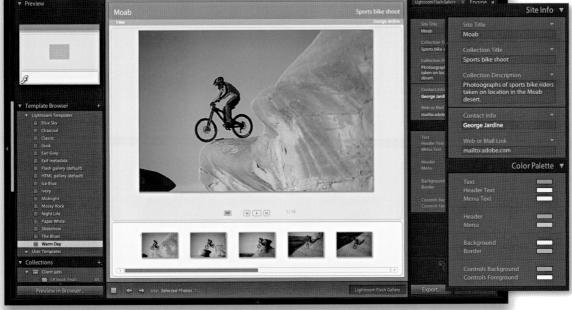

Figure 11.43 The Lightroom "Warm Day" Flash Gallery template.

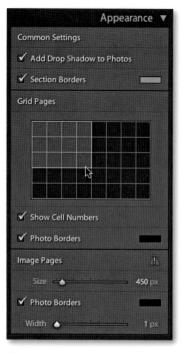

Figure 11.44 The HTML Gallery Appearance panel.

NOTE

When you initially increase the preview size, the image may at first appear pixelated, but don't worry. Once Lightroom has had a chance to refresh the Web gallery images, you will see revised versions of all the images in the gallery main page views.

NOTE

The image size for the image pages can be anywhere from 300 to 2071 pixels along the widest dimension of the gallery image.

Appearance panel

The Appearance panel (**Figure 11.44**) offers some additional control over the layout appearance of the different gallery layout styles.

Appearance settings for the HTML Gallery

The grid layout must have a minimum of three columns and three rows. You can customize the design layout by clicking anywhere in the grid to set the grid cell range (**Figure 11.45**). When you create a gallery with more images than can fit the grid layout, these overflow into successive, numbered index pages. If you have a saved collection of photos and are creating a Web gallery of the entire collection, it can be useful to check the Show Cell Numbers option, because this may make it easier for people to identify a particular image by using the cell index number rather than the filename. Also included here are check boxes for customizing the look of the HTML grid, such as adding drop shadows and borders. At the bottom, you have the Image Pages view options, where you can adjust the image size and the color and width of the photo borders. The exclamation point you see in Figure 11.44 indicates that these adjustments can be seen only if you click a grid image to make a single page visible in the content area preview.

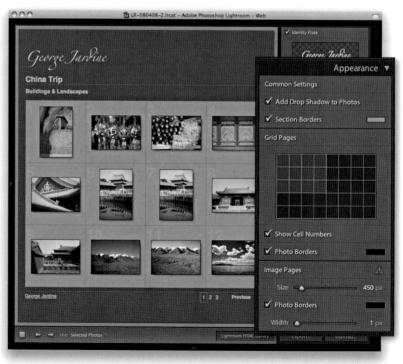

Figure 11.45 In this example, the Appearance panel was set to use a 3x4 grid in a Lightroom HTML Gallery style layout.

Appearance panel settings for the Flash Gallery

The Appearance panel for the Flash Gallery has four different layout options (**Figure 11.46**). The default Flash Gallery layout uses a Left scrolling thumbnail layout, in which the main image is displayed with a strip of thumbnails running down the left side of the layout, with a scroll bar to navigate through the thumbnails (**Figure 11.48**). Individual images can be selected by clicking a thumbnail or by using the right/down arrow keys to navigate forward through the pictures, or the left/up arrow keys to navigate backward one at a time. You can also use the slideshow navigation buttons (**Figure 11.47**) to progress through the images in the gallery.

The next two pages show a summary of the four Flash gallery views: In the Scrolling layout, the thumbnails are displayed in a horizontal row in the lower section with the scroll bar at the bottom (**Figure 11.49**). The Paginated layout presents the index page in two halves, with the main image displayed on the right and the thumbnails on the left inside a paginated grid (**Figure 11.50**). The layout of the grid also adapts to the overall size of the content area; this is how the final Flash Gallery will behave, too. Whenever you create a Paginated Flash Gallery, the cell layout automatically adapts as you resize the window of the Web browser. **Figure 11.51** shows the Left scrolling thumbnail layout, and **Figure 11.52** shows the Slideshow Only view, which displays the images without the thumbnails.

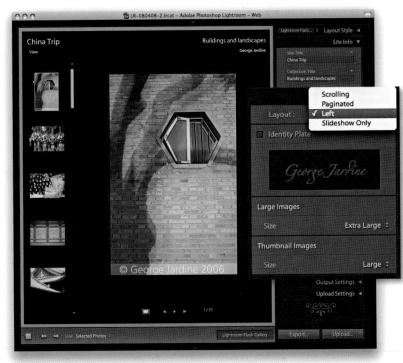

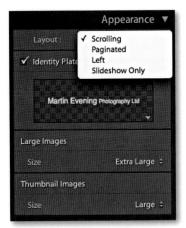

Figure 11.46 The Flash Gallery Appearance panel.

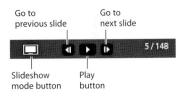

Figure 11.47 The Flash Gallery slideshow navigation controls.

NOTE

In the Flash Gallery Output Settings, you can choose from one of several preset sizes for the Thumbnail and Preview images: Small, Medium, Large, or Extra Large. In my opinion, the Small and Medium thumbnail sizes are too small to be of much use. For the main preview image, I would also suggest you pick either the Large or Extra Large options.

Figure 11.48 A Flash Gallery using a Left scrolling style.

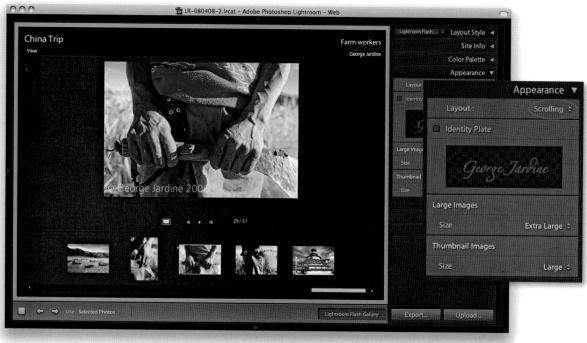

Figure 11.49 A Flash Gallery style using the Scrolling layout.

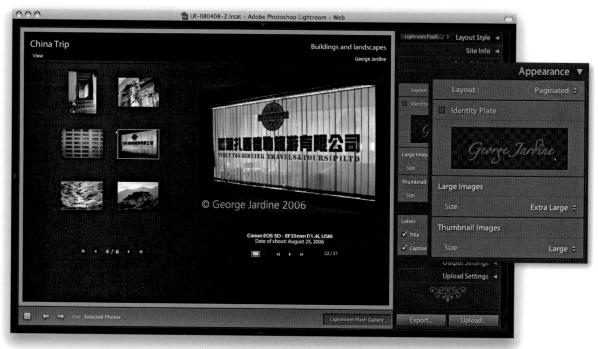

Figure 11.50 A Flash Gallery style using the Paginated layout.

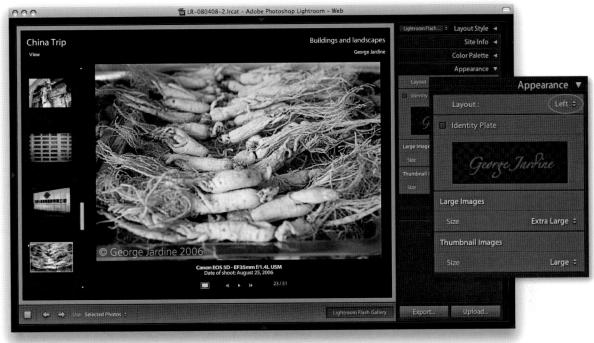

Figure 11.51 A Flash Gallery style using the Left scrolling layout.

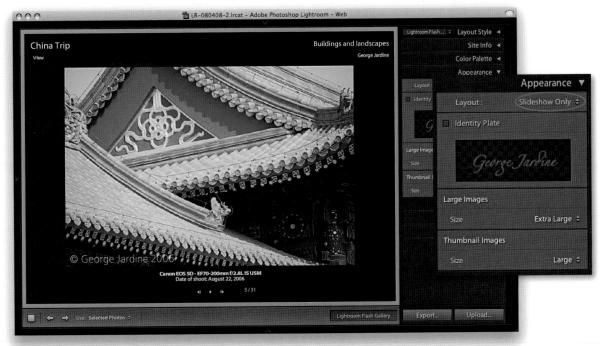

Figure 11.52 A Flash Gallery style using the Slideshow Only layout.

Appearance panel settings for the Airtight galleries

The Appearance panel options for the other gallery layout styles may well vary, but they are mostly self-explanatory. In **Figure 11.53**, I have shown the Appearance panel options for the Airtight PostcardViewer gallery layout style.

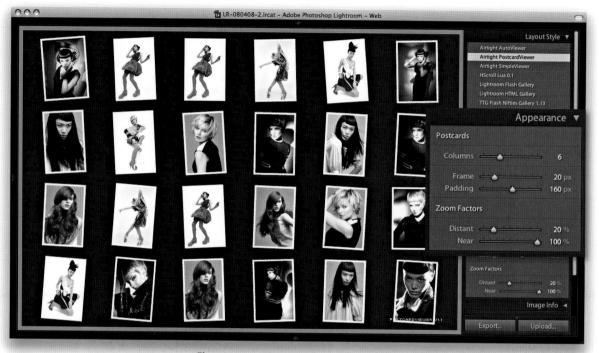

Figure 11.53 The Appearance palette options for the Airtight PostcardViewer gallery style allow you to set the zoom scale for the thumbnails and full-sized images.

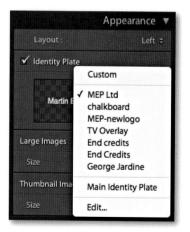

Figure 11.54 The Appearance panel showing the Identity Plate options.

Identity Plate options

If you are editing a Flash Gallery, the Identity Plate options will show up in the Appearance panel (**Figure 11.54**). However, if you are editing an HTML Gallery, they will show up in the Site Info panel instead. If you refer back to "Creating a custom identity plate" on page 549, you can remind yourself of the steps required to design and edit an identity plate and save it as a new setting. When working with the Web module, the only real options you have are to enable or disable an identity plate from appearing at the top of the Web gallery interface (in place of the site title). Unlike the Slideshow module, there are no further options that allow you to alter the position of the identity plate in the site layout, or add attributes such as a drop shadow.

Image Info panel

Adding titles and captions

The Image Info panel has a Title and Caption section where you can add imagerelated information to the main image views. In an HTML gallery layout, the Title appears above the image in the main image view, and the Caption is placed just below the picture. In a Flash Gallery layout, the Title is displayed beneath the main image view using a bold typeface, and the Caption appears in a lighter typeface just beneath the Title.

To create a custom setting, the simplest way is to click the pop-up menu to the right of the current setting and select an item from the list in **Figure 11.56**, which shows all the available Title and Caption menu options. For example, in **Figure 11.55**, I chose Custom Text for the Title, where I entered the desired custom text in the box below; for the Caption, I selected Equipment. These are the easy-to-access default options, but if you want to extend these, you can click the Edit item at the bottom to open the Text Template Editor shown over the page in **Figure 11.57**, where you can create your own custom template design.

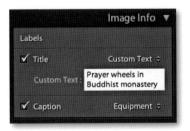

Figure 11.55 Here is a view of the Image Info panel, where the Custom Text item was selected for the Title, and I entered the custom text shown here.

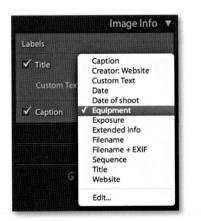

Figure 11.56 Here is a view of the Image Info panel, where I clicked the Caption menu and selected Equipment from the list.

TIP

It can sometimes take a few seconds or more to see changes update in the content area. For this reason, I sometimes recommend that you have only one or maybe just a few images selected while editing the Image Settings to create a new Title or Caption setting. You can choose the Reload command in the Web menu or press (#R (Mac) or Ctrl R (PC) to force a refresh in the content area, but since Lightroom automatically updates the content area all the time anyway, you shouldn't really need to use this command.

Customizing the title and caption information

Figure 11.58 shows a preview for a customized HTML Gallery that used the Image Info panel settings shown previously in Figure 11.55 and Figure 11.56. You can see that the custom text I entered for the Title appears in the matte frame just above the image, while the caption is placed below and shows the name of the camera and lens used.

As I just mentioned, if you choose Edit from the Image Info panel, this opens the Text Template Editor (Figure 11.57), which is identical to the one shown earlier in the Slideshow module section and allows you to insert metadata tokens from the pop-up menus and combine these with custom text. **Figure 11.59** shows a Flash Gallery layout in which I had selected the Date option for the Title and used the Text Template Editor settings shown in Figure 11.57 to create a custom Caption setting, which I saved as Extended Info.

Preset:	Extended info		
Example:	_MG_2712 • • Exposure: ½30 st	ec at f / 10	• ISO 400 •
ISO Sp	ne • Copyright • Exp eed Rating • Camera: Ma ength •	osure: E ike • Foo	xposure 🕜 • al Length:
Image Nam	e		
	Filename	•	Insert
	Original filename	:	Insert
Numbering			
	(Image # (1)	•	Insert
	Date (Month DD, YYYY)	:	Insert
EXIF Data			
	Exposure	•	Insert
	Dimensions	•	Insert
	Dimensions	:	Insert
IPTC Data			
	Title	•	Insert
	Caption	•	Insert
	Copyright	•	Insert
Custom			
	Custom Text	C	Insert
	-	Cancel	Done

Figure 11.57 The Text Template Editor.

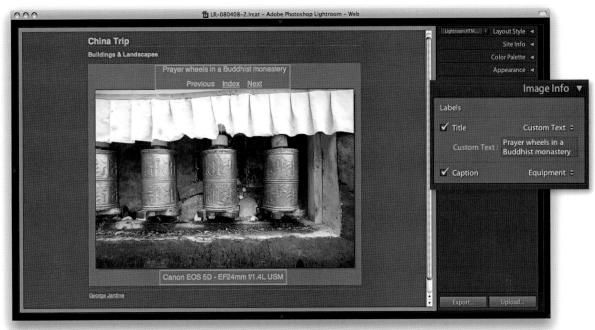

Figure 11.58 This shows how the Title and Caption information is displayed in an HTML Gallery style using the Image Info panel settings shown in Figure 11.55 and Figure 11.56.

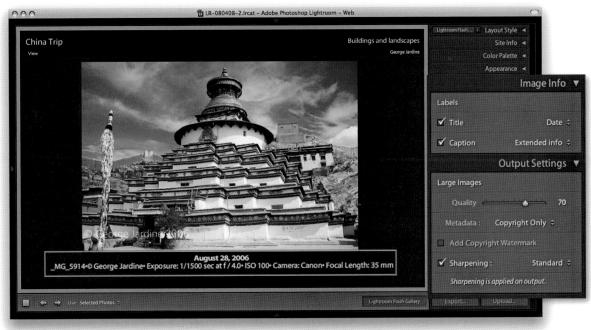

Figure 11.59 This shows how the Title and Caption information are displayed in a Flash Gallery style page view using the text template settings shown in Figure 11.57.

Figure 11.60 This shows the "Exif metadata" template selected in the Template Browser panel.

C-11.1.1.1.1.1.7.1	Text Templa	te cuitor	
Preset:	Filename		
Example:			
Filenan	ne	internation en en	
Image Nam			
	✓ Filename	-	Insert
	Filename number suffix	3	(Insert)
	Filename Extension Folder Name	9	insert
Numbering	Folder Name		
	(Image # (1)	•	(Insert)
	Date (Month DD, YYYY)	•	(Insert)
	Conce (anonan bo), 1111)		unsert
EXIF Data		L'ISALEI	
	Exposure	•	(Insert)
	Model		(Insert)
	Dimensions		Insert
	Lamensions		unsert
IPTC Data			
	Creator Website	•	(Insert)
	Caption	•	Insert
	Copyright		Insert
	Copyingin		unsert
Custom			
	Custom Text		Insert
		Cance	Done

Creating a custom Text template

Figure 11.61 shows a progression of screen shots in which the Text Template Editor was used to configure a new Image Info panel Title/Caption preset that can be seen in use in **Figure 11.62**. If you select a preexisting preset and choose Edit to make changes to the layout via the Text Template Editor, the preset name is marked as an edited version. If you want to update a current preset's settings, don't forget to choose Update Preset from the Preset menu in the Text Template Editor.

Custom presets cannot be formatted in any particular way, and the information is always displayed as a continuous flow of text in the Title or Caption field. However, if you choose the "Exif metadata" template from the Template Browser panel (**Figure 11.60**), it includes a unique, built-in custom setting where some of the camera EXIF metadata information is presented in a formatted way in the Caption section (**Figure 11.63**). You can't actually edit this setting, and the only way to access it is by selecting the Lightroom "Exif metadata" template.

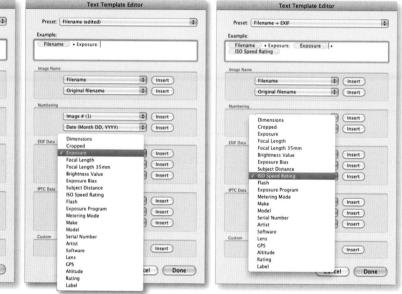

Figure 11.61 This shows a sequence of screen shots where in the Text Template Editor I created a new Title/Caption preset. I started by clicking one of the Image Name pop-up menus and selected a Filename token. This added a Filename token to the editor window above. I typed "• Exposure:" and clicked one of the EXIF Data menus to add an Exposure token. I went to the EXIF Data section again and added an ISO Speed Rating token. Then, from the Preset menu, I chose Save as New Preset. I named the preset "Filename + EXIF" and clicked Done. This preset then appeared added to the Image Info panel menus.

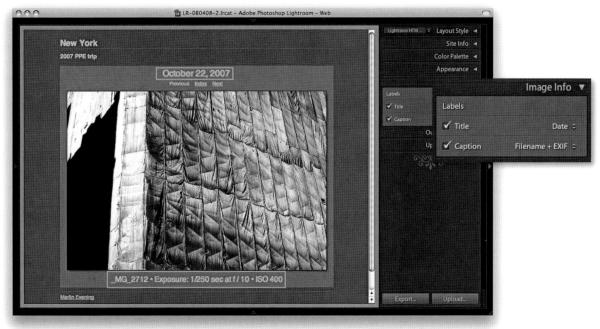

Figure 11.62 Here is how the Caption information appears on an HTML detail page when using the custom "Filename + EXIF" preset I created in Figure 11.61.

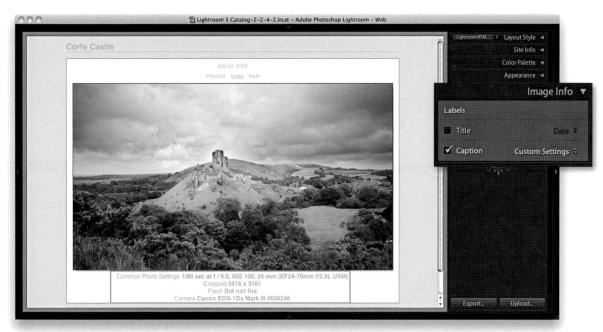

Figure 11.63 The "Exif metadata" template in the Templates Browser panel (Figure 11.60) features a unique custom setting that allows you to display the EXIF metadata information in a formatted layout (in the red box above).

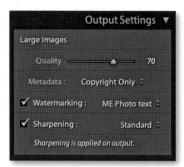

Figure 11.64 *The Output Settings panel.*

Output Settings panel

The Output Settings panel (**Figure 11.64**) can be used to establish the main image quality, Watermarking, and Sharpening settings. The Quality slider is used to set the amount of compression that is applied. The Web gallery images that you are previewing on the screen are all JPEG versions of the master images, and the JPEG file format uses a lossy method of compression to reduce the physical file size so that the JPEG images are small enough to download quickly. The choice boils down to high quality with minimal compression or lower quality with greater compression. Note that as you adjust the Quality slider, you should give Lightroom a chance to refresh the gallery so that you can accurately preview the effect the compression setting is having on the Web gallery image appearance.

The Metadata section allows you to choose between embedding All Metadata or Copyright Only. Embedding metadata is useful if you want to ensure that your photographs are output with all the essential metadata, such as the EXIF information and IPTC captions, and that these are preserved in the file header. The downside of doing this is that your JPEG Web images will become bigger in file size. So if your main concern is to keep the file size down and have your Web gallery sites load quickly, then choose the Copyright Only option. You can also check the Watermarking box to add a copyright watermark to all of the gallery images. This option also makes use of the new Watermark editor that was described earlier on pages 490–491 in Chapter 9.

The Sharpening section makes use of the output sharpening routines that have been added to Lightroom. When the Sharpening box is checked, Lightroom automatically calculates the correct amount of sharpening to apply to each image, based on the final output pixel dimensions. The sharpening that is applied here is not the same as that applied for print in the Print module; instead, it is based on sharpening routines that have been devised specifically for a computer display output. The Standard Sharpening setting applies what is regarded as the optimum auto-sharpness setting, but you can also choose to use Low or High, if you prefer a weaker or stronger sharpening effect. However, you won't see any changes take place to the images that are previewed in the Web module content area until you choose Preview in Browser or Export Web Photo Gallery. It is only at this stage that the photos are fully processed and the sharpening routines are applied. This will certainly increase the time it takes to export the Web gallery, but if you test how the gallery images look with and without sharpening, you'll find that the Web output sharpening is definitely worth applying.

Previewing Web galleries

One of the benefits of working with the Web module is that the content area gives you an almost exact preview of how a Web gallery will look (apart from the output sharpening), since it is effectively showing you a Web browser view. Even so, this might not be exactly how everyone will see your Web site after it has been uploaded. There are always a number of unknown factors, such as the variability of the displays used to view the images that are on your Web site (see "Image appearance in Slideshow and Web modules"). Therefore, in addition to previewing the gallery pages in the content area, you can check how a gallery looks in an external Web browser application by clicking the Preview in Browser button (**Figure 11.65**), or you can use the **(Mac)** or **(Ctrl (Att P)** (PC) shortcut. When you click this button, Lightroom creates a temporary export of the gallery and previews the result in whichever Web browser program is set as the default browser on your computer.

Image appearance in Slideshow and Web modules

Slideshow module colors

Lightroom uses a large, wide-gamut RGB space to carry out its image processing calculations, but for screen presentation work, the color space needs to be tamed to something that is more universally recognizable. When you create a slideshow, Lightroom utilizes the JPEG previews that have already been generated to preview the catalog images onscreen. These preview images are typically created in the Adobe RGB space, which is particularly optimal for screen presentations because it prevents any unexpected shifts in the colors or contrast. However, this, in turn, depends on the Catalog settings. This is because if the preview quality in the Catalog Settings File Handling section is set to Low or Medium, the raw file Lightroom catalog previews are in Adobe RGB, but if set to High, they will be in ProPhoto RGB. In the case of non-raw (rendered) files such as TIFF, JPEG, or PSD, the native RGB space is used to generate the previews; for slideshow work, the onscreen previews are preserved in whatever that space happens to be.

Web module colors

When you output images for the Web, you are usually heading into unknown territory. This is because once images have been published on the Web, you have absolutely no way of knowing how they will be seen. It is fair to assume that most people will be viewing them with displays that are uncalibrated. Some Web browser programs such as Apple's Safari are able to color-manage images that have an embedded profile, but most do not. For these reasons, the Web module converts the image previews on the fly to the universal sRGB space, which is an ideal choice for all Web output images.

Figure 11.65 The Preview in Browser button can be used to preview how a Web site looks in an external Web browser.

NOTE

The default Web browser is the one set as the default by your operating system. There is no Lightroom preference for selecting this.

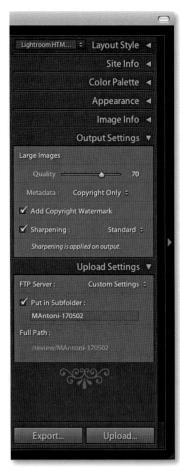

Figure 11.66 The Export and Upload buttons are located in the bottom-right corner of the Web module interface.

Exporting a Web gallery

If you create a Web gallery output from the Web module, you can export or upload a gallery as a complete Web site. The Export option is applicable if you wish to save a complete version of the Web site to a folder on the computer. This then allows you to preview a Web gallery in different Web browser programs (not just the system default browser) and upload the Web content manually using a dedicated FTP program.

To export a gallery, click the Export button (**Figure 11.66**), or use \textcircled (Mac) or \boxed{Ctrl} (PC). This opens a system navigational dialog where you can choose a location to save the exported gallery to (such as the Desktop), type in a name for the exported gallery folder, and click Save to start the export process. If you are familiar with FTP software, you can then manually upload the saved site folder to a server location.

1. To export a Web site, I clicked the Export button, chose a destination location, named the export folder, and clicked the Save button to save the Web site.

00

New Connection

3 items, 232 GB available	Hostname:	www.martinevening.com	Q. (%
	Username:	admins	
and the second se	Connect using:	FTP	
bin resources		Enable encryption	
	Password:	•••••	
STTME		Add to keychain	
index.html	Initial folder:	/root	
	Port:		
	Try to connect	times.	

2. This created a folder that contained all the elements for the Web site. You can preview a site off-line by opening the *Index.html* file within any Web browser program. You can also upload the folder site contents manually using a program like Fetch for Mac OS X. The URL path used to access the site depends on where you upload the site to and how your server site space is configured.

Uploading a Web gallery

You normally want to choose the Export option for those times where you need to manually edit a site before uploading it, or you want to store a backup copy of a Web site off-line. But for all other circumstances, you can configure Lightroom so that it uploads the files directly when you click the Upload button.

	Upload Settings 🔻
FTP Server :	✓ Custom Settings
Put in Subi	Camilla site Martin Evening site New book website
Full Path : /review/LR	PSN Edit

1. In the Upload Settings panel, I clicked the FTP Server preset menu and selected Edit.

Server:	www.martinev	ening.com			
Username:	admins		Password:		•
				Store password in pre The password will	eset be stored in plain te
Server Path:	/root				Browse
Protocol:	FTP 🛟	Port: 21	Passive mod	de for data transfers:	Passive

2. To create a new custom preset, I entered all the information that was required to access my server space (if in doubt, check with your Internet service provider). The Server address is usually the first part of the URL, and the Username and Password can sometimes be the same as those used for your e-mail account. The Server Path is used to enter the root folder on the server. Again, talk to your provider, because there may well be a root-level name that has to be entered to access the server space allocated to you; otherwise, the connection won't work. In this example, I entered *Iroot* as the root-level directory. (Note that it is important to always place a forward slash at the beginning of the server path.)

NOTE

There are various File Transfer Protocol (FTP) programs that you can choose from. Fetch from www. fetchworks.com is a popular program for the Mac. If you are working on a PC, I recommend using WS_FTP Pro (www.ipswitch.com) or FlashFXP (www.flashfxp.com).

Whichever platform you use, the same steps will be used to establish an FTP connection. You need to enter the server URL, the username, and password. Your Internet service provider will be able to supply you with all this information (assuming your Internet account includes server space).

NOTE

SFTP stands for Secure File Transfer Protocol and is a network protocol that provides both file transfer and manipulation across a reliable network connection.

NOTE

When you point a Web browser program at a Web link, it automatically searches for a Web page with the name *index.htm* or *index.html*. If you want to specify a published subdirectory link, you must place a forward slash (/) before the directory folder name and another forward slash at the end to tell the Web browser to search for an *index.htm* or *index.html* page.

e-selection	Date 224602740	Size -132746	
et	219500700	-132746	
	213618780	-132746	
oot	227090280	-132746	
Protocol: FTP	Port: 21	Passive mode for data transfers:	Passive 🛟

3. You don't necessarily have to memorize the structure of your server directory or the name of the server path. Here, I just clicked the Browse button in the Configure FTP File Transfer dialog and Lightroom scanned the server to reveal a folder view of the server directory. I clicked the *LRshoot* folder and clicked the Select button to make this the Server Path.

		Configur	re FTP File Transfer
Prese	/ Book website (edited)		
Us	Book website Camilla site Martin Evening site PSN Save Current Settings	as New Preset	
-	Update Preset "Book v	vebsite"	
	er Path: /root/LRshoot	Port: 21	Passive mode for data transfers Passive
			Cancel

4. In the Configure FTP File Transfer dialog, you can see that the Server Path directory has now been automatically updated to point to the *LRshoot* folder. You can use the Browse feature in this way to access different folders or subfolders on the server and save them as different upload presets. If you experience problems getting a connection when you click the Browse button (or later when you try to upload), it could be because of the firewall software on your computer system or router. If this is the case, try selecting the "Passive mode for data transfers" option (circled). Also, if you change any of the settings applied here, you will need to go to the Preset menu and choose Update Preset. Once I was done here, I clicked OK.

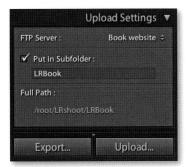

5. This took me back to the Upload Settings panel where the Put in Subfolder field needed to be completed. The folder name entered here completes the server path directory. The reason this section is left blank is because you *must* apply a unique name to the Web site folder you are about to create. Since the currently selected FTP Preset pointed to */root/LRshoot*, all I needed to do here was type in a name for this particular Web gallery. In this example, I typed in *LRBook* as the next part of the server directory. Note that there was no need to add a forward slash at the beginning of this section of the path or after. Lightroom adds the slash automatically, because the complete path I had created was, in fact, */root/LRshoot/LRBook/*. I then clicked the Upload button and Lightroom automatically uploaded the gallery files to this location on the server.

6. One of the reasons you are always required to enter a new server output path in the Upload Settings panel is to avoid uploading and overwriting a previous Web folder upload. If you enter a folder name destination that already exists, Lightroom warns you before letting you continue with the new upload. If you are re-editing an existing gallery, you will see this warning each time you refresh the gallery contents on the server, so in these circumstances, it is safe to click the Continue button.

TIP

If you are uploading Web gallery files to an existing Web server space that already contains your Web site, be careful that the subdirectory you choose does not conflict with existing folders. For example, it is not a good idea to upload new Web galleries to a folder called "images," since it is highly probable that your Web site already uses a folder of that name. Try using more unique and descriptive names for the folder locations, such as "client-review" or "snaps."

TIP

This tip has nothing to with Lightroom, but I find a preconfigured e-mail signature useful in lots of ways. I can use preformatted replies to do things like summarize an outline of basic services and costs or, as shown in Step 7, send an e-mail with instructions on how to view a Web link.

000	Ne	w Message			0
Send Chat	Attach Address Fonts Colors	Save As Draft			
To:	Attach Address Fonts Colors	Save As Draft			
Cc:					
Subject:					
=		Sig	gnature:	Go to weblink	•
Hi Simon,					
	ink below to see the most recent ph	oto collection:			
	ening.com/_Bshoot/_Bbook/				
Cheers,					
Martin					
www.martinevening	.com				

7. I also wanted to let people know how to access this Web site. The best way to do this would be to send them a link via e-mail. To make things even easier, I suggest you create a template e-mail that contains a brief message and the first part of the server link, and save it as a signature. (Note that, in this example, the */root* section of the path is hidden and must, therefore, be omitted from the final link.) In the e-mail message shown here, I selected a pre-saved signature with a readily composed e-mail and simply added the person's name and the name of the output folder (both highlighted in red).

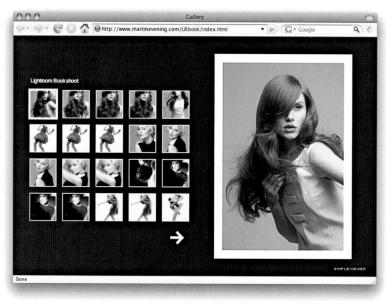

8. When recipients of the e-mail click the link, it automatically launches their Web browser and takes them straight to the uploaded Web site on your server.

Template Browser panel

You can easily end up putting a lot of time and effort into designing a customized Web gallery template, so it makes sense to save any template designs that you work on via the Template Browser panel in the Web module (Figure 11.67). To add a new preset, click the Add button, or press 🕱 🕅 (Mac) or Ctrl 🕅 (PC), and enter a new name for the template. To delete a preset, highlight the name in the Template Browser and click the Remove button. Most likely, you will continue to refine the design of your templates, so don't forget that as you select a preset, you can right-click (Control-click on older Macs) to access the contextual menu and select "Update with current settings." When you hover over the presets in the list, the Preview panel shows previews of the gallery page layout presets. The previews display the gallery showing the layout and colors used and also indicates if the gallery preset is a Flash or HTML layout design. You can also select Web ightarrowSave Web Gallery Settings, or press IS (Mac) or Ctrl S (PC), to quickly save the current Web settings without saving them as a specific template. As you select other pre-saved templates to compare the look of different layouts, you can always go to the Web menu again and choose Revert Web Gallery Settings to instantly return to the current, temporary Web layout.

Lightroom provides you with a simple way to upload Web sites, but the downside is that there is no way to remove them as easily! Bear in mind that server space costs money, and there may be a limit on how much space you have available, or there may be a surcharge if you exceed your limit. You will, therefore, still need access to FTP software in order to carry out general housekeeping maintenance of the server space and delete Web galleries that no longer need to be hosted.

Well, that brings us to the end of this chapter and also to the end of this main section of the book. The following appendixes provide further useful background reading on how to configure Lightroom, as well as some "behind the scenes" insights into how the program works. Don't forget to check out the new book Web site as well for the videos, further information, and support material.

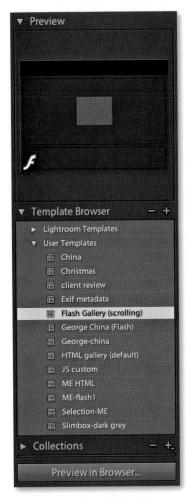

Figure 11.67 The Web Module Template Browser panel lists all saved gallery templates and shows previews of the layouts in the Preview panel above.

www.thelightroombook.com

Photograph: Beacon Court building, 58th Street, New York City © 2006 Martin Evenin Canon EOS 400D | 10 mm | ISO 800 | 173.5 @ 1/25t

Appendix A Lightroom Preferences

I reserved the appendix as a special section of the book that would allow me to go into more detail about certain aspects of Lightroom, including how you can customize the program to suit specific ways of working. This particular section provides a more detailed summary of the Lightroom Preferences. The Lightroom 3 Preferences have again been revised to simplify some of the choices on offer and provide additional new preference options. Even if you are familiar with previous versions of Lightroom, I still suggest you read through this chapter to acquaint yourself with the new dialogs.

The preference options described in this section can be accessed by choosing Lightroom \Rightarrow Preferences (Mac) or Edit \Rightarrow Preferences (PC), or by using the \mathbb{R}_{\rightarrow} (Mac), \mathbb{C} rd, (PC) keyboard shortcut. Where relevant, I have included references to earlier sections of the book.

Figure A.1 The main Lightroom 3 startup splash screen.

Figure A.2 The About Adobe Photoshop Lightroom 3 splash screen.

Figure A.3 *The alternative, Strangelove beta splash screen.*

General preferences

Splash screens

Let's begin with the General preferences and the startup options (**Figure A.4**). If you deselect "Show splash screen during startup," you can avoid seeing the Lightroom splash screen (**Figure A.1**) each time you launch Lightroom. This is just a cosmetic thing, and it's up to you whether you want to see the splash screen as the program loads. Once in the program, if you go to the Lightroom menu and select About Adobe Photoshop Lightroom 3, you will see the **Figure A.2** splash screen instead, but if you hold down the Alt key, you can display the introductory screen here, too. Also, if you hold down the **H** key (Mac) or **Ctrl** key (PC), you can toggle setting the alternate beta splash screen (**Figure A.3**) as the new splash screen.

Updates

When you first installed Lightroom, you had the option to choose whether to be notified automatically of any updates to the program. In case you missed checking this, you can click the "Automatically check for updates" check box.

<u> </u>			Preferences	
	General P	resets	External Editing File Handling Interface	
	Se		✓ Show splash screen during startup ✓ Automatically check for updates	
Default Catalog				
When starti	ng up use this ca	italog:	Load most recent catalog	•
Import Options				
Show import	dialog when a r	nemory	card is detected	110160
			nes when naming folders	
Treat JPEG fil	les next to raw fi	iles as s	separate photos	
Completion Sounds				
When finished i	mporting photo:	s play: (No Sound	٢
When finished e	exporting photo:	s play: (No Sound	•
Prompts				
		(Reset all warning dialogs	
Catalog Settings				
Some settings a	re catalog-speci	fic and	are changed in Catalog Settings. Go to Catalog Settings	\supset

Figure A.4 The Lightroom General preferences.

Catalog selection

In the Default Catalog section, you can select which catalog should be used each time you launch Lightroom, such as "Load most recent catalog" or "Prompt me when starting Lightroom." You can also jump directly to the Catalog Settings by clicking the Go to Catalog Settings button at the bottom of the General preferences dialog. As the alert message down here points out, this allows you to apply Catalog-specific settings. For more information about these settings and working with catalogs in Lightroom, please refer to Chapter 5.

Import options

When the "Show import dialog when a memory card is detected" item is checked, this forces the Import dialog to appear automatically whenever you insert a camera card into the computer. The "Ignore camera-generated folder names when naming folders" option can help shorten the import process if you wish to import everything directly from a camera card into a single Lightroom folder. For example, maybe you have a camera card with photos that were shot using more than one camera and they have ended up in several different folders. When this option is checked, the card folder contents are all grouped into one folder ready to be imported.

Some photographers like using their cameras' ability to capture and store JPEG file versions alongside the raw capture files. However, prior to the Lightroom 1.1 update, Lightroom would treat the JPEG captured versions as if they were sidecar files. But if the "Treat JPEG files next to raw files as separate photos" option is checked, Lightroom treats them as separate files that must be imported into the Lightroom catalog along with the raw versions. In addition, Lightroom does not treat as sidecar files any non-JPEG files that can be imported.

Completion sounds and prompts

Next are the Completion Sounds options, where you can choose an alert sound to play after completing an import or export from Lightroom. You will often see warning dialogs with a "Don't show again" check box at the bottom. If you click the "Reset all warning dialogs" button, you can restore all default warning alerts.

Presets preferences

The Presets preferences are shown in **Figure A.5**. If you are familiar with the controls found in Develop and Quick Develop, you'll know that you can click the Auto Tone button to automatically adjust the Exposure, Recovery, Blacks, Brightness, and Contrast to produce what Lightroom thinks would be the best combination. Checking "Apply auto tone adjustments" turns this feature on as a default setting.

NOTE

The Auto Tone feature can often produce quite decent automatic adjustments and may at least provide an OK starting point for newly imported photos. Although the logic has been improved further still in Lightroom 3, you may sometimes see less-than-perfect results. Experience seems to suggest that photographs shot of general subjects—such as landscapes, portraits, and most photographs shot using the camera auto exposure settings—will often look improved when using Auto Tone. Subjects shot under controlled lighting conditions, such as still life and studio portraits, can often look worse when using Auto Tone. It depends on the type of photography that you do as to whether selecting "Apply auto tone adjustments" would be a useful setting to have checked.

	Prefere	nces
C	General Presets External Edit	ing File Handling Interface
Default Develop Settings		
Apply auto tone	adjustments	
Apply auto mix	when first converting to black and	white
Make defaults s	pecific to camera serial number	
Make defaults s	pecific to camera ISO setting	
	Reset all default D	evelop settings
ocation		
Store presets wi	th catalog	Show Lightroom Presets Folder
ightroom Defaults		
\subset	Restore Export Presets	(Restore Keyword Set Presets)
R	estore Filename Templates	Restore Text Templates
Rest	ore Local Adjustment Presets	Restore Color Label Presets
	Restore Library	Filter Presets

Figure A.5 The Lightroom Presets preferences.

After this we have "Apply auto mix when first converting to black and white." You can leave this on because automatic black-and-white conversions usually always offer a good starting point. Automatic black-and-white conversions are linked to the Temp and Tint slider settings in the Basic panel White Balance section. If you adjust those settings and then click the Black & White button, you will see how the black-and-white settings adjust automatically.

Camera-linked settings

The next two items in the Default Develop Settings section are linked to a feature found in the Develop module Develop menu called Set Default Settings, discussed on pages 402–403. Basically, if you check "Make defaults specific to camera serial number" and "Make defaults specific to camera ISO setting," you can use these preference check boxes to determine whether certain default settings can be made camera-specific and/or ISO-specific. The "Reset all default Develop settings" button allows you to revert all the Develop settings to their original defaults.

Location section

Now that we have the ability to export photos as a catalog, you can check the "Store presets with catalog" option if you would like Lightroom to save the custom presets you have created within the main catalog folder. This is useful if you are migrating library images from one computer to another because it saves you having to transfer your custom settings (such as your Develop settings) separately, should you wish to share your custom settings with other users. But then again, maybe you would prefer not to give away your own custom presets. This preference item gives you that choice. We also have the Show Lightroom Presets folder button, which conveniently opens the Lightroom presets folder (wherever it is stored) so you can quickly access the folders that contain your Lightroom presets.

Lightroom Defaults section

The other buttons in this section are all reset buttons that can be used to restore various Lightroom settings. For example, the "Restore Export presets" button restores the preset list that's used in the File \Rightarrow Export dialog (see page 480) and if you click Restore Keyword Set Presets, this resets the Keyword Sets template list. To explain this in more detail, if you go to the Library module Keywording panel (**Figure A.6**), you will notice that Lightroom provides a few Keyword set templates that can be used for keywording photos such as Portrait Photography, Wedding Photography, and Outdoor Photography (**Figure A.7**). If you click the Keyword Set menu in the Keywording panel (or choose Metadata \Rightarrow Keyword Set \Rightarrow Edit), you can customize the default Keyword sets. "Restore Keyword Set

The Restore Filename Templates button restores the default file rename templates used in the Export dialog and Filename Template Editor (**Figure A.8**). However, this does not affect any of the custom templates you may have added here; it merely resets the settings for the default templates that you may have edited. The same thing applies to the Restore Text Templates button—this

Preset: Outdoor Ph	lotography		
Landscape	Macro	Flowers & Plants	
Spring	Summer	Wildlife	
Fall	Winter	People	
		Cancel Change	

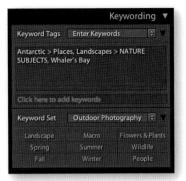

Figure A.6 The Keywording panel, showing the Keyword Set section.

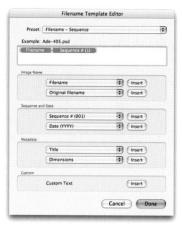

Figure A.8 *The Filename Template Editor.*

Preset:	Filename + EXIF		
Example:	Ade • Exposure: •		
Filenam	• Exposure: Exposure	e • 15	O Speed Rating
letaga Nam	e		
	Filename	10)	(Insert)
	Original filename		Insert
Numbering			
	Image # (1)	•	Insert
	Date (YYYY)	•	Insert
EXEF Data			
	Exposure		(Insert)
	Date Time Original	•	Insert
	Dimensions	•	Insert
IPTC Date			
	Title		Insert
	Caption	•	(Insert)
	Copyright	•	Insert
Custom			
	Custom Text		Insert
		Cancel	Done

Figure A.9 The Text Template Editor.

restores the default settings in the Text Template Editor (**Figure A.9**), which is used in the Slideshow and Web modules.

The Restore Local Adjustment Presets button resets the pop-up menu settings and all the other default tool presets for the Adjustment brush and Graduated filter tools.

On pages 197–199, I mentioned the potential confusion that can be caused by using color label text descriptions that don't match the text descriptions used in Bridge, or by another Lightroom user who sends you images labeled using another label description system. The Restore Color Label Presets button resets the label text descriptions to the default settings: Red, Yellow, Green, Blue, Purple.

You can save Filter presets that include things like "Filter by 1 star or higher," as well as things like the column layouts in the Metadata Filter bar (see page 171). The Restore Library Filter Presets button can, therefore, be used to reset the Filter Presets in case you inadvertently update the default settings with a new (and incorrect) setting.

External Editing preferences

The Lightroom External Editing preferences (**Figure A.10**) let you customize the pixel image editing settings for Photoshop as well as an additional external, pixel editing program, such as Adobe Photoshop Elements, Corel Paint Shop Pro, or even the same version of Photoshop.

The Edit settings allow you to establish the file format, color space, bit depth, and, where applicable, compression settings that are used whenever you ask Lightroom to open a catalog image in an external pixel editing program. As I explained in Chapter 9, the Open in Photoshop command (ﷺ) [Mac] or Ctrl)[E] [PC]) opens photos from the Lightroom catalog directly into whatever is the most current version of Photoshop, without adding an edit copy version of the master to the catalog. The same also applies when you choose one of the extended editing options such as Merge to HDR. It is important to note here that the External Editing preferences is the only place where you can establish the file format settings for opening images in this way. So with this in mind, you should use the Edit in Photoshop section to establish what these default file editing settings should be. In Figure A.10, ProPhoto RGB was selected as the color space, with a bit depth of 16-bits per channel, saving to the TIFF file format using ZIP compression.

When you open an image using the Edit in Photoshop command, the image opens using the color space, bit depth, and resolution settings applied in the External Editing preferences. However, the file format choice only comes into play when you choose to save the image out of Photoshop. The default behavior is also to save the file to the same folder as the original master, using the file format specified in the preferences, and then add it to the catalog.

			Preferences	
	General Presets	Exter	rnal Editing File Handling Interface	
Edit in Adobe Photos	hop CS4			
File Format:	TIFF	•	16-bit ProPhoto RGB is the recommended choice for best preserving color details from Lightroom.	
Color Space:	ProPhoto RGB			
Bit Depth:	16 bits/component	•		
Resolution:	300			
Compression:	ZIP			
Additional External E	ditor			
Preset:	Custom			
Application:	Adobe Photoshop CS4.	арр	Choose Clear	
File Format:	TIFF	•	8-bit files are smaller and more compatible with various programs and plug-ins, but will not preserve fine tonal detail as well as 16-bit	
Color Space:	ProPhoto RGB	•	data. This is particularly true in wide gamut color spaces such as ProPhoto RGB.	
Bit Depth:	8 bits/component	•		
Resolution:	300			
Compression:	None			
dit Externally File N	aming: IMG_0002-Edit.psd			
Template:	Custom Settings			
Custom Text:			Start Number:	

What to Edit		
• Edit a Copy	with Lightroom Ad	justments
Apply the Light		y of the file and edit that on
🔿 Edit a Copy		
Edit a Capy is n	ot applicable to raw or Dig	ital Negative files.
C Edit Origina		
Edit Origina Edit Original is	ll not applicable to raw or D	igital Negative files.
The second second second second	nat applicable to raw or D ons	gital Negative files.
Edit Originar is © Copy File Opti File Format:	nat applicable to raw or D ons	gital Negative files.
Edir Original is Copy File Opti File Format: Color Space:	not applicable to raw or Di ons TIFF	gita' Negative Nes.
Edir Original is Copy File Opti File Format: Color Space:	not applicable to raw or D ons TIFF ProPhoto RG8 [16 bits/component	gital Negative files

Figure A.11 When you choose the External Editor command (*HAILE* [Mac] or Ctrl AILE [PC]), you have the option to override the file format and other settings in the External Editing preferences.

Figure A.10 The Lightroom External Editing preferences.

In the Additional External Editor section, you can specify the default settings to use when editing photos in an alternative external editing application. The difference between this and Edit in Photoshop is that when you choose the External Editor command (Image Alt E) [Mac] or Ctrl Alt E [PC]), an edit copy of the master is always added to the Lightroom catalog. For example, you might want to use the settings shown in Figure A.10 to create new edit versions that are saved as 8-bits per channel using the ProPhoto RGB color space and saved as a TIFF with no compression. However, when you choose the Edit in External Editor command, you do have the opportunity to override the file format and other settings (see **Figure A.11**). You will also notice that you can save the Additional External Editor settings as preset settings. Saved presets then appear as menu options when you open the "Edit in" submenu from the Photo menu. For example, you might find it useful to have saved export settings for both TIFF and PSD formats and for different pixel editing programs. At the bottom we have the Edit Externally File Naming section. Lightroom normally appends –*Edit* to each externally edited image filename, and as you create further edit copies, Lightroom increments the numbering: –*Edit1*, –*Edit2*, and so on. In Lightroom, you can customize the file naming. For example, you can create a custom template that adds a date stamp after the original filename (**Figure A.12**) and apply this renaming scheme whenever you create an edit copy version from a master file.

Preset:	Custom		
Example: •	-IMG_0002_012005.ps	d	
Filenam	e _ Date (MM)	Date (DD)	Date (YY)
Image Name			
	Filename	•	Insert
	Original filename	•	Insert
Sequence and	i Date		
	Sequence # (1)	•	Insert
	Date (YY)	•	Insert
Metadata			
	Title	•	Insert
	Dimensions	•	Insert
Custom			
	Custom Text		Insert
		Cancel	Done

Figure A.12 The Filename Template Editor.

File Handling preferences

The File Handling preferences are shown in Figure A.13.

Import DNG Creation

The Import DNG Creation options in the File Handling preferences refer only to the DNG settings that are used whenever you choose to import photos using the Copy as DNG option. First off, we have the File Extension options, which can use lowercase dng or uppercase DNG, whichever you prefer.

As the Camera Raw specifications have been updated, so has the DNG file format. Because of this, you have the option to specify which versions of Camera Raw you wish your DNG files to be compatible with. If you are using Lightroom 3 with Photoshop CS4 or later, then you would want to select the "Camera Raw 5.4 and later" option. If, on the other hand, you are working with an older version

	Preferences
General Presets	External Editing File Handling Interface
Import DNG Creation	
File Extension: dng	•
Compatibility: Can	nera Raw 5.4 and later 🔹
JPEG Preview: Med	dium Size
	nbed Original Raw File
Reading Metadata	
Treat 'l' as a keyword separator	During import or when reading metadata Lightroom can recognize dot, forward slash, and backslash separated keywords as keyword hierarchies instead of flat keywords. The vertical bar is automatically recognized as a hierarchy separator.
File Name Generation	
Treat the following characters as illegal:	1:
Replace illegal file name characters with:	Dashes (-)
When a file name has a space:	Leave As-Is
Camera Raw Cache Settings	
Location: /Users/martin_evening/L	ibrary/Caches/Adobe Camera Raw Choose)
Maximum Size: 50.0 GB	Purge Cache

Figure A.13 The Lightroom File Handling preferences.

of Photoshop, you might want to select one of the other options. For example, if you selected the "Camera Raw 2.4 and later" option, this would allow the DNG files you create on import to Lightroom 3 to be compatible with Lightroom 1.0 or Photoshop CS. When I say "compatible," what this means is that the DNG files can open in older versions of Lightroom or Photoshop Camera Raw, but this won't allow you to see or access any settings adjustments that are specific to a later version of Camera Raw. So, for example, if you were to open a DNG image edited in Lightroom 3 where you had used the new noise reduction adjustments or applied a grain effect and added IPTC Extensions metadata information, an older version of Lightroom or Camera Raw would be able to open the image, but you would only be able to read the image and metadata settings that were understood by that version of Camera Raw.

If we assume this isn't going to be a problem for you and you are not bothered about maintaining backward compatibility, selecting a later version allows you to create DNG files that can take advantage of the latest DNG specifications. For example, the DNG 1.3 specification that coincided with the release of Camera Raw 5.4 saw the addition of correction and enhancement parameters, known as Opcodes. These allow complex processing such as geometric distortion correction to be moved off of the camera hardware and into a DNG reader program. In the case of Lightroom and Camera Raw, this enhancement enables the DNG

NOTE

Earlier versions of Lightroom offered additional DNG creation options such as the ability to preserve the raw capture data in its original "mosaic" format, or convert the original raw data to a linear image. There was no real need for either of these options, and few people if any were using them. These have since been removed from the preference options.

TIP

To get around the problem of DNG previews being out of sync with the current DNG file settings, you can go to the Metadata menu and choose Update DNG Previews & Metadata. This does two things: It updates the metadata the same way as the Save Metadata to Files command does, and it rebuilds the JPEG preview contained within the DNG file. 1.3 format to read optical lens correction metadata that has been embedded in the raw files of certain new camera systems and store this in the DNG format. For example, the lens correction data contained in the Panasonic DMC-LX3 raw camera files can be read when using Camera Raw 5.4 or Lightroom 2.4 or later. A lens correction adjustment is then applied at the Camera Raw processing stage after the demosaicing stage in the processing. Of course, if you import your DNG files using the older compatibility specification and change your mind later, you can always export your photos as DNGs and select a later compatibility version.

Next is the JPEG Preview section, which can be set to None, Medium Size, or Full Size. DNG previews are based on the Lightroom Develop settings created at the time a DNG file was created, such as at the import stage using the assigned import Develop settings. But note that these previews are no longer valid once anything further is done to alter the settings associated with the DNG, or when a DNG file is viewed in a different raw editor program (unless that other program is Bridge and is using the latest version of Camera Raw). It so happens that Lightroom takes no chances when it encounters a new DNG, because Lightroom always rebuilds the preview cache based on the embedded Develop settings rather than the embedded preview. However, if you import DNG photos into Lightroom using the Embedded & Sidecar option for generating the initial previews, Lightroom will make use of any embedded previews. The previews may eventually get updated, of course, but the initial DNG previews are the ones used at the time the DNG files are imported.

If you want to trim the file size, you could choose not to embed a preview, knowing that new previews are always generated again when DNG files are managed elsewhere. Therefore, you might select this option if you figure there is no value in including the current preview. A medium-sized preview economizes on the file size and would be suitable for standard library browsing. After all, most of the photos in your catalog probably only have medium-sized JPEG previews. But if you want the embedded previews (and remember, these are the previews embedded in the file and not the Lightroom catalog previews) to always be accessible at full resolution and you don't consider the resulting increased file size to be a burden. then choose the Full Size preview option. This has the added benefit that, if you want to view these DNGs in other applications such as Microsoft Expression, you can preview the DNGs at full resolution using a preview that was generated by Lightroom. This means that photos processed in Lightroom as DNGs should then preview exactly the same when they are viewed in other applications (but only after you have exported them). Generating full-sized previews in a DNG file can also allow you to make high-quality prints via other programs outside of Lightroom using the Lightroom rendered settings.

Embed Original Raw File embeds a copy of the original proprietary raw file inside the DNG file. This option allows you to preserve the original raw file data within the DNG file format but with the ability to reverse the process in order to access the original raw file format. The penalty for doing this is increased file sizes, and I do mean a *big* increase, since you are storing two versions of the raw file data in a single file. One argument in favor of doing this is that, by preserving the raw file in its original form, you can still access the original raw file and process it in the proprietary raw processing program. For example, the proprietary CR2 raw files produced by the newer Canon cameras allow the storing of dust-spotting data that can be written or read only using Canon's own software. If you choose not to embed the original raw file, you lose the means to extract the original raw file and process your photos using the camera manufacturer's software.

Convert and Export DNG options

The same DNG options are found in the Export dialog, as well as in the Library \Rightarrow Convert Photo to DNG dialog (see **Figure A.14**). In the case of the Convert Photo to DNG dialog, you have an option to "Only convert Raw files." Check this option to filter the conversion process so that it applies only to raw originals and not to JPEGs or other non-raw photos. You can also check the "Delete originals after successful conversion" option if you wish to clear all the original raw files from the folders. I always check this option since I'm usually OK with removing the original raws after I have converted everything to DNG.

Source Files		
Only convert Raw files		
Delete originals after su	ccessful conversion	
DNG Creation		
File Extension:	dng	•
Compatibility:	Camera Raw 5.4 and later	•
JPEG Preview:	Medium Size	•
	Embed Original Raw File	

Figure A.14 The Convert Photo to DNG dialog shares the same settings options as those listed in the Import preferences, except you have options to "Only convert Raw files" and "Delete originals after successful conversion."

DNG compression

There also used to be an option for adding file compression. This, too, has now been removed. It was always on by default anyway, because the DNG file format compression method compresses the file size without incurring any data loss. By this, I mean no loss of image data, no loss of metadata, or any other secret source data that's embedded in the original proprietary raw file. DNG compression

TIP

Personally, I have no trouble converting everything I shoot to DNG and never bother to embed the original raw data with my DNGs. I do, however, sometimes keep backup copies of the original raw files as an extra insurance policy. But, in practice, I have never had cause to use these—at least not yet!

TIP

One of the main Lightroom 3 selling points is the improved performance speed. However, in order to take advantage of this, I do think you should consider following the advice below and increase the Camera Raw cache size in order to see such benefits applied to the Develop module image processing. The Camera Raw cache has an upper limit of 50 GB. Why this can't be set higher I don't know, but seeing as the Camera Raw cache is so useful, I suggest you set it to 50 GB if you can afford to devote this much hard disk space. usually results in a file that is slightly smaller than the original, but this is because the DNG compression method is often better than that used by the camera manufacturers.

Reading Metadata options

If only there could be agreement on common standards for the way metadata information is handled between different programs. Adobe's open-source XMP specification has certainly gone a long way toward providing the industry with a versatile standard format for storing metadata information. But there are still a few gotchas that can prevent the smooth integration of informational data from one program to another. The Reading Metadata section in the File Handling preferences (see **Figure A.13**) is there to help solve such inconsistencies. If you check "Treat '.' as a keyword separator" and "Treat '/' as a keyword separator," this enables Lightroom to better interpret the keyword hierarchy conventions used in other programs.

File Name Generation options

Filenames that contain illegal characters can also cause hiccups when you import such files into Lightroom. The "Treat the following characters as illegal characters" item can be set to recognize "/:" as an illegal character, or you can select the extended list of characters to encompass more potential bad characters that would need to be replaced. In the "Replace illegal file name characters with" section, you can then choose a suitable replacement character to use, such as a hyphen (-), an underscore (_), or a similar character. Some database and FTP systems may prefer spaces to be removed from filenames. For example, when I upload files to my publisher, the FTP server does not allow such files to be uploaded. This is where the "When a file name has a space" item can be useful, because you can choose to replace a space with a hyphen (-) or an underscore (_) character.

Camera Raw cache

Whenever you attempt to view an image in the Develop module, Lightroom builds full, high-quality previews direct from the master image data. In the case of raw files, the early-stage processing includes the decoding and decompression of the raw data, as well as the linearization and demosaic processing. All this has to take place first before getting to the stage that allows the user to adjust things like the Basic panel Develop controls. The Camera Raw cache is, therefore, used to store the unchanging, early-stage raw processing data that is used to generate the Develop module previews so that the early-stage raw processing can be skipped the next time you view that image. If you increase the Camera Raw cache size, more image data will be held in the cache. This, in turn, results in swifter Develop module preview generation when you revisit these photos. The 1 GB default setting is *extremely* conservative, and if you increase the limit, you will see improved performance if it is set much higher—to, say, 20 GB or even more.

Interface preferences

The Interface preferences are shown in Figure A.15.

	General Presets Exte	ernal Editing File Handling Interface	
	General Presets Exte	that Editing File Handling interface	
anels			
End Marks:	Flourish (default)	Font Size: Small (default)	•
ights Out			
Screen Color:	Black (default)	Dim Level: 80% (default)	•
lackground			
	Main Window	Secondary Window	
Fill Color:	Medium Gray (default)	🗘 Medium Gray (default) 🔹	
Texture:	None	None	
Ceyword Entry			
Separate keyw	ords using: Commas	Spaces are allowed in	keywords
ilmstrip			
Show rating	and picks	Show photos in navigator on m	ouse-over
Show badg	es	Show photo info tooltips	
Show stack	counts		
Fweaks			
Zoom click	ed point to center	Use typographic fractions	

Figure A.15 The Lightroom Interface preferences.

Panel end marks

A panel end mark is the squiggly flourish that appears at the bottom of the panel list in the Lightroom modules. You can access Panel End Mark menu options via the contextual Panel End Mark menu shown in **Figure A.16**. Just right-click the end of the panels list, navigate to the Panel End Mark submenu, and select the desired panel end mark from there. You can also access these options in the Panels section of the Interface preferences (Figure A.15). Choose None if you don't want to see any kind of panel mark appearing in the Lightroom modules, or use the pop-up menu to select one of the many other Panel End Mark options. **Figure A.17** provides a visual reference for all the different panel end marks you can choose here.

NOTE

The "Use typographic fractions" option is not present in the Windows version of Lightroom. Instead, you'll see "Use system preference for font smoothing."

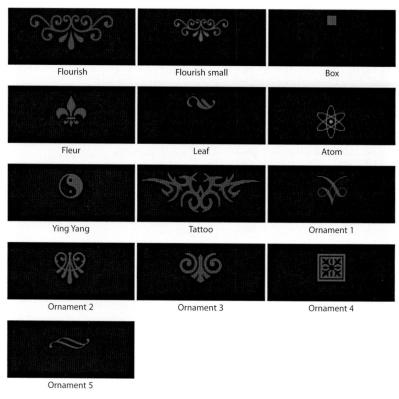

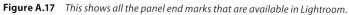

Custom panel end marks

Would you like to create your own panel end mark design? Well, it's actually not that difficult to do. To start with, take a screen shot of one of the current panel end marks to get an idea of the scale of the design and how it will look against the panel background color. Next, create a new custom design in Photoshop scaled to the correct size on a transparent layer and save this graphic using the PNG file format (which supports transparency). Now go to the Panel End Mark menu and select Go to Panel End Marks Folder (see Figure A.16). This reveals the folder in the Finder/Explorer location where all the panel end mark image files are stored. Place the PNG file you have just created there, and reopen the Lightroom Preferences. You will now see your custom design listed in the Panel End Mark menu!

Panel font size

There are two font size options: Small (which is the default setting) and Large. If you refer to **Figure A.18**, you can see how the difference between these two settings is actually quite subtle. But, by choosing the Large setting, you can make the panel fonts more legible when viewing on a large screen at a distance. However, this change does not take effect until after you have relaunched Lightroom.

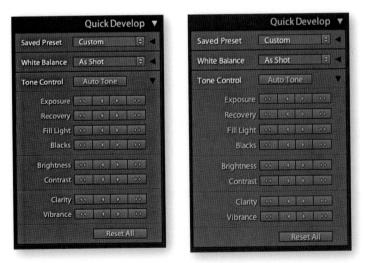

Figure A.18 This shows a comparison between the default Small panel font size setting (left) and the Large panel font size setting (right). Note how the Large panel font setting also makes the panels slightly bigger in size.

NOTE

You can see an example of the Lights Out mode in use on page 34 and an example of working with different Background settings on page 16.

NOTE

One reason why people would want to use spaces rather than commas to separate keywords would be if writing something like "20,000 soldiers." For this, the comma is important and should not be treated as a delimiter. Unfortunately, Lightroom will use the comma as a delimiter, even when "spaces" is selected. In this instance, the comma effectively overrides spaces. For Lightroom 3, it was decided to strip commas from keywords when spaces is used as delimiter. Doing this manages to make the use of spaces as a delimiter function work, although this won't please folk who use commas in words and numbers.

Lights Out

The Lightroom Interface preferences let you customize the appearance of the interface when using the Lights Out and Lights Dim modes. Bear in mind that these preference settings also allow you to create a "Lights up" setting. So, instead of using black as the Lights Out color, you could try setting it to light gray or white.

Background

The Background section lets you customize the background appearance in the Lightroom modules. You can set the fill color to several different shades of gray, as well as white or black, and in the "Overlay texture" section, you can choose to add a pinstripes pattern. Lightroom 3 now also provides preference options for those working with a two-display setup, letting you customize the background options for both displays independently.

Keyword Entry

Spaces are normally allowed when entering keywords in the Keywording panel and you separate keywords by typing a comma between them. If you prefer to use spaces to separate the keywords, this is now an option, but if you do this, you have to remember to type quotes around any keywords that contain spaces. For example, the keyword *Cape Fear* would need to be entered as "*Cape Fear*." If you didn't do this, you would end up with two keywords: *Cape* and *Fear*.

Filmstrip preference options

In the Filmstrip section you have the "Show ratings and picks," "Show photos in navigator on mouse-over," "Show badges," "Show photo info tooltips," and "Show stack counts" options. Some examples of these are shown in **Figure A.19**. All of these combine to make information about the catalog and catalog navigation more flexible. With these items checked, you have fuller access to Library module functions while working in other modules. For example, let's say you are working in the Develop module. You can use the Filmstrip to see at a glance all the current filtered images, with their labels, ratings, and pick statuses. You can use the mouse to hover over individual images to see a slightly larger preview in

Figure A.19 The Lightroom Filmstrip extra view options.

the Navigator panel, and the tooltip floating window can be used to quickly reveal the filename, time of capture, and pixel dimensions. The badge icons indicate whether keyword metadata has been added or the Develop settings have been edited. Clicking on a Metadata badge immediately takes you to the Keywording panel in the Library module, highlighting the keywords so they are ready to edit. Clicking the Develop edit badge takes you back to the Develop module again; there, you can resume editing the Develop settings. Finally, the new "Show stack counts" badge displays a badge for image stacks along with a stack count number. These Filmstrip options extend the usefulness of the Filmstrip as a way to manage the Lightroom catalog photos.

Interface tweaks

When "Zoom clicked point to center" is checked, the Loupe view uses the click point as the center for its magnified view. To understand how this works, try clicking the corner of a photo in the standard Loupe view. If "Zoom clicked point to center" is checked, the corner zooms in to become centered on the screen. When this option is unchecked, the photo zooms in with the corner point positioned beneath the mouse cursor. Personally, I find that deselecting this option offers a more logical and useful zoom behavior.

The "Use typographic fractions" option affects the way the fractions are presented in the Metadata panel in the Library module. When checked, Lightroom uses proper fraction characters or superscript and subscript characters. For example, **Figure A.20** shows how a shutter speed is displayed when this option is checked and unchecked.

EXIF	😂 Metada	ata 🔻	EXIF	🗧 Metada	ata 🔻
Preset	None	¢	Preset	None	9
File Name	_MG_4802.CR2		File Name	_MG_4802.CR2	
	Chapter 6	-	File Path	Chapter 6	
Dimensions	4368 x 2912		Dimensions	4368 x 2912	
	4368 x 2912	ET I	Cropped	4368 x 2912	
Date Time Original	25/08/2006 13:59:05	E.	Date Time Original	25/08/2006 13:59:05	
	25/08/2006 13:59:05		Date Time Digitized	25/08/2006 13:59:05	
	25/08/2006 13:59:05		Date Time	25/08/2006 13:59:05	
Exposure	1/125 sec at f / 4.0		Exposure	1/125 sec at f / 4.0	
Focal Length			Focal Length	35 mm	
Exposure Bias			Exposure Bias	0 EV	
ISO Speed Rating			ISO Speed Rating	ISO 400	
	Did not fire		Flash	Did not fire	
Exposure Program	Aperture priority		Exposure Program	Aperture priority	
Metering Mode			Metering Mode	Pattern	
	Canon		Make	Canon	
	Canon EOS 5D		Model	Canon EOS 5D	
Serial Number			Serial Number	420204404	
	EF35mm f/1.4L USM		Lens	EF35mm f/1.4L USM	

Figure A.20 The Metadata panel view (left) shows the shutter speed displayed when "Use typographic fractions" is switched off. The Metadata panel view (right) shows the shutter speed displayed when "Use typographic fractions" is switched on.

NOTE

To repeat the note I placed on page 611, the "Use typographic fractions" option is not present in the Windows version of Lightroom. Instead, you'll see "Use system preference for font smoothing."

Appendix B Lightroom settings

This appendix provides information and details on the Lightroom settings, such as the template settings files, catalog folder, and Lightroom RGB space. I decided to keep these topics separate, mainly because I did not want to clutter the earlier chapters with information that might have been too distracting. This is an unashamedly technical section aimed at advanced users, although I have tried to keep the explanations as clear and simple as possible.

The contents of this appendix are placed in no particular order. Some of the information and tips mentioned here may go out of date as later updates of the program are released, so please bear this in mind as you read through the following pages. But if you are keen to find out more detailed information about specific areas of Lightroom or want to explore some of the customization options, read on.

TIP

The Application Data folder on a PC computer is normally hidden. To reveal the folder in Windows Vista, go to the Control Panel, select Appearance and Personalization. choose Folder Options, and you will see an option to show hidden files and folders. To reveal the folder in Windows XP, go to the Explorer **Tools/Folder Options and navigate** to the View tab, where you will see the option to show hidden files and folders. Note that, on a PC system, the file extensions are often hidden by default, so you may not always see the file extensions, such as .Irtemplate and .Ircat.

NOTE

Windows XP users wishing to access the Lightroom preference file shown in Figure B.1 should use the following directory path: Documents and Settings/Username/Application Data/ Adobe/Lightroom/Preferences.

TP

Once you have established your Lightroom settings the way you like them, I suggest making a copy of the Lightroom preference file. If the preference file should ever become corrupted, you can simply replace the corrupt file with the saved copy. This saves you from having to reconfigure the Lightroom preferences all over again. This tip can be applied to working with Photoshop as well.

Lightroom settings and templates

The Lightroom preference file

The Lightroom preference file keeps a record of all your custom program settings. In Windows Vista, the *Lightroom 3 preferences.agprefs* file is located in the *Username/Roaming/Adobe/Lightroom/Preferences* folder (**Figure B.1**). On a Mac, the preference file is named *com.adobe.Lightroom.plist* and is located in the *Username/Library/Preferences* folder (**Figure B.2**). If the Lightroom program is behaving strangely and you have reason to believe that the preferences might be corrupted, delete this file so that Lightroom generates a new preference file the next time you launch the program.

♥ 🖟 « Roaming → Adobe → Lig	htroc	m Preferences	• +j	Search		
e Edit View Tools Help						
Organize 🔻 🏢 Views 🔻 🔳 Open	77 S	hare 🍪 Burn			TARGE STATE	
lders	~	Name	Date modified	Туре	Size	and the second second
Martin		Lightroom Prefe	01/12/2009 12:18	AGPREFS File		29 KB
Adobe						
AppData						
Local	10					
LocalLow	18					
Roaming	H					
Ja Adobe	1					
🗼 Adobe PDF						
Jightroom	13					
Color Profiles						
J Develop Presets						
Device Icons						
Export Presets						
External Editor Presets						
Filename Templates						
Filter Presets						
Import Presets						
Keyword Sets						
Label Sets						
local Adjustment Preset	s					
Metadata Presets						
Preferences	-					
Lightroom 3 Preferences.agpre	fs	Date modified: 01/12/20	009 12:18			
AGPREFS File		Size: 28.4 KB				

Figure B.1 The Adobe Lightroom preference file location for Windows Vista.

< >		0 4-	9	Here's
MacBook (2)				
MACOUCK (2)	Applications	► Mail	com.adobe.illustrator.plist	
Y PLACES	Desktop	PreferencePanes	com.adobe.InDesign.plist	
Desktop	Documents	Preferences	com.adobe.Lightroom.plist	
Applications	Downloads	Printers	com.adobe.LightroSharedFileLi	st.plis
THE REPORT OF TH	Library	PubSub	com.adobe.Lightroom2.plist	
nartin_evening	Movies	Receipts	com.adobe.LightroSharedFileLi	st nlis
III Library	Music	Recent Servers	com.adobe.Lightroom3.plist	(in the second
Movies	Pictures	Safari	com.adobe.mediabrowser.plist	
a Pictures	Public	Screen Savers	com.adobe.PDApp.plist	
Chronosync ba	Sites	III Snapz Pro X	com.adobe.photodownloader.plis	t
C Documents	Colorestation and a state of the state of th	The second second reaction of the last second second	Contraction of the second s	24

Figure B.2 The Adobe Lightroom preference file for Mac OS X.

Accessing saved template settings

When you save a setting in any of the Lightroom modules, the saved template settings are normally stored in the Lightroom template settings folder. In Windows Vista, use the following path directory: *Username/AppData/Roaming/Adobe/Lightroom* (Figure B.3). For Mac OS X, use: *Username/Application Support/Adobe/Lightroom* (Figure B.4). Inside these folders, you will see a set of subfolders that contain all the default and custom settings for the various Lightroom modules. For example, in Figure B.3, you can see a list of all the various settings folders including the Develop Presets folder that's highlighted here. You can make copies of these files and distribute them as preset settings for other Lightroom users to install on their computers, which they can do by dragging and dropping presets into the folder directories shown here.

Edit View Tools Help Organize - III Views - III Explore	😨 Share 🍓 Burn			
ers	V Name	Date modified	Туре	Size
Martin	Color Profiles	01/12/2009 11:35	File Folder	
Adobe	Develop Presets	07/05/2009 11:09	File Folder	
AppData	Device Icons	06/08/2009 08:06	File Folder	
Local	Export Presets	07/05/2009 11:09	File Folder	
l local ow	External Editor Presets	07/05/2009 11:09	File Folder	
Roaming	Filename Templates	26/11/2009 10:39	File Folder	
Adobe	J Filter Presets	07/05/2009 11:09	File Folder	
Adobe PDF	Import Presets	06/08/2009 07:15	File Folder	
Adobe Photoshop CS4	Keyword Sets	07/05/2009 11:09	File Folder	
Alle	Label Sets	07/05/2009 11:09	File Folder	
ameraRaw	🍶 Local Adjustment Pres	06/08/2009 09:58	File Folder	
Color	🃗 Metadata Presets	07/05/2009 11:09	File Folder	
CS4ServiceManager	J Preferences	07/05/2009 11:08	File Folder	
ExtendScript Toolkit	Print Templates	01/12/2009 11:35	File Folder	
Extension Manager2	🌡 Smart Collection Tem	07/05/2009 11:09	File Folder	
Flash Player	🚵 Text Templates	01/12/2009 11:35	File Folder	
Lightroom	- Watermarks	01/12/2009 11:35	File Folder	

Figure B.3 The Adobe Lightroom template settings folder (Windows Vista).

TIP

The quickest way to locate the Lightroom presets folder is to go to the Lightroom Presets preferences and click the Show Lightroom Presets Folder button.

NOTE

Windows XP users wishing to access the Lightroom template settings folder shown in Figure B.3 should use the following directory path: Documents and Settings/Username/ Application Data/Adobe/Lightroom.

TP

You can install custom settings simply by double-clicking them. This opens a dialog asking you to confirm if you wish to add the preset to Lightroom. You can also import presets using the contextual menu in the Presets or Template Browser panels.

TIP

Richard Earney hosts a Web site called Inside Lightroom that offers various Develop module presets: http:// insidelightroom.com.

Figure B.4 The Adobe Lightroom template settings folder (Mac OS X).

NOTE

Lightroom holds all the metadata information in the central catalog file. However, if you go to the File Management preferences and select the "Automatically write changes to XMP sidecar files" option, the metadata information will also be stored locally, either in the XMP header or in the sidecar files that accompany the images. But note that the collections, virtual copies, stacks, and snapshots data are stored in the central database only. For more information about sharing metadata information and automatically writing changes to the XMP data as you work in Lightroom, see pages 186-187 in Chapter 4.

NOTE

If more than one copy of Lightroom happens to be running over a network, you will see a Lightroom *catalogname.lrcat.lock* file listed in the Lightroom catalog folder (as shown in Figure B.5). The lock file is designed to prevent another Lightroom user from making any modifications to the images in this user's Lightroom catalog.

The Lightroom catalog folder

The first time you launch Lightroom, a catalog folder titled *Lightroom* is automatically placed in the *username/Pictures* folder (Mac OS X and Windows Vista) and in the *Documents and Settings/Username/My Documents/My Pictures/ Lightroom* folder (Windows XP). This folder contains a Lightroom catalogname. *Ircat* database file and a *catalogname Previews.Irdata* file that contains all the thumbnail previews and catalog images metadata information. The Backups folder that is seen in **Figure B.5** and **Figure B.6** is used for storing the backup catalog database files and will show up only after you have carried out your first catalog backup. But let's first take a look at the two main catalog files.

The catalog database file

The Lightroom *catalogname.lrcat* file is written using the SQLite3 database format, which is a robust database format that keeps all the catalog data in a single file and is easily transferable for cross-platform use. This file is used to store a database of information that relates to all the images in the Lightroom catalog, such as the metadata and Develop settings for each image, and which folders and/or collections the files belong to. Depending on the overall size of your catalog, the Lightroom *catalogname.lrcat* file can grow to be quite large in size.

Name	Date Modified	Size	Kind
Backups	01/05/2008	889.5 MB	Folder
LR-080408-2 Previews.Irdata	Today	3.62 GB	Adobe Lightroom Data
LR-080408-2.lrcat	Today	337 MB	Adobe Lightroom Library
LR-080408-2.lrcat.lock	Today	4 KB	Document

Figure B.5 The Lightroom catalog folder contents in Mac OS X.

Figure B.6 The Lightroom catalog folder contents in Windows Vista.

If you perform a new install of Lightroom or upgrade the program, a new catalog database file (containing all the current catalog data) will be generated and the old one saved to the *Backups* folder. If the Lightroom General preferences are configured to automatically create backup copies of the Lightroom database, the backup will normally be saved to the *Backups* folder, but you can choose an alternative location if you wish (**Figure B.8**). If you choose to run an integrity test of the catalog during the backup procedure, you'll see the dialog shown in **Figure B.7**.

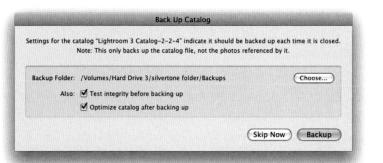

Figure B.8 In the General preferences, you can schedule how often Lightroom makes a backup copy of the Lightroom catalog database file. Then, when Lightroom is due for a catalog backup, you will see this dialog at the designated time. This gives you the option to skip the backup for now, or proceed. You can also check the "Optimize catalog after backing up" option, or do so any time via the Lightroom File menu (**Figure B.9**).

Figure B.10 shows an expanded *Backups* folder that contains a couple of saved backup folders. If for some reason you encounter a problem with the current catalog database when you launch Lightroom (or after running an integrity test), you can replace the main Lightroom *catalogname.lrcat* file with the most recent backup version. The catalog database file is, therefore, a precious component of the Lightroom catalog folder, and you need to safeguard it as you would a financial account file or other important data document and remember to perform regularly scheduled backups to a secondary storage system.

The second s	LR-08040	and the state of the second	All and the second second second second
Name	Date Modified	Size	Kind
Backups	Today	585.3 MB	Folder
2008-04-15 1814	15/04/2008	281.1 MB	Folder
v 2008-05-01 1234	01/05/2008	304.2 MB	Folder
Lr LR-080408-2.lrcat	01/05/2008	304.2 MB	Adobe Lightroom Library
Lightroom Settings	Today	Zero KB	Folder
LR-080408-2 Previews.Irdata	Today	3.62 GB	Adobe Lightroom Data
LR-080408-2.lrcat	Today	337 MB	Adobe Lightroom Library
LR-080408-2.lrcat.lock	Today	4 KB	Document

Figure B.10 The Lightroom catalog folder showing an expanded view of the Backups folder contents.

Figure B.7 In the Backup Catalog dialog (Figure B.8) is an option to test the integrity of the current database file. Depending on the size of your catalog, running an integrity check should take only a few minutes to complete. If you do come across any errors, replace the current catalog database file with the most recently saved file from the Backups folder.

Figure B.9 If you choose File \Rightarrow Optimize Catalog, you will see the dialog shown here, which informs you of the last time the catalog was optimized and gives you the option to proceed or cancel.

NOTE

If the "Store presets with catalog" option described on page 603 is checked, this copies the Lightroom settings folder and places the folder copy inside the Lightroom catalog folder, which is shown here in Figure B.10. If you want to select a new catalog file or need to check that the correct catalog database file is selected, you can do so by holding down the Att key (Mac) or Ctrl key (PC) while restarting Lightroom. When you do this, the Select Catalog dialog (**Figure B.11**) appears, allowing you to navigate to the correct Lightroom *catalogname.lrcat* file. Or, you can click the Create a New Catalog button to create a new Lightroom catalog in a new folder location. It is possible to have any number of separate Lightroom catalogs. For example, when several people are sharing the Lightroom program, such as in a college environment, each person can maintain his or her own separate catalog.

PLACES Desktop Applications martin_evening Kind Adobe Lightroom J Catalog-2-2-4.lrcat Kind Adobe Lightroom Library	Select a recent catalo	g to open		
Note: Lightroom Catalogs cannot be on network volumes or in read-only folders.	🛃 Lightroom 3 C	atalog-2-2-4.lrcat	/Volumes/Hard Drive 3/silverton	e folder
Choose a Different Catalog Quit Open Choose a Catalog Choose a Choose a Catalog Choose a Choose a Catalog Choose a Choose a C	Always load this c	atalog on startup		Test integrity of this catalog
Choose a Catalog Choose a Cat		Note: Lightroom Catalogs	cannot be on network volumes or in	read-only folders.
Choose a Catalog Choose a Cat	Choose a Differen	t Catalon Create a N	In Catalon	
Bit I III Index Index IIII Index IIIIIIIIIIIIIIIIIIIIIIIIIIIIIIIIIIII	Choose a Dineren	Create a M	vew Catalog)	Quit Open
Bit I III Index Index IIII Index IIIIIIIIIIIIIIIIIIIIIIIIIIIIIIIIIIII				
 Disk Unitiled Ubrary-HD Hard Drive 3 SHARED PLACES Desktop Applications martin_evening III Ubrary Movies - Process Chronosync Documents Music 	000	Choo	ise a Catalog	
Unitied Ubrary-HD Hard Drive 3 SHARED PLACES Desktop Applications martin_evening HUBARY Movies Chronosync Documents Music 4 Music	< ►) (88	Lightroom	• Q	
T Music	Untitled Library-HD Hard Drive 3 SHARED PLACES Desktop Applications martin_evening Library Movies - Process Process Desktop Movies - Desktop	Lightroom 3eviews.lr Lightroom 32-2-4.l	data reat p Name Lightroo Kind Adobe Size 207.8 M Created 27/09/2 Modified 06/11/2 Last opened 06 (11/2)	IIIIIIIIIIIIIIIIIIIIIIIIIIIIIIIIIIIIII
		Gunningeneration		and the second se

Figure B.11 If you hold down the <u>Alt</u> key (Mac) or <u>Ctrl</u> key (PC) as you launch Lightroom, the Select Catalog navigation dialog appears, allowing you to select a new Lightroom catalog file.

Journal file

The Lightroom *catalogname.lrcat-journal* file is a temporary file that you may see while Lightroom is processing library information. This is an important, internal work file that appears briefly and then disappears again. If your computer crashes, do not delete the journal file because it may contain important data that can help Lightroom recover recently modified data information.

Lightroom previews data

The *Lightroom Previews.Irdata* file is a self-contained file that holds all the previews and thumbnail data. In **Figure B.12**, I used the contextual menu to show the package contents of the *Lightroom Previews.Irdata file*. This particular package was just over 117 GB in size and contained lots of *.preview.noindex* files. These are the thumbnail and preview cache files that are used by Lightroom to display the photos in the Library module and Filmstrip. The size of the thumbnail cache depends on how you set the File Handling preferences in the Catalog Settings (**Figure B.13**). If you want to keep the *Lightroom Previews.Irdata* size to a minimum, select Automatically Discard 1:1 Previews, and then choose the After One Day or After One Week option. If you don't mind it growing in size, select After 30 Days or Never. The choice is yours, but as long as you have plenty of hard disk space, I suggest you choose the After 30 Days option. Otherwise, Lightroom will have to constantly rerender the 1:1 previews for the most commonly visited folders.

NOTE

The Develop module uses a separate Camera Raw cache folder to access the early stage processed raw files (see page 610). This is stored in the Adobe Camera Raw folder located in Library/Caches (Mac), Username/ AppData/Local/Adobe/Camera Raw (Windows Vista), Documents and Settings/username/Local Settings/ Application Data/Adobe/Camera Raw (Windows XP). Note that the Camera Raw cache folder shares its data between Camera Raw and Lightroom.

Label:

More

NAMES AND A	Name	Date Modified	 Size	Kind			
-	0	 11 May 2008, 09:48		Folder	0		
	0000	8 April 2008, 22:24		Folder	4		
	0000755B-2627-471.lr-preview.noindex	8 May 2008, 22:20	700 KB	Document	18		
	A000	1 May 2008, 13:36		Folder	18		Open
*	GA02	30 April 2008, 14:36		Folder	18	Hi internetienten	Show Package Contents
	OA2E	11 May 2008, 10:40		Folder	10	Adobe Lightroom 3 a	Move to Trash
	OA4B	12 April 2008, 12:21		Folder			Move to Trash
	0A4C	11 May 2008, 10:39		Folder	18		Get Info
	OA5C	11 May 2008, 10:38		Folder	1.0		Compress "Adobe Lightroom 3.app"
•	OA5F	11 May 2008, 09:48		Folder	1.8		Duplicate
	0A6A	8 April 2008, 09:06		Folder	¥.		Make Alias
	0A6E	9 April 2008, 22:18		Folder	+		Quick Look "Adobe Lightroom 3.app"
+	0A7A	 15 April 2008, 09:54		Folder	1.		Copy "Adobe Lightroom 3.app"
							Clean Up Selection

Figure B.12 This shows a package contents view of all the .lr-preview.noindex files that are contained in my Lightroom Previews.lrdata file.

Preview Cache	General File Handling Met	adata
St	andard Preview Size: 2048 pixels	
	Preview Qualit After One Day After One Week	
Automatically D	Siscard 1:1 Preview ✓ After 30 Days Never	
Import Sequence Num	ibers	
	Import Number: 46 Photos Imp	orted: 6266

Figure B.13 The File Handling section in the Catalog Settings.

NOTE

One of the problems associated with building previews from raw files is that the raw file contains a color preview that was generated by the in-camera software at the time of capture, and the preview that Lightroom generates will most likely look different. It can be argued that this, like the original embedded preview, is just another initial interpretation of the image and simply a starting point for you to make further Develop adjustments. Having said this, you can go to the Camera Calibration panel in the Develop module and select the Camera Standard profile. This calibration setting will make the Lightroom raw-processed image match the appearance of the camera JPEG preview.

The thumbnail and preview generation can take time—it really all depends on the size of your files and how many are waiting to be processed. Lightroom tries to let you start working on an image as soon as you select it. However, doing this diverts Lightroom to process this image first, before it resumes processing the remaining files in the background.

Thumbnail processing routines

When photos are first imported into Lightroom, the Import dialog offers a choice of options for the initial previews (Figure B.14). The Minimal option is quickest because highest priority is given to importing the photos into Lightroom. Where there are previews, Lightroom assumes everything to be in the sRGB space and the previews are updated only once all the images have been imported. This is a good choice for guickly importing pictures from a card. Such previews are usually fine as a rough visual of how the image looks, but they don't always offer much in the way of detail, since they are normally the small-sized JPEG previews that were embedded in the camera file at the time of capture. These types of previews usually appear pixelated and the color appearance is always subject to change after Lightroom has had a chance to build proper previews from the image data. After the initial import, Lightroom makes a second pass in which it processes the raw data using its internal color engine to build the standard-sized previews. These previews let you see a greater level of detail when displaying large thumbnails in the content area or at a Fit to view Loupe magnification. If requested, Lightroom makes a third pass to where high-quality, 1:1 resolution previews are generated (Figure B.15). If Embedded & Sidecar is selected, Lightroom uses whatever previews are available as it imports all the images, utilizing either the embedded JPEG or sidecar file previews to quickly build the thumbnails. This is useful if you are importing photographs that have already been edited in Lightroom (or some other program), as it can make full use of the larger previews that are already associated with the files. It is a particularly useful choice for importing DNG files, as there is a good chance that the preview is already based on previously applied Camera Raw/ Lightroom Develop settings. In such circumstances, the previews do not actually change in appearance when they are re-rendered in Lightroom.

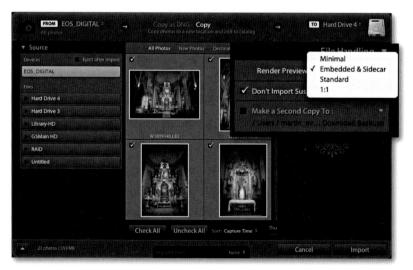

Figure B.14 The Import Photos dialog offers a choice of Initial Preview options.

When Standard previews is selected, Lightroom avoids using the embedded previews altogether and renders the standard previews directly. It reads the full image data and builds the thumbnails and initial previews to a standard size only, based on the default Lightroom Develop settings, but without applying Detail panel adjustments (which helps speed up the preview generation). However, if the 1:1 Initial Preview option is selected, Lightroom reads the full image data, builds thumbnails, creates standard and full-sized 1:1 previews, and applies all the Develop settings, including the Detail panel settings. The advantage of the Standard or 1:1 Initial Preview option is that you won't always get confused by seeing low-resolution previews that show one color interpretation (the embedded preview version), only for them to be replaced shortly by a new color interpretation (the Lightroom-processed standard-sized preview version).

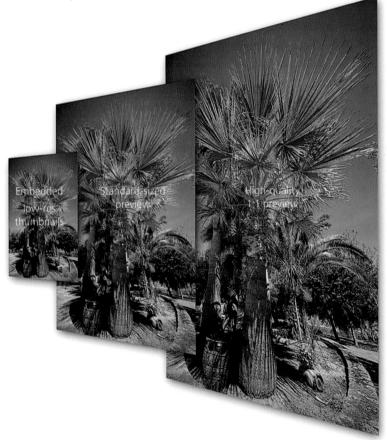

Figure B.15 Lightroom builds progressive quality thumbnails and previews. If Minimal or Embedded & Sidecar are selected (see Figure B.14), Lightroom starts by utilizing the embedded thumbnails already contained in the image or sidecar files. If Standard is selected, Lightroom builds new standard-sized previews that are suitable for large thumbnails or standard Loupe mode viewing. If you choose the 1:1 option, Lightroom also builds high-resolution 1:1 previews.

NOTE

Whenever you launch Lightroom, it initially loads all the low-resolution thumbnails and, within 30 seconds or so, starts running checks on the current catalog contents, checking the thumbnails in order of quality. Lightroom then looks to see if any of the standard-resolution previews need to be rebuilt. At the same time, Lightroom checks the existing thumbnail previews against their modification dates. If any file has been modified since the last time a preview was built, Lightroom rebuilds a new set of standard-sized previews.

NOTE

Lightroom automatically builds standard-sized previews whenever you instruct it to do so at the import stage (see Figure B.14). It also builds standard-sized previews whenever you point Lightroom at a specific folder or collection in the Library Grid view. You can also force-build standard-sized previews (as well as 1:1 previews) by going to the Library module Library ⇒ Previews submenu.

TIP

If the Low or Medium quality is selected, the cache files will be more compact. It is worth pointing out that although the high-quality previews were previously generated using ProPhoto RGB, all previews are now generated using Adobe RGB. This change was made because it was found that the ProPhoto RGB space was simply too big for generating reliable JPEG previews in 8-bit mode. You can also think of it this way: There are no current LCD displays capable of showing anything bigger than an Adobe RGB gamut anyway. You can set the Standard Previews size in the Catalog settings (**Figure B.16**). As was explained in Chapter 3, if you are using a large display, you should probably choose the "2048 pixels" option, but if you are working from a laptop computer, the "1024 pixels" setting will probably suffice.

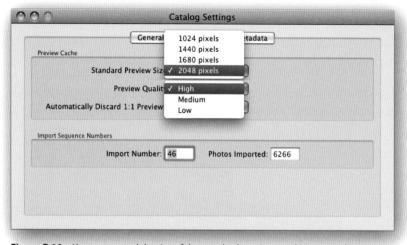

Figure B.16 You can control the size of the standard previews and image quality via the File Handling section in the Catalog Settings dialog.

Customizing the Lightroom contents

The Adobe Lightroom application is made up of modular components: the Library, Develop, Slideshow, Print, and Web modules. If you want to peek inside the Lightroom application folder, then follow the instructions shown in **Figure B.17** and **Figure B.18**. After you have revealed the package contents, you will see the various folders and files that make up Lightroom. In Figure B.18, I have expanded the *Plugins* folder to reveal the individual module components. Now that you know where the modules are kept, you know how to customize Lightroom.

Hacking the Lightroom contents

Advanced Lightroom users may already be aware that it is possible to hack into the program contents (as described above) to remove modules from Lightroom, and for the program to launch and run as normal, minus the module you just removed. This can, however, lead to some cross-module behavior problems. For example, if you remove the *Slideshow.lrmodule* file from the *Plugins* folder shown in Figure B.18, the Slideshow module will be missing after you launch Lightroom, and the Impromptu Slideshow menu will also be disabled in the Window menu. Likewise, if you remove the Export module, the Export menu commands will be omitted from the File menu.

NOTE

Note that the *Scripts* folder in the Mac OS X Lightroom package contents is a Lightroom-only *Scripts* folder. If you want to add custom scripts, place these in *Username*/ *Library/Application Support/Adobe*/ *Lightroom*. Alternatively, go to the Scripts menu next to the Help menu and choose Open User Scripts Folder. The Mac package contents even let you access the graphic files (these are located inside the various *Resources* folders), which this gives you the opportunity to sneakily customize the interface. Obviously, you want to be careful when playing around with the program components, because it is quite easy to damage or remove files that shouldn't really be messed with. If you are not careful, you can create problems that can be addressed only by carrying out a fresh reinstall of the program.

Figure B.17 On Windows XP and Vista, go to Program Files/Adobe to locate the Adobe Photoshop Lightroom folder. There you will find the Lightroom application program along with the program files and modules.

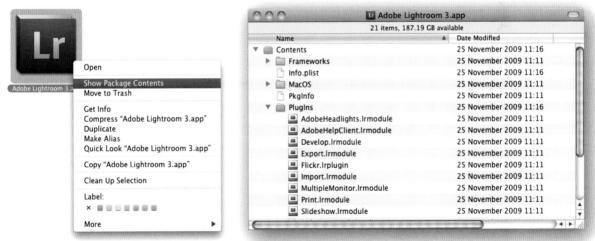

Figure B.18 On the Mac OS X system, you can reveal the package contents by rightclicking or Ctrl-clicking the Adobe Lightroom icon and selecting Show Package Contents from the fly-out menu. This opens a separate folder window, which allows you to access the program files and modules.

NOTE

Although it isn't officially named as such, I tend to call the Lightroom edit space Lightroom RGB. Mark Hamburg had suggested it might be more appropriate to call it "bastardized RGB" since the space is using ProPhoto RGB chromaticities, but with a gamma of 1.0 instead of 1.8. Meanwhile, the Lightroom viewing space uses the same ProPhoto RGB chromaticities but with an sRGB tone response curve. Melissa Gaul, who is the QE manager for Lightroom, suggested this space should be called Melissa RGB since all RGB spaces to date have been named after men!

The Lightroom RGB space

As you have probably gathered by now, there are no RGB workspace color settings options in Lightroom as there are in Photoshop. You have to bear in mind here that Photoshop's ICC-based color management system was introduced at a time when color management was not so well understood and it was thought necessary to incorporate the new ICC color management system in a way that would satisfactorily allow Photoshop users to accommodate their existing non-ICC color-managed workflows. At the same time, the RGB workspaces that were recommended at the time for use in Photoshop were mostly guite conservative.

Lightroom has largely been freed from these constraints and it is, therefore, safer these days to assume that most photographers are now working with RGB files that have embedded profiles. Since Lightroom is mainly intended as a tool for editing digital-capture images, these photos will mostly be imported into Lightroom either as profiled JPEGs or as raw files (in which case, the Adobe Camera Raw color engine knows how to interpret the colors, based on the embedded white balance information). If an imported RGB image happens to be missing a profile, Lightroom assumes the profile to be sRGB and assigns it when performing the image processing calculations.

All Develop module image processing in Lightroom is carried out using the Lightroom RGB space. This means that if you work with single-channel, grayscale images in Lightroom, these are, in fact, edited in RGB. With Lab mode images, the Lab mode data is converted to RGB when it is processed in Lightroom (although the master file remains in Lab mode), and the same goes for CMYK files—the master files remain in CMYK, but any Develop module editing is carried out in RGB.

Lightroom carries out the image processing calculations in its own RGB space, which uses the ProPhoto RGB coordinates but has a gamma of 1.0 instead of 1.8. The 1.0 gamma has been chosen with raw image processing in mind, because raw files all have a gamma of 1.0 and Lightroom can, therefore, process the raw images in their native gamma without needing to convert them to a gamma of, say, 1.8 or 2.2. Keeping Lightroom's image processing in the native gamma of the raw capture files is a better way to work because Lightroom processes the raw data directly without applying any gamma conversions to the decompressed/ demosaiced raw data. Also, Lightroom can achieve smoother blending when you perform certain types of image processing adjustments using 1.0 gamma.

For all non-raw images, as long as the image you are editing has a profile attached, Lightroom recognizes this, preserves the master file in its original RGB space, and uses this space to calculate the histogram and generate the catalog image previews that are used throughout Lightroom. For the Develop module processing and previews, however, Lightroom carries out these calculations in the Lightroom RGB space. If an image is missing a profile, Lightroom assumes the image should be in sRGB whenever it carries out an on-the-fly conversion to the Lightroom RGB space for the Develop module image processing. Note: Lightroom does not actually *assign* a profile to an unprofiled master.

The ProPhoto RGB coordinates describe a color space that's so massive, it includes colors that are invisible to the human eye. So the gamut of ProPhoto RGB is certainly large enough to include every possible color that a digital camera can capture, which means that the RGB space used by Lightroom never clips important colors when carrying out its calculations. Also, bear in mind that the image processing is carried out mostly in 16-bits per channel (some specific processing is even done in 32-bits) and, because Lightroom uses a 16-bit RGB edit space, it's able to preserve all of the levels that a digital camera can capture. For example, a typical digital SLR can capture up to 12-bits of levels data per channel. When a raw file from one of these cameras is edited in Lightroom, the 16-bit edit space is able to process the raw image data without losing any of the levels information. The deep-bit editing space should also allay any concerns about the risks of banding that might be caused by gaps in a color value representation between one level's data point and the next. I have to say that even with an 8-bit edit space, these initial concerns have been overstated, and I do accept now that it is safe to work with ProPhoto RGB, even if the final destination space will be an 8-bits per channel image. But obviously, if you are able to make all the principal image edits using all the captured levels data in a wide-gamut RGB space (as you are when you work in Lightroom), then so much the better.

But let's now take a look at why raw images are in a linear gamma space to start with. All digital images, whether they are scans or captures from a digital camera, contain data that is a linear representation of the light hitting the sensor. As the light intensity doubles, a sensor records a brightness value that is two times higher. This all sounds logical enough, but when you actually view an image that has been recorded in this way, you begin to realize that human vision perceives things quite differently from the way a sensor sees and records light. This is because unlike a scanner or camera sensor, our eyes compensate for increasing levels of brightness in a nonlinear fashion, which is why we are able to distinguish shades of tone over a wide dynamic range from the darkest shadows to the brightest highlights. When the light levels double, our eyeballs do not literally record the light levels hitting our retinas as being twice the brightness. Our human vision system is able to adapt to widely changing light levels by constantly compensating for such extremes in the light levels. So, if we compare the way a sensor records light and represents the captured image data, we see an image that looks very dark, even though it may, in fact, be perfectly exposed and contain a full range of usable tones from the shadows to the highlights. To get a normal digital capture to look right to our eyes, the linear data must, at some point, be gamma corrected (effectively lightened at the midpoint). Once a gamma curve has been applied to the linear capture data, the captured image looks more representative of the scene we perceived at the time the photograph was taken.

TIP

For a more detailed explanation of working in linear gamma, download the "Raw Capture, Linear Gamma, and Exposure" white paper written by Bruce Fraser (http://tiny. cc/7QJLM).

NOTE

RGB images can be exported as rendered pixel images using the standard ProPhoto RGB, Adobe RGB, or sRGB color spaces. A ProPhoto RGB export is capable of preserving all the color information that was captured in the original raw file after it has been processed in Lightroom. This can prove useful when making high-end print outputs where you need to preserve rich color detail.

Adobe RGB is a more commonly used RGB space among photographers and perhaps a safer choice if you are sending RGB images for others to work with.

sRGB is a standardized RGB space that is suitable for Web work and sending photos via e-mail. It is also a suitable "best guess" choice if you are unsure whether the recipient is using proper color management.

Note that in Lightroom you can choose Other in the Export dialog. This takes you to the system profiles folder and allows you to convert exported photos to any profile that is stored in your computer ICC profiles folder.

RGB previews

As I explained on page 626, the previews you see in the Library module are either in Adobe RGB or ProPhoto RGB JPEG, and these are stored in the preview cache that's used to generate the catalog previews. However, the Develop module previews are based on image calculations carried out in the wide-gamut Lightroom RGB space, which are filtered via an sRGB tone response curve. Therefore, the Develop module previews always show you the most reliable color view of the image you are editing. This is also the reason why you may sometimes see slight color shifts or banding when you switch between the Develop and Library modules. If you export photos from Lightroom using a smaller gamut sRGB space, you may again see some clipping or shifting of colors. This is because the sRGB color gamut is significantly smaller than the Adobe RGB, ProPhoto RGB, or Lightroom RGB space (plus Lightroom Tone Response curve), as seen in the Develop module.

With the Slideshow module, raw file slideshow images use the Adobe RGB or ProPhoto RGB space (depending on the Catalog settings), and non-raw files use the native RGB space for the image. With the Web module, all images are automatically converted to sRGB when generating the Web gallery previews. This is because sRGB is the most suitable space to use for Web-published images.

Tone curve response

There are clear advantages to working on raw data in a native, linear gamma edit space, but a linear gamma space is not so good when it comes to making direct image edit adjustments. When you edit an RGB image in Lightroom, there are two things going on. First, the Develop controls used to carry out the image processing do so filtered through the Lightroom RGB space plus an sRGB response curve. As a result, the data points in the underlying Lightroom RGB edit space are distributed more evenly so that the Basic and Tone Curve adjustments applied in Lightroom correspond to a more balanced tone scale. (The sRGB response curve is also used to generate the histogram display and color readout values seen in the Develop module.) What you see in the histogram is effectively the Lightroom ProPhoto RGB space in linear 1.0 gamma with an sRGB response curve applied to it. Figure B.19 shows a plot of the sRGB curve (in black), which matches closely to the 2.2 gamma curve (shown in pink). I had to show this graph quite big so you could see the subtle difference between these two curves. But note that the sRGB curve rises steeply from 0,0 and away from clipping the blacks just a little sooner than a pure 2.2 gamma curve—although the 2.2 curve hugs the y-axis high enough that several potential values very close to black (in the linear space) are crushed to black. The sRGB curve then leans away from the y-axis much sooner, and you maintain at least a tiny bit of differentiation between those very dark values. So, in the transformation from the linear space to the sRGB space, the sRGB curve is just a bit less draconian in where it leaves values in the very dark shadows.

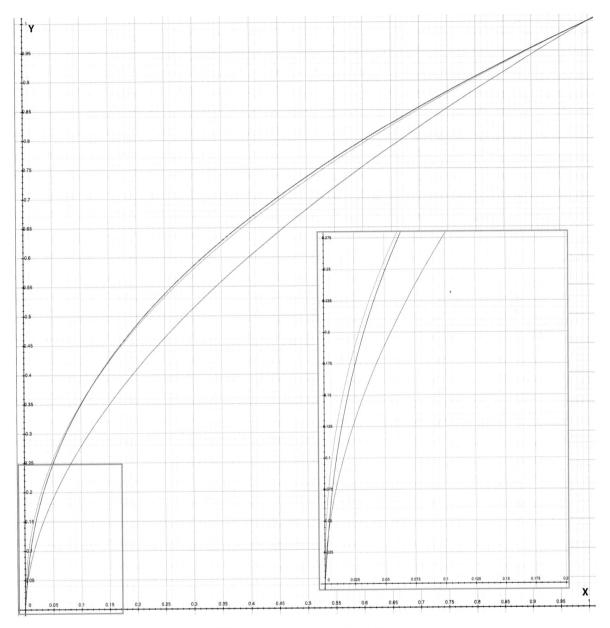

Figure B.19 This graph shows a plot for the sRGB response curve (black) for the Lightroom preview RGB space (also known as Melissa RGB), plotted against a standard 2.2 gamma curve (pink) and a 1.8 gamma curve (blue). Note the description in the main body text, which explains the subtle difference between the sRGB and 2.2 gamma curve shapes. The inset box shows a close-up view of the bottom end of the gamma curves.

Balancing the tone curve

Figures B.20 and **B.21** explain why it is necessary for the Lightroom preview RGB space to use an sRGB response curve before the linear RGB data reaches the Develop controls. Remember, you are, in fact, always editing 1.0 gamma data, and the sRGB response curve is applied only to make the Develop adjustments easier and more logical to control. Even so, you will still notice an element of asymmetric response when adjusting the Blacks slider. For example, have you noticed how small incremental adjustments to the Blacks have a far more pronounced effect compared to adjustments made with the Exposure slider?

Figure B.20 The problem with trying to edit the linear 1.0 gamma directly is that the midtones are all condensed in the left portion of the tone curve (shown here as a continuous gradient). If you were forced to directly edit an image with a 1.0 gamma, any attempt to make small adjustments in the shadow-to-midtone region would be very much amplified in the midtone-to-highlight regions. As shown here, it would be a bit like trying to balance a seesaw with an offset fulcrum point.

Figure B.21 When an sRGB tone response curve is applied to the underlying linear gamma data, the tones on the tone curve are more evenly distributed. This provides an image editing environment in which you are able to edit linear 1.0 gamma image data in a more balanced (and more natural) nonlinear fashion.

The ideal computer setup for Lightroom

The ideal computer setup for Lightroom depends on the size of the files you intend to work with. The raw file captures you will be working with may range in size from 6 to 25 megapixels, and the larger files will certainly place more demands on your computer resources. So, when looking for an ideal computer to run Lightroom, you definitely need to take the typical image file sizes into account. The most important factors affecting Lightroom performance are the processor speed and the amount of RAM that is available for Lightroom to use. This is followed by the speed and size of the hard disk and, to a lesser extent, the processing power of the graphics card. Lightroom is optimized to run on the latest Intel computer processors and, at a minimum, you need a Macintosh Intel processor computer with 2 GB of RAM, running Mac OS X 10.5 or later. And on the PC side, you need an Intel Pentium 4 with 2 GB of RAM, running Windows 7, Windows XP with Service Pack 3, Windows Vista Home Premium, Business, Ultimate, or Enterprise.

RAM

You will benefit from having as much RAM as possible, but you should take into account that the operating system and any other open applications will also consume some of that RAM. For example, if you happen to have just 2 GB of RAM installed in your computer, the operating system will use about 200 MB, while another 50 MB might be eaten up by various utilities. And that is before taking into account other, more memory-intensive applications that may be running in the background. So, if you double the amount of memory installed on the computer to 4 GB, you could easily triple the amount of RAM that is effectively made available to Lightroom. Keep in mind that with most laptops, you are probably limited to a maximum of 4 GB of RAM anyway, but if you have a desktop machine, you can probably install a lot more. Judging by the reports from various power users, you should see significant benefits in performance if you install 4 GB of RAM or more on a fast desktop computer. This is especially the case now that Lightroom is able to run as a 64-bit program and can, therefore, access RAM beyond the previous 4 GB limit.

Graphics card

The graphics card does not play such a vital role in Lightroom's overall performance. You simply need a graphics card that is capable of running the screen display at its native resolution. You don't necessarily need an ultrafast graphics card. For example, all the Apple Mini and MacBook computers, with the Core 2 Duo processor, use 64 MB of the system RAM to run the graphics display. As long as

NOTE

Megapixel has become better understood by digital photographers over the last five years or more, as it is at least a consistent term for describing file size. The number of megapixels always refers to the absolute number of pixels in an image. A 6-megapixel image will contain 6 million pixels, and when it is converted to an 8-bit per channel, RGB mode, flattened image, it will be equivalent to an 18 MB file. you have a suitable amount of memory installed, the amount of memory that's devoted to the graphics display should not necessarily limit the speed at which you can work in Lightroom. That said, video card performance and Open GL compatibility are important factors if using Photoshop CS4 or later.

Hard drives

On both the Mac and the PC platform, a default Lightroom installation installs the Lightroom catalog folder (that contains the catalog and previews files) inside the user's *Pictures* or *My Pictures* folder. As your catalog grows bigger, these catalog files will increase in size, although there are options in the Preferences to limit how long the 1:1 previews are preserved, automatically deleting them after a certain number of days. Don't forget that the Camera Raw cache may also be allowed to grow beyond the default 1 GB limit, and this, too, can consume more disk space.

The main considerations when selecting a hard drive are the interface type, hard drive configuration, speed, and buffer memory. All these factors affect the overall speed. Let's start with the interface connection. Internal drives usually offer a fast ATA interface connection, so one option would be to add more internal drives. I have learned from experience to be wary of relying too much on working files being kept on internal drives. Twice, I have had an internal power unit die and had to physically remove the drives and place them in a temporary drive housing in order to access the data. For this reason, you could choose to store all the Lightroom catalog image folders on fast external drives. This would allow you to free the main computer hard drive from an accumulating library of image folders. However, with some of the newer computers, it is actually much easier now to swap out the internal drives and move them from one machine to another. So, I am actually inclined to use internal drive units because they offer a faster internal interface connection speed.

Several external connection types are available. A USB 1 connection limits the data transfer rate and should be avoided. Instead, choose a USB 2 or FireWire 400/800 connection. You can now also buy Serial ATA (SATA) drives that promise very fast rates of data transfer, but you might need a PCI card that provides a SATA connection from your computer.

The hard drive spindle speed determines how fast data can be written to and retrieved from the disk drive unit. Most 3.5-inch desktop drives have a spindle speed of 7200 RPM, whereas the smaller 2.5-inch drives found in laptops and portable bus-powered drives mostly run at a speed of 4200 to 5400 RPM. You can get 7200 RPM 2.5-inch drives, but they are more expensive and are usually only offered as a custom option when buying a laptop. You can also get 3.5-inch drives that offer speeds of around 10,000 rpm, but they are expensive and the maximum storage space is only around 300 GB. Extra disk buffer memory helps take the pressure off the disk drive activity, which can also lead to improved drive performance.

Drive configurations

Multiple hard drives can be configured in a variety of ways, including the RAID system methods described below. You need a minimum of two disks to configure a RAID system and most off-the-shelf RAID solutions are sold as a bay dock that can accommodate two or more drives with a built-in RAID controller. For some people, RAID is the perfect solution, but for small photography businesses, it can be overkill. Let's start, though, by looking at some of the more popular RAID configurations and how they might suit a digital photography computer setup.

Striped RAID

A striped RAID 0 setup allows you to treat multiple drives as one. Here, two or more drives can be joined to become a single drive volume. RAID 0 is useful if you require fast hard-drive access speeds, because the drive access speed increases proportionally to the number of drives that are added. If you have four 500 GB drives configured using a RAID 0 system, you'll end up with a single 2 TB volume, with a hard drive access speed that is four times that of a single 500 GB drive. This setup might seem like a good idea for improving the data access speeds, but the disadvantage of such a setup is that if a single drive should fail, the entire RAID system fails, too, and all the data that's on it will be lost. A RAID 0 setup is, therefore, ideal for use as a Photoshop scratch disk but not for storing essential data you can't afford to lose.

Mirrored RAID

A mirrored RAID 1 system stores an exact duplicate of all the data on a backup drive. As data is written to one drive, it is updated to the other drive, too. The main advantage of a RAID 1 system is that, if any single drive within the system fails, you can swap it with a new one, and the data stored on the mirrored drive automatically rebuilds a copy of all the data to the replacement drive. RAID 1, therefore, offers you the most secure method for storing important data, such as an image archive, providing increased data integrity and fault tolerance. The downside is that you'll need double the disk space to store all your data. For example, a mirrored RAID 1 drive setup using two 1 TB drives would allow you to store only up to 1 TB of data.

Mirroring can provide security against immediate drive failure, but it does not offer a complete backup protection solution. Mirrored drives are necessary for businesses that must have absolute access to the data 24 hours a day, 7 days a week. But mirrored systems don't necessarily provide the full data security you would expect. For example, if the directory becomes corrupted, the continuous mirroring copies the corruption to the mirrored drive. This could happen before you are even aware of the problem, leading to a loss of data. For absolute protection, scheduled backups need to be carried out to a secondary storage system, which should, ideally, be kept off-site.

TIP

If you implement RAID internally, be aware that you should never try to run the operating system from a mirrored RAID 1 setup. The disk speed will be compromised by the RAID setup, which in turn can slow the computer's running speed.

TIP

When assessing your overall storage requirements, don't try to build a system to last you the next five years. Buy the storage system you need today, but make it expandable for the future.

A mirror of stripes

It is, therefore, tempting to look for a solution where it is possible to store large amounts of data on a fast, striped volume that is also combined with built-in mirroring backup. One such option is a RAID 0+1 setup, which requires four disks. The first two disks are configured using RAID 0, creating a single volume but with twice the disk access speed of a single disk. The other two disks are configured to create an overall RAID 1 setup, in which the data on the RAID 0 volume is safely mirrored across the two backup disks. A RAID 0+1 system is, therefore, both fast and secure, but such systems do come at a price. Plus, they can be quite noisy and are not particularly energy efficient.

RAID 5

RAID 5 has gained in popularity recently. This requires a minimum of at least three drives and allows you to store data more securely and more economically through parity striping. In practice, a RAID 5 configuration allows you to use the full drive storage capacity, less the capacity of one of the single drive units, and provides complete data backup should any single drive fail. So a 4 TB RAID 5 using four 1 TB drives would be able to store up to 3 TB of data. RAID 5 offers the most economical form of storage that can withstand a single drive failure, but the write speeds are necessarily slow.

The Drobo storage system (www.drobo.com) uses what is described as "virtualized storage," which appears to be very close in functonality to the way a RAID 5 system works. The Drobo system allows you to easily upgrade individual drives, thereby keeping pace with your data expansion needs. It is kind of scary to trust your valued data to a proprietary storage system, but arguably less so if you take the precaution of combining this with scheduled backups to a separate Drobo setup.

Just a bunch of disks

There are varied opinions about which is the best way to manage a photography archive storage system. In my view, RAID storage is ideal but not the best solution for all photographers. A perfect solution would be to have a high-capacity RAID drive system that is capable of storing all your images securely on a single RAID unit. I have seen photographers work with such setups, but even so, it is quite costly to have a multi-drive unit that holds all your data running continuously and consumes lots of power just so that, once or twice a year, you can dig up a file you shot six years ago. If you analyze your storage requirements, you will most likely find that the vast majority of the files you access are those shot in the last few years. When you think about it, the files you need to work with on a regular basis can probably be accommodated on a few standard single-drive units. This leads to a simpler solution known as "just a bunch of disks," or JBOD for short. With a JBOD setup, you can have a file storage system that is scalable to meet your expanding storage needs, which is not only economical to maintain but also

reliable (providing that you maintain a proper backup strategy). In my office, I use two internal 2 TB drives to store all the current catalog files and back these up to two external 2 TB drives. I also have eight other 250 GB drives that are used to store all of my older raw and master file images that date back over the last 16 years, plus another eight similar drives that are used for backing up to. Most of the time, I don't need to have these external drives running, and I back up regularly to the main two 2 TB drives. Whenever I need to access older images, I can switch on the necessary hard drive, as directed by Lightroom. JBOD can never be as foolproof as a RAID system, but it may be more appropriate for those photographers who think this would be an acceptable enough solution for their storage needs.

The ideal system?

These days it is worth purchasing a computer that has plenty of free internal space that allows you to install additional internal drives. For example, the latest Intel Mac computers have enough room to fit three extra drives. You can, therefore, equip a modern Intel Mac with either an internal mirrored RAID 1 or a striped RAID 0 setup. These will have to be controlled by software on the Mac via the Disk Utilities program. In the past, software-created RAIDs were a lot slower than a dedicated system with a hardware controller. The read/write speeds from a software RAID will still be slower than a true dedicated RAID system, since a software RAID will have to steal some of your computer processor cycles. But these days, the speed loss is not as bad as it used to be. A software-driven, internal striped RAID 0 can increase disk access speed by about 45 percent, but it comes with the inherent risk of losing all data in the event of a single disk failure. A software-driven, internal mirrored RAID 1 reduces speed by about 25 percent, but it improves reliability. Finally, if you ever need to see an overview of your system setup, you can go to the Help menu and choose System Info. This opens the dialog shown in Figure B.27, which also includes the Lightroom serial number (which isn't shown here for obvious reasons).

000	System Info	
Lightroom version: 3.0		Close
Version: 10.5 [8]		
Application architecture: x64		Com
Physical processor count: 8		Copy
Processor speed: 3.0 GHz		(Saus As
Built-in memory: 12288.0 MB		Save As
Real memory available to Lightroom: 1228	8.0 MB	
Real memory used by Lightroom: 756.1 ME	3 (6.1%)	
Virtual memory used by Lightroom: 5607.8	3 MB	
Memory cache size: 372.7 MB		
Displays: 1) 2560x1600, 2) 2560x1600		
Serial Number:		
Application folder: /Applications		
Library Path: /Volumes/Hard Drive 3/silver	tone folder/Lightroom 3 Catalog-2-2-4.lrcat	
Settings Folder: /Users/martin_evening/Lil	prary/Application Support/Adobe/Lightroom	

Figure B.27 The Lightroom System Info can be accessed via the Help menu.

Index

1:1 previews, 93, 439, 454, 625 16-bit printing, 534 16-bit processing, 244, 485–486, 629 64-bit processing, 10, 529

Α

ACR profiles, 340 actions export, 492-495 extended editina, 474 Adjustment brush, 365-375 Auto Mask option, 368-369 Clarity effect, 374-375 Color effect, 372-373 editing brush strokes, 366 gradient performance and, 366-367 initial settings, 365-366 previewing stroke areas, 370 saving effect settings, 366 Sharpness effect, 374-375 Soften Skin effect, 370-371 Adobe Bridge. See Bridge program Adobe Camera Raw. See Camera Raw Adobe color engine (ACE), 536 Adobe Kuler, 578 Adobe Photoshop. See Photoshop Adobe Photoshop Lightroom. See Lightroom Adobe Reader, 565 Adobe RGB color space, 273, 462, 485, 494, 591, 630 Airtight galleries, 573, 584 All Edges correction, 327-329 Amount slider Lens Corrections panel, 322 Post-Crop vignetting, 334 Sharpening controls, 440-441 anchor points, 552-553 aperture setting information, 169-170 Appearance panel (Web module), 580-584 Flash gallery settings, 581-583 HTML gallery settings, 580 Application Data folder, 618 Armes, Timothy, 496 artist name metadata, 139 aspect ratios, 264, 265, 268 attribute filter searches, 167 audio note file playback, 200 slideshow soundtrack, 561, 566, 567 task completion sounds, 601 Auto Dismiss option, 277 Auto Import Settings dialog, 65 Auto Mask option, 368-369 Auto Sync mode, 359, 386 Auto Tone setting, 90, 253, 283, 395, 602 Auto White Balance setting, 279 Auto-Align Lavers dialog, 475 automatic program updates, 600 Auto-Stack by Capture Time option. 120, 121 AutoViewer galleries, 573

В

B&W panel (Develop module), 406, 409 Auto button, 406, 410, 413 manual adjustments, 416–417 slider controls, 406, 408, 410–411, 417 *See also* black and white conversions Back Up Catalog dialog, 232, 233, 621 Backdrop panel (Slideshow module), 554–555 Background Color swatches, 554 Background Image option, 554, 555 backgrounds module, 614 print, 512 slideshow, 554-555 backups catalog, 232-235, 621 imported photo, 53-54 software for, 235 badges, thumbnail, 81 Barroso, Clicio, 370 Basic panel (Develop module), 274-299 Auto Tone setting, 283 Blacks slider, 282, 285, 288, 298-299 Brightness slider, 283, 299, 311 Clarity slider, 292-295 Contrast slider, 283, 299, 311 Exposure slider, 282, 284, 287, 296-299, 310 Fill Light slider, 282, 311 Histogram panel and, 282-288 image adjustment procedure, 276 keyboard shortcuts for, 276 overview of controls in, 274 Recovery slider, 282, 287, 297, 310 Saturation slider, 289-291 Temperature slider, 280, 410-411 Tint slider, 280, 410, 421 Tone Curve panel and, 283, 303, 308-313 Vibrance slider, 289-291, 427 White Balance tool, 277-281, 286, 309 beauty retouching, 370-371 Before/After viewing modes, 348-353 Copy settings buttons, 350 keyboard shortcuts, 349, 350 managing previews in, 350-353

Better Finder Attributes application, 137 bit depth, 13, 462, 485-486 Black & White button, 406 black and white conversions, 405-429 camera settings and, 408 desaturating color for, 426-429 Develop module controls, 406-407 fine-tuning B&W images, 422-429 infrared effect and, 418-421 manual adjustments for, 416-417 RGB channels and, 408 Saturation slider for, 406 Split Toning panel for, 406, 415, 421, 422-425 Temperature slider for, 410-411 Tint slider for, 410, 421 white balance adjustments for, 412-415 See also B&W panel Blacks adjustment Basic panel, 282, 284-285, 288, 298-299 Quick Develop panel, 254 Blacks slider, 274, 282, 285, 288, 298-299 border options, 514-515 Bridge program, 111, 190, 192, 198 Brightness adjustment Basic panel, 283, 299, 311 Quick Develop panel, 254 burning CDs/DVDs, 499

С

calibrating the display, 247–251 devices used for, 247–248 steps in process of, 249–251 white point and gamma, 248–249 Camera Calibration panel (Develop module), 340–347, 427, 429 camera profiles, 340–341 creative uses of, 345–347 custom calibrations, 342–345 Camera Raw, 4 Adobe programs and, 5 cache size for, 610–611 camera profiles, 340–341

Lightroom integration with, 245, 388-391, 464 processing images in, 4, 245, 246 See also raw files cameras black and white mode, 408 cleaning sensors on, 356 connecting to computers, 66-67 custom calibrations for, 342-345 default Develop settings for, 402-403, 602 exposure settings for, 275 memory cards for, 44-47 metadata info about, 139, 169-170 profiles for, 340-341 tethered shooting with, 22-23, 66-71 transmitting photos from, 66 Campagna, Matthew, 575 Candidate images, 96 Canon EOS Utility, 67, 71, 139 captions viewing in Metadata panel, 132 Web gallery, 585-589 Capture One software, 71 capture sharpening, 432, 487 capture time editing, 138 Cast Shadow option, 546, 547 Catalog panel (Library module), 78 Catalog Settings dialog, 12, 91, 92, 186-187, 191, 232 catalogs, 213-241 about, 214-215 backing up, 232-235 copying between computers, 221-225 creating new, 216, 622 database file, 620-622 default, 601 exporting, 217-219, 221, 222, 224, 499 filtering photos in, 112-119 folders and, 235-241 importing, 219-221, 225 journal file, 622 merging, 226-231 opening existing, 216, 223 optimizing, 214, 215, 232

previews data file, 623 removing photos from, 123 settings for, 232 single vs. multiple, 10 storing presets with, 603 using multiple, 214, 215 Causa, Ettore, 370 CD burning, 499 Cell Size sliders, 508 Cell Spacing sliders, 508 cells Picture Package layout options, 518-520 Single Image/Contact Sheet options, 507-511 Cells panel (Print module), 518-520 centering prints, 508 Chan, Eric, 4, 342, 433 Chromatic Aberration adjustments, 324-329 All Edges correction, 327-329 Highlight Edges correction, 326 lens aberration correction, 324-325 ChronoSync backup program, 235 Clarity adjustment Adjustment brush, 374-375 Basic panel, 292-295 negative, 294-295, 370-371 Quick Develop panel, 254 Clarity slider, 292-295 clipping gamut, 320-321 highlight, 273, 282, 284, 287 shadow, 273, 282, 284-285 clipping warnings, 273, 284 Clone mode, Spot Removal tool, 354, 356 close-up Loupe view, 84, 89 CMYK images, 54, 245, 494-495, 628 collections, 35, 176-180 module-specific, 178 print, 502, 525 publishing, 181-184 Quick Collections, 35, 130-131, 176, 177 renaming, 179 sets of, 180

collections (continued) slideshow, 178-179 Smart Collections, 35, 180 target, 179-180 uses for, 176 Web gallery, 577 Collections panel (Library module). 176-180 color adjustments Adjustment brush, 372-373 desaturated color, 426-429 HSL controls, 316-321, 426 noise reduction, 455, 456-457 Quick Develop panel, 253 Split Toning panel, 424-425 Color effect Adjustment brush, 372-373 Graduated Filter tool, 378 color gamuts, 320 color labels, 110-111 assigning to photos, 110, 111, 172-173 Bridge label compatibility, 111 choosing colors for, 110 filtering photos with, 116-117, 169 sort functions and, 197–199 Color Management settings, 528, 536 Color Palette panel (Web module), 578-579 Color picker, 372, 578 Color Priority vignette, 336, 337 Color sliders Detail panel, 455 HSL panel, 426 color spaces, 13, 273, 462, 485, 494 color themes, 578-579 Color Wash controls, 554, 555 ColorChecker chart, 279, 342 colorimeter, 247 ColorSync option, 530, 535 Compact Cells view, 80, 81 Compare view, 96-99 Completion Sound options, 601 compression settings, 565, 566, 609-610 computers connecting cameras to, 66-67 ideal setup for Lightroom, 633 system requirements for, 8, 633

See also Macintosh computers: Windows computers Configure FTP File Transfer dialog, 38, 593. 594 Constrain Aspect Ratio button, 264 Contact Info box, 577 contact sheets, 32, 510 content area, 19, 50-51 contextual menu, 76, 77 contiguous selections, 82, 169 Contrast adjustment Basic panel, 283, 299, 311 Quick Develop panel, 254 Contrast slider, 299, 455 controlled vocabulary, 150, 154, 155, 156 Convert to DNG feature, 59, 609 Copy as DNG option, 47, 48 Copy Name field, 134, 136 Copy Settings buttons, 350 Copy Settings dialog, 392 copying catalogs between computers, 221-225 Develop module settings, 392 importing photos by, 48, 60-61 copyright information, 149, 489 corrupted files, 47 Create New Catalog button, 11, 622 Crop Frame tool, 266 Crop Lock button, 268 Crop Marks option, 516 Crop Overlay mode, 264 Crop Ratio menu, 258 Crop tool panel, 264, 265 cropping photos, 264-271 aspect ratios for, 264, 265, 268 basic steps for, 266-267 cancelling crops, 271 guide overlays for, 269-271 metadata info on, 137 post-crop vignettes, 334–337 Quick Develop options, 258 repositioning crops, 268 rotating and, 264 custom filters, 171-175 custom keyword sets, 159 custom metadata, 140-145 Custom Package layout, 504, 522-525 custom profile printing, 535–538 Cut Guides option, 521

D

DAM Book, The (Krogh), 111, 234 darkening colors, 318-319 Darks slider, 302, 312 date/time information, 137, 138, 169 Default Catalog options, 601 Default Develop settings, 601–602 defringe controls, 326-329 All Edges correction, 327-329 Highlight Edges correction, 326 deletina files from memory cards, 47 history list, 380 metadata presets, 142 photos, 123 templates, 539 See also removing demosaic processing, 433, 434, 454 Density slider, 365 desaturated color adjustments, 426-429 Destination panel (Import dialog), 51-52 Detail panel (Develop module), 432 default settings, 435 Noise Reduction controls, 454-457 Sharpening controls, 432, 439-451 Detail slider, 444-446 Develop module, 4-5, 29, 243, 262-403 Adjustment brush, 365-375 applying settings from, 392-393 Auto Tone setting, 283, 395 automatic lens corrections. 272 B&W controls, 406-429 Basic panel controls, 274-299, 308-313 Before/After viewing modes, 348-353 Brightness adjustments, 283, 299, 311 Camera Calibration panel. 340-347 Camera Raw compatibility, 245 camera-specific settings, 402-403

Chromatic Aberration adjustments, 324-329 Clarity adjustments, 292-295 color adjustments, 316-321 Contrast adjustments, 283, 299, 311 copying settings from, 392 cropping procedures, 264–271 default settings, 601-602 Detail panel, 432, 439-457 Develop Presets panel, 341 Effects panel, 334-339 Exposure adjustments, 282, 284, 287, 296-301, 310 Fill Light adjustments, 282, 311 Graduated Filter tool, 376-378 highlight adjustments, 282, 296-297, 306, 312 Histogram panel, 273, 282-288 History panel, 379-380 HSL controls, 316-321 image processing engine, 244 interface overview, 262-263 Lens Corrections panel, 322-333 localized adjustments, 364–378 Match Total Exposures command, 300-301 presets used in, 394-403, 435 Process Versions, 246 Recovery adjustments, 282, 287, 296-297.310 Red Eye Correction tool, 360-364 retouching tools, 354-383 Saturation adjustments, 289-291 shadow adjustments, 284-285, 298-299, 308, 313 Snapshots panel, 380-383 Spot Removal tool, 354-359 synchronizing settings, 30, 257, 259. 386-387 Tone Curve panel, 302-315 Tool Overlay options, 272, 357 Vibrance adjustments, 289-291 White Balance tool, 277-281, 286, 309 Develop Presets panel, 341 Develop Settings menu, 57 Diagonal crop overlay, 269, 270

Discard 1:1 Previews warning dialog, 93 display screen calibrating, 247-251 dual-display setup, 102-105, 471 tips on choosing, 247 Distortion slider, 331 DNG files, 8, 59 compression for, 609-610 converting raw files to, 59, 609 copying photos as, 47, 48, 606-609 exporting images as, 499, 609 saving non-raw files as, 484-485 updating, 59, 608 DNG Profile Editor, 342-345 Draft Mode Printing option, 32, 510, 529, 533 drag-and-drop import method, 62-63 Drobo storage system, 636 drop shadows, 546, 548 droplets, Photoshop, 492-495 dual-display setup, 102-105, 471 Dubovov, Mark, 537 DVD media storage, 234, 499

E

Earney, Richard, 395, 619 Edit Capture Time dialog, 138 Edit in External Editor command, 461-462, 466 Edit in Photoshop command, 37, 461, 464,604 Edit Keyword Set dialog, 159, 603 Edit menu, 122 Edit Metadata Presets dialog, 141, 143 Edit Original option, 462 Edit Smart Collection dialog, 180 editing brush strokes, 366 capture time, 138 external editor options for, 461-467 images in Photoshop, 37, 460-479 metadata presets, 142 Effects panel (Develop module), 334-339 Grain effects sliders, 338-339

Post-Crop vignette controls, 334-337, 557 e-mail exporting photos to, 480, 481 links to Web sites in. 596 metadata links to. 148 preconfigured signature for, 596 Web gallery links to, 577 empty field searches, 171 Eraser mode, 366 EXIF metadata, 132, 139, 210, 588 ExifTool editor, 139 Expanded Cells view, 80, 81 Export as Catalog dialog, 217, 222. 224 Export dialog, 40, 480, 481, 482, 486, 494, 496, 497, 499 Export Photo command, 497 exporting, 40, 480–499 actions for, 492-495 bit depth options for, 485-486 catalogs, 217-219, 221, 222, 224, 499 to CDs or DVDs, 499 color space options for, 485 file formats for, 484-485 keywords, 156 location options for, 480 metadata options for, 488-489 naming files for, 484 output sharpening for, 488 plug-ins for, 496-498 post-processing options for, 491 presets for, 480, 481 to same folder, 482-483 selected photos, 222 sizing images for, 486-487 slideshows, 564-567 video files, 40 Web galleries, 592 exposure Basic panel adjustments, 282, 287, 296-299, 310 camera settings for optimum, 275 Match Total Exposures command, 300-301 overexposed image correction, 296-297

exposure (continued) Quick Develop panel adjustments, 253–254 underexposed image correction, 298–299 Exposure slider, 274, 282, 284, 287, 296–299, 310 external editing options, 460–467 preset creation, 465 program selection, 461–462 setting preferences for, 460, 604–606 steps for using, 466–467 Eye-Film technology, 66 Eye-One Photo calibration, 248, 249

F

favorite folders, 115 Feather slider Adjustment brush, 365 Post-Crop vignette, 334 Fetch software, 593 File Format options, 13, 484 file handling imported photos and, 52-53 setting preferences for, 13, 606-611 File Handling panel (Import dialog), 52-53 File Handling preferences, 606-611 Camera Raw cache settings, 610-611 Convert and Export DNG options, 609-610 File Name Generation options, 610 Import DNG Creation options, 606-609 Reading Metadata options, 610 File Renaming panel (Import dialog), 55-56 File Transfer Protocol. See FTP File Type filtering, 169 Filename Template Editor, 55, 603, 604,606 files corrupted, 47 moving to new drive, 236

naming/renaming, 134, 484, 606, 610 organizing, 52, 72-73, 236 saving metadata to, 185, 186-187 See also specific types of files Fill Light adjustment Basic panel, 282, 311 Quick Develop panel, 254 Fill Light slider, 274, 282, 311 Filmstrip, 21 applying Develop settings via, 392-393 creating image selections in, 122 filtering photos via, 113, 114-115 navigating photos via, 100-101 setting preferences for, 614-615 Filter bar, 19, 79, 163-175 advanced searches, 174-175 Attribute section, 167 component layout, 164 custom settings, 171-175 Metadata section, 167–170 searching with, 128-131, 164-166, 171-175 shortcut for toggling, 163 Text section, 164-166 filtering photos, 35, 112-119, 163-175 attribute searches, 167 catalog options for, 113 collections based on, 35, 180 color labels for, 110-111, 116-117 custom settings for, 171-175 filmstrip options for, 113, 114-115 flags used for, 106, 107, 115 keywords used for, 155 master copy filtering, 118 metadata searches, 167-170 refined selections for, 115 rules defined for, 165-166, 171-173 star ratings for, 108-109 subfolder filtering, 119 text searches, 164-166 virtual copy filtering, 118 Firewire connections, 66, 634 flagged photos, 81 deleting rejects, 123 filtering picks/rejects, 115 rating picks/rejects, 106, 107

Flash galleries, 570, 572 Appearance panel settings, 581-583 Color Palette panel settings, 578 Identity Plate options, 584 Site Info panel settings, 577 Title/Caption information, 585, 587 Flash updates, 10 FlashFXP software, 593 Flickr Web site, 181-184 Flow slider, 365 Folder Action button, 240 folders catalogs and, 235-241 copying photos from, 48, 60-61 creating new, 237 exporting to same, 482-483 favorite, 115 importing photos into, 45-46, 64 locating for photos, 240-241 moving to new drive, 236 organizing photos in, 52, 236 renaming, 238, 239 synchronizing, 72, 194-195 system, 235-236, 238-239 template settings, 619 Folders panel (Library module), 72, 73, 78-79, 194, 237 Fors, Tom, 345 fraction characters, 615 Fraser, Bruce, 338, 432, 447, 488 Friedl, Jeffrey, 134, 496 FTP (File Transfer Protocol) programs for using, 593 settings configuration, 38, 593-594 full-screen mode, 27

G

galleries. See Web galleries gamma, 248–249, 628, 629, 632 gamut clipping, 320–321 Gaul, Melissa, 628 General preferences, 600–601 GeoSetter program, 204–208, 210 geotagging software GeoSetter for PCs, 204–208, 210 HoudahGeo for Macs, 209–211 Golden Spiral crop overlay, 269, 271 Google Earth, 203 Google Maps, 203 Gorman, Greg, 285 GPS devices, 204 GPS metadata, 201-211 embedding into photos, 204-211 Google Maps and, 203 recording, 204 Graduated Filter tool, 376-378 Grain effects sliders, 338-339 graphics card, 633-634 gravscale conversions. See black and white conversions gravscale previews, 440, 445, 447 Gretag Macbeth ColorChecker chart. See X-Rite ColorChecker chart Grid crop overlay, 269 Grid view, 24, 80-83, 84, 86, 117 grouping photos, 120-121 guides and rulers, 509, 518 Guides panel (Print module), 509

Н

halo suppression, 444 Hamburg, Mark, 2, 300, 316, 628 hard drives, 634-637 Harvey, Phil, 139 HDR processed images, 498 Heal mode, Spot Removal tool, 354, 356, 359 Help menu, 17 hidina/showina panels, 26, 76 program interface, 34 toolbar, 20 hierarchy, keyword, 154-155, 488-489 High Pass filter, 447 Highlight Edges correction, 326 Highlight Priority vignette, 336, 337 highlights clipping, 273, 282, 284, 287 detail recovery, 296-297 reflective vs. nonreflective, 284 Tone Curve zones and, 306 Highlights slider, 306

Histogram panel Develop module, 273, 282-288 Library module, 252 History panel (Develop module), 379-380 Holbert, Mac, 292, 501 Horizontal transform slider, 331 HoudahGeo program, 209–211 HSL panel (Develop module), 316-321 B&W conversion method, 427 desaturated color adjustments, 426-429 false color hue adjustments, 319 overview of controls, 316 reducing gamut clipping with, 320-321 selective color darkening, 318-319 HSL/Color/B&W panel (Develop module), 316 HTML galleries, 570, 571 Appearance panel settings, 580 Color Palette panel settings, 578 Identity Plate options, 584 Site Info panel settings, 577 Title/Caption information, 585, 587 Hue sliders HSL panel, 316, 318, 319 Split Toning panel, 422

ICM Color Management, 531, 535 Identity Plate, 14-15 Custom Package, 522 photo border options, 514-515 slideshow options, 548, 549, 558, 560 steps for creating, 512-513 Web gallery options, 584 Identity Plate Editor, 512-513, 515, 549, 558, 560 Image Info panel (Web module), 585-589 Image Settings panel (Print module) Picture Package layout, 518 Single Image/Contact Sheet layout, 504-506 Image Size dialog, 556

images. See photos implied keywords, 156 Import dialog, 49-58 Apply During Import panel, 57 compact mode, 44, 45-46 content area, 50-51 Destination panel, 51-52 expanded mode, 49-58 File Handling panel, 52–53 File Renaming panel, 55–56 Import Presets menu, 58 Source panel, 50 Import DNG Creation options, 606-609 Import from Catalog dialog, 219, 220, 221, 225, 228 Import Presets menu, 58 importing photos, 22-23, 43-73 Auto Import feature, 65 backing up and, 53-54 camera card imports, 44-47, 48 catalog imports, 219-221, 225 develop settings and, 57 DNG conversion options, 59 drag-and-drop method for, 62-63 folder imports, 48, 60-61, 64 Import dialog options, 49-58 keyword imports, 155-156 metadata info and, 57, 72-73, 142, 150, 151 organizing and, 52, 72-73 pixel limit for, 54 preferences for, 601 presets created for, 58 previewing and, 52 renaming options, 55-56 storage locations for, 58 terminology used for, 48 tethered shooting and, 22-23, 66-71 importing video files, 64, 65 impromptu slideshows, 563 info overlay, 97, 550 information camera, 139, 169-170 caption, 585-589 copyright, 149, 489 date/time, 137-138, 169 photographic, 517

information (continued) title, 585-589 See also metadata infrared effect, 418-421 inkiet printers, 501, 529 Inside Lightroom Web site, 395, 619 installing Lightroom, 9-10, 221 interface component overview, 18-21 hiding or subduing, 34 setting preferences for, 611-615 simplifying, 26-27 Interface preferences, 611-615 Filmstrip settings, 614–615 keyword entry, 614 Lights Out/Dim modes, 614 module backgrounds, 614 panel settings, 611-613 interpolation methods, 487 inverse searches, 166 IPTC metadata, 57, 132, 142-144, 170, 551 ISO settings metadata info on, 170 noise reduction and, 455

J

JBOD systems, 636–637 JPEG files advantages of, 260 print files saved as, 532, 534 raw files vs., 260–261 saving metadata to, 185, 189–192 slideshows exported as, 566 specifying size limits for, 484 Web gallery images as, 590

Κ

keyboard shortcuts, 41, 262 Keyword List panel (Library module), 150, 151, 153, 154–156, 160 Keywording panel (Library module), 150, 151, 152, 156–159 keywords, 150–159 adding to photos, 150–151 applying existing, 152, 153 auto-completion of, 152 entry options, 614 exporting, 156 filtering, 155 hierarchy of, 154–155, 488–489 implied, 156 importing, 155–156 Painter tool and, 160–162 removing, 154 sets of, 158–159, 603 suggested, 157 *See also* metadata Knoll, John, 4 Knoll, Thomas, 4, 292, 316 Krogh, Peter, 111, 234 Kuler, Adobe, 578

L

Lab mode, 628 labeling photos. See color labels landscape sharpening, 437 Layout panel Print module, 507-509 Slideshow module, 545, 559 Layout Style panel (Print module), 504 Custom Package layout, 522–525 Picture Package layout, 518-521 Single Image/Contact Sheet layout, 502, 504-517 Layout Style panel (Web module), 570-577 AutoViewer gallery layout, 573 Flash gallery layout, 570, 572 HTML gallery layout, 570, 571 PostcardViewer gallery layout. 574, 584 SimpleViewer gallery layout, 575 third-party layout styles, 575-577 LCD displays, 247, 248 Lens Corrections panel (Develop module), 322-333 automatic lens corrections, 330 Chromatic Aberration adjustments, 324-329 custom lens profiles, 331 Lens Vignetting adjustments, 322-323 perspective corrections, 331-333 Transform controls, 331-333

Lens Profile Creator program, 331 lenses automatic corrections for, 272. 330 chromatic aberration from, 324-329 digital vs. film camera, 324 metadata information for, 169 profiles for, 331 vignetting problems, 322-323 Library menu, 113 Library module, 75–123 Catalog panel, 78 Collections panel, 176-180 color labels, 110-111 Compare view, 96–99 dual-display setup, 102–105 Edit menu, 122 Filmstrip, 100-101, 113, 114-115 filters, 79, 112-119, 163-175 Folders panel, 72, 73, 78-79, 194, 237 Grid view, 24, 80-83 Histogram panel, 252 Keyword List panel, 150, 151, 153, 154-156, 160 Keywording panel, 150, 151, 152, 156-159 Library menu, 113 Loupe view, 25, 84-89 Metadata panel, 132-149 Navigator panel, 78 numbered star ratings, 108-109 Painter tool, 160-162 panel controls, 76, 77 pasting Develop settings in, 392 picks and rejects, 106-107 previews, 90-93 Publish Services panel, 181–184 Quick Collections, 35, 176, 177 Quick Develop panel, 252–259 selection options, 122 shortcuts for, 41 Sort menu, 196-199 stacks, 120-121 Survey view, 33, 94-95 Toolbar, 78 View options, 24-25, 80

Lightroom appearance options, 16 Camera Raw integration, 245, 388-391, 464 catalog folder, 620-626 computer setup, 633–637 customizing, 626-627 Help menu, 17 Identity Plate, 14–15 installation, 9-10, 221 interface, 18-21 modular design, 2-3 performance, 3-5, 232 Photoshop integration, 7, 190, 460-479 preferences, 11-13, 599-615, 618 Process Versions, 246, 340 program updates, 600 quickstart guide, 22-40 system requirements, 8, 633 workflow, 5–7 Lightroom News Web site, 41 Lightroom Presets folder, 395 Lightroom Publishing Manager dialog, 181 Lightroom RGB color space, 273, 628-632 Lights Dim mode, 34, 614 Lights Out mode, 34, 614 linear gamma, 629, 632 links catalog to folder, 240-241 to e-mail addresses, 148, 577 restoring to source images, 72, 73 to Web sites, 148, 577, 596 localized adjustments, 36, 364-378 Adjustment brush, 365-375 Graduated Filter tool, 376-378 sharpening images, 452-453 lock files, 216, 620 Loupe view, 25, 84-89, 615 Luminance sliders Detail panel, 454-455 HSL panel, 316, 320, 321, 427, 429 luminous-landscape.com forum, 537 Lyons, Ian, 200, 474

Μ

Macintosh computers backups on, 235 Canon EOS Utility and, 71 geotagging program for, 209-211 Lightroom Preferences on, 11-13, 44 Macintosh 1.8 gamma setting, 248-249 Page Setup dialog, 526 printer settings on, 529-530, 536 switching between modules on, 3 system requirements for, 8 Managed by Lightroom print settings, 536-537 Managed by Printer option, 535 margin settings, 507, 508-509 Masking slider, 447-449 master images, 118, 384-385 Match Total Exposures command, 300-301 McCormack, Sean, 514, 567 megapixels, 633 Melissa RGB, 628, 631 memory cards, 44-47 menu bar, 18 Merge to HDR method, 472 merging catalogs, 226-231 metadata, 126-159, 185-193 copyright status, 149 custom information, 140-145 definition of, 126 displayed in Metadata panel, 132, 134-139 editing for multiple images, 146 efficient way of adding, 145 export options for, 488-489 filter searches using, 167-170 GPS coordinates as, 201-211 image management by, 72-73 imported photos and, 57, 72-73, 142, 150, 151 keywords and, 150-159 mail and Web links, 148 presets, 140-144 saving to files, 185, 186-187 searching with, 128-131

setting preferences for, 610 status information, 136, 188, 389, 391 synchronizing, 193 target photos and, 146-147 tracking changes to, 187-189 types of, 126-127 virtual copies and, 384 Web gallery images, 590 XMP space and, 185, 186-187, 189-192 Metadata panel (Library module), 132-149 action buttons, 148, 149 customizing data in, 140-145 editing data in, 146-147 information displayed in, 132, 134-139 Metadata Status item, 136, 188 view modes, 132-133, 134, 135 Metadata Preset dialog, 57 metadata presets, 140-144 editing/deleting, 142 IPTC metadata, 142-144 Microsoft Expression Media, 214 Midpoint slider, 322, 334 Minimize Embedded Metadata option, 488 Mirror Image mode, 85 mirrored RAID system, 234, 635, 636 missing photos, 170 modal plug-ins, 3 modules Lightroom design using, 2-3 menu for selecting, 18 removing from Lightroom, 626 shortcuts for, 3, 41, 262 See also specific modules monitor. See display screen Move photos option, 48 movies, slideshow, 566-567 music, slideshow, 561, 566, 567

Ν

Nack, John, 201 naming/renaming collections, 179 exported photos, 484 naming/renaming (continued) externally edited photos, 463, 606 folders, 238, 239 illegal characters for, 610 imported photos, 55-56 photo files, 56, 134 Nash, Graham, 501 Navigator panel (Library module), 28, 78 negatives exporting catalogs with/without, 217-218 importing catalogs without, 220 New Develop Preset dialog, 394, 396 newscodes.org Web site, 142 no content searches, 172-173 noise reduction, 454-457 color noise, 455, 456-457 shadow noise, 438 tips on using, 455 nonreflective highlights, 284 novelty layouts, 556-559 numbered star ratings, 108-109 numbering sequence, 56

0

Open as Layers option, 472, 474 Open Catalog dialog, 219, 223 optimizing catalogs, 214, 215, 232 Options panel (Slideshow module), 546-547 organizing photos, 52, 72-73, 236 Output Settings panel (Web module), 590 output sharpening, 435, 488 overexposed image correction, 296-297 Overlay blend mode, 447 overlays, 548-553 Identity Plate, 548, 549 text, 548, 550-553 Overlays panel (Slideshow module), 548-553

Ρ

Page Bleed view, 508 Page Grid area, 508–509

Page panel (Print module), 512-517 borders added in, 514-515, 516 Identity Plate options, 512-515 Page Background Color option, 512 Page Options, 516 Photo Info section, 517 Picture Package, 521 Page Setup dialog, 526 Paint Overlay vignette, 334-336 Painter tool, 160-162 panels contextual menu options, 76, 77 end mark options, 611-613 font size options, 613 hiding and revealing, 26, 76 left panel controls, 20 opening and closing, 21, 25 right panel controls, 21 solo mode for, 262 See also specific panels panoramas, 472-475 paper print profiles, 529, 531, 537, 538 size settings, 526 pasting settings from Develop module, 392 See also copying PCs. See Windows computers PDF documents print files saved as, 510, 532 slideshows exported as, 565–566 Perceptual rendering intent, 538 Photo Border slider, 518 photo galleries. See Web galleries photoGPS device, 201 PhotoKit Sharpener, 488, 533 Photomatix Pro plug-in, 472, 497-498 Photomerge dialog, 473 photos deleting, 123 exporting, 40 filtering, 35, 112–119 importing, 22-23, 43-73 labeling, 110-111 missing, 170 organizing, 52, 72-73, 236 presharpening, 431

publishing, 181-184 rating, 31, 106-109 renaming, 56 restoring links to, 72, 73 retouching, 36, 354-383 rotating, 264, 504, 506 searching for, 128-131 selecting, 122 sorting, 196-199 stacking, 120-121 viewing, 24-25 Photoshop, 6-7, 459, 460-479 droplet creation, 492-495 editing images in, 37, 460-479 extended editing in, 472-475 Lightroom integration with, 7, 190, 460-479 opening photos as Smart Objects in, 476-479 setting editing preferences for, 604-606 steps for working in, 468-471 version issues, 190 picks and rejects, 81 deleting rejected photos, 123 filtering photos flagged as, 115 flagging photos as, 106-107 keyboard shortcuts for, 50, 106 Picture Package layout, 504, 518-521 pixel limit, 54 Playback panel (Slideshow module), 561 Plug-in Manager, 496 plua-ins export, 496-498 modal. 3 slideshow, 567 PNG file format, 613 point curve editing mode, 304-305 Point Curve menu, 303 portrait sharpening, 436 PostcardViewer galleries, 574, 584 Post-Crop vignette controls, 334-337, 557 post-processing options, 491 preferences, 11-13, 599-615 accessing, 11, 44, 599 External Editing, 460, 604-606

file for storing, 618 File Handling, 606–611 General, 600-601 Interface, 611-615 Presets, 601-604 presentations, 541-597 slideshow, 542-567 Web gallery, 568-597 presets Auto Tone, 395 camera-specific, 402-403 Develop module, 394-403 export, 480, 481 how they work, 397 import, 58 keyword set, 158, 603 metadata, 140-144 preferences for, 601-604 resetting, 401 sharpening, 435-437 steps for using, 398-401 tone curve, 304 Presets folder, 394 Presets panel (Develop module), 394-395, 396, 435 presharpening images, 431 previews, 90-93 Adjustment brush, 370 Before/After, 348-353 camera vs. Lightroom, 624 data file for, 214, 219, 623 Detail slider, 447 Develop settings, 90-91 exporting catalogs with, 218-219 generating 1:1, 93, 625 grayscale, 440, 445, 447 Identity Plate, 558 imported photo, 52 Library module, 90–93 Masking slider, 448-449 Photoshop edit, 471 processing routines, 624-626 quality settings, 91-93, 626 Radius slider, 447 RGB color, 630-632 size settings, 91–93 slideshow, 562 Web gallery, 591

Print button, 528, 531, 532 print collections, 502, 525 Print dialog, 529, 536 print drivers, 528, 531 Print Job panel (Print module), 39, 528-538 Color Management settings, 528 Draft Mode Printing option, 533 Lightroom printing procedure, 528-532 Print Sharpening option, 533 Print to JPEG File option, 534 Profile menu, 535 Rendering Intent options, 538 Print module, 502-539 Cells panel, 518-520 Custom Package layout, 522–525 Guides panel, 509 Image Settings panel, 504-506, 518 interface overview, 502-504 Layout panel, 507-509 Layout Style panel, 504 Page panel, 512-517, 521 Page Setup dialog, 526 Picture Package layout, 518-521 Print Job panel, 528-538 Print Setup dialog, 526, 527 Rulers, Grid & Guides panel, 518 Single Image/Contact Sheet layout, 504-517 Template Browser panel, 539 Print One button, 528, 531, 532 print profiles, 529, 531, 535-538 Print Resolution option, 533 Print Setup dialog, 526, 527, 530, 537 Print Sharpening options, 435, 533 Print to JPEG File option, 532, 534 Printer Properties dialog, 531, 537 printing, 501-539 16-bit, 534 contact sheets, 32, 510 custom profiles for, 535-538 draft mode for, 32, 510, 529, 533 high-guality prints, 39 to JPEG file, 532, 534 Lightroom procedure for, 528-532 margin adjustments for, 507

mode settings for, 533 to PDF file, 510, 532 rendering intent for, 538 resolution for, 488, 509, 527, 533 saving settings for, 39 sharpening images for, 435, 488, 533 templates for, 39, 502, 525, 530, 539 Process Versions, 246, 340 profiles camera, 340-341 lens, 331 print, 529, 531, 535-538 ProPhoto RGB color space, 273, 462, 485, 494, 591, 628, 630 PSD files, 52-53 edit copy options and, 462 saving metadata to, 185, 189-192 Publish Services panel, 181–184 publishing photos, 181-184 Pupil Size slider, 362

Q

Quality slider, 565, 590 Quick Collections, 35, 176, 177 saving as permanent collections, 176 searching for photos using, 130–131 Quick Develop panel (Library module), 252–259 color controls, 253 cropping options, 258 synchronizing settings, 257, 259 tone controls, 253–254 typical workflow, 255–257 quickstart quide, 22–40

R

Radius slider, 442–443 RAID systems, 234, 635–636, 637 RAM memory, 633 rating photos, 31, 106–109 numbered star ratings, 108–109 picks and rejects, 106–107 slideshow options, 548

raw files advantages of, 260 converting to DNG, 59, 609 Detail panel adjustments, 435 editing in Photoshop, 461-462. 464 JPEG files vs., 260-261 previews of, 624 processing of, 433-435 See also Camera Raw Real World Image Sharpening with Adobe Photoshop CS4 (Fraser). 447 Recovery slider, 274, 282, 287, 297. 310 Red Eye Correction tool, 360-364 cursor size adjustment, 360 steps for using, 361-364 Redo command, 380 reflective highlights, 284 rejects and picks. See picks and rejects Relative rendering intent, 538 Reload command, 586 removina keywords from the Keyword List, 154 photos from the catalog, 123 red eye from images, 360-364 spots on photos, 354-359 See also deleting Rename Files switch, 55 Rename Photos dialog, 56 renaming. See naming/renaming Render Preview options, 52, 53 Rendering Intent options, 538 Repeat One Photo per Page option, 504, 506 Reset All button, 254 Resize to Fit options, 486 resizing. See sizing/resizing Resnick, Seth, 155 resolution image size and, 486, 533 print reproduction and, 488, 509, 527, 533 Restore Filename Templates button, 603

retouching photos, 36, 354-383 Adjustment brush for, 365-375 Graduated Filter tool for, 376-378 History panel and, 379-380 localized adjustments, 36, 364-378 Red Eye Correction tool for, 360-364 Snapshots panel and, 380-383 Spot Removal tool for, 354-359 RGB channels, 408 RGB workspace, 244, 247, 628 Riecks, David, 156 Rotate slider, 331 Rotate to Fit option, 504, 506, 518 rotating photos cropping and, 264 printing and, 504, 506 Roundness slider, 334 rulers and guides, 509, 518 Rulers, Grid & Guides panel (Print module), 518

S

Saturation adjustment Basic panel, 289-291 Quick Develop panel, 254 Saturation sliders Basic panel, 289-291 HSL panel, 316, 318, 426, 427 Split Toning panel, 422 saving Adjustment Brush settings, 366 Develop settings as presets, 394-401 metadata to photo files, 185, 186-187 print templates, 39, 539 Quick Collections, 176 slideshow templates, 564 variations as snapshots, 380-381 Web gallery templates, 597 Scale slider, 331 Schewe, Jeff, 436, 447, 454, 488, 524, 533 Screen output option, 488 Scripts folder, 626

searching attribute filter for, 167 example of advanced, 174-175 metadata used for, 128-131, 167-170 rules defined for, 165-166. 171-173 text filter for, 164-166 secondary backups, 53–54 Secure File Transfer Protocol (SFTP). 593 selections, 82 contiguous vs. noncontiguous, 82, 169 Edit menu options for, 122 Slideshow module options for, 563 sensors, cleaning, 356 sequence numbers, 56 sets collection, 180 keyword, 158-159 shadows clipping, 273, 282, 284-285 darkening, 285, 308, 313 drop, 546, 548 lightening, 298-299 noise in, 438 Shadows slider, 308, 313 sharpening, 431-453 capture, 432, 487 effects sliders, 439-443 evaluating at 1:1 view, 439 grayscale previews of, 440, 445, 447 improved features for, 433-435 interpolation and, 487 landscape, 437 localized, 452-453 luminance targeted, 439 negative, 453 output, 435, 488 portrait, 436 presets for, 435-437 print, 435, 488, 533 sample image for, 438 steps for using, 450-451 suppression controls, 444-449 Web gallery images, 590

Sharpening controls Adjustment brush, 374-375 Amount slider, 440-441 Detail panel, 432, 439-451 Detail slider, 444-446 Masking slider, 447-449 Ouick Develop panel, 254 Radius slider, 442-443 shortcuts, 41. 262 showing/hiding. See hiding/showing shutter speed information, 169 sidecar files, 134, 200 SimpleViewer galleries, 575 Single Image/Contact Sheet layout, 502, 504-517 Site Info panel (Web module), 577 Size slider Adjustment brush, 365 Spot Removal tool, 354, 356 sizing/resizing images for exporting, 486-487 interpolation and, 487 previews, 91-93 print output, 533 skin tone corrections, 317 Skurski, Mike, 488 Slide Editor view, 544, 550, 553 Slideshow module, 542-567 Backdrop panel, 554-555 interface overview, 542-543 Layout panel, 545, 559 Options panel, 546-547 Overlays panel, 548-553 Playback panel, 561 Preview mode, 562 Slide Editor view, 544, 550, 553 Template Browser panel, 563-564 Titles panel, 560 SlideshowPro plug-in, 567 slideshows, 542-567 backdrops for, 554-555 collections for, 178-179 color processing for, 591 exporting, 564-567 Identity Plates, 548, 549, 558, 560 impromptu, 563 navigating, 562-563 novelty layouts, 556-559

PDF or JPEG, 565-566 playing, 562 plua-ins for, 567 previewing, 562 selections for, 563 soundtracks for, 561, 566, 567 speed/duration options, 561 templates for, 542, 563-564 text overlays, 550-553 titles for, 560 video, 566-567 Smart Collections, 35, 180 Smart Objects, 245, 476-479 Snapshots panel (Develop module), 380-383 saving variations using, 380-381 Sync Snapshots feature, 380, 382-383 Soften Skin effect, 370-371 solo mode for panels, 262 sorting photos, 196-199 color labels and, 197-199 overview of options for, 196 tethered shooting and, 70 text labels and, 199 sounds, task completion, 601 See also audio soundtracks, slideshow, 561, 566, 567 Source panel (Import dialog), 50 specular highlights, 284 splash screen, 600 Split Toning panel (Develop module) black and white conversions, 406, 415, 421, 422-425 color image adjustments, 424-425 Spot Removal tool, 354-359 auto-select sample point mode, 357 instructions for using, 354-356 keyboard shortcuts for, 354 synchronized spotting with, 358-359 Tool Overlay options, 357 sRGB color space, 273, 462, 485, 494, 630 Stacking menu, 120, 121 stacks, 120-121 Auto-Stack feature, 120-121

expanding/collapsing, 120, 121 standard Loupe view, 84, 89 star ratings, 108-109 Stern, Zalman, 4 Straighten tool, 267 striped RAID system, 635, 636 Stroke Border option, 546, 547 subfolders, filtering, 119 suggested keywords, 157 Survey view, 33, 94-95 Sync Snapshots feature, 380, 382-383 Synchronize Folder command, 389 Synchronize Metadata dialog, 193 Synchronize Settings dialog, 257, 259, 358, 383, 386, 387 synchronizing Auto Sync mode for, 359, 386 Develop settings, 30, 257, 259, 386-387 folders, 72, 194-195, 389 Lightroom with Camera Raw, 389-391 metadata settings, 193 Photoshop edits, 469-470 snapshots, 380, 382-383 spot removal settings, 358-359 system folders, 235-236, 238-239 System Info dialog, 637 system requirements, 8, 633

Т

Target Adjustment tool, 302, 306, 316, 417, 427 target collections, 179-180 target images, 146-147, 537 Temperature slider B&W conversions, 410-411, 414 White Balance adjustments, 280 Template Browser panel, 32 Print module, 539 Slideshow module, 563-564 Web module, 597 templates print, 39, 502, 517, 525, 530, 539 saving custom, 539 settings folder for, 619 slideshow, 542, 563-564 text, 586, 588-589

templates (continued) updating, 539 Web gallery, 597 Tethered Capture Settings dialog. 23.68 tethered shooting, 22-23, 66-71 cable connection for, 66, 71 connecting cameras for, 66-67 software solutions for, 67, 71 speed considerations for, 71 steps in process of, 68-70 wireless, 66-67 text filter searches, 164-166 overlays, 548, 550-553 photo info, 517 Sort by Label option, 199 Text Template Editor, 604 Print module, 517 Slideshow module, 550, 551 Web module, 586, 588 TheTurningGate.net Web site, 575-576 third-party gallery styles, 575-577 thumbnails badges displayed with, 81 Flash gallery size settings, 581 preview building routine, 91 processing routines for, 624-626 restoring links from, 72, 73 TIFF files edit copy options and, 462 exporting photos as, 484 saving metadata to, 185, 189-192 Time Machine backups, 235 time/date information. See date/time information Tint slider B&W conversions, 410, 421 White Balance adjustments, 280 titles slideshow, 560 Web gallery, 577, 585-589 Titles panel (Slideshow module), 560 tone controls Quick Develop panel, 253-254 Tone Curve panel, 302-315

Tone Curve panel (Develop module), 302-315 Basic panel and, 283, 303, 308-313 Darks slider, 302, 312 Highlights slider, 306, 312 overview of controls in. 302-303 point curve editing mode, 304-305 Point Curve menu, 303 Shadows slider, 308, 313 Tone Curve zones, 306-308 tone range split points, 303, 314-315 Tool Overlay options, 272, 357 Toolbar, 20 Develop module, 357 Import dialog, 50 Library module, 78 Slideshow module, 542, 563 Triangle crop overlay, 269, 270 typographic fractions, 615

U

underexposed image correction, 298–299 Undo command, 380, 554 Unsharp Mask filter, 432 updates, automatic, 600 Upload Settings panel (Web module), 593–596 uploading Web galleries, 593–596 creating custom presets, 593 naming gallery subfolders, 595 USB connections, 66, 634

۷

Vertical transform slider, 331, 333 Vibrance adjustment Basic panel, 289–291 HSL panel, 427 Quick Develop panel, 254 Vibrance slider, 274, 289–291, 427 video files exporting, 40, 566–567 importing, 64, 65 slideshows as, 566–567

view modes Develop panel, 348–353 Metadata panel, 132–133 View Options (Library module) Compare view, 96-99 Grid view, 24, 80-83 Loupe view, 25, 84-89 Survey view, 33, 94-95 vianettina applying to photos, 322, 334-337 correcting problems with, 322-323 virtual copies copy names for, 134, 136 creating for photos, 384-385 external editing with, 469-470 filtering for, 118 snapshots vs., 384

W

warning alerts, 601 Watermark Editor, 490-491, 512 watermarks copyright, 489 creating, 490-491 print, 512 Web browsers, 592, 594 Web galleries, 38, 568-597 AutoViewer, 573 captions for, 585-589 color processing for, 591 color themes for, 578-579 exporting, 592 Flash, 570, 572 HTML, 570, 571 Identity Plate options, 584 layout appearance, 580-584 metadata information, 590 PostcardViewer, 574, 584 previewing, 591 quality settings, 590 sharpening images in, 590 SimpleViewer, 575 styles for, 570-577 templates for, 597 third-party, 575-577 titles for, 585-589 uploading, 593-596

Web module, 38, 568-597 Appearance panel, 580–584 Color Palette panel, 578-579 Export and Upload buttons, 592 Image Info panel, 585-589 interface overview, 568-569 Layout Style panel, 570-577 Output Settings panel, 590 Preview in Browser button, 591 Site Info panel, 577 Template Browser panel, 597 Upload Settings panel, 593–596 Web safe colors, 578 Web sites e-mail links to, 596 metadata links to, 148 Web gallery links to, 577 white balance B&W conversions, 412-415

Basic panel adjustments, 277-281, 286.309 display screen calibration, 248-249 Quick Develop panel adjustments, 253 White Balance tool, 277-281, 286, 309 white point, 248, 280 Windows computers Canon EOS Utility and, 71 geotagging program for, 204-208 Lightroom Preferences on, 11–13, 44 Print Setup dialog, 526, 527 printer settings on, 530-531, 537 switching between modules on, 3 system requirements for, 8

wireless shooting, 66–67 WS_FTP Pro software, 593

Х

 XMP space explanation of, 189 read/write options, 189–192 saving metadata to, 185, 186–187
 X-Rite Eye-One Photo, 248, 249
 X-Rite ColorChecker chart, 279, 342

Ζ

Zoom slider, 88, 89 Zoom to Fill Frame option Print module, 504, 505, 518 Slideshow module, 546, 547 zooming in/out, 28, 88

Meet Creative Edge.

A new resource of unlimited books, videos and tutorials for creatives from the world's leading experts.

Creative Edge is your one stop for inspiration, answers to technical questions and ways to stay at the top of your game so you can focus on what you do best—being creative.

All for only \$24.99 per month for access—any day any time you need it.

creative

peachpit.com/creativeedge